D0911827

Vito Acconci	Susan Hiller
Eve Arnold	Candida Höfer
Art & Language	Komar and Melamid
Michael Asher	Louise Lawler
Lothar Baumgarten	Jean-Baptiste Gustave Le Gray
Barbara Bloom	Jac Leirner
Christian Boltanski	Zoe Leonard
Marcel Broodthaers	Sherrie Levine
Daniel Buren	El Lissitzky
Sophie Calle	Allan McCollum
Janet Cardiff	Christian Milovanoff
Henri Cartier-Bresson	Vik Muniz
Christo	Claes Oldenburg
Joseph Cornell	Dennis Oppenheim
Jan Dibbets	Charles Willson Peale
Lutz Dille	Hubert Robert
Mark Dion	Edward Ruscha
Herbert Distel	David Seymour
Marcel Duchamp	Robert Smithson
Kate Ericson	Thomas Struth
Elliott Erwitt	Hiroshi Sugimoto
Roger Fenton	Charles Thurston Thompson
Robert Filliou	Stephen Thompson
Larry Fink	Jeff Wall
Fluxus	Gillian Wearing
Günther Förg	Christopher Williams
Andrea Fraser	Fred Wilson
General Idea	Garry Winogrand
Hans Haacke	Mel Ziegler
Richard Hamilton	

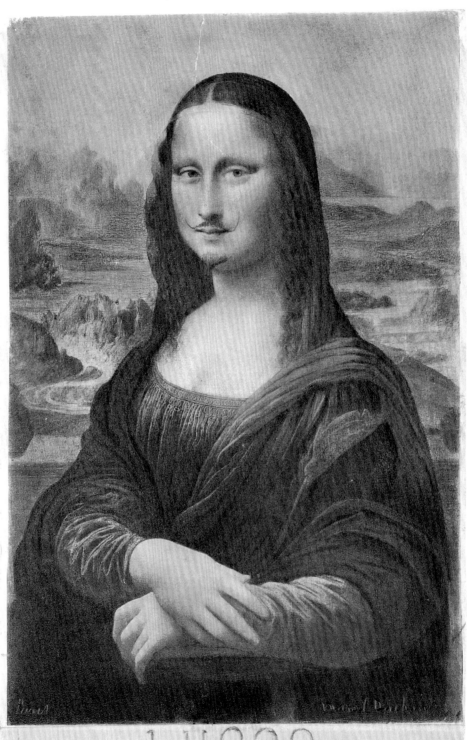

L.H.O.O.Q.

The Museum as Muse
Artists Reflect

Kynaston McShine

The Museum of Modern Art, New York

Published on the occasion of the exhibition *The Museum as Muse: Artists Reflect*, organized by Kynaston McShine, Senior Curator, Department of Painting and Sculpture, The Museum of Modern Art, New York, March 14–June 1, 1999.

The exhibition is made possible by the Contemporary Exhibition Fund of The Museum of Modern Art, established with gifts from Lily Auchincloss, Agnes Gund and Daniel Shapiro, and Jo Carole and Ronald S. Lauder.

The artists' commissions are made possible by The Bohen Foundation.

Additional generous support of the exhibition is provided by The International Council of The Museum of Modern Art.

The accompanying publication is supported by The Andy Warhol Foundation for the Visual Arts.

The accompanying Web site and on-line artists' projects are made possible by The Contemporary Arts Council and The Junior Associates of The Museum of Modern Art.

Produced by the Department of Publications
The Museum of Modern Art, New York
Edited by Harriet Schoenholz Bee,
David Frankel, and Jasmine Moorhead
Designed by 2 X 4, Penny Hardy and Michael Rock
Production by Marc Sapir
Printed and bound by Arnoldo Mondadori S.p.A., Verona

Copyright © 1999 by The Museum of Modern Art, New York
Certain illustrations are covered by claims to copyright cited in the Photograph Credits.
All rights reserved.

Library of Congress Catalogue Card Number: 98-068644
ISBN 0-87070-091-X (MoMA, T&H, clothbound)
ISBN 0-87070-092-8 (MoMA, paperbound)
ISBN 0-8109-6197-0 (Abrams, clothbound)

Published by The Museum of Modern Art
11 West 53 Street, New York, New York 10019
www.moma.org
Clothbound edition distributed in the United States and Canada by Harry N. Abrams, Inc., New York. www.abramsbooks.com
Clothbound edition distributed outside the United States and Canada by Thames & Hudson, Ltd., London

Printed in Italy

Front and back covers (background): Vik Muniz. *Equivalents (Museum of Modern Art)*. 1998. Gelatin silver print, 8 x 10" (20.3 x 25.4). Collection the artist

Front cover: Marcel Duchamp. *Boîte-en-valise (de ou par Marcel Duchamp ou Rrose Sélavy)*. 1935–41. Leather valise containing miniature replicas, photographs, and color reproductions of works by Duchamp, and one "original": *Large Glass*, collotype on celluloid (69 items), 7 ½ x 9 ¼" (19 x 23.5 cm); overall 16 x 15 x 4" (41 x 38 x 10 cm). [IX/XX, from Deluxe Edition]. The Museum of Modern Art, New York. James Thrall Soby Fund

Back cover, top: Jan Dibbets. *Guggenheim I*. 1986. Color photographs, watercolor, and grease pencil on paper, mounted on laminated particleboard, 6' ⅞" x 6' ⅞" (185 x 185 cm). Private collection, Amsterdam

Back cover, center: El Lissitzky. *Sketch for the Kabinett der Abstrakten*. 1927–28. Watercolor on paper, sheet 5 ⅝ x 8 3/16" (14.2 x 20.7 cm). Sprengel Museum, Hannover

Back cover, bottom: Thomas Struth. *Musée du Louvre IV, Paris*. 1989. Cibachrome print, 6' 7/16" x 7' 1 1/16" (184 x 217 cm). Marieluise Hessel Collection, on permanent loan to the Center for Curatorial Studies, Bard College, Annandale-on-Hudson, New York

Frontispiece: Marcel Duchamp. *L.H.O.O.Q.* 1919. Rectified Readymade: pencil on a reproduction, 7 ¾ x 4 ⅞" (19.7 x 12.4 cm). Private collection, Paris

Endpapers: Designed by Daniel Buren

Contents

Foreword

Museums are generally understood to be places of learning and inspiration, the home of the muses. Although the earliest museums owed their origins to collections first formed in the Hellenistic era, and the Alexandria of the Ptolemies, in particular, the institution as we know it today is primarily a creation of the Enlightenment, at the end of the eighteenth century. Like other institutions of the Enlightenment, the museum was construed to be fundamentally educational, a venue for the systematic organization and presentation of artistic and natural phenomena. Inherent in this conception of the museum is the idea of the institution as a public space, dedicated to the diffusion of knowledge. This notion of the museum stands in stark contrast to the medieval treasury and the *Wunderkammer*, or cabinet of curiosities, of the Renaissance, where odd rarities were brought together either as ecclesiastic trophies or for private contemplation and pleasure. But the Enlightenment ideal of the museum as an instrument of broad public education has always been tempered by the reality that looking at art is as much a sensory experience as it is a pedagogical one. More recently the museum has also become a place of "religious" or quasi-religious experience, the cathedral or temple of our times. For members of an ever-increasing public, the opportunity to spend quiet moments contemplating art, often in an architecturally distinctive space, enables the kind of spiritual repose and intellectual regeneration so essential to individual emotional and psychic well-being.

These points are raised not to give a short history of the museum but to underscore the nature of *The Museum as Muse: Artists Reflect*. For this exhibition is about the rich, varied, and complex relationship that exists between artists and museums. It argues that during the twentieth century, if not before, the museum ceased to be simply a repository of objects and became, instead, an independent locus of artistic inspiration and activity. In this guise the museum is no longer the home of the muses nor a center of learning or spiritual discovery, but a muse itself.

Artists, of course, have a unique relationship with museums. They are, at once, visitors and users of the institution and the creators of the objects that constitute the institution. Museums, for them, are thus both venues of stimulation and ideas and home to the results of those inspirations and ideas. This means that artists are constantly negotiating a delicate balance within the museum between being the observer and the observed. *The Museum as Muse* takes as its point of departure the fact that the museum, as it has evolved in the twentieth century, has become an important site not only of inspiration but of practice and of patronage. This wider activity, however, is not simply about production and support, for museums are highly charged institutions where a variety of issues and ideas intersect. These range from what works of art to acquire to when, where, and how to display and interpret them. Interwoven into these issues are larger questions about the "space" of the museum and the way in which the intellectual and curatorial framework of the institution shapes and structures the experience of looking at art. For artists to enter into the complex web of associations generated by the dynamic of the museum involves not only their having met the already formidable challenges of creative activity but extends to their intervening in the narrative of the institution, a narrative formed by the unique relationship of ideas and objects that is the museum.

The Museum as Muse: Artists Reflect comes at a timely moment. Over the last two decades many new art museums have been created, a great portion of which are devoted to modern and contemporary art. Once seen as elite, such institutions have become highly attended attractions, with soaring attendance, escalating budgets, diverse educational programs, and broad popular appeal. No longer are museums simply artistic and intellectual centers; they are now equally important as social and cultural venues as well as vital economic forces in their communities. They are quickly emerging as the preeminent cultural institutions of our time. *The Museum as Muse: Artists Reflect* examines in detail how the museum is perceived and understood by artists, and also how it has inspired them. The more than sixty artists in the

exhibition explore everything from the theoretical and conceptual underpinnings of the institution to its ethical and financial practices and internal politics. They question and challenge the museum, engage and react to it, some with passion and deep affection, others with skepticism and concern. What they reveal about the museum, as an institution and as a source of knowledge and inspiration, is fascinating, informative, and provocative and enriches our understanding of the museum as well as the practice of each of the artists involved in this show.

The exhibition and the publication that accompanies it were conceived and organized by Kynaston McShine, Senior Curator in the Department of Painting and Sculpture at The Museum of Modern Art. Both are enriched by the enormous insight, sensitivity, knowledge, and erudition that Mr. McShine has brought to nearly four decades of involvement with museums and artists. On behalf of the Trustees of the Museum, the staff, and the public who have the opportunity and privilege of viewing the exhibition and reading the book, I wish to acknowledge, with great pleasure, the debt that all of us at The Museum of Modern Art owe him for having brought this project into being.

Finally, the most essential element of any exhibition is necessarily the generosity of the artists and lenders. Without their cooperation an exhibition, however well conceived, cannot be realized. In this instance, their help has been extraordinary and represents a high tribute to the theme of the exhibition. On behalf of the Trustees, the curator, and the staff of The Museum of Modern Art, I wish to express our deepest appreciation to the Contemporary Exhibition Fund, established with gifts from Lily Auchincloss, Agnes Gund and Daniel Shapiro, and Jo Carole and Ronald S. Lauder, which has made this exhibition possible. I also thank The Bohen Foundation for its generous and far-sighted support of the production and installation of the works of art commissioned for this exhibition. Similarly, the support received from The International Council of The Museum of Modern Art continues its distinguished tradition of furthering contemporary art. The Contemporary Arts Council and The Junior Associates of The Museum of Modern Art have made possible the accompanying Web site and on-line artists' projects. This publication has been generously supported by The Andy Warhol Foundation for the Visual Arts.

Glenn D. Lowry, Director
The Museum of Modern Art, New York

Acknowledgments

The Museum as Muse: Artists Reflect has been an extraordinary undertaking, especially given its complex topic. However, the intricacy of the organization of both the exhibition and its accompanying publication has been simplified by the remarkable collaboration and cooperation of many friends and colleagues. We all owe them an immeasurable debt of gratitude. I am especially grateful to the contemporary artists included in the exhibition, particularly those who created new work: Michael Asher, Daniel Buren, Janet Cardiff, Mark Dion, Louise Lawler, Allan McCollum, and Fred Wilson. Several artists also have been particularly helpful to us during the preparation, and I cite Vito Acconci, Lothar Baumgarten, Christian Boltanski, AA Bronson, Sophie Calle, Henri Cartier-Bresson, Herbert Distel, Vik Muniz, and Jeff Wall.

This endeavor would not have been possible without the essential support of the lenders, many of whom have made extraordinary concessions in parting with important works for the duration of the exhibition. I specifically wish to thank the following individuals and institutions: the Musée du Louvre, Paris; Museum moderner Kunst Stiftung Ludwig, Vienna; Martine Schneider of Galerie Beaumont, Luxembourg; Robert Lehrman; The Menil Collection, Houston; the Kunsthaus Zürich; Ronny and Jessy Van de Velde; The Royal Photographic Society, Bath; the Howard Gilman Foundation; The Bohen Foundation; Ydessa Hendeles Foundation; The Victoria and Albert Museum, London; the Kunstmuseum Lucerne; The Museum of Contemporary Art, Los Angeles; and the Pennsylvania Academy of the Fine Arts, Philadelphia.

Many friends and colleagues went to much trouble to facilitate the loans and the research for this project. I am especially indebted to Pierre Apraxine, Barry Barker, Martin Barnes, Norton Batkin, Douglas Baxter, Marie-Claude Beaud, Tawnie Becker, Monique Beudert, Ecke Bonk, Manuel Borja-Villel, Marie-Puck Broodthaers, Benjamin H. D. Buchloh, Recha Campfens, Riva Castleman, Tim Clifford, Paula Cooper, Jean-Pierre Cuzin, Susan Davidson, Hugh Davies, Colin de Land, Luca Dosi Delfini, Martin Durrant, Dietmar Elger, Ronald Feldman, Susan Ferleger Brades, Barry Flanagan, Richard Flood, Maria Gilissen, Marian Goodman, Pamela Griffin, José Guirao Cabrera, Anthony Hamber, Jürgen Harten, Linda Hartigan, Mark Haworth-Booth, Thomas Healy, Jon Hendricks, Walter Hopps, Christian Klemm, Richard Koshalek, Susan Lambert, Steingrim Laursen, James Lavender, Kate Linker, Nicholas Logsdail, Michelle Maccarone, Jacqueline Matisse, Daniel McDonald, Ivo Mesquita, James Meyer, Francis M. Naumann, Richard E. Oldenburg, Maureen Paley, Richard Palmer, David Platzker, Amy Plumb, André Rogger, Pierre Rosenberg, Marie-Catherine Sahut, Daniel Rosenfeld, Paul Schimmel, Thomas Schulte, Nicholas Serota, Linda Shearer, Joanne M. Stern, Sophie Streefkerk, Alain Tarica, Ann Temkin, Vicente Todoli, Gordon VeneKlasen, Marcantonio Vilaça, Joan Weakley, John Weber, Michael Werner, and Charmaine Wheatley.

The Museum of Modern Art has given its wholehearted support of this exhibition, and I acknowledge the vital contribution of the Museum's staff with profound appreciation. Glenn D. Lowry, Director, has not only provided an insightful foreword to this volume, but his enthusiasm for this project and astute judgment have been an unfailing source of encouragement to me. Kirk Varnedoe, Chief Curator in the Department of Painting and Sculpture, has contributed essential and much-valued advice and has generously allowed this exhibition to intrude on spaces in the collection galleries. His confidence in this project has been a true source of inspiration. I am especially indebted to John Elderfield, Chief Curator at Large and former Deputy Director for Curatorial Affairs, for his assistance. We are all personally indebted to Jennifer Russell, Deputy Director for Exhibitions and Collections Support, who has supervised all aspects of this exhibition from its inception.

I wish to single out the four people who have been most intimately involved in the realization of this publication and exhibition. Mattias Herold, Executive Secretary, has, with extraordinary patience, amazing good will, and competence, undertaken formidable tasks of organization, and I cannot adequately thank him for his dedication and effectiveness. James Trainor, Research Assistant, skillfully did a great deal of preliminary research, and his contribution to the publication cannot be underestimated. Kristen Erickson, Curatorial Assistant, has brought to the project superb skills and abilities combined with grace, good judgment, and highly developed professionalism. Her efforts could not be more deeply appreciated. Above all, Lilian Tone, Curatorial Assistant, has been a collaborator in this project. Her curatorial insights, her relentless dedication, her effective intelligence, and her mastery of problems and complex issues has been amazing. Her enthusiasm for this project has been unflagging and boundless. She has my most sincere and deeply felt gratitude. Without the labors and professional excellence of these individuals, this exhibition and publication would not have been possible. We and the Museum owe them an enormous debt.

The main burden of this project has fallen on the Department of Painting and Sculpture and particularly on the curatorial and research team that worked directly with me. Outside those who worked directly on the project, my deepest thanks must go to Curator Carolyn Lanchner, whose counsel and extraordinary insights have been indispensable. She is a much valued colleague and friend. Cora Rosevear, Associate Curator, was, as always, attentive to complicated loan arrangements. Others in the department who have contributed in various ways with intelligence and goodwill and to whom we are much in debt are: Ramona Bannayan, Manager; Fereshteh Daftari, Assistant Curator; Beth Handler, Curatorial Assistant; Robert Storr, Curator; and Anne Umland, Assistant Curator. Delphine Dannaud, Administrative Assistant, helped with preliminary research and carefully translated several texts. We have had a great deal of research facilitated by interns Beck Feibelman, Mary Kiplok, Susanne König, Georgia Lobacheff, Lisa Pasquariello, and Regine Rapp.

The publication of this book has been a complicated task and I am profoundly indebted to the members of the Department of Publications for their efforts in its realization. Michael Maegraith, Publisher, has taken an informed and open-minded interest in this project. His advice has been well-measured and appreciated. Harriet Schoenholz Bee, Managing Editor, has, with her customary aplomb and expertise, supervised all the issues of publication, and her skills have transformed the concept into the object. She has my sincere thanks. I cannot adequately express my personal debt to Editor David Frankel. With sensitivity and thoughtfulness as well as his truly generous spirit he made incalculable and invaluable contributions to my essay. He has my true admiration and gratitude. Marc Sapir, Production Manager, oversaw the book's production with his customary high professionalism and skilled eye. In the same department, essential contributions were also made by Nancy T. Kranz, Manager, Promotion and Special Services, Jasmine Moorhead, Assistant Editor, and Gina Rossi. The publication was sensitively and imaginatively designed by 2x4, especially Michael Rock and Penny Hardy.

This volume brings together written contributions from a number of authors addressing a disparate body of work. I am particularly grateful to those

who provided new essays for this volume, often under tight deadlines, and also thank those who allowed us to reprint previously published texts: Vito Acconci, Michael Asher, Lothar Baumgarten, Christian Boltanski, Ecke Bonk, AA Bronson, Coosje van Bruggen, Benjamin H. D. Buchloh, Daniel Buren, Sophie Calle, Jacqueline Darby, Magdalena Dabrowski, Mark Dion, Herbert Distel, Kristen Erickson, Andrea Fraser, Richard Hamilton, Jodi Hauptman, Dave Hickey, Susan Hiller, Candida Höfer, Vincent Katz, Thomas Kellein, Sherrie Levine, Kate Linker, Allan McCollum, Thomas McEvilley, Vik Muniz, Dennis Oppenheim, Birgit Pelzer, John Roberts, Martin Schwander, Kitty Scott, Willoughby Sharp, Susan Stewart, Thomas Struth, Hiroshi Sugimoto, Lilian Tone, James Trainor, Jeff Wall, Brian Wallis, Fred Wilson, Sally Yard, and Mel Ziegler. I also wish to thank those authors and publishers who permitted us to reprint excerpts of texts about museums in the artists' writings section of this volume.

Jerome Neuner, Director of the Department of Exhibition Design and Production, and his assistants creatively solved a variety of complex problems in planning the installation of the exhibition. As always, I have relied on his imaginative solutions. I cannot adequately express my thanks to him. In the Department of Exhibitions, I wish to thank Linda Thomas, Coordinator of Exhibitions, and Eleni Cocordas, Associate Coordinator, for their professional attention to the many issues associated with an international project of this sort. Their assistance has been invaluable. Special thanks are also extended to the Department of the Registrar, especially Terry Tegarden, Associate Registrar, who handled myriad problems relating to complicated loans from both domestic and foreign institutions. Within the Registrar's office, I also wish to thank Pete Omlor, Manager, Art Handling and Preparation, and my friends the preparators for their assistance in preparing and mounting the exhibition. As is customary, we have relied on the indispensable advice of James Coddington, Chief Conservator, and his staff for their scrupulous attention to the loans entrusted to the Museum. The exhibition has relied on existing and new photography, and I wish to thank the Museum's photographers, Kate Keller, Chief Fine Arts Photographer, and John Wronn, Fine Arts Photographer, who provided new images of several works for the publication. I also wish to thank the entire Department of Photographic Services and Permissions, especially Jeffrey Ryan, Senior Assistant, Photographic Archives, who assisted Fred Wilson with a special project.

Elsewhere in the Museum, Peter Galassi, Chief Curator in the Department of Photography, unstintingly shared his vast knowledge of photography and I deeply appreciate his insights. The staff of the photography department, as well as the chief curators and staff in the departments of Drawings, Prints and Illustrated Books, Architecture and Design, and Film and Video, have all contributed and been sympathetic to this project. We thank them. Guidance on the legal issues relating to this exhibition has been expertly and professionally offered by the General Counsel's office, and I extend special thanks to Stephen W. Clark, Associate General Counsel, for his advice. Elizabeth Addison, Deputy Director for Marketing and Communications, and her staff were effective in promoting this exhibition, and I wish to thank Mary Lou Strahlendorff, Director, and Graham Leggat, Assistant Director, in Communications for skillfully handling public-relations issues. In the International Program, Director Jay Levenson deserves our gratitude and so does Carol Coffin, Executive Director of The International Council.

Patterson Sims, Deputy Director for Education and Research Support, has been a creative force in the development of public programs, educational projects and issues relating to the Web site. Greg Van Alstyne, Design Manager,

New Media, oversaw the exhibition's subsite and on-line projects, and Stadium was particularly helpful with the Web project created by Allan McCollum. The graphics of the exhibition in the galleries, and of the Web site, were the responsibility of Senior Graphic Designer Ed Pusz and Isabel Hernandez. The Museum's Library has been the source of much useful documentation; Chief Librarians Janis Ekdahl and Daniel Starr, and especially Jenny Tobias, Associate Librarian, all contributed to the book's preparation. In the Museum Archives, former Chief Archivist Rona Roob and Assistant Archivist Michelle Elligott deserve mention.

James Gara, Chief Financial Officer, has attended to the financial planning of the project with his customary generosity and goodwill. The Department of Development, directed by Michael Margitich, Deputy Director for Development, deserves special mention for its efforts in ensuring that the exhibition could take place, and I particularly thank Monika Dillon, Director of Major Gifts, for the unflagging efforts made to enlist important financial assistance for this endeavor. Many other members of the Museum's staff have contributed in innumerable ways, and I wish to specially cite the following: Darsie Alexander, Deanna Caceres, Andrew Davies, Richard Dobbs, Irene Grassi, Amy Horschak, Laurence Kardish, Susan Kismaric, Maria Martin, Melanie Monios, Lynn Parrish, Jo Pike, Francesca Rosenberg, Ethel Shein, Mari Shinagawa, and Mark Steigelman. I also wish to recognize several departments whose contributions often remain invisible to the visitor: Building Operations, Graphics, Sales and Marketing, Security, Visitor Services, Writing Services, and the carpenters, framers, and painters.

For their assistance in facilitating the publication of this book and the preparation of the exhibition in various ways, I wish to acknowledge Carlos Barbot, Catherine Belloy, Natalie Blue, Wendy Brandow, Maureen Bray, Hermione Cornwall-Jones, Lance and Bobbie Entwistle, Pat Evans, Jeff Gauntt, Victoria Garvin, Archibald W. Gillies, Jay Gorney, Frederick B. Henry, Lela Hersh, the Donald Judd Estate and Chinati Foundation, Patricia Maloney, Elizabeth Miller, Laura Muir, Joyce Nereaux, Susan Richmond, Mary Sabatino, Claudine Scoville, John Stack, Roger Taylor, Gill Thompson, Robin Vousden, Rob Wiener, Helen Wright, Trudy Wilner Stack, and Jason Ysenburg.

I would like to add my personal thanks to The Bohen Foundation for its enlightened grant, which has enabled us to commission several works of art specifically for the exhibition, and to The International Council of The Museum of Modern Art for the crucial financial assistance it has provided. We are also grateful to The Contemporary Arts Council and to The Junior Associates for their funding of the accompanying Web sites, and to The Andy Warhol Foundation for the Visual Arts for its generous grant for this publication.

Finally, a personal comment. An exhibition that has the museum as its subject cannot ignore that one of the most significant components of this institution is its Trustees. The Museum of Modern Art's Trustees are essential to its relationship to artists; they insist on the preeminence of the artist in this Museum's life. I would like to pay particular homage to two friends of artists who are also exemplary Trustees, Agnes Gund and Ronald S. Lauder. Their openness and generous spirit have contributed much both to the Museum and to the artistic life of this community. I salute them.

Kynaston McShine, Senior Curator
Department of Painting and Sculpture
The Museum of Modern Art, New York

MUSEUM

According to the Great Encyclopedia, the first museum in the modern sense of the word (meaning the first public collection) was founded in France by the Convention of July 27, 1793. The origin of the modern museum is thus linked to the development of the guillotine. . . .

A museum is like a lung of a great city; each Sunday the crowd flows like blood into the museum and emerges purified and fresh. The paintings are but dead surfaces, and it is within the crowd that the streaming play of lights and of radiance, technically described by authorized critics, is produced. It is interesting to observe the flow of visitors visibly driven by the desire to resemble the celestial visions ravishing to their eyes. . . .

The museum is the colossal mirror in which man, finally contemplating himself from all sides, and finding himself literally an object of wonder, abandons himself to the ecstasy expressed in art journalism.

Georges Bataille, "Museum," *October*, no. 36
(1986), p. 25; trans. Annette Michelson;
pub. first in *Documents* 2, no. 5 (1930), p. 300.

Introduction	Kynaston McShine

Having worked in a museum for virtually my entire career, I have long been pondering the different ways in which artists have made the museum a subject throughout the twentieth century and even earlier, and I have felt that this has provided the basis for an exhibition and publication. As time progressed, I realized that many more artists were dealing with this topic than I had initially thought, and in many more ways. The museum as an institution generally, and maybe even The Museum of Modern Art specifically, has had great meaning for contemporary artists, and they often have felt strong emotional connections to it, whether of love or hate. They have probably spent a lot of time in the Museum and been influenced by individual exhibitions. We have frequently seen what we have shown here being reflected in what we have later received in new art. Most artists' education involves the habit of visiting museums and reflecting on what is seen there. This, of course, also has led artists to think about museum practices.

The fascinating thing about the relationship between artists and museums is that artists have studied every aspect of the museum, as if anatomizing an organism. Although the ways in which they deal with the museum in their work go far beyond any purely pragmatic consideration, their interest is, of course, partly professional: their sense of what the museum means in terms of public acceptance makes many of them eager to be represented in museum collections, and worry if they are absent. Others, meanwhile, question whether their work should be in a museum at all, feeling that to be included is to succumb to the establishment. In either case, artists are often, ultimately, wrestling with the issue of their dependence on the museum to endorse their place in art history. It is the civil institution of today, they feel, that will make them the cultural institutions of tomorrow.

The use of the museum as a subject for art has accelerated during the twentieth century in response both to developments within art and to the altered social role of the museum. In the early part of the century, however, the artist was distanced from the museum, which made little acknowledgment of contemporary art. Russian artists after the Revolution of 1917 were an exception: desiring a total integration of art and life, they harbored the utopian dream of a museum administered by artists, and they brought art to the public on boats and trains and through theater design in ways intended to make the museum and its mission vital parts of everyday life. El Lissitzky, for example, designed an exhibition room for the Hannover Museum (now the Sprengel) in Germany in 1926, preparing detailed plans and drawings. Lissitzky's practice, however, was unique. The Parisian art milieu of the same period was marked by disdain for the museum as a traditional, antiquated, aristocratic authority, lacking understanding of the art of its time. It was Marcel Duchamp who pointed the way in this attitude, poking fun at the museum, puncturing its pomposity, and catalyzing the Dadaists' and Surrealists' relative indifference to it. Independent of authority and tradition, Duchamp and his colleagues were essentially derisive about the kind of history that the museum of that time promoted and constructed.

Curiously, though, it is not possible to ignore Duchamp's role in guiding artists *toward* museums. Despite his irreverent gestures, Duchamp was an essential advisor to the formation of contemporary art collections in the 1920s and 1930s such as those of Katherine S. Dreier and Louise and Walter Arensberg, which eventually led to the placement of works by himself and others in The Museum of Modern Art, the Philadelphia Museum of Art, and the Yale University Art Gallery. This phenomenon of the artist actively fostering a relationship with a museum developed further with the exile of European artists to the United States during World War II; The Museum of Modern Art, along with other institutions, provided financial support to help a number of artists leave Europe and assisted them in finding employment in the United States. In consequence, exiles such as Joseph Albers and Fernand Léger, among others, created a certain energy around these institutions that stimulated a new relationship between museums and artists.

At around the same time, American artists in particular began to realize that museums were not

paying adequate attention to them. In 1950 the Irascibles wrote their famous letter of complaint to The Metropolitan Museum of Art, protesting hostility toward the avant-garde in the organization of a large exhibition of American art. Their effort was followed by the Americans series of exhibitions at The Museum of Modern Art and by other exhibitions of new work, leading to a less adversarial relationship between the artist and the museum.

This new relationship in the 1950s, however, was partly undone in the 1960s, when crises in the postcolonial world, exemplified by the Vietnam War, brought with them a basic distrust of society and its institutions. In 1960 The Museum of Modern Art agreed to show Jean Tinguely's *Hommage à New York*, an amazing and elaborate construction designed to self-destruct—as indeed it did, in an event in the sculpture garden that was finally closed down by firemen. By 1969, however, when Yayoi Kusama arranged for six women and two men to shed their clothing and frolic in the pools and among the sculptures on the same site, her intention was subversive rather than collaborative; the event took place without the Museum's consent, and, indeed, Kusama had organized it precisely to protest the institution's *lack* of modernity, its function as, in her words, a "mausoleum of modern art."

Something else changed in the 1960s. Before that decade there was a provincial quality to the art world; British artists were British, French artists were French—artistic activity was nationally compartmentalized. In the 1960s, however, the insular aspect of the art world was altered by travel. The new American painting had a profound impact on Europe, and European artists began to voyage frequently to the United States; the scene appeared to open up. This increasingly global situation contributed to a more open and relaxed attitude toward art and the art object, which also became more conceptual. The definition of art, and of how it was to be not only created but presented, broadened fundamentally. The result was that by the late 1960s artists had come to feel quite free in relation to the museum. One day they could love it, the next they could hate it, and the next ignore it, as in any family.

Conceptual art, with its fluid notions of the art object, presented a challenge to traditional museum practices. Yet an artist like Marcel Broodthaers was distinctly interested in the museum, and developed a complex series of works around it. From the 1970s on, in fact, a good deal of art took the museum as its central interest, for the range of ideas about and attitudes toward the institution grew and deepened. A variety of techniques came into play; almost any method and medium could be used to address the subject, from installation, video, and more cerebral mediums to traditional photography and even, by the 1980s, traditional painting in oil on canvas. Still, in the 1980s, the museum took a bit of a back seat in the art world. The driving force became an economic well-being involving private money, the gallery structure, and, in Europe, government funding. Nonprofit institutions in the United States did not have these kinds of resources, so the intervention of the museum became less necessary in artists' careers; the life of the artist, now potentially lucrative, was sustained by large international exhibitions, by international collecting, by shows in commercial galleries, and by auction sales. The museum was a relatively passive participant in this activity. Nevertheless, the 1980s and 1990s have seen widespread growth in museum expansion and building. Temporary exhibitions at galleries and international venues have been unable to displace the museum's historical role as a storehouse of aesthetic memory.

These historical shifts in patronage are matched by an ambivalence toward the assumed ability of the museum to immortalize the artist in relation to history. Artists have seen the museum as a place that establishes and codifies their place in history; they have also resented the power that it may exert over their lives. Collecting is a byproduct of producing work, and most artists accept its necessity, but some of them are sensitive about the museum's possession of their art. They see patronage as patronizing, and question their dependence on a system based on private or public acquisition. The idea of the public patron is perhaps more offensive to some artists if they see it as representing political affiliations or alignments in

conflict with the more progressive attitudes that are often components of the artistic temperament.

This kind of tension is evident in the work of many artists represented in *The Museum as Muse* and also in work that cannot be included here. For even as many artists have struggled to be included in the museum, others have resisted dependence on art-world patronage structures and have developed intricate critiques of museum practices. As an outgrowth of these approaches, many artists have purposely made works that, due to their size, ephemeral materials, or location, are not collectible by museums (nor by the commercial gallery system); still others have chosen to avoid the institution altogether. Although this kind of work is addressed in the present essay, it is by definition generally absent from the exhibition *The Museum as Muse*. Other artists, however, have examined the museum's political structure in works designed for conventional viewing and, particularly, for the expanded and increasingly various audience of The Museum of Modern Art.

The Museum as Muse is designed as a survey of some of the most notable museum-related art. It does not pretend to exhaust the field. Similarly, it does not attempt to establish a theoretical basis for the multiple focuses of artists. Rather, recognizing the variety of motives and interests that artists have brought to the subject, it illuminates the approaches taken by artists and discusses the aspects of the museum's life on which they have chosen to settle.

The fact that collecting is an obsessional activity both for museums and for private individuals has led me to become intrigued by artist collectors. Not only have some artists formed large art collections (those of Edgar Degas, Pablo Picasso, Andy Warhol, and Arman are only a few such), but more modestly and practically artists' studios have always been the sites of collections of materials they have wanted around them as they worked, for example photographs, *objets*, exotic ephemera, and copies of other art. This practice long predates modernity, but it has relatively recently expanded into the idea of making a museum of one's own, not just to preserve one's own work,

in a kind of monument to oneself (for example, the Paris studio of Constantin Brancusi, which he bequeathed, with its contents, to the Musée national d'art moderne, sanctifying his working process along with his sculpture) but to apply museological principles to the production of art.

A prime example must be Marcel Broodthaers's *Musée d'Art Moderne, Département des Aigles (Museum of Modern Art, Department of Eagles)*, a conceptual museum created by the artist in 1968. Broodthaers's museum was a fiction in that it had neither permanent collection nor permanent location. It manifested itself in its various "sections" created between 1968 and 1972. Another must be Claes Oldenburg's *Mouse Museum* (1965–77), a freestanding structure containing a collection of fictionalized objects (some found and altered, others created by the artist) displayed in vitrines: a landscape painting and objects relating to landscape; articles in the form of human beings; food forms; body parts; clothing remnants, cosmetics, and objects of adornment; tools; objects relating to animals; representations of buildings and monuments as well as souvenirs; money containers; smoking articles; and fragments from the artist's studio. The *Mouse Museum* is a comment partly on collecting (the selection's combination of irrationality and obvious system throwing the whole practice into question) and partly on the ingenious, yet inane, mass of mechanically reproduced material that floods our society. And although this may not be immediately apparent to the visitor, the museum's architectural plan is defined by the head of a certain cartoon mouse; so that *Mouse Museum* is also part comic, a parody. Filling this architectural space, the collection figuratively becomes Mickey's brain.

Quite different in mood is Susan Hiller's *From The Freud Museum* (1991–96), an example of the museum as a construct of the artist's imagination. Creating a museum from the "unspoken, unrecorded, unexplained, and overlooked," Hiller's installation comprises fifty cardboard boxes packed with specifically personal objects. But the poetic connotations of these objects are likely to engage the visitor's own experiences and memories as well. One box, titled

Nama.ma (Mother), contains a photocopied diagram showing Uluru cave paintings and Australian native earth in different pigments that were collected by the artist, ground into powder, and placed in cosmetic containers. Another box, *Chamin'Ha (House of Knives)*, contains a photocopy of a classic Mayan calendar, glyphs, numerals, day names, and modern obsidian blades, all in a customized cardboard box. The boxes together become a personal epic with biographical, archaeological, and political elements that move the spectator through a gamut of intellectual and emotional tonalities, from the banal and sentimental to the academic and metaphysical. Meanwhile the work addresses a basic issue of the museum, both for the visitor and the curator: the need for viewers to establish their own rapport with what is presented and to create for themselves a unique, personal poetic experience. Hiller's work may also stimulate them to consider their own activities as curators and collectors in their private lives.

Christian Boltanski's *Archives* (1987) is a group of racks suggesting a museum art-storage room of several hanging screens filled with photographs of 355 anonymous individuals. These people are completely unidentified, but the installation is infused by a sense of morbidity, created partly by the relative darkness (the work is lit only by small lights at the top of each screen) and partly by the idea of storage—as if this museum existed to preserve some unnamed collective memory. Were these people victims of the Holocaust or of some other disaster? As an assembly of data, an archive is often almost abstract in atmosphere, but Boltanski's version is rooted in a sense of loss. His *Vitrine of Reference (II)* (1970), more personal and autobiographical, contains artifacts from his childhood—photographs, a 45 r.p.m. record, a slingshot—but the museological display makes them feel as if they came from a prehistoric civilization.

More romantic than these artists is Joseph Cornell, who made assemblages, dossiers, and constructions to house collections that sentimentally memorialize women he admired—ballerinas, the heroines of novels, and film stars. The nostalgia for the past that breathes through these works parallels the mood of, for example, a museum's period rooms, its rooms of miniatures, and its occasional re-creations of a historical space, often a personal one—the living room of an aristocratic household (containing a collection, probably) or some other room furnished to demonstrate a period in history. But those displays are whole environments, as is Oldenburg's expansion of an apparently frivolous collection far beyond any expectation. Hiller similarly lets the "unrecorded and overlooked" take up an attention-getting amount of room. Cornell, on the other hand, follows a principle of compression, focusing the power of the artwork through the sense that a carefully chosen collection is concentrated in a diminutive space.

Cornell greatly admired Duchamp, who worked more compactly still, reproducing his own entire oeuvre as miniatures carefully organized in a valise. What a great conceit it is—to put your life's work into a little briefcase, which is editioned (one edition being partially assembled by Cornell), and so available to numbers of people simultaneously. Duchamp made several full-scale copies of his Readymades over the years, and those works are in visual terms functionally identical to their originals; but the miniaturization of the works in the various versions of the *Boîte-en-valise* (the first appeared in 1941) creates a peculiar class of objects, neither originals nor reproductions, worthy of that peculiar curator Duchamp.

Presaged here, I think, is the issue of the museum's traffic in reproductions, which, as the century proceeds, becomes a major preoccupation in a museum's marketing life. Perhaps schoolchildren in a museum store, buying postcards of works they have just seen, are creating a reference almost equivalent to the one Duchamp provided to his own work: they may feel they now have the work, if on a smaller scale. And of course postcards and posters have become ubiquitous manifestations of the museum, from the student's dorm to the dentist's office. Recognizing this as early as 1919, Duchamp used a color reproduction of one of the icons of painting—Leonardo's *Mona Lisa*, in the Louvre—to allow us a certain irreverence toward a

museum-sanctioned artwork: applying a mustache and beard to the *Mona Lisa*'s face, and titling the work *L.H.O.O.Q.* (in French, a lubricious pun), he not only plays with gender issues but reminds us that a reproduction is a reproduction. Embellishing the best-known painting in the world, but doing so harmlessly—for how can you vandalize a paper reproduction?—Duchamp desanctifies the object, allowing us a mental proximity to it that we would not otherwise have even in the Louvre, standing before the painting itself. The reproduction is that much closer to our lives.

A recent descendant of Duchamp's work in this respect is the rigorous art of Sherrie Levine, which comprises copies, produced by a variety of different methods, of artworks of the past. Her black-and-white images of paintings by van Gogh (1994) are all photographed from the pages of books. Perhaps Levine can be seen as building her own, somehow poignant collection of the art she desires—a "museum without walls," in André Malraux's term. The 480 *Plaster Surrogates* (1982–89) of Allan McCollum form another collection that, like Levine's van Goghs, has had its content meddled with: each of these 480 "paintings" is a plaster mold in the shape of a painting, including the frame, but with blackness where the image should be. Is the world so full of images that it is redundant to maintain a storehouse of them? McCollum's works address ideas about the aura of the artwork in the age of the mass-produced object. Ironically enough, the Surrogates come close to suggesting that a museum of multiple imageless frames would be somehow viable: beyond our appreciation of a large installation of these works as a visual spectacle in its own right, our memories of paintings, our ideas about what painting is, almost allow us to fill in the blanks.

Another of Duchamp's heirs, dealing this time, as in the *Boîte-en-valise*, with miniaturization, might be the Swiss artist Herbert Distel, who in 1970–77 asked artists around the world to contribute a work to a museum he was creating in a many-drawered cabinet, each drawer divided into compartments. A found object, the cabinet was designed to store silk thread; Edward Kienholz made the base for it. Nearly everyone asked by Distel happily submitted an exquisitely executed miniature. (A few works were donated by others, for example, the piece by Piero Manzoni, who had died before Distel's project began.) The result, *Museum of Drawers*, contains works by 500 artists (or, rather, 501, including Kienholz). Some of the artists are well known—Picasso, for example—while others are more obscure. The museum is usually displayed with several of its drawers removed and open to view in a vitrine. Where Oldenburg and Duchamp created museums of their own work, Distel is here claiming the function of the archetypal curator, creating his own selection of the art of a certain period, if insisting on the slightly unusual condition that it be shrunken to fit in his compact portable case. (At least Distel escapes the need of so many museums for a new building at regular intervals.) A similar wood cabinet, this one made for the occasion, was used by members of the Fluxus movement in 1975–77 to create a museum of Fluxus artists; created almost simultaneously, these two "museums" stand as mini-monuments to the art of their time.

An ancestor of the personal museum is surely the *Wunderkammer*, or cabinet of curiosities, of the eighteenth and nineteenth centuries. In a work painted in 1822, the artist and naturalist Charles Willson Peale depicted himself as the epitome of the gentleman amateur/connoisseur who has amassed a treasury of the marvelous and fabulous. How proudly he shows us his extremely special collection of natural history objects, which symbolizes his status as a man of learning. *The Artist in His Museum* is a great nineteenth-century work tracing the emotions once available to an artist who had created his own museum.

Artists in this century generally show more complex attitudes to the museum than Peale's obvious pride. But the thrill Peale got from nature survives, perhaps against the odds, in Mark Dion, who is fascinated by the idea of the *Wunderkammer* and the miscellaneous specimens it contained. *The Great Chain of Being*, created for *The Museum as Muse*, is a modern

Wunderkammer, a variety of objects—animal, vegetable, and mineral—that invokes different branches of knowledge and implies an evolution that ends with the human. Dion has a comfortable familiarity with the disciplines of mineralogy and geology, zoology and biology, but utilizes them toward the goal of making art. Like Peale but working in sculpture, he accumulates a variety of materials and displays them in an orderly way, in the process creating a self-portrait.

The Frenchman Daniel Buren has been one of the artists most associated with the use of the museum as subject matter, for example in installations at the Haus Lange and Haus Esters, Krefeld, in 1982. He has also written extensively on museological and artistic theory. Buren, in some sense, appropriates to himself the role of the curator of *The Museum as Muse* by adding to its roster of artworks four de Chirico paintings from the permanent collection of The Museum of Modern Art. By incorporating the permanent collection (the maintenance of which is a separate activity from the preparation of a temporary exhibition) in the show, he engages the visitor's understanding of this Museum as a place. The de Chiricos are installed in the usual mode of the permanent galleries for painting and sculpture; at the same time, in those galleries themselves, Buren frames with his trademark stripes the blank spaces where the paintings usually hang, so that he imposes *The Museum as Muse* on those rooms, where viewers will have come to see something else. The viewer in the permanent collection confronts a situation that is not of the permanent collection, in a certain transference of concept over memory.

It is not, of course, that visitors expect no conceptual intelligence in the permanent collection, but many of them go there to see old favorites and to rehearse a particular, familiar narrative of which that installation gives an account. Most artists are extremely aware of that narrative, if not through their concern for their own place in it, then because artists tend to be interested in art history. For the general public too, one of the pleasures of museum-going—especially to an institution like the Louvre, or the National Gallery in London—is those museums' basically settled nature: the artworks have their more-or-less fixed place. There is a collective memory that we all share of the great museums. It is therefore poignant when Sophie Calle points out how fragile our memories are, in *Last Seen. . .* (1991): at her request, a variety of employees at Boston's Isabella Stewart Gardner Museum—curators, guards, and other museum staff—used their memories of several paintings stolen from the collection to provide descriptions of them. These descriptions, differing not only in their degree of detail but in those details themselves, are incorporated as text in Calle's series, which accordingly undermines our sense of the reliability of our memory of what was there and is not there now. Of course it also speaks of the museum as workplace, of the perceptions that museum staff may have of an object that is a part of their daily business rather than something they travel and pay admission to see. But *Last Seen. . .* finally enters a larger territory: at the same time that its verbal translations of a visual artwork arouse a need to see that work, they prove their own inadequacy as a substitute for it, and as such become an exercise in frustration and unsatisfied desire.

If the museum is a site of a culture's memory, of the story the culture tells itself about where it has been, then the work Fred Wilson has made for this exhibition, *Art in Our Time* (the title of a show at The Museum of Modern Art in 1939, celebrating the institution's tenth anniversary), explores a memory's memory of itself: the Museum's photographic archive of its own exhibitions and public and private spaces over the years. From this archive Wilson has culled images of a diversity of visitors, of installations in both temporary exhibitions and the permanent collection, of storage rooms, and so on, the whole a fragment of the extraordinary memory that a museum has and embodies. What is not on display in the Museum is as crucial to it as what is: the large collections not on view, the library, the loaned works arriving for an exhibition and leaving after it, the works being considered for acquisition, the works being deaccessioned, the files on artists and on specific objects, the collective memory of the staff—together become an

infinite resource. A museum constitutes a less visible framework for the more visible art it exists to preserve; Wilson's work puts part of that frame on view. He shares this interest with Louise Lawler, another artist interested in the context in which the artwork appears, be it the museum, the home, or the auction house. Fascinated by the methods of presentation and the indirect functions to which art is subjected in these places, she documents them photographically, obliquely commenting on the different kinds of value that artworks come to comprise, and on the ways in which these values are expressed.

Lawler, of course, is far from the only artist to photograph the museum; the practice began within fifteen years of the invention of the photographic process in 1839. Once again, though, the attitudes discernible in those early photographs are less ambiguous and intellectually complex than those of an artist like Lawler. Victorian images by Roger Fenton, Stephen Thompson, and Charles Thurston Thompson are more documentary than analytic, recording both spaces and specific objects, and showing an absolute fascination with the special place that the museum was. It was not a religious space, it was not a domestic space, but it was a major place of convocation, of coming together. It was also a little closer in time than we are to the old-fashioned idea of the *Wunderkammer*, and additionally to another of the museum's ancestors, the royal or aristocratic collection of objects of great worth. The public accordingly saw the museum's objects as curiosities and rich marvels. In fact many spectators today still enter the museum with this innocent desire for the marvelous, no matter what form it takes—whether a well-conceived kettle displayed by the architecture and design department or an Alberto Giacometti sculpture. But artists of this century have shown a desire to explore the frame within which that sense of wonder is maintained.

Candida Höfer, for example, photographs museums' empty lobbies and lounges, revealing their blandness, their impersonality, and perhaps even their tastelessness. Her photographs suggest an irony of the contemporary museum: it is often thought of as an arbiter of taste, but it is also a large public institution, a role it may manifest in its architecture, its furniture, its lighting, and its general ambiance. Thomas Struth, similarly, has observed that "many people compare modern museums with train stations," a view to which he contrives a "resistance": his photographs' color and scale bestow on the museum a certain splendor. And the variety of the viewers he shows before large artworks in the galleries demonstrates the richness that art is capable of possessing for diverse people. Struth sees the beauty in the art, in the museum, and in the public. The interesting interplay happens when museum visitors confront a Struth photograph of museum visitors: it is as if they somehow step through the glass and become part of the situation they see. "Therein lies a moment of pause or of questioning," Struth remarked; "Because the viewers are reflected in their activity, they have to wonder what they themselves are doing at that moment."

Photographers other than Struth have been attracted to the spectator, and to the spectator's gaze—to looking at people looking. Given the exposure time needed by nineteenth-century film, this happened somewhat rarely in Victorian photography; Jean-Baptiste Gustave Le Gray's "*Les Demoiselles du Village" at the Salon of 1852*, for example, shows a museum hall entirely without visitors. But in the twentieth century it became as easy to capture the museum visitor as the inanimate object. Henri Cartier-Bresson could pursue an interest in people as observers, and in the relationship between viewer and object. Eve Arnold and David Seymour have photographed particularly notable museum visitors (Edward Steichen, Bernard Berenson), but the general visitor, too, became a journalistic subject quite independent of the artwork; Lutz Dille provides a typical example, showing a couple holding slides up to a window on the garden at The Museum of Modern Art. Meanwhile photographers such as Larry Fink and Garry Winogrand found their imaginations grabbed by the museum's evolving aura as a social space. Observing the public behavior emergent as the museum increasingly became a place of socializing as much as of study, these photographers commented on the distance between the basic act of

contemplation and some of what now seems to be ordinary museum activity.

Hiroshi Sugimoto's photographs, by contrast, are unpeopled, appearing to show wildlife in its natural habitat. Somehow, though, they seem to heighten the frozen quality that a still photograph necessarily must have, and on scrutiny we awkwardly realize that we are viewing not the vacation shots of a tourist on safari but stuffed animals in the dioramas of a natural history museum. Insisting on the artificiality of the museum experience, where, at least traditionally, there is nothing we come to see that lives and breathes, these images ask us to ponder the relationship between that experience and the world beyond: it is as if there were some creeping artifice in contemporary life, inspiring the artist to take these photographs. Artificiality is taken to an even more peculiar extreme in Christopher Williams's *Angola to Vietnam★* of 1989, a series of photographs of glass flowers in the Botanical Museum at Harvard University. Evoking the exoticism of these flowers—painstakingly accurate reproductions of specimens from around the world—by titling his photographs according to their countries of origin (all nations in which people had gone missing for political reasons during 1985), Williams catches in photography a museum-specific kind of beauty far removed from the experience of a tropical garden. The reproductions are so realistic that you almost have to be told they are glass.

The wonderful thing about photographers roaming in museums is the individual eye's response to the subject. Elliott Erwitt and Zoe Leonard provide idiosyncratic and pointed museum experiences, and Christian Milovanoff gives us an amusingly personalized tour of the Louvre, focusing on a single recurring detail: the feet of the figures in masterpiece paintings. An intellectually provocative sense of humor is also shown by Vik Muniz, who, photographing the marble floor in the garden hall of The Museum of Modern Art, captured it as a series of abstractions resembling and titled after Alfred Stieglitz's much-analyzed Equivalents, photographic studies of clouds. More somber and ominous are Günther Förg's large studies of the Munich Pinakothek, the play of light and shadow on the building's grand staircase evoking a darkness attuned to the architecture's authoritarian style. Jan Dibbets takes a more redemptive approach, photographing natural light in the museum and mounting the photographs in geometrically organized assemblages informed by his love of the light in Dutch painting. The seventeenth-century Dutch artist Pieter Jansz Saenredam, a direct inspiration for Dibbets, painted church light; Dibbets gives us the light of a contemporary church. His work suggests more reverence for the museum than do many of the later photographs discussed here, which are subtly and not so subtly critical.

Clearly there is a generation of artists whose attitude to the museum seems ambiguous and skeptical. One of these, perhaps, is Lothar Baumgarten, whose *Unsettled Objects* (1968–69) comprises photographic slides of the collection of the Pitt Rivers Museum in Oxford, England, and of individual artifacts contained there. The Pitt Rivers is a Victorian anthropological or natural history museum; the installation has not been significantly updated, and as a visual presentation evokes the past tale of Western culture's attempt, through its museums, to represent the lives of cultures that did not share its taxonomies and informing assumptions. Within each image, Baumgarten inscribes paired terms—"claimed/accumulated," "climatized/confined," "displayed/imagined," "selected/fetishized"—that suggest alternate and often mutually exclusive ways of understanding the anthropologist's museological practice. The issue, in part, is the meanings of the objects displayed—generally utilitarian things—in the terms of the society in which they originated. Never intended to be collected and aestheticized or anesthetized in a vitrine, these objects have been in a way embalmed by museology. The system has paradoxically preserved them while also depriving them of their history and life. "The name," Baumgarten writes, "directs memory—and forgetting."

Invited to prepare a project for *The Museum as Muse*, Michael Asher challenged The Museum of

Modern Art by proposing that a list of all of its deaccessions, from its founding to the present day, in painting and sculpture, be made available to the public as a printed booklet. This information is no secret, but has never been compiled in one list, and presenting it as such asserts that a museum is neither static and somehow outside history (as it may sometimes seem) nor incapable of mistakes and misjudgments. Following a demythologizing impulse, Asher does not take into consideration what works may have been acquired, what possibilities opened up, through the deaccessioning of other works, but he does powerfully conjure an imaginary *musée des refusés*.

Richard Hamilton's fiberglass molds of Frank Lloyd Wright's instantly recognizable building for the Solomon R. Guggenheim Museum, reproduced as multiples, in various bright colors, to hang on the wall, divorce us from that institution and its contents and reduce it to a decorative object. Art & Language's series *Index: Incidents in a Museum* (1986–88) also comments on museum architecture and the art it contains: paintings showing the again quite recognizable galleries of New York's Whitney Museum of American Art, designed by the modernist architect Marcel Breuer, they pose questions about the ideological proximity of art and architecture—about the kind of art that the architecture seems to demand. Showing a Whitney gallery containing paintings leaning against the wall, as if in their studio, this group of theoretical artists, whose work is often literary, also aggressively stakes a claim for their own right to be in the museum, and establishes the reciprocal relationship between artist and museum as one of eternal recurrence. These paintings stand as illustrations of their theories and philosophies about the making of art.

Some sense of the museum's darker side, or else a darker way of viewing the museum, dates back to its very beginnings. In 1796, Hubert Robert, an artist who was also the first "curator" at the Louvre and was instrumental in its transition from royal palace to public building, created a wonderful painting of his projected design for the museum's *Grande Galerie*. The oldest museum open to the public, the Louvre has long represented a summit of grandeur for artists and art audiences; countless artists have used it as their classroom, examining and copying the works displayed there. Many artworks, then, derive from or refer to its holdings. Much of this was yet to come when Robert painted his view of the *Grande Galerie*, but even then, one imagines, the companion piece he made for the painting must have caused a certain shock: perhaps in irreverence, perhaps with France's recent social upheaval in mind, he imagined the gallery in ruins. It is left to the viewer to conjecture whether the ruin stems from neglect, or from some act of violence, or simply from the passage of an enormous span of time. But surely one message of Robert's painting is the ultimate temporariness of even great works of art, and the vanity of the museum's efforts to preserve them.

One suspects that the impulse to imagine the museum in ruins goes hand-in-hand with the artist's dependence on the museum, which becomes a personality either producing or withholding affection. How to circumvent the overbearing parent? Yves Klein, for example, conceived of immaterial artworks—gold foil, for example, that is thrown into the Seine and washed away. Work demanding an individual's physical presence is hard to collect, as when Manzoni signed a woman's naked body as a work of art. (Nakedness, incidentally, is a strategy artists often embrace when trying to challenge curators and trustees.) A Christo project of 1968, represented in this exhibition by drawings and a scale model of the imagined scene, inverts the usual relationship of museum to art: rather than the museum containing the art, the art contains the museum. Christo proposed to wrap The Museum of Modern Art in cloth. He also wanted to block all entrance to the building by filling Fifty-third Street with 441 barrels. It is as if he wished to possess and appropriate the institution, to muffle its powers, to control the possibilities situated in it, to seal up the memory it embodies, and to remove it for a time from the world, implicitly asking whether we could live without it.

Another recourse artists have explored is the production of works that physically challenge or defy the limitations of an institutional building, for

example the earthworks produced by Walter de Maria, Michael Heizer, Robert Smithson, and others, works that are both specific to outdoor sites and enormous. Dennis Oppenheim's *Gallery Transplant* (1969) was both large and ephemeral, and dealt with the museum more directly than much of this work: he drew the floor plan of gallery 4 from the Andrew Dickson White Museum (now the Herbert F. Johnson Museum of Art), at Cornell University, in the snow in a bird sanctuary near Ithaca, New York. Oppenheim's piece, however, also reveals some of the contradictions of this kind of art, in that it did result in collectible objects—photographs and a map, which appear in *The Museum as Muse*. Smithson, too, developed a practice adapted to the gallery by placing within it aspects of contemporary nature, ingredients of the landscape—pieces of rock, a "non-site." Yet this involved a certain dislocation of the museum's conceptual premises. Smithson also created plans for the almost inconceivable museum that could have housed his *Spiral Jetty* piece in Utah, and a Smithson drawing, *The Museum of the Void* (1969), shows the museum as an empty space, a tomb.

The desire to stretch the capacities of collecting is not aimed solely at the museum; this art, after all, cannot be acquired by private collectors either, and it stretches the parameters of both art dealers and art historians. But there is a body of recent art that seems hostile to the museum specifically—Edward Ruscha's *The Los Angeles County Museum on Fire* (1965–68), for example, a painting depicting the scene described in the title. (The work seems in part a wry response to the unpopular and unfriendly building designed in 1964 by William Pereira.) Ruscha's piece might be said to update Robert's *Vue Imaginaire de la Grande Galerie en ruines*, although the mood of the latter painting is more closely echoed by Komar and Melamid's scenes of the Solomon R. Guggenheim Museum and The Museum of Modern Art as ruins in a pastoral setting. A more literal threat was embodied in *Samson*, an installation created by Chris Burden in 1985 at the Henry Art Gallery at the University of Washington, Seattle. Burden linked a 100-ton jack to beams aimed at the museum's load-bearing walls; the jack was also hooked up to a gearbox in a turnstile through which every visitor to the exhibition had to pass. Since every turn of the turnstile marginally expanded the jack, Samson could theoretically have brought the building down. In 1986, similarly, Burden had deep excavations dug below the floor of the Temporary Contemporary building of the Museum of Contemporary Art, Los Angeles. Revealing the concrete footing supporting three columns, Burden literally bared the museum's foundations. Steps enabled visitors to descend into the excavation to observe where the concrete met the earth.

A museum is a corporate body in which no one person has full authority: there is governance, committees that have to be assembled, and clearances that have to be obtained. It is, by definition, a conservative institution, and its bureaucratic and hierarchical situation—its funding as well as its often labyrinthine decision-making process—is something a lot of artists have felt it simpler to ignore and circumvent. Others address a head-on challenge to the institution's internal politics and corporate morality. Hans Haacke, for example, is well known for questioning aspects of museum practices, ethics, and finances, and for highlighting the role that the museum plays in the commerce of art. His *Cowboy with Cigarette* collage (1990) gently asks what could have inspired a tobacco company to sponsor an exhibition on the interplay between Braque and Picasso in early Cubism. In *Seurat's "Les Poseuses" (Small Version), 1888–1975* (1975), Haacke frames and displays biographies of each successive owner of the pointillist picture, documenting its passage through various collections—including those of John Quinn, Henry P. McIlhenny (Curator of Decorative Arts at the Philadelphia Museum of Art), and the European art investment group Artemis—thus representing it through its commercial history.

In the late 1960s in New York, the Art Workers' Coalition tried to make museums sit up: this was a group of artists protesting the institutions' lack of involvement with art by women and minorities. The Coalition was a strong force, particularly at The Museum of Modern Art, which it specifically tar-

geted. A certain amount of this antagonism came out of the general questioning of institutional authority in the 1960s, which we have already noticed; but whatever its sources, it led to an interrogation of the degree to which a museum is implicated in the class structure (a museum's fund-raising demands tend to make some such implication inevitable), and a debate over its politics. Should the Museum, for example, have taken a position on the Vietnam War? The period's questioning of a museum's workings was to be pursued with the rigor of art by Haacke and others.

Vito Acconci's *Service Area*, first enacted in 1970 and revived for *The Museum as Muse*, gently subordinates the institution to the artist: for the duration of the show, Acconci has his mail forwarded to the Museum, which must look after it for him—letting visitors walk away with it would literally be a federal offense. Regularly stopping by to pick up his letters as if he had rented a post office box, Acconci is treating the Museum, he says, "not as a display (exhibition) area but as a place that provides services: since I've been granted a space in the show, I should be able to use that space for my own purposes, make that space part of my normal life." *Proximity Piece* (1970), also revived for this exhibition, disturbs the museum visitor's expectation of a sort of contemplative privacy: as Acconci has written, the piece involves "standing near a person and intruding on his/her personal space. During the exhibition, sometime each day, I wander through the museum and pick out, at random, a visitor to one of the exhibits: I'm standing beside that person, or behind, closer than the accustomed distance—I crowd the person until he/she moves away, or until he/she moves me out of the way." This transgression of the museum experience ruptures the institution's aura as "rarefied-space/isolation-box/home-for-museum-pieces."

The strategy is, in a sense, the inverse of Manzoni's in positing an artwork that a museum could not collect (a living woman's body): Acconci is creating an artwork by temporarily invading the museum with his own living presence. In *Oh Dracula* (1974), at the Utah Museum of Art in Salt Lake City, Burden worked similarly by replacing a painting on the wall with a large cloth "chrysalis" into which he then climbed. Invisible inside the cloth, Burden hung on the wall for one full day during ordinary museum hours. A lit candle stood on the floor beneath his head, another beneath his feet. Next to the work was an identifying label similar to those for the paintings around it.

Other manifestations of physical presence disturbing the museum air might include Duchamp playing chess with a nude woman in front of the *Large Glass* (that work's "bride"?) during his retrospective at the Pasadena Museum in 1963. In *The Physical Self*, an exhibition at the Boijmans Van Beuningen Museum, Rotterdam, in 1991–92, the filmmaker Peter Greenaway installed several nude models in vitrines. More recently, in a more accepting atmosphere, the British performance artist Vanessa Beecroft has presented performances in which unclothed or bikini-clad models have simply stood motionless on the museum floor, like mannequins in a store window. The attack on the museum's taboo against the living was taken to an extreme by the late Bob Flanagan, who, in failing health from a chronic and terminal illness, installed himself in his hospital bed with all its accoutrements for the duration of an exhibition held first at the Santa Monica Museum of Art, from December 4, 1992, to January 31, 1993, and then at the New Museum of Contemporary Art, New York, from September 23 to December 31, 1994.

Andrea Fraser's parodistic performances as a docent in different museums are shown on video in *The Museum as Muse*. Fraser seems to question the institution's premises even while accepting them as a reality. Finally, two more artists, through the use of fictional constructs, also manage to play with human presence in the museum without actually being present: Gillian Wearing's video piece *Western Security* (1995) shows a gunfight between cowboy gangs enacted at the Hayward Gallery, London, by amateurs of Westerns; and Janet Cardiff, in a work created for the exhibition, provides an aural guided tour of The Museum of Modern Art. While traditional museum guided tours seek to instruct the public and

provide a didactic experience, Cardiff's tours alter the visitor's perception of the ordinary surroundings, simultaneously adding mystery and wonder.

This last group of artists shows a welcome sense of humor about the museum. Also witty is Kate Ericson and Mel Ziegler's *MoMA Whites* (1990), a group of eight jars containing the various white paints, in subtly variant shades, chosen by different curators for the walls of this institution's galleries. *Leaf Peeping* (1988), by the same artists, is thirty-one jars of latex paint, in colors associated with fall foliage, installed on the wall in a kind of chart of the placement of the trees in The Museum of Modern Art's sculpture garden. Acknowledging the supercharged space that a museum becomes, with every decision on interior and exterior decor provoking much debate, these works refer such choices to the systematic procedures and the principles of seriality that have been so important in various schools of twentieth-century art.

General Idea's sales counter in the shape of the dollar sign, which carries this Canadian group's multiples, is amusing at the expense of the museum's commercial side, the merchandising of which many people are quite critical. Jac Leirner takes aim at the same target, presenting a large wall piece assembled from the shopping bags of museums around the world. Leirner implicitly asks us to compare museum practices—here, marketing and advertising—with the quite cerebral and ambitious art of the past whose approaches and formats (for example the grid) she appropriates. That art too may suffer from her wit, but she emphasizes the fact that the public's expectations of a museum now permanently include the presence of a shop and a range of commercial products. Robert Filliou, by contrast, addresses the museum's templelike aura, collecting, boxing, and presenting the dust from major artworks as if they were holy relics; but his activity too has its hilarious aspect. Finally, Barbara Bloom's room-sized installation *The Reign of Narcissism* (1988–89) returns us to the idea of the artist's personal museum, but Bloom takes it to its logical extreme: all the images, objects, and artifacts in her collection carry her own likeness. Her fantasy is the ultimate museum that many covet.

Wit and humor are certainly facets in artists' reflections on museum activity, as they may be for the general audience also. But the museum remains an enormously complex body. Whether as members of the public or as staff, we all have a great many expectations of our museum visits, including, generally, the hope of a sublime memory and a pleasurable time; few, though, would say that ordinary pleasure or entertainment was the museum's raison d'être. If, for better or worse, the museum is in fact to remain a crucial site of its culture's memory, that must mean that inside the museum there is work to be done.

Jeff Wall's *Restoration* (1993) dramatizes one relatively uncelebrated aspect of that work. Wall's photographs often describe staged and fictional scenes that reveal intricate relationships to earlier art. Here, however, he articulates his concern with art history in a different way: by documenting the museum's preoccupation with restoration and conservation. This very large photograph (it is over sixteen feet wide) was taken in the conservation laboratory of the Kunstmuseum Lucerne. The transparency—illuminated from the back, as advertisements in public spaces often are—has an extraordinary luminescence, which, with the almost 180-degree field of vision, makes the activity of conservators at work into a near-Cinemascope display.

If the role of viewer risks introducing an element of passivity into our experience in the museum, Wall counteracts that problem by making us strain to grasp this enormous image in its entirety. Meanwhile the conservators are restoring a painting that is itself so enormous—it is a panoramic battle scene—that it swallows them in its spectacle; and we expend a certain effort simply trying to unravel the figures of the workers on their scaffolds from the image on which they toil. The result is a sense of layered, complex activity, a heightened realism, an awareness of the need for decipherment, and an awe at the labor involved in coming to terms with the past and extending its reach into the future.

Although the museum's art restorers generally enter the public eye only on occasions of unusual success or disaster, in *Restoration* Wall gives their work an epic scale, unveiling its heroic dimension. Yet conservation is only one of the museum's tasks, only one of the departments through which the museum performs its role; the security staff, for example, is no less vital to the preservation of the artwork than the conservators are. As a large institution, the museum is a compound organism. For many artists, I suspect, it is Kafka-esque in quality: it is the castle they must penetrate, the bureaucracy they must learn to manage. Having negotiated the paperwork, they must also take on the history laid out in the galleries: artists often disrupt the linear story that those galleries tend to tell. Their responses to what they see there come from a different perspective than that of the curators, and are no less well informed.

It is a peculiar relationship of mutual interdependence, and one in which the curator ends up on a tightrope. Does he represent the artist to the institution or the institution to the artist? Is he an intermediary between the artist and the museum, or the museum's personification? Overall, the relationship between museum and artist is far less adversarial than it was a few decades ago; occasional disruptions aside, the status quo prevails. Museums are allowed to maintain their lofty functions, and artists are allowed to behave in the expected way, their transgressions against the museum being usually consistent with the romantic definition of the artist. Even so, this fascinating cohabitation and coexistence will probably always contain an element of wariness. Like two superpowers that mutually respect each other, even mutually depend on each other, artists and museums nevertheless watch each other vigilantly—as if practicing for the field on which they are engaged together, the miraculous field of visual art.

The Museum as Muse: Plates

The works of art illustrated in the following pages are arranged in a general narrative sequence. In the captions, the name of the artist is followed by the title of the work (in italics), the date(s), the medium(s), the dimensions, and the collection or lender. Dimensions are given in feet and inches and in centimeters, height before width before depth.

Many of the sections include commentaries by or about the artists. Some of these texts are reprinted or adapted for this format with the permission of the authors or publishers; some texts were written expressly for this volume. Additional texts by artists can be found under Artists on Museums: An Anthology.

Charles Thurston Thompson

(British, 1816–1868)

Charles Thurston Thompson
*Venetian Mirror, c. 1700, from
the Collection of John Webb.* 1853
Albumen print from wet-
collodion-on-glass negative,
7 ¼ x 8 ⅜" (19.1 x 21.3 cm)
Victoria and Albert Museum,
London

Charles Thurston Thompson
*Rock Crystal Cup, 16th Century,
the Louvre, Paris.* c. 1855
Albumen print from wet-
collodion-on-glass negative,
8 3/8 x 10 5/8" (21.3 x 27.2 cm)
Victoria and Albert Museum,
London

Roger Fenton

(British, 1819–1869)

Roger Fenton
Discobolus. c. 1857
Albumen print, 9 7/8 x 11 5/8"
(25.1 x 29.5 cm)
The Royal Photographic Society,
Bath

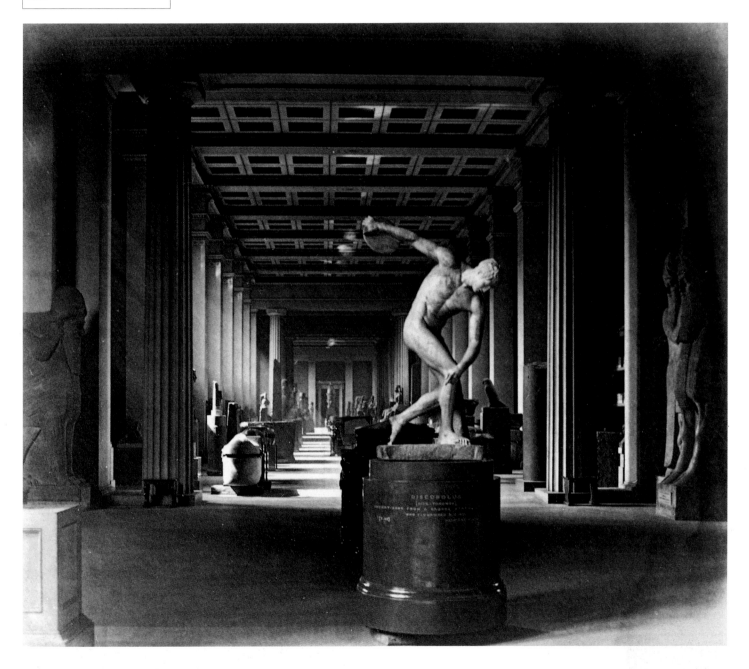

Roger Fenton
*British Museum, Gallery of
Antiquities.* c. 1857
Albumen print, 10⁵/₁₆ x 11⁹/₁₆"
(26.2 x 29.3 cm)
The Royal Photographic Society,
Bath

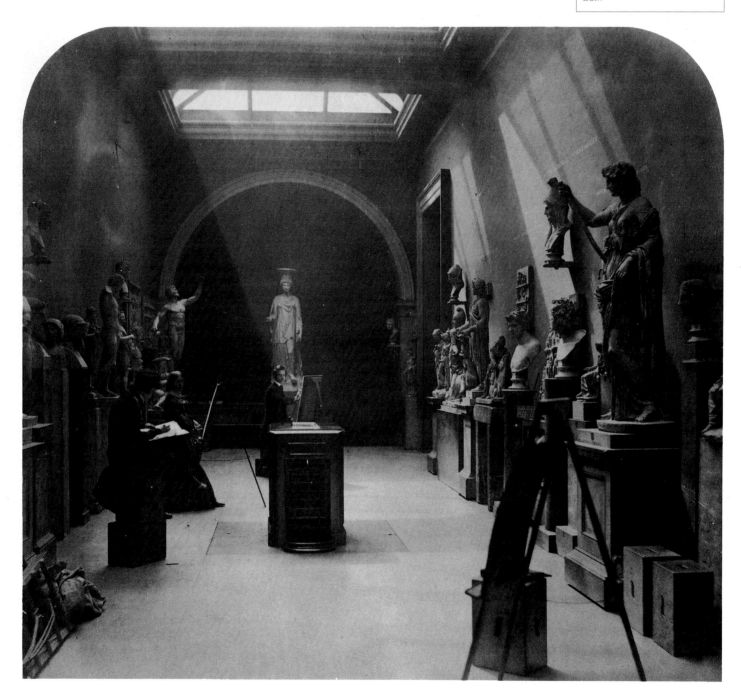

Jean-Baptiste Gustave Le Gray

(French, 1820–1882)

Jean-Baptiste Gustave Le Gray
*"Les Demoiselles du Village" at the
Salon of 1852.* 1852
Salted paper print from paper
negative, 9 $\frac{7}{16}$ x 14 $\frac{15}{16}$" (24 x 38 cm)
Gilman Paper Company Collection

Stephen Thompson
Satyr, British Museum. c. 1869–72
Albumen silver print from glass
negative, 11 x 8 ⅝" (28.2 x 21.9 cm)
Gilman Paper Company Collection

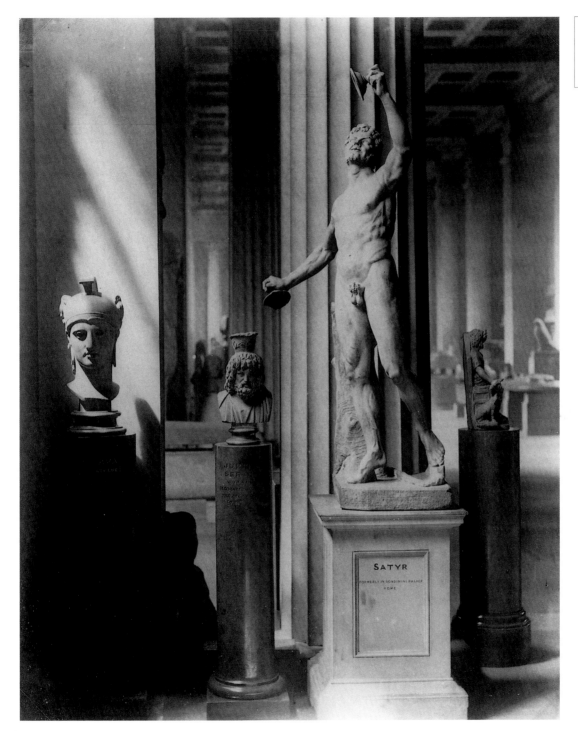

Elliott Erwitt
(American, born 1928)

Elliott Erwitt
Untitled. 1976
Gelatin silver print, 20 x 16"
(50.8 x 40.6 cm)
Collection the artist

top:
Elliott Erwitt
Abguss Sammlung Antiker Plastik Museum, Berlin. 1996
Gelatin silver print, 16 x 20"
(40.6 x 50.8 cm)
Collection the artist

bottom:
Elliott Erwitt
Greece. 1963
Gelatin silver print, 16 x 20"
(40.6 x 50.8 cm)
Collection the artist

Elliott Erwitt
*Victoria and Albert Museum,
London.* 1996
Gelatin silver print, 20 x 16"
(50.8 x 40.6 cm)
Collection the artist

Elliott Erwitt
Venice. 1965
Gelatin silver print, 9 ¼ x 13 ⅞"
(23.5 x 35.2 cm)
Collection the artist

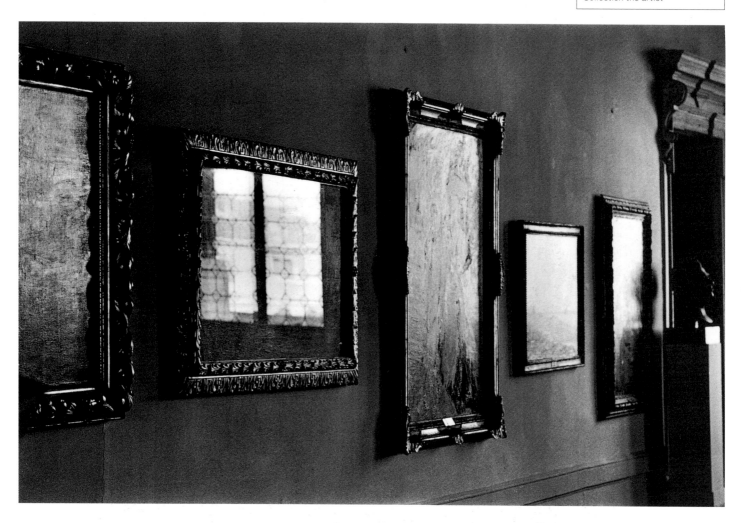

Zoe Leonard

(American, born 1961)

Zoe Leonard
*Mirror #1—Metropolitan
Museum.* 1990
Gelatin silver print, 42 x 29"
(106.6 x 73.6 cm)
Courtesy the artist and
Paula Cooper Gallery, New York

Zoe Leonard
*Mirror #2—Metropolitan
Museum.* 1990
Gelatin silver print, 42 x 29"
(106.6 x 73.6 cm)
Courtesy the artist and
Paula Cooper Gallery, New York

Eve Arnold
(American, born 1913)

Eve Arnold
Untitled (Silvana Mangano at
The Museum of Modern Art). 1956
Gelatin silver print, 12 x 16"
(30.4 x 40.6 cm)
Courtesy Eve Arnold/Magnum

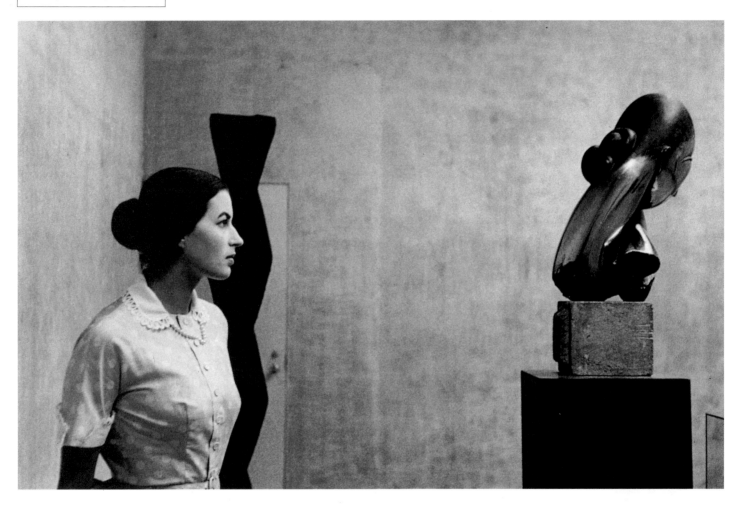

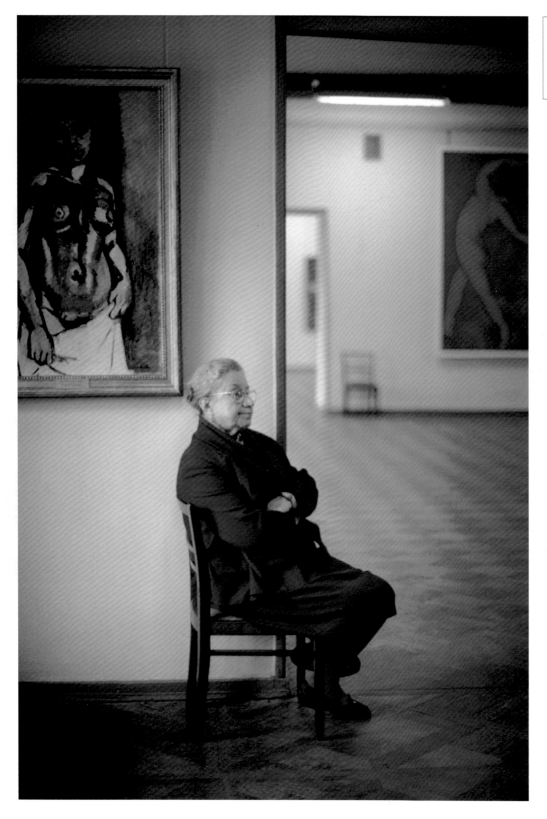

Eve Arnold
Untitled (On Guard at the Matisse
Section of the Hermitage,
Leningrad). 1966
Cibachrome, 16 x 12" (40.6 x 30.4 cm)
Courtesy Eve Arnold/Magnum

David Seymour

(American, born Poland. 1911–1956)

David Seymour
Bernard Berenson. 1955
Gelatin silver print, 16 x 20"
(40.6 x 50.8 cm)
Collection Ben Shneiderman,
Washington, D.C.

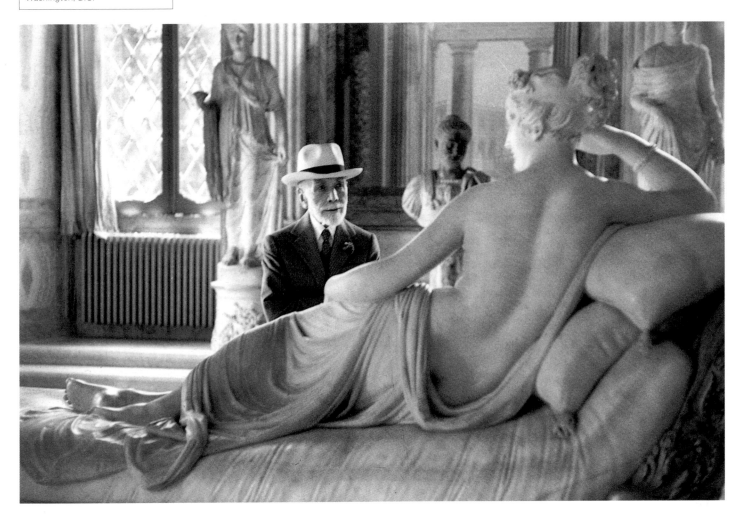

Henri Cartier-Bresson
Musée du Louvre. 1954
Gelatin silver print, 13 3/16 x 19 3/4"
(33.7 x 50.2 cm)
Collection Henri Cartier-Bresson

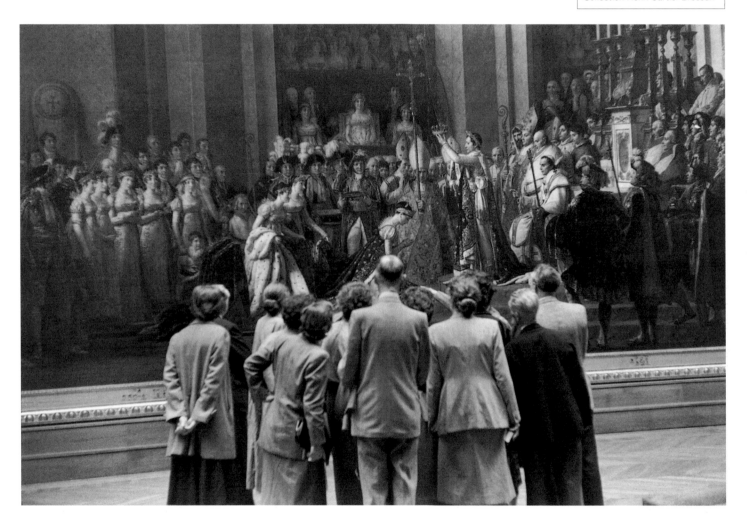

Henri Cartier-Bresson
*An Eye at the Museum of
Modern Art, New York.* 1947
Gelatin silver print, 13 5/8 x 9 1/8"
(34.7 x 23.4 cm)
The Museum of Modern Art,
New York. Gift of Monroe Wheeler

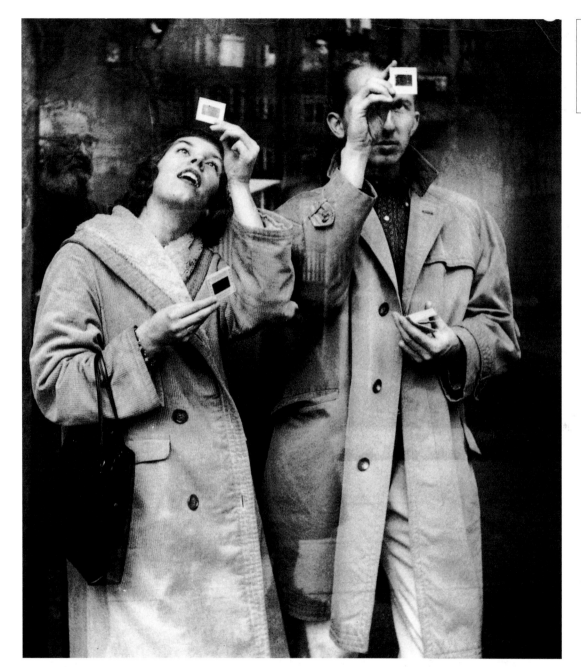

Lutz Dille
Three in a Window. 1959
Gelatin silver print, 14 ⅝ x 12 ½"
(37.1 x 31.8 cm)
The Museum of Modern Art,
New York. Mr. and Mrs. Clark
Winter Fund

Charles Willson Peale

(American, 1741–1827)

Charles Willson Peale was born on the eastern shore of Maryland in 1741, the son of a schoolteacher who had been a convicted felon in England. The family moved to various small Maryland towns until they settled in Annapolis when Peale was nine. First apprenticed as a saddler, Peale practiced various professions throughout his life: repairer of bells, watches, and saddles, sculptor, miniature painter, portrait painter, Revolutionary soldier, propagandist, civic official, mezzotint engraver, museum keeper, zoologist, botanist, and inventor of such mechanisms as a portable steam bath, a fan chair, a velocipede, a physiognotrace for making silhouettes, a polygraph for making copies of documents, a windmill, a stove, a bridge, and false teeth. He studied painting in London with Benjamin West for two years. When he returned he moved with his family to Philadelphia; there, at the height of the Revolution, he served as both a soldier and a maker of banners and posters for the war effort.

Most established artists of the eighteenth century had a painting room or gallery for displaying works for sale or those in the artist's personal collection. In Peale's case, this exhibition gallery eventually became the first American museum, embracing both cultural and natural history. During the War of Independence, Peale expanded his display gallery into an exhibition of portraits of Revolutionary heroes, beginning with his first portrait of George Washington in 1772. By 1782, Peale had established a long skylighted chamber for showing portraits. There he arranged portraits high on the walls in order to represent the primates and placed the lower forms of life he had collected in cases and on a lower floor. In addition to the vertical, hierarchical, and evolutionary arrangement, the materials were also organized according to what Peale knew of the Linnaean system. He explained: "An extensive collection should be found, the various inhabitants of every element, not only of the animal, but also specimens of the vegetable tribe; all the brilliant and precious stones, down to the common grit; all the minerals in their virgin state; petrifactions of the human body, of which two instances are known; and through that immense variety which should grace every well stored Museum. Here should be seen no duplicates, and only the varieties of each species, all placed in the most conspicuous point of light, to be seen to advantage without being handled."

He proposed that the "gentle intelligent Oran Outang," lacking speech, should be placed nearer to the monkey tribe than to that of humans and that the flying squirrel, ostrich, cassowary, and bat would provide the connecting links between quadrupeds and birds. Peale was also an innovator in museum display techniques. Finding that ordinary taxidermy did not produce a lifelike effect, he stretched skins over wood cores he had carved to indicate musculature, and he offered a painted background of the proper context for each speci-men. The museum displayed both live and dead animals. (When a live grizzly on display escaped and ran through the hall, Peale was forced to shoot him.)

By 1774, his collection had grown so large that the museum had to be moved to Philosophical Hall. Following Rousseauist principles of nature as the proper teacher of mankind and his deeply held Deist beliefs in a nonintervening God, Peale saw his enterprise as a "School of Wisdom" designed to teach the public to follow the example of nature. Clearly, Peale's painting and collecting activity served the interests of postwar American society: his portraits memorialized the heroes and patrons of the war, while his collections of cultural and natural objects provided a synopsis of the New World in miniature, linking recent historical events to the grand context of nature and providing evidence of a natural providence legitimizing those events.

Among his last works is his 1822 self-portrait, *The Artist in His Museum*. Peale had been asked by the museum trustees to paint a life-sized, full-length portrait of himself. Peale wrote to his son Rembrandt on July 23, 1822: "I think it is important that I should not only make a lasting ornament to my art as a painter, but also that the design should be expressive that I bring forth into public view the beauties of nature and art, the rise and progress of the Museum." Peale holds back the curtain so that his collection can be seen. In the foreground, he placed a giant mastodon jaw and tibia (the mounted skeleton can be discerned to the right just above the palette). In the middle distance, a Quaker woman holds up her hands in astonishment at the mastodon, while the father talks with his son, who is holding an open book, and another figure looks at the birds. Peale here experimented with the relation between artificial and natural light, the latter coming from behind, in the museum, and the former coming from a mirror that reflects a secondary light onto his head. The light of the painting thus turns back from the foreground of the picture, the light of nature moves forward from the back, with Peale outlined by their interrelation. Yet the curtain reminds us of the staged qualities of this nature. And the life-sized figure of Peale appears "realistically" on the near, and most artificial, side of the curtain.

Peale frequently referred to himself as a "memorialist," meaning by this that he was painting the dead in the service of future memory. Further, just as Freud's theory of mourning is developed around the traumatic consequences of war, Peale developed his museum as an antidote to war's losses and as a gesture against disorder and the extinction of knowledge. In the nexus of motion and emotion, arrested life and animation, and loss and memory that Peale's work evokes, we can begin to address with a sense of urgency a central issue of representation.

Susan Stewart[1]

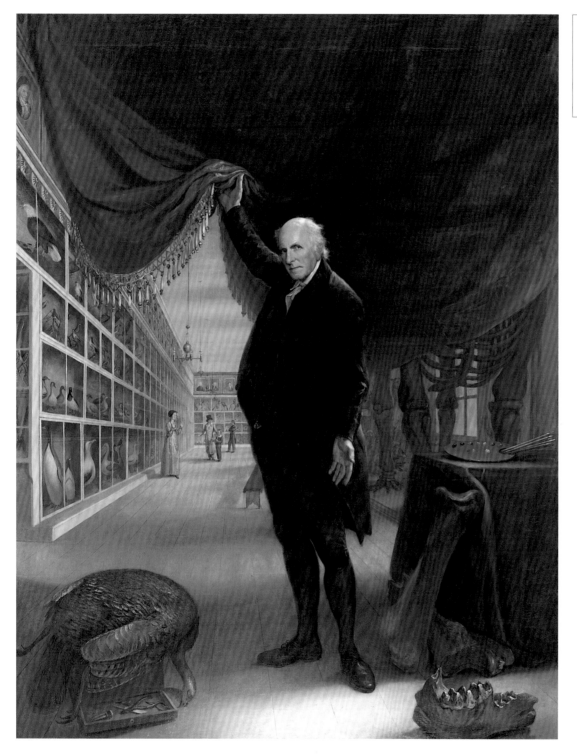

Charles Willson Peale
The Artist in His Museum. 1822
Oil on canvas, 8' 7¾" x 6' 7⅞"
(263.5 x 202.8 cm)
Pennsylvania Academy of the
Fine Arts, Philadelphia. Gift of
Mrs. Sarah Harrison (The Joseph
Harrison, Jr., Collection)

El Lissitzky

(Russian, 1890–1941)

A very personal vision of a museum exhibition space is depicted in El Lissitzky's design for a gallery of geometric abstract art at the Hannover Museum, which was executed (with some changes) in 1927–28. The concept of the *Kabinett der Abstrakten (Cabinet of the Abstract)*, as it was popularly referred to, applied Lissitzky's Constructivist principles to the organization of space. The design of exhibition spaces constituted one of the most important aspects of creative activity for this artist during the late 1920s and 1930s. *Kabinett der Abstrakten* was commissioned in 1926–27 by Alexander Dorner, the director and chief curator of the Hannover Museum (later the Sprengel). The exhibition room was the second of the so-called demonstration spaces that conveyed Lissitzky's special concept of interior design. Considered by Lissitzky as uniquely appropriate for the display of modern art, his concept represented an elaboration of his project for a temporary display, *Raum für konstruktive Kunst (Room for Constructivist Art)* at the Dresden International Art Exhibition in the summer of 1926.

Although the two projects differed in several respects, they essentially applied the same principles. In keeping with his Constructivist philosophy, Lissitzky believed that modern art required different spaces for display than those traditionally used for older art. In his view, the space appropriate for the presentation of modern art had to be part of a total perceptual experience. It had to involve the viewer actively in the process of looking, studying, and absorbing the art. In his text on exhibition spaces Lissitzky wrote: "The great international picture reviews resemble a zoo, where the visitors are roared at by a thousand different beasts at the same time. In my room the objects should not all suddenly attack the viewer. If on previous occasions in his march in front of the picture-walls, he was lulled by the painting into a certain passivity, now our design should make the man active. This should be the purpose of the room."[1]

His intention in designing an appropriate exhibition space was the creation of a visual backdrop rather than walls as mere carriers of paintings. This optical background for paintings was created through the use of pure color or tone and a different manner of isolation and illumination of the individual works. He resolved the problem by evolving a special treatment of the wall surfaces, which allowed for light and color control as well as elimination of a crowded impression. Thin, perpendicular laths (7 cm in depth) were placed in front of the wall at regular intervals (of 7 cm); they were painted white on the left side, black on the right side, while the wall itself was painted gray. As a result, depending on the position of the viewer within the space, the picture could be seen on either a white, gray, or black background and become part of an active perceptual process. To avoid the impression of an overcrowded installation, Lissitzky devised a system of moving screens that could be changed by the viewer and allow him to change the contemplated work. The result was an optical dynamic with shifting visual axes: vertical, horizontal, and diagonal, where every movement of the spectator caused an impression of constant wall changes, activating both spectator and space. In fact, the exhibition space itself became a constantly changing work of art. In addition to color, light-

ing was an important activating factor. Lissitzky described the action of light in great detail: "Here the light comes through a window which takes up almost the whole wall. My aim was to transform the window area into a tectonic lighting agent, which would let in only the amount of light that was necessary."[2]

Every element of the space was precisely thought out. The viewing cases by the window contained special devices that rotated on a horizontal axis and comprised four surfaces intended for the display of watercolors and other works on paper. For sculpture, he devised a corner with a platform whose two visible square sides were painted black and red; from the red square a red line ran horizontally around the room, and a mirror was placed in the wall so the spectator had a fuller view of the piece. On the adjacent wall, Lissitzky built a horizontally moving showcase (like a sliding door) for the display of four major works; the third wall had a vertically sliding frame for two works; and the fourth wall had a frame for three pictures, equipped with a rolling Venetian blind. The light entering from the corner affected the colors as they continually changed, consecutively, from white to gray to black and back again, altering the viewer's perception of the space. He also suggested that electrical light could supply additional illumination to the walls in different colors. The color scheme of white, gray, and black, with the addition of red, was the classic color combination of Russian Constructivism. The black and red squares of the sculpture platform were a throwback to the symbols of Suprematism, the geometric abstract movement begun in Russia in 1915 by Kazimir Malevich. The Suprematist highlights included Malevich's famous black square and red square, which affected Lissitzky's early art and prompted, in 1919, his personal idiom, *Prouns* (Projects for the affirmation of the new in art). These pictorial compositions, combining two- and three-dimensional axonometric views of geometric shapes, were in 1923 translated into the physical third dimension as a *Proun*-room, exhibited at the *Grosse Berliner Kunstausstellung* (*Great Berlin Art Exhibition*), where three-dimensional geometric elements adhered to the walls of the room, altering the spatial environment.

These "demonstration spaces" evolved out of Lissitzky's discomfort in presenting his *Prouns* in traditional exhibition spaces. Yet, they were not an extension of the *Proun*-room. They were the spatial art form developed by an artist initially trained as an architect who perceived art and space as an indissoluble whole. They were also the apotheosis of Constructivist principles of the fusion of art and life and the creation of a more active art spectator. Lissitzky's "demonstration spaces" were more progressive and successful creations than many other utopian attempts at three-dimensional pictorial space, for example, Piet Mondrian's design for a de Stijl Salon for Ida Bienert (1925–26), projects by Theo van Doesburg and Cornelis van Eesteren (1922), or those by Vilmos Huszar and Gerrit Rietveld (1923). Exceptionally avant-garde at the time of its creation, Lissitzky's concept of the presentation of art within an artwork itself remains even today an innovative way of seeing museum space as a dynamically conceived design.

Magdalena Dabrowski

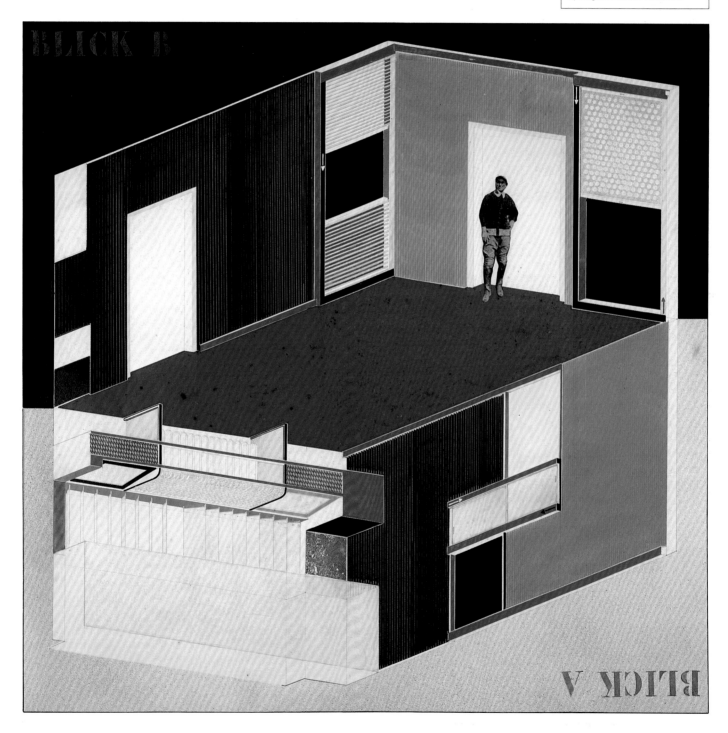

El Lissitzky
Sketch for the Kabinett der Abstrakten. 1927–28
Watercolor on paper, sheet
5 5/8 x 8 3/16" (14.2 x 20.7 cm)
Sprengel Museum, Hannover

top left: El Lissitzky *Design for Exhibition Room in the Hannover Museum.* 1926 Graphite, gouache, metallic paint, black and red ink, and typewritten labels on card, 9 13/16 x 14 1/4" (24.9 x 36.2 cm) Busch-Reisinger Museum, Harvard University Art Museums. Gift of Mrs. Lydia Dorner in memory of Dr. Alexander Dorner	top right: El Lissitzky *Design for Exhibition Room in the Hannover Museum.* 1926 Graphite, gouache, metallic paint, black and red ink, and typewritten labels on card, 9 13/16 x 14 5/16" (24.9 x 36.4 cm) Busch-Reisinger Museum, Harvard University Art Museums. Gift of Mrs. Lydia Dorner in memory of Dr. Alexander Dorner
bottom left: El Lissitzky *Design for Exhibition Room in the Hannover Museum.* 1926 Graphite, gouache, metallic paint, black and red ink, and typewritten labels on card, 10 x 14 1/4" (25.2 x 36.2 cm) Busch-Reisinger Museum, Harvard University Art Museums. Gift of Mrs. Lydia Dorner in memory of Dr. Alexander Dorner	bottom right: El Lissitzky *Design for Exhibition Room in the Hannover Museum.* 1926 Graphite, gouache, metallic paint, black and red ink, and typewritten labels on card, 10 x 14 1/4" (25.2 x 36.2 cm) Busch-Reisinger Museum, Harvard University Art Museums. Gift of Mrs. Lydia Dorner in memory of Dr. Alexander Dorner

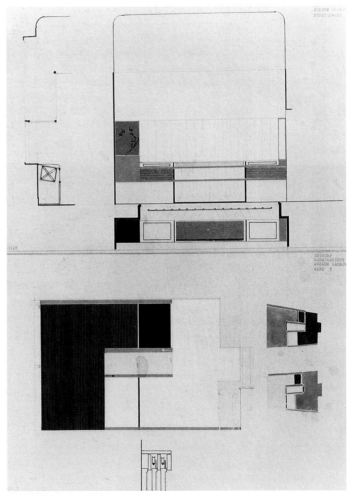

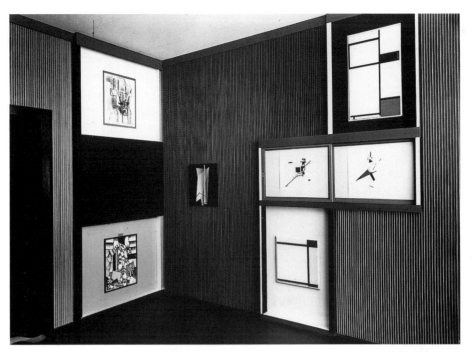

top:
El Lissitzky
Kabinett der Abstrakten (Interior View). 1927–28
Sprengel Museum, Hannover

bottom:
El Lissitzky
Kabinett der Abstrakten (Interior View). 1927–28
Sprengel Museum, Hannover

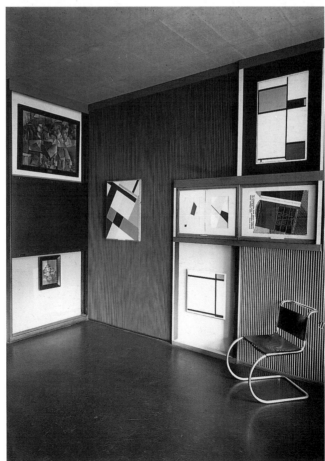

Capital M . . . is for Modern: Marcel Duchamp arrived in New York in January 1920, carrying in his luggage a small glass vial—approximately 125 cc *Air de Paris*—as a present for art collectors Walter and Louise Arensberg, whom he had not seen since his departure from New York for Argentina in 1918. In the early months of 1920, while his first optical machine, *Rotative plaques verre (Rotary Glass Plates)*, was taking shape, Duchamp was involved in discussions with Katherine S. Dreier and Man Ray about founding a new institution concerned with modern art. On April 29th, with preliminary plans agreed upon, a certificate of incorporation was signed by the founders: Marcel Duchamp, President, Katherine Dreier, Treasurer, and Man Ray, Secretary. By New York statute the suffix "Inc." was added, thus providing a Dada flair to the venture, since S.A. (Société Anonyme) in French business dealings is the English equivalent of Inc. and was chosen as the name of the museum for its literal translation as an "anonymous society." A subtitle, "Museum of Modern Art," was added by the founders, and on April 30th, the Société Anonyme Inc. Museum of Modern Art opened with the *First Exhibition of Modern Art* in a townhouse at 19 East Forty-seventh Street. Its corporate logo was the symbol of a chess knight, adopting one of Duchamp's studies for a set of chess stamps.

Six years later, at The Brooklyn Museum, the Société Anonyme staged the impressive *International Exhibition of Modern Art*, organized by Dreier with significant support from Duchamp. Connecting the exhibition to the Armory Show of 1913 by replicating its official title, Duchamp hinted at the source of his celebrity: his notorious painting *Nu descendant un escalier (Nude Descending a Staircase)* of 1912, which was first shown at the Armory Show in Manhattan. In the Brooklyn exhibition Duchamp was represented by an even more challenging work, the first public showing of *La Mariée mise à nu par ces célibataires même (Large Glass) (The Bride Stripped Bare by Her Bachelors, Even [Large Glass])* of 1915–23.

It was not until November 1929 that the "other" Museum of Modern Art opened in New York, on the twelfth floor of the Heckscher Building at Fifth Avenue and Fifty-seventh Street. By 1932 the Museum had moved to a converted five-story townhouse belonging to the Rockefeller family, which linked the presentation of modern art to a setting of domestic origin. It would be another ten years before the absence of windows, high ceilings, and well-lit, wide white walls became the standard museum environment for twentieth-century art.

Duchamp's representation in the Museum's early exhibitions was at best sporadic. He was first shown with *To Be Looked At (From the Other Side of the Glass) with One Eye, Close To, for Almost an Hour*, a 1918 study for the *Large Glass*, in *Modern Works of Art* in 1934–35; this was

followed with five works, among them *Nu descendant un escalier*, in the 1936 show *Cubism and Abstract Art*. Then, in the Museum's *Fantastic Art, Dada, Surrealism* of 1936–37, Duchamp's seminal role was acknowledged by eleven artworks in the two rooms that opened the exhibition. By 1943 the *Large Glass* was transferred to New York and included the following year in the Museum's fifteenth-anniversary exhibition, *Art in Progress*. It remained at the Museum on extended loan until April 1946. By 1945 The Museum of Modern Art had acquired the painting *La Passage de la vierge à la mariée (The Passage from the Virgin to the Bride)* of 1912, and in 1952, as an executor of Dreier's estate, Duchamp added three works from her collection: *3 Stoppages Étalon (3 Standard Stoppages)* (1913–14), *To Be Looked At (From the Other Side of the Glass) with One Eye, Close To, for Almost an Hour*, and *Fresh Widow* (1920). Duchamp thus created the second largest public representation of his work, after the holdings in Philadelphia.

Capital M . . . is for Monte Carlo: In 1924, Duchamp's enthusiasm for chess had led him to investigate another game in which the player is exposed to institutionalized chance. While in Nice attending chess championships, Duchamp relocated his ambulant research laboratory on game theory, chance, and probability to Monte Carlo, where he began to work on a winning system. He wrote to Francis Picabia: "With very little capital I have been trying out my system for five days. Every day I have won steadily—small sums—in an hour or two. I'm still putting the final touches to it and when I come back to Paris the system will be perfect. I haven't stopped being a painter, I'm drawing on chance now."[1] At the end of 1924, Duchamp issued a homemade bond, the *Obligations de roulette de Monte Carlo (Monte Carlo Bond)*, for the commercial exploitation of roulette, offering interested investors a share in his stake. But the fundraising scheme did not prove sufficiently profitable and Duchamp's patience quickly evaporated: "The system was too slow to have any practical value."[2] Ultimately, the scheme did not fulfill its "obligations."

By late 1938 Duchamp, while engaged in the elaborate production of his new, as yet untitled, thesaurus of facsimiles, placed an insert of the *Monte Carlo Bond* in the magazine *XXe siècle*. An offprint was to be part of his forthcoming edition of the *Boîte-en-valise*. When, in early 1939, The Museum of Modern Art celebrated its tenth anniversary with the opening of a new building, Duchamp sent as a gift the preparatory study for this work. Duchamp's reflection on chance and strategy, on the notion of art-as-stock/stock-as-art, thus became his first work in the collection of The Museum of Modern Art—an institution funded substantially from the stock-exchange profits of a group of wealthy trustees. Duchamp later mused on posterity and tradition: "Artists of all times are like gamblers of Monte Carlo, and this blind lottery allows some to succeed and ruins others. In my opinion,

Marcel Duchamp
Boîte-en-valise (de ou par Marcel Duchamp ou Rrose Sélavy). 1935–41
Leather valise containing miniature replicas, photographs, and color reproductions of works by Duchamp, and one "original": *Large Glass*, collotype on celluloid (69 items), 7 ¹/₂ x 9 ¹/₄" (19 x 23.5 cm); overall 16 x 15 x 4" (41 x 38 x 10 cm) [IX/XX, from Deluxe Edition]
The Museum of Modern Art, New York. James Thrall Soby Fund

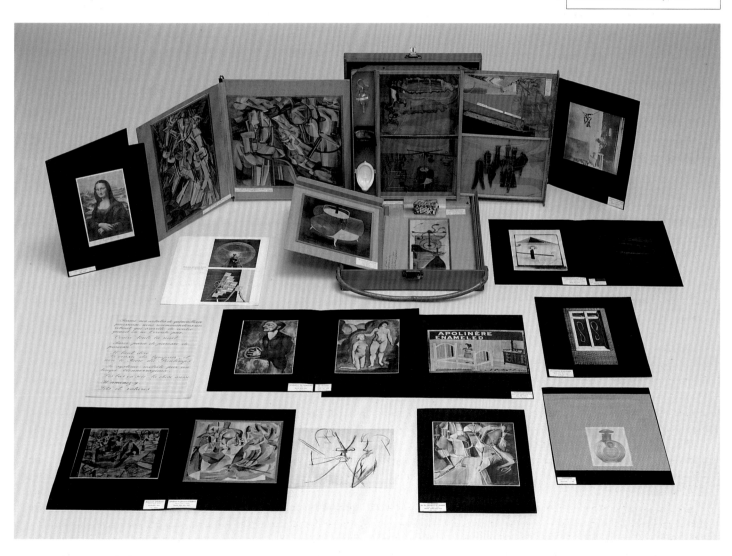

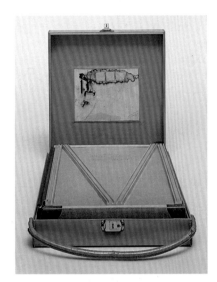

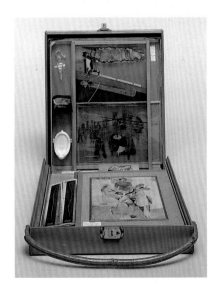

neither the winners or losers are worth worrying about. Everything happens through pure luck. Posterity is a real bitch who cheats some, reinstates others (El Greco), and reserves the right to change her mind every 50 years."[3]

Capital M . . . is for Museum: Duchamp's efforts throughout the 1920s to establish an influential institution concerned with collecting and presenting modern art included avoiding normal art dealings of his own, such as gallery transactions. By then he had seen to it that most of his oeuvre had gone directly into the hands of two private collectors: Dreier and the Arensbergs. But Duchamp was looking for an institutional context for his art. He accepted, and even promoted, the museum as a natural haven of the arts, emphasizing the undercurrent meaning of the Greek *museion* as the home and permanent address of the nine muses. A plan for the public placement of works by Duchamp was initiated in the 1930s when Dreier contacted the architect and sculptor Frederick Kiesler about a museum for her personal collection and that of the Société Anonyme. Then, after tedious and strained negotiations with several museums, the Arensbergs agreed to donate their collection to the Philadelphia Museum of Art in December 1950. The public opening did not occur until the summer of 1954; by then both the Arensbergs and Dreier had died. To augment the museum presentation of his oeuvre and as an executor of Dreier's estate, Duchamp gave the *Large Glass* to Philadelphia in 1952. With the opening of the Arensberg Collection, the majority of his works of art were installed on permanent view in a museum, an accomplishment unlike that of any other living artist. In 1955, in an interview with James Johnson Sweeney, Duchamp stated: "I never had such a feeling of complete satisfaction. Exhibiting one thing here and another there feels like amputating a finger or a leg each time."[4]

Duchamp explored the concept of a body of work by metaphorical logic. The strategic input is flawless and the projected maneuvers precise in their choreography through the time-space continuum of twentieth-century art: the concentration of the originals in one or two collections and their subsequent transfer into the care of a museum. And while his "operation museum" was still in progress, Duchamp counterbalanced his efforts by producing a multiplied set of miniaturized replicas housed in a portable and convertible space. He had devised a backup of his system software.

Capital M . . . is for Miniature Monograph: Beginning with the reproduction of *La Bagarre d'Austerlitz (The Brawl at Austerlitz)* in 1936 and ending with the title and graphic concept used for the subscription bulletin for the edition in late 1940, the intended miniature monograph—comprising sixty-nine items—was realized. Sources tapped for the album project included photographers, several printshops, typesetters, paper merchants, two or three pochoir studios, dye-cut specialists,

opposite top, center, and bottom:
Marcel Duchamp
Boîte-en-valise (additional views)

below:
Marcel Duchamp
*De ou par Marcel Duchamp ou
Rrose Sélavy.* (Boîte series C,
Paris, 1958)
Box covered in natural linen and
lined with gray-blue Ingres paper
containing miniature replicas and
color reproductions of works by
Duchamp (68 items), overall
15 ³/₄ x 15 x 3 ¹/₂" (40 x 38 x 9 cm)
Collection Ronny Van de Velde,
Antwerp, Belgium

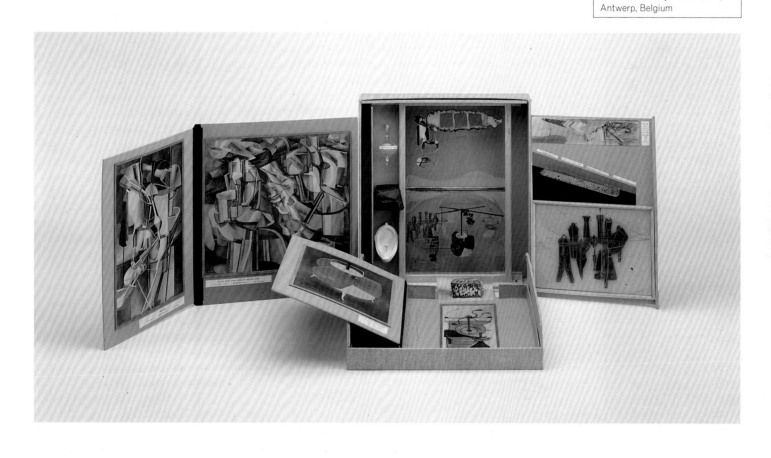

bookbinders for the standardized cardboard parts and assorted binding materials, carpenters for the framing parts, glassblowers, vitreous china craftsmen, and ceramicists—not to mention oilcloth suppliers and suitcase-makers for locks and leather.

Sixty-nine reproductions, their labels, black paper folders, customized and mitered cardboard strips for the mock-framing of several reproductions of paintings, specially designed wood frames for the replicas of the *Large Glass* and *9 moules málic (Nine Malic Molds)*, wood sliding elements, different metal items necessary for the final assembly, small screws, and metal rods (together, more than 180 individual pieces) belonged to a single *Boîte*. Each had to be decided on, designed, ordered, and manufactured in advance. The assemblage of a single *Boîte* could easily take ten days or more and certainly involved boring, repetitive work. Between January 1941 and summer 1942, only four or five copies of the new edition were ready.

Finally, on the top of the finished container, four mitered pieces of wood (ready-made parts from the electric hardware store) form an upper-case M—capital M for Marcel. The title itself is printed between the V-shaped element of this letter: "de ou par MARCEL DUCHAMP ou RROSE SELAVY."

In September 1942, *Time* magazine wrote under the heading "Artist Descending to America": "Here he is working on his 'Monograph.' It consists of a collection, in cardboard boxes, of reproductions of his work since 1910. Eventually he intends to bind the boxes in beautiful leather cases."[5] By the end of the year, Duchamp had negotiated a reduced price of $175 for The Museum of Modern Art to acquire from Peggy Guggenheim's Art of This Century gallery a deluxe copy of his "Monograph." Signed and dedicated January 1943, the *Boîte-en-valise*, no. IX/XX entered the Museum's permanent collection. Parallel to this effort, Duchamp was instrumental in securing the extended loan of the *Large Glass* for the Museum. Appropriately, the original artwork included in the Museum's *Boîte-en-valise* is a miniature study of the upper half of the *Large Glass*, the domain of the *Bride* (1938). Thus, Duchamp first tested his concept of having an object present in one institution in two formats: the *Large Glass* full-scale and *en miniature*: "Everything important I have done, can be put in a small suitcase."[6]

Capital M . . . is for Money: In 1919, Duchamp paid his dentist Dr. Daniel Tzanck with a hand-drawn check, "all by myself—on no bank at all," made out for $115.[7] In 1923, he modified a mock poster: *Wanted/$2000 Reward*; and in 1924, thirty *Monte Carlo Bonds* were issued at 500 francs each. The *Tzanck Check*, the *Wanted/$2000 Reward* poster, and the *Monte Carlo Bond* were all re-produced for the *Boîte-en-valise*, placed in one of the black folders together with a full-sized replica of *L.H.O.O.Q.* of 1919. The placement at first seems odd in combination with the featured monetary transactions; but in 1965 Duchamp drew another check: "Pay to the order of Philip Bruno, unlimited $, on the Banque Mona Lisa." Personal value systems provide multiple exchange rates.

Within the framework of Duchamp's financial operations, one reference to money and currency passed unnoticed: the Louis Vuitton Company, a purveyor of travel gear, also supplied money bags: *porte-monnaies* of all kinds and currencies. Their *porte-monnaie* production included, for exclusive gamblers, a small, well-proportioned, polished pigskin suitcase with visible stitching and a rounded handle. The relation between the possible amount of money and the standard size of the largest values made it necessary to supply the gambler with a container both spacious and unobtrusively elegant.

Although not relevant to his particular gambling system, Duchamp encountered these elegant transport cases at the Monte Carlo casinos, and in 1940 he adapted the Readymade *porte-monnaie* as a model for his own purposes. Certainly not lost on Duchamp was the fact that the French word for purse—*porte-monnaie*—had a common denominator with certain of his Readymades of 1914–17: the *Porte-bouteilles*, the *Porte-chapeau*, the *Portemanteau*, and the previously unrecorded *Porte-serviettes*. Duchamp's art purse relates to his statement on posterity—the roulette of fame. The special *Porte-monnaie des beaux-arts* served as his personal instrument of transfer and transport of embossed or imprinted objects of value. For an artist who relied on the concept of *hasard en conserve* (canned chance), this Readymade valise—designed for big losses as well as big wins—served as the proper container for his own personal monograph. Not by chance, of course, do the same initials link *Porte-Monnaie* and Portable Museum.

Ecke Bonk

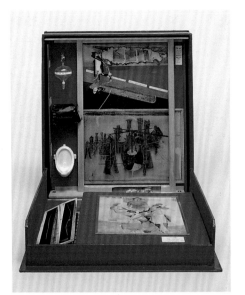

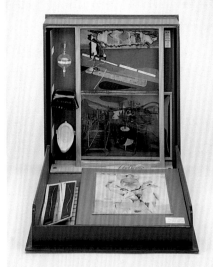

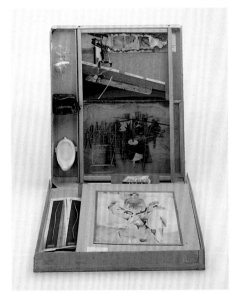

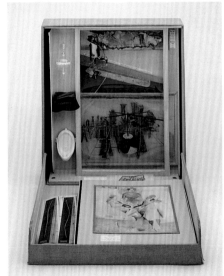

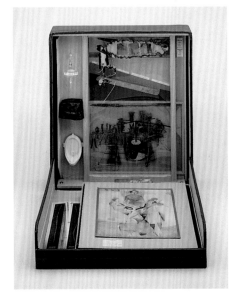

top left:
Marcel Duchamp
*De ou par Marcel Duchamp ou Rrose
Sélavy.* (Boîte series F, Paris, 1966)
Box covered in red leather and lined
in red linen containing miniature
replicas and color reproductions of
works by Duchamp (80 items),
overall 16 5/16 x 15 3/16 x 3 7/8"
(41.5 x 38.5 x 9.9 cm)
The Museum of Modern Art,
New York. Gift of the artist

top right:
Marcel Duchamp
*De ou par Marcel Duchamp ou Rrose
Sélavy.* (Boîte series G, Paris, 1968)
Box covered in green leather and
lined in green linen containing minia-
ture replicas and color reproductions
of works by Duchamp (80 items),
overall 16 5/16 x 15 3/16 x 3 7/8"
(41.5 x 38.5 x 9.9 cm)
Collection Ronny Van de Velde,
Antwerp, Belgium

center left:
Marcel Duchamp
*De ou par Marcel Duchamp ou Rrose
Sélavy.* (Boîte series B, begun Paris,
1941, and continued New York,
1942–54)
Box containing miniature replicas and
color reproductions of works by
Duchamp (68 items), overall 15 3/8 x
13 3/4 x 3 1/8" (39 x 35 x 8 cm)
Collection Ronny Van de Velde,
Antwerp, Belgium

center right:
Marcel Duchamp
*De ou par Marcel Duchamp ou Rrose
Sélavy.* (Boîte series D, Paris, 1961)
Box covered in light green linen and
lined in light green Ingres paper
containing miniature replicas and
color reproductions of works by
Duchamp (68 items), overall 15 3/4 x
15 x 3 1/2" (40 x 38 x 9 cm)
Collection Ronny Van de Velde,
Antwerp, Belgium

bottom:
Marcel Duchamp
*De ou par Marcel Duchamp ou Rrose
Sélavy.* (Boîte series E, Paris 1963)
Box covered in dark green imitation
leather and lined in light green
Ingres paper containing miniature
replicas and color reproductions of
works by Duchamp (68 items), overall
15 3/4 x 15 x 3 1/2" (40 x 38 x 9 cm)
Collection Ronny Van de Velde,
Antwerp, Belgium

Joseph Cornell
(American, 1903–1972)

top:
Joseph Cornell
Romantic Museum. 1949–50
Wood box containing 12 glasses
in velvet-lined interior, open
12 x 9 x 5" (30 x 23 x 13 cm)
Collection Mr. and Mrs. Gene Locks

bottom left:
Joseph Cornell
*L'Égypte de Mlle. Cléo de Mérode
Cours Élementaire d'Histoire
Naturelle (The Egypt of Miss Cléo
de Mérode Elementary Course in
Natural History)*. 1940
Box construction, closed 4 ¹¹⁄₁₆ x
10 ¹¹⁄₁₆ x 7 ¼" (12 x 27 x 18 cm)
Collection Mr. and Mrs. Robert
Lehrman, Washington, D.C.

bottom right:
Joseph Cornell
Taglioni's Jewel Casket. 1940
Wood box containing glass ice
cubes, jewelry, etc., closed 4 ¾ x
11 ⅞ x 8 ¼" (12 x 30.2 x 21 cm)
The Museum of Modern Art, New
York. Gift of James Thrall Soby

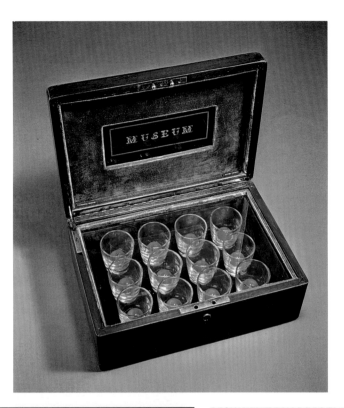

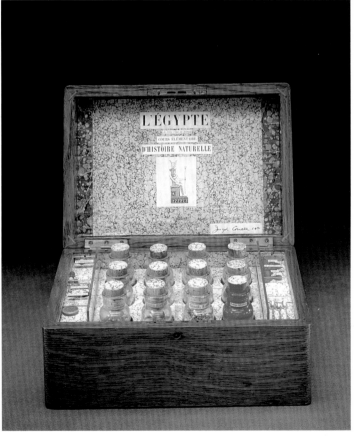

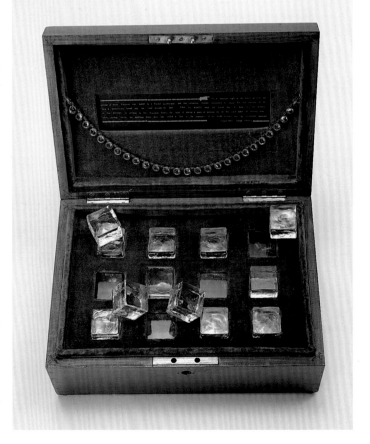

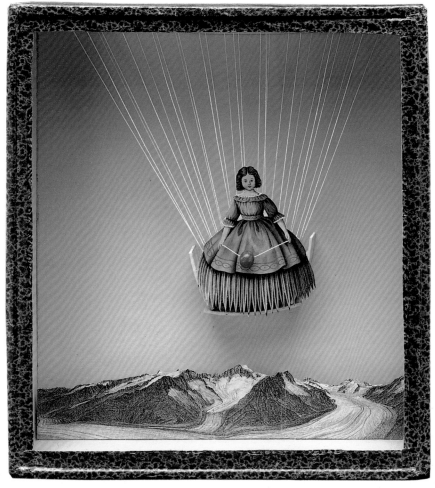

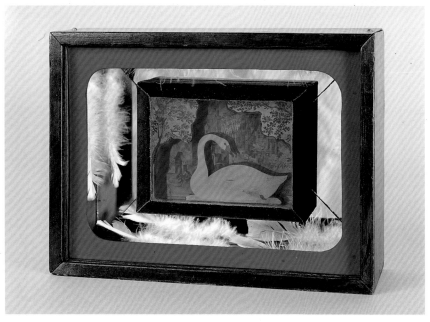

top:
Joseph Cornell
Tilly Losch. c. 1935
Box construction, 10 x 9 ³/₁₆ x
2 ¹/₈" (25.4 x 23.4 x 5.3 cm)
Collection Mr. and Mrs. Robert
Lehrman, Washington, D.C.

bottom:
Joseph Cornell
*A Swan Lake for Tamara
Toumanova (Homage to the
Romantic Ballet).* 1946
Box construction: painted wood,
glass pane, photostats on
wood, blue glass, mirrors,
painted paperboard, feathers,
velvet, and rhinestones, 9 ¹/₂ x
13 x 4" (24.1 x 33 x 10.1 cm)
The Menil Collection, Houston.
Gift of Alexander Iolas

"One sunny afternoon," during a typical day of searching through "dusty bookstalls off the beaten track," Joseph Cornell came upon "a rare and well-preserved portrait" of the "radiant and starry-eyed" nineteenth-century ballerina Fanny Cerrito. For Cornell the image of the dancer, best known for her role as the water sprite Ondine, came "disturbingly to life, and . . . stepped forth as completely contemporaneous as the skyscrapers surrounding her. . . . In the unfurling of an image was the danseuse set free . . . and the englamoured presence . . . enmesh[ed] the surroundings with a magical expectancy."[1] Believing that Cerrito had "assumed mortal guise," Cornell turned his attention to the "tokens of enchantment" accumulating in her wake.[2] He amassed these souvenirs, in the form of ephemera related to the dancer, and combined his discoveries with fantasies of spying her dressed in unexpected costumes in equally surprising settings: she substitutes for the guards of the Manhattan Storage and Warehouse building, and she appears on the Long Island Railroad as the conductor, accepting the artist's ticket. The unearthed articles soon expanded beyond Cerrito's personal history to the "spirit of ballet" itself, and compelled the artist to cross time and space: he found Cerrito's "magical expectancy" in the paintings of Giorgio de Chirico and Eugène Delacroix, in the poetry of Guillaume Apollinaire, and in the crowds of New York City.[3] Cornell's unending pursuit yielded a great reward: the record of this wide-ranging voyage became her portrait.

Comprising ephemera accumulated over the years, Cornell's *Portrait of Ondine* offers not only a biography of the ballerina but also sets out the artist's key methodology: a technique of accumulative assemblage that would determine Cornell's portraiture and characterize his entire oeuvre. The various materials housed in the work's paperboard box exemplify Cornell's unique form of art-making, and his notes for the project clarify his methodological goals. "Part of the intention of this exploration," Cornell wrote, "is the possibility of so developing it that it becomes a kind of image-hunting akin to poetry wherein the perceptive student may find and work out for himself a modus operandi and application to his own discovery or predilection."[4] Adapting the skills of the archivist for this image hunt, Cornell collected a wide range of materials—prints, photographs, newspaper accounts, memorabilia, and legends—about, related to, or inspired by his subjects, placing these discoveries into scrapbooklike souvenir albums, archivelike filing systems, miniature museums, and ephemera-filled box constructions. Sometimes these articles came directly from a particular individual—a bit of tulle donated by a ballerina, for example—while others made contact only in the artist's imagination. The artist's ceaseless pursuit and juxtaposition of tiny treasures suggests the impossibility of finding satisfaction in any one of them. In the *Portrait of Ondine*, as in all of his work, Cornell put *desire* into practice through *collection*.

In Cornell's attention to the castoff and the trifling, and in his ardor for the chance encounter, we can detect the core of Surrealism's "marvelous," but his exploitation of abandoned bits and pieces as doorways into ever-expanding worlds reveals a particular kind of historiography. To justify the collection of detritus and debris as a basis for his own "writing" of history, Cornell turned to the ballet historian Cyril W. Beaumont, who advised that although "the secrets" of each great ballerina are "lost forever . . . even the smallest details that have to do with her should be preserved."[5]

Cornell focused on these "secrets" in his 1946 exhibition, *Romantic Museum: Portraits of Women,* at the Hugo Gallery in Manhattan, preserving the "smallest details" of a diverse pantheon of dancers, divas, and movie stars of whom he was enamored. The contents of the gallery have all but disappeared, and descriptions of the exhibition installation are limited: the interior was a "theatrical environment of blue velvet, hairpins, and coins," and the artist installed flowers and songbirds in cages.[6] But the surviving exhibition brochure, consisting of a single sheet folded into four pages—designed, written, and illustrated by the artist—offers crucial clues to the philosophy and program of the Romantic Museum.

The exhibition, we learn from the brochure, consisted of mixed-medium portraits of ballerinas Fanny Cerrito and Marie Taglioni; opera divas Giuditta Pasta, Conchita Supervia, Eleanora Duse, María Malibran; actresses Jeanne Eagels, Greta Garbo, Lauren Bacall, and Jennifer Jones. In addition to these talents, Cornell presented a fictional child he referred to as "Berenice." Since Cornell often revisited subject matter, which resulted in multiple portraits of a number of these performers, it is difficult to reconstruct exactly which work of those surviving in museums and private collections appeared in the Hugo Gallery exhibition, but the brochure's list and short descriptions, along with the artist's diaries, allow for a few fairly reliable conclusions. In addition to the *Portrait of Ondine*, Cornell offered legendary stories of ballerina Marie Taglioni through a box construction filled with pieces of tulle and shards of glass, and presented opera diva

left and right:
Joseph Cornell
Brochure: *Romantic Museum:
Portraits of Women*. New York:
Hugo Gallery, 1946. Cover and
page 3

Giuditta Pasta through an embellished lithographic portrait. According to one source, Cornell depicted the operatic voice of María Malibran "by a small box with a stuffed bird on a spring which quivered to life when the interior music box played *La Traviata*."[7]

Calling attention to his curatorial strategies—his reconfiguration of the museum's typical ambitions of conservation, perpetuation, and protection—Cornell compared his exhibits to passing visions: "Unknown of Past and Present, Fugitive Impressions, Faces Seen But Once, Faces Seen in Crowds, Tabloid Portraits."[8] Having posed his subjects as figures for time's passage, Cornell deployed his method of collection not in order to hold on to these evanescent women but, instead, to let them go.

The "romance" of Cornell's museum, then, is its display of flotsam and jetsam, marginalia and memory traces. The artist often referred to abandoned artifacts as brimming with "infinite legend and romance."[9] Based as they are on endless and futile image hunts and the archiving of fragments, each of Cornell's works can be described as a Romantic Museum, from the velvet-lined case of his *A Swan Lake for Tamara Toumanova*, which protects "an actual wisp or two of a white feather from a head piece worn by Toumanova in 'Swan Lake'" to tiny glass jars holding rock specimens, reproductions, shell fragments, and plastic rose petals that evoke the *fin-de-siècle* courtesan Cléo de Mérode; or from the boxed forest that locks away the decaying nineteenth-century doll *Bébé Marie* to the tokens of Ondine that document her brief presence and confirm her absence. Cornell expressed his desire for these figures through a poetic image hunt undertaken to gain access and hold fast as well as to let go. The bits and pieces found in the Hugo Gallery, in the *Portrait of Ondine*, and in each and every one of his Romantic Museums are but evanescent fragments. And, as an artist and a curator, all that Cornell could do was journey after them.

Jodi Hauptman

Joseph Cornell
The Crystal Cage (Portrait of Berenice). 1943
Hinged box containing photographs, collages, and assorted ephemera, closed 4 5/16 x 15 9/16 x 20" (10.9 x 39.6 x 50.3 cm)
Collection Richard L. Feigen, New York

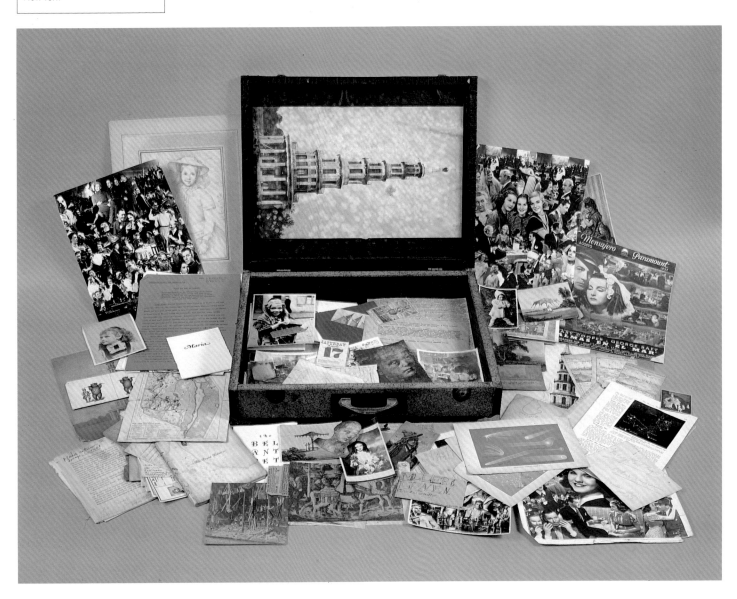

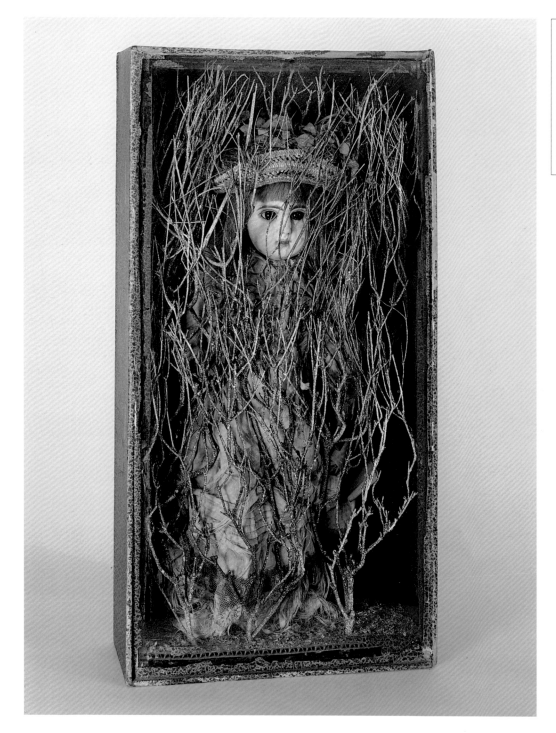

Joseph Cornell
Untitled *(Bébé Marie)*. Early 1940s
Papered and painted wood box,
with painted corrugated cardboard
floor, containing doll in cloth
dress and straw hat with cloth
flowers, dried flowers, and twigs,
flecked with paint, 23 $\frac{1}{2}$ x 12 $\frac{3}{8}$ x
5 $\frac{1}{4}$" (59.7 x 31.5 x 13.3 cm)
The Museum of Modern Art,
New York. Acquired through the
Lillie P. Bliss Bequest

Marcel Broodthaers

(Belgian, 1924–1976)

In 1964 the Belgian writer and poet Marcel Broodthaers announced that he would curtail his literary career and devote himself to making art. "I, too, wondered if I couldn't sell something and succeed in life," he declared on the invitation to his first exhibition. "The idea of inventing something insincere finally crossed my mind, and I set to work at once." [1] This initial statement encapsulates two ideas that were central to Broodthaers's twelve years as an artist, the intersection of art and commerce, and the related concept of the fiction: "A fiction allows one to see the truth and also that which it hides." [2] Beginning in 1964 with his first work of art *Pense-Bête*—fifty copies of his last book of poetry embedded in plaster—his artistic production was characterized by a love of word play and puns, and by an investigation of the relationship between word and object.

Fundamental to Broodthaers's career as a "fine" artist was his *Musée d'Art Moderne, Département des Aigles (Museum of Modern Art, Department of Eagles)*, a conceptual museum that manifested itself in various guises and locations between 1968 and 1972. Created in the wake of the May 1968 political protests by students, artists, and activists against government controls of cultural production and against the increasing commercialization of art, Broodthaers's museum was at once "a political parody of artistic events and . . . an artistic parody of political events." [3] It had neither a permanent collection nor a permanent location, and Broodthaers was its director, chief curator, designer, and publicity agent. Over the course of four years, at various galleries, museums, and art fairs, Broodthaers opened consecutive sections of his museum devoted to nineteenth-century art, seventeenth-century art, cinema, images of eagles in art, modern art, ancient art, and other subjects. He designed invitation cards and held inaugural ceremonies for each of his new sections.

The first department to open, the *Section XIXe siècle (Nineteenth-century Section)*, was inaugurated in Broodthaers's Brussels home with a formal ceremony on September 27, 1968. It consisted of about thirty fine-art crates from around the world, bearing typical stenciled instructions: "Picture," "With Care," "Keep Dry," etc.; about fifty postcards with reproductions of nineteenth-century French paintings by such artists as Courbet, Corot, Delacroix, and Ingres, all stuck on the walls with transparent tape; a slide projection showing nineteenth-century caricatures and paintings; inscriptions on the windows reading "Musée–Museum" and on the garden wall reading "Département des Aigles"; and, on the occasion of the opening and the closing of the section one year later, an empty art transport truck parked outside the studio windows. The truck and crates suggested the presence of real paintings (although there were none), and the postcards, deemed worthy of a museum display, also served as stand-ins for "real" works of art. As Douglas Crimp has pointed out, in the *Section XIXe siècle*, Broodthaers conflated the sites of production and consumption by situating the museum in the home, thereby calling into question "the ideological determination of their separation: the bourgeois liberal categories *private* and *public*." [4]

Broodthaers had announced his museum's inauguration with an open letter, one of many he would issue from the *Musée d'Art Moderne, Département des Aigles*, that stated: "We hope that our formula 'disinterestedness plus admiration' will seduce you." [5] He typed on the letter the heading "Cabinet of the Minister of Culture" (in French), lending an official air to the announcement. At the opening, lectures were presented by Broodthaers and, in German, by Dr. Johannes Cladders, director of the Städtisches Museum Mönchengladbach. Cladders read the manuscript of a recent article on the subject of the museum, which in the cultural climate of the late 1960s was being pilloried as a fusty, outmoded institution. Cladders went against the grain by suggesting that the causes, rather than the results, of the problem be evaluated, proposing a new, "anti-museum" that would accommodate the new "anti-art" being produced. The discussion that followed the inaugural lectures addressed the artist's relation to society. Excerpts of this exchange appear in Broodthaers's film *Une Discussion inaugurale* (1968).

The *Section XIXe siècle* closed on September 27, 1969, with a lecture in Flemish by Piet Van Daalen, director of the Zeeuws Museum Middleburg; a "for sale" sign was posted in the window, and the garden wall inscriptions were painted out. On the same day, Broodthaers opened the *Section XVIIe siècle (Seventeenth-century Section)* at an alternative exhibition space in Antwerp directed by Kasper König and named for its telephone number: A 37 90 89. Bus transport was arranged to take his guests from the closing in Brussels to the opening in Antwerp, where Van Daalen again gave a lecture. Fine-art crates were obtained from an Antwerp museum and arranged in the art space; postcards of works by Peter Paul Rubens were hung on the walls; on the gallery windows inscriptions reading "Sectie XVII Zeeuws" were painted; and on a garden wall opposite "Département des Aigles" was painted in large letters so as to be visible from the inside. This second manifestation of the *Musée d'Art Moderne*, as a museum for seventeenth-century Flemish art, existed for only about a week.

Approximately five months later, in the *Section XIXe siècle (bis) (Nineteenth-century Section [encore])*, Broodthaers installed eight actual nineteenth-century paintings borrowed from the Kunstmuseum Düsseldorf in conjuction with an exhibition titled *Between 4* at the Städtische Kunsthalle Düsseldorf. The eight paintings, by German painters of the Düsseldorf School, were arranged in a grid according to size, shape, and genre. On the opposite walls, in another part of the installation called *Dokumentation–Information*, the slide projection of nineteenth-century caricatures and paintings was again shown, and the film *Une Discussion inaugurale* (1968) was given its first public screening. On an adjacent wall, photographs of the first nineteenth-century section were exhibited, as well as those postcards of nineteenth-century paintings that had been shown in Brussels. Central to this manifestation was the juxtaposition of "real" art (paintings) with art fictions (slides, postcards), which challenged the supremacy of the "original." Inaugural lectures were given by Broodthaers and Jürgen Harten, curator of the Städtische Kunsthalle

SECTION FINANCIERE

MUSEE

D'ART MODERNE

A VENDRE

1970 - 1971

POUR CAUSE DE

FAILLITE

DEPARTEMENT DES AIGLES

left:
Marcel Broodthaers
*Musée d'Art Moderne, Département
des Aigles, Section Financière
(Museum of Modern Art, Depart-
ment of Eagles, Financial Section)*.
1970–71
Book cover for Cologne Art Fair
catalogue, 1971
Courtesy Michael Werner Gallery,
New York and Cologne

right:
Marcel Broodthaers
*Musée d'Art Moderne, Département
des Aigles, Section Financière
(Museum of Modern Art, Depart-
ment of Eagles, Financial Section)*.
1970–71
Gold bar stamped with an eagle
Courtesy Galérie Beaumont,
Luxembourg

Düsseldorf and of the "Between" exhibitions. This incarnation of Broodthaers's museum lasted just two days.

The most transitory instance of the museum's existence was its one-day appearance on the beach at Le Coq, on the North Sea coast of Belgium, during the summer of 1969. Broodthaers and a friend carved a museum foundation in sand (while wearing hats inscribed "museum") and posted signs saying: "Touching the objects is absolutely forbidden." This realization, known as the *Section Documentaire (Documentary Section)*, captured the ephemeral nature of Broodthaers's museum in the form of a sand castle, doomed to be destroyed by the next tide. As Martin Mosebach has suggested: "This conspicuous submerging of the *Musée d'Art Moderne* predated its real liquidation, but foretold that event in its necessity."[6]

Broodthaers first attempted to "liquidate" his museum with, ironically, the opening of another department: the *Section Financière (Financial Section)*, which included an installation organized for the Cologne Art Fair of 1971. A flyer in the form of a book jacket encasing the Art Fair catalogue announced: "Museum of Modern Art for sale on account of bankruptcy." With this gesture, Broodthaers turned a fic-

tional museum into a commodity, the ultimate parody of the art market. No buyers were found. As part of the *Section Financière*, he also publicized a venture aimed at raising funds for the museum: the sale of an unlimited edition of gold ingots stamped by the artist with an eagle. The charge for each ingot was calculated by doubling its market value as gold; the surcharge represented its value as art. Mosebach has suggested that the gold ingot can be seen to relate to a banknote in the same way that Broodthaers's postcard installations stood in for the paintings they reproduced, banknote and postcard each representing a fiction that survives so long as no one questions its legitimacy.

The next section of the museum to open, the *Section Cinéma (Cinema Section)*, was inaugurated in January 1971 in a rented basement in Düsseldorf. It encompassed two rooms—a large outer room and an interior room constructed of wood—with walls painted either black or white, and floors painted either gray or black and gray. In one room, a white "screen" was painted on a black wall, and references such as "fig. 1," "fig. 2," and "fig. A" were painted onto the screen. Various films, including Broodthaers's *Une Discussion inaugurale* and *Un Voyage à Waterloo (Napoléon 1769–1969)* (1969), as well as a

Chaplin compilation, were projected onto the screen over black rectangles with painted words. Next to the painted screen, another Broodthaers film, *Le Musée et la discussion* (1969), was occasionally projected over a map of the world. At one end of the outer room Broodthaers edited films, and his wife, Maria Gilissen, printed photographs. In the inner room, Broodthaers displayed an array of objects, most relating to the cinema, including a folding chair, film reels, a pipe (a reference to Magritte), a clock, an accordion case, a piano with the inscription "Les Aigles," and George Sadoul's book *The Invention of Cinema*. Each object was accompanied by labels reading "fig. 1," "fig. 2," "fig. A," "fig. 1&2," or "fig. 12." The *Section Cinéma* was open to the public every afternoon during the course of its yearlong existence in Düsseldorf.

In the *Section des Figures (Figures Section)* of 1972, held again at the Städtische Kunsthalle Düsseldorf, Broodthaers installed over three hundred works depicting eagles from the Oligocene era to the present, borrowed from numerous museums and private collections. In one room objects were presented in an encyclopedic display recalling the traditional cabinet of curiosities. All of the works were accompanied by a label reading: "This is not a work of art!" Broodthaers explained that this phrase was "a formula obtained by the contraction of a concept by Duchamp and an antithetical concept by Magritte."[7] He also stated that the *Section des Figures* analyzed the "structures of the museum in comparison to the structures of the authoritarian symbol." The importance accorded to eagles in Broodthaers's museum may be attributed in part to their symbolic association with power and victory, and to their widespread use in mythology, Christian imagery, heraldry, and national propaganda (notably in the United States and Germany). However, the artist preferred that the precise meaning of the eagle remain ambiguous and even issued false theories to ensure this was the case.

Broodthaers staged the official closing of his museum in 1972, with two installations presented simultaneously at Documenta 5 in Kassel, Germany, which was directed by Harald Szeemann. The *Section Publicité (Publicity Section)* appeared in an area of Documenta that included Marcel Duchamp's *Boîte-en-valise*, a portable "museum" in a suitcase, and Claes Oldenburg's *Mouse Museum*. In the *Section Publicité*, Broodthaers explored the link between the eagle in the history of art and the eagle in advertising. This manifestation of the museum consisted of manifold images of eagles drawn from art history, advertising, consumer products, and other sources, as well as empty frames, slide projections, and documentary photographs from the *Section des Figures*. The eagle for Broodthaers was "the sign of publicity itself," which "in advertising . . . preserved all of its character of magic suggestiveness, yet in the service of industrial production."[8] In the *Section Publicité*, he succeeded in transforming his museum into a form of public relations.

The other Broodthaers section at Documenta 5, the *Section d'Art Moderne (Modern Art Section)* of his museum, appeared in an area devoted to "individual mythologies," which was supervised by Johannes Cladders. The *Section d'Art Moderne* was a room-sized installation with, at its center, a black square painted on the floor on which the words "Private Property" were written in gold (in English, French, and German). The square was surrounded by stanchions mimicking the display of a sacred or valuable object. On the walls, the words "Direction, Cloak-room, Cashier, Office," accompanied by arrows and the words "fig. 1," "fig. 2," etc., suggested graphic signs for guiding museum visitors. On the window he painted the words "Museum/Musée," legible from the outside, and "fig. 0," legible from the inside. In this installation, Broodthaers aimed to satirize the identification of art with private property. In mid-August, halfway through the run of Documenta 5, he transformed the museum by changing integral elements of this installation. He replaced the words "Private Property" with "to Write, to Paint, to Copy, to Represent, to Speak, to Form, to Dream, to Exchange, to Make, to Inform, to Be Able To" (in French). He drew a boat on a wall in blue chalk and wrote underneath it: "Le noir c'est la fumée" (Black is smoke). The window inscriptions remained the same, but he covered the wall inscriptions with black paint and then inscribed in gold the name of his new museum: *Musée d'Art Ancien, Département des Aigles, Galerie du XXe siècle (Museum of Ancient Art, Department of Eagles, Twentieth-century Gallery)*.

The various manifestations of Broodthaers's fictional museum represent a pioneering effort to dispute traditional museum practices—their modes of classifying, labeling, storing, and exhibiting works of art—by appropriating and altering those very same practices as the form of critique. His strategies drew on the work of Duchamp and Magritte, whom he acknowledged as important influences. Yet the performative and ephemeral nature of his museum connects it to the Conceptual art and Happenings of his own period. By staging his museum acts in such sites as the Städtische Kunsthalle Düsseldorf and at Documenta, by using traditional museum-style invitations and press releases, and by organizing formal opening lectures by himself or by actual museum curators, he elevated the ruse to the point where the boundaries between his "fictional" museum and a "real" museum (or museum exhibition) were sometimes blurred. Broodthaers recognized the threat this occurrence posed and closed his museum at the point where it seemed "to have shifted from a heroic and solitary form to one that approximates consecration." With this shift, he explained, it was "only logical" that his museum would "grind down in boredom."[9]

Kristen Erickson

Illustrated Chronology: Marcel Broodthaers. *Musée d'Art Moderne, Département des Aigles (Museum of Modern Art, Department of Eagles)*

Musée d'Art Moderne, Département des Aigles, Section XIXe siècle (Nineteenth-century Section)
Broodthaers's home, rue de la Pépinière, Brussels
September 27, 1968–September 27, 1969 **>**
Broodthaers, Johannes Cladders, and others at the opening of the museum. **v**

M.U.SÉ.E..D'.A.R.T. CAB.INE.T D.ES. E.STA.MP.E.S., Département des Aigles (Museum of Art Print Department, Department of Eagles)
Librairie Saint-Germain des Prés, Paris
October 29–November 19, 1968
This section was identified in an announcement for an exhibition of Broodthaers's plastic plaques and the "book-film" Le Corbeau et le renard *at the Librairie Saint-Germain des Prés.*

Musée d'Art Moderne, Département des Aigles, Section Littéraire (Literary Section)
Brussels and Cologne, 1968–71
Broodthaers used the term Section Littéraire *on some of his museum letterhead and for various written projects.*

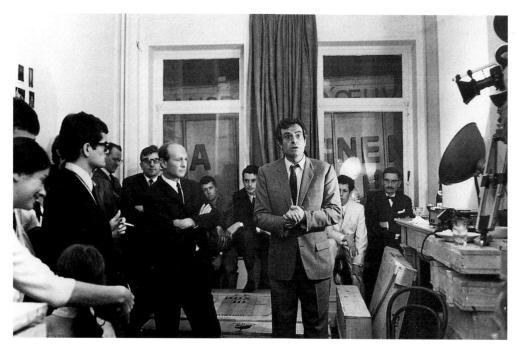

*Musée d'Art Moderne, Département des Aigles, Section Documentaire
(Documentary Section)*
Beach at Le Coq, Belgium, Summer 1969 ∧

*Musée d'Art Moderne, Département des Aigles, Section XVIIe siècle
(Seventeenth-century Section)*
A 37 90 89, Antwerp, Belgium, September 27–October 4, 1969 <

*Musée d'Art Moderne, Département des Aigles, Section XIXe siècle (bis)
(Nineteenth-century Section [encore])*
Städtische Kunsthalle, Düsseldorf, February 14–15, 1970 >

*Musée d'Art Moderne, Département des Aigles, Section Folklorique /
Cabinet des Curiosités (Folkloric Section / Cabinet of Curiosities)*
Folkloric Department, Zeeuws Museum, Middelburg, the
Netherlands, 1970
*This section encompassed Broodthaers's gift of a painting to the Folkloric
Department of the Zeeuws Museum; it also was to include photographs by
Maria Gilissen depicting objects from this collection.*

*Musée d'Art Moderne, Département des Aigles, Section Cinéma (Cinema
Section)*
Burgplatz 12, Düsseldorf
January 1971–October 1972
Replaced Cinéma Modèle (Model Cinema), *same venue,*
November 15, 1970–January 1971.v

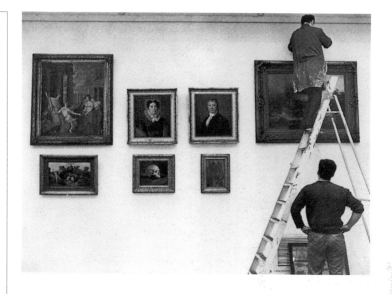

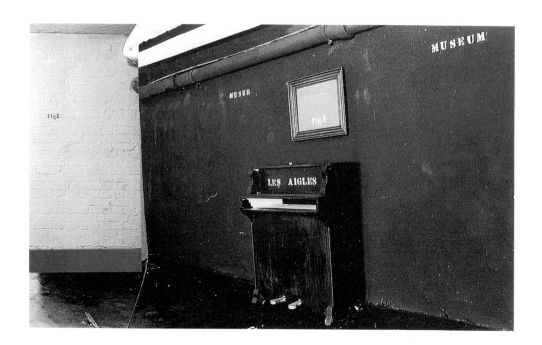

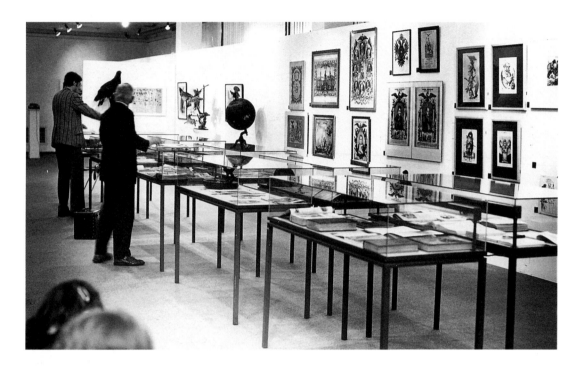

Musée d'Art Moderne, Département des Aigles, Section Financière (Musée d'Art Moderne à vendre pour cause de faillite, 1970–1971) (Financial Section [Museum of Modern Art for sale on account of bankruptcy, 1970–1971])
Cologne Art Fair, October 5–10, 1971; Düsseldorf
This section encompassed the sale of an unlimited edition of gold bars stamped with an eagle (see page 63).

Musée d'Art Moderne, Département des Aigles, Section des Figures (Der Adler vom Oligozän bis heute) (Figures Section [The Eagle from the Oligocene to the Present])
Städtische Kunsthalle, Düsseldorf, May 16–July 9, 1972 ʌ

Musée d'Art Moderne, Département des Aigles, Section Publicité (Publicity Section)
Documenta 5, Neue Galerie, Kassel, June 30–October 8, 1972 <

Musée d'Art Moderne, Département des Aigles, Section d'Art Moderne (Modern Art Section)
Documenta 5, Neue Galerie, Kassel, June 30–August 15, 1972
The painted floor as it appeared until August 15, 1972. **>**

Musée d'Art Ancien, Département des Aigles, Galerie du XXe siècle (Museum of Ancient Art, Department of Eagles, Twentieth-century Gallery)
Documenta 5, Neue Galerie, Kassel, August 15–October 8, 1972
The painted floor after its modification, in which the Section d'Art Moderne *was transformed into the* Musée d'Art Ancien. *This manifestation marked the closing of the Museum.* **v**

Claes Oldenburg

(American, born Sweden, 1929)

Claes Oldenburg
Mouse Museum. 1965–77
Enclosed structure of wood,
corrugated aluminum, and plexi-
glass display cases containing
385 objects, 10' x 31' 6" x 33'
(304 x 960 x 1030 cm)
Museum moderner Kunst
Stiftung Ludwig, Vienna

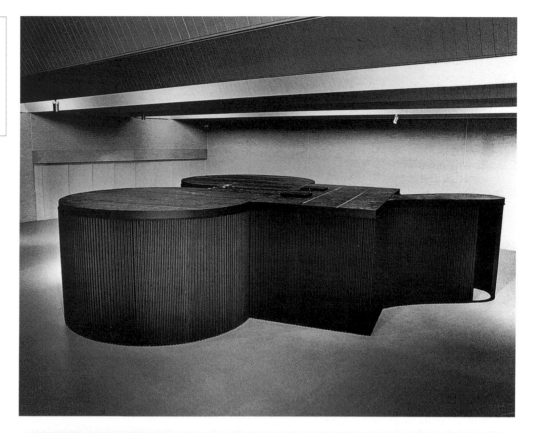

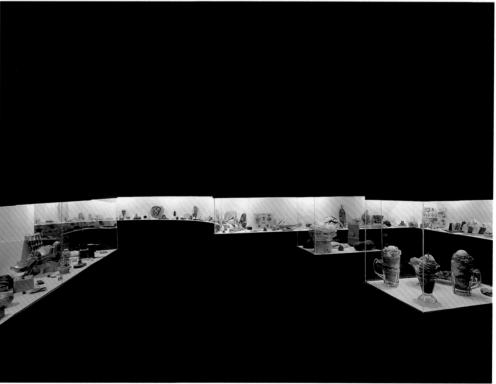

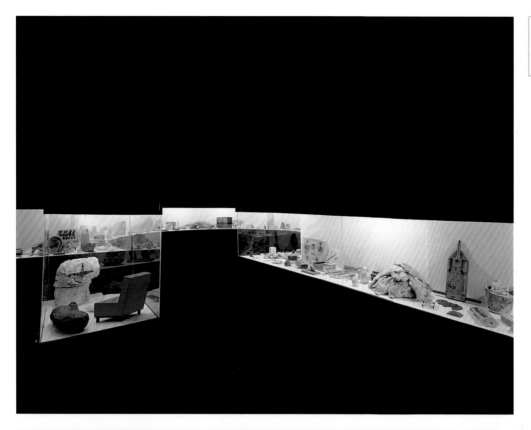

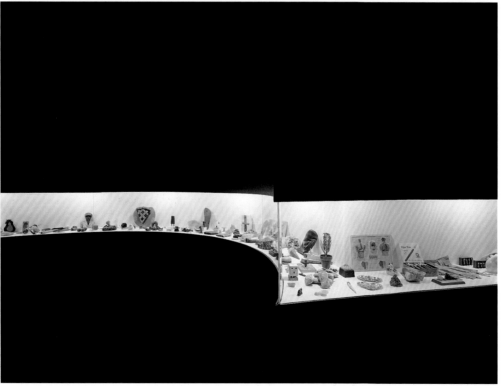

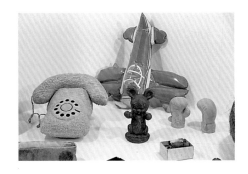 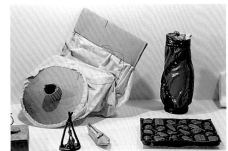

 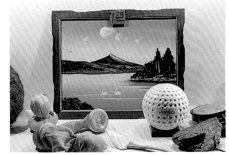 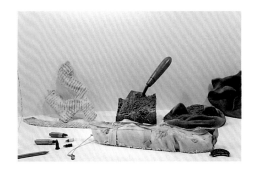

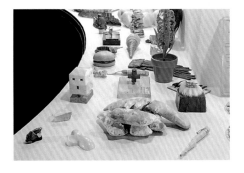 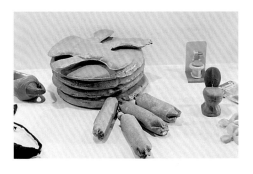

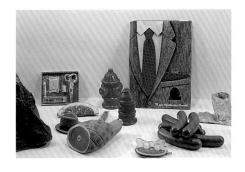 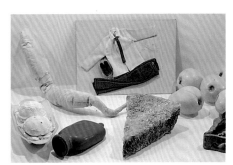

Collecting objects that surround us, whether they be bubble-gum cards of baseball players, African statuettes, or Art Deco, is an activity in which almost everyone indulges at some time. For some people it never stops. Artists who have a particular preference for the collecting of images often put their collector's mania to use by keeping a sort of visual archive to which they can refer while making their own work. Actual fragments and objects can even become part of the work of art....

The form of the *Mouse Museum* is based on Claes Oldenburg's *Geometric Mouse*, a combination of the early film camera and a stereotypical cartoon mouse. The result is two circles, a rectangle and an organic form which may be likened to the nose of a cartoon mouse.... Three kinds of objects are collected in the *Mouse Museum*: studio-objects, which are small models Oldenburg himself has made as well as fragments left over from work processes; altered objects, which are objects changed by the artist; and unaltered objects, those which have been found on the street or bought in stores. The experiences in his own life and art, expressed in studio objects and fragments, are joined with the experiences of others, embodied in stereotypical images and objects (often toys made in Hong Kong and Japan). The collection of objects is the visualization of a process in time, which represents not only Oldenburg's working method but also his perception of American society.

The world of the *Mouse Museum* . . . is populated only by objects. Human beings in this "city nature" are objectified as stereotypes (such as "Campus Cutie"), as parts of the body, or as tiny figures used to indicate scale. Within this microcosm, separated from reality by a plexiglass wall, the unaltered objects and studio objects remain in their own worlds despite the link provided by the altered objects. Oldenburg's solution to this lack of unity is to relate the objects by emphasizing form, color, texture, and proportion. The objects thus become part of the entire composition of the *Mouse Museum*.... At the same time each object is isolated in space and treated in a nonhierarchical way. In its insular position it can maintain its own identity.

Concise History of the *Mouse Museum*

1965: Claes Oldenburg moves into a large loft at 14th Street and First Avenue in New York. Small objects,

ray guns, and other fragments of "city nature" (items found on the street, toys bought in stores, residues of performances, souvenirs of travel, etc.) that have accumulated and been carried along with works and furniture from studio to studio are placed onto a set of shelves found on the premises. Oldenburg paints the shelves white, which gives them an architectural appearance, like a doll house highrise, and stencils on the top: "museum of popular art n.y.c." Studies and remnants from working processes are added to the collection....

1965–66: Oldenburg's notebooks contain plans to found a "museum of popular objects" consisting of two wings, one for unaltered objects and the other for small objects he has made himself. There is to be a committee for new acquisitions, a bulletin, and a movie titled "Tour Through the Museum," in which the objects will be filmed in such a way as to make them appear as large as sculptures in a real museum.

He makes drawings for a museum building in the shape of a geometrically formed mouse, one of which is drawn on stationery designed for the "museum of popular art" with the same mouse in the letterhead....

1966: *As Found*, an exhibition of objects collected by artists at the Institute of Contemporary Art in Boston, from March 5 to April 10, stimulates Oldenburg's first museum-style cataloguing of fifty unaltered objects from his collection.

Oldenburg uses the geometrically formed mouse in studies for a catalogue cover of his first retrospective at Moderna Museet in Stockholm, organized by Kasper König. Ultimately the mouse is not used for the cover but, at König's suggestion, becomes the letterhead on stationery printed for the exhibition. Oldenburg calls the geometrically formed mouse "Strange Mickey Mouse." The image is appropriate because in Swedish the word for mouse, *mus*, is similar to the word for museum, *museet*. Oldenburg's play with these words and the Swedish name for Mickey Mouse, *Musse Pigg*, anticipates the title *Mouse Museum*: "Mickey Mouse=Multi Mouse= Multi Mousse=Movey House=Musee Mousse=Musse Pigg=Mussee Pigg" (*Notes*, New York, 1966).

1967: The geometrically formed mouse is proposed as an alternative façade for the new Museum of Contemporary Art in Chicago.

1968: Studies for sculptures using the mouse are

opposite:
Claes Oldenburg
Mouse Museum (details): objects on display

left:
Claes Oldenburg
*Model for Mouse Museum,
Documenta 5.* 1972
Cardboard and wood, 4 ³/₄ x 20 x 20"
(12.1 x 50.1 x 50.1 cm)
Collection Claes Oldenburg and
Coosje van Bruggen, New York

right:
Bernhard Leitner and Heidi Bechinie
Poster for Maus Museum. 1972
Ink on paper, 30 ⁷/₈ x 29 ⁷/₈"
(78.4 x 75.9 cm)
Collection Claes Oldenburg and
Coosje van Bruggen, New York

published in *Notes* at Gemini G.E.L. in Los Angeles; a first model is made in cardboard (later remade in metal).

1969: Oldenburg moves his studio to a factory building on the outskirts of New Haven....

1969–71: At the Lippincott factory in New Haven, Oldenburg makes the first large version of the mouse in metal, which he titles *Geometric Mouse, Scale A, 1/6.* It is shown together with banners in the form of the *Geometric Mouse* in his retrospective exhibition at The Museum of Modern Art, New York, in September 1969....

1971: Oldenburg returns to New York, setting up a studio on West Broome Street, where the collection of objects is re-installed in shelves.

1972: At Documenta 5 at Kassel, Germany, Oldenburg is given the opportunity to realize his idea of a "'museum of popular art'" in the structure of the *Geometric Mouse.* He selects 367 items from the collection, which are catalogued with the help of Kasper and Ilka König. König is designated "director" of the *Mouse Museum.* In the first concept of the *Mouse Museum* building the form of the *Geometric*

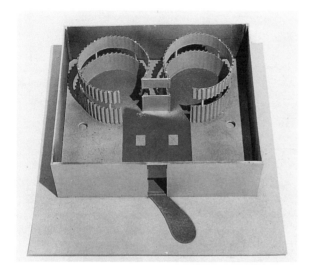

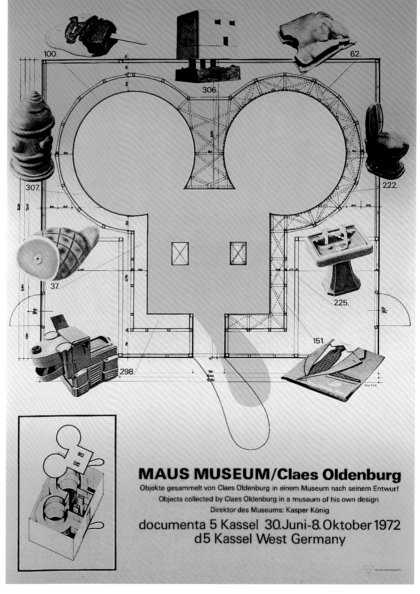

MAUS MUSEUM/Claes Oldenburg
Objekte gesammelt von Claes Oldenburg in einem Museum nach seinem Entwurf
Objects collected by Claes Oldenburg in a museum of his own design
Direktor des Museums: Kasper König
**documenta 5 Kassel 30.Juni-8.Oktober 1972
d5 Kassel West Germany**

Mouse is hidden from the outside in a boxlike structure and can only be experienced from the inside. The *Mouse Museum* is built in the Neue Galerie in Kassel after plans drawn by Bernhard Leitner and Heidi Bechinie.

1975: The reconstruction of the *Mouse Museum* is discussed with Carlo Huber, director of the Kunsthalle Basel....

1976: In the spring, Oldenburg thinks about a new design for the *Mouse Museum* with Coosje van Bruggen, who proposes the elimination of the box around the *Geometric Mouse* so that the form can be seen from the outside. Furthermore, it is decided to construct it in such a way that it can be taken apart in sections and is strong enough so that it can travel without being packed. The outside is to have a corrugated aluminum facing—a direct translation of the cardboard model. The nose will be part of the structure and ventilation will be improved through the use of air conditioning. Oldenburg selects the color black for the exterior, making an association with "Black Maria," the first primitive film studio developed by Thomas A. Edison. In June, Oldenburg moves to Deventer in the Netherlands, where he lives and works until January 1978. The death of Carlo Huber in July interrupts plans to rebuild the *Mouse Museum*. Attempts by the Kunsthalle to continue the project fail due to the high costs of construction in Switzerland.

1976–77: In the summer of 1976 the Museum of Contemporary Art in Chicago agrees to build and circulate the new *Mouse Museum* with the aid of a grant from the National Endowment for the Arts....

In November 1977 Oldenburg flies to Chicago to install the objects. A plastic hyacinth from Holland is the last piece added to the collection of the *Mouse Museum*, which now consists of 385 items....

Coosje van Bruggen [1]

Claes Oldenburg
System of Iconography. 1969
Pencil on paper, 11 x 14"
(28 x 35.6 cm)
San Francisco Museum of Modern Art. Gift of John Berggruen

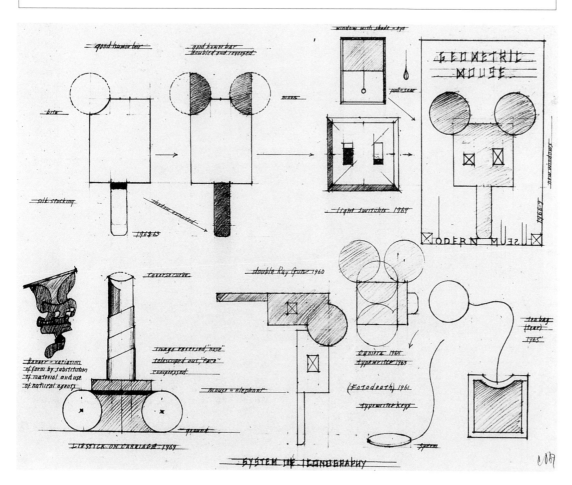

Herbert Distel

(Swiss, born 1942)

Museums, especially museums of fine art, are places where we become conscious of time. Like a preserving jar, they all have the task of conserving and presenting a subject curdled with time—the artwork. But through and behind these works the artists appear, falling out of the screen of time, as it were, and become immortal.

The *Museum of Drawers* is almost exclusively filled with art of the 1960s and 1970s, represented by the five hundred pieces installed within it, giving a comprehensive survey of a period of art whose currents were more numerous than ever before, unlike the last two decades of the twentieth century, in which there are no more currents to find at all. But there are also some works of the classical avant-garde; they form the background for all the currents that complete one hundred years of modern art and oscillate between artists like Pablo Picasso and Marcel Duchamp.

The Museum as Muse—to be kissed by the muse of the *Museum of Drawers*—this was my hope when I invited each of the five hundred artists to realize a work for the tiny rooms ($2\frac{3}{4}$ x $1\frac{7}{8}$ x $1\frac{11}{16}$"). My hope has become reality.

Herbert Distel

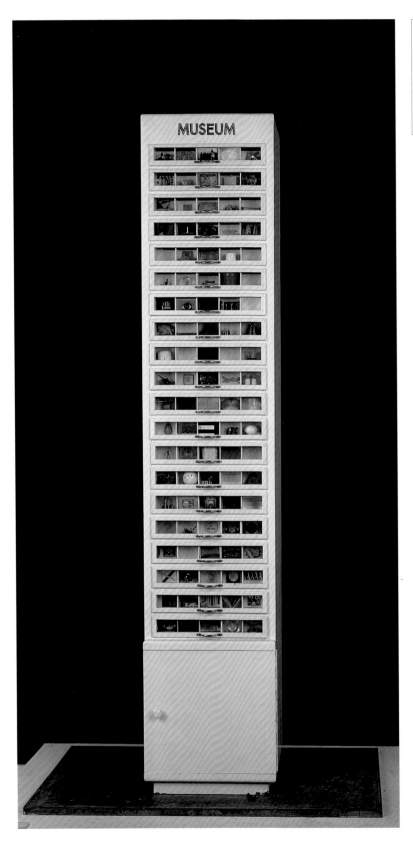

Herbert Distel
Museum of Drawers. 1970–77
Chest of drawers containing
miniature works by various artists,
overall (approx.) 72 x 28 ⁹/₁₆ x
28 ⁹/₁₆" (183 x 42 x 42 cm)
Kunsthaus Zürich. Donation of
Herbert Distel and The Founda-
tion Julius Bär

top and bottom:
Herbert Distel
Museum of Drawers (details):
drawers nos. 1 and 5

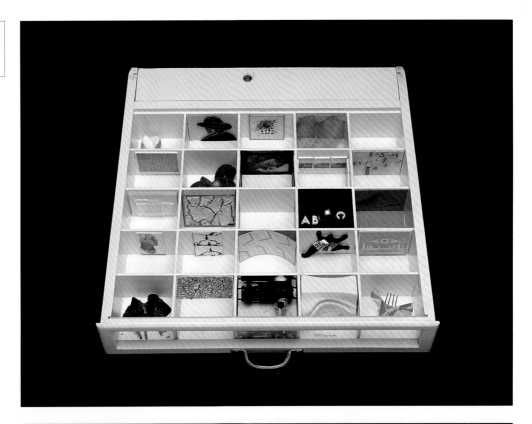

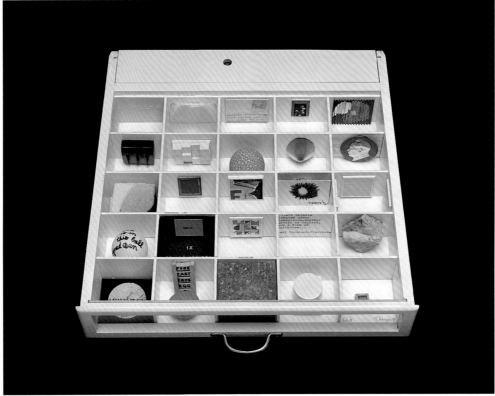

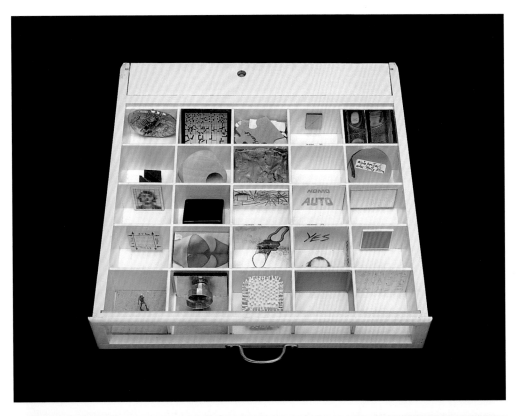

top and bottom:
Herbert Distel
Museum of Drawers (details):
drawers nos. 13 and 19

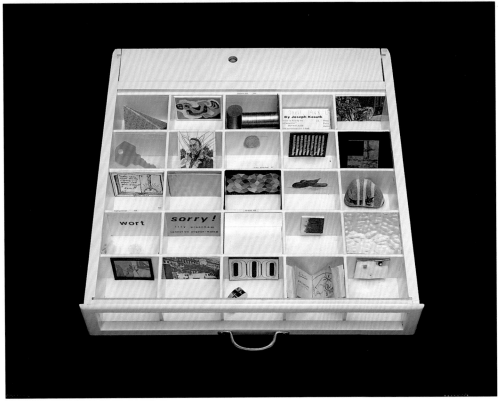

Barbara Bloom

(American, born 1951)

Barbara Bloom
The Reign of Narcissism. 1988–89
Mixed-medium installation, overall
(approx.) 12 x 20 x 20' (365 x
609 x 609 cm)
The Museum of Contemporary Art,
Los Angeles. Purchased with
funds provided by The Frederick
R. Weisman Art Foundation, Los
Angeles

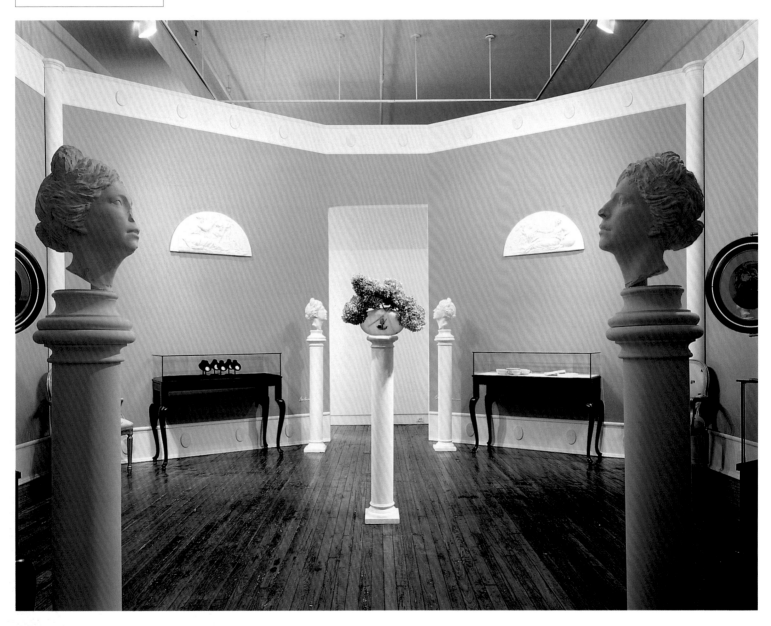

Quite distinct from the motives of the public museum are those psychological imperatives that drive the private collector.

The almost fetishistic desire of the private collector to assemble, organize, touch, and cohabit with objects is the animating force behind Barbara Bloom's tour-de-force installation *The Reign of Narcissism*. Originally created for the *Forest of Signs* exhibition at the Museum of Contemporary Art in Los Angeles in May 1989, *The Reign of Narcissism* consists of thirteen parts of generic types of work, ranging from cameos to gravestones and silhouettes to signatures, all skillfully deployed within a hexagonal rotunda and all focusing on a single subject, the artist Barbara Bloom herself.

On one level, the series provides a virtual catalogue of the body and the senses; on another, it is a hilarious parody of the monomania that consumes some collectors. Bloom is interested in both the psychological aspects of collecting and in the organization of objects and images. Despite her own repeated presence, she is quick to note that "this work is not really about Freudian narcissism, but about the narcissistic aspects of art making and of collecting."

In another context, a work that so aggressively refers to the artist's own life and portraiture might seem repulsive; but Bloom's work is clever enough to be both fascinating and cloying. It is a Conceptual piece but the style of the installation is profoundly anti-Minimalist. It is overabundant, even exuberant, in its all-encompassing array of visual formats. Yet, despite its overdetermination and obsessiveness, the work is fastidiously ordered and classically balanced. Bloom has said: "My goal was to create a work that was pretty and obnoxious at the same time; both a critique of beauty *and* a collection of the things I like most."

The result is like a personal collection, not only centered on the self but also arranged according to personal whims. Thus *The Reign of Narcissism* conforms to a very particular museological tradition, that of the private museum, such as those created by Sir John Soane in London and Gabrielle d'Annunzio on Lake Garda in Italy. In Soane's museum, the specially designed rotunda was crammed from floor to ceiling with three stories of sculptures and architectural fragments, at the center of which Soane placed a bust of himself. Such museums adopt personal methods of selection and display, an attitude that recalls the Renaissance *Wunderkammer*, or cabinet of curiosities.

Central to understanding this work is Bloom's guidebook *The Reign of Narcissism*. This book is not like an ordinary art catalogue: it offers excerpts from fictional and critical texts by various authors that address the subjects and generic forms of Bloom's work. For instance, the chapter on cameos features an essay by Ernst Gombrich on physiognomy, and the section on gravestones reproduces a section of Oscar Wilde's *The Portrait of Dorian Gray*. "In any museum the object dies—of suffocation and the public gaze—whereas in private, ownership confers on the owner the right to handle and the need to touch," says the obsessive collector of Meissen china in Bruce Chatwin's short story *Utz*, which is reprinted in Bloom's guidebook. "Ideally, museums should be looted every fifty years, and their collections returned to circulation."

Brian Wallis

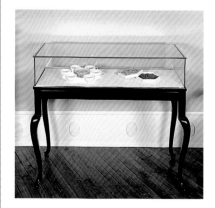

top to bottom:
Barbara Bloom
The Reign of Narcissism (details):
• Tombstone.
• Ornamental plaster relief restyled to depict the muse painting her own face.
• *The Complete Works of Barbara Bloom*. Berlin: Edition René Block, 1989.
• Vitrine with chocolate box and teacups.

Fluxus

(International collective, founded 1962)

Fluxus
Flux Cabinet. 1975–77 (Fluxus
Edition, designed and assembled
by George Maciunas 1977)
Wood cabinet with 20 drawers
containing objects by different
artists, cabinet 48 x 13 x 14"
(122 x 33 x 33.5 cm); drawers
(approx.) 12 x 12" (30.4 x 30.4 cm)
The Gilbert and Lila Silverman
Fluxus Collection Foundation,
Detroit

opposite:
Fluxus
Flux Cabinet (detail): partially
open drawers showing contents

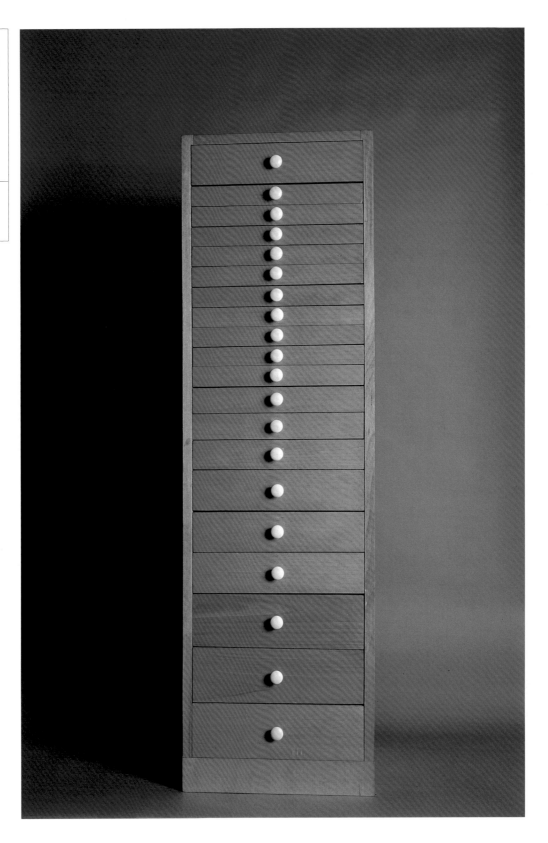

The *Flux Cabinet* represents the culmination of a sixteen-year effort to anthologize the creative output of the Fluxus collective of the 1960s and 1970s. Created by Fluxus founder George Maciunas, the *Flux Cabinet* stacks up in a taut vertical row works by fourteen different Fluxus artists, including George Brecht, Robert Watts, Ben Vautier, and Claes Oldenburg. These built-in miniature displays—some whimsical, others threatening or enigmatic—demonstrate the varied experimental practices of Fluxus, which encompassed such diverse activities as concrete music, Conceptual art, neo-Dadaist poetry, mail art, modified ready-mades, and antic participatory events. As the group's vociferous promoter and authoritarian scoutmaster, Maciunas recognized from its inception in 1962 the critical importance of structure and organization in sustaining the movement's collective identity and ensuring its continued existence. Between 1963 and 1978 Maciunas designed and executed numerous Fluxus anthologies, collections of works produced in editions and sold through a special mail-order system, intended to serve multiple functions: to give coherent order to the voluminous creative product of the individual artists associated with Fluxus; to propagandize the Fluxus name and the movement's declared anti-formalist, anti-art ideals; and to establish a distribution system independent of the mainstream art market.

Maciunas favored works (or collections of works) that provided their own venues of display, and the box, with its allusion to museum vitrines, became an obvious vehicle. The first anthology, *Fluxus Year Box I* (1963), was an edition of wood boxes containing musical scores, handbills of "Fluxevents," concrete poems, conceptual pieces, diminutive objects, photographs, and pull-outs of various kinds. Predominantly paper-based and often randomly organized according to chance procedures, the contents of the Year Boxes were bolted together and neatly inserted into their own wood repositories.

The Fluxkits (1964–65 to the late 1960s) represented an intermediate stage between the Year Boxes and the *Flux Cabinet* of 1975–77. Intended as an unlimited edition, although only a moderate number were actually produced, these three-dimensional anthologies took the form of attaché cases, with the contents varying widely from copy to copy. Maciunas referred to the Fluxkits as "miniature Fluxus museums,"[1] emphasizing their cheapness, mass-producibility, and portability.

For the *Flux Cabinet*, Maciunas assumed the role of museum curator, organizing and literally "pigeonholing" his roster of artists, assembling a miniature "Fluxshow," drawer by drawer. In

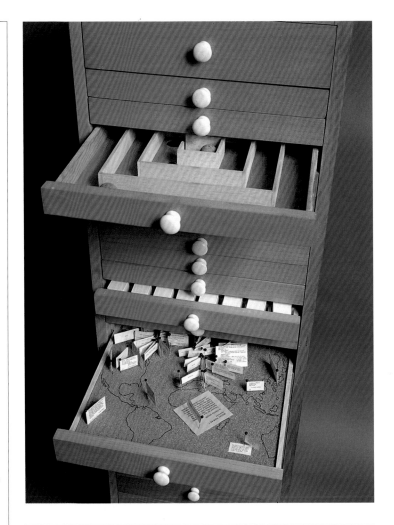

drawer 7, Ben Vautier concocted a *Flux Suicide Kit*, an assortment of razors, sleeping pills, matches, and other potentially lethal objects. For drawer 1, John Lennon devised a *Magnification Piece*, a pair of binoculars embedded in the bottom of the drawer, offering viewers close-up inspections of their own feet. Maciunas contributed his *Excreta Fluxorum* to drawer 12, a wryly pseudoscientific taxonomy of insect and mammalian feces, arranged according to their order of "evolutionary development."[2] Conceived as a deluxe version of the typical Fluxus anthology, the *Flux Cabinet* was originally planned as an edition of two, although only one was completed before Maciunas's death in 1978.

James Trainor

Dennis Oppenheim

(American, born 1938)

It didn't occur to me at first that I was using earth as sculptural material. Then gradually I found myself trying to get below ground level. . . . I wasn't very excited about objects that protrude from the ground. I felt this implied an embellishment of external space. To me a piece of sculpture inside a room is a disruption of interior space. It's a protrusion, an unnecessary addition to what could be a sufficient space itself. My transition to earth materials took place in Oakland a few summers ago, when I cut a wedge from the side of a mountain. I was more concerned with the negative process of excavating that shape from the mountainside than with the making of an earthwork as such. It was just a coincidence that I did this with earth. . . .

But at that point I began to think very seriously about place, the physical terrain. And this led me to question the confines of the gallery space and to start working with things like bleacher systems, mostly in an outdoor context but still referring back to the gallery site and taking some stimulus from the outside again. Some of what I learn outside I bring back to use in a gallery context. . . .

I think that the outdoor/indoor relationship in my work is subtle. I don't really carry a gallery disturbance concept around with me; I leave that behind in the gallery. Occasionally I consider the gallery site as though it were some kind of hunting ground. . . . But generally when I'm outside I'm completely outside.

Dennis Oppenheim[1]

In the Gallery Transplants Oppenheim took the dimensions of a gallery, then marked off a similarly bounded space outdoors. A cognitive reversal is involved; the real-world index ironically was derived from the gallery, and then transposed to the outside world as a rejection of the reality of the gallery. Structurally, Smithson's non-sites are similar in mediating the ideological opposition between the autonomous artwork isolated in the gallery and the engaged artwork sited in the outside world. The non-sites are simpler, however, than the Gallery Transplants in that they do not involve the ironic reversal.

Another transplant piece, *Gallery Transplant* of 1969, originally done for the first *Earth Art* show organized by Willoughby Sharp for the Cornell University gallery, further complicated the method. Oppenheim redrew the boundary lines of the gallery in the snow of a bird sanctuary nearby. The gallery space transplanted into nature was then randomly activated by flocks of birds alighting on it in different compositions that were unaffected by the artist's intentions. The piece involved another important antimodernist rule or tendency that was being articulated in the works as they emerged. The modernist aesthetic view of art promulgated a myth of the complete control exercised by the artist—in whose work, for example, it was supposedly impossible to change anything without losing aesthetic integrity. Duchamp had articulated the counterprinciple, that of allowing chance to decide parts of the work, and that part of his artistic legacy was also bearing fruit now. In Oppenheim's Cornell *Gallery Transplant*, for example, the intervention of flights of birds was an element outside the artist's control. Increasingly, Oppenheim would come to feel that the artist should create the circumstances for an artwork to occur in—or set going the chain of causes which would produce it—but not the work itself, which remains hidden or unknown till it appears out of the manipulated causal web. The concept resembles the modernist idea of the artwork as something self-created or miraculous, but reverses the power hierarchy. In the modernist discourse the artwork, though in a sense self-created, still sprang somehow from the artist as medium; in this approach the artwork springs from the world as medium, the artist being more distanced.

Thomas McEvilley[2]

Dennis Oppenheim
Gallery Transplant (Floor
specifications: Gallery #4,
A. D. White Museum, Cornell
University, transplanted to bird
sanctuary near Ithaca, New York.
Activated surface: dirt and
snow). 1969
Color photograph, black-and-
white photograph, and stamped
topographic map, overall 50" x
13' 4" (127 x 406.3 cm)
Collection the artist

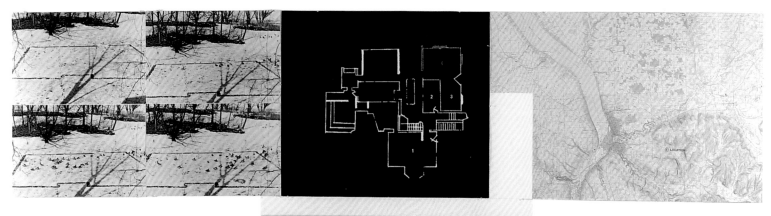

GALLERY TRANSPLANT 1969
Floor specifications: Gallery #4, A.D. White Museum transplanted to bird sanctuary
near Ithaca, New York. Activated surface: dirt and snow.

Toward the end of the film *The Spiral Jetty*, Robert Smithson enigmatically intones: "He leads us to the steps of the jail's main entrance, pivots and again locks his gaze into the sun."[1] Sometime before, a passage from Samuel Beckett—"Nothing has ever changed since I have been here"—is heard against a backdrop of footage shot through a red filter of the single museum space that seems to have captivated Smithson from the moment he encountered it as a boy: the Hall of Late Dinosaurs in the American Museum of Natural History in New York. "Blindly the camera stalked through the sullen light. . . . These fragments of a timeless geology laugh without mirth at the time-filled hopes of ecology."[2]

Smithson first saw the Great Salt Lake in 1970. It was "late in the afternoon" that the lake came into view, "an impassive faint violet sheet held captive in a stoney matrix, upon which the sun poured down its crushing light." On this site—reverberating "out to the horizons only to suggest an immobile cyclone"[3]—Smithson built *Spiral Jetty*, its fifteen-foot-wide path tracing a 1,500-foot-long spiral of black rock, salt crystals, and earth out into the algae-reddened waters. In 1971, the year following the completion of *Spiral Jetty* itself and the film, Smithson made the first drawings for a *Museum Concerning Spiral Jetty*. With a spiral staircase leading to an underground projection room, the proposed mastabalike structure of rubble suggests a profusion of associations. The archetype of the counterclockwise spiral as a path into the underworld butts up against the Native American myth that a whirlpool links the Great Salt Lake to the Pacific Ocean. The suggestion that the museum is a mausoleum is countered by the vision of "a cinema in a cave or an abandoned mine."[4] The museum was to be located near the Golden Spike Monument, where the visitor leaves Highway 83 for the dirt road that leads to *Spiral Jetty*. The Monument commemorates the coming together in 1869 of the final stretch of the first transcontinental railroad. With the barely inhabited land around it marked by "No Trespassing" signs, this celebration of technological progress appears, like the defunct oil rigs and other wreckage along the shoreline of the Great Salt Lake, to be stranded—"mired in abandoned hopes."[5] The juxtaposition would have been compelling—the deflated symbolism of the two locomotive engines joining the country into one sweeping vista side-by-side the chthonic

realm of a museum devoted to Smithson's monument to entropy. A crystalline surface of salt would have insinuated corrosion into the moist darkness of Smithson's projection room, entropy enacting its disordering work—irreversible, almost eternal.

Smithson's concern with salt lakes had begun at Mono Lake in California: "The closer you think you're getting to it and the more you circumscribe it, the more it evaporates. It becomes like a mirage." Smithson seems quickly to have contemplated the ways in which he might construct its absence: "The site is a place where a piece should be but isn't. The piece that should be there is now somewhere else, usually in a room. Actually everything that's of any importance takes place outside the room. But the room reminds us of the limitations of our condition."[6] In the room—in the museum—of course, is the *Mono Lake Non-Site*. A shallow painted steel container, shaped like a square gutter, contains pumice and cinders—the geological end-product of volcanic activity. The map, like the container that rests on the floor, is in "the shape of a margin—it has no center." But if the non-site is a "central focus point," then "the site is the unfocused fringe where your mind loses its boundaries and a sense of the oceanic pervades. . . . There's nothing to grasp onto except the cinders. . . . One might even say that the place has absconded or been lost."[7] The non-sites, in other words, always direct our attention elsewhere. If the non-sites are "like three dimensional maps that point to an area,"[8] then the actual map will scarcely guide you to Mono Lake, let alone to Black Point, the spot where Smithson collected the ashen debris. Contained by the geometric configuration which is imposed on both unruly matter and map alike, the topographical details are at best evocative: Sulphur Pond and Warm Springs are among the few discernible place names.

The tension between the museum or gallery and the world outside its confines was fundamental, not incidental, to the conception of the non-sites. Works such as *Mono Lake Non-Site* set in motion the dialectical play that governed Smithson's work. The periphery—remote and earthen—is implied by the center, the non-site in the museum. Entropic dissipation, which operates like a law outside the boundaries of the exhibition space, is only momentarily deflected by the formal cohesion wrought within; weighty materiality troubles the disembodied

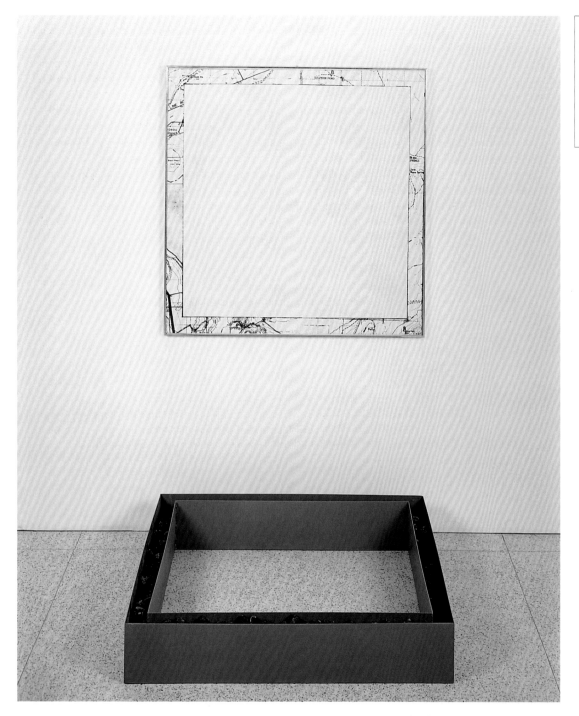

Robert Smithson
Mono Lake Non-Site (Cinders Near Black Point). 1968
Painted steel container, cinders and site map, container 7 x 39 ¾ x 39 ¾" (17.8 x 101 x 101 cm); map 40 ¼ x 40 ¼" (102.2 x 102.2 cm)
Museum of Contemporary Art, San Diego. Museum Purchase

Robert Smithson
The Museum of the Void. 1969
Pencil on paper, sheet 18 ⅞ x 24"
(47.9 x 61.1 cm)
The Over Holland Collection

abstraction of maps, photographs, and even the isolated geological evidence on display.

"Visiting a museum is a matter of going from void to void," Smithson remarked cryptically. "I'm interested for the most part in what's not happening…in the blank and void regions or settings that we never look at. A museum devoted to different kinds of emptiness could be developed."[9] In his proposed *The Museum of the Void*, the walls of the single chamber that is, in fact, a corridor recede toward a dark rectangular space that absorbs their vanishing point, as if to swallow the very devices of illusion and block the intimation of infinity with a mirror image of abyss. A veritable skyline of ziggurats that loom like some promiscuous refraction of the image of the Tower of Babel festoons the roof, oddly lurid like mourners dancing on a grave.

In the end the dialectic that Smithson replays in site/non-site, earthwork/museum does not—cannot—resolve its essential tension. Pointing always somewhere else, what the work brings unmistakably into focus are the parameters of that distance between here and there, now and then. They are, of course, the coordinates of our finitude—that yawning gap of time and space. "I posit that there is no tomorrow," Smithson pronounced, while acknowledging the assuaging possibilities of irony and a "cosmic sense of humor."[10] "Oblivion," he mused, "to me is a state when you're not conscious of the time or space you are in. You're oblivious to its limitations."[11] In the stillness of the art museum, Smithson could point with precision to the chasm obscured amidst the chaos beyond the pristine walls. As the viewer's focus shifts back and forth, registering absence, marking off time with Beckett-like persistence—Smithson's meaning scores itself across the transcendent field of the museum, for the moment fending off oblivion.

Sally Yard

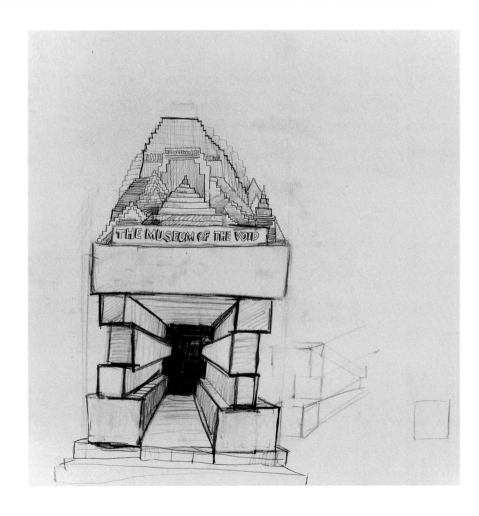

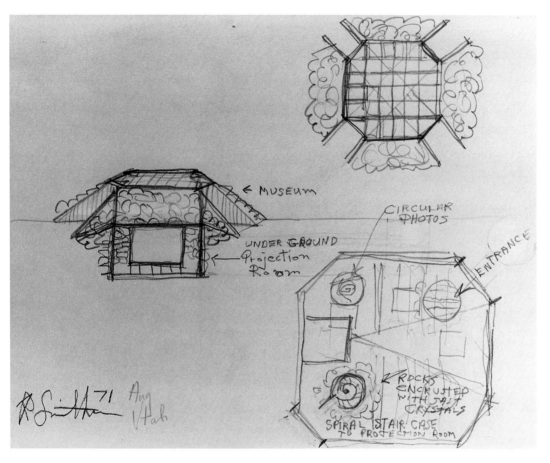

top:
Robert Smithson
Underground Projection Room. 1971
Pencil on paper, 9 x 12"
(22.8 x 30.4 cm)
Estate of Robert Smithson, courtesy
John Weber Gallery, New York

bottom left:
Robert Smithson
Plan for Museum Concerning Spiral Jetty. 1971
Pencil on paper, 15 ½ x 12 ½"
(39.4 x 31.7 cm)
Estate of Robert Smithson, courtesy
John Weber Gallery, New York

bottom right:
Robert Smithson
Museum Plan—Utah. 1971
Blue ink and pencil on paper, 9 x 12"
(22.8 x 30.4 cm)
Estate of Robert Smithson, courtesy
John Weber Gallery, New York

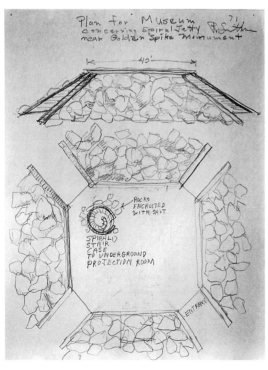

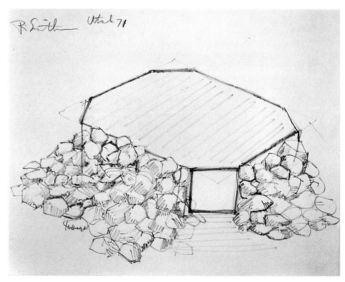

Christian Boltanski
(French, born 1944)

Christian Boltanski
Archives. 1987
355 black-and-white photographs
under glass, 6 metal screens, assem-
bled in groups of 2, and electric
lamps, each photograph 7 x 7 $^7/_8$" to
15 $^3/_4$ x 23 $^5/_8$" (18 x 20 cm to 40 x
60 cm); each screen 89 $^3/_8$ x 55 $^7/_8$"
(227 x 142 cm)
Collection Ydessa Hendeles,
courtesy Ydessa Hendeles
Foundation, Toronto

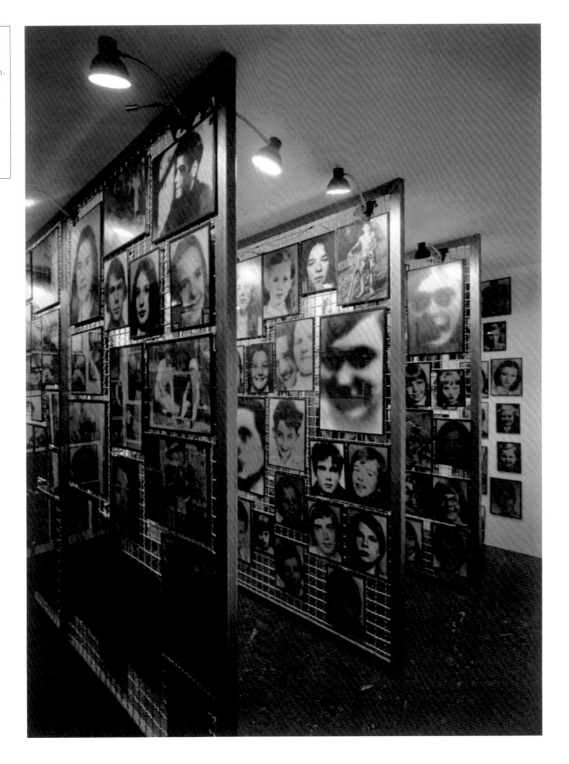

When I made the Inventories, and in the pieces titled *Réserves* or *Vitrines de référence*, I was recalling the ethnological and historical museums that I visited as a child. Preventing forgetfulness, stopping the disappearance of things and beings, seemed to me a noble goal, but I quickly realized that this ambition was bound to fail, for as soon as we try to preserve something we fix it. We can preserve things only by stopping life's course. If I put my glasses in a vitrine, they will never break, but will they still be considered glasses? This object helps me to see better; it is useful to me. Once glasses are part of a museum's collection, they forget their function, they are then only an image of glasses. In a vitrine, my glasses will have lost their reason for being, but they also will have lost their identity,

their history. These glasses: I like them, I know them, I know where I bought them, how the saleswoman praised them, the time when I forgot them in a restaurant, and my concern not to have them with me anymore. All this constitutes some kind of friendship, and this relationship, these shared memories, the museum cannot convey. This object will have lost its identity.

It is the same with hundreds of photographic portraits piled up in the small space of the *Archives*. None of these superimposed faces tells us anything about the destiny of these beings, the different lives of each of them remain unknown to us. They are here, next to each other, they who had no reason to meet, waiting, until someone can name them again.

Christian Boltanski

Christian Boltanski
Vitrine of Reference (II). 1970
Wood vitrine containing various objects, 27 ¾ x 47 ½ x 5"
(70.4 x 120.6 x 12.7 cm)
Courtesy Marian Goodman
Gallery, New York

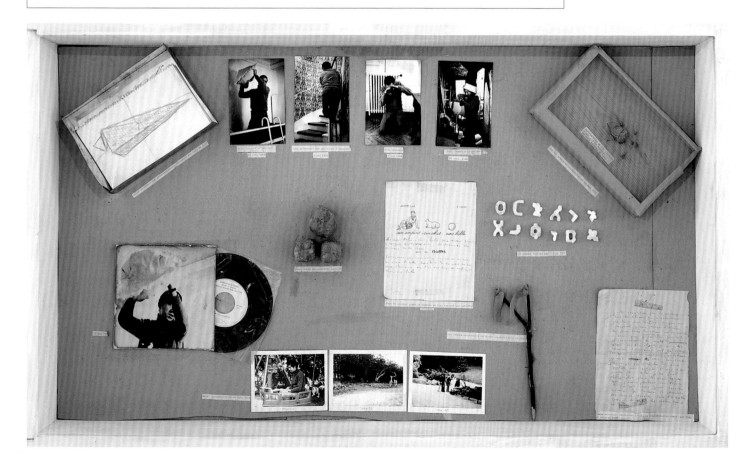

Susan Hiller

(American, born 1942)

Susan Hiller
From The Freud Museum. 1991–96
Vitrine installation: 50 customized cardboard boxes fitted with artifacts, texts, images, etc.; each box individually titled, dated, and captioned; one box contains miniature LCD monitor showing artist's silent video program *Bright Shadow* on a continuous loop, each box, closed 2 ½ x 10 x 13 ¼" (6.3 x 25.4 x 33.6 cm)
Tate Gallery, London. Purchased 1998
Installation view, Hayward Gallery, London, Summer 1997

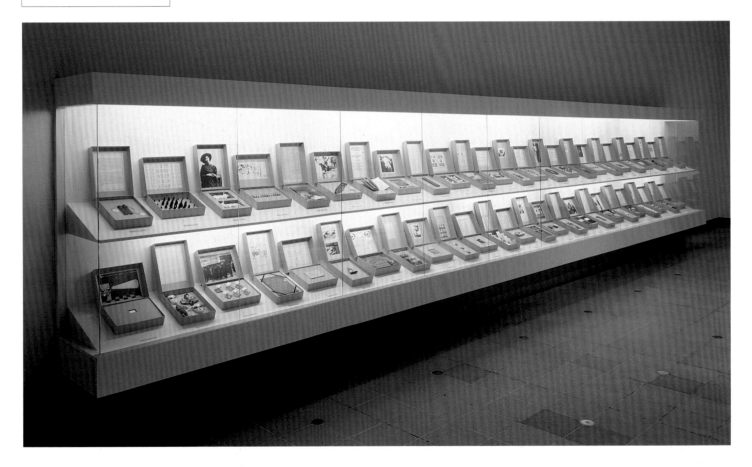

Little "Drink Me!" bottles of water I collected from the springs of Lethe and Mnemosyne (Forgetting and Remembering) are at the heart of my work in this exhibition.

From The Freud Museum is one of several large-scale installations I've made using museological formats, beginning in the early 1970s. While what to do about what's out of sight or invisible is the dilemma of most contemporary museums, my "museums" have concentrated on what is unspoken, unrecorded, unexplained, and overlooked—the gaps and overlaps between content and context, dream and experience; the ghosts in the machine; the unconscious of culture.

The title, *From The Freud Museum*, looks back to my experience of creating an earlier version of the work for the Freud Museum at 20 Maresfield Gardens, London, Sigmund Freud's last home. I feel the title also refers to a situation or a place that inspires a particular kind of self-awareness—an intensely personal recognition of living inside a specific, historically determined culture. For me it is appropriate to call this place *The Freud Museum*. Of course, I'm not its only inhabitant.

On one level, my vitrine installation is a collection of things evoking cultural and historical points of slippage—psychic, ethnic, sexual, and political disturbances. Individual items in my collection range from macabre through sentimental to banal. Many of the objects are personal, things I've kept for years as private relics and talismans, mementos, references to unresolved issues in earlier works, or even as jokes. Sigmund Freud's impressive collection of classical art and artifacts inspired me to formalize and focus my project. But if Freud's collection is a kind of index to the version of Western civilization's heritage he was claiming, then my collection, taken as a whole, is an archive of misunderstandings, crises, and ambivalences that complicate any such notion of heritage.

I worked on the piece for five years. My starting points were artless, worthless artifacts and materials—rubbish, discards, fragments, souvenirs, and reproductions—which seemed to carry an aura of memory and to hint they might mean something—something that made me want to work with them and on them. I've stumbled across or gone in quest of objects, I've orchestrated relationships, and I've invented or discovered fluid taxonomies. Archeological collecting boxes play an important role in the installation as containers or frames appropriate to the processes of excavating, salvaging, sorting, naming, and preserving—intrinsic to art as well as to psychoanalysis and archaeology.

Not editing out and not forcing strange juxtapositions and unanswered questions to conform to theory are aspects of my style. I'm interested in a perspective where figure-ground relationships can be allowed to shift. *From The Freud Museum* is structured by the gaps that punctuate it. The not-said matters. Like all my work, it aims to clarify a shared situation by providing space where viewers can experience their own roles as active participants/collaborators, interpreters, analysts, or detectives.

Susan Hiller

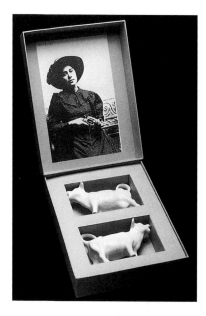

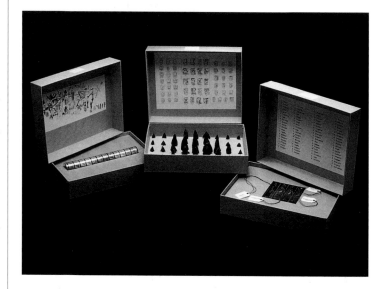

top:
Susan Hiller
From The Freud Museum (detail): Cowgirl

bottom:
Susan Hiller
From The Freud Museum (details): *Nama.ma (Mother)*; *Chamin'ha (House of Knives)*; *Sophia (Wisdom)*

Unsettled Objects. 1968–69. Pitt Rivers Museum, Oxford, England

As Enigma creates a Cosmos of Desire, so is Longing the Force to possess the Unknown.

The display of powerful objects in vitrines and the desire to make use of their energy for a didactic exhibition displaces them and makes them enigmatic.

The transformation is shown here in the diversity of collected ethnographic objects. In exhibition-like storage they reflect their use, form, and material. As none of them is in a so-called scientific system of organization, they offer a picture of chaos, acquired in haste and provisionally catalogued, as representing the cosmos. The aspiration for encyclopedic completeness has resulted in a vast appropriation and accumulation of unknown artifacts. This claim and desire to possess the objects have caused them to be: *displayed imagined classified reinvented generalized celebrated lost protected consumed climatized confined collected forgotten evaluated questioned mythologized politicized admired analyzed negotiated patronized salvaged disposed claimed accumulated decoded composed disciplined named transformed neutralized simulated photographed restored neglected studied subtitled rationalized narrated valued typified framed obfuscated selected fetishized registered juxtaposed owned moved counted treasured polished ignored traded stored taxed sold. . . .*

These objects, taken out of their original context, undergo not only a change in their immediate geoclimatic circumstances, which can make them easily fall apart, but also become either specimens of conservation work and scientific treatment or simply of classification. The uprooted character of their new existence reduces them often to the aesthetic or curious nature of their appearance. Their true aura, appropriate to their application and meaning, is seldom allowed in this new existence. The handling of the objects in a museological context does not permit a lasting, growing presence. Seasonally incorporated into various didactic exhibitions, these objects, as if in a constant superfluous wash cycle, are robbed of their last patina. In the name of science, they have been stripped and deformed, reduced to research material. There is no peace to be found for them as acquisitions. The unsolved mystery of their origins and the ignorance about their rituals or purposes remain intact. This unknown makes them coveted and provides them with an exotic quality. Works of art or ethnographic objects need to find a protective place to envelop their presence; they need the power to occupy a location.

Works of art handled as adjuncts of contemporary installations will become the toys, rather than the witnesses, of their time.

Lothar Baumgarten

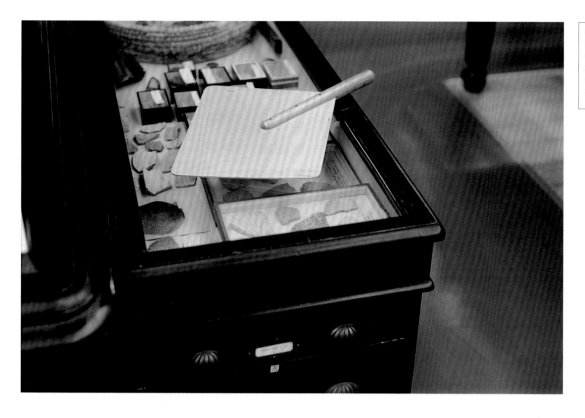

top and bottom:
Lothar Baumgarten
Unsettled Objects. 1968–69
Series of slide projections
Courtesy Marian Goodman
Gallery, New York

top, center, and bottom:
Lothar Baumgarten
Unsettled Objects

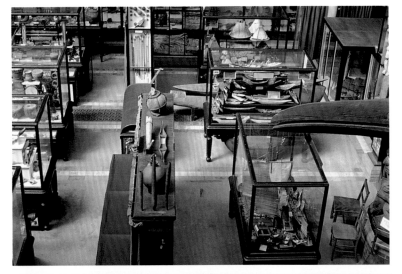

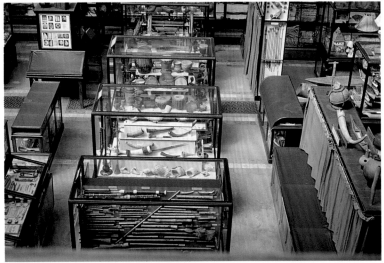

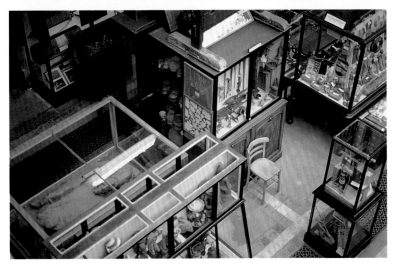

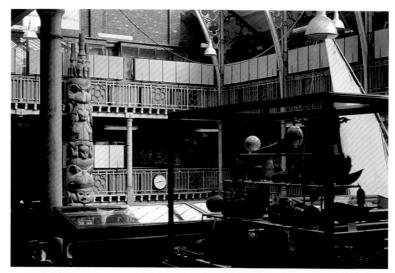

top, center, and bottom:
Lothar Baumgarten
Unsettled Objects

Fundamental to my work as an artist is an attempt to chart the evolution of the natural history museum, as an exploration of what gets to stand for nature at a particular time for a distinct group of people. Some of my projects have been forays into how early private collections (cabinets of curiosities) develop into the Enlightenment museum, which evolves into the public space we recognize as the modern didactic institution. It is a complex gradual process with numerous false starts, aberrations, and dead ends.

Arriving in a new city, I scarcely allow my luggage to be stowed at the hotel before I'm back in a taxi speeding toward the local museum of natural history. I collect experiences in such institutions as tangibly as a bird watcher ticks off a name on a list or a stamp collector fills a glassine envelope. The details of the quarry are usually known long before the encounter through fellow enthusiasts or guidebooks. Each exhibition space ranks according to a rigid set of criteria: how many type-specimens (an individual for which a species is named) does the collection contain; which extinct animals are represented in the collection (the natural history museum's equivalent of a Vermeer); which eminent biologists have worked at the museum and how have they left their stamp on it. The museums are then carefully classified based on when and how they were organized, which master narratives they employ: systematics (orthodox taxonomy or cladistics), biogeography, evolution, pure spectacle, realism (dioramas), ecology, the story of human progress, etc. Accumulating the experiences of these museums I gain insight not so much into nature itself but into the ontology of the story of nature—modern society's cosmology.

There is a sense of urgency in my pursuit, since at any moment a perfectly remarkable dusty old collection and arrangement might be turned into a banal scientific video arcade passing off hackneyed facts as miraculous discoveries. I have witnessed so many cities give up unforgettable and historically priceless spaces for Formica, steel, and text-gorged push-button shopping malls of information. No words are more heartrending than "closed for renovation." Still, many natural history museums are time machines; stepping through their portals vividly evokes the obsessions, convictions, and projections of the past. In Paris one can visit the Gallery of Comparative Anatomy and find it virtually unchanged since it opened in 1885. One can see the Tyler Museum in Haarlem in much the same way as Napoleon did on his visit. These have become museums of museums.

My interest in natural science museums is not about connoisseurship. I approach them to help me conceptualize problems in the representation of nature or, rather, to trace the development of the social construction of nature. What better place to painstakingly explore how ideas about nature shift than the didactic institutions mandated to explain the science of life to a general public. These places generate and distribute the official story. By critically analyzing the master narratives and techniques of display employed by the institutions, I can discern the ideology embedded in them. Being critical may also be just another way to love these museums. That contradiction is what I try to explore through my production of artwork. I don't lose sleep over the fact that the contradiction may be irresolvable. Work should be pleasure.

In order to investigate the social construction of "Nature" through the natural history museum, it helps to use some of the institution's own tactics, particularly the microcosmic and the macrocosmic. To better understand the museum, I have at various times had to become the museum, taking on duties of collecting, archiving, classifying, arranging, conserving, and displaying. Personifying the museum condenses its activities and articulates how the museum's various departments function like vital organs in a living being. This organism lives in an ecological relationship with other institutions, which have their own functions, their own niches.

How is the story of life told? What are the principles of organization, the master narratives, employed to construct the tale of nature? What does each set of assumptions, each conceit, promote or conceal? What fantasies or dreary fictions are indulged when one attempts to tell "the truth" about nature? Each museum and every text book and nature show on television possess a narrative skeleton. One of the most persistent and pernicious of these is the Great Chain of Being or the *Scala Naturae*. This ancient visual metaphor, rooted in Aristotle's zoological works, dominated natural-history thought until well into the nineteenth century. The Great Chain of Being depicts life as a one-dimensional progression from the simplest of forms (sometimes even minerals) to the most complex: almost always to humans, who construct the hierarchy, but sometimes even beyond to the invisible realm of angels, archangels, etc. The imagery of this progression has become such a ubiquitous feature in biological language that even today its tenacity is demonstrated in numerous popular expressions of evolution. The *Scala Naturae* became bound to the Enlightenment development of orthodox hierarchical taxonomy, which remained until the middle of this century the dominant principle of arrangement for most natural history museums. The Great Chain of Being and the early taxonomic arrangements and nomenclature firmly seat humankind on the throne of the animal kingdom. This powerful idea demands particular scrutiny, since the chain of being is a crucial conceptual footprint, which helps to retrace the path of where we have been in order to get a better bearing on where we are and where we are going.

Mark Dion

Mark Dion
The Great Chain of Being. 1998
Red and blue pencil on paper,
11 x 14" (27.9 x 35.5 cm)
Collection the artist

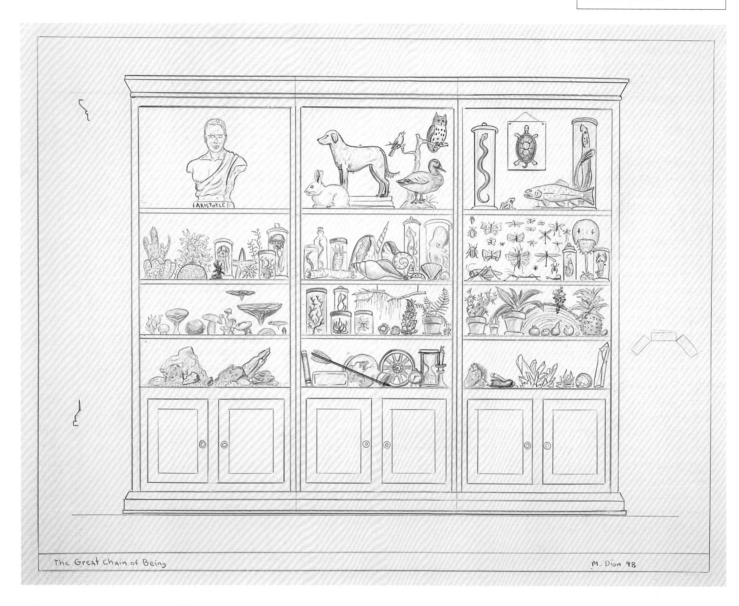

top:
Mark Dion
*Wexner Center Cabinet of
Curiosities.* 1996
Color pencil and collage on
bristol board, 24 x 19" (61 x
42 cm)
Private collection

bottom:
Mark Dion
Installation view, *Cabinet of
Curiosities for the Wexner Center
for the Arts,* Wexner Center for
the Arts, Columbus, Ohio,
May 10–August 10, 1997

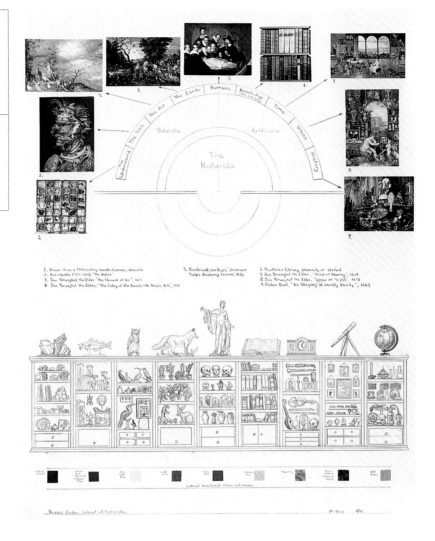

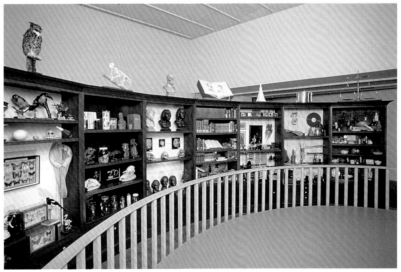

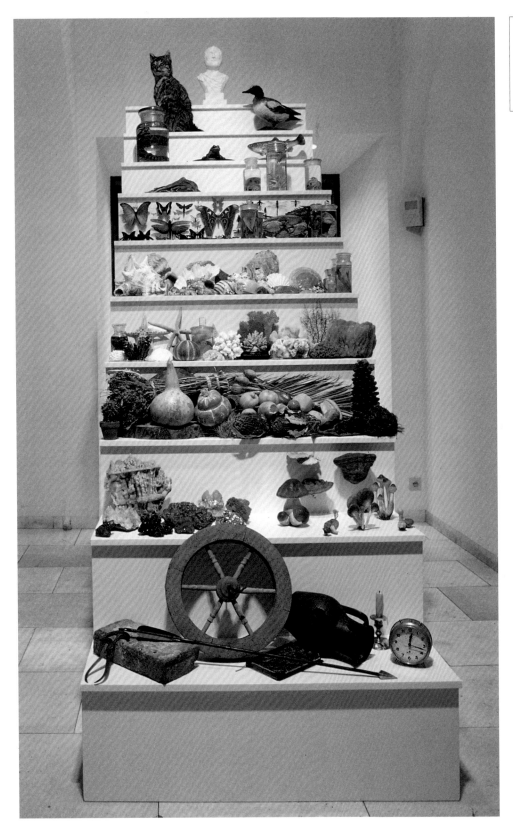

Mark Dion
Scala Naturae. 1994
Stepped plinth, artifacts, specimens, taxidermic animals, and bust, 9' 8 15/16" x 3' 3 3/8" x 9' 3 7/16" (297 x 100 x 238 cm)
Courtesy Georg Kargl, Vienna

Hiroshi Sugimoto

(Japanese, born 1948)

Taking photographs for his dioramas in a number of natural history museums, Hiroshi Sugimoto has concentrated on those illusionistic three-dimensional displays that are designed to bring to life for the benefit of children, adults, and school classes the evolutionary ages and epochs and the specific phenomena of life on earth. . . .

Sugimoto photographs and "transforms" reality. The results show, however, that there is something wrong with our source images. The Dioramas, with their posed figures against a contrived landscape, already look so mummified that the source image itself resembles a stereoscopic photograph. Sugimoto's two-dimensional, black-and-white images noticeably alleviate the stiffness, lifelessness, and artificiality of the showcase arrangements in question, which were installed in the American Museum of Natural History, New York, under the Federal Art Project of the 1930s. Since then, as he sees it, our experience of wild-animal parks, magazines, films, and television has destroyed much of the credibility of these spaces (each the size of a horse stall) and of their naturalistic coloring.

In order to recapture a lifelike effect, Sugimoto dispenses with color and spatial depth. The artist thus takes a phenomenon that was originally designed to create a lifelike impression of animals or past ages in the history of the earth, but which in the "real" world has now become unreal, and he intervenes to restore its validity. The authentic photograph helps the obsolete illusion to retain its effects. In contrast to the source material, the result looks like a kind of surrealistic snapshot: you see two dinosaurs going down to a water hole; or you credit a pack of Alaskan wolves with a touch of rationality as they gaze into the distance, and after a moment's thought you shake your head. It cannot be. Only on closer inspection of the photographs does it become clear that—as you can tell at once in the American Museum of Natural History—these are painted museum backdrops with stuffed animals and odds and ends of stage decor. . . .

By presenting individual mammals or prehuman forebears in the guise of ancestral portraits, spirits, or tutelary deities, Sugimoto's Dioramas insistently call into question the value of aids to contemplation and image cults of every kind. The artist accepts the touch of surprise and reverence that they will inspire; it is just that he can no longer believe in the old "path" to salvation that these gods offered. And so, when they face the camera in its capacity as the mirror of reality, he grants them a more excitingly framed shot and subtler distribution of light and shade. Ultimately, perhaps, he is using photography to construct them as a shrine that combines science, religion, and art. But, in the meantime, what on earth are we to do with an effigy of a gorilla in an art museum?

Sugimoto has recently coined the phrase "Time Exposed" to characterize his whole output. The time factor in his work was discussed in print at a relatively early date. His Theaters freeze screening time into a single image, and all other images become one. The Dioramas and Wax Museums preserve quasihistoric documents of our own past, and of our ancestors and popular favorites, like unreal documents of our own contemplative obsessions.

Thomas Kellein [1]

top:
Hiroshi Sugimoto
Still Life. 1976
Gelatin silver print, 16 ⅝ x 21 ½"
(42.3 x 54.6 cm)
The Museum of Modern Art,
New York. Purchase

bottom:
Hiroshi Sugimoto
Ostrich—Wart Hog. 1980
Gelatin silver print, 19 ½ x 24"
(49.5 x 60.9 cm)
Courtesy Sonnabend Gallery,
New York

top:
Hiroshi Sugimoto
White Mantled Colobus. 1980
Gelatin silver print, 19 ½ x 24"
(49.5 x 60.9 cm)
Courtesy Sonnabend Gallery,
New York

bottom:
Hiroshi Sugimoto
Permian Land. 1992
Gelatin silver print, 20 x 24" (50.8 x
60.9 cm)
Courtesy Sonnabend Gallery,
New York

top:
Hiroshi Sugimoto
Devonian Period. 1992
Gelatin silver print, 20 x 24"
(50.8 x 60.9 cm)
Courtesy Sonnabend Gallery,
New York

bottom:
Hiroshi Sugimoto
Silurian Period. 1992
Gelatin silver print, 20 x 24"
(50.8 x 60.9 cm)
Courtesy Sonnabend Gallery,
New York

Behind the series of twenty-seven photographs by Christopher Williams known as *Angola to Vietnam*★ lurk the efforts of both a curator and a collection cataloguer. At first sight, these pictures appear as splendid, straightforward still lifes, only to reveal themselves as installation views, close-ups of a museum display. The site is the Botanical Museum at Harvard University; the subject, an exceptional collection of painstakingly accurate glass replicas of plant specimens made between 1887 and 1936 by the highly specialized father-and-son workshop of Leopold and Rudolph Blaschka of Dresden.

In his incisive investigations into the institutional world of archives and museums, Williams goes to great lengths to invest his photographs with layers of elaborate references that become increasingly self-referential. His initial approach to the Harvard collection was to subject it to a new filter. Relying on information available in the museum's records, Williams used, from the numerous specimens in the collection, those that survived his screening process. He described his process in a seemingly didactic yet fundamentally cryptic addendum to the title: "*Angola to Vietnam*★, an abbreviation of the list of twenty-seven countries, is the result of filtering the list: *Angola, Argentina, Bolivia, Brazil, Central African Republic, Chile, Colombia,* Cyprus, *Dominican Republic, El Salvador, Ethiopia, Guatemala,* Guinea, *Haiti, Honduras, Indonesia,* Iran, Iraq, *Lebanon, Mexico,* Morocco, *Namibia,* Nepal, *Nicaragua, Paraguay, Peru, Philippines,* Seychelles, *South Africa, Sri Lanka,* Syria, *Togo, Uganda, Uruguay, Vietnam,* and Zaire*—thirty-six countries where disappearances are known to have occurred during 1985, as noted on page twenty-nine of *Disappeared!, Technique of Terror*, a report for the Commission on International Humanitarian Issues, 1986, Zed Books, Ltd., London and New Jersey—through the 847 life-size models representing some 780 species and varieties of plants in 164 families from the Ware Collection of Blaschka Glass Models, the Botanical Museum, Harvard University, Cambridge, Massachusetts."

This group of photographs resulted from the intersection of two somewhat irreconcilable sets. Williams took the first set, that of the Botanical Museum itself, and then crossed it with the list of thirty-six countries where persons went missing for political reasons in 1985. He found out that twenty-seven of these countries (the ones italicized in his description) were represented in the collection through their native plants. This involved reclassifying the glass replicas by country of origin instead of using the Museum's standard taxonomy: on top of the institution's botanical classification, one based on science, the artist proposes another, based on politics. As a result, the political contaminates the natural, and the socially determined adulterates what is supposed to be absolute. Williams also mimics the museum's modus operandi by paying careful attention to the minutia involved in the cataloguing of each object. His titles and labels are an intrinsic part of his work. Every detail is included, but the hierarchy of information is rearranged into an order suggestive of Williams's interests. The content of his labels also speaks to a certain impulse toward excessive research and fastidious record keeping.

Despite their seriality, the depiction of the glass replicas is far from homogeneous. Some photographs de-emphasize not only their hand-crafted quality but also their lifelessness. These are the ones that most directly play with illusion (*Vietnam, Nicaragua*), and here the frame is neither documentary nor objective: it denotes fragmentation, and makes the glass replicas seem real. While photography has traditionally been the medium of arrested movement, here it makes these models come alive. The embalming tendency of the museum has been reversed. Other photographs draw the viewer's attention to the details of their display: the sustaining U-shaped wires, the installation devices and labels in the foreground, or the museum's vestiges, traces, marks (*Brazil, Indonesia*). Still others bring the objects' defects to the foreground: we can see traces of restoration, general wear and tear, the imprints of museum life (*Philippines, Angola*). Curiously, the same image may reappear with the names of different countries. Or, the same plant, seen from different angles, may represent different countries. These inconsistencies are included as if to remind us that the systems of art are arbitrary. We begin to wonder if the plants are really from the designated countries or if the label information is reproduced correctly, until we realize that here it really does not matter.

Images of flowers, celebrated for their eroticism and lusciousness, provide a number of references within the history of photography. *Angola to Vietnam*★ provides access to this vast archive, which runs from Henry Fox Talbot to Robert Mapplethorpe, through Karl Blossfeldt, Albert Renger-Patzsch, Edward Weston, and many others. But where these artists looked at nature in its unbridled state, Williams looks at nature in the museum. By drawing on this other archive, one generally hostile to unmediated nature, Williams affirms his photographs' empathy with the museum object, derived from their essential condition as museum objects, not documents.

Lilian Tone

top:
Christopher Williams
Indonesia. 1989
[Blaschka Model 693, 1903; Genus no. 1318; Family, Musaceae; *Musa paradisiaca* Linn.; *subsp. sapientum* (Linn.) Ktze; Banana]
Gelatin silver print, 11 x 14"
(28 x 35.5 cm)
The Museum of Contemporary Art, Los Angeles. The El Paso Natural Gas Company Fund for California Art

bottom:
Christopher Williams
Nicaragua. 1989
[Blaschka Model 424, 1894; Genus no. 4546; Family, Anacardiaceae; *Anacardium occidentale* Linn.; Cashew Acajou]
Gelatin silver print, 11 x 14"
(28 x 35.5 cm)
The Museum of Contemporary Art, Los Angeles. The El Paso Natural Gas Company Fund for California Art

top:
Christopher Williams
Vietnam. 1989
[Blaschka Model 272, 1892; Genus
no. 8594; Family, Cucurbitaceae;
Luffa cylindrica (Linn.) Roem]
Gelatin silver print, 11 x 14"
(28 x 35.5 cm)
The Museum of Contemporary Art,
Los Angeles. The El Paso Natural
Gas Company Fund for California
Art

bottom:
Christopher Williams
Brazil. 1989
[Blaschka Model 104, 1889; Genus
no. 3870; Family, Leguminosae;
Erythrina Crista-galli Linn.; Coral-
tree, Coral-plant, Cockscomb]
Gelatin silver print, 11 x 14"
(28 x 35.5 cm)
The Museum of Contemporary Art,
Los Angeles. The El Paso Natural
Gas Company Fund for California
Art

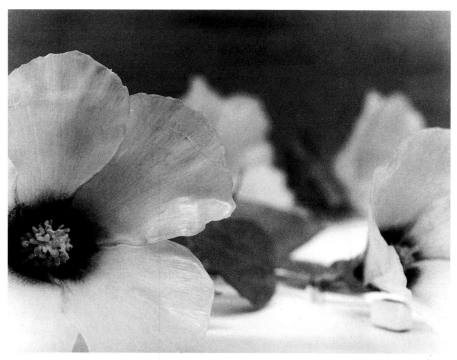

top:
Christopher Williams
Philippines. 1989
[Blaschka Model 387, 1893; Genus
no. 5020; Family, Malvaceae;
Gossypium herbaceum Linn.;
Gossypium Nanking Meyen;
Nanking Cotton]
Gelatin silver print, 11 x 14"
(28 x 35.5 cm)
The Museum of Contemporary Art,
Los Angeles. The El Paso Natural
Gas Company Fund for California
Art

bottom:
Christopher Williams
Angola. 1989
[Blaschka Model 439, 1894; Genus
no. 5091; Family, Sterculiaceae;
Cola acuminata (Beauv.) Schott
and Endl.; Cola Nut, Goora Nut]
Gelatin silver print, 14 x 11"
(35.5 x 28 cm)
The Museum of Contemporary Art,
Los Angeles. The El Paso Natural
Gas Company Fund for California
Art

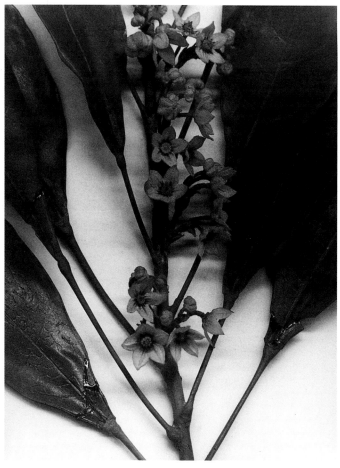

Richard Hamilton

(British, born 1922)

left:
Richard Hamilton
*The Solomon R. Guggenheim
(Black and White)*. 1965–66
Fiberglass and cellulose, 48 x 48 x
7 ¹/₂" (122 x 122 x 19 cm)
Solomon R. Guggenheim Museum,
New York

right:
Richard Hamilton
*The Solomon R. Guggenheim
(Black)*. 1965–66
Fiberglass and cellulose, 48 x 48 x
7 ¹/₂" (122 x 122 x 19 cm)
Solomon R. Guggenheim Museum,
New York

Between 1964 and 1967 Richard Hamilton produced an interior, a still life, a landscape, a self-portrait, a mother and child, and a scene of bathers. His approach to subject matter was to think in terms of categories. During this time he also examined buildings as a possible case of subject matter. Piranesi's romantic ruins, Lichtenstein's paintings, classical temples, and Artschwager's skyscrapers are examples of the genre. Hamilton's choice of buildings represents a structural antithesis to the post-and-lintel or steel-frame grid, but he was interested to know if a successful work could be based on a new building—one conceived as a work of high art in itself, an aim related to his use of Braun appliances.

Hamilton's ventures into perspective are wide-ranging: from the extreme of side-stepping the issue to mockery of the convention. When he does undertake a serious project involving perspective, it is liable to be absurdly problematic. His *Five Tyres Remoulded* of 1971, which required putting into accurate perspective the patterns on the double curve of a torus, was solvable only with the help of a computer. The expanding helix in false perspective of the Guggenheim Museum is another such exercise.

The Solomon R. Guggenheim Museum on Fifth Avenue in New York was designed by Frank Lloyd Wright between 1943 and 1946 and was built in 1956–59. The spiral form of the museum looks back to the shells and horns of Hamilton's *Growth and*

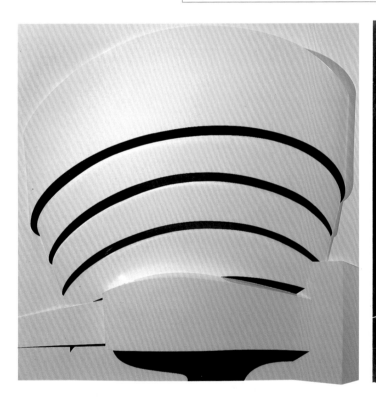

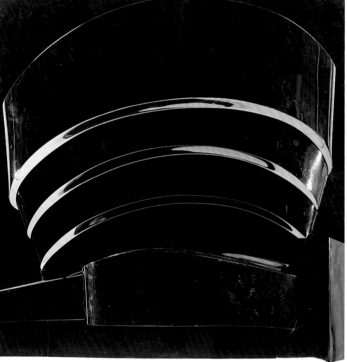

Form exhibition of 1951 and, like the spiral structure of the Exquisite Form bra, encourages a false illusionistic reading as concentric circles (here stacked). The spectator is again made very conscious of shifting viewpoints, and the use of heavy relief is the culmination of a preoccupation originating in 1951.

In both appearance and in the process of their making, the Guggenheim reliefs contrast with Hamilton's work to date. A single centralized image represented a departure from anthologies of shape, technique, and source; and the careful preparatory plan, elevation, and section drawings he made were quite different from previous "studies" for his paintings, being analogous to the blueprints for a building. These constitute an account of Frank Lloyd Wright's *magnum opus*, which Hamilton went to great lengths to distill for these essays on style. They show Hamilton's interest in process—whether aesthetic or technical—the reliefs echoing the design and construction. He wrote: "It was an attempt to mirror the whole activity of architecture in the confines of a four-foot-square panel."

Although the form of each relief is the same, there is considerable variation of treatment in the cellulose lacquer finish, always applied with an air gun. All the treatments disembody the building's dramatic three-dimensional form by transposing it into a skin of color and texture with quite independent associations and effects.

Jacqueline Darby and Richard Hamilton [1]

left:
Richard Hamilton
The Solomon R. Guggenheim (Gold). 1965–66
Fiberglass, cellulose, and gold leaf, 48 x 48 x 7 1/4" (122 x 122 x 18 cm)
Louisiana Museum of Modern Art, Humlebaek, Denmark

right:
Richard Hamilton
The Solomon R. Guggenheim (Spectrum). 1965–66
Fiberglass and cellulose, 48 x 48 x 7 1/2" (122 x 122 x 19 cm)
Solomon R. Guggenheim Museum, New York

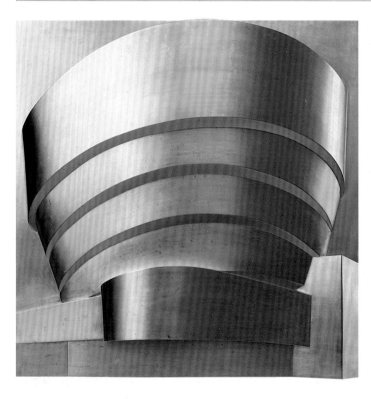

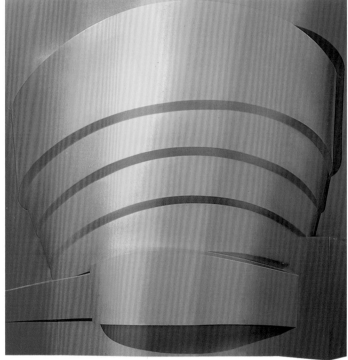

Günther Förg

(German, born 1952)

Günther Förg
Pinakothek München. 1983–86
Black-and-white photograph,
8' 10 5/16" x 3' 11 1/4" (270 x 120 cm)
Grässlin Collection, St. Georgen

Günther Förg
Pinakothek München. 1983–86
Black-and-white photograph,
5' 10 7/8" x 3' 11 1/4" (180 x 120 cm)
Collection Rudolf Bumiller,
Stuttgart

Jan Dibbets

(Dutch, born 1941)

top:
Jan Dibbets
Guggenheim I. 1986
Color photographs, watercolor,
and grease pencil on paper,
mounted on laminated particle-
board, 6' ⅞" x 6' ⅞" (185 x
185 cm)
Private collection, Amsterdam

bottom:
Jan Dibbets
Kröller-Müller—Saenredam II. 1987
Two color photographs and pencil
on paper, mounted on chipboard,
each photograph 6' ¼" x 6' ¼"
(183.5 x 183.5 cm)
Collection the artist

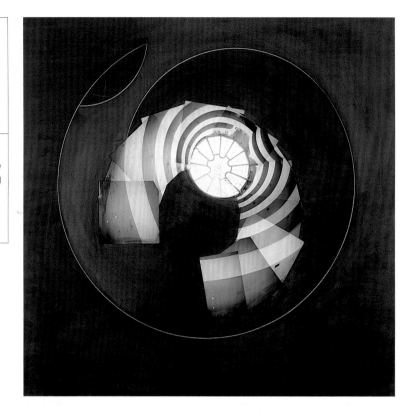

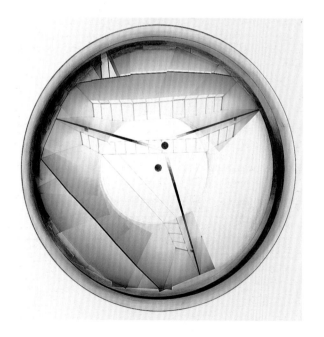

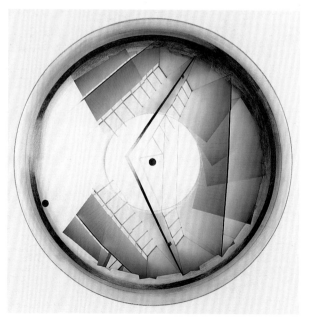

Jan Dibbets
The Shortest Day at the van Abbemuseum Eindhoven. 1970
Color photographs mounted on aluminum, 69 3/4 x 67 3/8" (177 x 171 cm)
Stedelijk van Abbemuseum Eindhoven

Thomas Struth

(German, born 1954)

My interest in the museum photos came through the portraits, which then led to my preoccupation with portrait painting, principally with that of the Renaissance. The trick was to regard portrait painting as I would look at photographs, to understand the original act of portrait painting like this: as an interpretation of the world executed with means that were common and appropriate at that time. From there arose the idea of bringing these two things to the same level of reproduction through the currently appropriate medium; to make a reproduction of a painted image and at the same time produce a new image in which real persons of today are shown. That's why, for example, in the museum photos you see exclusively figurative paintings, no abstract works, and few sculptures.

I felt a need to make these museum photographs because many works of art, which were created out of particular historical circumstances, have now become mere fetishes, like athletes or celebrities, and the original inspiration for them is fully obliterated. What I wanted to achieve with this series, which will be limited to maybe thirty photographs, is to make a statement about the original process of representing people leading to my act of making a new picture, which is in a certain way a very similar mechanism: the viewer of the works seen in the photograph finds him/herself in a space in which I, too, belong when I stand in front of the photograph. The photographs illuminate the connection and should lead the viewers away from regarding the works as mere fetish-objects and initiate their own understanding or intervention in historical relationships.

Today museums are no longer the institutions they were fifteen years ago; they have become institutions of significance or popularity less comparable to the shopping mall than to the sports field or to religion; churches today are probably emptier than museums. That is why the museum is a place that is essentially nonprivate. It is not for nothing that many people compare modern museums with train stations. That's a statement which is heard very often, for example, about the Museum Ludwig or the Louvre; many people pass through and you never know what they're doing or why they're there—because of the works or for entertainment?

I got the first ideas for these works in the Louvre around Christmastime; it was very crowded and I thought that the world of visitors in the Louvre, people of the most diverse ages and ethnicities, were incredibly similar to the themes in the paintings. And my other conclusion was that I wondered why all the people were there; what were they getting out of it; was any change occurring in their personal lives because of it, in their public lives, in their activity, in their family, with their friends? Is any change through the museum visit even possible, or is it an entertainment, like watching music videos or the way one needs visual refreshment to keep from getting bored.

The family portraits as well as the architectural and museum photographs convey a sense of arrested time. That happens even during the production of the photographs, which have a long exposure time, and especially in the museum photographs—although the scenery is constantly moving, the minimum exposure time is a quarter, a half, or even a full, second. It could be said that showing situations about an intensity of viewing is preferable to me and should constitute a kind of counterexample.

On a broader level, that is how I understand my museum photographs when I exhibit a few works at an exhibition like *Aperto* in Venice. Where the mechanisms of spectacle—of the contemporary museum business—are staged, my photographs can offer a reflection about the very situation.

Thomas Struth[1]

Thomas Struth
Galleria dell'Accademia I, Venice.
1992
C-print laminated to plexiglass,
6' 2 ⅞" x 7' 7 ¾" (190.2 x 233.1 cm)
Museum of Fine Arts, Boston.
Robert L. Beal, Enid L. and
Bruce A. Beal Acquisition Fund
and the Contemporary Art
Support Group Fund

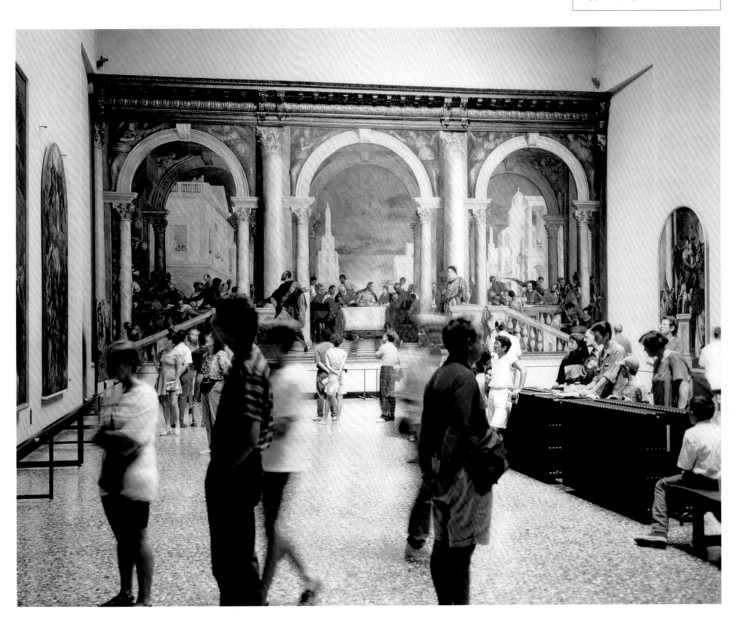

Thomas Struth
Museum of Modern Art I, New York.
1994
Cibachrome print, 70 $\frac{7}{8}$" x
7' 9 $\frac{11}{16}$" (180 x 237.9 cm)
Private collection

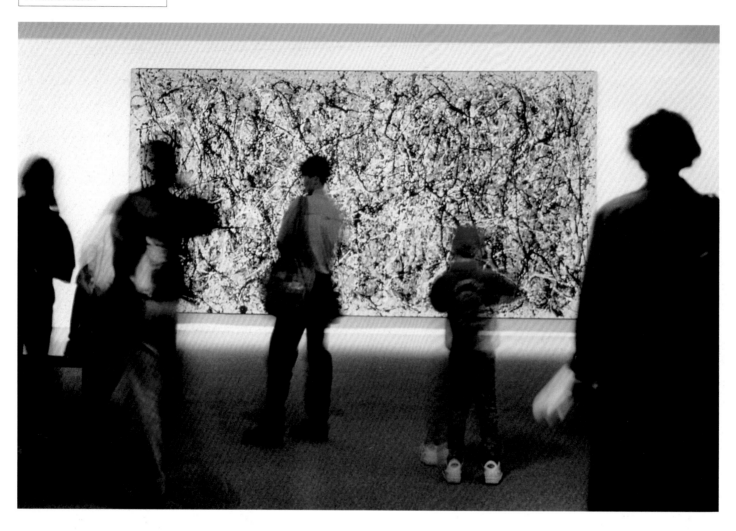

Thomas Struth
Musée du Louvre IV, Paris. 1989
Cibachrome print, 6' $7/_{16}$" x
7' 1 $7/_{16}$" (184 x 217 cm)
Marieluise Hessel Collection, on
permanent loan to the Center for
Curatorial Studies, Bard College,
Annandale-on-Hudson, New York

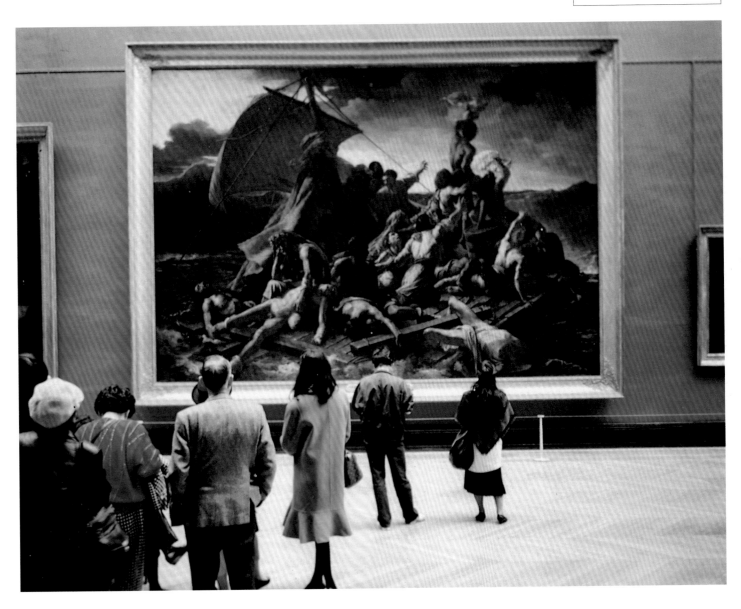

Candida Höfer

(German, born 1944)

Candida Höfer
Kunsthaus Zürich I. 1994
C-print, 15 ½ x 23 ⅛" (39.3 x
58.7 cm)
Courtesy Sonnabend Gallery,
New York

Museums interest me as types of public or semi-public spaces. Museums have layers of showing: their original architecture, their different ways of exhibiting over time, the different ways in which their rooms have been used with or against their will, the way their rooms have served each other. Each of these uses leaves behind traces, and all of these traces are present at the same time. There is always a time of day in a museum when these traces, together with the structures of the space, the walls, windows, doors, and stairs, their proportions, their relation to each other, the colors and the light, become much more visible among the people that visit and the objects exhibited.

Candida Höfer

Candida Höfer
*Kunstsammlung Nordrhein-
Westfalen, Düsseldorf.* 1995
C-print, 14 x 14 ⅛" (35.5 x 35.8 cm)
Courtesy Sonnabend Gallery,
New York

Candida Höfer
Galleria Nazionale d'Arte Moderna, Roma. 1990
C-print, 14 ³/₁₆ x 20 ¹/₁₆" (36 x 51 cm)
Courtesy Sonnabend Gallery, New York

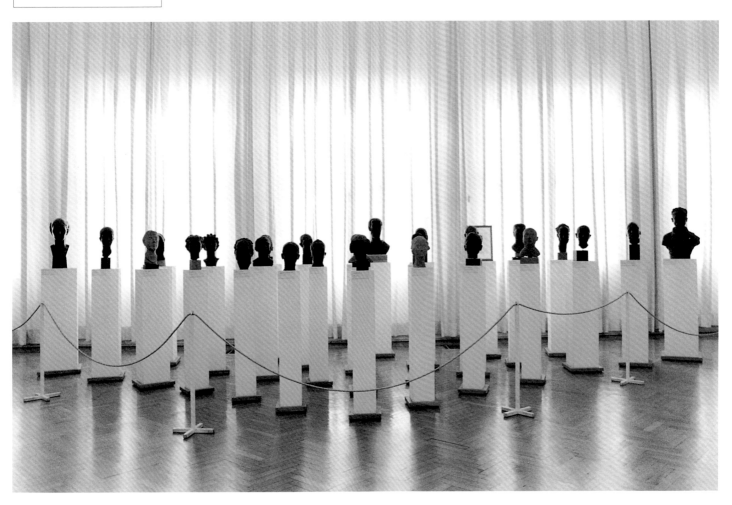

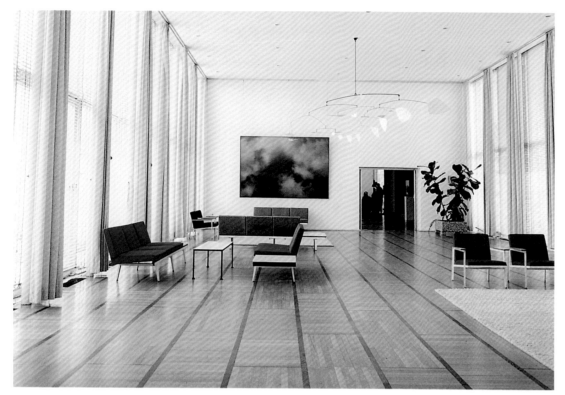

top:
Candida Höfer
Museum Folkwang Essen. 1982
C-print, 15 x 20 ⁹/₁₆" (38.1 x 52.2 cm)
Courtesy Sonnabend Gallery, New York

bottom:
Candida Höfer
Museum Van Hedendaagse Kunst Gent III. 1995
C-print, 15 ¹/₂ x 23" (39.3 x 58.4 cm)
Courtesy Sonnabend Gallery, New York

Christo
(American, born Bulgaria 1935)

In the tumultuous cultural climate of early 1968, the thirty-two-year-old artist Christo approached The Museum of Modern Art in New York with an unusual proposition: to wrap the entire Museum in a 70,000-square-foot shroud of heavy-gauge canvas tarpaulin, bound with thousands of feet of nylon rope, temporarily yet radically transforming the Museum's physical and functional space. Known primarily as an artist who wrapped ordinary, every-day articles (magazines, bottles, boxes, chairs, bicycles) with similarly common materials (cloth, plastic sheeting, twine, rope), by the mid- to late 1960s Christo was shifting his activities toward a process of making art that negotiated an increasingly public, political, environmental, and often controversial terrain.

Prompted by a perceived affinity between Christo's enigmatic wrappings and the work of Man Ray, William Rubin, the Museum's director of painting and sculpture, welcomed the proposal, suggesting the event mark the closing of the exhibition *Dada, Surrealism, and Their Heritage*. The artist produced a series of visually compelling architectural render-ings, photomontages, and scale models to convey the breadth of his plan to the Museum. These prelimi-nary studies were exhibited at the Museum in lieu of the actual wrapping of the building (which was vetoed by the authorities). They illustrate the tripar-tite character of the scheme, which called for the bundling of the building itself, the enveloping of the Museum's sculpture garden within a vast, glimmer-ing skin of translucent polyethylene, and the con-struction of a twenty-foot-high steel barricade, composed of 441 stacked oil barrels, to be placed across Fifty-third Street, perpendicular to the façade of the Museum.

The project to wrap the Museum represented one aspect of the repositioning of attitudes toward institutions of art in the late 1960s. Like the emer-gent activities of his contemporary practitioners of what were later termed Earthworks, Christo's ephemeral gestures similarly suggested a possible strategy for art-making that was removed from the studio and the museum gallery. Their transitory nature, and their independence as self-financed ven-tures (through the sale of preparatory works), allowed to a degree the circumvention of the normal constraints of the art market. As with Christo's epic 1969 project to wrap a mile of the rocky coastline of Australia, such "events" could not, by their nature, be absorbed by museums through established means of acquisition and display. The Museum project provided Christo with a potentially ideal situation in which to actualize this new "public" art. Ironic in its inversion of the traditional relationship between the museum and the art object, the project served to destabilize the familiar dichotomy of the container and the thing contained.

Anticipated in the daily press as a grandiose, if somewhat pointless, endeavor, the project was received by city authorities as a potentially provoca-tive and dangerous municipal headache. In early 1968, with public street demonstrations occurring with increasing regularity, officials refused to sanc-tion the creation of a possible locus for more civil unrest. Additionally, the Museum's insurance com-pany would agree to coverage during the brief event only at a prohibitively high price. The small exhibi-tion in the Museum's lobby, shown in June 1968, was called *Christo Wraps the Museum: Scale Models, Pho-tomontages, and Drawings for a Non-Event*.

Although he later lamented the fact that The Museum of Modern Art was not his first wrapped museum, in July 1968 Christo was invited to wrap the Kunsthalle Bern, in Switzerland, to commemo-rate its fiftieth anniversary. The public and political scale of Christo's projects, which he realized collabo-ratively with his wife, Jeanne-Claude, increased in subsequent years, culminating most recently in the wrapping of the Reichstag in Berlin.

James Trainor

THE MUSEUM OF MODERN ART WRAPPED (PROJECT FOR THE MOMA, NEW YORK - June 1968) 19/100 Christo

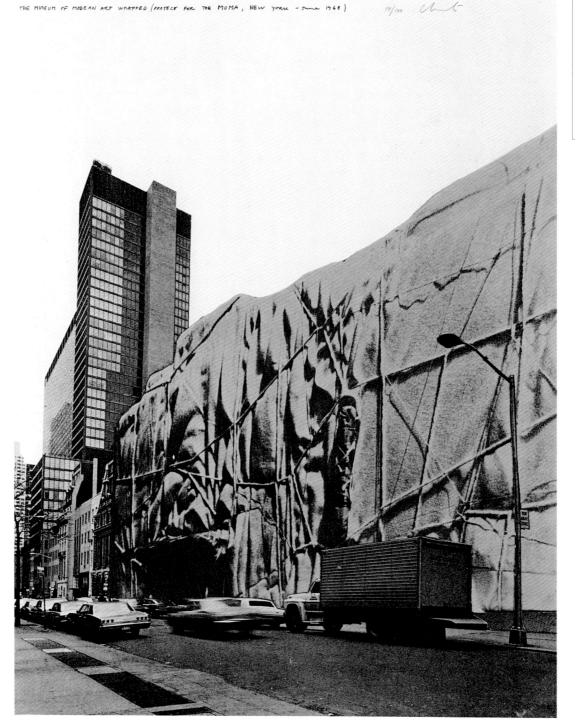

Christo
The Museum of Modern Art Wrapped (Front): Project for New York. From the portfolio *(Some) Not Realized Projects.* April 9 and September 27, 1971
Lithograph printed in color, 27 13/16 x 21 7/8" (70.7 x 55.6 cm)
The Museum of Modern Art, New York. Larry Aldrich and Walter Bareiss Funds

Christo
*The Museum of Modern Art
Wrapped: Project for New York.* 1968
Scale model: painted wood, cloth,
twine, and polyethylene, 16 x
48 ⅛ x 24 ⅛" (40.3 x 122 x 61 cm)
(including base)
The Museum of Modern Art,
New York. Gift of D. and J. de Menil

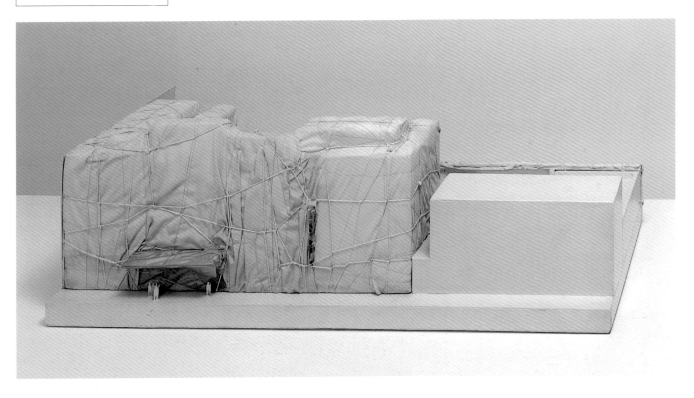

Christo
*441 Barrels Structure—The Wall
(53rd Street between Fifth and
Sixth Avenues).* 1968
Photomontage and enamel paint
on cardboard, 22 ⅛ x 28 ⅛"
(56 x 71.2 cm)
The Museum of Modern Art,
New York. Gift of Louise Ferrari

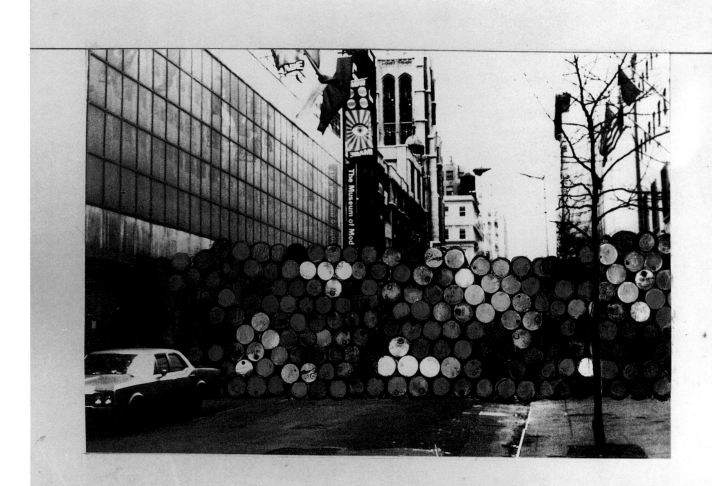

"441 BARRELS STRUCTURE - THE WALL " 53 RD STREET between 5TH. and 6TH. AVENUE. (PROJECT FOR JUNE 9, 1968 - MUSEUM OF MODERN ART N.Y.) Christo 1968

Kate Ericson and Mel Ziegler

(American, 1955–1995; American, born 1956)

The Museum of Modern Art, New York, is a repository of the things our culture sanctions as high art, a place where comparisons and critical dialogue are everyday occurrences. More than most institutions, it is the art world's Bureau of Measurements and Standards, much like a government headquarters for collecting, collating, and hemming and hawing over the new juxtaposed against the old. Rejecting, reacting, embracing, and imitating are a few of the ways in which artists respond to institutional standards.

The idea for *MoMA Whites* began to develop when Kate and I discovered, while researching our project *Signature Piece,* that the names of the various shades of white used for exhibitions at MoMA included not just those of the manufactured paint (Decorator White, High Hide White) but also those of the custom mixtures preferred by the curators who direct the house-painting staff (McShine White, Rubin White, Riva White). Working with the idea that using these whites as a "neutral" institutional standard for displaying artworks is undermined simply by the names of the whites themselves, we simply re-presented the paints as specimens in jars to be scrutinized and seen in their own right.

Leaf Peeping was inspired by the Museum garden. Here, an institutional space carefully designed by architects and landscapers is juxtaposed with the uncontrolled processes of nature. Viewing works of art and "leaf peeping" are both ritual activities that deal with the aesthetic appreciation of certain "specimens." By carefully documenting the leaves in the Museum garden in their transitional phase, using etched jars of paint to represent the colors and shapes of the leaves and mapping their predetermined locations, we turn the activity of appreciating art and nature into a standard aesthetic wall specimen.

Mel Ziegler

As an architectural space, the modern art museum preserves many of the attributes of the home but often treats these domestic features as annoying distractions. Thus, things like furniture, plants, signs, and lighting are suppressed or de-emphasized in favor of the works of art. It was precisely these overlooked elements of museum furnishing that commanded the curiosity of Kate Ericson and Mel Ziegler. Trained at the California Institute of the Arts, Ericson and Ziegler collaborated from 1982 until Ericson's death in 1995. Their works are typical of the deconstructive neoconceptualism of the late 1980s, which consists of site-specific installations heavily invested with detailed information. Their method was to isolate a single feature, such as paint, and conduct extensive research on that subject to discover what kind of paint was used, where it came from, who made it, who applied it, and so on. This information was then translated into elegant "signage" or highly designed objects that neatly organized the data in reference to the exhibition context; at the same time, it made specific connections to individual "collaborators" and distant "sources." Two particular concerns that recur in their works are labeling and geographical specificity, both ways of classifying natural and industrial information.

All of Ericson and Ziegler's museum works are site-specific, and several of them investigate aspects of The Museum of Modern Art. One of the most striking, *Leaf Peeping,* consists of thirty-one clear glass jars filled with various shades of latex paint and etched on the front with an image of a single leaf. Each jar corresponds to an individual tree in The Museum of Modern Art's Abby Aldrich Rockefeller Sculpture Garden, with the paint color matching the fall coloration of that tree's leaves. The jars are arranged on individual brackets on the wall in a pattern that corresponds to the groundplan of the garden.

Another work, *MoMA Whites,* consists of jars of white paint in all the various shades used in The Museum of Modern Art. The source for this work can be traced back to a piece called *Whisper* of 1987, which comprises a single, one-gallon glass jar of white paint of the precise shade used to paint the exterior of the White House. Etched on the front of the jar is the commercial name of that shade, Whisper.

For a related installation of 1988, titled *Signature Piece,* prepared for the Projects exhibition series at The Museum of Modern Art, Ericson and Ziegler collected autographs of the workers who produced such industrial fixtures as the track lighting, the windowpanes, and the furniture in the Museum's galleries. These signatures were then silkscreened onto the wall next to the objects to assert the workers' subjective involvement in what is generally regarded as anonymous production.

As a consequence of their visual austerity, such works appear to some as dry and intellectual. But, in fact, their modest focus on the generally anonymous contributions of workers, their attention to largely unconscious everyday choices, and their awareness of private gestures in public spaces place their corpus among some of the most subtle and intellectually engaging works about the modern museum.

Brian Wallis

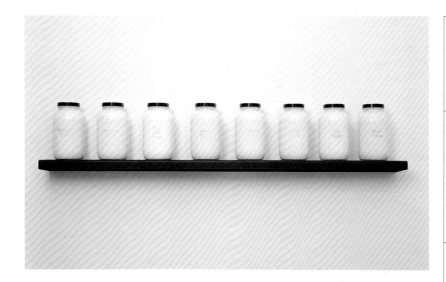

top:
Kate Ericson and Mel Ziegler
MoMA Whites. 1990
Various white pigments in glass
jars, steel shelf, 10 x 56 x 5"
(25.4 x 142.2 x 12.7 cm)
Private collection, Basel

bottom right:
Kate Ericson and Mel Ziegler
Leaf Peeping. 1988
Thirty-one sandblasted jars filled
with latex paint, metal shelves,
each jar 3 ¾ x 3 ⅝" (9.5 x 9.2 cm);
overall variable
Museum of Contemporary Art,
San Diego. Museum Purchase,
Contemporary Collectors Fund

bottom left:
Kate Ericson and Mel Ziegler
Leaf Peeping (detail)

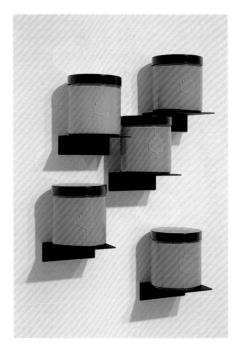

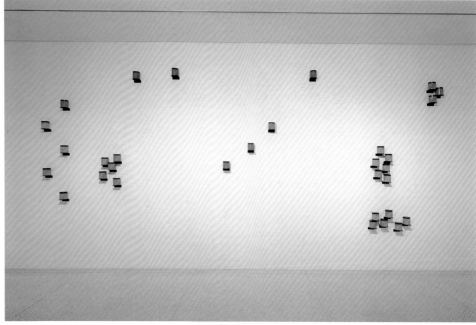

Christian Milovanoff

(French, born 1948)

top left:
Christian Milovanoff
Le Louvre Revisité (Andrea Mantegna, Saint Sébastien) *(The Louvre Revisited [Andrea Mantegna, Saint Sebastian]).* 1986
Black-and-white photograph,
19 ¹¹⁄₁₆ x 15 ¾" (50 x 40 cm)
Collection the artist

bottom left:
Christian Milovanoff
Le Louvre Revisité (Ingres, La Grande Odalisque) *(The Louvre Revisited [Ingres, Grand Odalisque]).* 1986
Black-and-white photograph,
15 ⅜ x 10 ⅝" (39 x 27 cm)
Collection the artist

right:
Christian Milovanoff
Le Louvre Revisité (Léonard de Vinci, La Vierge, l'enfant Jesus, et Sainte Anne) *(The Louvre Revisited [Leonardo da Vinci, The Virgin, the infant Jesus and Saint Anne]).* 1986
Black-and-white photograph,
18 ⅞ x 13" (48 x 33 cm)
Collection the artist

left:
Christian Milovanoff
Le Louvre Revisité (Jacques-Louis David, Le Serment des Horaces) *(The Louvre Revisited [Jacques-Louis David, The Oath of the Horatii])*. 1986
Black-and-white photograph, 19 ½ x 14 ³⁄₁₆" (49.5 x 36 cm)
Collection the artist

top right:
Christian Milovanoff
Le Louvre Revisité (Philippe de Champaigne, Le Christ Mort) *(The Louvre Revisited [Philippe de Champaigne, The Dead Christ])*. 1986
Black-and-white photograph, 11 ¹³⁄₁₆ x 11 ¹³⁄₁₆" (30 x 30 cm)
Collection the artist

bottom right:
Christian Milovanoff
Le Louvre Revisité (Ingres: Oedipe Expliquant l'Énigme) *(The Louvre Revisited [Ingres: Oedipus Explaining the Enigma])*. 1986
Black-and-white photograph, 17 ⁵⁄₁₆ x 17 ⁵⁄₁₆" (44 x 44 cm)
Collection the artist

Robert Filliou

(French, 1926–1987)

opposite, top left:
Robert Filliou
Poussière de Poussière de l'effet Frans Hals "La Bohèmienne." 1977
Cardboard box with cloth duster and Polaroid, 4 ¾ x 6 ½ x 2 ½"
(12 x 16.5 x 6.2 cm)
Collection Andersch, Neuss, Germany

opposite, top right:
Robert Filliou
Poussière de Poussière de l'effet Cimabue "La Vierge aux Anges." 1977
Cardboard box with cloth duster and Polaroid, 4 ¾ x 6 ½ x 2 ½"
(12 x 16.5 x 6.2 cm)
Collection Andersch, Neuss, Germany

opposite, bottom left:
Robert Filliou
Poussière de Poussière de l'effet Fra Angelico "La Couronnement de la vierge." 1977
Cardboard box with cloth duster and Polaroid, 4 ¾ x 6 ½ x 2 ½"
(12 x 16.5 x 6 cm)
Collection Andersch, Neuss, Germany

opposite, bottom right:
Robert Filliou
Poussière de Poussière de l'effet de Da Vinci "La Sainte Anne." 1977
Cardboard box with cloth duster and Polaroid, 4 ¾ x 6 ½ x 2 ½"
(12 x 16.5 x 6.2 cm)
Collection Feelisch, Remscheid, Germany

Robert Filliou was a poet trained as an economist, a philosopher who became an artist. Born in France in 1926, his first thirty years suggest a blur of contingent identities in economics, politics, and journalism. Finally, in 1959, he became an artist and poet in a newly affluent France, intentionally removing himself from its burgeoning prosperity, even living for a time in a tent on the outskirts of Paris. From that point on, Filliou lived his life as a kind of continuing experiment, concocting artistic propositions and curiously prying away at artificial divisions between art and life, work and play, and between political economy and what he termed "poetical economy." He inscribed on a 1970 sculpture: "I hate work which is not play."

An early contributor to the Fluxus movement, Filliou sought to redefine not only what art could be, but also what new role the artist could play in society. He was not interested in making marketable art objects, nor in art as a professional occupation. Instead, the art that Filliou created (poetic notations combined with ephemeral or delicately altered found materials) was concerned with the concept of creativity itself. Avoiding notions of taste, quality, and talent, his works enact a series of imaginative philosophical proposals, encouraging new ways of thinking about life and creativity. Filliou theorized the existence of an "Eternal Network," describing the vast interconnectedness of all creative activity, happening everywhere and all the time, of which intentional art-making was but a part, and which included private parties, weddings, divorces, and factory work. "The artist is everybody," Filliou said, suggesting society's need for a more profound understanding of interactions between creativity, labor, and play.

Filliou's emphasis on the artistic and social value of play should not be underestimated. During the political and social upheavals in France in May of 1968, Filliou supported the goals of students, workers, and intellectuals united by the concept of freeing leisure from its associations with bourgeois prosperity, and repositioning it as a radical platform for social change.[1] The act of play became a revolutionary stance, a tool for personal and political freedom, and Filliou's work until his death in 1987 radiated this revaluation of creative and intellectual play.

In 1977, Filliou committed a series of seriously playful acts in major museums in the French capital. At the Louvre and the Musée d'art moderne de la Ville de Paris, Filliou quietly approached paintings and sculptures, old and modern masters alike, and cleaned them. Filliou had his actions photographed, and snapshots, dust-rags, and precious particles of dust from each were placed with mock solemnity in their own archival boxes.

While artist-activists had in recent years similarly entered museums to perform overt actions upon renowned works of art (in 1969 the Guerrilla Art Action Group removed Kazimir Malevich's *White on White* from a wall at The Museum of Modern Art in New York, temporarily replacing it with a manifesto listing demands for Museum reforms), they had done so with specific political intentions. By contrast, Filliou's action was an obscure, discreetly impish gesture. He removed from the aging objects a coating of dust, while creating a new piece with the resulting accumulated dirt. The equivalence of this relationship is made manifest by the title of the series, *Poussière de Poussière* (Dust to Dust), which, with its familiar funereal overtones, underscores the works' ultimate immateriality, emphasizing the spirit of the gesture over the object of art. For Filliou, while all material objects must perish (museums and their collections are not exempt), the ideas and creative energies they embody are immutable.

James Trainor

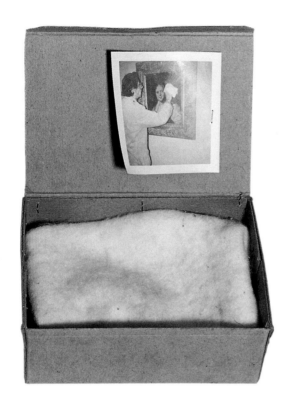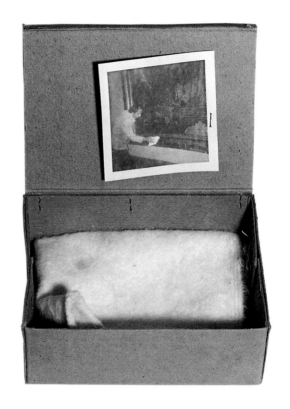

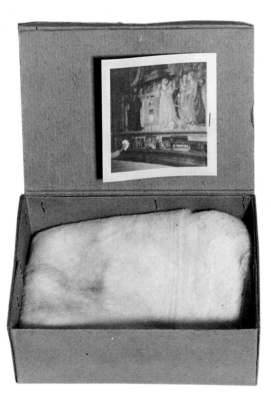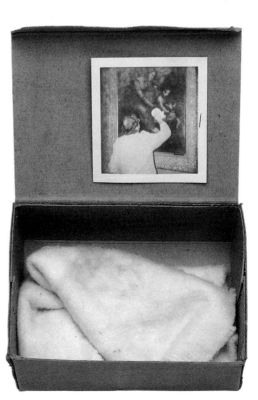

Vik Muniz
(Brazilian, born 1961)

left:
Vik Muniz
Equivalents (Museum of Modern Art). 1995
Gelatin silver print mounted on museum board, 14 x 11" (35.5 x 27.9 cm)
Collection the artist

right:
Vik Muniz
Equivalents (Museum of Modern Art). 1995
Gelatin silver print mounted on museum board, 14 x 11" (35.5 x 27.9 cm)
Collection the artist

I went to The Museum of Modern Art to see *Alfred Stieglitz at Lake George*, and I looked at his Equivalents. Clouds have always fascinated me, because you can picture clouds, and you can do anything with them. You can make an image of a cloud and an image of a seal at the same time. After Stieglitz did it, a lot of people took pictures of clouds, but most of the subsequent photographers who tried to adopt a concept of equivalence to natural forms worked with stones. During the Museum's show, I thought a lot about equivalents—how Aaron Siskind and Edward Weston photographed rocks—and when I came out of the exhibition, the first thing I saw was the marble floor of the Museum. It just came. Boom! Like this. That's equivalency. I was looking at the floor of the Museum, thinking about the sky. At the same time, I'd be photographing the Museum. Photographing things in museums has always fascinated me.

I went outside to buy film, and I went into the Museum shop and bought this bad photography book because it had a lot of black pages in it and I cut all the black pages to make props. I had a flashlight. I had a dime, and I asked the woman from the membership desk if I could borrow some Wite-Out. She had Wite-Out, and I painted the dime white. I made the props (for the landscapes and the trees that appear in them) while drinking coffee in the garden.

So I went back inside the Museum. All these photos were taken inside the Museum, not in the garden. The floor of the garden is too dirty. I just had this idea, and in forty-five minutes I had done the whole thing. These prints are exactly the same size and on the same paper as Stieglitz's. They're going to be framed and mounted in exactly the same way as the Equivalents. They are called *Equivalents (Museum of Modern Art)*.

Vik Muniz [1]

left:
Vik Muniz
Equivalents (Museum of Modern Art). 1995
Gelatin silver print mounted on museum board, 14 x 11" (35.5 x 27.9 cm)
Collection the artist

right:
Vik Muniz
Equivalents (Museum of Modern Art). 1995
Gelatin silver print mounted on museum board, 14 x 11" (35.5 x 27.9 cm)
Collection the artist

On March 18, 1990, five drawings by Degas, one vase, one Napoleonic eagle, and six paintings—by Rembrandt, Flinck, Manet, and Vermeer—were stolen from the Isabella Stewart Gardner Museum in Boston. In front of the spaces left empty, I asked curators, guards, and other staff members to describe for me their recollections of the missing objects.

Sophie Calle [1]

In 1990 two burglars disguised as police officers stole thirteen works from the Isabella Stewart Gardner Museum in Boston—the Venetian-style palazzo, with its imposing collection of paintings, drawings, sculpture, furniture, books, and manuscripts that had been bequeathed to the public when Mrs. Gardner died in 1924. The directives of her will enforce the perpetual impression of the stolen art's absence, since this dauntless Victorian woman had determined that the rooms at Fenway Court should remain just as she had arranged them. So it is that the green brocade-lined walls of the Dutch Room—from which four paintings were taken—appear unmistakably to be the scene of the crime. Sophie Calle's series *Last Seen...* of the following year, its title drawn from the lingo of the police blotter, traces the missing images in memory. Each work in the series is composed of two elements: a color photograph, architectural in scale, records the space left empty; and a text, pieced together from recollections of those who work at the Gardner Museum, is contained in a frame matching the dimensions of the missing image itself. "I am not surprised by what they say. It might be the smallest little details that move me the most. There is no rule." [2]

The first voice to speak of Jan Vermeer's *The Concert* reports its unknowability: "I'll always remember this painting because I couldn't see it. It was displayed at waist height, behind a chair, covered with glass but next to the window so that the glare caught the glass." The crystalline interior and cloistered domesticity of *The Concert* prompted reticence in one viewer: "I could hear them singing but it seemed very private, quiet, and pure. You felt like an intruder and you wouldn't want them to know you were watching." The quotidian existence of the painting was disclosed in routines of companionable or contemplative proximity: "It's a peaceful thing. I used to look at it every morning before work;" "I used to come here at night, late at night and just go up there and stand." The observer who has the last word brusquely concludes: "I didn't like it much, not my style."

The uncanny shadow presences of *Last Seen...* and of *Ghosts*, an installation made for the 1991 exhibition *Dislocations* at The Museum of Modern Art, are charged transmutations of the impassive, matter-of-fact *fantôme,* as it is called in French—a brief notice explaining the unexpected absence of a work from view.

With its "blinding concentration of light towards the point of danger," and the "look of terror on people's faces," Rembrandt's *Storm in the Sea of Galilee* (one of two paintings by Rembrandt taken that night) pumped up one viewer's adrenaline and recalled, for another, a childhood Christmas present, a five-pound tin of candy with a reproduction of the painting on the lid: "It was my prized possession. I loved it, absolutely loved it." Why, some puzzled, had Rembrandt included himself in this story of Christ and the twelve apostles? "It was so arrogant of him." "I thought it was a rather humble thing to do." "It was my favorite because he put himself in the boat. I swear that's where Hitchcock got the idea to put himself in his movies. But, of course, Rembrandt was the best looking one." In *Last Seen...,* the remembrances of the paintings are spoken by those "who simply go because they follow that same path, like when you take a road to go back to your house and you cross a street again and again, because it's just there on your way." [3] The imperviousness of the masterpiece softens in the face of such modest encounters.

Calle's disturbance of the cool objectivity with which museums customarily present their contents escalated at the Museum Boijmans Van Beuningen, Rotterdam. A tour, guided by the voice of Calle on a Walkman headset, was available to the viewer of *Autobiographical Stories* (1994), an installation of paintings, documents, clothes, and household objects, "which belong to and occupy a sentimental place," Calle noted, "in my personal 'museum.'" [4] The variously banal and enigmatic pretenders—a red bucket, a rotary telephone, a blonde wig, and a wedding dress—were interposed discretely, if incongruously, into the collection of design and decorative arts. Insinuating the promiscuity of imagination and the illicitness of fantasy into the public decorum of the museum, the mementos were tokens of a virtual encyclopedia of psychic archetypes and psychological neuroses. There was the theft of love letters; the shoplifting of red shoes; a daily ritual, at age six, of undressing in the elevator; a brief occupation, later on, as a striptease artist; and a wedding in a drive-through chapel in Las Vegas.

In the foreground, on the right-hand side of the painting, there was a woman sitting, gazing towards the left. Behind her, in the center, was a man. Her husband, I guess. He was wearing a black cape and a hat. He had a pair of gloves, wearing one and holding the other. She was also in black except for this fluffy thing around her neck, this white ruffle. It seemed very impersonal, very static. He gazed out towards the viewer. She gazed at no one. There were stairs nearby and a reference to travel with a map hanging on a wall in the background ♦ The composition felt a little funny. There's a man and a woman and no connection between them. They're in different worlds. It has a very solitary feeling even though there are two people. This given the painting a mysterious quality because you can't quite figure out this lack of contact. What are they looking at ? It just never made sense. It looked wrong ♦ There's a woman sitting, looking out into space and a man standing up with gloves on, as if he's ready to go out. When they X-rayed the painting, they found that there had been a child in the picture, between the two figures, holding onto his mother's hand and clutching something that looked like a whip ♦ There was a theory that a little boy had been sitting in the chair with a rattle in his hand and somehow the missing spirit of the child lit the painting with melancholy. When you knew that there was a child who had been playing between them, it felt like a ghost was present. The painting became much deeper, it had a new dimension. One can speculate why he was painted out. ♦ The story was that the child had died so they removed him, and instead Rembrandt painted a chair. I had just had a child when I heard the story so, I used to come over here when there was no one in the room. It was just like sitting with them. They were friends of mine. Good, solid friends who had experienced a loss ♦ It was a traditional pose, her sitting and him standing. I assume they were husband and wife but they didn't seem in love. I think there was a third interest in the painting. It might have been a dog. ♦ They were like porcelain dolls. They didn't seem very realistic. The woman had a far away look in her eyes but she was not looking out, she was probably looking at the child ♦ They removed the child after the portrait had been painted so there's not a look of sadness or grief on their faces because the child was there initially ♦ The woman had a very maternal impact. Everyone's dream of what you want your mother to be like, proper, solid and well-fed. Someone who contributes to your future and with whom you could live your entire life ♦ I loved her face, she had ruddy sort of cheeks but she didn't look common. She looked more alive than the man who was well-assured and a little pompous. But it was the detail in the clothing that spoke to me. I remember the flowers embroidered on her hair and those gorgeous white collars. I don't remember the woman's feet ♦ It was another dark painting except for the very white lace. The black and white clothes stood out sharply against the neutral background. The black was very deep and the crisp white lace against it really brought the painting out. It was a little smaller than *The Storm*, maybe it was 3 feet x 4 feet, something like that. They were a very impressive couple. They dominated the room.

<table>
<tr><td>

top:
Sophie Calle
Last Seen... (Rembrandt, A Lady and a Gentleman in Black). 1991
Ektachrome print and text, photograph 7' 11 ¼" x 61 ½" (242 x 156.2 cm); text 52 ½ x 43 ½" (133.4 x 110.5 cm)
Courtesy the artist and Luhring Augustine, New York

</td></tr>
<tr><td>

bottom:
Sophie Calle
Last Seen... (Manet, Chez Tortoni). 1991
Ektachrome print and text, photograph 53 ⁹⁄₁₆ x 64 ⁹⁄₁₆" (136 x 164 cm); text 16 ⅛ x 19 ¹¹⁄₁₆" (41 x 50 cm)
Collection the artist

</td></tr>
</table>

137

The account of "the bathrobe" inverts the Freudian Medusa complex: it is the eighteen-year-old Calle who is unable to look at her first lover "naked from the front" throughout the year of their affair. The story of "the bucket" reads as a covert exorcism of the trauma of Freud's construction of the feminine affliction of penis envy and French psychoanalist Jacques Lacan's corollary of absence: "In my fantasies, I am a man. Greg was quick to notice this. Perhaps that's why he invited me one day to piss for him. It became a ritual: I would come up behind him, blindly undo his pants, take out his penis, and do my best to aim well. Then, after the customary shake, I would nonchalantly put it back and close his fly." The narrator was scrupulous in pinpointing the circumstantial facts—the particular date, exact hour, and specific location. But the stories were, for all their pretense of disengaged factuality, rigorously one-sided. Rebuffing the scholarly neutrality with which either art history or anthropology would order the artifacts, the Walkman tour instead assumed the narrative demeanor of literature or of psychoanalysis. The visitor was hard-pressed to ascertain the truthfulness of the riveting vignettes which cumulatively comprised an elliptical and presumably fraudulent autobiography. The distinction between fact and fiction blurred, as remembering and making up stories loomed as intertwined processes driven by desire and will.

The appeal of the film-noir detective surely has as much to do with his capacity to tell a story as it does with an ability to ferret out the facts. In the early 1980s, Calle assumed a succession of personae modeled on the detective, always watching, seldom seen. Her identity purportedly obscured by a blonde wig, she trailed a virtual stranger, Henri B., from Paris to Venice in 1980, the photodocumentation together with her journal of his trip gathered as *Suite venitienne*. On April 16, 1981, the artist herself was followed by a private investigator unwittingly in her employ. Starting at 10 a.m., he dutifully recorded the details of her day, until at 8 p.m., having tired of the exercise, he concluded his report with a lie. This detective story, with its device of double cross, intimates the strategy played out in the video *Double Blind* (1992): "The story of two artists, Sophie Calle and Gregory Shephard, who drive cross country at cross purposes." She wants to marry him, and he wants to make a movie. "The difference between his story and hers is the story the tape has to tell."[5] Deploying the shifting vantage points of shot/ reverse-shot, *Double Blind* succeeds in stalemating the contentious forces of observer and observed.

The one who tells the story wields the power. Calle has been insistent in troubling the seamlessness of history and the unities of vantage point with which museums tell the stories of the past. The Isabella Stewart Gardner Museum, with its flagrant domesticity—however opulent—and rampant subjectivity—however astute—must have seemed to Calle to be her kind of museum. Mrs. Gardner's certainty that her sensibility should be forever evident in the museum suggests a peculiar kind of intellectual humility more than vanity: that this should always read as one woman's view of things. Throughout Calle's work, meaning proves to be as mutable as motive, and motive as private as desire. In the equipoise that matches narrator against narrator in *Double Blind,* there is enacted one aspect of *Last Seen...*: that the facts endure most palpably in the phantoms of imagination.

Sally Yard

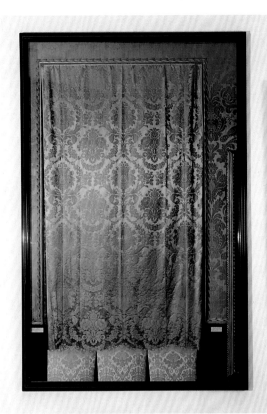

top:
Sophie Calle
Last Seen... (Rembrandt, The Storm in the Sea of Galilee). 1991
Ektachrome print and text, photograph 95 ¼ x 61 ½" (242 x 156.2 cm); text 64 ¼ x 51 ½" (163 x 130 cm)
Courtesy the artist and Luhring Augustine, New York

bottom:
Sophie Calle
Last Seen... (Vermeer, The Concert). 1991
Ektachrome print and text, photograph 66 ¾ x 50 ⅞" (169.5 x 129.2 cm); text 34 x 30 ¹¹⁄₁₆" (86 x 77.9 cm)
Collection The Bohen Foundation, New York

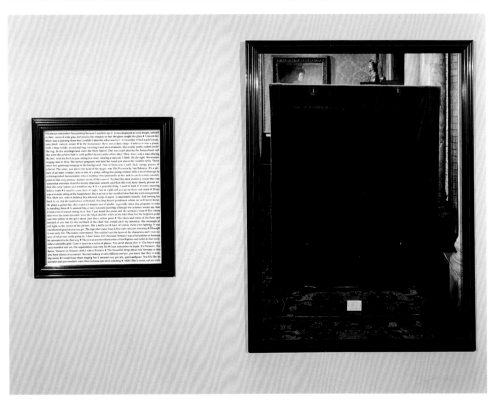

Sherrie Levine

(American, born 1947)

top:
Sherrie Levine
After van Gogh: 6. 1994
Black-and-white photograph,
10 x 8" (25.4 x 20.3 cm)
Courtesy Margo Leavin Gallery,
Los Angeles

center:
Sherrie Levine
After van Gogh: 4. 1994
Black-and-white photograph,
10 x 8" (25.4 x 20.3 cm)
Courtesy Margo Leavin Gallery,
Los Angeles

bottom:
Sherrie Levine
After van Gogh: 5. 1994
Black-and-white photograph,
10 x 8" (25.4 x 20.3 cm)
Courtesy Margo Leavin Gallery,
Los Angeles

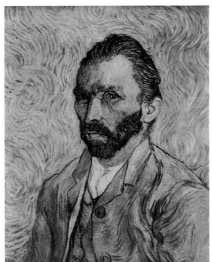

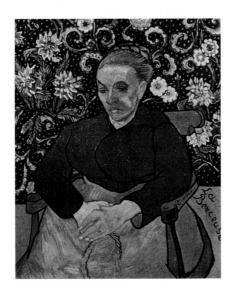

I consider myself a still-life artist—with the book plate as my subject. I want to make pictures that maintain their reference to the book plates. And I want my pictures to have a material presence that is as interesting as, but quite different from the originals. (1984)

The pictures I make are really ghosts of ghosts; their relationship to the original images is tertiary, i.e., three or four times removed. By the time a picture becomes a book plate it's already been rephotographed several times. When I started doing this work, I wanted to make a picture that contradicted itself. I wanted to put a picture on top of a picture so that there are times when both pictures disappear and other times when they're both manifest; that vibration is basically what the work is about for me—that space in the middle where there's no picture, rather an emptiness, an oblivion. (1985)

I am grateful to photography, which has created a museum without walls. I aspire to the condition of music and poetry, where there is no such thing as a forgery; every performance, every reading, every photograph, every sculpture, every drawing, every painting is an original, genuine, authentic, the same. I like a situation where notation becomes content and style. All the different manifestations equally represent the work. (1997)

Sherrie Levine

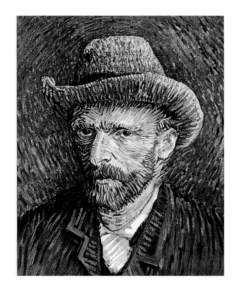

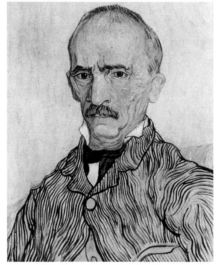

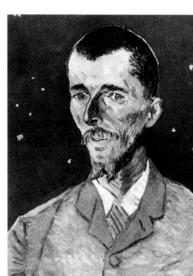

top left:
Sherrie Levine
After van Gogh: 3. 1994
Black-and-white photograph,
10 x 8" (25.4 x 20.3 cm)
Courtesy Margo Leavin Gallery,
Los Angeles

top right:
Sherrie Levine
After van Gogh: 2. 1994
Black-and-white photograph,
10 x 8" (25.4 x 20.3 cm)
Courtesy Margo Leavin Gallery,
Los Angeles

bottom left:
Sherrie Levine
After van Gogh: 7. 1994
Black-and-white photograph,
10 x 8" (25.4 x 20.3 cm)
Courtesy Margo Leavin Gallery,
Los Angeles

bottom right:
Sherrie Levine
After van Gogh: 1. 1994
Black-and-white photograph,
10 x 8" (25.4 x 20.3 cm)
Courtesy Margo Leavin Gallery,
Los Angeles

Louise Lawler
(American, born 1947)

Louise Lawler
The Public Life of Art: The Museum.
1988
Production still from video,
written and performed by Andrea
Fraser, production design by
Louise Lawler; 14 minutes, color
Produced by Terry McCoy
Collection the artist

opposite:
Louise Lawler
Paperweights. 1982–95
Crystal, Cibachrome, and felt,
each 2 x 3 ½" (5.1 x 9 cm)
[Edition of 10]
Collection the artist

Untitled (*Reception Area*). 1982–93
Crystal, Cibachrome, and felt
Longo, Stella

Repetitive, purposeful, and intentional behaviors, which
are designed to neutralize or prevent discomfort.

Untitled (*Oslo*). 1993–95
Crystal, Cibachrome, and felt

She made no attempt to rescue art from ritual
☐ YES ☐ NO

Untitled (*Dreams*). 1993
Crystal, Cibachrome, and felt

Edward Ruscha
Dreams #1. 1987
Acrylic on paper, 17 x 46 inches

To 420 from artist 3/14/89
To Thaddeus Ropac, Salzburg "Freud" 5/2/89
To Castelli Gallery, 578 Broadway for group drawing
exhibition 9/26/89
Purchased by Leo Castelli 9/28/89
To LC apartment 1/22/90

Roy Lichtenstein
Ball of Twine. 1963
Pencil and tusche on paper, 15 x 12 1/2 inches

Gift to Leo Castelli from the artist 6/64
To LC apartment 6/24/64
To Philadelphia Museum of Art for Exhibit
(6/63–9/65)
To LC apartment 1/5/65
To Pasadena Museum (first Museum Retrospective
4/18–5/28/67), travels
To Walker Art Center (6/23–7/3/67)
To Stedelijk Museum, Amsterdam 1/5/67
To LC apartment 6/26/68
To Guggenheim Museum (first museum retrospective
in New York), travels
To Nelson Gallery of Art, Kansas City; Seattle Art
Museum; Columbus Gallery of Fine Arts; and Museum
of Contemporary Art, Chicago
To LC apartment 12/9/70
To Centre National d'Art Contemporaine, Paris,
retrospective drawing exhibition, *Dessins
sans Bande*, travels to Nationalgalerie, Staatliche
Museen Preussischer Kulturbesitz, Berlin
To Ohio State University 1/21/75
To Metropolitan Museum & Arts Center, Miami
2/17/76
To LC apartment 5/8/79
To MoMA *In Honor of Toiny Castelli: Drawings from
Toiny, Leo, and Jean-Cristophe Castelli Collection*
(4/6–7/17/88)
To LC apartment 1/24/89
To Guild Hall, East Hampton *A View from the Sixties:
Selections from the Leo Castelli Collection and the Michael
and Ileana Sonnabend Collection* (8/1–9/22/91)
To LC apartment 1/21/91

This will mean more to some of you than others.

Allan McCollum

(American, born 1944)

Allan McCollum
Plaster Surrogates. 1982–89
Enamel on solid cast hydrostone,
dimensions variable
Installation view, Kohji Ogura
Gallery, Nagoya, Japan, 1993

Whenever I walk into a museum, I am very much aware—and maybe this is increased because I have sometimes worked in museums for money, as a laborer—of the fact that I had nothing to do with choosing what got in there. The objects that are important in my life, or my family's life, or your life, or in the vast majority of people's lives are never going to end up in a museum, because most people aren't in a position to enforce the meanings in their lives and say, "this should be the meaning in your life, too." Museums are filled with objects that were commissioned by, or owned by, a privileged class of people who have assumed and presumed that these objects were important to the culture at large—and who have made sure that they are important to the culture at large. My awareness of what kind of people decide what goes into these shrines, and how we are expected to emulate their tastes in our own lives, and find personal meaning for ourselves in their souvenirs, causes a hostility to arise within me, which becomes the major factor in my experience of being in a museum. Obviously, if I felt that all was well with the world and if I approved of the mechanisms of connoisseurship and expertise, and thought that these were value-free talents that some people had, it would be very different. But I believe that connoisseurship has always been part of a sort of self-answering structure which has supported a class of people who feel themselves better than everybody else, an attitude on account of which others suffer. . . . [1]

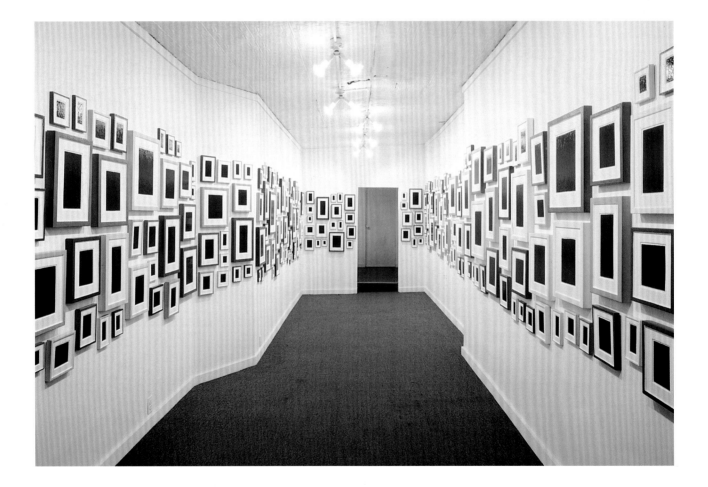

In the late 1960s and the early 1970s . . . I was concerned . . . with the gallery itself as the true site, the site where art received its meaning, even if the artwork was happening elsewhere, on the periphery, in the desert, or somewhere—this seemed to be the irony in Robert Smithson's work, for instance, at least as I experienced it then, and I responded to that in my work, especially with the Surrogate paintings. I made the Surrogates because they were exactly what you'd expect to find in an art gallery, not something you'd be surprised to find there.

The gallery or the museum, the home . . . all of these places are the normal sites of paintings. I wanted to create a homogenous view of their functioning, a kind of generic, portable art object for the wall. And if you can't really discover the terms of painting within painting, if you have to look for it in the system of objects that give the painting its identity, then when you think about that, that the same features you find in a painting could be found elsewhere, in a garage door, or the surface of a fence, or a dry creek bed, or whatever, then suddenly the site of painting becomes very fragmented and dispersed. There doesn't seem to be one particular location where you can find anything that is really defining, so I think I must have been figuring out my work in response to this kind of reasoning . . . this dichotomy of the site and the non-site that engaged Smithson so much, and his humor about it, his sort of romance with detritus, with the peripheries of things in relation to the centers. But I wanted to be really site-specific in the gallery.[2]

Allan McCollum

Allan McCollum
Plaster Surrogates. 1982–84
Enamel on solid cast hydrostone,
dimensions variable
Installation view, Cash Newhouse
Gallery, New York, 1985

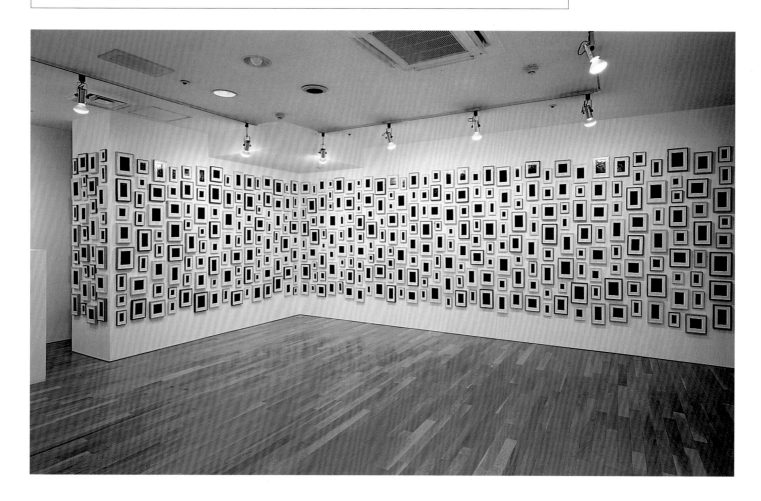

Art & Language

(Michael Baldwin, British, born 1945;
Mel Ramsden, British, born 1944)

Art & Language
Index: Incident in a Museum XV. 1986
Oil and alogram on canvas,
7' 11 ¹¹/₁₆" x 12' 5 ³/₁₆" (243 x 379 cm)
Fonds National d'Art Contemporain,
Ministère de la culture et de la
communication, Paris

In 1982 Art & Language embarked on what were to become two large groups of paintings addressing contemporary art's principal sites of production and consumption: the studio and the museum. The works in the two series, *Studio at 3 Wesley Place* and *Index: Incidents in a Museum*, employed a theatrical, perspectival space, in the sense that the interior of the studio and the museum act as a kind of stage and repository for the inclusion of objects, surfaces, words, and signs.

Art & Language have always incorporated, as a part of their modus operandi, a reflection on the ideological and aesthetic materials out of which their work is made. The indexical incorporation and displacement of aspects of their previous production have defined their practice since the days of Conceptual art. For instance, their 1972 *Documenta Index* involved the presentation of eight filing cabinets filled with cross-referenced Art & Language texts and group conversations, objects, and projects arranged by compatibility, incompatibility, and incomparability. Their use of the index to suppress conven-

tional or emotive responses in both the artist and the spectator remains central to their practice.

What distinguishes the Museum series, first and foremost, is its anomalous, or imaginary, status. Art & Language have chosen to represent a site that by definition excludes them as British artists: the Whitney Museum of American Art. In order to represent the museum as a site of power, they had to place their work and themselves in a convincing position of exclusion. In setting out to represent the alienated distance the artwork travels from the ideological spaces of the studio to its canonization in the museum, they had to represent their own work as alienated from the conditions of its presentation. Thus, given that the Whitney was one museum that was never going to show their work, the representation of their paintings within its spaces provided a set of material and symbolic resistances which they could then work against. In this sense, their occupation of the Whitney's interiors in these paintings is a convenient way of engaging with the exclusions and hierarchies of

museums, without its being an attack on the Whitney itself, although the choice of the Whitney as one of the pillars of American modernism's success should not to be overlooked.

In these terms, the series isn't strictly concerned with the representation of the Whitney at all, it is a means of staging the confinement of the artwork in the modern museum, what Art & Language call a form of hostage taking. As such, the representation of earlier paintings and texts hanging on the walls of the museum, narrates those events and structures of the journey from a collectivist avant-garde to the fame and professional plaudits of an international career. However, this is not an act of bad faith, as if the alienations of the museum served as a backdrop for lost illusions. Art & Language's Museum series may employ theatrical effects, but they are not a form of literary self-flagellation. On the contrary, the mechanisms of the paintings enact a kind of artistic homelessness, in which the very shifts in perspective and scale are a way of making the representation of the museum bear the weight of the reifications of cultural modernity. Thus in *Index: Incident in a Museum XV* the shifts in scale and autoreferentiality serve to inflect the viewing of the museum with uncertainty and instability. The representation of the partition wall depicted in the picture wall forms a small painting inserted ambiguously either on the surface of the painting or in the wall itself. It is impossible for the spectator to secure his or her bearings. This frustration of the spectator is also manifest in *Index: Incident in a Museum XXI*. Leaning against the walls are sections from the photographic works in the Studio series. The wall, which supports the second panel on the right, is mysteriously truncated below the other panels, revealing one of the Whitney's walls behind it. Perspective is rendered nonverifiable. This interpenetration of Art & Language's works, or parts of works, with the architectural space itself, as well as the representation of the museum with discrete works in its interior, disturbs the direct surveyance of the interior.

John Roberts

Art & Language
Index: Incident in a Museum XXI. 1987
Oil and photograph on canvas, mounted on plywood, 7' 11 $\frac{11}{16}$" x 12' 5 $\frac{3}{16}$" (243 x 379 cm)
Courtesy Lisson Gallery, London

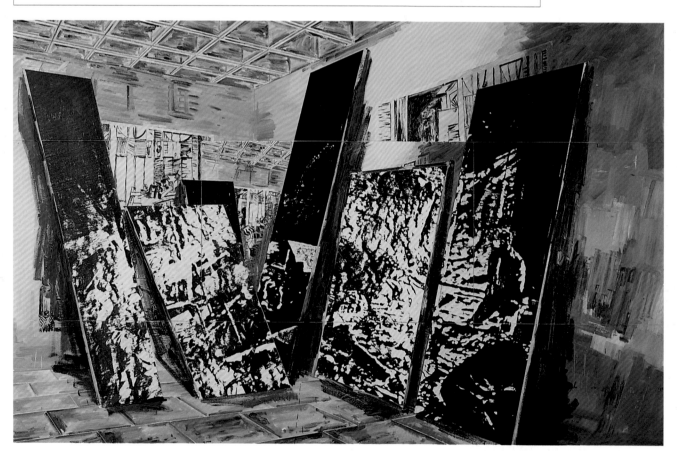

Daniel Buren
(French, born 1938)

Daniel Buren
Installation view, paintings by
Giorgio de Chirico in the Painting
and Sculpture Galleries, The
Museum of Modern Art, New York,
August 1998

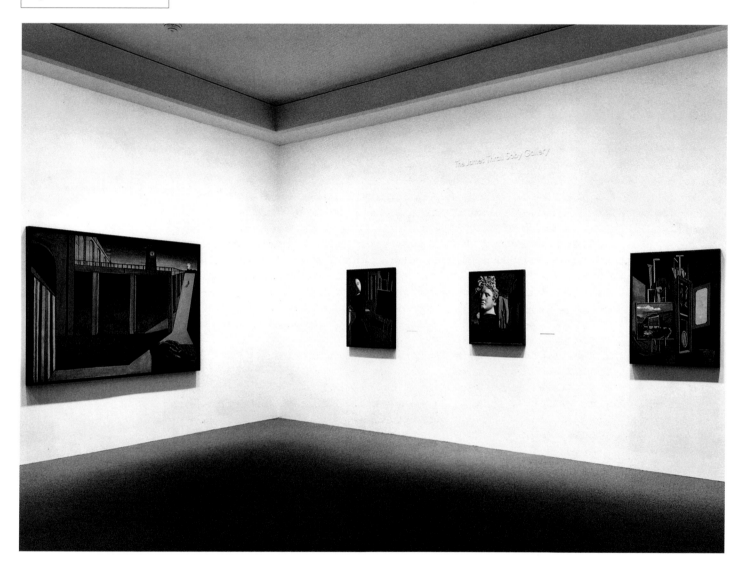

To Displace: The four paintings by Giorgio de Chirico from the permanent collection of The Museum of Modern Art are among the works of art that give this Museum its specific identity. They are permanent in terms of the collection and continually mobile in terms of the object. To be displaced and reinstalled—one by one, all together, or in pairs—within their own context or in different historical ones is part of their destiny as paintings. In this work *in situ* four paintings from gallery 8 are placed within the exhibition *The Museum as Muse: Artists Reflect*.

To Place: Before transporting and installing the four de Chiricos, we had to prepare a place for them. We decided to build a new room, an exact copy of gallery 8. Then, in this new room placed inside the exhibition, we can move and install the four paintings in the same position in which they were situated previously. Finally, the labels correspond to their paintings, as they were in gallery 8. We can now say that the four de Chiricos moved from one context to another, remaining in the very same museum, not as independent objects but as part of an installation, as if their arrangement on the walls were indispensable to them.

To Replace: Meanwhile, what was left empty on the walls in gallery 8 by the departure of the four paintings is replaced by vertical stripes alternately white and colored, each one 8.7 cm wide. These walls are entirely covered by the stripes with the exception of the four surfaces previously covered by the four paintings (including their own frames). These four surfaces, untouched, are kept to the exact color of the existing wall (more-or-less white). Then, the striped walls themselves become a kind of frame indicating the missing paintings. Labels indicate which paintings are missing (following the way it is usually done at The Museum of Modern Art), where they are now placed and may be seen, how long they will be displaced, and when they will be returned to their original places. The walls, treated as described, replace the previous ones where the de Chirico works were installed. At the end of the exhibition *The Museum as Muse: Artists Reflect,* the de Chirico paintings will be replaced in their own section, the walls where they were temporarily placed will be dismantled, and the stripes glued inside gallery 8 will be destroyed.

Some Remarks: The paintings used for my work in this exhibition have been selected by the authorities of the Museum. • They could have been different. • I have had nothing to do with this decision. • I would have done the same work with any other rooms and/or works selected. • For such a work, it is deeply important to understand that it is out of the question for me to interfere with the choice of the works of art. • Therefore, it will be meaningless to make any comment on the content of these works or on their use in the present exhibition even if their meanings remain intact and visible. • The color chosen for the stripes is arbitrary. • If works of art, inside any museum, are like cards on a game table, the art of making a new exhibition, for a curator, is to shuffle the cards indefinitely in order to try to show the unknown possibilities for each new game found that way. • Shuffling the walls might reinforce the fact that, as banal and convenient as people want us to believe they are, they embody everything possible and are never neutral.

Daniel Buren
Procida, Italy
July 30, 1998

Daniel Buren
*Photo-Souvenir: "Peinture–
Sculpture."* February 1971
Detail of a work *in situ*, *VI
Guggenheim International*,
Solomon R. Guggenheim
Museum, New York

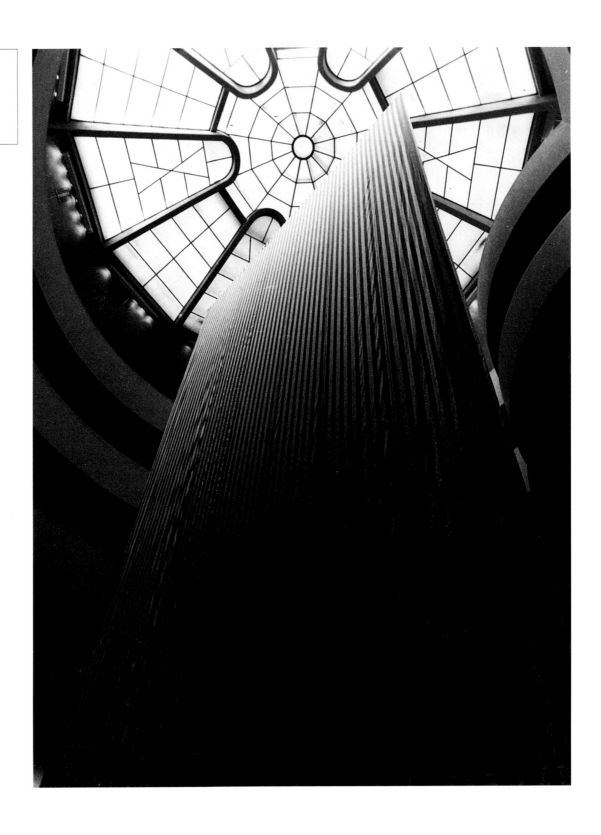

top:
Daniel Buren
Photo-Souvenir: "Dominoes." 1977
Detail of a work *in situ*,
Wadsworth Atheneum, Hartford

bottom:
Daniel Buren
Photo-Souvenir: "A partir de là."
November–December 1975
Detail of a work *in situ*,
Städtisches Museum, Mönchen-
gladbach, Germany

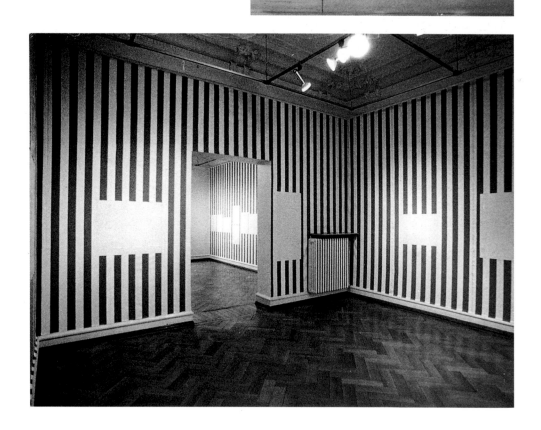

Hans Haacke
(German, born 1936)

"Les Poseuses"
(small version)
acquired, probably as a present, by

Jules F. Christophe

Born 1840 in Paris. Son of a merchant.

Writer and government official. 1889 appointed Deputy Chief of Staff in the French Ministry of War.

Author of theater plays and fiction. 1887 co-author with Anatole Cerfberr of "Repertoire de la Comédie humaine," a biographical dictionary for Balzac readers. Contributor of theater and art criticism, essays and biographical articles to numerous literary magazines associated with symbolism and anarchist communism. Publishes 1890 one of the early extensive articles on Seurat and his theories ever written, in "Les Hommes d'Aujourd'hui," a symbolist weekly. In the same magazine appear his articles on the painters Dubois-Pillet and Maximilian Luce. He himself is the subject of a biographical sketch by Félix Fénéon in "Les Hommes d'Aujourd'hui."

Closely related to circle of symbolist/anarchist writers and neo-impressionist painters, including Fénéon, Gustave Kahn, Charles Henry, Paul Adam, Jean Ajalbert, Jules Laforgué, Seurat, Signac, Pissarro.

Has strong sympathies with anarchist communism. Contributes to fund for the destitute children of imprisoned anarchists.

Author of Seurat's obituary in "La Plume," 1891.

Reportedly gives his son "Les Poseuses" during his own life time. Date of death unknown.

Detail of Drawing by Dubois-Pillet, 1888

"Les Poseuses"
(small version)
purchased 1936 through Mrs. Cornelius Sullivan for $40,000 by

Henry P. McIlhenny

Born 1910 Philadelphia, Pennsylvania. Descendant of wealthy Irish family of Philadelphia society.

His father John D. McIlhenny, member of boards of directors of several large gas companies; partner of Helme & McIlhenny, manufacturers of gas meters in Philadelphia; member of the board of managers of Savings Fund Society of Germantown, Pa. Collector of European decorative arts, oriental rugs and paintings. President of Pennsylvania Museum and School of Industrial Art (now Philadelphia Museum of Art) and Director of Philadelphia Art Alliance.

His mother Frances Galbraith Plumer. Collector of 19th and early 20th century art. Trustee of Philadelphia Museum.

His uncle Francis S. McIlhenny, lawyer; vice president of Sun Oil Company; member of Board of Directors of numerous large corporations; member of Pennsylvania Senate (1907-15); director and officer of YMCA.

His sister Mrs. John (Bernice) Wintersteen married to lawyer. Collector of 19th and early 20th century art. Trustee and President (1964-68) of Philadelphia Museum of Art.

Studied at Episcopal Academy and Milton Academy, elite prep schools near Philadelphia and Boston. Bachelor of Arts 1933, Harvard; graduate studies in art history, 1933-34, Harvard, under Prof. Paul J. Sachs.

Curator of Decorative Arts at Philadelphia Museum of Art 1935-64. Since 1964 trustee and 1968 vice president of the Museum. Member Smithsonian Art Commission, Washington. 1949-62 director of Philadelphia Orchestra Association and Metropolitan Opera Association, New York.

Served to Lieutenant Commander in U.S. Naval Reserve. During World War II on active duty.

Major part of his collection purchased with his mother's financial backing during depression: silver, period furniture, and predominantly 19th century French painting and sculpture, including Cézanne, Chardin, Daumier, David, Degas, Delacroix, van Gogh, Ingres, Matisse, Renoir, Rouault, Toulouse-Lautrec, Vuillard.

Bachelor, frequent society host in his mansion, 2 adjoining mid-19th century town houses, with ballroom, on Rittenhouse Square in Philadelphia. Employs 8 servants there. Spends part of year at Victorian Glenveagh Castle, his property in County Donegal, Ireland; maintained by 30 servants.

Member of Philadelphia Club and Rittenhouse Club, in Philadelphia, Century Association and Grolier Club in New York.

Together with Seurat's "Les Poseuses" buys Picasso's "L'Arlequin" from Mrs. Mary Anderson Conroy, for a total of $52,500. Her friend, Mrs. Cornelius Sullivan, co-founder of the Museum of Modern Art, New York, and a private art dealer, receives a commission of 10%.

Photo by Richard Noble, New York

Hans Haacke
*Seurat's "Les Poseuses" (Small
Version), 1888–1975.* 1975
Fourteen wall panels and one
color reproduction of Georges
Seurat's *Les Poseuses,* all in
thin black frames, under glass,
each panel 30 x 20" (76 x 50 cm);
color reproduction (by Dia Blauel,
Munich) 23 ⅜ x 27 ¼"
(59 x 69 cm)
Collection Gilbert and Lila
Silverman, Detroit, Michigan
Installation view, John Weber
Gallery, New York, 1975.

opposite:
Hans Haacke
*Seurat's "Les Poseuses" (Small
Version), 1888–1975* (details)

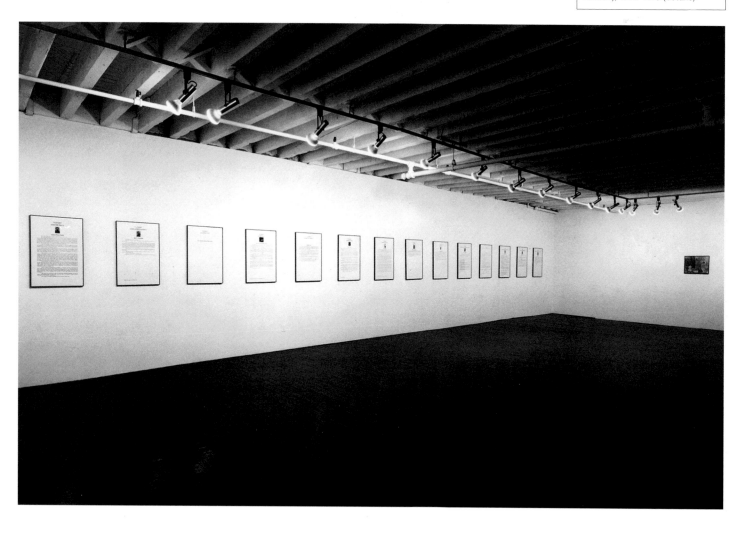

Museums often deny their involvements in politics and finance, or disguise them behind a veil of disinterested aestheticism. Endowing the "masterpieces" they collect with an aura of universal or transcendent meanings, museums hope to skirt discussions of the complicated entanglements that deliver these artworks to the space of exhibition. But artists like Hans Haacke, who has been active since the mid-1960s, make it their purpose to expose the structure of outside influences and internal mechanisms that support the well-concealed ideologies of cultural institutions. Haacke, in particular, is known for artworks that investigate the business affiliations of individual private donors and the motivations of corporate patrons. In his *Seurat's "Les Poseuses" (Small Version), 1888–1975*, Haacke adopts the role of an art historian and traces the provenance, or history, of ownership of a small pointillist painting by Georges Seurat. The tiny painting itself is rather inauspicious; a study for a larger work, it depicts three seminude female models standing before Seurat's famous painting *La Grand Jatte*. But Haacke's detailed history of the work is quite revealing and complex. His presentation consists of a framed color photograph of the painting along with fourteen panels, recording, as he says, "the social and economic position of the persons who have owned the painting over the years and the prices paid for it."

Through his impressive assemblage of biographical data on the painting's successive owners and their political affiliations, Haacke shows that the meaning and value of a work like this are neither timeless nor autonomous, as museum displays suggest, but historically contingent and shaped by shifting class interests. Thus, Seurat's work was originally given by him to an anarchist acquaintance in Paris as a gift. Then it was briefly circulated in avant-garde art circles in New York, before being acquired by the wealthy lawyer and art collector John Quinn. After passing through the hands of various wealthy relatives of Quinn and other upper-class connoisseurs, the work was sold in 1970 for over a million dollars to a newly formed art-investment group called Artemis. In other words, Haacke's little history traces the shift from the old-style family patronage to a new brokering of art works as commodities.

For the art historian a provenance is like a pedigree; it certifies the authenticity of a work by establishing an unbroken chain of ownership leading back to the artist. But for Haacke this investigation establishes the painting as, among other things, more property first caught in a legal system of inheritance through patrimony and then subjected to the speculative bartering of the international art market. As sociologist Howard Becker described it: "The big jump in value came when the paintings ceased to be circulated among family members or a small group of upper-class acquaintances and moved into the open market."

Indeed, what first attracted Haacke to the Seurat painting was its splashy appearance in the annual report of Artemis, S.A., a Luxembourg-based firm founded in 1970. In the early 1970s, the concept of trading in fine art as with a commodity, like any other, was still relatively rare. Artemis was notable not only as one of the first such firms but because its board included an impressive array of international art dealers and investors, including New York dealer

Eugene V. Thaw, Walter Bareiss (a Museum of Modern Art trustee), and Paris dealer Heinz Berggruen. In 1971, Berggruen purchased the Seurat painting from Artemis for what the company's annual report called "an impressive profit," though Haacke's work suggests that the financial arrangements were more elaborate than disclosed at the time.

Haacke's work is paradigmatic of what is often called institutional critique, that aspect of Conceptual art of the 1970s that shifted attention from the internal aesthetic aspects of a work of art to the physical and ideological influences of the site of exhibition. Artists working in this mode, such as Daniel Buren, Marcel Broodthaers, and Michael Asher, were not anti-museum, as in the historic avant-garde; rather, they were determined to develop their critical works within the museum, to reveal both the institution's specific social and economic affiliations and the ritualistic ways it shapes and addresses its audience. The credo of this approach was summed up by Buren in 1973: "Any work presented within the museum, if it does not explicitly examine the influence of that framework upon itself, falls into the illusion of self-sufficiency—or idealism."

The Seurat piece was first shown by Haacke at the John Weber Gallery in New York, along with *On Social Grease* (1975), a work that consists of six aluminum panels, each featuring a statement by a prominent business leader extolling the financial benefits of supporting art exhibitions. For instance, one panel, quoting former CBS executive Frank Stanton, reads: "But the significant thing is the increasing recognition in the business world that the arts are not a thing apart, that they have to do with all aspects of life, including business—that they are, in fact, essential to business." In subsequent work Haacke continued to trace the role of private art donors and corporate patrons.

Haacke has been a sharp critic of corporations that support art exhibitions, especially the cigarette manufacturer Philip Morris, which sometimes uses the advertising tagline, "It takes art to make a company great." Haacke's 1990 work *Cowboy with Cigarette* gently mocks the corporation's sponsorship of an exhibition of works by Picasso. Far from disinterested sponsorship, Philip Morris's support of the arts is both a public-relations ploy to enhance its image and a way of implicitly shaping the development of general cultural attitudes. With corporate funding, Haacke notes, "Shows that could promote critical awareness, present products of consciousness dialectically and in relation to the social world, or question relations of power have a slim chance of being approved. . . . Without exerting any direct pressure, corporations have gained a veto in museums."

By providing this information, Haacke is doing more than simply presenting a muckraking exposé. His critiques of patronage provide the basis for a materialist history of art and, more generally, for a critical understanding of the ways in which all artworks are circulated. Ultimately, Haacke's observations point to the singular fact that all works of art—even those as seemingly benign as Seurat's study—are profoundly ideological.

Brian Wallis

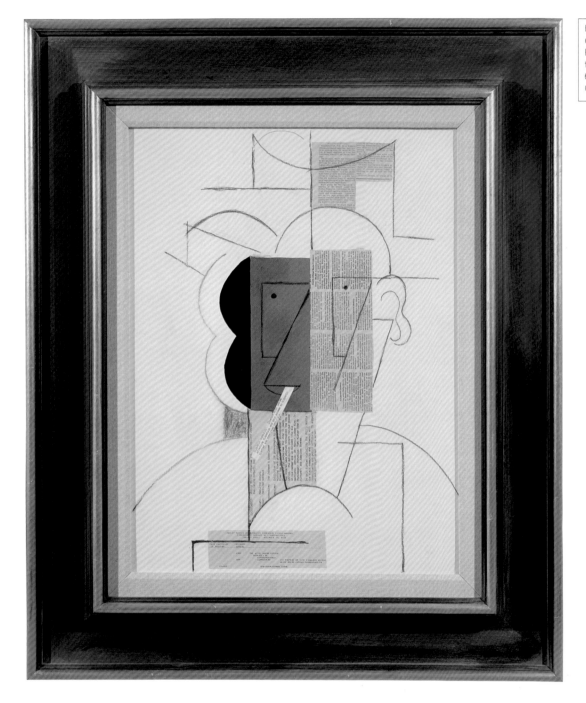

Hans Haacke
Cowboy with Cigarette. 1990
Pasted paper, charcoal, ink, and frame, 37 x 31 x 2 ⅜" (94 x 80 x 6 cm)
Collection Joseph Lebon

Michael Asher
(American, born 1943)

The construction of the museum collection suggests at least two histories, the one that the museum wants to tell to the viewer and the history of selection. The history of selection includes, in addition to new acquisitions, the removal of works to sharpen the collection. My project for the exhibition *The Museum as Muse: Artists Reflect* is a printed inventory of all the paintings and sculptures that have been deaccessioned, and thereby subtracted, from the permanent holdings since the founding of The Museum of Modern Art.

Michael Asher

One of the aims of Michael Asher's work is to produce, in the field of art, analytical models for functions that do not have immediately observable purposes. Reflecting predetermined forms of particular structural dispositions, he attempts to locate the network of forces that orient activities and decisions within a given cultural system. In each work he tries to materialize the implications of function (with all the impasses and paradoxes that this notion implies) and cultural discourse in order to emphasize the legibility of a structure.

One of the focal points of his method is that he is the author of a situation and not of the elements comprising it. The question seems to be how to address the conditions of abstraction in which the artworks exist—including those that claim to integrate context from a critical perspective. Asher begins with the purpose of an institution, most often a museum. There he tries to establish a point of vacillation in revealing what remains of antagonism and irreducible disconnectedness in an implicit social contract. From this position he analyzes the laws of a mode of production/circulation and the disjunctions it induces. The subtractions carried out by Asher in the field of representation seek to fix the very point of inconsistency and ambiguity in which a social relationship is subsumed into the form of an object.

His instruments are the usable elements present or active in the particular context and discourse. Asher's practice is based on operations of subtraction, addition, division, permutation, rotation, displacement, and inversion of elements. It involves the allocation of places and discourses by that which determines and connects them. Constants of his practice are: isolating an elementary and necessary function for encountering art; presenting a condensation of time in a work that defines its materiality as episodic; directing wandering attention by questioning institutionalized visibility; opening a debate around the paradigm of the Readymade; identifying the work by means of a support, often from the category of circulation and documentation (fliers, brochures, postcards, booklets); and broaching the question of nothingness and absence, showing and making this concrete.

Asher most frequently operates in a closed metonymic chain. As his installations do not leave their given spaces or their given discourse and as he makes the elements, terms, and places intersect within their own networks, the works most often involve a device that includes articulation and framing. Asher crosses sets with various properties—such groupings as sculpture/architecture, art/design, economy/labor, history/modernism—and in this case The Museum of Modern Art's two histories: those of the accession and deaccession of artworks. Just as he rearranges space according to its coordinates, he replies to the institution on its own terms.

By reversing the stages of readability and meaning pertaining to the elements in a given context, Asher subverts, underscores, and changes their order in space and their symbolic level, thus showing the degree to which their connection exists in a shadow zone. Some humor is related to the substitution in the canon here. Where an artwork is expected, a chronology is displayed as a list of objects no longer present. Unseen, hidden details become all important. By the very fact of substitution, an unstable differential appears.

In fact, his work appears as a practice of response framing various historical trends, the contemporary context, institutional order, and certain points of consequence in the institution's development. The aim is to link up with the axes of a particular space and the marks of a certain history. By introducing procedural changes in the supporting structure, the artist is attempting to encourage the spectator to question the ways in which the institution communicates its history to him. The need to contextualize the present and to provide the spectator with elements in which to situate it are revealed and point to the difficulties inherent in what could be a decisive reappropriation of experience.

Asher attempts to leave the object's place vacant. What, after all, is an object? What makes it different from a possession or from what is left after the removal of the object? His earliest works presented space, air, sound, and light as such. He came to the conclusion that he escaped the supplement, the anecdote, and the object when he used the given function in a given space. The functions still worked, but they became the objects of representation. By transposing function into semantic values, Asher participates in the paradigm of designation—in a particular way. In the relational procedure of displacement and withdrawal, the elements become designators in their absence.

Later, his inventions had as common denominators a questioning of the circulation of knowledge, the sites of the discourse and the code, the history a subject builds up, and the site of semblance occupied by each object. How can a tension be restored to a space made amorphous by the inertia of established significance? How can the artist materialize the substitution underlying the symbolism?

The important thing for Asher is that this subtraction, addition, or relocation not be reduced to a simple aesthetic declaration, diversion, or fetishization. It must always be a location for our relation to history, oblivion, knowledge, and memory. What finally appears as the outgrowth of this logic is that Asher is intersecting a network of connections. Faced with the proliferation of an imaginary function, Asher, by assembling the underlying interlinking elements of a structure, sets out to reduce them to bare symbolism.

Asher's interventions are specific in the way he handles nothingness as a shifted, repositioned void. What is thus revealed is that nothingness positioned in a symbolic order is something. In fact, the inserted void is not exactly nothing. An order of connections, open or closed proximities, is determined. The circular structure of the staged continuities circumscribes that which makes circulation possible in this or that ensemble. The relationship of variables, achieved by alterations, reversals; and equivalencies seeks in this way to fix what is beyond that about which we might be deceived: the imaginary, the figure.

Birgit Pelzer

Fred Wilson
(American, born 1954)

Much of my work is about looking and being looked at, what is being seen and how it is being interpreted. I have also had a longstanding interest in spaces and the margins of things. I am fascinated by images and ideas that are present but go unnoticed by the average viewer. As art generally involves looking, I find art and museums fertile territory to mine.

The process of making this piece, aspects of the piece itself, and many of the photographs dovetail with these interests and reveal for me much about our present views and about those in the past. In going through the photographic archives at The Museum of Modern Art, I saw myself in terms of the otherness created by modern art and the Museum. The Museum's archives reveal that a modernist appropriation of third-world culture, "ethnographic" artifacts, brown bodies, and "exotic types," existed marginally and centrally, simultaneously, within its walls. Though diverse, this art was obviously created, displayed, seen, and interpreted through the disfiguring lens of colonial and racial ideas of its time. However, my late twentieth-century viewpoint does not allow me to ignore the narrowness of the modernist gaze. Despite the dignity in the photographs of black subjects in many art images, I felt a separation of visual aesthetics from its complex cultures, the spirit from the black body. The distance of time makes obvious the culturally specific, disguised as the universal.

The margins of the Museum intrigued me. I was only able to see them through the installation photographs of past exhibitions. I felt there was a code in these mysterious bits of visual information which said something about the art and the Museum as a whole. Perhaps the importance of beauty, or the unknown, are the factors they are illuminating. Perhaps the artworks allude to the fact that seeing beauty or contemplating the unknown does not necessarily reveal the truth.

This artwork looks at The Museum of Modern Art, particularly the Department of Painting and Sculpture, over its long history. Its title refers to the Museum's tenth anniversary exhibition of 1939. The opening of a new building for the Museum that year was an event that President Franklin Delano Roosevelt touted as an emblem of democracy, saying in a radio address: "In encouraging the creation and enjoyment of beautiful things we are furthering democracy itself. That is why this museum is a citadel of civilization." With idealistic fervor, the modern aesthetic was exported and promoted around the world through traveling exhibitions. Perhaps the locus of modernist art and thinking, the Museum has focused on refining and simplifying its display spaces to reflect contemporary notions about the primacy of looking. But what is it seeing? Was modernism pointing to the "other" without accepting "otherness?" Was modernism the "colored" filter through which all of us now see? Is the only way to see a world beyond modernism through startling acts?

Is our reliance on seeing making us blind to other ways of understanding ourselves, our cultures, and those of others? Could the way we see and the studied act of looking be only a partial view: a beautiful, tantalizing, satisfying view, perhaps, but very narrowly defined? I question this view—so pervasive, persuasive, and accepted—that the possibility of this being only the tip of the iceberg of perception is totally unthinkable and unthought. When we step back and view *Art in Our Time* from the vantage point of our own time, we see how tied its curators were to their time and, by extension, how we are tied to ours. We see, by looking back, how invisible the present can be.

Fred Wilson

Fred Wilson
Art in Our Time. 1998
Wall installation of 18 black-and-white photographs (3 shown), dimensions variable (approx.) 12 x 20' (365 x 609 cm)
Collection the artist and Metro Pictures

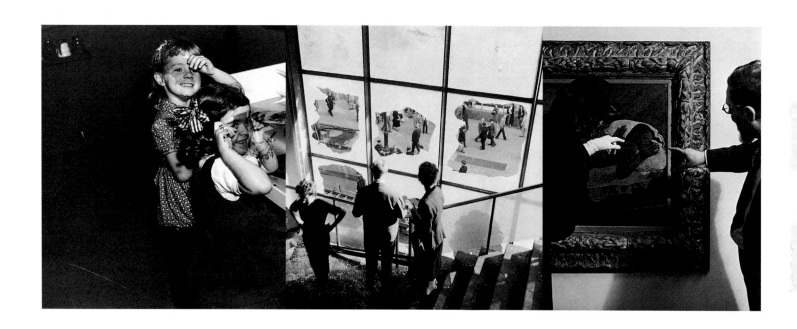

Jac Leirner's process is about amassing things and endlessly organizing them into works of art. But her particular brand of compulsive collecting has little to do with the search for the rare and the best. For over ten years, she has held on to leftovers: objects destined for the wastebasket, which she rescued from imminent disposal. "I deal with a lot of things that share the fact that they cannot be found in the market. These are things that are apparently worthless, and I use them in the same way I would use a 'virgin' material. The difference is that they come impregnated with a former life."[1] Leirner's work is often made of materials that, in their former life, were involved with exchange, as in the case of devalued bank notes, business cards, shopping bags, and used envelopes. These objects are born to circulate; their primary mission is to end up elsewhere. Leirner has said that she does not actively search for a material to work with. It insinuates itself by its insistent recurrence in her life. So the material inevitably carries an element of her biography, as a discreet index of where she has been and whom she has met, and of her recurring activities and habits. Acting as repositories of everyday memory, these souvenirs testify to the artist's experience, and are then reinserted, transmuted by an artistic operation, into the world of circulation. Because of the accumulation stage, time is central to Leirner's work. The date attributed to each piece is actually a span, incorporating both the accumulation period and the maturation required in the studio until Leirner settles on the final form.

Much of Leirner's accumulating is directed toward museum-made articles: not the merchandise available in museum shops but the residue of its activities. Leirner's museum-related work differs substantially from that of artists who, during the 1970s and 1980s, were concerned with the critique of the institution. Artists such as Hans Haacke, Daniel Buren, and Michael Asher directed their attention toward high-minded subjects such as ethics and politics, all in capital letters, and their reflections on museological display. Instead, Leirner focuses on the institution's "lowly protocols"[2]: its bureaucratic processes, its exhibition production details, and its appeal to consumerism. In this way, she draws attention to the trail of signs of the museum's pedestrian, mundane activities.

One such work is *To and From (Museum of Modern Art, Oxford)* of 1990, for which Leirner requested that the museum keep all the envelopes of its incoming correspondence for ten months (a similar work was later made for the Walker Art Center). She then sorted the envelopes by formal quality, such as size, type, or color. The rearrangement of these envelopes—spent containers of everything from invoices and contracts to anxiety and hope—into vertical alignments resulted in a series of floor works. Tracing uncertainly sloping geometries, these volumes literally embodied the museum's bureau-cratic life, while discreetly concealing the identity of the senders.

For another series, Leirner laid claim to museum graphics, including past exhibition labels. Her exhibition at the Walker Art Center in Minneapolis in 1991 dedicated one wall to the display of labels representing the Walker's entire permanent collection. Three horizontal bands corresponded, respectively, to the museum's paintings, sculptures, and drawings (Leirner used blanks to fill the space where a category had ended). Taken individually, the exhibition label, displayed in its rightful place, replaces the artwork, though its promotion from accessory to stand-in guarantees its continued subservience. Taken as a whole, the concept suggests a curatorial point for all-inclusiveness.

The plastic shopping bags Leirner accumulated for years eventually took the form of an environment, a significant change of scale for her work. Installed at the 1989 Bienal Internacional de São Paulo, the first piece in this series comprised four walls padded with sewn bags that were stuffed with polyester foam, forming a gridlike panorama of familiar brand names, attention-grabbing logos, and bright colors; each individual bag was virtually indiscernible within the busy display of flashy information. The series, titled *Names*, is perhaps closest to painting of any of Leirner's works, and was later typically developed into smaller, more focused works that mirrored her continuing examination of the material and the affinities she detected among the affiliations. One outcome of this parsing process is *Names (Museums)*, a series of variations of wall and floor pieces composed solely of museum shopping bags; others are *Identicals*, a two-part work made from the same bags, and *Swimming Pool*, featuring only blue plastic bags. Among the most austere is a wall piece in which several bags featuring the logo of the Frankfurt Art Fair are displayed in an upward semicircular arrangement forming a solid blue wave on white ground, reminiscent of hard-edged abstractions.

In the above appropriations of museum leftovers, Leirner's brand of recycling reached a paroxysm of success. As she pointed out several years ago: "Art and institution live in partnership, since the site of art history is precisely the institution: the museum, the art foundation, the centers of culture. And what drives art is precisely its history. In the case of the works using plastic bags from museum shops, there is a circular movement in this direction. The bag leaves the museum as consumer packaging and returns as art, the reason for the place's existence."[3] These humble bags leave the museum through the back door, deformed by the weight of their temporarily more valuable contents—knick-knacks ranging from "signature" mugs to paintings made into scarves—only to return by the front door, sewn-together and pressed into higher service.

Lilian Tone

Jac Leirner
Names (Museums). 1989–92
Plastic bags, polyester foam, and buckram, 9' 7" x 9' 7 ¾" (292 x 294 cm)
Collection The Bohen Foundation

Andrea Fraser

(American, born 1965)

An Artist's Statement

Sigmund Freud ended a paper called "The Dynamics of the Transference" with this statement: "In the last resort no one can be slain *in absentia* or *in effigie*."

My investment in site specificity is defined by this idea. My engagement in institutional critique follows from the fact that, as an artist, I locate my activity at the sites of art and academic institutions. Psychoanalysis largely defines my conception of those sites as sets of relations, although I think of those relations as social and economic as well as subjective. And psychoanalysis also defines, largely, what is for me both a practical and an ethical imperative to work site specifically.

The practical imperative is well represented by this statement of Freud's. If one considers practice—that is, critical practice, counter-practice—as the transformations of social, subjective, or economic relations, the best, and perhaps only, point of engagement is with those relations in their enactment. The point is not to interpret those relations, as they exist elsewhere, the point is to change them.

Freud might say, the point is not to repeat or reproduce those relations, but to try to free oneself and others from them, with an intervention—an intervention that may include an interpretation, but the effectivity of which is limited to the things made actual and manifest in the particular site of its operation. This limit also defines the ethical dimension of site specificity.

"No one can be slain *in absentia* or *in effigie*."

Freud is certainly writing of himself in this statement, or rather, of the position of the analyst, who is authorized, by the institutions of psychoanalysis and of medicine, to be called upon to execute the functions of authority from which his or her patients suffer: the authority to represent them, to represent their histories, their future, their wants, their appropriate demands, the criteria according to which they might see themselves as acceptable.

[Jacques] Lacan wrote that Freud "recognized at once that the principle of his power lay there . . . but also that this power gave him a way out of the problem only on the condition that he did not use it."

The limit imposed by the ethics of psychoanalysis to the things made "actual and manifest" in the site of its operation is thus, first, a limit on the uses to which this power can be put, as any appeal to an outside would not only reproduce it but extend its field of authority; and second, a limit imposed on the analyst to the position determined within that site, as any attempt at displacement would only obscure it.

This is simply how I would like to understand artistic practice, as counterpractice within the field of cultural production.

The relations I might want to transform may be relations in which I feel myself to be a victim or a perpetrator. The ethical dimension of the imperative of site specificity, however, pertains entirely to my status as a perpetrator, that is, of the agency and authority accorded me as a producer, and as the subject of discourse, by the institutions in which I function. So when it comes to institutional critique, I am the institution's representative and the agent of its reproduction I am the enemy. And I cannot be slain in absentia, in effigy.

I am an artist. As an artist my basic function is the relatively autonomous and specialized production of bourgeois domestic culture, or beyond that, if I refuse to produce objects that can be appropriated materially, the production of the discourse and practices that surround that culture.

Museums abstract this culture from its social location. The primary operation of art museums is the turning of bourgeois domestic culture and specialized artistic culture into public culture. And the induction of those not predisposed to this culture into the habits and manners of its appropriation is what constitutes the public education that defines museums as educational institutions. It is also the mechanism through which the cultural dispositions acquired in economic privilege are imposed, in the public sphere and thus across the social field, as exclusively legitimate cultural competencies.

Museums accord me, and other individuals of recognized competence, an exclusive prerogative to produce culture and discourse, to possess legitimate cultural opinion.

While museums in some cases appropriate objects, I produce objects for them. They privilege this latter group—those works produced within their

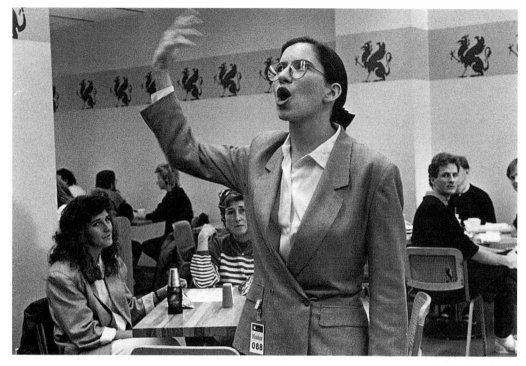

Andrea Fraser
Museum Highlights: A Gallery Talk.
1989
Video, approx. 29 minutes
Collection the artist

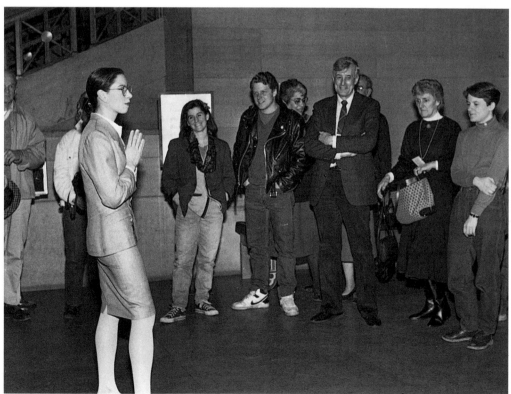

privileged discourse, which directly accords that discourse its authority to describe them. These are the objects produced as the common culture of the subjects of this discourse; the domestic culture of the patrons who appropriate them materially; the more or less professional culture of the patrons who appropriate them materially; and the more or less professional culture of the class, defined by educational capital, that appropriates them symbolically. A struggle between these, domestic and scholastic learning of culture and the modes of appropriation they privilege, is internal to most art museums. It's played out between the voluntary sector of a museum (its patrons and board of trustees) and the professional staff. While the former group is clearly the locus of economic power in museums, I would say that it is the struggle between these two sectors that constitutes the museum's discourse, the conditions of its reproduction, and the mechanism of its power. This is not only because professionals, in a competition to impose their mode of appropriation, take bourgeois domestic culture as their stake, investing in this privileged cultural capital and thereby increase its value. It is because this competition constitutes the discourse of museums as a discourse of affirmation and negation, putting the culture it presents into play within a system of differentiated consumption that represents and objectifies the class hierarchies on which it's based.

The stakes in the struggle between domestic and scholastic relations to culture, as it's played out in art institutions, are not really art objects, or even the dispositions they objectify, but rather the museum's public. It's the recognition by this public that will establish the primacy of those dispositions, and the subjects of them, as that to which this public should aspire.

As an artist I may be situated on one side or the other of this struggle, depending on the mode of appropriation demanded by the objects and services

I produce, and according to where I position myself within an institution.

My rejection of the museum's patron class and the familiar, familial relation to culture that it privileges is expressed in my analysis of institutional discourse. Providing such analysis is what I do as a practitioner of institutional critique. When I conducted gallery talk performances in the past, museum professionals tended to identify with me in this critique, against the museum's voluntary sector—its patrons and trustees but especially the volunteer museum guides whose function I took up. What was being rejected was actually the museum's public, as museum guides represent an extreme effort to satisfy the contradictory and impossible demands the museum addresses to that public. The training they receive from the museum professionals is usually limited to particular museum collections, and leaves the docent without the means to generate a legitimate opinion independently of the institution. And while, as volunteers, they invest their bodies and time in an effort to attain the effortless elegance of the high level patron, for lack of economic and familial cultural capital they continuously and necessarily fall short.

I stopped producing gallery talk performances, or at least posing as a museum guide in doing so. While I have the means to identify with museum guides— being a woman, an autodidact, and someone short on economic and objectified familial cultural capital— such an identification remains a misidentification, and a displacement of my status within these institutions. And, like all such displacements, its function is to obscure the relations of domination which these institutions produce and reproduce.

Now I perform as an artist.

As an artist, I may try to situate myself outside of the struggle between the domestic and the scholastic relations to culture. . . .

Andrea Fraser [1]

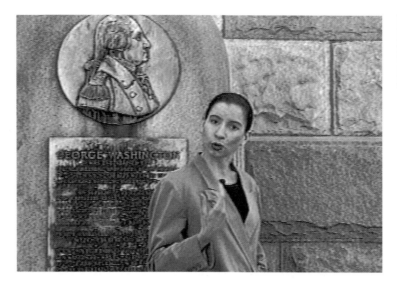

Andrea Fraser
*Welcome to the Wadsworth:
A Museum Tour.* 1991
Video, 25 minutes
Collection the artist

Visitors to museums have much to contend with these days: their journeys are complicated by the fact that art is only one part of an ever-expanding equation that includes gift shops, cafés, sculpture gardens, and fund-raising lotteries. Not only are there more of these visitors than ever before, but the museum itself is insistent on educating them. Didactic panels, tour guides, handouts, and audio guides inundate audiences. While numerous artists have made critical interventions into this defined context, Janet Cardiff takes the audio-guide technology down a diverging path. Instead of critiquing the museum's strategies, the artist's material is the nature of the visit itself and her practice is informed by theater, performance art, and radio. Those wanting to experience her "audio walks" don a CD player and headset; they listen, while strolling, to an unfolding narrative. Cardiff has produced these works for a variety of sites including museum grounds and interiors.

Such sequences often begin with the artist seductively saying, "I want you to walk with me . . . try to follow the sounds of my footsteps so we can stay together." As the disembodied voice continues, it is accompanied by a dense and deliberate mix of voices and sounds that commingle with the frequencies of the site. The headset transmits the ambient noise of the venue—people walking by, a woman speaking very close to you, a deafening gunshot, piercing screams, and someone running by. Cardiff might request that you pay attention to the security guards, and they, as if on cue, might return your passing smile with a watchful eye. This kind of random synchronicity, once a byproduct of the situation, is more and more a distinct characteristic of the walks.

This soundtrack has the ability to subtly transform the immediate area into an ever-changing backdrop for Cardiff's *mise-en-scène*. The artist, whose practice resembles that of a film director's, achieves this kind of cinematic complexity with the lifelike effects of binaural audio. When recording tracks for the audio walks she places miniature microphones in the ears of a person (or sometimes a dummy head) moving through the space so as to resemble the passage of the spectator. Played back on a headset, the prerecorded events sound as good as they did live. As the participant listens, the story is at times in sync with the environment, while at others not so. In the gap between the listeners' reality and the origin of the recorded sound, the work itself performs.

These audio walks make possible private communion with the work of art within the crowded and noisy museums of today. They simultaneously spectacularize and subsume the body of the listener. Those engaged with the work unwittingly become performers who complete the circuit both literally and metaphorically. These silent voyeurs resist the category of the innocent bystander seen in many films; they are more like the walk-on actors, who rarely speak but are crucial to the staging of any scene. They are living reference points, and Cardiff implicates them emotionally. Playing the leading role is the artist, of course, whose signature voice hypnotically invites participation.

Kitty Scott

Janet Cardiff
Chiaroscuro. 1997
Audio, video, sculptural, and
electronic elements
First created for *Present Tense:
Nine Artists in the Nineties*,
San Francisco Museum of
Modern Art, 1997–98
Courtesy Thomas Healy Gallery,
New York

Few things could disrupt the solemn and reverential atmosphere of museums more than the ricocheting violence of the gun battle seen in Gillian Wearing's *Western Security*. For this video installation, commissioned by the Hayward Gallery in London, the artist placed stationary cameras in the upper corners of the empty exhibition rooms at the Hayward—where one would expect to find the museum's security cameras—and filmed goofy gangs of real-life cowboy "wannabes" shooting at each other. Four friends dressed up as museum guards step into the commotion, bundle the leftover "corpses" in bubble wrap, and drag them away from the galleries, reenacting the institution's sanitizing role. Oblivious to their presence, the cowboys, sometimes followed by their women, run back and forth, chasing and shooting at their rivals. "Those white spaces usually command such respect, and I like the complete disrespect of it. How many times have you been to a gallery and had pure fun? It's always very contrived fun. . . . Galleries will always do that, there's no way you can actually break that down."[1] The footage, totaling thirty minutes, is screened in black and white on a grid of nine monitors, each displaying a different gallery, much in the way museums' own surveillance systems work. A tenth monitor, placed nearby, shows a series of steps leading to the basement of the building where the artist, in costume, plays the role of captured heroine, gagged and roped to a chair, with museum crates visible in the background.

Western Security overturns general notions of museums as safe and aloof environments by introducing the acting out of fiction, violence, and fantasy. And, by mimicking museum equipment—the cameras and monitors of the institution's own security apparatus—the work places the museum's own tools at the service of the general public. In Wearing's transformation of the museum space into a vast theatrical set, the protagonists are not actors but amateur Western enthusiasts, whose home is not the rural Midwest of the United States, but densely urban South London. Wearing's fascination with their bizarre obsession dovetails with her recurring interest in social misfits. "The cowboys notched up something that to a certain extent society would frown upon, and yet they've done it. I like people who go outside what we perceive to be normal."[2]

Western Security departs from Wearing's other work by being heavily and atypically dependent on its site; it demonstrates her effective command of space by activating the entire building in one sweep. But it shares other aspects of her work, such as a direct technical simplicity, a documentary, nonjudgmental camera, and a certain uneasiness in the Magritte-like juxtaposition of elements at odds with one another (murderous cowboys in a museum, adults speaking with children's voices, silent dancing, air-guitar concerts). It is also characteristic of Wearing's approach to oscillate between documentation and fiction, combining, within the same gesture, actors with people talking about their real selves. While Wearing so often turns the viewer into a voyeur in her works, exposing people's fantasies and hidden secrets, in *Western Security* she projects the viewer into the control booth, assuming the institution's privileged, omnipresent point of view. As an unwitting accomplice, the viewer is the only one to witness the whole, though everything is presented fragmentarily, as it appears to a guard monitoring the array of screens.

The French poet Paul Valéry said that in museums one speaks louder than in church, yet softer than in real life. Likewise, in *Western Security*, Wearing speaks to our expected behavior within the museum space, our tacit etiquette: "I wanted to do something anarchic in this amazing labyrinth where we are normally so well behaved."[3] By undermining the composure of the museum gallery with a sense of comedy and danger, laughter and slaughter, Wearing makes the viewer acutely aware of the formality of its environment, and, ultimately, its discontinuity with real life.

Lilian Tone

Gillian Wearing
Western Security. 1995
Video installation: 10 monitors,
each 10 x 17" (25.4 x 43.1 cm)
Courtesy Maureen Paley/Interim
Art, London

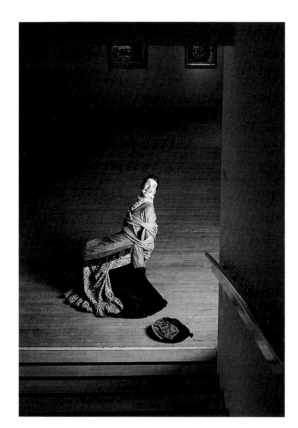

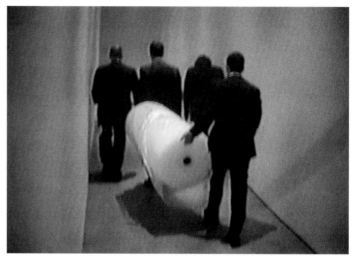

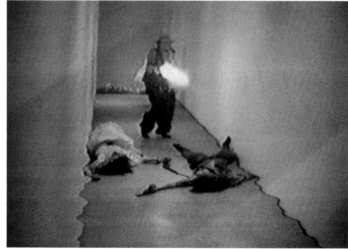

Vito Acconci's *Service Area* and *Proximity Piece*, both of 1970, can be situated within the expanding aesthetic environment of the late 1960s and early 1970s, in which protoconceptual forms—body art, performance, Happenings, street works, and mail art—not only tested established definitions of the art object but also rechanneled its location, altering the nature of exhibition space. For Acconci, who had begun his career in 1964 as a poet and a writer, the changing artistic terrain of the period offered undeniable interest. Through rigorously logical and analytical exercises, he was gradually working away from the space of the literary page and the play of language over that page to actual physical activities, performed in "real" space. The terms *language* and *page* gave way to body and space in a series of performance "situations" and "exercises" executed from 1968 through 1971.

In these works, Acconci performed a sequence of basic activities—for example, running in place, stepping on and off a stool, or rubbing his arm—attempting to catalogue the body's physical and motor capacities in or on its new-found spatial "ground." In other pieces, Acconci sounded his relations with one or more individuals in interactive situations, performed equally before audiences and in private. All works from this period were recorded in photographs. In this manner, Acconci made use of the camera's inherent ability to transform private acts into public information, accessible to multiple distribution channels, permitting the artist to enter the distribution system of art.

For Acconci, the exhibition space of the museum represented an institutional space that was different from, but related to, the space of the literary institution with its various "little magazines" and publications. Both *Service Area* and *Proximity Piece* were performed in museums, and both invoke the contemporary idea of system, conceived as a large distribution network or as a smaller, independent system that the artist could penetrate and manipulate. In the former work, presented in The Museum of Modern Art's *Information* exhibition in summer 1970, Acconci had his mail forwarded to the Museum for three months, thereby transforming the exhibition space into a mailbox and annexing the postal service to art. The normal services of the Museum guards were extended to those of "mail guards," protecting against the federal offense of mail theft. Here the evident material components of the artwork—a plastic table, plexiglass box, calendar, and accumulated mail—are secondary to the activity and conceptual activity that circumscribe them. Acconci traveled to and from the Museum daily by subway to inspect and collect his mail. In this manner, a public institutional space was employed for private ends, and a personal activity ("picking up my mail") performed in a socially visible arena. Although *Service Area* depended on contemporaneous prototypes such as mail art, it extended the use of systems further by making the New York City transit system a necessary component of the work. Thus, the exhibition space required for performing the work became a kind of extended apartment, reached through distribution and transportation systems, vitally transforming the museum concept.

In subsequent comments Acconci described the gallery as employed in this and other works as an "exchange point" or a "transaction area," rather than "a place for a perceiver." The traditional view of the museum gallery as a space for the individual delectation of artworks is replaced by a perspective based on activity and interchange. *Proximity Piece*, executed during The Jewish Museum's *Software* exhibition, shortly following *Information*, interrogated the private space of the individual perceiver and the "system" linking the artwork and the viewer. Throughout the exhibition period, the artist walked from room to room, moving close to different viewers attempting to penetrate the boundaries of their personal spaces. *Proximity Piece* made use of the notions of "region," "boundary," and "power field" as defined by the psychologist Kurt Lewin, who conceptualized the "space" of psychological activity in terms of the interrelationships of different regions. In the context of the museum exhibition, the individual and inviolate space of the viewer is subjected to pressure, discomfort, and invasion, as force is exerted by Acconci on the boundaries surrounding the space of observation. The institutional parameters of the museum are thus destabilized by Acconci's assault on one of its underlying premises—the individual observer—and the security of aesthetic perception is threatened by the pressure of social activity.

Kate Linker [1]

Vito Acconci
Proximity Piece. 1970
Performance
Vito Acconci performing *Proximity
Piece*, at the exhibition *Software*,
The Jewish Museum, 1970

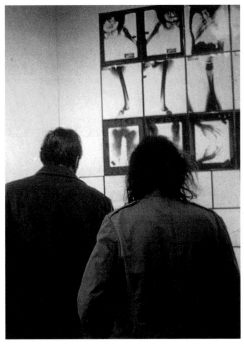

Proximity Piece: Standing near a person and intruding on his/her personal space.

During the exhibition, sometime each day, I wander through the museum and pick out, at random, a visitor to one of the exhibits: I'm standing beside that person, or behind, closer than the accustomed distance. I crowd the person until he/she moves away or until he/she moves me out of the way.

(Attached to the wall, in the midst of the other exhibits, a 3 x 5" index card notes the activity and describes it as above; the card might or might not be noticed by a viewer passing by.)

Notes: Performance as absorption (reduction of the status of a move when payment for it is no longer automatic but is dependent on decisions made at the end of the game, or before the game is begun). • Performer as environment (the other performer adapts to that environment): performance as resemblance, camouflage (recognizing self from non-self). • Performance as operational mode: preference pattern of the opponent (utility function). • Performer as a regulator/performer as conformer. • Performance as non-integral organization/performance as directive correlation. • Performance as double assessment: A's assessment of the situation when B tries to penetrate that assessment (A knowing all the while that it has as one of its features the fact that B will try to penetrate it). (A performance can consist of a series of conditional avowals, where one performer will pursue a given course of action if the other party engages, or does not engage, in another course of action.) • A photograph of the piece—a photo of a crowding incident—would store the specific responses to a specific agent (the nonspecific responses—the alarm

signals which indicate merely activity—being dependent on, and limited to, the live performance). • Moving. (Intransitive: clear space.) Moving into something—which becomes, inevitably, "moving something." (Transitive: cluttered space.) • Performance as loss of focus (we're too close to each other to focus on each other). • Performance as blur (get your face out of my face—he shook his fist in my face—he can't face me, he can only feel me as the space he's been forced into). • Flexibility/rigidity. Availability/virtual indifference. Saturation/insufficiency. • Tenacious performance (I'm clinging to the viewer; I won't lose the viewer; the viewer can't move away). • Elastic performance (I'm moving with the viewer as the viewer shifts around; I'm bending with the viewer in order to keep at the viewer). • Self-determinative performance (my decision is to make my place; the viewer is incidental; the viewer happens to be in the way). (Or, vice versa: the viewer clings to me; the viewer won't lose me.) • Agglutinative performance. Participative performance. Adjunctive performance. Subjective performance. Complemental performance. • Groupings of performers according to the way they can be produced by, or derived from, one another: performance as the step-by-step production of performers. • "Performing a person" by bringing that person to a finished state (closing the person in, forcing the person to stay where he/she is, as he/she is). "Performing a person" by accomplishing that person (becoming that person, playing that person's role as he/she moves out of his/her role and I stay in). (1970)

Additional Notes (1972): Reasons to move: move to a point, move in order to make a still point (if someone is there, I have to keep that person from getting away from the point, missing the point).

Service Area: During the *Information* exhibition, my mail is forwarded by the post office to the Museum. My space in the show functions as my mailbox: an open plastic box is fixed to the top of a table. When my mail is delivered to the Museum, the Museum staff deposits it in my mailbox.

Whenever I want my mail, whenever I need my mail, I go to the Museum to get it. (On a calendar attached to the wall, above the table, I mark off the dates and times of pick-up.)

Notes, 1: The Museum guard is transformed into a mail guard; the Museum guard's normal services are reused now to guard against a federal offense. • The piece is performed, unawares, by the postal service, and by whoever is sending me mail. • Museum= rarefied-space/isolation-box/home-for-museum pieces. (In order to justify having a piece in a museum, I have to connect museum space to my everyday-life space.) • The Museum is treated not as a display (exhibition) area but as a place that provides services: since I've been granted a space in the show, I should be able to use that space for my own purposes, make that space part of my normal life.

Notes, 2: Performance as a day-to-day role (picking up mail): performing that role in a different style. • Performing here means reacting to stimuli (wanting or needing my mail, fearing that my mail might be stolen). • Perform=Anti-form. Performing the piece means going against a form (the materials decreased as I pick up my mail). If I don't perform, the material builds up (the mail increases) while I'm at rest. Left alone, the mail seeks equilibrium, which would be reached at the end of the exhibition (all the mail piled together in one place: saturation). • Living on the land. (Farmers.) Living off the land. (Nomads.) (Skimming; scanning.) Accessibility (availability) of person: artist on exhibit, required to act because of everyday living, wherever he/she may happen to be at the time. • Performer as producer, going from step to step (linear). Performer as consumer, with agencies converging on the performer (radial). • Performance as channel: finding the pathway of a change by removing one station at a time and checking whether the changes persist in the other stations. • What is in place at the Museum is "out of place" (the mail doesn't belong there, it's there only so that it won't be there in the future, after I pick it up). (1970)

Additional Notes (1972): Reasons to move: performing a space by making it available, for my use—making myself available, by my use of the space, to a viewer (unwitting moves/my moves are not oriented to an observer's assessment/information as side-effect). • Reasons to move: adapt to a circulation route (get on track—keep to the track—go through a point, go by point after point).

Vito Acconci

Turning On Different Parts of the Brain

(A) Reading activates part of the visual cortex in the back of the brain.

(B) Listening to speech makes the auditory cortex light up.

(C) Thinking about words makes Broca's area — the articulation center — light up.

(D) Thinking about words and speaking generates widespread activity.

A B

C D

FINISHED FILES ARE
THE RESULT OF YEARS
OF SCIENTIFIC STUDY
COMBINED WITH THE
YEARS OF EXPERIENCE

How Many F's Are in This Sentence?

Most people say four. They skip the F's in the word *of* because the brain processes short familiar words as a single whole symbol instead of breaking them down into smaller units as they do with longer or less familiar words. Thus they don't immediately recognize that there are six F's. The two types of words are probably processed in different parts of the brain.

AR!

HERE IS

TIVE.

T MAKES
GAIN!"

GEOFFREY RUSH COLIN FIRTH BEN AFFLECK AND JUDI DENCH

PEARE IN LOVE

www.miramax.com

SOUNDTRACK AVAILABLE ON: SONY

MIRAMAX

AND AT
THEATRES
EVERYWHERE

MIRAMAX BOOKS

QUEENS

LESSER
• KEW GARDENS
CINEMAS
KEW GARDENS 441-9835

• LOEWS ELMWOOD
THEATRE
ELMHURST #733
777-FILM #733

W CINEMAS
LY TWIN
4 6TH AVE 777-FILM #603
B 600, 9:00

CRISP AND DELICIOUS!"
—DAVID ANSEN, NEWSWEEK

The Winslow Boy

A NEW FILM FROM THE DIRECTOR OF "THE SPANISH PRISONER"

A DAVID MAMET FILM

www.sonyclassics.com

SONY PICTURES

MANHATTAN

LINCOLN PLAZA CINEMAS
63RD ST. & B'WAY 757-2280
ADV. TICKET SALES
777-FILM #740
11:10, 1:15, 3:30, 5:55, 8:10, 10:20

LOEWS KIPS BAY
THEATRE
2ND AVE. & 32ND ST.
50-LOEWS #558
11:45, 2:50, 6:00, 9:00, 12:00AM

UNITED ARTISTS
UNION SQUARE 14
13TH ST. & BROADWAY
777-FILM #777
10:30, 1:15, 3:45, 6:15, 8:50, 11:30

SUFFOLK

CINEMA ARTS
CENTRE
HUNTINGTON
423-FILM

WEST

ACKERM
FINE A
SCARSD
723-6899

Vito Acconci
Service Area. 1970
Performance and installation:
table, clear plexiglass container,
and wall text.
Vito Acconci performing *Service
Area*, at the exhibition *Information*,
The Museum of Modern Art,
New York, 1970

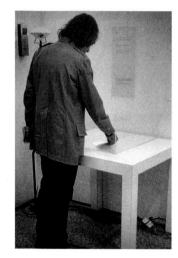

General Idea

(AA Bronson, Canadian, born 1946;
Felix Partz, Canadian, 1945–1994;
Jorge Zontal, Italian, 1944–1994)

The *Boutique* was one of a number of museum-based projects by General Idea conceived as fragments of the *1984 Miss General Idea Pavillion*, a decentralized museum, which would ultimately consist of various installations in museum collections around the world, collectively forming their own independent museum structure unrelated to the museums that would house them. We conceived and announced this project in 1971, our intention being to complete it by 1984, but we were still creating new rooms for the pavilion as late as 1987.

We planned the *Boutique* in the form of a dollar sign, inspired by a typical postwar advertisement we found in *Fortune* magazine, which proposed a sculpture of a dollar sign as a symbol of progress, a cultural concept that was clearly empty of meaning and waiting for inhabitation. In the late 1980s, with the collapse of the dollar and the rise of the yen, we felt compelled to build a new version of the *Boutique* in the form of a yen sign. However, it is the original dollar-sign version that remains true to the heart of the museum concept, which is, after all, an outgrowth of the concept of progress itself. The unparalleled expansionist activities of the museum world in the last years are simulacra of possibilities in the global political arena that no longer exist: in a sense, the museum today plays the part of the war game for the corporate board member, its primary player.

The *Boutique* offers "for sale" a selection of early General Idea publications and multiples, chosen from over two hundred we ultimately produced, which ranged from the handprinted ephemera of the late 1960s and early 1970s to the sterling-silver AIDS ring completed only after the deaths of my two partners, Jorge and Felix, in 1994. The *Boutique* proposes those products as a collective work, which they are, a collective work grouped around the twin ideas of distribution and display (hence consumerism) and initially inspired by Andy Warhol, Joseph Beuys, and the International Situationists. We were very much children of the 1960s.

We conceived of the *Boutique*, then, as General Idea's museum shop. We were obsessed with the structure of the art world, which we found reflected in the structure of the museum world: the restaurant and the shop, for example, are integral aspects of the museum concept, which we noted are played down, even ignored, in any discussion of the museum. And of course the consumable art souvenir, the silk scarf printed with a Mondrian painting, is at the very heart of the museum concept, a fact we all know so well, but we conveniently look the other way. We could say it is the very act of looking the other way, presumably toward the art object itself, that defines the museum experience; it is that experience we set out to explore in *The Boutique from the 1984 Miss General Idea Pavillion*.

AA Bronson

General Idea
The Boutique from the 1984 Miss General Idea Pavillion. 1980
Galvanized metal and plexiglass, containing various General Idea multiples, prints, posters, and publications, overall 60 ½" x 11' 1 ½" x 8' 6" (153.7 x 339.1 x 259.1 cm)
Art Gallery of Ontario, Toronto. Gift of Sandra L. Simpson
Installation view, Carmen Lamanna Gallery, Toronto, 1980

Larry Fink
(American, born 1941)

Larry Fink
The Metropolitan Museum of Art,
New York, Costume Ball.
December 1995
Gelatin silver print, 14 ⅝ x 14 ⅝"
(37.1 x 37.1 cm)
Collection the artist

Larry Fink
*The Metropolitan Museum of Art,
New York, Costume Ball.*
December 1995
Gelatin silver print, 14 ⅝ x 14 ⅝"
(37.1 x 37.1 cm)
Collection the artist

Larry Fink
*Benefit, The Museum of Modern Art,
New York*. June 1977
Gelatin silver print, 14 1/16 x 14"
(35.8 x 35.6 cm)
The Museum of Modern Art,
New York. Gift of the photographer

Larry Fink
*The Metropolitan Museum of Art,
New York, Costume Ball.*
December 1995
Gelatin silver print, 14 ⅝ x 14 ⅝"
(37.1 x 37.1 cm)
Collection the artist

Larry Fink
*Benefit, The Corcoran Gallery of
Art, Washington, D.C.* February
1975
Gelatin silver print, 14 x 14"
(35.6 x 35.6 cm)
Collection the artist

Larry Fink
*The Corcoran Gallery of Art,
Washington, D.C.* May 1975
Gelatin silver print, 17 x 14 ⅝"
(43.1 x 37.1 cm)
Collection the artist

Garry Winogrand

(American, 1928–1984)

Garry Winogrand
*Opening, Alexander Calder
Exhibition, The Museum of
Modern Art, New York.* 1969
Gelatin silver print, 10 ⅝ x 15 ¹³⁄₁₆"
(27.1 x 40.3 cm)
The Museum of Modern Art,
New York. Purchase

Garry Winogrand
Opening, Frank Stella Exhibition,
The Museum of Modern Art,
New York. 1970
Gelatin silver print, 10 ⅝ x 15 ⅞"
(27.1 x 40.5 cm)
The Museum of Modern Art,
New York. Purchase and Gift of
Barbara Schwartz in memory
of Eugene M. Schwartz

Garry Winogrand
Tenth Anniversary Party,
Guggenheim Museum, New York.
1970
Gelatin silver print, 10 ⅝ x 15 ⅞"
(27.1 x 40.3 cm)
The Museum of Modern Art,
New York. Purchase and Gift of
Barbara Schwartz in memory
of Eugene M. Schwartz

Garry Winogrand
Opening, Frank Stella Exhibition,
The Museum of Modern Art,
New York. 1970
Gelatin silver print, sheet 14 x 17"
(35.6 x 43.2 cm)
Courtesy Fraenkel Gallery,
San Francisco

Garry Winogrand
*Tenth Anniversary Party,
Guggenheim Museum, New York.*
1970
Gelatin silver print, sheet 14 x 17"
(35.6 x 43.2 cm)
Courtesy Fraenkel Gallery,
San Francisco

Garry Winogrand
Untitled, from the series *Women
Are Beautiful*. Before 1975
Gelatin silver print, 8 ¾ x 13"
(22.2 x 33.1 cm)
The Museum of Modern Art,
New York. Gift of Mitchell Deutsch

Komar and Melamid

(Vitaly Komar, American, born Russia 1943;
Alexander Melamid, American, born Russia 1945)

Komar and Melamid
*Scenes from the Future: The
Guggenheim Museum.* 1975
Oil on Masonite, 15 ¾ x 12"
(40 x 30 cm)
Collection Bente Hirsch

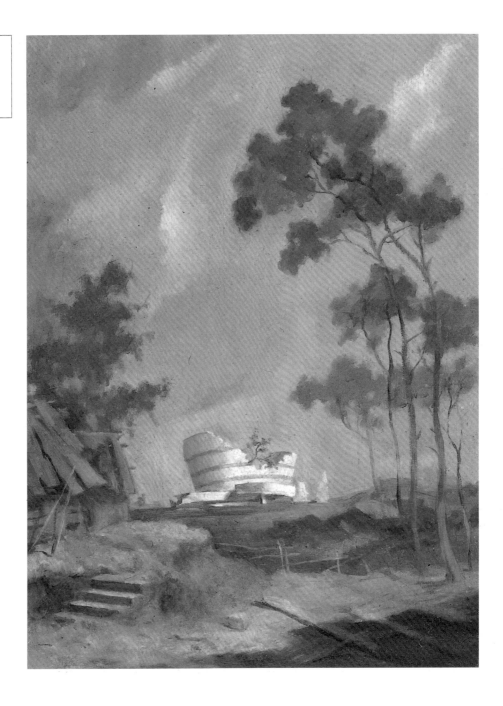

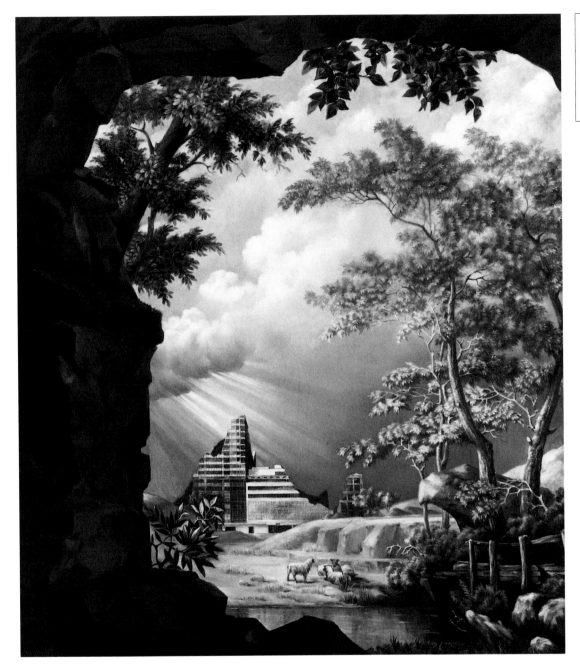

Komar and Melamid
Scenes from the Future: The Museum of Modern Art. 1983–84
Oil on canvas, 6' x 63" (182.9 x 160 cm)
Collection Cindy and Alan Lewin, courtesy Ronald Feldman Fine Arts, New York

In its Los Angeles debut, Edward Ruscha's deadpan critique of timeless, modernist, civic virtue, *The Los Angeles County Museum on Fire*, was announced to the public with a sense of historical urgency. As Frederick Church once offered his exotic landscapes of Uruguay to the citizens of nineteenth-century New York, Ruscha's painting ("three years in the making") was offered to twentieth-century Angelenos as a public spectacle, as the latest intimation of the dreaded and much anticipated apocalypse. A Western Union Telegram from the Irving Blum Gallery on North La Cienega Boulevard informed its patrons: THE GALLERY OPENS AN EXHIBITION BY EDWARD RUSCHA, FEATURING A NEW PAINTING TITLED "L.A. COUNTY MUSEUM ON FIRE," ON TUESDAY, JANUARY 30, 1968 STOP LOS ANGELES FIRE MARSHALL SAYS HE WILL ATTEND STOP SEE THE MOST CONTROVERSIAL PAINT-ING TO BE SHOWN IN LOS ANGELES IN OUR TIME STOP.

In the gallery, Ruscha's painting, accompanied by preparatory and ancillary drawings, was exhibited behind a velvet rope, as if to keep the crowds away—as if new paintings, like new movies, were still a matter of lively public interest. So the irony was perfect and neither cheap nor ineffective. At this resolutely historical moment, replete with riots, festivals, wars, fads, and assassinations, the inference of Ruscha's painting, as it was presented, couldn't have been clearer: were it not for the transcendent isolation of art practice imposed by institutions like the Los Angeles County Museum, art and artists might participate in this urgent social cacophony as they once did. And, in fact, by portraying the modern museum—the putative "heaven" for works of art at that historical moment—as a combina-tion hell and Bastille, Ruscha's painting doubtless contributed, for worse or glory, to the reformation of such institutions over the inter-vening thirty years. A museum exhibiting a painting of a museum on fire is, after all (and almost by definition), a more self-critical institu-tion than one without such an image.

Within the body of Ruscha's work, *The Los Angeles County Museum on Fire* marks the culmination of a series of paintings he began with *Trademark with Eight Spotlights* (1962) and *Standard Station, Amarillo, Texas* (1963). Impressed by Jasper Johns's ability to make figu-rative paintings that are not pictures by painting visual ideas—targets, flags, words, and numbers that have analogs, but no "originals," in the phenomenal world, Ruscha began painting a series of lexical icons whose ontological status was commensurate with the weightless, size-less, placeless domain of Western pictorial space. Unlike Johns's paint-ings, then, Ruscha's lexical icons are, in fact, pictures. Their illusionism derives from the format of the painting, but they do not picture objects in the phenomenal world. Rather, they portray icons in lin-guistic space that reference *classes* of objects in the world—as words in a dictionary reference classes of objects in the world and reflexively invest them with cultural meaning.

Like Johns's Flags and Targets, Ruscha's lexical icons have no "actual" size. They take their size from the size of the painting and (with the exception of the museum painting) derive their illusions from the hard diagonal within its rectangle. Ruscha's 20th Century-Fox trademarks, his Standard Stations, his Wonder Bread drawing, and his painting of Norms Restaurant are all based on this simple graphic device. *The Los Angeles County Museum on Fire*, however, though equally "fitted" into the rectangle and driven by its diagonals, does have an atmosphere, a linguistic one. For this image, Ruscha appropriated the horizonless "bubble" space that Leonardo invented for the *Mona Lisa* to create an enclosed pictorial atmosphere. John Everett Millais adapted this space for his *Ophelia* to make his drowned heroine seem to float, and Ruscha exploits Millais's effect, in *The Los Angeles County Museum on Fire* and numerous other paintings, to invest his generalized icons with a palpable and slightly ominous atmospheric presence while insisting upon their conceptual weightlessness and placelessness.

All of Ruscha's lexical icons, then, are generalizations. They have undergone a linguistic apotheosis that the artist insists upon by select-ing subjects whose names betray the procedure. His Standard Stations have been *standardized*: his painting of Norms Restaurant has been *nor-malized*: his drawing of Wonder Bread, invested by the *word*, is replete with metaphysical wonder (the reference here is to the Eucharist). In a slightly different way, Ruscha insisted on the generality of *The Los Angeles County Museum on Fire* by painting, not the museum itself, but a decontextualized architectural rendering of it—a modernist idea of a museum. Ruscha's concern in these pictures, however, is not purely with making pictures of things that can be properly pictured, as Johns sought to make paintings of images that could be properly figured.

Ruscha is ultimately concerned with the reflexive function of word making, with the manner in which the word, created to describe the world in its general configuration, reimposes its mystical generality upon the contingent particulars of the physical reality it describes. He is interested in the process through which the Standard Station becomes not just a "standardized" station, but a station that dispenses standards—through which Norms Restaurant becomes, not just a "normalized" restaurant, but a site upon which norms are *served* and *imposed*, just as the Los Angeles County Museum imposes and dispenses both norms and standards. Ruscha's appraisal of this regulatory linguistic function may be inferred from the fact that, in his paintings, he has set all three of the administrative icons on fire, portrayed them in conflagration, subject to the very emblem of contingent flux, destruction, and renewal. We may take the text for this iconography, I think, from a later painting of Ruscha's titled *Mean as Hell* (1979), since, taken as a trilogy, *The Los Angeles County Museum on Fire* (1965–68), *Burning Gas Station* (1964–66) and *Norms, La Cienega, on Fire* (1964) all construct the mean as hell, and infer that artistic grace lies elsewhere, in the physical com-plexity of the material, historical world.

Dave Hickey

Edward Ruscha
*The Los Angeles County Museum
on Fire.* 1965–68
Oil on canvas, 53 ½" x 11' 1 ½"
(135.9 x 339.1 cm)
Hirshhorn Museum and
Sculpture Garden, Smithsonian
Institution, Washington, D.C.
Gift of Joseph H. Hirshhorn, 1972

Hubert Robert

(French, 1733–1808)

Hubert Robert
*Projet d'Aménagement de la
Grande Galerie du Louvre*
(*Refurbishment Project of the
Grande Galerie of the Louvre*).
1796
Oil on canvas, 3' 9 ¼" x 4' 9 ¹⁄₁₆"
(115 x 145 cm)
Réunion des Musées nationaux,
Musée du Louvre, Paris

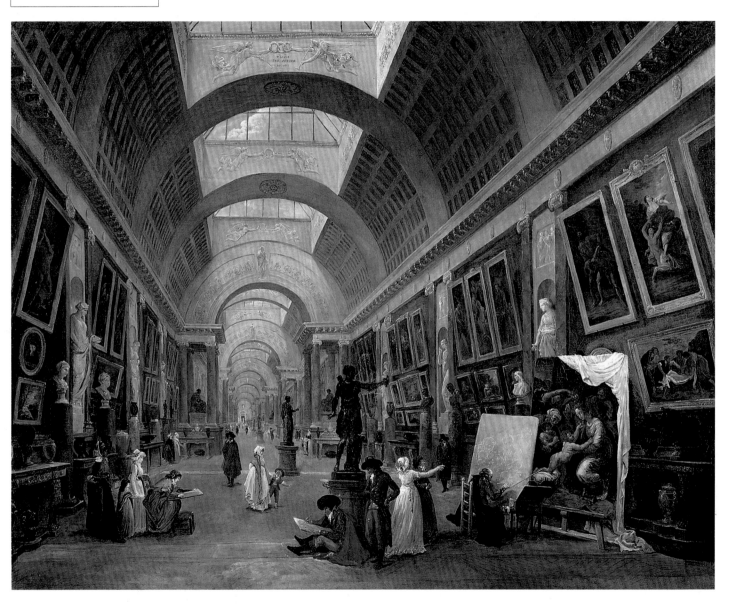

Hubert Robert
Vue Imaginaire de la Grande Galerie en ruines (Imaginary View of the Grand Galerie in Ruins).
1796
Oil on canvas, 3' 9 $\frac{1}{16}$" x 4' 9 $\frac{1}{2}$"
(114.5 x 146 cm)
Réunion des Musées nationaux, Musée du Louvre, Paris

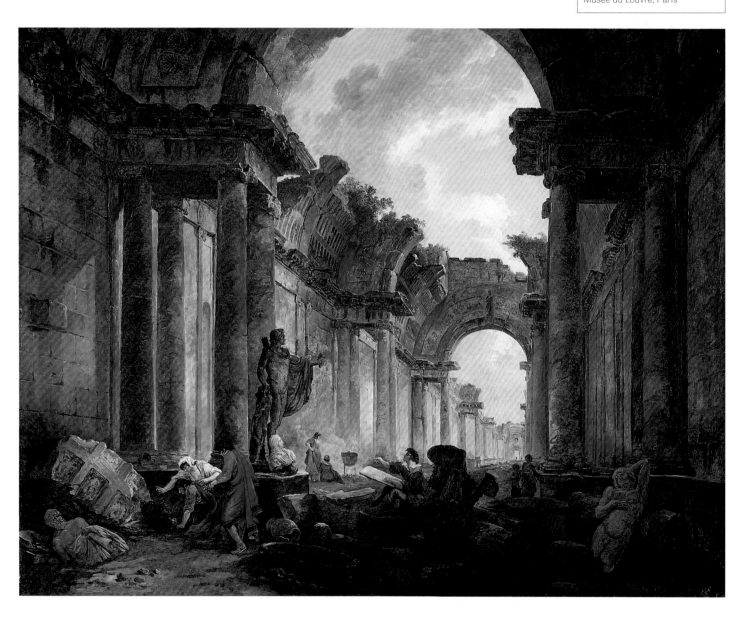

Born in Paris in 1733, Hubert Robert lived in Italy from 1754 to 1765, where he developed the art that would establish his fame in France: landscapes of ruins in a sentimental and decorative style. Upon his return to Paris, he was admitted to the Academy of Painting and Sculpture as an architectural painter. He went on to paint numerous, mostly imaginary, Italian landscapes, along with views of Parisian scenery and architecture, the most notable of which are the representations of the Louvre, executed between 1780 and 1805.

The Louvre was at the time the official center of artistic life, the seat of the Academy, where the public came to admire the works that were exhibited every two years in the *Salon Carré* by artists of the Academy (the Salon). The idea of installing the royal collection in the Louvre's *Grande Galerie* and opening it for the enjoyment of the public was born shortly before 1750, but it was only in 1776 that the project began to receive serious consideration thanks to the personal initiative of the superintendent of the king's buildings, the Count of Angiviller (1730–1809). The installation, painstakingly planned under Louis XVI, was only carried out during the French Revolution. On August 10, 1793, the royal castle took on its present-day role and the Louvre Museum was born. Robert took an active part in the elaboration of the creation of the Louvre as a public museum: he lived in the Louvre itself, painted scenes of it, and from 1784 to 1792 and again from 1795 to 1802, was in charge of the collection and its arrangement.

In April 1778, the Count of Angiviller appointed Robert, as a representative of the Academy of Painting and Sculpture, to a committee charged with a study of the arrangement of the *Grande Galerie*. The mandate for Robert's post of *Garde du Musoeum* (literally, Keeper of the Museum) clearly specified that the king retained him as "one of the keepers of his paintings, statues, vases, etc. . . ." Robert should, in fact, be considered the first "curator" of the Louvre. He assumed all the tasks associated with a curator's function: inventory of the collection, acquisitions, supervision of restoration, and participation in the refurbishment of the building (as is reflected in his paintings).

It is not known when Robert ceased to perform his function as *Garde* of the museum; it is probable that he continued to carry out his activities, to a certain extent, until the fall of the royalty, when he too fell out of favor. At the time the Louvre opened as a public museum, Robert was not part of its organizing body. In October 1792 he was arrested by a Surveillance Committee set up by the Revolutionaries and was imprisoned for eight months. By 1795, however, he was called back to the Louvre as his services were required to accelerate the implementation of plans for the museum; he carried on his duties until 1802.

Rarely have painters taken the Louvre as their subject. Exterior views of the Louvre, mostly topographical in nature, are known since the fifteenth century. However, interior views of the building are practically nonexistent until the time of the Revolution. At the Salon of 1796, Robert exhibited an important painting of the Louvre's interior expressing his desire to see the *Grande Galerie* divided into bays with a skylight in the vaulted ceiling. In this period, the gallery was a long hallway with neither divisions nor décor, dimly lighted by narrow windows. The painting that Robert exhibited at the Salon of 1796, *Projet d'Aménagement de la Grande Galerie du Louvre* (*Refurbishment Project of the Grande Galerie of the Louvre*) of 1796, carried an evocative title borrowed from architectural language. At the time of the exhibition of this painting, basic refurbishment of the *Grande Galerie* had been undertaken. Robert proposed more elaborate renovations, calling for the division of the gallery into at least seven bays by a discreet system of "serliennes," niches surrounded by ionic pilasters, heavy architraves, and, surrounding the skylight, a coffered, vaulted ceiling.

In his painting *Refurbishment Project of the Grande Galerie of the Louvre*, a copyist (Robert himself) works in front of Raphael's *Holy Family*. On the wall to the right, in the first bay are Guido Reni's *Nessus Abducting Deianeira*, Reni's *Hercules and Achelous*, and Titian's *The Entombment*. At the Salon of 1796, critical opinion about the painting was divided. Critics revisited the reproaches that had been addressed at Robert during the previous thirty years: lack of finish and lack of respect for the laws of perspective.

At the same Salon, Robert exhibited a startling painting, *Vue Imaginaire de la Grande Galerie en ruines* (*Imaginary View of the Grand Galerie in Ruins*) also of 1796. This type of painting earned him the nickname "Robert of the Ruins." Most of the ruins he depicted were those of reality—buildings from antiquity or modern buildings in the course of destruction—or were those of an imaginary past: "pseudo-antique" scenes. Rarely were they of a utopian realm. Perhaps the artist shared Diderot's sentiment: "It is necessary to ruin a palace to make it an interesting object."[1]

Robert conceived *Imaginary View of the Grand Galerie in Ruins* as a pendant to his painting *Refurbishment Project of the Grande Galerie of the Louvre*, scrupulously copying the same architectural elements but skillfully changing his point of view. In the latter painting, the *Apollo Belvedere* is used as a counterpoint to Raphael's *Holy Family*. Robert creates an opposition between the antique masterpiece and the modern masterpiece that presides in all of his pendant paintings, in which he unites antique Rome and modern Rome, antique France and modern France. The originality of these two pendant paintings resides in the fact that the artist does not compare here the past and the present, but the near future (the rearrangement of the gallery) and the far future (its destruction by time). Robert seems to want to extend beyond the simple expression of the ephemeral: to shock the spectator by projecting him simultaneously seventeen centuries backward and seventeen centuries forward, to close the circle of life and the death of civilization, and finally to celebrate the enduring nature of Art.

Marie-Catherine Sahut [2]

In terms of genre, my panorama picture, *Restoration*, is like one of those eighteenth-century pictures that depict activity going on in a public building, like a church, where people are carrying on their normal business, as, for example, in a painting by Hubert Robert. The fact that it is the restoration of a picture that is going on in my picture may be secondary. The immediate theme of the picture, its subject, may be secondary. The curious thing about the phenomenon of a genre tradition is that it is a fluid construct that operates regardless of the consciousness of the artist. It is fluid in that it isn't clear whether its constructs can be very strictly defined, its borders easily located.

In *Restoration*, the restorers simulate the preservation of a large-scale panorama [Swiss painter Edouard Castres's *Arrivée de l'armée du général Bourbaki,* 1881, a scene from the Franco-Prussian War] in alarmingly poor condition. I was interested in the massiveness of the task the figures are undertaking. That for me was an important part of the theme. There might be associations of that massiveness with the futility of ever bringing the past into the "now."

I find the contrast between the drama of the vast space of the picture and the almost intimate depiction of the two restorers in the foreground very poetic and very political. One can make gestures that are very intimate and personal in a public scene, and they become sort of models of behavior that function as social models. These women, as restorers, are acting out a kind of conceptual model of what their idea of civilization is like, their idea of a certain valid way of life. I think one of the historical roles of pictorial art was to make images that, in a way, are models of behavior, too. First, they are conceptual models of what a picture should be because every picture can be thought of as a proposal of a model of what a valid picture is. But, also, the behavior of the figures in the picture may be that of models or at least proposals of models, of social behavior, of whatever kind. So, in the panorama picture, the characters are developing and enacting an intimate, meditative relation to a work of art through their practice, their work. This is a kind of statement.

The large panorama is worth preserving for two main reasons. First, it is a beautiful pictorial construction. For its size, it is a very good painting. I have had the opportunity to examine it carefully. Most of it is very nicely painted in its conventional, rather naturalistic style. There are a few bad areas, but I have the impression those are things added later, in botched restorations. Some of the horses in the foreground are not so good. But the atmospheric treatment of the landscape is excellent; there are many good figures and figure groups, very well-handled. The composition is remarkable, and, as a pictorial conception it is, in my opinion, one of the most interesting pictures of the nineteenth century. It should be better known and appreciated than it is. The second reason is the originality of the subject. Edouard Castres (1839–1902) was not a great artist, but he did have one great inspiration: being in the Bourbaki army was the most important experience of his life, something like Stendhal's experience of Napoleon's campaigns. The subject of the defeated army receiving asylum and assistance from the army of another country and from its citizens is very unusual, particularly in a work of this scale. Usually, huge war pictures deal with victory, spectacle, or defeat and not with assistance, sanctuary, and healing.

In the picture under restoration women from the village assist foreign soldiers; in my picture, young women are trying to save the picture itself from deterioration. To be a restorer, you must be in a very complex relationship with the past. Why would young people want to undertake this immense and tedious labor of preservation and repair, to work for such a long time in such a dusty place, so patiently, to preserve a monument which they themselves realize is part of a tradition—a patriarchal tradition—that they are probably battling with in the other aspects of their lives? To place a young woman in such a position is in my view, something very pictorial, and so many restorers are women. In any case, I think there is something striking in the confrontation of a young woman with a monumental painting; that something is evocative, dramatic, what I called "pictorial."

When I was doing dramatic pictures, like *Mimic*, for example, I was interested in a certain type of picture, one I identified with painters like Caravaggio, Velázquez, and Manet. In that type of thing, the figures are in the foreground; they are life-size, they are close to the picture surface, and the tension between them is what is central. Behind them there is space, a background. That is a very traditional kind of picture, I think. But I have gotten interested in other types of pictures, and other types of pictorial space. I have made quite a few pictures that are very differently structured, in which the figures are further away from the picture plane, smaller, and more absorbed in the environment. You could say it's a move from Caravaggio to Vermeer to Brueghel. I am not necessarily interested in different subject matter, but rather in different types of pictures. A different kind of picture is a different way of experiencing the world; it is a different world almost. *Restoration* is more this latter type of picture, which does not require the kind of dramatic intensity of the earlier pieces. It is not a question of doing one or the other, but of opening different paths, and following them simultaneously.

Jeff Wall [1]

Jeff Wall
Restoration. 1993
Cibachrome transparency in
display case illuminated with
multiple florescent light fixtures,
54" x 16' 7 ⅝" (137.1 x 506.9 cm)
Kunstmuseum Luzern

Peale, page 44:
1. Adapted from Susan Stewart, "Death and Life, in that Order, in the Works of Charles Willson Peale" (© copyright 1995 by Dia Center for the Arts), in Lynne Cooke and Peter Wollen, eds., *Visual Display: Culture Beyond Appearances* (Seattle and New York: Bay Press, in association with Dia Center for the Arts, 1995), pp. 32–34, 51–53. Reprinted by permission of the publisher and the author.

El Lissitzky, page 46:
1. El Lissitzky, "Exhibition Rooms" (Typescript in the Niedersächsisches Landesmuseum, Hannover), in *Die Zwanziger Jahre in Hannover* (Hannover, 1962); English translation in Sophie Lissitzky-Küppers, *El Lissitzky: Life–Letters–Texts* (London: Thames and Hudson, 1968), p. 366.
2. Ibid., p. 367.

Duchamp, pages 50, 52, 54:
1. Michel Sanouillet, *Marchand du Sel, écrits de Marcel Duchamp [Salt Seller, Writings of Marcel Duchamp]* (Paris: Le Terrain Vague, 1958).
2. Ibid.
3. Ibid.
4. Marcel Duchamp, interview with James Johnson Sweeney, 1955.
5. "Artist Descending to America," *Time* 60, no. 10 (September 7, 1942), p. 102.
6. Winthrop Sergeant, "One Man Show in a Suitcase," *Life* (April 1952).
7. Duchamp, interview with Sweeney.

Cornell, pages 58–59:
1. "Ballet," Joseph Cornell Papers, Archives of American Art, Smithsonian Institution, New York, reel 1066, frame 1266.
2. Ibid.
3. "Ondine—Fanny Cerrito," Cornell Papers, AAA, reel 1074, frame 0700.
4. Ibid., reel 1074, frame 0703.
5. "Museum Bottles Material," Cornell Papers, AAA, reel 1066, frame 0227.
6. Quoted in Deborah Solomon, *Utopia Parkway: The Life and Work of Joseph Cornell* (New York: Farrar, Straus, Giroux, 1997), p. 175. See also Dore Ashton, *A Joseph Cornell Album* (New York: Viking Press, 1974); repr. DaCapo Press, p. 32.
7. Ibid.
8. Joseph Cornell, *The Romantic Museum: Portraits of Women* (New York: Hugo Gallery, 1946), unpaginated brochure.
9. "Nostalgia of the Sea," Cornell Papers, AAA, reel 1067, frame 0426.

Broodthaers, pages 62–64:
1. Invitation: *"Moi aussi je me suis demandé si je ne pouvais pas vendre quelque chose"* (Brussels: Galerie Saint-Laurent, April 10–25, 1964).
2. Marcel Broodthaers, in *Section Publicité* (Kassel: Documenta 5, June 1972), unpaginated handout.
3. Marcel Broodthaers, "Section des Figures," in *Der Adler vom Oligozän bis Heute* (Düsseldorf: Städtische Kunsthalle, 1972), vol. I, pp. 18–19.
4. Douglas Crimp, "This Is Not a Museum of Art," in *Marcel Broodthaers* (Minneapolis: Walker Art Center; New York: Rizzoli, 1989), p. 79.
5. Marcel Broodthaers, letter (September 7, 1968), repr. in *Marcel Broodthaers* (Paris: Galerie Nationale du Jeu de Paume, 1991), p. 194.
6. Martin Mosebach, "The Castle, the Eagle, and the Secret of the Pictures," in *Marcel Broodthaers*, Walker Art Center, p. 177.
7. Marcel Broodthaers, [Interview with Irmeline Lebeer], in *Catalogue-Catalogus* (Brussels: Palais des Beaux-Arts, 1974).
8. Marcel Broodthaers, [Interview by George Adé], in Maria Gilissen and Benjamin H. D. Buchloh, eds., *Section Publicité du Musée d'Art Moderne, Département des Aigles, Marcel Broodthaers* (New York: Marian Goodman Gallery, 1995), p. 11.
9. See ibid., pp. 9, 87.

Oldenburg, pages 73–75:
1. Adapted from Coosje van Bruggen, *Claes Oldenburg: Mouse Museum/Ray Gun Wing* (Cologne: Museum Ludwig, 1979).

Fluxus, page 83:
1. Quoted in Jon Hendricks, "Introduction to the Exhibition," in *Fluxus: Selections from the Gilbert and Lila Silverman Collection* (New York: The Museum of Modern Art, 1988), p. 21.
2. Barbara Moore, "George Maciunas: A Finger in Fluxus," *Artforum* 21 (October 1982), p. 43.

Oppenheim, page 84:
1. Adapted from Willoughby Sharp, "Discussions with Heizer, Oppenheim, Smithson," *Avalanche* 1 (Fall 1970), p. 4.
2. Adapted from Thomas McEvilley, "The Rightness of Wrongness: Modernism and Its Alter-ego in the Work of Dennis Oppenheim," in Alanna Heiss, *Dennis Oppenheim: Selected Works, 1967–90* (New York: Institute for Contemporary Art, P.S. 1 Museum, in association with Harry N. Abrams, 1992), pp. 17, 20.

Smithson, pages 86, 88:
1. See Eva Schmidt, "Et in Utah Ego: Robert Smithson's 'Entropologic' Cinema," in *Robert Smithson: Drawings from the Estate* (Munster: Westfalisches Landesmuseum für Kunst und Kulturgeschichte Munster, 1989), p. 59; and Gary Shapiro, *Earthwards: Robert Smithson and Art after Babel* (Berkeley: University of California Press, 1995), pp. 8, 13, 242. The passage is taken from *The Most Dangerous Man*.
2. Robert Smithson, "The Spiral Jetty" (1972) in Nancy Holt, ed., *The Writings of Robert Smithson* (New York: New York University Press, 1979), p. 115.
3. Ibid., p. 111.
4. Robert Smithson, "A Cinematic Atopia" (1971) in Holt, *Writings*, p. 108.
5. Smithson, "The Spiral Jetty," p. 111.
6. Robert Smithson, in "Discussions with Heizer, Oppenheim, Smithson" (1970), in Jack Flam, ed., *Robert Smithson: The Collected Writings* (Berkeley: University of California Press, 1996), p. 250.
7. Ibid., p. 249.
8. Robert Smithson, "Interview with Robert Smithson" (1970), in ibid., p. 236.
9. Robert Smithson, "Some Void Thoughts on Museums" (1967), in Holt, *Writings*, p. 58; and "What Is a Museum? A Dialogue between Allan Kaprow and Robert Smithson" (1967), in ibid., p. 60.
10. Robert Smithson, "Fragments of an Interview with P. A. Norvell" (1969), in Flam, *Collected Writings*, p. 195.
11. Robert Smithson, "Fragments of a Conversation" (1969), in ibid., p. 190.

Sugimoto, page 102:
1. Adapted from Thomas Kellein, [On an Interview with Sugimoto], in *Hiroshi Sugimoto: Time Exposed* (Stuttgart: Edition Hansjörg Mayer; New York and London: Thames and Hudson, 1995), pp. 9, 11–12, 13.

Hamilton, pages 110–111:
1. Adapted from Richard Morphet, ed., *Richard Hamilton* (London: Tate Gallery, 1992), p. 162.

Struth, page 116:
1. Adapted from "Interview between Benjamin H. D. Buchloh and Thomas Struth," in *Thomas Struth* (New York: Marian Goodman Gallery, 1990), pp. 29–40. Translated by Sarra Ogger.

Muniz, page 134:
1. Adapted from Vincent Katz, "The Cunning Artificer: An Interview with Vik Muniz," *On Paper* 1, no. 4 (March–April 1997), pp. 30–31.

Calle, pages 136, 138:
1. Sophie Calle, in *Sophie Calle: Proofs* (Hanover, N.H.: Hood Museum of Art, Dartmouth College, 1993), p. 26.
2. Sophie Calle, "Artist's Notes," in Robert Storr, *Dislocations* (New York: The Museum of Modern Art, 1991), p. 49.
3. Ibid.
4. Sophie Calle, in *Absence* (Rotterdam: Museum

Boijmans Van Beuningen Rotterdam, 1994); see also *La Visite guidée* (Rotterdam: Museum Boijmans Van Beuningen Rotterdam, 1996).
5. Robert Beck, "Paranoia by the Dashboard Light: Sophie Calle's and Gregory Shephard's *Double Blind*," *Parkett* 36 (1993), p. 109.

McCollum, pages 144–145:
1. Adapted from "Allan McCollum Interviewed by Gray Watson," *Artscribe* (December 1985–January 1986).
2. Adapted from "Allan McCollum: Interview with Catherine Queloz," *Documents sur l'art* (Spring 1995).

Leirner, page 160:
1. Interview with Gaudêncio Fidelis, on November 3, 1993, in *Jac Leirner* (Porto Alegre, Brazil: Galeria de Arte da Casa de Cultura Mario Quin-

tana, 1994), unpaginated brochure.
2. Lorenzo Mammí, "Jac Leirner," in *Jac Leirner, Waltercio Caldas: XLVII Bienal de Veneza, Representação Brasileira* (São Paulo: Fundação Bienal de São Paulo, 1997), p. 25.
3. Fidelis, Interview.

Fraser, pages 162, 164:
1. Adapted from Andrea Fraser, "An Artist's Statement," in Ine Gevers, ed., *Place Position Presentation Public* (Amsterdam: De Balie, 1998), pp. 61–70.

Wearing, page 168:
1. Gillian Wearing, in Ben Judd, "Gillian Wearing Interviewed," *Untitled* (London) 12 (Winter 1996–97), pp. 4–5.
2. Ibid., p. 5.
3. Gillian Wearing, quoted in Dominic Canvendish, "Gallery Gunslingers on a Shoot to Kill,"

The Independent (September 11, 1995).
Acconci, page 170:
1. Adapted from Kate Linker, *Vito Acconci* (New York: Rizzoli, 1994).

Robert, page 194:
1. Denis Diderot, Salon (1767).
2. Excerpted from Marie-Catherine Sahut, *Le Louvre d'Hubert Robert* (Paris: Éditions de la réunion des musées nationaux, 1979). Translation by Delphine Dannaud and Kristen Erickson.

Wall, page 195:
1. Adapted from Jeff Wall, "Restoration: Interview with Martin Schwander, 1994," in Thierry de Duve et al., *Jeff Wall* (London: Phaidon Press, 1996), pp. 126–139; first published in *Jeff Wall: Restoration* (Lucerne: Kunstmuseum Luzern; Düsseldorf, Kunsthalle, 1994), pp. 22–30.

The following overview of artists' writings and statements attempts to map the frontiers of ambivalence felt by several artists towards museums. While the Futurists, like many after them, called for the outright abolition of museums, other early modern artists, such as Vasily Kandinsky and Aleksandr Rodchenko, envisioned an active role for themselves in museum management. Artists such as Allan Kaprow and Robert Smithson, whose work mainly occurred beyond museum walls, approached the subject in very different terms from Donald Judd, who sought to create an ideal environment, taking upon himself the control of the space and duration of exhibitions. For many artists, the verbal complements the visual, and provides an added dimension to their work; a case in point is the extensive body of writings on this topic by Hans Haacke, Daniel Buren, and Andrea Fraser, for whom the critique of the museum has been a major focus.

The writings and meditations that follow are arranged chronologically and appear, without editorial change, as previously published except that portions of texts have been excised in some cases. For complete texts the reader is referred to the citations that appear at the head of each excerpt. In a few instances, statements are reproduced in facsimile as they originally appeared as posters or handouts.

Filippo Tommaso Marinetti

Filippo Tommaso Marinetti, "The Founding and Manifesto of Futurism" (1909), in R. W. Flint, ed., *Marinetti: Selected Writings*. Translation by R. W. Flint and Arthur A. Coppotelli. New York: Farrar Straus and Giroux, 1971, pp. 41–43. [First published in *Le Figaro* (Paris) (February 20, 1909).]

MANIFESTO OF FUTURISM

1. We intend to sing the love of danger, the habit of energy and fearlessness.

2. Courage, audacity, and revolt will be essential elements of our poetry.

3. Up to now literature has exalted a pensive immobility, ecstasy, and sleep. We intend to exalt aggressive action, a feverish insomnia, the racer's stride, the mortal leap, the punch and the slap.

4. We affirm that the world's magnificence has been enriched by a new beauty; the beauty of speed. A racing car whose hood is adorned with great pipes, like serpents of explosive breath—a roaring car that seems to ride on grapeshot—is more beautiful than the *Victory of Samothrace*.

5. We want to hymn the man at the wheel, who hurls the lance of his spirit across the Earth, along the circle of its orbit.

6. The poet must spend himself with ardour, splendor, and generosity, to swell the enthusiastic fervor of the primordial elements.

7. Except in struggle, there is no more beauty. No work without an aggressive character can be a masterpiece. Poetry must be conceived as a violent attack on unknown forces, to reduce and prostrate them before man.

8. We stand on the last promontory of the centuries!... Why should we look back, when what we want is to break down the mysterious doors of the Impossible? Time and Space died yesterday. We already live in the absolute, because we have created eternal, omnipresent speed.

9. We will glorify war—the world's only hygiene—militarism, patriotism, the destructive gesture of freedom-bringers, beautiful ideas worth dying for, and scorn for woman.

10. We will destroy the museums, libraries, academies of every kind, will fight moralism, feminism, every opportunistic or utilitarian cowardice.

11. We will sing of great crowds excited by work, by pleasure, and by riot; we will sing of the multicoloured, polyphonic tides of revolution in the modern capitals; we will sing of the vibrant nightly fervour of arsenals and shipyards blazing with violent electric moons; greedy railway stations that devour smoke-plumed serpents; factories hung on clouds by the crooked lines of their smoke; bridges that stride the rivers like giant gymnasts, flashing in the sun with a glitter of knives; adventurous steamers that sniff the horizon; deep-chested locomotives whose wheels paw the tracks like the hooves of enormous steel horses bridled by tubing; and the sleek flight of planes whose propellers chatter in the wind like banners and seem to cheer like an enthusiastic crowd.

It is from Italy that we launch through the world this violently upsetting, incendiary manifesto of ours. With it, today, we establish *Futurism*, because we want to free this land from its smelly gangrene of professors, archaeologists, ciceroni, and antiquarians. For too long has Italy been a dealer in secondhand clothes. We mean to free her from the numberless museums that cover her like so many graveyards.

Museums: cemeteries!... Identical, surely, in the sinister promiscuity of so many bodies unknown to one another. Museums: public dormitories where one lies forever beside hated or unknown beings. Museums: absurd abattoirs of painters and sculptors ferociously macerating each other with color-blows and line-blows, the length of the fought-over walls!

That one should make an annual pilgrimage, just as one goes to the graveyard on All Souls' Day—that I grant. That once a year one should leave a floral tribute beneath the *Gioconda*, I grant you that.... But I don't admit that our sorrows, our fragile courage, our morbid restlessness should be given a daily conducted tour through the museums. Why poison ourselves? Why rot?

And what is there to see in an old picture except the laborious

contortions of an artist throwing himself against the barriers that thwart his desire to express his dream completely?... Admiring an old picture is the same as pouring our sensibility into a funerary urn instead of hurling it far off, in violent spasms of action and creation.

Do you, then, wish to waste all your best powers in this eternal and futile worship of the past, from which you emerge fatally exhausted, shrunken, beaten down?

In truth I tell you that daily visits to museums, libraries, and academies (cemeteries of empty exertion, Calvaries of crucified dreams, registries of aborted beginnings!) are, for artists, as damaging as the prolonged supervision by parents of certain young people drunk with their talent and their ambitious wills. When the future is barred to them, the admirable past may be a solace for the ills of the moribund, the sickly, the prisoner.... But we want no part of it, the past, we the young and strong *Futurists*!

So let them come, the gay incendiaries with charred fingers! Here they are! Here they are!... Come on! set fire to the library shelves! Turn aside the canals to flood the museums!... Oh, the joy of seeing the glorious old canvases bobbing adrift on those waters, discolored and shredded!... Take up your pickaxes, your axes and hammers, and wreck, wreck the venerable cities, pitilessly!

Aleksandr Rodchenko

Aleksandr Rodchenko, "Declaration on the Museum Management" (1919), in Selim Omarovich Khan-Magomedov, *Rodchenko: The Complete Work*. Introduction by Vieri Quilici; translation by Huw Evans. Cambridge, Mass.: MIT Press, 1987, p. 288. [First published in *In Izobrazitel'noe iskusstvo (Figurative Art),* no. 1 (1919), p. 85.]

DECLARATION ON THE MUSEUM MANAGEMENT
On 7 September 1919 a special declaration was received by the Board of the Section of Figurative Arts and Production Art concerning the problems of museum management. Among other things, the declaration stated:

The history of all the European museums has shown how the space devoted to the activity of art historians and theorists, who work de facto in the museums (the cultural operators of the museums), is not commensurate with the space reserved for artistic and creative activity (of the painters) ...

It is in the nature of their profession that cultural operators in the museums tend to preserve what has been done, in contrast to the artists who would like to replace the old by the new; since it is the artist who is the creative force in the field of art, it ought to be his task to guide the country's artistic education ...

The old anachronism, whereby the museums are filled with works of modern art chosen by the aforesaid cultural operators, should be done away with. The job of buying modern works is strictly the province of artists....

The artist wants to know about the past of his own profession and must be familiar with it ...

The artist is free to choose from among all the monuments of the past those works which best typify the culture of each type of art.

This culture ... is determined by the creative moment, hence by the moment of invention. Only those works of the past which are indicative in one way or another of a professional or artistic discovery are of interest to the artist.

It should be conceded that: 1) artists, as the only people with a grasp of the problems of contemporary art and as the creators of artistic values, are the only ones capable of directing the acquisition of modern works of art and of establishing how a country should be educated in artistic matters; 2) as professionals who develop their own theories on the basis of worldwide artistic culture, they should have access to the works of art of the past in order to choose, from amongst them all, those which are typical of artistic culture. Once chosen, they should use these to create a *museum of creative artistic culture* which would also serve to promote the artistic life of the country.

Aleksandr Rodchenko

Aleksandr Rodchenko, "Thesis of Rodchenko's Report on the 'Museum of Artistic Culture,'" in Selim Omarovich Khan-Magomedov, *Rodchenko: The Complete Work*. Introduction by Vieri Quilici; translation by Huw Evans. Cambridge, Mass.: MIT Press, 1987, p. 288.

THESIS OF RODCHENKO'S REPORT ON THE "MUSEUM OF ARTISTIC CULTURE"
1. The Museum of Artistic Culture is a collection of works from all the genres of figurative art: painting, sculpture, spatial forms, reliefs, bas-reliefs, three-dimensional works, graphics, artistic production linked to industry, architectural projects, in short everything that testifies to the presence of an artistic culture.

The Museum has the following tasks:
I. To provide a service for State-employed workers in the field of art, i.e. to have a pedagogical aim that is pursued by means of a series of meetings held in the State Workshops on the principles of the Museum of Artistic Culture.

II. To carry out a work of cultural education, consisting in the improvement of existing museums and organizations and, where these do not exist, in the creation of new museums by following the principle of development of artistic form.

2. Both these tasks are equally necessary: the first because it facilitates the creative work of the artist-producer, the second because it predisposes the cultural consumer to observation of works of art and helps him to find his way through the output of art in all its forms and tendencies.

The museums are structured along the lines of a scientific approach to art of a material and professional kind.

The new building will be constructed on the basis of the principle that a museum should document the stages of development of artistic form, and not on the basis of a historical principle, which is exhausted in precise static forms, as happens in the Capitalist countries.

3. The historical museum of the past is only an archive, only a store-house of works, not a museum as maker of culture. It is constructed to serve the ethnographer, the specialist and the amateur. Given its aims, even the old-style historical museum's technique of construction is totally different from that of the new museum.

The selection of works in a historical museum is haphazard, dictated by a subjective standard of aesthetic evaluation of the individual artist, without any analysis of his achievements with respect to the goals that this artist had set himself.

There is no provision for hanging the walls of one room with the works of a single artist, and the only effort of a historical museum lies in getting hold of everything indiscriminately, without making any value judgement about the works.

4. The new museum will be primarily a museum of works and not of artists. The works will have pride of place. They will be selected according to the criteria that they should either reveal the presence of a movement or some future achievement, or indicate the presence of art as a profession.

The first factor might be called the factor of invention. It will be a dynamic principle that will carry art forward, without conceding anything to fragmentation or stagnancy, which favour the development of imitation.

This factor will sweep away unshakable classical *dogmas* and *canons* and get rid of the idea of an *eternal beauty* in Art.

Everything exists in time and space, and so does the work of art, which by passing away smooths and opens up the way to new conquests. The museum will be made up of *living* works which do not yet have a 'historical value' (in the narrow sense of the term).

5. The second factor, the one that concerns the occupation of art, will bring the work of the artist to a professional and scientific level. It will put an end to that absurd orgy of subjective qualitative judgments that make the work into a sort of spiritual gluttony, and which satisfies the refined *greediness* of the consumer who is looking for nothing more than the gratification of his desires.

A museum that sets out to be an organized form of art exhibition, that is, which aims to publicize art, must bear witness to the development plan of artistic form and to the technique of the artist's trade.

In our analysis of the system by which works are selected in the old and new type of museum, we have neglected a very important technical problem: the *display* of the works. In museums which follow the historical principle, the way in which the pictures are displayed, like the choice of the works themselves, is indicative of its special character: that of being an *archive*.

6. According to the criterion of individualistic evaluation of an artist, the problem of how to put the works on show was solved in a very simple manner: the best place was reserved for the most highly esteemed artist; the setting of one artist alongside another was justified by chronological succession.

This was the reason for the sudden leaps and imbalances on the walls which made it so difficult to follow the development of methods in art.

In confirmation of its nature as an *archive*, the habit has grown up in the historical museum of plastering walls with paintings from top to bottom. The physical impossibility of looking at the works of art was not even taken into consideration.

Works considered of secondary importance were either hung at the top or in the darkest parts of the room. The primary concern was to economize on space. The possibility of looking at the works was conditioned by the utilization of the walls of the room. The space between pictures was utilized to the last centimetre, with works hung next to each other, according to size.

7. The aesthetic criterion of how pictures should be hung coincided with the criterion of decoration of the walls, i.e. the picture was used, like any other decorative element of the surroundings, to cover the walls.

The system of display was based on symmetrical distribution of the pictures on the wall, with pictures of the same size being set side by side.

8. The new museum building cannot accept such a superficial criterion, which takes no account whatsoever of the problem of putting a picture on show. Posed in these terms, the problem excludes the economic utilization of a wall.

9. The principle of entirely covering the walls should be totally rejected. The wall no longer has a role of its own and the work of art, being the true protagonist, should not be subordinated to the wall.

Pictures should be hung according to a criterion of choice that reflects the stages of development of artistic form and methods, without reference to chronological order.

What should be taken into account when a painting is hung is not the fame of a given artist but the value of a given phase of development and the quality and technique of a given work.

When a work is hung on the wall it should be given the space needed for it not to impinge on another.

In order to find the right point at which a picture should be hung it is necessary carefully to take into account both the height of those looking at it and the character of the work itself, i.e. whether its pictorial representation is rendered on a large or small scale.

Vasily Kandinsky

Vasily Kandinsky, "The Museum of the Culture of Painting" (1920), in Kenneth C. Lindsay and Peter Vergo, eds., *Kandinsky: Complete Writings on Art*. Translation by Peter Vergo. Vol. I. Boston: G. K. Hall,

1982, pp. 437–444. [First Published in *Khudozhestvennaia Zhizn'* (*Artistic Life*) (Moscow), 1920.]

THE MUSEUM OF THE CULTURE OF PAINTING

The usual approach to museum organization, an approach that is well-established everywhere (i.e., in Russia as well as abroad), is a historical one. Museums divide art up into period after period, century after century, regardless of whether one period has any relation to another, apart from that of historical sequence. Thus, the usual type of museum is reminiscent of some chronicle that draws its thread from one event to the next, without seeking to penetrate their inner meaning. Such art historical museums have a definite value as a treasury of artistic production that can serve as the raw material for different kinds of research and exposition. But the evident deficiency of this kind of museum is, in general, its lack of any guiding principle or system.

In this respect, the Department of Fine Arts has decided to embark on a new path in setting up museums, making a definite principle and system its first priority, in conformity with one general aim.

This one, general aim is our desire to show the development of art not in chronological, chaotic fashion, but on the contrary by giving strict prominence to two aspects of artistic development:

1. New contributions of a purely artistic nature, i.e., the invention, as it were, of new artistic methods.

2. The development of purely artistic forms, independent of their content, i.e., the element, as it were, of craft in art.

This unconventional method of museum organization has been dictated to the Department by the burning desire of our age to democratize generally every aspect of life. This method, opening the doors as it does to the artist's studio, will illuminate with complete clarity that aspect of the artist's activity which, thanks to the way matters were previously arranged (by museums and exhibitions), has remained unknown to the nonspecialist.

For this reason, the task that holds the highest importance for the artist, namely, the study of the technical aspect of his art, has been completely ignored and lost from sight. The general impression that artists, without exception, create somehow mysteriously and naturally; the general ignorance of the artist's need to struggle painstakingly with the purely material aspect of his work, with technique—all this has placed the artist, as it were, above and beyond the conditions that determine the life of the working man. The artist has appeared pampered by fortune, habitually living in luxury, a law unto himself, creating at his leisure objects of value, and being rewarded for them by all the benefits life has to offer.

Whereas, in fact, the artist works doubly hard: (1) he himself must be the inventor of his own art, and (2) he had to master the techniques necessary for him. His importance in the history of art can be measured by the extent to which he possesses these two qualities.

Illuminating the activity of the artist from this point of view, which has long remained shrouded in obscurity, reveals the new image of the artist as a worker who, by a combination of genius and toil, creates works of real value, and demonstrates his definitive right to take, at the very least, equal place among the ranks of the working population.

This same viewpoint gives the broad masses an accurate insight into art as the result of labor, no less essential for life in general than any other kind of creative work, and not as a mere adjunct of life, with which, *in extremis*, society could equally well dispense.

These will be the natural results of the museums brought to life by the Department [of Fine Arts], to say nothing of their constant value in illuminating fully the history of art, i.e., for the scholar, but also for artists themselves, for whom these museums must function as strict and fertile schools.

This principle was first elaborated last year at the conference held in Petrograd (see at greater length *Art of the Commune* and *Proceedings of the Petrograd Department of Fine Arts*), in which members of the Moscow and Petrograd Departments of Fine Arts took part, as well as staff of the Moscow and Petrograd museums. After a series of papers from the Departments of Fine Arts and some heated discussion, the museum principle outlined was accepted by the conference, and a resolution was adopted designating such museums Museums of the Culture of Painting. The following took an active part in putting into practice the principles of the Departments of Fine Arts: D. Shterenberg, N. Punin, O. Brik, Grishenko, and Chekhonin.

Immediately after the conference, the college of the Moscow Department selected from its midst a Purchasing Commission, which proceeded to acquire for the general state reserve a whole series of works of painting and sculpture. Following upon which, a special commission was selected from the college for the purpose of organizing the Museum of the Culture of Painting. This commission, having established the general basis for setting up the museum, chose about a hundred pictures from the total number of works acquired for the state reserve, leaving the remaining works in the reserves for provincial museums to draw upon, in response to the provinces' continual demands for both the further development of existing museums and the foundation of new ones.

The Museums Commission has defined the character and aim of the Museums of the Culture of Painting as follows:

"The Museum of the Culture of Painting shall have as its goal to represent the different stages of purely pictorial attainment, pictorial methods, and resources in all their fullness, as expressed in the paintings of all periods and peoples."

Methods that have enriched the resources of pictorial expression, solutions to the problem of the correlation of color-tones, the correlation between the color-tone and the application of color, compositional methods—i.e., the building up of the whole composition and of its individual parts, their treatment, the overall *facture* and structure of parts, *etc.*—these are examples of the criteria that shall determine the acquisition of works by the museum.

It follows from this that the Museum of the Culture of Painting will not try to show in its entirety the work of any one artist, nor to trace the development of the above problems solely in any one period or country, but will show, independently of any trends, only those works which introduce new methods. In this manner, the Museum of the Culture of Painting is distinguished by its definite approach to the question of evaluating the products of different epochs: it will classify the historical development of painting from the point of view of the conquest of the material, both real and ideal, as a purely pictorial phenomenon. In this way the Museum, having set itself purely technical-professional objectives, will at the same time be seen as indispensable for the masses, who until this time have never in any country had a collection capable of opening the way to this branch of painting, without which the complete understanding of art is unthinkable.

Being of the view that museums and repositories of art in the Russian Republic should contribute from their own resources to the general state reserves, the Department has taken steps to obtain from the Moscow collections of Western European art those works which are regarded as essential for the Museum of the Culture of Painting and which, at the same time, can be removed from these collections without detracting from their scope and effectiveness.

To this end, the Museums Department and the Department of Fine Arts have established a Commission for [Public] Contacts. The Museums Department, in accordance with the principle and the necessity of the Museum of the Culture of Painting, has agreed that a series of works by French artists should be selected from collections of Western European art (principally from the galleries of Shchukin and Morozov). For this purpose, pictures by Braque, van Gogh, Gauguin, Derain, Le Fauconnier, Matisse, Manet, Monet, Picasso, Pissarro, Rousseau, Renoir, Cézanne, Signac, Vlaminck, and Friesz were chosen.

Developing further the principles upon which the Museum of the Culture of Painting is to be constructed, and bearing in mind the aim outlined above, namely, that the Museum should reflect the technical side of the artist's craft, the Museums Commission adopted the following resolution:

"The Commission for the organization of the Museum of the Culture of Painting considers it essential for its work that a section for [the study of] experimental techniques in painting should be established."

The materialistic-realistic trend in painting in the nineteenth century, in general bound up with excessive enthusiasm for materialistic systems in science, morals, literature, music, and other areas of spiritual life, severed all connection with the purely pictorial methods of previous ages. The thread leading from antiquity to modern times was broken. The major preoccupation of all art—composition—was, from the point of view of artistic resources, pushed into the background by materialistic-realistic aims: pictorial composition was to be derived from nature. Deprived of this, its most important foundation, painting ceased to be an autonomous art of expression and became instead an art of representation: all the painter's skills were directed exclusively toward the depiction, the almost mechanical rendering of natural phenomena. It was evidently from the middle of the nineteenth century onward that European artists, under the influence mainly of Japanese prints, began to realize that painting had embarked on a life, not of independence, but of mere imitation: all that remained was a mere soulless semblance.

From this moment dates the beginning of the striving to create the so-called new art, which is nothing other than the organic continuation of the growth of art in general.

The distinctive characteristic of the art of painting is its striving to clothe pictorial content in pictorial form. The emergence of this striving has given such prominence to the question of form that in many cases it has come to be seen as the one essential problem in painting. Despite the one-sidedness of this attitude, and apart from certain damaging temporal consequences, it has brought to formal refinement a tension that provides art with a powerful arsenal of expressive means. The fruitfulness of these discoveries—of inventions as one says today—needs no further proof.

The Museum of the Culture of Painting will display from its own resources a collection of works of art based on painterly principles—painterly content and painterly form. Thus, there will be no room for works of purely and exclusively formal value. Such works must still be collected, however, both as a testimony and monument to one particular artistic attitude of our day, and as a stimulus for the production of further formal discoveries. The enrichment of the means of pictorial expression will be the first consequence of this proposed section.

In connection with this, it will be necessary to make experiments, starting with formal construction and going all the way through to questions of technique in the completely specialized sense of the word, i.e., ending up with different kinds of treatment of the ground. These are all the different trials of the resources of pictorial expression that must flow from the hand of the experimenting artist. In this way, there will be no place here for canvases, brushes, colors, or other instruments that have not been treated by the artist himself. Only if they have been prepared by the artist's own hand must these material means find a place in the collection. Further, it is the task of the Department to collect all essential and significant experiments with the treatment of raw materials, *facture*. Finally, for the purposes of comparison, there must be room for experiments with formal construction, according to the principle of juxtaposition: the colored surface and the linear surface; the correspondence, collision, dissolution of surfaces; the correspondence between surface and volume; the handling of surface and volume as self-sufficient elements; the coincidence or divergence of linear or painterly surfaces or volumes; attempts to create purely volumetric forms, either in isolation or in combination, etc. It is, of course, difficult to draw an exact line between an experiment and a work of art, inasmuch as a carefully thought-out experiment may become a work of art, while a carefully

calculated work of art may fail to transcend the boundaries of the experimental. The possibility of error in drawing this line, however, and an unavoidable degree of subjectivity in the evaluation of a given work should not constitute a hindrance to beginning to assemble a collection of specifically experimental techniques.

Any such mistakes will be corrected by the lapse of time, and by the burning necessity to create, slowly but surely, a theory of painting.

Thus, the second result of this section of experimental techniques will be to accelerate and facilitate the development of a theory of painting we can sense even today.

In Petrograd, the purchase of works of art for the museums will be carried out by a commission for acquisitions, consisting of members of the Department of Fine Arts, of the Museums Department, and professional organizations. They will acquire works representative of every tendency in art, starting with the realists of the second half of the nineteenth century: didactic painting (Repin, the two Makovskys, Kustodiev, etc.), painterly Naturalism, Neo-Academicism, Retrospectivism; then Impressionism, Neo-Impressionism, and Expressionism, whence begins contemporary painting, or what is called the new art (whose point of departure is, historically speaking, the work of Cézanne): Primitivism, Cubism, Simultaneity, Orphism, Suprematism, Nonobjective Creation, and the transition from painting to the new plastic art—relief and counter-relief.

In this way, the Departments of both capital cities have given an unprecedented breadth and freedom to the matter of museums. The professional museum directors have distinguished themselves by unwarranted caution in the formation of their museums, fearing every new movement in art, and recognizing it as a rule not at the moment of its blossoming (except in rare cases), but only at the moment it begins to wither and decay. One encounters this practice especially in the state museums of the West. In this respect, the artistically more significant countries—France and Germany—may serve as an instructive example of how the state usually not only fails to encourage any new movement, but places in the way of any newly developing, powerful idea in art every means of obstruction the state has at its disposal. Thus, everything new in art, its immeasurable value being with time generally accepted and understood by all nonspecialists, has either had to surmount these officially devised obstacles, or else pursue its path in spite of the state, receiving more or less accidental, capricious, and arbitrary support from the private sector.

Exceptions have been so rare that they have been perceived as an entire revolution and are indelibly imprinted upon one's memory. The agents of the state who have resolved to go against the routine tendency in museum affairs have had to possess heroic qualities of personal bravery, energy, tenaciousness, and finally, self-sacrifice, for they have brought down on their heads the wrath not only of the government, but of every basest representative of public opinion—especially the press.

Thus, in Berlin occurred the battle between Tschudi, the director of the Prussian Museums, and Wilhelm. This battle concluded with (1) the private donation of the pictures by the great French masters in the National Gallery, the purchase of which had not been authorized by Wilhelm or his servile committee for acquisitions; (2) the dismissal of Tschudi; and (3) the first collective protest against this dismissal by the hitherto loyal student body. This battle exerted an enormous influence upon the conduct of museums in Germany, bringing in its train two consequences: (1) the organization of a succession of private and profoundly significant museums in several quite small centers (Barmen, Hagen, Elberfeld, Krefeld), and (2) the emergence of a new type of young museum director who modeled himself after Tschudi. Thus, thanks to this one powerful man's selfless, independent love of art occurred a serious change in direction in one of the most important areas of public life.

In this respect, Russia offers an unparalleled example of state organization of museums. The definite principle of the Museum of the Culture of Painting; its complete freedom to establish the right of every innovator in art to seek and to receive official recognition; encouragement and adequate reward—these are the unparalleled attainments in the field of museum affairs that have been achieved by the Fine Arts Commission of the People's Commissariat of Enlightenment. And if the Department has had the practical opportunity of bringing these principles to life, then it is thanks to the Commissar of Enlightenment himself, A. V. Lunacharsky.

Le Corbusier

Le Corbusier, "Other Icons: The Museums" (1925), in Le Corbusier, *The Decorative Art of Today*. Translation by James I. Dunnett. Cambridge, Mass.: MIT Press, 1987, pp. 15–23. [First published in Le Corbusier, *L'Art décoratif d'aujourd'hui*. Paris: Editions Crès, 1925.]

There are good museums, and bad. Then there are those with the good and bad together. But the museum is a sacred entity which debars judgement.

The birth of the museum: 100 years ago; the age of humanity: 40 or 400,000 years.

To see your happy smile, dear lady, as you say 'My daughter is at the museum', you would appear to feel you are one of the pillars of the world!

The museums are a recent invention; once there were none. So let us admit that they are not a fundamental component of human life like bread, drink, religion, orthography.

True enough, there is good in the museums; but let us risk a devastating deduction: the museum allows one to reject it all, because once the full story is known, it becomes clear that everything has its time and place and that nothing from the past is directly of use to us. For our life on this world is a path on which we can never retrace our steps. This is so clear that I can conclude with an immutable law: in their tendentious incoherence, the museums provide no model; they offer only the elements of judgement. The strong in spirit always get out of them, they

understand and recognize the poison, and the opiate does not interest them; they see clearly, and do not slide pitifully down the precipice.

But should social reality be considered only in terms of the strong in spirit? It is a dangerous limitation. The phenomenon of nature manifests itself in the form of a pyramid, a hierarchy: at the summit there are the aces; lower down in ever-increasing waves, those of less excellent, inferior quality. The ratio is quickly evident: for every 10 units of height there is a singe example of excellence at the summit and 100 of middling or mediocre quality at the bottom; for 100 units of height there are 10 of excellence at the top and 10,000 mediocrities at the bottom, etc., and the space in between is occupied by the mass of intermediate quality. Those at the top are supported there by the presence of the lower levels, graded in ascending order.

The pyramid expresses a hierarchy. Hierarchy is the organisational law of the world, both natural and human.

So it is important to consider whether the museums help or hinder appreciation of the principle of hierarchical gradation.

THE MUSEUM REVEALS THE FULL STORY, AND IT IS THEREFORE GOOD: IT ALLOWS ONE TO CHOOSE, TO ACCEPT OR REJECT.

Let us imagine a true museum, one that contained everything, one that could present a complete picture after the passage of time, after the destruction by time (and how well it knows how to destroy! so well, so completely, that almost nothing remains except objects of great show, of great vanity, of great fancy, which always survive disasters, testifying to vanity's indestructible powers of survival). In order to flesh out our idea, let us put together a museum of our own day with objects of our own day; to begin:

A plain jacket, a bowler hat, a well-made shoe. An electric light bulb with bayonet fixing; a radiator, a table cloth of fine white linen; our everyday drinking glasses, and bottles of various shapes (Champagne, Bordeaux) in which we keep our Mercurey, our Graves, or simply our *ordinaire* … A number of bentwood chairs with caned seats like those invented by Thonet of Vienna, which are so practical that we use them ourselves as much as do our employees. We will install in the museum a bathroom with its enamelled bath, its china bidet, its wash-basin, and its glittering taps of copper or nickel. We will put in an Innovation suitcase and a Roneo filing cabinet with its printed index cards, tabulated, numbered, perforated, and indented, which will show that in the twentieth century we have learnt how to classify. We will also put in those fine leather armchairs of the types developed by Maples: beneath them we might place a label saying: 'These armchairs, invented at the beginning of the XXth century, were a real innovation in the art of furniture design; furthermore, they were a good example of intelligent research into comfort: but at that time what was done best was not yet what was most highly prized; bizarre and expensive furniture was still preferred which constituted an index of all the kinds of carving and colouring that had graced the more showy furni-

ture of earlier epochs.' In this section of the museum we would have no hesitation in displaying other labels explaining that all objects on exhibition had performed some real function; in this way one would come to appreciate a new phenomenon characteristic of this period, namely that the objects of utility used by the rich and by the poor were not very different from one another, and varied only in their finish and quality of manufacture.

Clearly, this museum does not yet exist. Such a museum would be truly dependable and honest; its value would lie in the choice that it offered, whether to approve or reject; it would allow one to understand the reasons why things were as they were and would be a stimulant to improve on them.

Tourists on their way to climb Vesuvius sometimes stop in the museums of Pompeii and Naples, and there they eagerly look at the sarcophagi incrusted with ornament.

But Pompeii, as a result of a miraculous event, constitutes the single true museum worthy of the name. To confirm its value for the education of the masses, one can only hope to see the immediate establishment of a second Pompeian museum, of the modern epoch: societies have already been formed for this purpose; they have put together the displays in the Pavillon de Marsan, the museum of contemporary decorative arts; there they certainly give some indication of the present century, but it is only partial and fragmentary. The inhabitant of another planet who suddenly landed there would be more likely to think he was at Charenton.[*]

THE MUSEUM IS BAD BECAUSE IT DOES NOT TELL THE WHOLE STORY. IT MISLEADS, IT DISSIMULATES, IT DELUDES. IT IS A LIAR.

The objects that are put in the showcases of our museums are sanctified by this fact: they are said to be collectable, to be rare and precious—valuable, and therefore beautiful. They are pronounced beautiful and held up as models, and thus is established that fatal chain of ideas and their consequences. Where do they come from? From the churches, ever since these espoused magnificence to dazzle, impress, attract, and impose respect for an omnipotent deity. God was in the gold and in the carving; He had failed to keep an appointment with St. Francis of Assisi and, many centuries later, had still not come down into the suburbs of our 'tentacle cities'.

These objects also came from the palaces and country houses: to impress, astound, appease the gaudy Punch who jerks somewhere in us all and whom culture catches, ties up and muzzles. We feel very indulgent towards the distant past; we are full of indulgence and very ready to find everything good and beautiful, we who afterwards are so critical of the disinterested and passionate efforts of our contemporaries. We forget too easily that bad taste was not born yesterday; without extensive research, but simply by sticking one's nose into a few old tomes from the eighteenth century, one can become well aware that even at that time people of good taste and position were continually

protesting against the profligacy of the arts and crafts, and against the manufacturers of rubbish.

At the Bibliotèque Nationale there is valuable evidence of the decadence that has sometimes been rife, for example: *Fashionable Architecture, Including the Latest Designs for the Decoration of Buildings and Gardens, by the Best Architects, Sculptors, Gardeners, Locksmiths, etc., at Paris, published by Langlois.*

And also *Designs for Various Ornaments and Mouldings, Antique and Modern, Suitable for Architecture, Painting, Sculpture, Goldsmithing, Embroidery, Marquetry, Damask, Joinery, Locksmithing and Other Arts, with the Name of Each Ornament.*

There, engraved on copper, are the most revealing ornaments, the most useless knick-knacks which the Faubourg Saint-Antoine has been able to produce; their date is 1700–1750, Louis XIV–Louis XV.

A Book of Mirrors, Tables and Pedestal-tables designed by Le pautre, A Book of Scroll Ornaments Newly Designed and Engraved by Jean d'Olivar and sold in Paris by Langlois, with the Authority of the King.

Among the chimney-pieces of imitation marble and pier glasses of gilt icing sugar, some have angels, some crowns, some medallions, etc.

What a collection to send the world of its time to sleep! It makes one feel that the bourgeois must date from before the Revolution. The utter lack of taste is stupefying.

In addition there are twenty plates, each one with about thirty friezes, gadroons, rosettes, scotias, astragals, volutes, fleurons, plinths, echini, acanthus leaves, etc. And all this is disgustingly drawn, cheap rubbish, designed as announced, for the engraver and architect, and for the painter. And the architects certainly took their pick, with the expected results: a great deal of old furniture laden with brass ornament, etc. And on what principle are these albums organised? Each plate is divided into four quarters along its two main axes; on either side of the axes there are four segments of mirror, four segments of vase, four segments of chimney-piece, etc. One can see the matching up from here! Catalogues of monumental masonry are better presented today.

And where have the objects made from these elements ended up? In the homes of high society, with collectors, with antiquarians, and in the museums. Inevitably in such a heap there are some very beautiful things. But what is undeniable is our own automatic admiration and total loss of critical faculties when it comes to the heritage of past centuries. Who was this job lot from the reign of the great kings intended for? For a kind of person for whom we do not have much respect today; so it is disastrous and almost immoral to send our children into the museums to learn a religious respect for objects that are ill-made and offensive. And here again the Conservators would do us an immense service if they agreed to display labels alongside their exhibits declaring for example: 'This armchair or this commode would have belonged to a parvenu grocer living in about 1750, etc.'

The honest ethnographic museum is itself incomplete. This can be explained, and therefore excused: a colonial deep in the virgin forest prefers to bring back, in the limited space available, an object of display belonging to a negro chief or the local deity, rather than to encumber himself with numerous utensils that would give a picture of the cultural condition of the peoples with whom he has come into contact. Admittedly, we are at least as keen that the colonial should bring back the image of a god from the virgin forest as a calabash which served as a bowl or a bottle. But where this question becomes serious is when our educationalists, both in their books and in the schools, disregard the origin and purpose of the objects displayed in the museums, and use them as the basis of their teaching, to urge on their pupils to outdo, if that is possible, examples already exceptional of their kind, and thus encourage them to fill our everyday lives with the impractical showpieces which clutter and distort our existence, leaving it quite simply ridiculous.

ICONOCLASTS AGAIN: MAN, MAN QUITE NAKED.
The naked man does not wear an embroidered waistcoat; so the saying goes!

The naked man—but he is an animal worthy of respect who, feeling a head with a brain on his shoulders, sets himself to achieve something in the world.

The naked man sets himself to think, and by developing his tools, seeks to free himself from the dominance of external circumstance and the necessity for exhausting labour. He uses his tools to make objects of utility, and the purpose of these objects is to lighten the unpleasant tasks of everyday life.

The naked man, once he is fed and housed … and clothed, sets his mind to work and focuses his thoughts on what he thinks best and most noble.

The fabulous development of the book, of print, and the classification of the whole of the most recent archaeological era, have flooded our minds and overwhelmed us. We are in an entirely new situation: *Everything is known to us.* Peoples, periods, apogees, declines. We even know the shape of the cranium of the contemporaries of the dinosaurs, and from the slope of the forehead the thoughts which must have occupied them. Whenever a problem arises, we can apply exhaustive analysis to conjure up a picture of what any peoples did or would have done at any period. Ours is certainly an era of documentation.

But the museums have made the arbitrary choice that I have just denounced; this warning should be engraved on their pediments: 'Within will be found the most partial, the least convincing documentation of past ages; remember this and be on your guard!' Truth is thus re-established, and we can proceed without further comment to our own very different programme. Our own purpose is not to imitate the weaknesses of the weaker classes of earlier ages; we intend our culture to serve some purpose, and spur us on to the best. The museums are a means of instruction for the most intelligent, just as the city of Rome is a fruitful lesson for those who have a profound knowledge of their craft.

The naked man does not wear an embroidered waistcoat; he

wishes to think. The naked man is a normally constituted being, who has no need of trinkets. His mechanism is founded on logic. He likes to understand the reasons for things. It is the reasons that bring light to his mind. He has no prejudices. He does not worship fetishes. He is not a collector. He is not the keeper of a museum. If he likes to learn, it is to arm himself. He arms himself to attack the task of the day. If he likes occasionally to look around himself and behind himself in time, it is in order to grasp the reasons why. And when he finds harmony, this thing that is a creation of his spirit, he experiences a shock that moves him, that exalts him, that encourages him, that provides him with support in life.

NOTE:

★ The well known lunatic asylum, J.I.D.

Piet Mondrian

Piet Mondrian, "An International Museum of Contemporary Art" (1931), in Harry Holtzman and Martin S. James, eds., *The New Art— The New Life: The Collected Writings of Piet Mondrian*. Translation by Harry Holtzman and Martin S. James. Boston: G. K. Hall & Co., 1986, pp. 242–243. [Unpublished manuscript, dated August 1931, written in response to Christian Zervos, "Pour la création à Paris d'un musée des artistes vivante," *Cahiers d'art* (Paris) 5, no. 7 (1930), pp. 337–339.]

I would regard a contemporary museum as *truly international*[1] and therefore generally useful only if established in Paris, the center of Western civilization. Everyone visits Paris, everyone could benefit from it. All countries should therefore collaborate in building this "unique" museum. Because the basic problem is "money," funds could be raised through *national committees*, which would remit them to an *international executive and financial committee*. There *should also be an international art committee* to meet periodically in Paris, composed of architects, painters, and sculptors, the leading representatives of the various new tendencies in art. This committee would choose one or more architects to design a modern and practical building for the new museum. The art committee would judge the acceptability of the project, which should make possible the following:

1. The museum should have a permanent exhibition of several examples of the best works by artists of every tendency since naturalism (conventional or Impressionist)—the point from which art decisively began to transform natural vision.

2. The work should be exhibited in a series of galleries arranged successively from naturalism to the most abstract art—Neo-Plastic, which appears as the end of painting. To show that this end is only a beginning, it is essential that

3. This series of galleries be followed by a room in which painting and sculpture will be realized by the interior itself: *dissolved as separate objects and projected directly into life*. Thus, Neo-Plastic architecture and chromoplastic are shown as a unity determining everything in the

room, and demonstrating that what is lost for art is gained for life. This room could therefore be designed for use as a lecture room, a restaurant … as a bar with an American jazz band.

4. The series of exhibition galleries should be preceded by rooms of various uses (library, music room, reception room, entrance hall, etc.) and of diverse aesthetic conceptions, demonstrating that the evolution of architecture in the broadest sense—the evolution of our entire material environment—*goes hand in hand with the evolution of free art*. In order to observe and study the development of general aesthetic culture, not only in the conception of the interior itself, furniture, etc., but also in *all existing varieties of useful objects and machines*, the best examples of all such utilitarian objects should also be exhibited in photographs. Applied art will be seen as losing itself in the process of life's aesthetic evolution … in the process of artistic evolution: in the evolution of free art.

Such a museum will clearly demonstrate the trend of artistic and utilitarian evolution, and therefore *the trend of all human culture*: it will become clear that we are constantly moving further from primitive nature and constantly coming closer to the establishment of truly "human" reality.

NOTE:

1. Although every museum is international, I think it necessary to add and stress that word.

Pablo Picasso

Pablo Picasso, "Conversation with Picasso" (1935), in Alfred H. Barr, Jr. *Picasso: Fifty Years of His Art*, New York: The Museum of Modern Art, 1946, p. 274. [First published as Christian Zervos, "Conversation avec Picasso," *Cahiers d'art* (Paris) 7–10 (1935), pp. 173–178.]

I'm no pessimist, I don't loathe art, because I couldn't live without devoting all my time to it. I love it as the only end of my life. Everything I do connected with it gives me intense pleasure. But still, I don't see why the whole world should be taken up with art, demand its credentials, and on that subject give free rein to its own stupidity. Museums are just a lot of lies, and the people who make art their business are mostly impostors. I can't understand why revolutionary countries should have more prejudices about art than out-of-date countries! We have infected the pictures in museums with all our stupidities, all our mistakes, all our poverty of spirit. We have turned them into petty and ridiculous things. We have been tied up to a fiction, instead of trying to sense what inner life there was in the men who painted them. There ought to be an absolute dictatorship … a dictatorship of painters … a dictatorship of one painter … to suppress all those who have betrayed us, to suppress the cheaters, to suppress the tricks, to suppress mannerisms, to suppress charms, to suppress history, to suppress a heap of other things. But common sense always gets away with it. Above all, let's have a revolution against that! The true dictator will always be conquered by the dictatorship of common sense … and maybe not!

Ad Reinhardt, *How Modern Is The Museum of Modern Art?* Flyer for American Abstract Artists, April 15, 1940. The Museum of Modern Art Library.

Herbert Ferber

Herbert Ferber, "Editorial Symposium: What Should a Museum Be?" *Art in America,* no. 2 (1961), p. 31.

Museums are too much with us and, for good and for evil, will continue to be. Those which show contemporary art have many problems which beset them in their mushroom growth, and I do not wish to propose Utopian ideals for their future. However, as an artist who has come of age during the same two decades in which their formidable shadow has lengthened over the land, I can try to convey some of the ways in which this shadow has touched me and my work. I believe that museums, caught in an upsurge of art activity, often contribute to a confusion of values by an indiscriminate use of their prestige.

Malraux imagined his "museum without walls" as a means by which all art could be seen and compared regardless of size, history or purpose, in terms of its value as Art, thus formulating the dominant trend in art appreciation over the last 30 years. Certainly one was glad to hear this proclamation of Art for Art's sake. But at the same time his metaphorical concept implied the assemblage and equalization of all art.

And so we find ourselves not only surrounded by museums without walls, in innumerable books, magazines and reproductions, but also, by museums with movable walls which are filled again and again with a multiplicity of art objects moving so quickly that it is almost impossible to keep up with them.

We are involved with a vast moving panorama in which, in lunar cycles, the paintings and sculptures come and go, only to be replaced by more paintings and sculpture. Change is keyed to flagging interest and the audience is spurred to restless wandering. People do not pursue a work of art nor are they encouraged to prepare themselves for confronting it; rather this cycle of change brings thousands of works to them whether they are receptive or not, on the assumption that seeing is believing.

Paul Valéry found even those museums which give permanent space to art bewildering and depressing, because they force the visitor to see a landscape, a bowl of fruit and a crucifixion all in one view. To add to the confusion, each is the work of a master. The result, in Valéry's opinion, can only be superficiality. How would he have reacted if he had witnessed our dilemma in which the recognition of a new master is hampered even more by the limit of exhibition time?

On the other hand, we all have experienced that special pleasure and excitement generated by entering a place in which a unified statement is encountered. This may be a church, a room where a single work is shown, or where the works of one artist are gathered.

But these occasions, in most museums of contemporary art, become more and more infrequent, because the emphasis is on a notion of democratically presenting many artists in a continuous sequence. Museums compete with dealers whose legitimate business consists of showing all their artists in rotating exhibitions. It is the dealer who should discover new talent.

This is what I find wrong with museums: too many pictures by too many artists; quick changes; and the general lack of mood or place for confronting the unique image for which the artist has presumably spent years in searching. The pace at which this unquiet world revolves only serves to fuse all art into one vast, impersonal image of culture, which is then shipped from city to city so that every one, everywhere, can be exposed to it for an equally short length of time.

Of course I know the arguments for bringing art to the people. But what I am concerned with is the fate of specific art and artists and the full exposition of their work. The aesthetic results of the prevailing hurry and bustle is a diminution of impact and a cheapening of the very values which the museums should sustain.

In one sense the large pictures of contemporary painters may be interpreted as a revolt against art used as a replaceable emblem to be moved from gallery to gallery. These artists are creating walls to replace those which Malraux demolished and in the process have produced an environment which is inescapable. Standing in front of one of these paintings one is drawn into the substance of the environment which it emanates.

In sculpture, too, there is a trend away from the cabinet piece. I have, for some time, worked on making sculpture and space participants in a drama which unfolds to the spectator. By giving the space and the forms a scale which allows a man to move into them, an environment is created which becomes the measure of his experience and which negates Malraux's museum by the concreteness and sensuousness of its specific image. Once in such an ambience the visitor cannot change the perspective of his experience except by leaving. He must deal with it alone when he crosses the threshold.

What should the function of the museum be? Surely museums cannot subscribe to the idea of "the more, the better" of both art and audience. Surely it is true that the places and works of art we remember and return to are those with an undiluted statement. Why cannot museums be on the order of such places? If an artist is worth showing at all in a museum, can one or two of his works do more than touch the long, meandering path of his creative search? They may illuminate his signature but hardly reveal the text. The whole text would be worth traveling far to see. Art for Art's sake does not imply that art has no place.

Robert Motherwell

Robert Motherwell, "Editorial Symposium: What Should a Museum Be?" *Art in America*, no. 2 (1961), pp. 32–33.

The value of an artist's testimony derives from his discipline in truthfulness to his own experience. Such experience is limited, but specific.

Foreigners often focus on what we blur from habit. The trickle of Europeans and Japanese through my New York studio (mainly persons interested in what Clement Greenberg called "American-style" painting) consistently express two judgments: profound admiration for the

completeness and quality of the collections of the Museum of Modern Art in general; shocked and often angry disappointment at the Whitney Museum of American Art, whose whole name is taken seriously. As one museum director from the Continent said, "You go straight from your hotel to the Whitney, but in order to see the American art, you have to go to Ben Heller's apartment, or to the Albright Art Gallery in Buffalo; even in the Museum of Modern Art you can't see the new American art whole." As for the Guggenheim, no one seems to know what it is—its identity, I mean.

This particular failure of the Whitney is not especially hard on New Yorkers, who can see everything in private galleries; but to a visitor who does not know his way around and who is limited in time, the failure hurts. The Whitney's rationale seems to be democratic, to give a fair sampling from hundreds of artists of what is going on in America at any given moment, like the Daily News; but the truth is that what all the artists in any country at any given moment (even in cross-section) are painting, is depressing to view. The powers at the Whitney are certainly humanitarian, learned, and filled with good will; but unless all that is coupled with insight—i.e., perception of what is creative enough to bring about changes—the selections remain empty as an ensemble, meaningless to the individuals participating, and ultimately irresponsible to the public. My point is, should the subject matter of an art museum be history, or that which moves the eye? The effort to do both (which everyone more or less tries) invariably ends on the side of history. No one but an art historian could endure those large paintings in the Louvre by Ingres, which misunderstand everything, painting and history both.

American artists are in a unique position among artists to see the workings of a museum, because American museums are the most committed to showing living artists. Whether this is a desirable situation I am inclined to doubt, though I myself have benefited—unless the museum is devoted only to contemporary art, in which case the sanctification of history is not implied, but gambled on. The Museum of Modern Art is a great museum and the exception to the dangers that I see—because of the insight, wisdom, and magnitude of character of Alfred H. Barr, Jr. I would think that such a man in such a position would appear once in a century, and I could almost wish that his museum remain unchanged (as the Frick should have) when Barr retires. I believe in specific men, not institutions, and I do not believe (nor do my foreign visitors) that there is his like anywhere. Still, it only takes the appearance of another man of such qualities to negate what I say …

Perhaps, the most remarkable experience that I have had of a museum was in the new Léger Museum in the south of France, at Biot, not because it was devoted to Léger, but because its hundreds of works by him show the whole working life of an artist of stature. There one can have the sense, the real sense, of just what Léger was, just by looking, just by looking in one place. What a joy! And a relief from the anthology museum. Most museums are conceived like a vaudeville show, a series of acts, sampling everything, but only a sample … And so one's joy with the Picasso Museum at Antibes. But less so, because there are many fewer works than those of Léger at Biot, and only from one period in Picasso's life, even though he interests me more personally than Léger.

If I had absolute control of American museums—God forbid!—my first, emergency act would be to install Charles Egan or Clement Greenberg to choose all the works to be shown at the Whitney Museum of American Art; and my second, long-range act would be to redistribute all the great artists, so that each museum, according to its importance, place, and scale would have a preponderance—preferably all—of the works in American public collections of specific artists. I would love to go to San Francisco, say, to see all the Matisses, to Cambridge for the Sassettas (if there are that many), to Chicago for the Goyas, to New York for the Rembrandts, to Merion for Renoirs, to Washington for Titians, to Philadelphia for cubism, to Boston for Greek pots; or to any small town to see all of a minor artist, say, Boudin or Marin or Guardi or Constantin Guys. And how incredibly less dull would travel be in America if, say, in Falmouth one could see all the Homer watercolors; in Ciccero, Sullivan's architectural renderings; in Gettysburg, all the Mathew Bradys (instead of Charlie Weavers and Dwight Eisenhowers); in Oxford, Audubon; in Fargo, Frederic Remington; in New Orleans, Degas pastels—as one can, for example, in Colorado Springs see all the Santos statues. Just the other day, for the first time in my life I had a desire to visit Wilmington, because I learned that there is a Pre-Raphaelite collection. But as the general situation is, everywhere in America one sees the same Main Street, same Woolworth's, same Coca-Cola, same chain drugstore, same movie, same motel, same fried shrimps, and the same local museum reflecting in the same lesser way the same big museum. O sameness! Bolton Landing, N.Y., is to me one of the great places in America because of David Smith's metal sculpture strewn across his acres, and in his house and studios; otherwise, it is a banal resort on Lake George, where I suppose the main place to eat is at Howard Johnson's …

I like museums that show a single man's work, or a series of men in depth, not because I am especially involved in a given man's identity or glory—all men of stature are of interest, though not equally interesting to the eye. It is more that I am strongly against the existing museum tendency (like society in general) to reduce its works of art, to reduce them to objects. One of the most insidious enemies of art is within museums, the gentleman-connoisseur, the effete apprentice, who, though he is discriminating, discriminates among objects. The Metropolitan Museum is an enlarged Parke-Bernet; the National Gallery in Washington would have been matched in contents and similarly housed by Hermann Goering, had he had world enough and time. Hardly anywhere is art shown as what art is, the ecstasy of the eye, or, as Picasso says, the emotion given off by a picture so you do not notice its technique, how it was made. Is Princeton University or the New York University Institute of Fine Arts the place to learn ecstasy? When you have a retrospective at a museum, the first thing

they ask you for in you biography is where you studied, as if that counts! I always remember Rothko's stories as a Jewish immigrant student at Yale, or my own misery in the Graduate School at Harvard. Are traditional New Englanders or modern German scholars, who mainly staff our museums, noted for their eye for painterly abilities or warm passions? Of course not!

Main Street is the creation of banks, supermarkets, and drugstores; museums are the creation of art historians, object-collectors, tax-deductors (what a bargain basement is the Chrysler Museum in Provincetown!), and assorted dilettantes and functionaries. No wonder museums exist apart from one's real self, impersonal, remote, everything reduced to rows of objects, whether you are an artist, art lover, student, or child. In the end, one experiences nothing of art from the history of objects. The issue is passion, whether quiet or wild. Museums distort the history of artistic passion, just as do the societies which museums reflect. For passion is only recognized by the passionate. The rest is objects, a false history of art and artists.

Ad Reinhardt

Ad Reinhardt, "Art-as-Art," in Barbara Rose, ed., *Art-as-Art: The Selected Writings of Ad Reinhardt.* Berkeley and Los Angeles: University of California Press, 1975, p. 54. [Originally published in *Art International* (Lugano) 6, no. 10 (December 20, 1962), pp. 36–37.]

The one meaning in art-as-art, past or present, is art meaning. When an art object is separated from its original time and place and use and is moved into the art museum, it gets emptied and purified of all its meanings except one. A religious object that becomes a work of art in an art museum loses all its religious meanings. No one in his right mind goes to an art museum to worship anything but art, or to learn about anything else.

The one place for art-as-art is the museum of fine art. The reason for the museum of fine art is the preservation of ancient and modern art that cannot be made again and that does not have to be done again. A museum of fine art should exclude everything but fine art, and be separate from museums of ethnology, geology, archaeology, history, decorative arts, industrial arts, military arts, and museums of other things. A museum is a treasure house and tomb, not a counting-house or amusement center. A museum that becomes an art curator's personal monument or an art-collector-sanctifying establishment or an art-history manufacturing plant or an artists' market block is a disgrace. Any disturbance of a true museum's soundlessness, timelessness, airlessness, and lifelessness is a disrespect.

Ad Reinhardt

Ad Reinhardt, [unpublished and undated notes], in Barbara Rose, ed., *Art-as-Art: The Selected Writings of Ad Reinhardt.* Berkeley and Los Angeles: University of California Press, 1975, pp. 128–129.

MUSEUM
Museum
"Mouseion"—place where muses meet to discuss art (Greek)
"civilization's attic"—F.H. Taylor
Futurists—"Tear them down- " 1909

Art museum—born—French Revolution
Royal collections declared property of the people
"Palace-" store-house palatial-storehouse
"Public" exhibition hall—school

X Place of entertainment, brokerage house, fun-house
"Home, private club" (Hartford) Private-mansion (Frick)
Pseudo-palaces, indoor gardens, pavilions
Public-private club
"Clinic"—Mus-mod-art
Spiral-ramp-top-down, turnstile-elevator
"Get more out of life, go to a movie," Go to a museum?
"Art has become the beauty parlor of civilization-"—Dewey
"Religion is not a masquerade or a costume-party."

"Museum," school, academy point of view
Only possible point of view, no two ways about it

Museum (Malraux) "without walls," "imaginary-"
Museum of fine art—clean up rooms (Met. Mus.)

Art-as-art, work of art itself only
Fine, free, pure art
"Fine art"—Lautrec, fauves, Duchamp, expressionists, surrealists,
Handicrafts, technical processes, new materials, objects,
commercial
Divisions, separations
"Major-minor," "high-low," "Fine-practical-" pragmatic
"Free-servile"—superior, intellectual, noble
"Detached-engaged-"—absolute, pure, disinterested
★ "Useless," liberal, free
★ "Meaningless-"
Attribute meanings, aims it does not, cannot have
no "respect," "faith," "credit"

Marcel Duchamp

Pierre Cabanne, *Dialogues with Marcel Duchamp*. Translation by Ron Padgett. New York: Viking Press, 1971, pp. 67, 70–71. [First published as *Entretiens avec Marcel Duchamp*. Paris: Editions Pierre Belfond, 1967.]

When I go to a museum, I don't have a sort of stupefaction, astonishment, or curiosity in front of a picture. Never. I'm talking about the old masters, the old things.... I was really defrocked, in the religious sense of the word. But without doing it voluntarily. All that disgusted me....

I think painting dies, you understand. After forty or fifty years a

picture dies, because its freshness disappears. Sculpture also dies. This is my own little hobbyhorse, which no one accepts, but I don't mind. I think a picture dies after a few years like the man who painted it. Afterward it's called the history of art. There's a huge difference between a Monet today, which is black as anything, and a Monet sixty or eighty years ago, when it was brilliant, when it was made. Now it has entered into history—it's accepted as that, and anyway that's fine, because that has nothing to do with what it is. Men are mortal, pictures too.

The history of art is something very different from aesthetics. For me, the history of art is what remains of an epoch in a museum, but it's not necessarily the best of that epoch, and fundamentally it's probably even the expression of the mediocrity of the epoch, because the beautiful things have disappeared—the public didn't want to keep them. But this is philosophy....

Properly, any masterpiece is called that by the spectator as a last resort. It is the onlooker who makes the museum, who provides the elements of the museum. Is the museum the final form of comprehension, of judgment?

The word "judgment" is a terrible thing, too. It's so problematical, so weak. That a society decides to accept certain works, and out of them make a Louvre, which lasts a few centuries. But to talk about truth and real, absolute judgment—I don't believe in it at all....

[I] almost never [go to museums]. I haven't been to the Louvre for twenty years. It doesn't interest me, because I have these doubts about the value of the judgments which decided that all these pictures should be presented to the Louvre, instead of others which weren't even considered, and which might have been there. So fundamentally we content ourselves with the opinion which says that there exists a fleeting infatuation, a style based on a momentary taste; this momentary taste disappears, and, despite everything, certain things still remain. This is not a very good explanation, nor does it necessarily hold up.

Allan Kaprow

Allan Kaprow, "Death in the Museum: Where Art Thou, Sweet Muse? (I'm Hung Up At the Whitney)" *Arts Magazine* 41, no. 4 (February 1967), pp. 40–41.

DEATH IN THE MUSEUM: WHERE ART THOU, SWEET MUSE? (I'M HUNG UP AT THE WHITNEY)
Discussion about museums can only be academic if limited to the usual questions of function and good looks. The primary question is *whether or not museums have any relevance at all for contemporary art.*

I once wrote ... that "the public museums developed principally as substitutes for the patronage of the Palace and Church. Physically, the museum is a direct parallel in mood, appearance and function to the cloistered, unattainably grand surrounding art once had. In Europe, it was the unused monastery and former chateau that were taken over for the purpose, while in America the style was imitated.

Therefore, we have the "aristocratic" manners of curators, the hushed atmosphere, the reverence with which one is supposed to glide from work to work ..."

The modern museum, though up-to-date in architectural style and occupied with rapidly changing shows, movies, concerts, symposia, art classes and publishing programs—as if it were just another college—still has not been able to shake off this aura of quasi-religion and high rank. It still enshrines its contents, still demands a worshipful attitude that reflects benignly on the spectator's growing cultivation and status. By seeming to wish only to offset and enframe pictures and sculpture from the rest of nature for the sake of focus, the museum environment actually transforms everything into a true *nature morte* because of the kind of history evoked.

Initially, it was an appropriate reflection of an aesthetics of detachment born of the social and professional isolation of artists in the last century and a half. The artist, art work, and house of art grew to share a positive commitment to the notion of separating high culture from low life. The museum-as-temple spoke of special sufferings and rare gratifications to a small band of Israelites lost in the wilderness. As such, it served a profound need and one can only be grateful for it.

But today, the middle-class background of the artist, his non-professionalized university schooling, his job-oriented attitude (usually toward teaching), his inclination toward raising a family in a neighborhood, together tend to preclude an authentic sense of alienation while at the same time opening paths of social mobility and social usefulness.

Similarly, private patronage—relatively limited in cash and still dressed for the nostalgic role it might have played in the past—is steadily losing ground to impersonal corporate stimulation and sponsorship. Federal and municipal subsidies to the arts in much greater amounts, added to funds from large, private foundations established through the machinery of tax relief, are spent on the direct advisement of the nation's higher education industry—which say culture is a good buy.

As a result, the patron-to-artist relationship has been eliminated as a major cultural force; and the corresponding concept of the art work as a hand-made and individualized object seems as quaint as the cobbler's boot. Instead, the vanguard tends to view art as a social process; as an ironic idea per se expressed in vacuities and absurdities; as a multi-media organism extending into the space of daily existence; as a slice of life needing no transformation since the mind transforms anyway; as a technological game or a psychological probe into the effects of technology on humans; it even views art as a shifting identity incapable of embodiment beyond allusive words and thus implies total inactivity. Clearly, such art can neither fit physically into an art temple nor feel comfortable with the latter's mood of sanctity.

To my way of thinking, then, the museum is a fuddy-duddy remnant from another era. It resembles the symphony: no matter how many electronic sounds, power tools and other unusual noisemakers are used to give it a sense of modernity, there remains the grand

conductor leading his grand group of performers on a grand stage of a grand hall, with a grand audience out in front to grandly applaud or boo. Only the details are altered in a frozen framework. The museum may hire a modern architect, may install jazzy lighting effects and piped-in lectures, may offer entertainment and baby-sitting facilities, but it will always be a "place of the muses" because its directors take for granted the necessary connection between it and art.

One may generalize that *the environmental context of the art work today is of greater importance than its specific forms; and that it is this surrounding, furthermore, which will determine the nature and shape of the container of these forms.* It leads to speculation that as the museum is obsolete, so are the kinds of art—pictures and statues—for which it was conceived. I suggested in the article referred to above that in all probability, "the spirit and body of our (art) is on our TV screens and in our vitamin pills … The modern museums should be turned into swimming pools and night clubs …," or in the best looking examples, emptied and left as environmental sculpture.

Robert Smithson

Robert Smithson, "Some Void Thoughts on Museums," *Arts Magazine* 41, no. 4 (February 1967).

History is a facsimile of events held together by flimsy biographical information. Art history is less explosive than the rest of history, so it sinks faster into the pulverized regions of time. History is representational, while time is abstract; both of these artifices may be found in museums, where they span everybody's own vacancy. The museum undermines one's confidence in sense-data and erodes the impression of textures upon which our sensations exist. Memories of "excitement" seem to promise something, but nothing is always the result. Those with exhausted memories will know the astonishment.

Visiting a museum is a matter of going from void to void. Hallways lead the viewer to things once called "pictures" and "statues." Anachronisms hang and protrude from every angle. Themes without meaning press on the eye. Multifarious nothings permute into false windows (frames) that open up onto a verity of blanks. Stale images cancel one's perception and deviate one's motivation. Blind and senseless, one continues wandering around the remains of Europe, only to end in that massive deception "the art history of the recent past." Brain drain leads to eye drain, as one's sight defines emptiness by blankness. Sightings fall like heavy objects from one's eyes. Sight becomes devoid of sense, or the sight is there, but the sense is unavailable. Many try to hide this perceptual falling out by calling it abstract. Abstraction is everybody's zero but nobody's nought. Museums are tombs, and it looks like everything is turning into a museum. Painting, sculpture and architecture are finished, but the art habit continues. Art settles into a stupendous inertia. Silence supplies the dominant chord. Bright colors conceal the abyss that holds the museum together. Every solid is a bit of clogged air or space. Things flatten and fade. The museum spreads its surfaces everywhere, and becomes an untitled collection of generalizations that immobilize the eye.

Allan Kaprow and Robert Smithson

Allan Kaprow and Robert Smithson, "What Is a Museum? A Dialogue between Allan Kaprow and Robert Smithson," *Arts Yearbook,* no. 9 (1967), pp. 94–101.

ALLAN KAPROW: There was once an art which was conceived for the museums, and the fact that the museums look like mausolea may actually reveal to us the attitude we've had to art in the past. It was a form of paying respect to the dead. Now, I don't know how much more work there is available from the past that has to be displayed or respected. But if we're going to talk about the works being produced in the last few years, and which are to be produced in the near future, then the concept of the museum is completely irrelevant. I should like to pursue the question of the environment of the work of art; what kind of work is being done now; where it is best displayed, apart from the museum, or its miniature counterpart, the gallery.

ROBERT SMITHSON: Well, it seems to me that there is an attitude that tends toward McLuhanism, and this attitude would tend to see the museum as a null structure. But I think the nullity implied in the museum is actually one of its major assets, and that this should be realized and accentuated. The museum tends to exclude any kind of life-forcing position. But it seems that now there's a tendency to try to liven things up in the museums, and that the whole idea of the museum seems to be tending more toward a kind of specialized entertainment. It's taking on more and more the aspects of a discotheque and less and less the aspects of art. So, I think that the best thing you can say about museums is that they really are nullifying in regard to action, and I think that this is one of their major virtues. It seems that your position is one that is concerned with what's happening. I'm interested for the most part in what's not happening, that area between events which could be called the gap. This gap exists in the blank and void regions or settings that we never look at. A museum devoted to different kinds of emptiness could be developed. The emptiness could be defined by the actual installation of art. Installations should empty rooms, not fill them.

KAPROW: Museums tend to make increasing concessions to the idea of art and life as being related. What's wrong with their version of this is that they provide canned life, an aestheticized illustration of life. "Life" in the museum is like making love in a cemetery. I am attracted to the idea of clearing out the museums and letting better designed ones like the Guggenheim exist as sculptures, as works, as such, almost closed to people. It would be positive commitment to their function as mausolea. Yet, such an act would put so many artists out of business.… I wonder if there isn't an alternative on the fringes of life and art, in that marginal or penumbral zone which you've spoken so eloquently of, at

the edges of cities, along vast highways with their outcroppings of supermarkets and shopping centers, endless lumberyards, discount houses, whether that isn't the world that's for you at least. I mean, can you imagine yourself working in that kind of environment?

SMITHSON: I'm so remote from that world that it seems uncanny to me when I go out there; so not being directly involved in the life there, it fascinates me, because I'm sure of a distance from it, and I'm all for fabricating as much distance as possible. It seems that I like to think and look at those suburbs and those fringes, but at the same time, I'm not interested in living there. It's more of an aspect of time. It is the future—the Martian landscape. By a distance, I mean a consciousness devoid of self-projection.

I think that some of the symptoms as to what's going on in the area of museum building are reflected somewhat in Philip Johnson's underground museum, which in a sense buries abstract kinds of art in another kind of abstraction, so that it really becomes a negation of a negation. I am all for a perpetuation of this kind of distancing and removal, and I think Johnson's project for Ellis Island is interesting in that he's going to gut this nineteenth-century building and turn it into a ruin, and he says that he's going to stabilize the ruins, and he's also building this circular building which is really nothing but a stabilized void. And it seems that you find this tendency everywhere, but everybody is still a bit reluctant to give up their life-forcing attitudes. They would like to balance them both. But, I think, what's interesting is the lack of balance. When you have a Happening you can't have an absence of happening. There has to be this dualism which I'm afraid upsets a lot of ideas of humanism and unity. I think that the two views, unity and dualism, will never be reconciled and that both of them are valid, but at the same time, I prefer the latter in multiplicity.

KAPROW: There is another alternative. You mentioned building your own monument, up in Alaska, perhaps, or Canada. The more remote it would be, the more inaccessible, perhaps the more satisfactory. Is that true?

SMITHSON: Well, I think ultimately it would be disappointing for everybody including myself. Yet the very disappointment seems to have possibilities.

KAPROW: What disturbs me is the lack of extremity in either of our positions. For instance, I must often make social compromises in my Happenings, while, similarly, you and others who might object to museums nevertheless go on showing in them.

SMITHSON: Extremity can exist in a vain context too, and I find what's vain more acceptable than what's pure. It seems to me that any tendency toward purity also supposes that there's something to be achieved, and it means that art has some sort of point. I think I agree with Flaubert's idea that art is the pursuit of the useless, and the more vain things are the better I like it, because I'm not burdened by purity.

I actually value indifference. I think it's something that has aesthetic possibilities. But most artists are anything but indifferent; they're trying to get with everything, switch on, turn on....

KAPROW: Realistically speaking, you'll never get anybody to put up the dough for a mausoleum—a mausoleum to emptiness, to nothing—though it might be the most poetic statement of your position. You'll never get anyone to pay for the Guggenheim to stay empty all year, though to me that would be a marvelous idea.

SMITHSON: I think that's true. I think basically it's an empty proposal. But . . . eventually there'll be a renaissance in funeral art.

Actually, our older museums are full of fragments, bits and pieces of European art. They were ripped out of total artistic structures, given a whole new classification and then categorized. The categorizing of art into painting, architecture and sculpture seems to be one of the most unfortunate things that took place. Now all these categories are splintering into more and more categories, and it's like an interminable avalanche of categories. You have about forty different kinds of formalism and about a hundred different kinds of expressionism. The museums are being driven into a kind of paralyzed position, and I don't think they want to accept it, so they've made a myth out of action; they've made a myth out of excitement; and there's even a lot of talk about interesting spaces. They're creating exciting spaces and things like that. I never saw an exciting space. I don't know what a space is. Yet, I like the uselessness of the museum.

KAPROW: But on the one side you see it moving away from uselessness toward usefulness.

SMITHSON: Utility and art don't mix.

KAPROW: Toward education, for example. On the other side, paradoxically, I see it moving away from real fullness to a burlesque of fullness. As its sense of life is always aesthetic (cosmetic), its sense of fullness is aristocratic: it tries to assemble all 'good' objects and ideas under one roof lest they dissipate and degenerate out in the street. It implies an enrichment of the mind. Now, high class (and the high-class come-on) is implicit in the very concept of a museum, whether museum administrators wish it or not, and this is simply unrelated to current issues. I wrote once that this is a country of more or less sophisticated mongrels. My fullness and your nullity have no status attached to them.

SMITHSON: I think you touched on an interesting area. It seems that all art is in some way a questioning of what value is, and it seems that there's a great need for people to attribute value, to find a significant value. But this leads to many categories of value or no value. I think this shows all sorts of disorders and fractures and irrationalities. But I don't really care about setting them right or making things in some ideal fashion. I think it's all there—independent of any kind of good or bad. The categories of 'good art' and 'bad art' belong to a commodity value system.

KAPROW: As I said before, you face a social pressure which is hard to reconcile with your ideas. At present, galleries and museums are still the primary agency or 'market' for what artists do. As the universities and federal education programs finance culture by building even more museums, you see the developing picture of contemporary patronage. Therefore, your involvement with 'exhibition people,' however well-meant they are, is bound to defeat whatever position you take regarding the non-value of your activity. If you say it's neither good nor bad, the dealers and curators who appropriate it, who support you personally, will say or imply the opposite by what they do with it.

SMITHSON: Contemporary patronage is getting more public and less private. Good and bad are moral values. What we need are aesthetic values.

KAPROW: How can your position then be anything but ironic, forcing upon you at least a skepticism. How can you become anything except a kind of sly philosopher—a man with a smile of amusement on your face, whose every act is italicized?

SMITHSON: Well, I think humor is an interesting area. The varieties of humor are pretty foreign to the American temperament. It seems that the American temperament doesn't associate art with humor. Humor is not considered serious. Many structural works really are almost hilarious. You know, the dumber, more stupid ones are really verging on a kind of concrete humor, and actually I find the whole idea of the mausoleum very humorous.

KAPROW: Our comparison of the Guggenheim, as an intestinal metaphor, to what you've called a "waste system" seems quite to the point. But this of course is nothing more than another justification for the museum man, for the museum publicist, for the museum critic. Instead of high seriousness it's high humor.

SMITHSON: High seriousness and high humor are the same thing.

KAPROW: Nevertheless, the minute you start operating within a cultural context, whether it's the context of a group of artists and critics or whether it's the physical context of the museum or gallery, you automatically associate this uncertain identity with something certain. Someone assigns to it a new categorical name, usually a variant of some old one, and thus he continues his lineage or family system which makes it all credible. The standard fate of novelty is to be justified by history. Your position is thus ironic.

SMITHSON: I would say that it has a contradictory view of things. It's basically a pointless position. But I think to try to make some kind of point right away stops any kind of possibility. I think the more points the better, you know, just an endless amount of points of view.

KAPROW: Well, this article itself is ironic in that it functions within a cultural context, within the context of a fine-arts publication, for instance, and makes its points only within that context. My opinion has been, lately, that there are only two outs: one implying a maximum of inertia, which I call "idea" art, art which is usually only discussed now and then and never executed; and the other existing in a maximum of continuous activity, activity which is of uncertain aesthetic value and which locates itself apart from cultural institutions. The minute we operate in between these extremes we get hung up (in a museum).

Various artists

L[awrence] A[lloway], "Artists on Museums," *Arts Yearbook,* no. 9 (1967), pp. 83–92.

QUESTION:

1. Do you want your work in a museum?

2. If not in a museum, where?

3. If in a museum … what are ideal museum conditions?

<div align="right">L.A.</div>

LUCAS SAMARAS

1. Yes.

3. The ideal museum would have many floors, many rooms, a floor or room each devoted to one artist.

NICHOLAS KRUSHENICK

1. Yes.

2. I don't particularly believe in this mass art kick. I have heard that several artists want to put art on billboards from New York to Washington, D.C. What makes them think truck drivers are a responsive audience?

3. Museum conditions that are ideal—Every artist gets a room 100 feet by 100 feet, lighted with sunshine 24 hours a day.

ÖYVIND FAHLSTRÖM

1. Yes, if my work could be displayed permanently, or most of the time.

2, 3. I would prefer to have my works in a pleasure-house, i.e., the future, enlarged concept of a museum, as combination theater, discothèque, meditation grotto, luna park, restaurant, garden, overnight hotel, swimming pools.

Wherever my works were to be shown, there ought to be duplicates of them. So in a museum or gallery, besides the untouchable original, you would have a duplicate that the public could manipulate.

In a *pleasure-house* a sample duplicate could be displayed and other duplicates sold. In this private home the owner of a duplicate would be at ease to meditate and or play with the art work.

JAMES ROSENQUIST

1. I don't care, but maybe not.

2. I'd like to have the work in new vestigial areas—like on top of old thruways and metropolitan high rooftops with warm-air-walls. For the mid-west and the territories… old missile silos deep in the ground.

3. Good restaurants and good humidity control.

CLAES OLDENBURG

When I began studying art I used museums very much, and my fixed idea of museums as places of the dead and places of study comes from that time.

Nowadays, I am comparatively indifferent to museums. The occasional hostile remarks I make about museums serve to emphasize the problem of keeping a work *in life*, active and useful, resisting as long as possible the historical-critical suction. Or I criticize the tendency of museums to lose their dignity. I believe museums should be austere and dignified, and packed with experts completely in love with art and detached from everything else.

But the rare times when a museum relaxes and risks the penetration of life can be sublime. I have just returned from two months in the Moderna Museet in Stockholm. I had a studio with all privileges and expenses, overlooking my show. I could run down and set the spectators straight if I wished. I did a performance in the middle of the show. In gratitude for what was one of the best times of my life, I made and donated 250 pieces of Swedish bread, cast in iron and rusted, and other items besides.

This followed the rape of the museum by Niki de Saint-Phalle with her *Hon*. But the Moderna Museet has the capacity of absorbing life and remaining a museum. I am not sure all museums have this capacity. However, all museums might consider the advantages of artists residency (especially in connection with one-man shows). Also they might consider providing proper burial places for the artist. Is there any reason why museums can't handle this? The politics of gravestones (placement, size, style, etc.) is terrifying to imagine!

LARRY RIVERS

1. Yes.
2. Public buildings, universities, restaurants, billboards, Bronx Zoo, etc. Everywhere.
3. Large light space with a separate wing designed with my help which will include a partially comprehensive selection of my life's work which will also allow space for whatever keeps coming from me. As for an ideal as it relates to the public, it is hard to give a reasonable answer. I'm not sure of its proper function. At the bottom I really don't think it matters. What gives pleasure, and makes one think, suffices. Certainly the museum's political role in society is tiny. However, more variation relating to aims or ideals will produce a scene in which there will be a little something for everyone.

BARNETT NEWMAN

I can only say, in reply to the question, what are the ideal museum conditions for the presentation of my work, that it is my hope that whether it be a museum, a gallery or a private collection that my work be shown, as closely as possible, the way it looks in my studio where it was created.

Since I do not make a painting, nor do I do a painting, but I hope to create a painting, it is this alive quality that I wish to be maintained, rather than any so-called 'ideal' placement of it as an object in some 'ideal' installation.

This means that whether my work be a roomful, or whether it be shown singly, I do not wish it to be a shrine; nor do I want the work to sit in showcases.

It is the shrine and the showcase that I wish avoided since I am not moved by demands for worship. Nor am I impressed by the fake drama of display. *Nox Buffalois caveator pintoribus*.

DON JUDD

1. Yes, anywhere.
2. A large rectangular space with a fairly high ceiling is fine—the Jewish Museum's upper room, or the fourth floor of the Whitney as they've left it for the sculpture annual. A smaller room is all right if the ceiling is high and there isn't too much work in it. There shouldn't be any mouldings or grooves. The walls and floors should be smooth and square, not flagstones, for example at the Whitney. The floor shouldn't be patterned. Ideally, the architecture of the building should be good, outside and inside. That excludes the elegance of most new galleries and museums. A museum certainly shouldn't be inferior to the best that might be in it. It shouldn't be as trivial and eclectic as Edward Stone's art center for New Jersey or Lincoln Center. These are becoming a type for the present just as the modern classical building became a type for the thirties. Only Atlanta still intends to build a modern temple. Everywhere else they build modern, modern temples.

ALEX KATZ

1. I like my work to be acquired by and exhibited in museums.
2,3. I would like the work the museums own to be exhibited at all times. I don't like my work to be shown in lobbies, passageways, or near bathrooms. I would like to have an Alex Katz room in a museum of contemporary art.

Art Workers' Coalition

Art Workers' Coalition, "Art Workers' Coalition: Statement of Demands" (1969), in Lucy R. Lippard, "The Art Workers' Coalition: Not a History," *Studio International* (London) 180, no. 927 (November 1970), pp. 171–172.

A. WITH REGARD TO ART MUSEUMS IN GENERAL THE ART WORKERS' COALITION MAKES THE FOLLOWING DEMANDS:

1. The Board of Trustees of all museums should be made up of one-third museum staff, one-third patrons and one-third artists, if it is to continue to act as the policy-making body of the museum. All means should be explored in the interest of a more open-minded and democratic museum. Art works are a cultural heritage that belong to the

A CALL FOR THE IMMEDIATE RESIGNATION OF ALL THE ROCKEFELLERS FROM THE BOARD
OF TRUSTEES OF THE MUSEUM OF MODERN ART

There is a group of extremely wealthy people who are using art as a means of self-glorification and as a form of social acceptability. They use art as a disguise, a cover for their brutal involvement in all spheres of the war machine.

These people seek to appease their guilt with gifts of blood money and donations of works of art to the Museum of Modern Art. We as artists feel that there is no moral justification whatsoever for the Museum of Modern Art to exist at all if it must rely solely on the continued acceptance of dirty money. By accepting soiled donations from these wealthy people, the museum is destroying the integrity of art.

These people have been in actual control of the museum's policies since its founding. With this power they have been able to manipulate artists' ideas; sterilize art of any form of social protest and indictment of the oppressive forces in society; and therefore render art totally irrelevant to the existing social crisis.

1. According to Ferdinand Lundberg in his book, The Rich and the Super-Rich, the Rockefellers own 65% of the Standard Oil Corporations. In 1966, according to Seymour M. Hersh in his book, Chemical and Biological Warfare, the Standard Oil Corporation of California - which is a special interest of David Rockefeller (Chairman of the Board of Trustees of the Museum of Modern Art) - leased one of its plants to United Technology Center (UTC) for the specific purpose of manufacturing napalm.

2. According to Lundberg, the Rockefeller brothers own 20% of the McDonnell Aircraft Corporation (manufacturers of the Phantom and Banshee jet fighters which were used in the Korean War). According to Hersh, the McDonnell Corporation has been deeply involved in chemical and biological warfare research.

3. According to George Thayer in his book, The War Business, the Chase Manhattan Bank (of which David Rockefeller is Chairman of the Board) - as well as the McDonnell Aircraft Corporation and North American Airlines (another Rockefeller interest) - are represented on the committee of the Defense Industry Advisory Council (DIAC) which serves as a liaison group between the domestic arms manufacturers and the International Logistics Negotiations (ILN) which reports directly to the International Security Affairs Division in the Pentagon.

Therefore we demand the immediate resignation of all the Rockefellers from the Board of Trustees of the Museum of Modern Art.

Supported by:
ART WORKERS
COALITION

New York, November 10, 1969
GUERRILLA ART ACTION GROUP
Jon Hendricks
Jean Toche

*Jon Hendricks, Jean Toche
Poppy Johnson, Silvianna*

COMMUNIQUE

Silvianna, Poppy Johnson, Jean Toche and Jon Hendricks entered the Museum of Modern Art of New York at 3:10 pm Tuesday, November 18, 1969. The women were dressed in street clothes and the men wore suits and ties. Concealed inside their garments were two gallons of beef blood distributed in several plastic bags taped on their bodies. The artists casually walked to the center of the lobby, gathered around and suddenly threw to the floor a hundred copies of the demands of the Guerrilla Art Action Group of November 10, 1969.

They immediately started to rip at each other's clothes, yelling and screaming gibberish with an occasional coherent cry of "Rape." At the same time the artists burst the sacks of blood concealed under their clothes, creating explosions of blood from their bodies onto each other and the floor, staining the scattered demands.

A crowd, including three or four guards, gathered in a circle around the actions, watching silently and intently.

After a few minutes, the clothes were mostly ripped and blood was splashed all over the ground.

Still ripping at each other's clothes, the artists slowly sank to the floor. The shouting turned into moaning and groaning as the action changed from outward aggressive hostility into individual anguish. The artists writhed in the pool of blood, slowly pulling at their own clothes, emitting painful moans and the sound of heavy breathing, which slowly diminished to silence.

The artists rose together to their feet, and the crowd spontaneously applauded as if for a theatre piece. The artists paused a second, without looking at anybody, and together walked to the entrance door where they started to put their overcoats on over the bloodstained remnants of their clothes.

At that point a tall well-dressed man came up and in an unemotional way asked: "Is there a spokesman for this group?" Jon Hendricks said: "Do you have a copy of our demands?" The man said: "Yes but I haven't read it yet." The artists continued to put on their clothes, ignoring the man, and left the museum.

NB: - According to one witness, about two minutes into the performance one of the guards was overheard to say: "I am calling the police!"
- According to another witness, two policemen arrived on the scene after the artists had left.

New York, November 18, 1969
GUERRILLA ART ACTION GROUP
Jon Hendricks
Poppy Johnson
Silvianna
Jean Toche

A Call for the Immediate Resignation of All the Rockefellers from the Board of Trustees of The Museum of Modern Art. Guerrilla Art Action Group (Jon Hendricks, Poppy Johnson, Silvianna, and Jean Toche), New York, November 10, 1969. Courtesy Jon Hendricks.

Communiqué. Guerrilla Art Action Group, New York, November 18, 1969. Courtesy Jon Hendricks.

people. No minority has the right to control them; therefore, a board of trustees chosen on a financial basis must be eliminated.

2. Admission to all museums should be free at all times and they should be open evenings to accommodate working people.

3. All museums should decentralize to the extent that their activities and services enter Black, Puerto Rican and all other communities. They should support events with which these communities can identify and control. They should convert existing structures all over the city into relatively cheap, flexible branch-museums or cultural centres that could not carry the stigma of catering only to the wealthier sections of society.

4. A section of all museums under the direction of Black and Puerto Rican artists should be devoted to showing the accomplishments of

Black and Puerto Rican artists, particularly in those cities where these (or other) minorities are well represented.

5. Museums should encourage female artists to overcome centuries of damage done to the image of the female as an artist by establishing equal representation of the sexes in exhibitions, museum purchases and on selection committees.

6. At least one museum in each city should maintain an up-to-date registry of all artists in their area, that is available to the public.

7. Museum staffs should take positions publicly and use their political influence in matters concerning the welfare of artists, such as rent control for artists' housing, legislation for artists' rights and whatever else may apply specifically to artists in their area. In particular, museums, as

central institutions, should be aroused by the crisis threatening man's survival and should make their own demands to the government that ecological problems be put on a par with war and space efforts.

8. Exhibition programs should give special attention to works by artists not represented by a commercial gallery. Museums should also sponsor the production and exhibition of such works outside their own premises.

9. Artists should retain a disposition over the destiny of their work, whether or not it is owned by them, to ensure that it cannot be altered, destroyed, or exhibited without their consent.

B. UNTIL SUCH TIME AS A MINIMUM INCOME IS GUARANTEED FOR ALL PEOPLE, THE ECONOMIC POSITION OF ARTISTS SHOULD BE IMPROVED IN THE FOLLOWING WAYS:

1. Rental fees should be paid to artists or their heirs for all work exhibited where admissions are charged, whether or not the work is owned by the artist.

2. A percentage of the profit realized on the re-sale of an artist's work should revert to the artist or his heirs.

3. A trust fund should be set up from a tax levied on the sales of the work of dead artists. This fund would provide stipends, health insurance, help for artists' dependents and other social benefits.

Sol LeWitt

Sol LeWitt, "Some Points Bearing on the Relationship of Works of Art to Museums and Collectors" (1969), in Alicia Legg, ed., *Sol LeWitt*. New York: The Museum of Modern Art, 1978, p. 172.

SOME POINTS BEARING ON THE RELATIONSHIP OF WORKS OF ART TO MUSEUMS AND COLLECTORS

1. A work of art by a living artist would still be the property of the artist. A collector would, in a sense, be the custodian of that art.

2. The artist would be consulted when his work is displayed, reproduced, or used in any way.

3. The museum, collector, or publication would compensate the artist for use of his art. This is a rental, beyond the original purchase price. The rental could be nominal; the principle of a royalty would be used.

4. An artist would have the right to retrieve his work from a collection if he compensates the purchaser with the original price or a mutually agreeable substitute.

5. When a work is resold from one collector to another, the artist would be compensated with a percentage of the price.

6. An artist should have the right to change or destroy any work of his as long as he lives.

Sol LeWitt

Sol LeWitt, "Some Points Bearing on The Museum of Modern Art and its Relationship to Artists and the General Community" (1969), in Alicia Legg, ed., *Sol LeWitt*. New York: The Museum of Modern Art, 1978, p.172.

SOME POINTS BEARING ON THE MUSEUM OF MODERN ART AND ITS RELATIONSHIP TO ARTISTS AND THE GENERAL COMMUNITY

1. The MoMA would be limited to collecting work no more than 25 years old.

2. Older work would be sold and the proceeds used to maintain a truly modern collection.

3. The shows should reflect an interest in and the promotion of modern works of art.

4. A system of branch museums would awaken interest in modern art in the communities of the city. More exhibition space would then be available and curators would be responsive to elements within the community.

5. The museum could not only purchase work but also commission works of painting, sculpture, film, dance, music, and drama and use its facilities to show them.

6. The works of artists not usually shown or works of art not readily available because of size or location should be encouraged and shown.

HOW MANY WOMEN HAD ONE-PERSON EXHIBITIONS AT NYC MUSEUMS LAST YEAR?

Guggenheim 0
Metropolitan 0
Modern 1
Whitney 0

SOURCE ART IN AMERICA ANNUAL 1985-86 A PUBLIC SERVICE MESSAGE FROM **GUERRILLA GIRLS**

How Many Women Had One-Person Exhibitions at NYC Museums Last Year? (1985). From the portfolio *Guerrilla Girls Talk Back: The First Five Years,* 1985–90. Photolithograph, sheet 16 15/16 x 21 15/16" (43.1 x 55.8 cm).

Daniel Buren

Daniel Buren, "Function of the Museum" (1970), in AA Bronson and Peggy Gale, eds., *Museums by Artists*. Translation by Laurent Sauerwein. Toronto: Art Metropole, 1983, pp. 57–74. [First published in *Daniel Buren*. Oxford: Museum of Modern Art, 1973, n.p.]

FUNCTION OF THE MUSEUM[1]
Privileged place with a triple role:

1. Aesthetic. The Museum is the frame and effective support upon which work is inscribed/composed. It is at once the centre in which the action takes place and the single (topographical and cultural) viewpoint for the work.

2. Economic. The Museum gives a sales value to what it exhibits, has privileged/selected. By preserving or extracting it from the common-place, the Museum promotes the work socially, thereby assuring its exposure and consumption.

3. Mystical. The Museum/Gallery instantly promotes to "Art" status whatever it exhibits with conviction, i.e. habit, thus diverting in advance any attempt to question the foundations of art without taking into consideration the place from which the question is put. The Museum (the Gallery) constitutes the mystical body of Art.

It is clear that the above three points are only there to give a general idea of the Museum's role. It must be understood that these roles differ in intensity depending on the Museums (Galleries) considered, for socio-political reasons (relating to art or more generally to the system).

I. PRESERVATION
One of the initial (technical) functions of the Museum (or Gallery) is preservation. (Here a distinction can be made between the Museum and the Gallery although the distinction seems to be becoming less clear-cut: the former generally buys, preserves, collects, in order to exhibit; the latter does the same in view of resale. This function of preservation perpetuates the idealistic nature of all art since it claims that art is (could be) eternal. This idea, among others, dominated the 19th century, when public museums were created approximately as they are still known today.

Painted things are generally attitudes, gestures, memories, copies, imitations, transpositions, dreams, symbols … set/fixed on the canvas arbitrarily for an indefinite period of time. To emphasize this illusion of eternity or timelessness, one has to preserve the work itself (physically fragile: canvas, stretcher, pigments etc.) from wear. The Museum was designed to assume this task, and by appropriate artificial means to preserve the work, as much as possible, from the effects of time—work which would otherwise perish far more rapidly. It was/is a way—another—of obviating the temporality/fragility of a work of art by artificially keeping it "alive", thereby granting it an appearance of immortality which serves remarkably well the discourse which the

prevalent ideology attaches to it. This takes place, it should be added, with the author's i.e. the artist's delighted approval.

Moreover, this conservatory function of the Museum, which reached its highest point during the 19th century and with Romanticism, is still generally accepted today, adding yet another paralysing factor. In fact nothing is more readily preserved than a work of art. And this is why 20th century art is still so dependent on 19th century art since it has accepted, without a break, its system, its mechanisms and its function (including Cézanne and Duchamp) without revealing one of its main alibis, and furthermore, accepting the exhibition framework as self-evident. We can once again declare that the Museum makes its "mark", imposes its "frame" (physical and moral) on everything that is exhibited in it, in a deep and indelible way. It does this all the more easily since *everything that the Museum shows is only considered and produced in view of being set in it.*

Every work of art already bears, implicitly or not, the trace of a gesture, an image, a portrait, a period, a history, an idea … and is subsequently preserved (as a souvenir) by the Museum.

II. COLLECTION
The Museum not only preserves and therefore perpetrates, but also collects. The aesthetic role of the Museum is thus enhanced since it becomes the single viewpoint (cultural and visual) from which works can be considered, an enclosure where art is born and buried, crushed by the very frame which presents and constitutes it. Indeed, collecting makes simplifications possible and guarantees historical and psychological weight which reinforce the predominance of the support (Museum/Gallery) inasmuch as the latter is ignored. In fact, the Museum/Gallery has a history, a volume, a physical presence, a cultural weight quite as important as the support on which one paints, draws. (By extension, this naturally applies to any sculpted material, transported object or discourse inscribed in the Museum.) On another level, let us say social, collecting serves to display different works together, often very unalike, from different artists. This results in creating or opposing different "schools"/"movements" thereby cancelling certain interesting questions lost in an exaggerated mass of answers. The collection can also be used to show a single artist's work, thus producing a "flattening" effect to which the work aspired anyway, having been exclusively conceived—willingly or not—in view of the final collection.

In summary, the collection in a Museum operates in two different but parallel ways, depending on whether one considers a group or a one-man show.[2]

A. In the case of a confrontation of works by different artists the Museum imposes an amalgam of unrelated things among which chosen works are emphasized. These chosen works are given an impact which is only due to their context-collection. Let it be clear that the collection we are speaking of and the selection it leads to are obviously economically motivated. The Museum collects the better to

isolate. But this distinction is false as the collection forces into comparison things which are often incomparable, consequently producing a discourse which is warped from the start, and to which no one pays attention (cf. Introduction to "Beware!").

B. In collecting and presenting the work of a single artist (one-man show) the Museum stresses differences within a single body of work and insists (economically) on (presumed) successful works and (presumed) failures. As a result, such shows set off the "miraculous" aspect of "successful" works. And the latter therefore also give a better sales value to juxtaposed weaker works. This is the "flattening" effect we mentioned above, the aim of which is both cultural and commercial.

III. REFUGE

The above considerations quite naturally lead to the idea, close to the truth, that the Museum acts as a refuge. And that without this refuge, no work can "exist". The Museum is an asylum. The work set in it is sheltered from the weather and all sorts of dangers, and most of all protected from any kind of questioning. The Museum selects, collects and protects. All works of art are made in order to be selected, collected and protected *(among other things from other works which are, for whatever reasons, excluded from the Museum)*. If the work takes shelter in the Museum-refuge, it is because it finds there its comfort and its frame; a frame which one considers as natural, while it is merely historical. That is to say, a frame necessary to the works set in it (necessary to their very existence). This frame does not seem to worry artists who exhibit continually without ever considering the problem of the place in which they exhibit.

Whether the place in which the work is shown imprints and marks this work, whatever it may be, or whether the work itself is directly—consciously or not—produced for the Museum, any work presented in that framework, if it does not explicitly examine the influence of the framework upon itself, falls into the illusion of self-sufficiency—or idealism. This idealism (which could be compared to Art for Art's sake) shelters and prevents any kind of break....[3]

In fact every work of art inevitably possesses one or several extremely precise frames. The work is always limited in time as well as in space. By forgetting (purposefully) these essential facts one can pretend that there exists an immortal art, an eternal work ... And one can see how this concept and the mechanisms used to produce it—among other things the function of the Museum as we have very rapidly examined it—place the work of art once and for all above all classes and ideologies. The same idealism also points to the eternal and apolitical Man which the prevalent bourgeois ideology would like us to believe in and preserve.

The non-visibility or (deliberate) non-indication/revelation of the various supports of any work (the work's stretcher, the work's location, the work's frame, the work's stand, the work's price, the work's verso or back etc....) are therefore neither fortuitous nor accidental as one would like us to think.

What we have here is a careful camouflage undertaken by the prevalent bourgeois ideology, assisted by the artists themselves. A camouflage which has until now made it possible to transform "the reality of the world into an image of the world, and History into Nature."

Daniel Buren
New York, 1970

NOTES:
1. It must be quite clear that when we speak of "the Museum" we are also referring to all types of "galleries" in existence and all other places which claim to be cultural centres. A certain distinction between "museum" and "gallery" will be made below. However the impossibility of escaping the concept of cultural location must also be stressed.
2. We are here referring more particularly to contemporary art and its profusion of exhibitions.
3. A detailed demonstration of the various limits and frames which generally constitute a work of art—painting, sculpture, object, ready-made, concept...—has been removed for technical reasons from the original text. However, this subject matter can be found in other texts already published, such as: "Critiques Limites" (a), "Around and about" (b), "Beware!" (c), "Standpoints" (d), "Exposition d'une exposition" (e).
(a) Edited by Yvon Lambert, Paris, October 1970 (text in French)
(b) in *Studio International*, London, June 1971
(c) in *Studio International*, London, March 1970
(d) in *Studio International*, London, April 1971
(e) in catalogue *Documenta V* (text in German and French) 1972.

Daniel Buren

Daniel Buren, "Function of the Studio" (1971), translation by Thomas Repensek, *October* (New York) 10 (Fall 1979), pp. 51–52.

FUNCTION OF THE STUDIO

Of all the frames, envelopes, and limits—usually not perceived and certainly never questioned—which enclose and constitute the work of art (picture frame, niche, pedestal, palace, church, gallery, museum, art history, economics, power, etc.), there is one rarely even mentioned today that remains of primary importance: *the artist's studio*. Less dispensable to the artist than either the gallery or the museum, it precedes both. Moreover, as we shall see, the museum and gallery on the one hand and the studio on the other are linked to form the foundation of the same edifice and the same system. Analysis of the art system must inevitably be carried on in terms of the studio as the *unique space* of production and the museum as the *unique space* of exposition. Both must be investigated as customs, the ossifying customs of art.

What is the function of the studio?

1. It is the place where the work originates.

2. It is generally a private place, an ivory tower perhaps.

3. It is a *stationary* place where *portable* objects are produced.

The importance of the studio should now be apparent; it is the first frame, the first limit, upon which all subsequent frames/limits will depend.

What does it look like, physically, architecturally? The studio is not just any hideaway, any room.[1] Two specific types may be distinguished:

1. The European type, modelled upon the Parisian studio of the turn of the century. This type is usually large and is characterized primarily by its high ceilings (a minimum of 4 metres). Sometimes there is a balcony, to increase the distance between viewer and work. The door allows large works to enter and to exit. Sculptors' studios are on the ground floor, painters' on the top floor. In the latter, the lighting is natural, usually diffused by windows oriented toward the north so as to receive the most even and subdued illumination.[2]

2. The American type,[3] of more recent origin. This type is rarely built according to specification, but, located as it is in reclaimed lofts, is generally much larger than its European counterpart, not necessarily higher, but longer and wider. Wall and floor space are abundant. Natural illumination plays a negligible role, since the studio is lit by electricity both night and day if necessary. There is thus equivalence between the products of these lofts and their placement on the walls and floors of modern museums, which are also illuminated day and night by electricity.

This second type of studio has influenced the European studio of today, whether it be in an old country barn or an abandoned urban warehouse. In both cases, the architectural relationship of studio and museum—one inspiring the other and vice versa—is apparent.[4] (We will not discuss those artists who transform part of their studios into exhibition spaces, nor those curators who conceive of the museum as a permanent studio.)

These are some of the studio's architectural characteristics; let us move on to what usually happens there. A private place, the studio is presided over by the artist-resident, since only that work which he desires and allows to leave his studio will do so. Nevertheless, other operations, indispensable to the functioning of the galleries and museums, occur in this private place. For example, it is here that the art critic, the exhibition organiser, or the museum director or curator may calmly choose among the works presented by the artist those to be included in this or that exhibition, this or that collection, this or that gallery. The studio is thus a convenience for the organizer: he may compose his exhibition according to his own desire (and not that of the artist, although the artist is usually perfectly content to leave well enough alone, satisfied with the prospect of an exhibition). Thus chance is minimized, since the organizer has not only selected the artist in advance, but also selects the works he desires in the studio itself. The studio is thus also a boutique where we find ready-to-wear art.

Before a work of art is publicly exhibited in a museum or gallery, the studio is also the place to which critics and other specialists may be invited in the hope that their visits will release certain works from this, their purgatory, so that they may accede to a state of grace on public (museum/gallery) or private (collection) walls. Thus the studio is a place of multiple activities: production, storage, and finally, if all goes well, distribution. It is a kind of commercial depot.

Thus the first frame, the studio, proves to be a filter which allows the artist to select his work screened from public view, and curators and dealers to select in turn that work to be seen by others. Work produced in this way makes its passage, in order to exist, from one refuge to another. It should therefore be portable, manipulable if possible, by whoever (except the artist himself) assumes the responsibility of removing it from its place of origin to its place of promotion. A work produced in the studio must be seen, therefore, as an object subject to infinite manipulation. In order for this to occur, from the moment of its production the work must be isolated from the real world. All the same, it is in the studio and only in the studio that it is closest to its own reality, a reality from which it will continue to distance itself. It may become what even its creator had not anticipated, serving instead, as is usually the case, the greater profit of financial interests and the dominant ideology. It is therefore only in the studio that the work may be said to belong.

The work thus falls victim to a mortal paradox from which it cannot escape, since its purpose implies a progressive removal from its own reality, from its origin. If the work of art remains in the studio, however, it is the artist that risks death … from starvation.

The work is thus totally foreign to the world into which it is welcomed (museum, gallery, collection). This gives rise to the ever-widening gap between the work and its place (and not its *placement*), an abyss which, were it to become apparent, as sooner or later it must, would hurl the entire parade of art (art as we know it today and, 99% of the time, as it is made) into historical oblivion. This gap is tentatively bridged, however, by the system which makes acceptable to ourselves as public, artist, historian, and critic, the convention that establishes the museum and the gallery as inevitable neutral frames, the unique and definitive locales of art. Eternal realms for eternal art!

The work is made in a specific place which it cannot take into account. All the same, it is there that it was ordered, forged, and only there may it be truly said to be in place. The following contradiction becomes apparent: it is impossible by definition for a work to be seen in place; still, the place where we see it influences the work even more than the place in which it was made and from which it has been cast out. Thus when the work is in place, it does not take place (for the public), while it takes place (for the public) only when not in place, that is, in the museum.

Expelled from the ivory tower of its production, the work ends up in another, which, while foreign, only reinforces the sense of comfort the work acquires by taking shelter in a citadel which insures that it will survive its passage. The work thus passes—and it can only exist in this way, predestined as it is by the imprint of its place of origin—from one enclosed place/frame, the world of the artist, to another, even more closely confined: the world of art. The alignment of works on museum walls gives the impression of a cemetery: whatever they say, wherever they come from, whatever their meanings may be, this is where they all arrive in the end, where they are lost. This loss is relative, however, compared to the total oblivion of the work that never emerges from the studio!

Thus, the unspeakable compromise of the portable work.

The status of the work that reaches the museum is unclear: it is at the same time in place and in *a* place which is never its own. Moreover, the place for which the work is destined is not defined by the work, nor is the work specifically intended for a place which preexists it and is, for all practical purposes, unknown.

For the work to be in place without being specially placed, it must either be identical to all other existing works, and those works in turn identical among themselves, in which case the work (and all other identical works) may travel and be placed at will; or the frame (museum/gallery) that receives the original work and all other original—that is, fundamentally heterogeneous—works must be adjustable, adapting itself to each work perfectly, to the millimeter.

From these two extremes, we can only deduce such extreme, idealizing, yet interesting formulations as:

1. All works of art are absolutely the same, wherever and whenever produced, by whatever artist. This would explain their identical arrangement in thousands of museums around the world, subject to the vagaries of curatorial fashion;

2. All works of art are absolutely different, and if their differences are respected and hence both implicitly and explicitly legible, every museum, every room in every museum, every wall and every square meter of every wall, is perfectly adapted to every work.

The symmetry of these propositions is only apparent. If we cannot conclude logically that all works of art are the same, we must acknowledge at least that they are all installed in the same manner, according to the prevailing taste of a particular time. If on the other hand we accept the uniqueness of each work of art, we must also admit that no museum ever totally adapts itself to the work; pretending to defend the uniqueness of the work, the museum paradoxically acts as if this did not exist and handles the work as it pleases.

To edify ourselves with two examples among many, the administration of the Jeu de Paume in Paris has set Impressionist paintings into the museum's painted walls, which thereby directly frame the paintings. Eight thousand kilometers away at the Art Institute of Chicago paintings from the same period and by the same artists are exhibited in elaborate carved frames, like onions in a row.

Does this mean that the works in question are absolutely identical, and that they acquire their specific meanings only from the intelligence of those who present them? That the "frame" exists precisely to vary the absolute neutrality of all works of art? Or does it mean that the museum adapts itself to the specific meaning of each work? Yet we may ask how it is that, seventy years after being painted, certain canvases by Monet, for example, should be recessed into a salmon-colored wall in a building in Paris, while others in Chicago are encased in enormous frames and juxtaposed with other Impressionist works.

If we reject numbers 1 and 2 proposed above, we are faced with a third, more common alternative that presupposes a necessary relationship between the studio and the museum such as we know it today. Since the work which remains in the studio is a nonentity, if the work is to be made, not to mention seen in another place, in any place whatsoever, either of two conditions must apply; either,

1. The definitive place of the work must be the work itself. This belief or philosophy is widely held in artistic circles, even though it dispenses with all analysis of the physical space in which the work is viewed, and consequently of the system, the dominant ideology, that controls it as much as the specific ideology of art. A reactionary theory if ever there was one: while feigning indifference to the system, it reinforces it, without even having to justify itself, since by definition (the definition advanced by this theory's proponents) the space of the museum has no relation to the space of the work; or

2. The artist, imagining the place where his work will come to grief, is led to conceive all possible situations of every work (which is quite impossible), or a typical space (this he does). The result is the predictable cubic space, uniformly lit, neutralized to the extreme, which characterizes the museum/gallery of today. This state of affairs consciously or unconsciously compels the artist to banalize his own work in order to make it conform to the banality of the space that receives it.

By producing for a stereotype, one ends up of course fabricating a stereotype, which explains the rampant academicism of contemporary work, dissimulated as it is behind apparent formal diversity.

In conclusion, I would like to substantiate my distrust of the studio and its simultaneously idealizing and ossifying function with two examples that have influenced me. The first is personal, the second historical.

1. While still very young—I was seventeen at the time—I undertook a study of Provençal painting from Cézanne to Picasso with particular attention given to the influence of geography on works of art. To accomplish my study, I not only traveled throughout southeastern France but also visited a large number of artists, from the youngest to

the oldest, from the obscure to the famous. My visits afforded me the opportunity to view their work in the context of their studios. What struck me about all their work was first its diversity, then its quality and richness, especially the sense of reality, that is, the "truth," that it possessed, whoever the artist and whatever his reputation. This "reality/truth" existed not only in terms of the artist and his work space but also in relation to the environment, the landscape.

It was when I later visited, one after the other, the exhibitions of these artists that my enthusiasm began to fade, and in some cases disappear, as if the works I had seen were not these, nor even produced by the same hands. Torn from their context, their "environment," they had lost their meaning and died, to be reborn as forgeries. I did not immediately understand what had happened, nor why I felt so disillusioned. One thing was clear, however: deception. More than once I revisited certain artists, and each time the gap between studio and gallery widened, finally making it impossible for me to continue my visits to either. Although the reasons were unclear, something had irrevocably come to an end for me.

I later experienced the same disillusion with friends of my own generation, whose work possessed a "reality/truth" that was clearly much closer to me. The loss of object, the idea that the context of the work corrupts the interest that the work provokes, as if some energy essential to its existence escapes as it passes through the studio door, occupied all my thoughts. This sense that the main point of the work is lost somewhere between its place of production and place of consumption forced me to consider the problem and significance of the work's *place*. What I later came to realize was that it was the reality of the work, its "truth," its relationship to its creator and place of creation, that was irretrievably lost in this transfer. In the studio we generally find finished work, work in progress, abandoned work, sketches—a collection of visible evidence viewed simultaneously that allows an understanding of process; it is this aspect of the work that is extinguished by the museum's desire to "install." Hasn't the term *installation* come to replace *exhibition*? In fact, isn't what is installed close to being established?

2. The only artist who has always seemed to me to exhibit real intelligence in his dealings with the museum system and its consequences, and who moreover sought to oppose it by not permitting his works to be fixed or even arranged according to the whim of some departmental curator, is Constantin Brancusi. By disposing of a large part of his work with the stipulation that it be preserved in the studio where it was produced, Brancusi thwarted any attempt to disperse his work, frustrated speculative ventures, and afforded every visitor the same perspective as himself at the moment of creation. He is the only artist who, in order to preserve the relationship between the work and its place of production, dared to present his work in the very place where it first saw light, thereby short-circuiting the museum's desire to classify, to embellish, and to select. The work is seen, for better or worse, as it was conceived. Thus, Brancusi is also the only artist to preserve what the museum goes to great lengths to conceal; the banality of the work.

It might also be said—but this requires a lengthy study of its own—that the way in which the work is anchored in the studio has nothing whatsoever to do with the "anchorage" to which the museum submits every work it exhibits. Brancusi also demonstrates that the so-called purity of his works is no less beautiful or interesting when seen amidst the clutter of the studio—various tools; other works, some of them incomplete, others complete—than it is in the immaculate space of the sterilized museum.[5]

The art of yesterday and today is not only marked by the studio as an essential, often unique, place of production; it proceeds from it. All my work proceeds from its extinction.

Daniel Buren
1971

NOTES:

1. I am well aware that, at least at the beginnings of and sometimes throughout their careers, all artists must be content with squalid hovels or ridiculously tiny rooms; but I am describing the studio as an archetype. Artists who maintain ramshackle work spaces despite their drawbacks are obviously artists for whom the *idea* of possessing a studio is a necessity. Thus they often dream of possessing a studio very similar to the archetype described here.

2. Thus the architect must pay more attention to the lighting, orientation, etc., of the studio than most artists ever pay to the exhibition of their works once they leave the studio!

3. We are speaking of the New York, since the United States, in its desire to rival and to supplant the long lamented "School of Paris," actually reproduced all its defects, including the insane centralization which, while ridiculous on the scale of France or even Europe, is absolutely grotesque on the scale of the United States, and certainly antithetical to the development of art.

4. The American museum with its electric illumination may be contrasted with its European counterpart, usually illuminated by natural light thanks to a profusion of skylights. Some see these as opposites, when in fact they merely represent a stylistic difference between European and American production.

5. Had Brancusi's studio remained in the Impasse Ronsin, or even in the artist's house (even if removed to another location), Brancusi's argument would only have been strengthened. (This text was written in 1971 and refers to the reconstruction of Brancusi's studio in the Museum of Modern Art, Paris. Since then, the main buildings have been reconstructed in front of the Centre Beaubourg, which renders the above observation obsolete—author's note.)

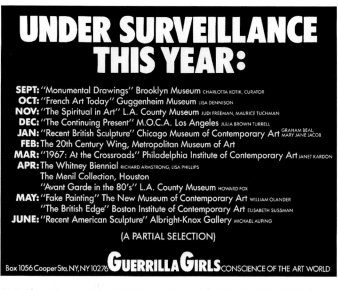

UNDER SURVEILLANCE THIS YEAR:

SEPT: "Monumental Drawings" Brooklyn Museum CHARLOTTA KOTIK, CURATOR
OCT: "French Art Today" Guggenheim Museum LISA DENNISON
NOV: "The Spiritual in Art" L.A. County Museum JUDI FREEMAN, MAURICE TUCHMAN
DEC: "The Continuing Present" M.O.C.A. Los Angeles JULIA BROWN TURRELL
JAN: "Recent British Sculpture" Chicago Museum of Contemporary Art GRAHAM BEAL, MARY JANE JACOB
FEB: The 20th Century Wing, Metropolitan Museum of Art
MAR: "1967: At the Crossroads" Philadelphia Institute of Contemporary Art JANET KARDON
APR: The Whitney Biennial RICHARD ARMSTRONG, LISA PHILLIPS
The Menil Collection, Houston
"Avant Garde in the 80's" L.A. County Museum HOWARD FOX
MAY: "Fake Painting" The New Museum of Contemporary Art WILLIAM OLANDER
"The British Edge" Boston Institute of Contemporary Art ELISABETH SUSSMAN
JUNE: "Recent American Sculpture" Albright-Knox Gallery MICHAEL AUPING

(A PARTIAL SELECTION)

Box 1056 Cooper Sta. NY, NY 10276 **GUERRILLA GIRLS** CONSCIENCE OF THE ART WORLD

Under Surveillance this Year (1986). From the portfolio *Guerrilla Girls Talk Back: The First Five Years,* 1985–90. Photolithograph, sheet 16 15/16 x 21 15/16" (43.1 x 55.8 cm).

Robert Smithson

Robert Smithson, "Cultural Confinement" (1972), in Jack Flam, ed., *Robert Smithson: The Collected Writings.* Berkeley: University of California Press, 1996, pp. 154–155. [First published in *Artforum* (October 1972) and in the catalogue *Documenta 5* (1972).]

CULTURAL CONFINEMENT

Cultural confinement takes place when a curator imposes his own limits on an art exhibition, rather than asking an artist to set his limits. Artists are expected to fit into fraudulent categories. Some artists imagine they've got a hold on this apparatus, which in fact has got a hold of them. As a result, they end up supporting a cultural prison that is out of their control. Artists themselves are not confined, but their output is. Museums, like asylums and jails, have wards and cells—in other words, neutral rooms called "galleries." A work of art when placed in a gallery loses its charge, and becomes a portable object or surface disengaged from the outside world. A vacant white room with lights is still a submission to the neutral. Works of art seen in such spaces seem to be going through a kind of esthetic convalescence. They are looked upon as so many inanimate invalids, waiting for critics to pronounce them curable or incurable. The function of the warden-curator is to separate art from the rest of society. Next comes integration. Once the work of art is totally neutralized, ineffective, abstracted, safe, and politically lobotomized it is ready to be consumed by society. All is reduced to visual fodder and transportable merchandise. Innovations are allowed only if they support this kind of confinement.

Occult notions of "concept" are in retreat from the physical world. Heaps of private information reduce art to hermeticism and fatuous

metaphysics. Language should find itself in the physical world, and not end up locked in an idea in somebody's head. Language should be an ever developing procedure and not an isolated occurrence. Art shows that have beginnings and ends are confined by unnecessary modes of *representation* both "abstract" and "realistic." A face or a grid on a canvas is still a representation. Reducing representation to writing does not bring one closer to the physical world. Writing should generate ideas into matter, and not the other way around. Art's development should be dialectical and not metaphysical.

Marcel Broodthaers

Marcel Broodthaers, in Benjamin H. D. Buchloh, "Contemplating Publicity: Marcel Broodthaers' Section Publicité," in Maria Gilissen and Benjamin H. D. Buchloh, eds., *Marcel Broodthaers: Section Publicité du Musée d'art Moderne Département des Aigles.* New York: Marian Goodman Gallery, 1995, p. 89. [Quote first published in Irmeline Lebeer, "Musées personelles," in *Chroniques de l'art vivant* (Paris) 35 (December 1972/January 1973), p. 21.]

The structure within which an artist produces will always determine the artistic event created under these circumstances, and it is always the latter that will win.… As a result, I am against the museum as a center of research for avant garde art. The museum should emphasize its role as being strictly a place of conservation. The centers of contemporary research are enterprises of ideological confusion, destined to transform art into some kind of Olympic Games.… Long live the art fair, there at least things are clear and evident.

Donald Judd

Donald Judd, "Complaints: Part II," in Donald Judd, *Complete Writings 1959–1975.* Halifax: Press of the Nova Scotia College of Art and Design; New York: New York University Press, 1975, p. 208. [Originally published in *Arts Magazine* 47, no. 5 (March 1973), pp. 30–32.]

The museums are charities that are monuments to the rich. The increase in the number of museums is evidently not so much an increase in interest in contemporary art as it is an increase in an idea of monuments. As a monument the building is crucial and not its contents. Whether private, partially public, or public, a museum is run by its benefactors and everything goes downhill from there. The museums are always doing artists the favor of showing their work. It's an honor to be associated with the company and don't ask for a raise. Museums want to be given work or pay very little because, after all, you're the suppliant. There's almost no sign of support or interest in getting work done. If any purpose is mentioned it's that the museums are educating the public. Museums are show business paid for by the artists and the dealers.

The museums patronize, isolate, and neutralize artists. When I received the press release from the Guggenheim Museum in April, 1971, about the cancellation of Hans Haacke's show I thought it a classic case

of self-indictment. The two main paragraphs are worth printing.

"The contents of the exhibition were to include presentations that in the view of counsel might raise legal objections and in view of the Foundation's trustees would run counter to established policies that exclude active engagement toward social and political ends."

"We have held consistently that under our Charter we are pursuing creative and educational objectives that are self-sufficient and without ulterior motive," Thomas M. Messer, director of the museum states. "We have high regard for Mr. Haacke as an artist and regret that agreement could not be reached on a manner of presenting his ideas."

I sent this letter to Tom Messer.

"I got your press release and a copy of your letter to Haacke and his statement. You made a big mistake. You can't refuse to show one kind of art. Any political statement, either by declaration or incorporation into a context, can be art. You renege on every kind of art when you refuse to show a kind that is political. I've always thought that most museums and collectors didn't understand what they were buying; your statement that exhibitable art should be generalized and symbolic confirms that. I'm interested in making so-called abstract art and I don't like the idea that it is exhibitable by virtue of its abstractness or unintelligibility. Since the big business in New York is real estate, it's pretty interesting that that's what bothers you, the lawyers and your trustees. I imagine something against the war would have been general enough and easy enough."

The Guggenheim tried to get me to lend a piece after that and two memorable ideas in that conversation were that I shouldn't harm the institution and that the role of the staff is that of mediators between the artists and the trustees. Other than a great building and shows of contemporary art it's hard to find the institution. I wasn't surprised at the second idea.

The museums never have much money for contemporary art but they have millions for fancy buildings. As most people know Pasadena spent 3 million or so on an awful building and then couldn't afford anything to put in it, and in fact, I think, had to sell some things and close a couple of days a week. The new Walker Art Center, which isn't unpleasant, cost about 4.5 million. Their budget for art has never sounded like that. While the museum was being built, its director, Martin Friedman, talked about the possibilities of the building; things could go outside; a piece of mine could go on the wall of the central highest section, which didn't seem like a good idea. As the building was being finished he asked me to come to Minneapolis and figure out what I wanted to do. I wanted to make a new piece that would go along the edge of one of the lower sections involving the angle between it and the opposite side of the street below. The piece, maybe 20 feet long, would replace the balustrade. After all that talk it took Friedman a second to dismiss the idea. It was unsafe, although it would be hard to get through the piece, and it would interfere with Ed

Barnes's architecture. Friedman called Barnes just to make sure, and sure enough it was unsafe and would interfere. I consider the chance to make a new piece by a good artist very important. To be fair, I should say that Martin Friedman is one of the best directors, that the installation of shows at the Walker is good, and that the museum is fairly careful with works. However the incident has the quality of liberalism, that is, smiling conservatism.

It's Even Worse in Europe (1986). From the portfolio *Guerrilla Girls Talk Back: The First Five Years,* 1985–90. Photolithograph, sheet 16 15/16 x 21 15/16" (43.1 x 55.8 cm).

Joseph Beuys

Frans Haks, "Interview with Joseph Beuys," in *Museum in Motion?: The Modern Art Museum at Issue.* Amsterdam: Government Publishing Office in association with the Stedelijk Museum, 1979, pp. 184–192.

FRANS HAKS: A lot has already been written about your work as an artist, so now I should like to talk to you about its implications for museums and how you think a museum ought to function. Have you found that museums generally stick to their traditional role, or have they adapted to the more ambitious aims of some contemporary artists?

JOSEPH BEUYS: Well, I can only say that museums have tried to adapt as well as possible to the wishes of present-day artists. It's only fair to say that. Some museums, of course, have been less active in this respect, while others have been extremely progressive. But generally speaking, the museums and other cultural institutions that put on exhibitions and so on have endeavored to a greater or lesser degree to keep pace with new developments. I think the fact that new art forms such as "action art", "land art", "conceptual art", etc. have been exhibited more or less successfully in museums speaks for itself.

F.H. You are active in various fields. Firstly there is your work at the academy—in other words, your teaching; then there are your political activities, and of course your objects and drawings. Should these fields be considered separately, or as different modes of adaptation to various social strata?

J.B. No, they aren't separate, but I should mention that one area—my objects and drawings—is only just being exhibited for the first time. Part of my work, you see, has been purely traditional. Though it may have taken more or less revolutionary artistic form, I recognise that my innovations in this sphere (my objects, my action art etc.) are in the established tradition and can be exhibited in a traditional manner. But as to what you said just now about a broader concept of art with political dimensions, including plans for adult education or even the economy—well, that's more than present-day museums can cope with. I can pursue this objective anywhere but in a museum, because there it's so often misconstrued. All the same, I've been able to impart some information about this broader concept of art in museums too; in the museum in Dublin, for instance, I had an excellent opportunity to tell people about this idea, and about the need for establishing a completely totalised concept of art and setting up institutions for its promotions. But you can only do that occasionally.

F.H. What does it depend on?

J.B. On the personality and character of those who organize the museum, and whether or not they get what they want.

F.H. Is that a good or a bad thing, do you think?

J.B. One has to take a positive attitude wherever possible. If a museum that has always been completely traditional suddenly decides to present a totalised concept of art, I'd say it's undergone an inner change, at least temporarily. The question is, of course, whether this is simply an isolated venture or something that will change its style completely in the future. Sometimes it's quite definitely just an isolated occasion after which the museum reverts to its old function. But this doesn't seem to me to be a question of museums, but of places. Any place will do where something can happen to broaden the concept, whether it's in parliament, in church, in a museum, in the street, in a commune, in a working class neighbourhood or in a factory. I welcome any place where people are prepared to set the scene for something to happen which will promote the future evolution of culture, democracy and the economy. And occasionally a museum takes part in such positive campaigns too.

F.H. Do you mean there can never be an ideal museum, since a museum that wished to achieve its objectives as completely as possible would have to include your political and educational activities?

J.B. Yes that's a big problem, a very big problem …

F.H. I can imagine an ideal exhibition or collection in which everything was incorporated.

J.B. Oh, certainly, it's always a good thing for us to demand that the museum should aim at functioning on a broader basis and present all cultural manifestations and all the problems of society within its walls. But we must realise that this will change its very nature. Certainly it'll be a change for the better, but the museum will no longer be a museum, but a university. And that's what I want. I want to make museums into universities, with a department for objects.

F.H. Do you regard a university as a better institution than a museum?

J.B. Yes, because in a university there is an interdisciplinary relation between all the fields of human activity, and this interdisciplinary relation is capable of developing a new concept of art… because it's doubtful whether artists will do so. In my experience, artists have no interest in an interdisciplinary concept of art. Most of them—I'd say about 99% have an interest in perpetuating the traditional concept for selfish reasons: because it suits the style of their work, for instance, or for financial advantage. Few artists are interested in a totalised concept of art which would transform museums into universities and equate the concept of creativity with the possibility of shaping the world. If I have to define my concept of the fundamental meaning of art, it is that the world needs to be shaped by man. But the business of shaping with one's personal talent and creativity concerns not only the artist but also bridge-builders, engineers, doctors; it applies to hospitals, to the building of streets and towns, to creative financing; it applies to production, the market, consumption, agriculture and so on: in fact, to every aspect of our environment. So creativity isn't the monopoly of artists. This is the crucial fact I've come to realise, and this broader concept of creativity is my concept of art. When I say everybody is an artist, I mean everybody can determine the content of life in his particular sphere, whether in painting, music, engineering, caring for the sick, the economy or whatever. All around us the fundamentals of life are crying out to be shaped, or created. But our idea of culture is severely restricted because we've always applied it to art. The dilemma of museums and other cultural institutions stems from the fact that culture is such an isolated field, and that art is even more isolated: an ivory tower in the field of culture surrounded first by the whole complex of culture and education, and then by media—television, radio, the press—which are also part of culture. We have a restricted idea of culture which debases everything; and it's a debased concept of art that has forced museums into their present weak and isolated position. I repeat: our concept of art must be universal and have the interdisciplinary nature of the university, and there must be a university department with a new concept of art and science. But for the time being this concept, as I've said, is an ideal for which we must work, campaign and found institutions, and we've only just started. In this transitional period museums could be an asset, depending on the personality of those in charge of them. You can't say the museum is useless, even a hindrance, because another museum might well be helpful, as those in Dublin and Belfast were. They gave me plenty of scope to campaign

for my political ideas about a broader concept of art, and I've no reason to suppose they won't do so again. I think many museums feel—in fact know—that they should change, and it all depends, as I've said, on those who run them.

The other problem, of course, is the dependence of museums on central and local government authorities. The fact that museums are state institutions presents a political problem, but then schools, universities, the press, television, radio, films and so on also suffer from this dependence: the state's tutelage of culture in general has an equally undesirable effect in museums, universities, schools, the media, right down to the daily papers. You see, we live in a political system where every cultural activity up till now has been dependent on the interests of the state. Since the state often deals and gets involved with economic powers, it often happens that international capitalism, in dominating the state, paralyses and subjugates all cultural initiative. That's why I advocate a free and autonomous education system, a free university, free museums and so on … independent of state tutelage.

F.H. Couldn't the interests of the state change?

J.B. No. The state will always have an interest in retaining its hold and its influence on these institutions. The only thing would be to abolish the state, or make it truly democratic in concept. Then it would simply administer the law and regulate the legislative, judicial and executive authorities that ensure that the laws are kept, right down to the police. But then the police would be different: they'd be an instrument of the people, a democratic executive body responsible for ensuring that democratic legal forms (you notice I use the word forms—another creative concept) are observed. But this is a completely different concept for the state. It would no longer be in charge of cultural activities: the principle of autonomy would be universally accepted in the cultural and democratic spheres, production, consumption and the economic system; the difference being that the democratic forms would then influence everything—but in the best possible way, since they'd be shaped by those who were active in the cultural field. We can talk until we're blue in the face, but until the principles of form are applied to democracy, which is now in a state of chaos, and to the economic principles, which are in a similar state, we shan't achieve culture that will serve man better and therefore have a revolutionary effect. A small museum can do very progressive work if it has a good director. But the director can't free the museum of its legal dependence except by rebelling against the powers that be and, knowing he has the whole populace behind him, proclaiming its independence. Where the funds are to come from—well, that's another question, for we can only finance a museum organically if we have a different system, a different creative economic principle of operation. You see, we've got an economic system that works most undemocratically and egotistically and is quite impervious to the laws of democracy: an anarchistic system—but anarchistic in a negative sense—which has a subversive effect on the whole social organism. So from this point of view one could say that our most urgent need is not to create pictures or sculpture but to shape the economy: that's what needs reforming. And the democratic legal structure, which at present is a shambles, needs re-shaping too. That's my concept of creativity, and in this sense I'm justified in saying that every person is an artist. But only in this sense; in any other it would be a foolish, sentimental statement. Only by trying to apply my concept of art and creativity to everyone and all aspects of society can I totalise it, and this justifies my saying that every person is an artist. I don't mean of course that he's already one, but he's fundamentally capable of becoming one.

F.H. From what you say, even the ideal museum couldn't present your complete work, could it?

J.B. No. While museums are in their present legal and economic position in the social structure as a whole, the ideal museum can't be realised. But I started, you'll remember, with a positive approach and then went on to say that every institution at present is in the same undesirable position. That doesn't mean that I'll refuse to go and give a talk at the primary school next door if I'm invited, because I may possibly be able to do some good there. I can certainly work now for the day when there will be an ideal museum. But if it's going to achieve anything, I've got to think along quite different lines from the present-day museum with its isolated cultural work. Its traditional function is, of course, to promote culture in the narrow sense of the world. It can therefore exhibit new art forms, but on a very restricted basis which is extremely remote from everyday life. Small-scale revolutions in the world of culture displayed on this narrow basis are not enough to bring about the big revolution in the creative principles of society. In order to do this, it's no use revolutionising the disciplines: changing from impressionism to expressionism, for instance, or introducing minimal art, land art, body art and conceptual art; these are traditional revolutions in the same basic trend, which art historians can easily recognise and keep each in its separate pigeon-hole. Such stylistic innovations and revolutions won't suffice to reform the social creative concept. Therefore the logical thing seems to me not only to develop new forms within the disciplines, but to change—transform—the very concept of art. And I believe that can only be done by applying the concept not only to painters, sculptors, writers, musicians and the like, but to everyone. It must become an anthropological concept applicable to every aspect of society.…

F.H. Everyone is an artist—that's one of your visions of the future, isn't it? But if it were realised, wouldn't museums be quite superfluous?

J.B.. Not at all. There'd have to be somewhere where people could go to discuss colour. We'll need specialists in the future too, or there'll be no power, no water, no heating, no teachers, no doctors, only amateurs, that would be awful! I've got nothing against specialists—nothing at all—but I want a man to acquire a completely new faculty that will make him a universalist as well, so that he can assume responsibil-

ity and make decisions in his particular field. But if in the future people want to find out about colours—I don't mean about paints for decorating purposes, but about the imaginative, spiritual, mystical or intellectual aspects of colours—they must go to a museum, because that's where these things have their temple. You notice I've used a word from mythology, because words like shrine and temple have a symbolic meaning in art … that's why art can no longer tackle the problems of life, because it's ceased to radiate religion. Well, in the future people will be able to go to museums again as though they were going to a religious service … they'll be able to concentrate on the intellectual side of human nature which is wholly spiritual, wholly religious: the very thing that gives man human dignity. People will know that colour is capable of doing that, and so they'll return to its temple.

F.H. That means that museums will have the same limited function as they have now—they'll be restricted.

J.B. Only in the sense that they can simply present a single, specialised facet of society. But museums nowadays are divorced—completely removed—from all the problems of the world … that's what museums are like nowadays. The museum of the future—want to draw a genuine antique temple—will permeate every aspect of society. This is a temple to colour—we'll confine ourselves to colour—but the question of colour is tied up with all the others, it's in the midst of life and impregnated with it. Suppose there were a university here that specialised in medicine … there'd be a connection between colour and medicine … we already know such a connection exists, but in the future it'll really be the therapeutic model: it'll be part of the medicine, just as part of medicine will be part of art. But the problem isn't to overcome specialisation—we can't and mustn't do that—at most we can regard it as a problem for the individual … but this brings up a fundamental question: what is human life, what are human beings? You notice immediately that we haven't enough concepts for such a cultural discussion. Nowadays our attitude to man is: he's born—he's here—and suddenly he's gone. We don't ask where he came from or where he goes to. The religious element is lacking—we don't know how men enter the world or how they leave it—these are the unsolved mysteries. But it seems to me they are precisely the subjects that art should deal with, and they've been excluded….

Then human life will be defined right to the end by the concept of art, and not by some technological, foreshortened, materialistic principle of so-called evolution which isn't evolution at all. What's evolving? Only technology, which is growing, getting more complicated, and reaching more and more formidable proportions, and in doing so is crowding out the real values of life, especially art. I'm not opposed in principle to technology, but it must develop as a part of a whole, and only as a part. The fundamental question is: how can the museum and those in charge of it end their isolation and make it the scene of this special kind of creativity that is concerned not only with the plastic arts and music but also with democracy, the economy and production? How can the museum escape from its isolation and look forward to being liberated: a prospect that can only be realised, however, if those [who] run it [are] aware of the fundamental political issue … which is that cultural institutions that are under the jurisdiction of the state aren't really cultural institutions at all.

F.H. Then shouldn't the museum give a regular account of its work so that everyone—in accordance with democratic principles—has the opportunity of objecting?

J.B. No, that's a misconception of democracy. It's impossible for everyone to decree what the museum's to do … No, it's a difficult matter. Obviously it's impossible for everybody to decide—by popular vote, for instance—what the museum shall exhibit; if that happens it'll exhibit nothing at all or a load of rubbish. Because the general public aren't capable of making such a decision. It can only be done by persons with special knowledge of the subject who are capable of making judgments.

F.H. But if you're advocating an institution that will encourage everyone to be an artist, it must be prepared to comply with all the public's requests.

J.B. That's right … but the work that will teach people to be creative and allow every possible new form of art to be exhibited and maintain complete tolerance must be organised by competent persons, or else nothing at all will be achieved … if it's done by democratic procedure nothing at all will get done. It can only be achieved by a number of competent persons who have a clear idea in their minds of the artistic trend and see it as their task to make it understandable to the general public and totalise the concept of art. Only qualified persons can do it—it can't be done by popular vote or democratic procedures. If the organisers can't exhibit the very best art, there's no point in having a museum. On the other hand, to ensure that we continue to progress towards this model, we must be absolutely tolerant in promoting work of whatever style that will enable general evolution to take place. We must be tolerant, and tolerance isn't in itself a democratic quality, it's simply an intellectual attitude which make some say, "I'm not the only one with talent around here. The other fellow's no fool, either". Of course there will also be democratic processes as in factories, where workers' organisations establish their own constitution. The members of a workers' organisation produce their own factory constitution: that's to say, they decide what kind of constitution they want. In that case all the members have a say … in others, a select body deals with specialised matters such as navigation and so on. Decisions can only be made by persons qualified in these special areas, but the constitution must be laid down by everyone. Basic rights must be decided by everyone, but democratic decisions with regard to schools and universities can only be made by select bodies. In the case of a university this means that teachers and students draw up their own regulations and elect new teachers. They also appoint professors and so on.

F.H. Situations like what that where teachers and students make the decisions are in marked contrast to museums and the world of culture, where it seldom or never happens …

J.B. … but it's got to be developed, and that's why I say museums should have students. Suppose a new museum director has to be appointed in Eindhoven. First the qualified staff of the museums in the Netherlands are asked to submit their ideas on the subject, and a vote is taken to decide who is to be the director. But there should also be a body of students—that's why I think museums should be like universities—who also have a say in the matter and can put forward their ideas when these decisions are being made. They should take part in the consultation.

F.H. We haven't got a system like that yet …

J.B. No, we haven't reached that stage yet, but there's no reason why we shouldn't … it's just a matter of wanting it …
(laughs)

Guerrilla Girls Review the Whitney (1987). From the portfolio *Guerrilla Girls Talk Back: The First Five Years*, 1985–90. Photolithograph, sheet 21 ¹⁵⁄₁₆ x 16 ¹⁵⁄₁₆" (55.8 x 43.1 cm).

Donald Judd

Donald Judd, "On Installation" (1982), in Donald Judd, *Complete Writings 1975–1986*. Eindhoven: Stedelijk van Abbemuseum, 1987, pp. 19–24. [First published in *Documenta 7*. Kassel, 1982, pp.164–167.]

ON INSTALLATION

The art museum was first the palace of a failed noble and then a bourgeois copy growing increasingly distant as the new rich grew distant from the disappearing aristocracy and as liberal functions developed, such as the obligations of the new rich to educate those they left behind. Right away it's clear that this has little to do with art. The new rich in the last century, the old rich in this, and the new rich now, are basically middle class. Unlike some of the aristocracy, and of course like many, the present rich, the trustees of the museum, do not intend to know anything about art. Only business. The solution to the problem of having culture without having to think about it is to hire somebody. The rich middle class is bureaucratic, so there's an expert for everything. The result is that there's little pleasure in art and little seriousness for anyone anywhere. A museum is the collection of an institution and it's an anthology. A few anthologies are all right, but some hundred in the United States alone is ridiculous. It's freshman English forever and never no more no literature.

Art is only an excuse for the building housing it, which is the real symbol, precise as chalk screeching on a blackboard, of the culture of the new rich. The new National Gallery is a fine example. It's the apotheosis of the public space. The main exhibition area is leftover space within the solids of a few triangles and a parallelogram, containing offices and boutiques. The power of the central government, the status of the financiers and the mediocre taste of both are dignified by art, much of it done by artists very poor most of their lives. So much money spent on architecture in the name of art, much more than goes to art, is wrong, even if the architecture were good, but it's bad.

The handling and preservation in a museum, which is expected to be careful, is often careless. Sometimes the staff seems to resent the art. Usually the view is that the damage doesn't matter and can be repaired. Even with the best intentions of a director or curator the installation is seldom good because the rooms are not. Always of course the exhibitions are temporary. Finally, the artist lends work, accepts damage to it—insurance is a joke—gives time, and gets next to nothing: "The work is out in the public." The artist should be paid for a public exhibition as everyone is for a public activity.

Some effort has been made by artists to take care of their work. Clyfford Still deserves credit for the installations of his paintings, about thirty each, at the Albright-Knox Art Gallery and The San Francisco Museum of Modern Art and the museums also for accepting the responsibility. Recently Henry Moore has given work to Toronto and Rufino Tamayo has made a museum in Ciudad Mexico. There are examples in Europe of museums made after an artist's death and of enterprises such as the chapel by Matisse. There are also Giuseppe

Panza's installations of contemporary art which are meant to be permanent. In the United States there is the so called Rothko Chapel. But of all the great and very good art done in the United States in the last forty years very little can be seen. From 1946 to 1966 an exceptional amount of good art was done in New York City. A visitor now can see only two or three paintings each by Newman, Pollock, Rothko, de Kooning, Kline, Guston, Reinhardt, David and others and usually none by less inventive artists, still good, such as James Brooks, if the visitor goes to four museums, the Modern, the Whitney, the Guggenheim, and the Metropolitan. And then there's a list of younger artists. It is impossible for a visitor to acquire the knowledge of the excellence, variety and extent of the art of this period that someone has who was in New York during this time. The three museums, not the Metropolitan, may be comprehensive as anthologies but they are not comprehensive in relation to what was done. Most of the work of that twenty years has been sold out of New York, much out of the United States. The art was in no way indigenous to New York and the lack of interest of the people there is proven. That includes the museums. In the late forties and the fifties the proportion of the best contemporary art in the museums was little more than it is now, which is meager.

It's easy to imagine the magnificence of a museum in New York containing a couple of dozen paintings by Pollock or by Newman. It's too late to make such an installation for Pollock, almost for Newman. There are probably enough paintings to do so for Rothko and especially for de Kooning, who fortunately is alive. In 1966 one hundred and twenty paintings by Reinhardt were shown at the Jewish Museum for longer than usual. These probably will never be assembled again and if assembled will not be the same, since almost all have been damaged and extensively restored. In 1966 these paintings should have been hung and never moved again. Reinhardt died the next year. David Smith's sculpture should have been left in the field where he placed it. I never saw the work there and will never see so much together. And as he placed it, not as it was shown, for example, in the stupid recreation of the theater at Spoleto in the National Gallery.

A good installation is too much work and too expensive and if the artist does it, too personal, to then destroy. Paintings, sculptures, and other three-dimensional work cannot withstand the constant installation and removal and shipping. The perpetual show business is beyond the museum's finances and capacities. The show business museum gets built but the art does not, nor even handled well, when the art is the reason for the building. And the architecture is well below and behind the best art. An example of something much better for less money is to have saved Les Halles in Paris, an important deed itself, and then to have given two hundred thousand dollars each, sufficient at the time, to a dozen of the world's best artists to make work to remain forever. This would have been the achievement of the century. Instead Beaubourg was built, an expensive, disproportionate monster, romanticizing the machinery of an oil refinery, not scarce. The building makes change the main characteristic of paintings and sculptures that don't change. The building and the change are just show business, visual comedy....

Millions are spent by the central government for and in the name of art and the same by the semi-public museums. All that money does not produce more first rate art, in fact there is less since the government became involved. And the government is too dangerous to be involved. Money will not make good art; ultimately art cannot be bought. The best artists living now are valuable and not replaceable and so the society should see that their work gets done while they're alive and that the work is protected now and later. If this society won't do this, at least it could revise some of its attitudes, laws and tax laws to make it easier for the artists to do so. Art has no legal autonomy....

Permanent installations and careful maintenance are crucial to the autonomy and integrity of art to its defense, especially now when so many people want to use it for something else. Permanent installations are also important for the development of larger and more complex work. It's not so far from the time of easel painting, still the time of the museum, and the development of the new work is only in the middle of the beginning.

Donald Judd

Donald Judd, "A Long Discussion Not About Masterpieces But Why There Are So Few of Them (Part II)" (1984), in Donald Judd, *Complete Writings 1975–1986*. Eindhoven: Stedelijk van Abbemuseum, 1987, pp. 70–86. [First published in *Art in America* 72 (October 1984), pp. 9–11.]

A LONG DISCUSSION NOT ABOUT MASTERPIECES BUT WHY THERE ARE SO FEW OF THEM (PART II)

Most things happen by accident and continue by convention. The contemporary art museum is one of the most unusual and unlikely of these developments in this century and one of the most rapid. Every city has to have one, as they once had to have cathedrals. Obviously these symbolize culture. They are serious financial efforts. But no one has thought much about them. Their function isn't clear: perhaps to educate, perhaps to collect, mostly just to symbolize. The money has already gone to the bad architecture that degrades its justification; the museums are little support for the art that justifies them. The museum has developed from the collecting of the European nobility, and whether this activity is useful now or even enjoyable is debatable. Also the museums are chronically behind, slowed by art history and uncertain whether they are past or present, so that they are seldom suitable for contemporary art and almost never represent it well. I've written about this elsewhere.... Copious and brilliant work has been dispersed and will never be seen in New York again and never together, either that of one artist or of one period of place, since everything goes to the museums of art anthologies all over the world. Gianfranco Verna says that in Kenya elephants are becoming scarce, so that they may have to be put in zoos to save them. And also the other animals. He thinks this is happening to art. Everything will be in the anthological museums. Nothing will be outside.

The museums primarily assemble their shows from the galleries, which seriously implicates them in commercialism. The dealers have already been to the studios and made the selections. They have preferred art to sell. The museums should try to be independent of the galleries in their judgment and in the search for new artists. Of course most artists are with galleries, but the galleries must be considered as only the business that they are. At present they form too much of the context of art. The directors and curators should be strongly independent. This is their professional identity, their defence, squeezed as they are between the support and interference of the businessmen and the ingratiating insistence of the art business. Their independence would be, next to criticism, the most important defence of art. At present directors and curators blend too well into the bureaucracies around them, perform similarly and advance similarly, with unusual insecurity. They should be more the scholars they're supposed to be. Their integrity should be respected by the trustees and not considered an offence. As some artists are black-listed for being 'difficult' through protecting the integrity of their work, so are some of the people who work in museums. There are always persons sufficiently presumptuous to attempt to tell the artists what to do, but to some extent artists are protected by the aura of the past and by the intrinsic nature of their activity as an individual one. However, museums are new and unclear in function and are mostly the conventional creation of businessmen, so that the people working there are more vulnerable than artists. Also they're vulnerable because their job of judging, writing, and installing exhibitions is impinged upon by other chores, prosaic and social, where they are open to coercion.

Directors and curators constantly fight the trustees, who are resentful and puzzled because they joined the museum board to be culturally benign and powerfully charitable, little knowing that the museum wasn't a settlement house. Directors and curators who won't fight live happily ever after. The exhibition which may have been difficult to do, and new internationally as well as locally, is seen only by that same reporter on 'Living', all forms of it, whose publisher is one of the board members who didn't want the show in the first place. There is no critical and external defence for these exhibitions, again a failure of art criticism and an instance of its parochial nature.

The museums provide some sense of quality in their collections and exhibitions but mainly this is obscured by an increasing emphasis on new art. This should be shown promptly when it's good, but often work is shown merely because it's newly made. Art is encouraged to become fashionable, so that it will seem like the easy entertainment that it is not, which appeals more than plain art to the trustees, and to the public. Art is forced to be somehow educational—educational about itself? It's watered down to educate the public about itself. An uninformed public is supposed to be eager to see the latest work. Education is the big fund raiser. Education is certainly a function of museums but it's not the chief function, which is the collection, care and installation of art. Beyond that, art is the chief function. The emphasis on new artists each year, a new movement every two years, began with the situation in the early '60s when two or three excellent artists first showed each year. These were gathered and labeled and each year there was supposed to be a new movement. Excellent artists nearly ceased to appear but the need and the invention of movements continued, beginning with 'conceptual art' and drifting downwards through 'photo-realism' to the present 'expressionism.' The emphasis on fashion demeans art, which after all includes the philosophical subject of duration. It turns art solely into commerce and consumption. It projects the American condition of advanced adolescence, the myth of youth, upon art, requiring it to become adolescent art for adolescents. This childishness and faithlessness causes some of the neglect of good artists working across decades.

WHAT'S FASHIONABLE, PRESTIGIOUS & TAX-DEDUCTIBLE?

DISCRIMINATING AGAINST WOMEN & NON-WHITE ARTISTS.

THESE CORPORATIONS & FOUNDATIONS SPONSORED...	THESE EXHIBITIONS...	CONTAINING THESE PERCENTAGES:
Owen Cheatham Foundation, The National Endowment for the Arts	"Transformations in Sculpture: Four Decades" 1985. Guggenheim Museum. Diane Waldman, curator	95% men 96% white
Exxon, Grand Marnier Foundation Enichem Americus, Inc., The NEA	"Emerging Artists 1978-1986: Selections from the Exxon Series" 1987. Guggenheim Museum. Diane Waldman, Curator	75% men 98% white
McGraw-Hill Foundation	"Printed Art: A View of Two Decades" 1980 The Museum of Modern Art Riva Castleman, curator	94% men 93% white
The New York State Council on the Arts, The NEA	"Monumental Drawings: Works by Twenty-two Contemporary Americans" 1986. Brooklyn Museum. Charlotta Kotik, curator	82% men 100% white
A.T. & T., The NEA	"International Survey of Recent Painting and Sculpture" 1984. The Museum of Modern Art. Kynaston McShine, curator	92% men 98% white
Philip Morris Companies, Deutsche Bank, Bohen Foundation, The Federal Republic of Germany, The NEA	"BerlinArt 1961-1987" 1987. The Museum of Modern Art. Kynaston McShine, curator	95% men 100% white
Kaufman Foundation, Lauder Fund, Lipman Foundation, Rose Foundation,	"BLAM! The Explosion of Pop, Minimalism and Performance 1958-1964" 1984. Whitney Museum. Barbara Haskell, curator	85% men 91% white
Chase Manhattan Bank, The NEA	"High Styles: Twentieth Century American Design" 1986. The Whitney Museum. Lisa Phillips, curator	87% men 97% white

Please send $ and comments to:
Box 1056 Cooper Sta. NY, NY 10276 **GUERRILLA GIRLS** CONSCIENCE OF THE ART WORLD

What's Fashionable, Prestigious and Tax-Deductible? (1987). From the portfolio *Guerrilla Girls Talk Back: The First Five Years*, 1985–90. Photolithograph, sheet 21 15/16 x 16 15/16" (55.8 x 43.1 cm).

Hans Haacke

Hans Haacke, "Museums, Managers of Consciousness" (1983), *Art in America,* no. 72 (February 1984), pp. 9–17.

MUSEUMS, MANAGERS OF CONSCIOUSNESS

The art world as a whole, and museums in particular, belong to what has aptly been called "the consciousness industry." More than 20 years ago, the German writer Hans Magnus Enzensberger gave us some insight into the nature of this industry in an article which used that phrase as its title. Although he did not specifically elaborate on the art world, his article did refer to it in passing. It seems worthwhile here to extrapolate from and to expand upon Enzensberger's thoughts for a discussion of the role museums and other art-exhibiting institutions play.

Like Enzensberger I believe the use of the term "industry" for the entire range of activities of those who are employed or working on a free-lance basis in the art field has a salutary effect. With one stroke that term cuts through the romantic clouds that envelop the often misleading and mythical notions widely held about the production, distribution and consumption of art. Artists as much as their galleries, museums and journalists, not excluding art historians, hesitate to discuss the industrial aspect of their activities. An unequivocal acknowledgement might endanger the cherished romantic ideas with which most entered the field, and which still sustain them emotionally today. Supplanting the traditional bohemian image of the art world with that of a business operation could also negatively affect the marketability of art-world products and interfere with fund-raising efforts. Those who in fact plan and execute industrial strategies tend, whether by inclination or need, to mystify art and conceal its industrial aspect and often fall for their own propaganda. Given the prevalent marketability of myths, it may sound almost sacrilegious to insist on using the term "industry."

On the other hand, a new breed has recently appeared on the industrial landscape: the arts managers. Trained by prestigious business schools, they are convinced that art can and should be managed like the production and marketing of other goods. They make no apologies and have few romantic hang-ups. They do not blush in assessing the receptivity and potential development of an audience for their product. As a natural part of their education they are conversant with budgeting, investment and price-setting strategies. They have studied organizational goals, managerial structures and the peculiar social and political environment of their organization. Even the intricacies of labor relations and the ways in which interpersonal issues might affect the organization are part of their curriculum.

Of course, all these and other skills have been employed for decades by art-world denizens of the old school. Instead of enrolling in arts administration courses taught according to the Harvard Business School's case method, they have learned their skills on the job. Following their instincts they have often been more successful managers than the new graduates promise to be, since the latter are mainly taught by professors with little or no direct knowledge of the peculiarities of the art world. Traditionally, however, the old-timers are shy in admitting to themselves and others the industrial character of their activities and most still do not view themselves as managers. It is to be expected that the lack of delusions and aspirations among the new art administrators will have a noticeable impact on the state of the industry. Being trained primarily as technocrats they are less likely to have an emotional attachment to the peculiar nature of the product they are promoting. And this attitude, in turn, will have an effect on the type of products we will soon begin to see.

My insistence on the term "industry" is not motivated by sympathy for the new technocrats. As a matter of fact, I have serious reservations about their training, the mentality it fosters, and the consequences it will have. What the emergence of arts administration departments in business schools demonstrates, however, is the fact that in spite of the mystique surrounding the production and distribution of art, we are now and indeed have been all along dealing with social organizations that follow industrial modes of operation, and that range in size from the cottage industry to national and multinational conglomerates. Supervisory boards are becoming aware of this fact. Given current financial problems, they try to streamline their operations. Consequently, the present director of the Museum of Modern Art in New York has a management background, and the boards of trustees of other U.S. museums have or are planning to split the position of director into that of a business manager and an artistic director. The Metropolitan Museum in New York is one case where this split has already occurred. The debate often rages only over which of the two executives should and will in fact have the last word.

Traditionally the boards of trustees of U.S. museums are dominated by members who come from the world of business and high finance. The board is legally responsible for the institution and consequently the trustees are the ultimate authority. Thus the business mentality has always been conspicuously strong at the decision-making level of private museums in the United States. However, the state of affairs is not essentially different in public museums in other parts of the world. Whether the directors have an art-historical background or not, they perform, in fact, the tasks of the chief executive officer of a business organization. Like their peers in other industries they prepare budgets and development plans and present them for approval to their respective public supervising bodies and funding agencies. The staging of an international exhibition such as a Biennale or a Documenta presents a major managerial challenge with repercussions not only for what is being managed, but also for the future career of the executive in charge.

Responding to a realistic appraisal of their lot, even artists are now acquiring managerial training in workshops funded by public agencies in the United States. Such sessions are usually well attended, as artists recognize that the managerial skills for running a small business could

have a bearing on their own survival. Some of the more successful artists employ their own business managers. As for art dealers, it goes without saying that they are engaged in running businesses. The success of their enterprises and the future of the artists in their stables obviously depend a great deal on their managerial skills. They are assisted by paid advisors, accountants, lawyers and public relations agents. Furthermore, collectors too often do their collecting with the assistance of a paid staff.

At least in passing, I should mention that numerous other industries depend on the economic vitality of the art branch of the consciousness industry. Arts administrators do not exaggerate when they defend their claims for public support by pointing to the number of jobs that are affected not only in their own institutions but also in the communications and particularly in the hotel and restaurant industry. The Tut show of the Metropolitan Museum is estimated to have generated $111 million for the economy of New York City. In New York and possibly elsewhere real-estate speculators follow with great interest the move of artists into low-rent commercial and residential areas. From experience they know that artists unwittingly open these areas for gentrification and lucrative development. New York's Soho district is a striking example. Mayor Koch, always a friend of the realtors who stuff his campaign chest, tried recently to plant artists into particular streets on the Lower East Side to accomplish what is euphemistically called "rehabilitation" of a neighborhood, but what in fact means squeezing out an indigenous poor population in order to attract developers of high-rent housing. The recent "Terminal Show" was a brainchild of the city's Public Development Corporation. It was meant to draw attention to the industrial potential of the former Brooklyn Army Terminal building. And the Museum of Modern Art, having erected a luxury apartment tower over its own building, is also now actively involved in real estate.

Elsewhere city governments have recognized the importance of the art industry. The city of Hannover in West Germany, for example, sponsored widely publicized art events in order to improve its dull image. As large corporations point to the cultural life of their location in order to attract sophisticated personnel, so Hannover speculated that the outlay for art would be amortized many times by the attraction the city would gain for businesses seeking sites for relocation. It is well documented that Documenta is held in an out-of-the-way place like Kassel and given economic support by the city, state and federal government because it was assumed that Kassel would be put on the map by an international art exhibition. It was hoped that the event would revitalize the economically depressed region close to the German border and that it would prop up the local tourist industry.

Another German example of the way in which direct industrial benefits flow from investment in art may be seen in the activities of the collector Peter Ludwig. It is widely believed that the motive behind his buying a large chunk of government-sanctioned Soviet art and displaying it in "his" museums was to open the Soviet market for his chocolate company. Ludwig may have risked his reputation as a connoisseur of art, but by buying into the Soviet consciousness industry he proved his taste for sweet deals. More recently he recapitalized his company by selling a collection of medieval manuscripts to the Getty Museum for an estimated price of $40 to $60 million. As a shrewd businessman, Ludwig used the money to establish a foundation that owns shares in his company. Thus the income from this capital remains untaxed and, in effect, the ordinary taxpayer winds up subsidizing Ludwig's power ambitions in the art world.

Aside from the reasons already mentioned, the discomfort in applying industrial nomenclature to works of art may also have to do with the fact that these products are not entirely physical in nature. Although transmitted in one material form or another, they are developed in and by consciousness and have meaning only for another consciousness. In addition, it is possible to argue over the extent to which the physical object determines the manner in which the receiver decodes it. Such interpretive work is in turn a product of consciousness, performed gratis by each viewer but potentially salable if undertaken by curators, historians, critics, appraisers, teachers, etc. The hesitancy to use industrial concepts and language can probably also be attributed to our lingering idealist tradition, which associates such work with the "spirit," a term with religious overtones and one that indicates the avoidance of mundane considerations.

The tax authorities, however, have no compunction in assessing the income derived from the "spiritual" activities. Conversely the taxpayers so affected do not shy away from deducting relevant business expenses. They normally protest against tax rulings which declare their work to be nothing but a hobby, or to put it in Kantian terms, the pursuit of "disinterested pleasure." Economists consider the consciousness industry as part of the ever-growing service sector and include it as a matter of course in the computation of the gross national product.

The product of the consciousness industry, however, is not only elusive because of its seemingly nonsecular nature and its aspects of intangibility. More disconcerting, perhaps, is the fact that we do not even totally command our individual consciousness. As Karl Marx observed in *The German Ideology*, consciousness is a social product. It is, in fact, not our private property, homegrown and a home to retire to. It is the result of a collective historical endeavor, embedded in and reflecting particular value systems, aspirations and goals. And these do not by any means represent the interests of everybody. Nor are we dealing with a universally accepted body of knowledge or beliefs. Word has gotten around that material conditions and the ideological context in which an individual grows up and lives determine to a considerable extent his or her consciousness. As has been pointed out, and not only by Marxist social scientists and psychologists, consciousness is not a pure, independent, value-free entity, evolving according

to internal, self-sufficient and universal rules. It is contingent, an open system, responsive to the crosscurrents of the environment. It is, in fact, a battleground of conflicting interests. Correspondingly, the products of consciousness represent interest and interpretations of the world that are potentially at odds with each other. The products of the means of production, like those means themselves, are not neutral. As they were shaped by their respective environments and social relations so do they in turn influence our view of the human condition.

Currently we are witnessing a great retreat to the private cocoon. We see a lot of noncommittal, sometimes cynical playing on naively perceived social forces, along with other forms of contemporary dandyism and updated versions of art for art's sake. Some artists and promoters may reject any commitment, and refuse to accept the notion that their work presents a point of view beyond itself or that it fosters certain attitudes; nevertheless, as soon as work enjoys larger exposure it inevitably participates in public discourse, advances particular systems of belief, and has reverberations in the social arena. At that point, art works are no longer a private affair. The producer and the distributor must then weigh the impact.

But it is important to recognize that the codes employed by artists are often not as clear and unambiguous as those in other fields of communication. Controlled ambiguity may, in fact, be one of the characteristics of much Western art since the Renaissance. It is not uncommon that messages are received in a garbled, distorted form and that they possibly even relay the opposite of what was intended—not to speak of the kinds of creative confusion and muddle-headedness that can accompany the art work's production. To compound these problems, there are the historical contingencies of the codes and the unavoidable biases of those who decipher them. With so many variables, there is ample room for exegesis and a livelihood is thus guaranteed for many workers in the consciousness industry.

Although the product under discussion appears to be quite slippery, it is by no means inconsequential, as cultural functionaries from Moscow to Washington make clear every day. It is recognized in both capitals that not only the mass media deserve monitoring, but also those activities which are normally relegated to special sections in the backs of newspapers. *The New York Times* calls its weekend section "Arts and Leisure" and covers under this heading theater, dance, movies, art, numismatics, gardening and other ostensibly harmless activities. Other papers carry these items under equally innocuous titles such as "culture," "entertainment," or "life style." Why should governments, and for that matter corporations which are not themselves in the communications industry, pay attention to such seeming trivia? I think they do so for good reason. They have understood, sometimes better than the people who work in the leisure-suits of culture, that the term "culture" camouflages the social and political consequences resulting from the industrial distribution of consciousness.

The channeling of consciousness is pervasive not only under dic-

tatorships but also in liberal societies. To make such an assertion may sound outrageous because according to popular myth liberal regimes do not behave this way. Such an assertion could also be misunderstood as an attempt to downplay the brutality with which mainstream conduct is enforced in totalitarian regimes or as a claim that coercion of the same viciousness is practiced elsewhere, too. In nondictatorial societies, the induction into and the maintenance of a particular way of thinking and seeing must be performed with subtlety in order to succeed. Staying within the acceptable range of divergent views must be perceived as the natural thing to do.

Within the art world, museums and other institutions that stage exhibitions play an important role in the inculcation of opinions and attitudes. Indeed, they usually present themselves as educational organizations and consider education as one of their primary responsibilities. Naturally, museums work in the vineyards of consciousness. To state that obvious fact, however, is not an accusation of devious conduct. An institution's intellectual and moral position becomes tenuous only if it claims to be free of ideological bias. And such an institution should be challenged if it refuses to acknowledge that it operates under constraints deriving from its sources of funding and from the authority to which it reports.

It is perhaps not surprising that many museums indignantly reject the notion that they provide a biased view of the works in their custody. Indeed, museums usually claim to subscribe to the canons of impartial scholarship. As honorable as such an endeavor is—and it is still a valid goal to strive after—it suffers from idealist delusions about the nonpartisan character of consciousness. A theoretical prop for this worthy but untenable position is the 19th-century doctrine of art for art's sake. That doctrine has an avant-garde historical veneer and in its time did indeed perform a liberating role. Even today, in countries where artists are openly compelled to serve prescribed policies, it still has an emancipatory ring. The gospel of art for art's sake isolates art and postulates its self-sufficiency, as if art had or followed rules which are impervious to the social environment. Adherents of the doctrine believe that art does not and should not reflect the squabbles of the day. Obviously they are mistaken in their assumption that products of consciousness can be created in isolation. Their stance and what is crafted under its auspices has not only theoretical but also definite social implications. American formalism updated the doctrine and associated it with the political concepts of the "free world" and individualism. Under Clement Greenberg's tutelage, everything that made worldly references was simply excommunicated from art so as to shield the grail of taste from contamination. What started out as a liberating drive turned into its opposite. The doctrine now provides museums with an alibi for ignoring the ideological aspects of art works and the equally ideological implications of the way those works are presented to the public. Whether such neutralizing is performed with deliberation or merely out of habit or lack of resources is irrele-

vant: practiced over many years it constitutes a powerful form of indoctrination.

Every museum is perforce a political institution, no matter whether it is privately run or maintained and supervised by governmental agencies. Those who hold the purse strings and have the authority over hiring and firing are, in effect, in charge of every element of the organization, if they choose to use their powers. While the rule of the boards of trustees of museums in the United States is generally uncontested, the supervisory bodies of public institution elsewhere have to contend much more with public opinion and the prevailing political climate. It follows that political considerations play a role in the appointment of museum directors. Once they are in office and have civil service status with tenure, such officials often enjoy more independence than their colleagues in the United States, who can be dismissed from one day to the next, as occurred with Bates Lowry and John Hightower at the Museum of Modern Art within a few years' time. But it is advisable, of course, to be a political animal in both settings. Funding as much as one's prospect for promotion to more prestigious posts depend on how well one can play the game.

Directors in private U.S. museums need to be tuned primarily to the frame of mind represented by the *Wall Street Journal*, the daily source of edification of their board members. They are affected less by who happens to be the occupant of the White House or the mayor's office, although this is not totally irrelevant for the success of applications for public grants. In other countries the outcome of elections can have a direct bearing on museum policies. Agility in dealing with political parties, possibly even membership in a party, can be an asset. The arrival of Margaret Thatcher in Downing Street and François Mitterrand at the Élysée noticeably affected the art institutions in their respective countries. Whether in private or in public museums, disregard of political realities, among them the political need of the supervising bodies and the ideological complexion of their members, is a guarantee for managerial failure.

It is usually required that, at least to the public, institutions appear nonpartisan. This does not exclude the sub rosa promotion of the interests of the ultimate boss. As in other walks of life, the consciousness industry also knows the hidden agenda which is more likely to succeed if it is not perceived as such. It would be wrong, however, to assume that the objectives and the mentality of every art executive are or should be at odds with those on whose support his organization depends. There are natural and honorable allegiances as much as there are forced marriages and marriages of convenience. All players, though, usually see to it that the serene facade of the art temple is preserved.

During the past 20 years the power relations between art institutions and their sources of funding have become more complex. Museums used to be maintained either by public agencies—the tradition in Europe—or through donations from private individuals and philan-thropic organizations, as has been the pattern in the United States. When Congress established the National Endowment for the Arts in 1965, U.S. museums gained an additional source of funding. In accepting public grants, however, they became accountable, even if in practice only to a limited degree, to government agencies.

Some public museums in Europe went the road of mixed support, too, although in the opposite direction. Private donors came on board with attractive collections. As has been customary in U.S. museums, however, some of these donors demanded a part in policy making. One of the most spectacular recent examples has been the de facto takeover of museums (among others, museums in Cologne, Vienna and Aachen) that received or believed they would receive gifts from the German collector Peter Ludwig. As is well known in the Rhineland, Count Panza di Biumo's attempt to get his way in the new museum of Mönchengladbach, down the Rhine from Ludwig's headquarters, was successfully rebuffed by the director, Johannes Cladders, who is both resolute and a good poker player in his own right. How far the Saatchis in London will get in dominating the Tate Gallery's Patrons of New Art—and thereby the museum's policies for contemporary art—is currently watched with the same fascination and nervousness as developments in the Kremlin. A recent, much noticed instance of Saatchi influence was the Tate's 1982 Schnabel show, which consisted almost entirely of works from the Saatchis' collection. In addition to his position on the steering committee of the Tate's Patrons of New Art, Charles Saatchi is also a trustee of the Whitechapel Gallery. Furthermore, the Saatchis' advertising agency has just begun handling publicity for the Victoria and Albert, the Royal Academy, the National Portrait Gallery, the Serpentine Gallery and the British Crafts Council. Certainly the election victory of Mrs. Thatcher, in which the Saatchis played a part as the advertising agency of the Conservative Party, did not weaken their position (and may in turn have provided the Conservatives with a powerful agent within the hallowed halls of the Tate).

If such collectors seem to be acting primarily in their own self-interest and to be building pyramids to themselves when they attempt to impose their will on "chosen" institutions, their moves are in fact less troublesome in the long run than the disconcerting arrival on the scene of corporate funding for the arts—even though the latter at first appears to be more innocuous. Starting on a large scale towards the end of the '60s in the United States and expanding rapidly ever since, corporate funding has spread during the last five years to Britain and the Continent. Ambitious exhibition programs that could not be financed through traditional sources led museums to turn to corporations for support. The larger, more lavishly appointed these shows and their catalogues became, however, the more glamour the audiences began to expect. In an ever-advancing spiral the public was made to believe that only Hollywood-style extravaganzas are worth seeing and give an accurate sense of the world of art. The resulting box-office pressure made the museums still more dependent on corporate fund-

ing. Then came the recession of the '70s and '80s. Many individual donors could no longer contribute at the accustomed rate, and inflation eroded the purchasing power of funds. To compound the financial problems, many governments, facing huge deficits, often due to sizable expansions of military budgets, cut their support for social services as well as their arts funding. Again museums felt they had no choice but to turn to corporations for a bail-out. Following their own ideological inclinations and making them national policy, President Reagan and Mrs. Thatcher encouraged the so-called private sector to pick up the slack in financial support.

Why have business executives been receptive to the museums' pleas for money? During the restive '60s the more astute ones began to understand that corporate involvement in the arts is too important to be left to the chairman's wife. Irrespective of their own love for or indifference towards art they recognized that a company's association with art could yield benefits far out of proportion to a specific financial investment. Not only could such a policy attract sophisticated personnel, but it also projected an image of the company as a good corporate citizen and advertised its products—all things which impress investors. Executives with a longer vision also saw that the association of their company, and by implication of business in general, with the high prestige of art was a subtle but effective means for lobbying in the corridors of government. It could open doors, facilitate passage of favorable legislation and serve as a shield against scrutiny and criticism of corporate conduct.

Museums, of course, are not blind to the attractions for business of lobbying through art. For example, in a pamphlet with the telling title "The Business Behind Art Knows the Art of Good Business," the Metropolitan Museum in New York woos prospective corporate sponsors by assuring them: "Many public relations opportunities are available through the sponsorship of programs, special exhibitions and services. These can often provide a creative and cost-effective answer to a specific marketing objective, particularly where international, governmental or consumer relations may be a fundamental concern."

A public relations executive of Mobil in New York aptly called the company's arts support a "goodwill umbrella," and his colleague from Exxon referred to it as a "social lubricant." It is liberals in particular who need to be greased because they are the most likely and sophisticated critics of corporations, and they are often in positions of influence. They also happen to be more interested in culture than other groups on the political spectrum. Luke Rittner, who as outgoing director of the British Association of Business Sponsorship of the Arts should know, recently explained: "A few years ago companies thought sponsoring the arts was charitable. Now they realize there is also another aspect; it is a tool they can use for corporate promotion in one form or another." Rittner, obviously in tune with his Prime Minister, has been appointed the new Secretary General on the British Arts Council.

Corporate public relations officers know that the greatest publicity benefits can be derived from high-visibility events, shows that draw crowds and are covered extensively by the popular media; these are shows that are based on and create myths—in short, blockbusters. As long as an institution is not squeamish about company involvement in press releases, posters, advertisements and its exhibition catalogue, its grant proposal for such an extravaganza is likely to be examined with sympathy. Some companies are happy to underwrite publicity for the event (which usually includes the company logo) at a rate almost matching the funds they make available for the exhibition itself. Generally, such companies look for events that are "exciting," a word that pops up in museum press releases and catalogue prefaces more often than any other.

Museum managers have learned, of course, what kind of shows are likely to attract corporate funding. And they also know that they have to keep their institutions in the limelight. Most shows in large New York museums are now sponsored by corporations. Institutions in London will soon be catching up with them. The Whitney Museum has even gone one step further. It has established branches—almost literally a merger—on the premises of two companies. It is fair to assume that exhibition proposals that do not fulfill the necessary criteria for corporate sponsorship risk not being considered, and we never hear about them. Certainly, shows that could promote critical awareness, present products of consciousness dialectically and in relation to the social world, or question relations of power have a slim chance of being approved—not only because they are unlikely to attract corporate funding, but also because they could sour relations with potential sponsors for other shows. Consequently, self-censorship is having a boom. Without exerting any direct pressure, corporations have effectively gained a veto in museums, even though their financial contribution often covers only a fraction of the costs of an exhibition. Depending on circumstances, these contributions are tax-deductible as a business expense or a charitable contribution. Ordinary taxpayers are thus footing part of the bill. In effect, they are unwitting sponsors of corporate policies, which, in many cases, are detrimental to their health and safety, the general welfare and in conflict with their personal ethics.

Since the corporate blanket is so warm, glaring examples of direct interference rare and the increasing dominance of the museums' development offices hard to trace, the change of climate is hardly perceived, nor is it taken as a threat. To say that this change might have consequences beyond the confines of the institution and that it affects the type of art that is and will be produced therefore can sound like an over-dramatization. Through naiveté, need or addiction to corporate financing, museums are now on the slippery road to becoming public relations agents for the interests of big business and its ideological allies. The adjustments that museums make in the selection and promotion of works for exhibition and in the way they present them create a climate that supports prevailing distributions of power and

capital and persuades the populace that the status quo is the natural and best order of things. Rather than sponsoring intelligent, critical awareness, museums thus tend to foster appeasement.

Those engaged in collaboration with the public relations officers of companies rarely see themselves as promoters of acquiescence. On the contrary, they are usually convinced that their activities are in the best interests of art. Such a well-intentioned delusion can survive only as long as art is perceived as a mythical entity above mundane interests and ideological conflict. And it is, of course, this misunderstanding of the role that products of the consciousness industry play which constitutes the indispensable base for all corporate strategies of persuasion.

Whether museums contend with governments, power-trips of individuals or the corporate steamroller, they are in the business of molding and channeling consciousness. Even though they may not agree with the system of beliefs dominant at the time, their options not to subscribe to them and instead to promote an alternative consciousness are limited. The survival of the institution and personal careers are often at stake. But in nondictatorial societies the means for the production of consciousness are not all in one hand. The sophistication required to promote a particular interpretation of the world is potentially also available to question that interpretation and to offer other versions. As the need to spend enormous sums for public relations and government propaganda indicates, things are not frozen. Political constellations shift and unincorporated zones exist in sufficient numbers to disturb the mainstream.

It was never easy for museums to preserve or regain a degree of maneuverability and intellectual integrity. It takes stealth, intelligence, determination—and some luck. But a democratic society demands nothing less than that.

Andrea Fraser

Andrea Fraser, "Notes on the Museum's Publicity," *Lusitania* 1 (Fall 1990), pp. 49–53.

NOTES ON THE MUSEUM'S PUBLICITY

According to the National Endowment for the Arts, in order for an institution to qualify as a museum in the United States it must, among other things, have "permanent facilities open to the public on a regularly scheduled basis," and be "a nonprofit tax-exempt organization."[1] The nonprofit tax-exempt status of an art museum, even and particularly its income-generating activities, such as merchandising, depends on the museum's primary charitable purpose of "providing educational experiences for the public."[2] This educational purpose is conceived of as accomplished in the first instance, not in any actively educational programs or practices, but simply in the presentation of art to the public; not only "on a regularly scheduled basis" (like any commercial art gallery), but specifically by "a nonprofit tax-exempt organization."

It would seem, then, that it is this nonprofit tax-exempt status that qualifies an art work to be the object of the educational experiences on which this tax-exempt status depends.

This tautology can be broken by introducing a single displacement; it is not tax-exempt status as such that conditions the educational value of the art objects, but the philanthropic gestures through which those objects find their way into the nonprofit sphere.

So I arrive at the rather contradictory logic of the private nonprofit art museum's status as a public institution. The material condition of the art museum's publicity is that it is publicly subsidized—directly through municipal support and state and Federal grants; indirectly through its tax-exempt status and the charitable deduction. (Under the Tax Reform Act of 1969 the tax-payer's share of every $1000 donated to a tax-exempt organization was estimated at 60–70¢.)

Yet this publicity is predicated on, and at the same time concealed by, the much more highly publicized privacy of the bankers and financiers, lawyers and industrialists, executives and corporations, on whose philanthropic engagement in a nonprofit organization the museum's educational function depends.

Public subsidy is allowed no such publicity. The charitable deduction is invisible; municipal support goes to the most menial, least visible aspects of the museum's functioning—utilities, building maintenance, and security. There are no plaques reading, "This light bulb was given to the museum by the city of New York."

The museum's purpose is to publicize art, but to publicize it only as an emblem of bourgeois privacy, in a sense, to publicize privacy. It is in this, I would say, that the museum's educational function consists.

But of course, this has always been the logic of American public policy. Public provision, if it must exist to stabilize a population subject to the violent vacillations of capital, should exist always only as a promise (never a right), perpetually retreating into the private sphere. Historically, this retreat has left a trail of institutions and organizations operating in the name of public education.

When art museums began to be established in numbers in the United States, in the last quarter of the 19th century, what limited public relief programs that existed were being systematically dismantled and privatized. Some of the proponents of privatization founded museums and libraries, others established Charity Organization Societies. Like museums, these Societies would offer only things of the mind and spirit. Instead of providing material relief, they sought to educate.

In what did this education consist? Not schooling, not training, but rather "friendly visits" that aimed "to regenerate character, which involved the direct influence of kind and concerned, successful and cultured, middle and upper-class people upon the dependent."[3] Education by example; education by identifications structured within public policy and institutional discourse.

If the museum's publicity has the function of structuring popular identification with bourgeois privacy, it does so first simply through its visibility and accessibility; open "on a regularly scheduled basis," it

offers up the content of homes to public display.

Second, as "a non-profit tax-exempt organization," often with direct municipal subsidy, the museum imposes on a population an economic investment in itself, in as much as the museum comes to that population already with the population's support.[4]

Third, on this, the museum's real "debt" to the public, is superimposed a symbolic debt of the public to it; a debt produced in the philanthropic gestures of the patrons who provide it with more visible support. The museum draws a population into a cultural covenant, making that population beholden to make itself worthy of capital's gifts.

Finally, after indebting a population to it, obliging that population to enter it, the museum offers to it, as its own, what has already been made "public" culture.

If culture consists of the narratives, symbolic objects and practices, with which a particular group represents its interests and its experience, its history and possible futures, fine art represents the interests and experiences first of the professional community of primarily middle-class artists who produce it, and second of the bourgeois patrons who collect it and re-present it in museums under their own names.

The museum, as a public institution, offers up this high culture as the general public culture, the national and universal culture, turning it into the single cultural currency that would define an individual as a member of civilization; representing the bourgeoisie as being in primary and privileged possession of this civilization; and banishing all symbolic objects produced outside of the specialized sphere of publicized artistic activity to the oblivion of individual lives—where they would have no authority to represent "public" experience.

NOTES:

1. National Endowment for the Arts. *Museums USA* (Washington D.C.: U.S. Government Printing Office, 1974), 4. Other criteria include: facilities open at least three months per year, an operating budget of a minimum of $1,000 (in 1971–72), ownership of at least part of the collection exhibited, and at least one full-time paid employee with academic training.

2. *Museums USA*, 25–35. In the late 19th century, this educational purpose was articulated as "improving public morals by improving public taste"; now one usually hears the slightly more modest "promoting public awareness of art."

3. Walter I. Trattner, *From Poor Law to Welfare State: A History of Social Welfare in America* (New York: The Free Press, 1974), 97.

4. Art museums, like public schools historically, may in this way function to foster a material impoverishment of local cultural practices. In New York City for example, the aim and direct effect of instituting a public school system—or rather, a public school tax—in the mid-19th century, was to prohibit most immigrant Irish from sending their children to Catholic parochial schools, for which they would have to pay again. Thus public schools functioned to break down community organizations by forcing a mass investment in a public sphere controlled of course by an American-born Protestant bourgeoisie.

Guerrilla Girls' Code of Ethics for Art Museums (1990). From the portfolio *Guerrilla Girls Talk Back: The First Five Years,* 1985–90. Photolithograph, sheet 16 ¹⁵⁄₁₆ x 21 ¹⁵⁄₁₆" (43.1 x 55.8 cm).

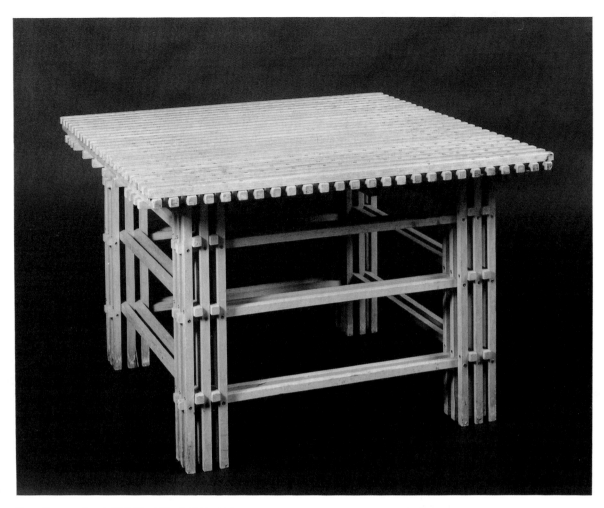

Barry Flanagan. *Bench.* 1979. Wood (Rowford process),
16 ⅛ x 24 ⁹⁄₁₆ x 24 ⁹⁄₁₆" (41 x 62.4 x 62.4 cm). Hayward Gallery, London.

Vito Acconci

American, born Bronx, New York, January 24, 1940
Studied College of the Holy Cross, Worcester, Massachusetts, B.A.
(1958–62); University of Iowa, Iowa City, M.F.A. (1962–64)
Lives in Brooklyn, New York

SELECTED INDIVIDUAL EXHIBITIONS:

1969 Rhode Island School of Design, Providence, Rhode Island
1970 Nova Scotia College of Art and Design, Halifax, Nova Scotia
1971 112 Greene Street, New York
1972 Sonnabend Gallery, New York
1973 Galleria Schema, Florence
1976 Franklin Furnace, New York
 Sonnabend Gallery, New York
1977 The Clocktower, Institute for Art and Urban Resources, New York
1978 San Francisco Museum of Modern Art, San Francisco
 The Kitchen Center for Video and Music, New York
1979 De Appel, Amsterdam
1980 *Vito Acconci: A Retrospective 1969–1980*, Museum of Contemporary
 Art, Chicago
1985 The Brooklyn Museum, Brooklyn, New York
1986 Kent State University, School of Art Gallery, Kent, Ohio
1988 *Vito Acconci: Public Places*, The Museum of Modern Art, New York
 Vito Acconci: Photographic Works, 1969–70, Rhona Hoffman Gallery,
 Chicago
1992 Museo d'Arte Contemporanea Prato, Prato, Italy; traveled to Cen-
 tre national d'art contemporain, Grenoble, France
1993 *Vito Acconci: The City Inside Us*, Österreichisches Museum für
 Angewandte Kunst, Vienna

SELECTED GROUP EXHIBITIONS:

1968 *Poetry Events*, Central Park, New York
1969 *Street Works I–IV*, Architectural League, New York
1970 *Information*, The Museum of Modern Art, New York
 Software: Information Technology: Its Meaning for Art, The Jewish
 Museum, New York; traveled to Smithsonian Institution, Washing-
 ton, D.C., 1971
1971 *Projects: Pier 18*, The Museum of Modern Art, New York
 Body Works, John Gibson Gallery, New York
1972 *Documenta 5*, Museum Fridericianum, Kassel
 Book as Artwork, 1960–1972, Nigel Greenwood Gallery, London
1974 *Projekt '74*, Kunsthalle Köln, Cologne
 Eight Contemporary Artists, The Museum of Modern Art, New York
1976 *Rooms*, P.S. 1, Institute for Art and Urban Resources, New York
1982 *'60–'80: Attitudes / Concepts / Images*, Stedelijk Museum, Amsterdam
1989 *Image World: Art and Media Culture*, Whitney Museum of American
 Art, New York
1993 *Vito Acconci, Bruce Nauman, Paul Thek*, Brooke Alexander Editions,
 New York
1995 *Reconsidering the Object of Art: 1965–75*, The Museum of Contempo-
 rary Art, Los Angeles
1998 *Out of Actions: Between Performance and the Object, 1949–1979,* The
 Museum of Contemporary Art, Los Angeles

Eve Arnold

American, born Philadelphia, 1913
Studied New School for Social Research, New York, under Alexey
Brodovitch (1947–48)
Lives in London

SELECTED INDIVIDUAL EXHIBITIONS:

1980 *In China: Photographs by Eve Arnold*, The Brooklyn Museum,
 Brooklyn, New York; toured the United States, 1980–82
1981 *In Britain*, National Portrait Gallery, London

SELECTED GROUP EXHIBITIONS:

1960 *Magnum*, Tokyo
1982 *Paris–Magnum*, Musée du Luxembourg, Paris
 Lichtbildnisse: Das Porträt in der Fotografie, Rheinisches Landesmu-
 seum, Bonn
1983 *Photography in America 1910–83*, Tampa Museum, Tampa, Florida
1984 *Sammlung Gruber*, Museum Ludwig, Cologne

Art & Language

Michael Baldwin, British, born Chipping Norton, Oxfordshire, England 1945
Mel Ramsden, British, born Ilkeston, Derbyshire, England, 1944
Both live in Banbury, England

SELECTED INDIVIDUAL EXHIBITIONS:

1967 *Hardware Show*, Architectural Association, London
1968 *Dematerialisation Show*, Ikon Gallery, Birmingham, England
1973 Lisson Gallery, London
1975 *Art & Language 1966–75*, Museum of Modern Art, Oxford
1980 *Portraits of V.I. Lenin in the Style of Jackson Pollock*, University
 Gallery, Leeds
1983 Los Angeles Institute of Contemporary Art, Los Angeles
1986 *Confessions: Incidents in a Museum*, Lisson Gallery, London
1987 *Art & Language: The Paintings*, Palais des Beaux-Arts, Brussels
1990 *Hostages XXIV–XXXV*, Marian Goodman Gallery, New York
1992 *Art & Language: Now They Are*, Galerie Isy Brachot, Paris
1993 Galerie Nationale du Jeu de Paume, Paris
1994 *Early Work 1965–1976, Recent Work 1991–1994*, Lisson Gallery, London
1995 Galería Juana de Aizpura, Madrid

SELECTED GROUP EXHIBITIONS:

1968 *Language II*, Dwan Gallery, New York
1970 *Information*, The Museum of Modern Art, New York
 Conceptual Art and Conceptual Aspects, New York Cultural Center,
 New York
1972 *Documenta 5*, Museum Fridericianum, Kassel
 The New Art, Hayward Gallery, London
1974 *Projekt '74*, Kunsthalle Köln, Cologne
1982 *Aspects of British Art Today*, Metropolitan Museum, Tokyo
1986 *Prospekt '86,* Frankfurter Kunstverein, Frankfurt
1992 *1968*, Espace FRAC, Dijon
1995 *Reconsidering the Object of Art: 1965–75*, The Museum of Contempo-
 rary Art, Los Angeles
1997 *Skulptur Projekte in Münster 97*, Westfälisches Landesmuseum für
 Kunst und Kulturgeschichte, Münster
 Documenta 10, Museum Fridericianum, Kassel
1998 *Then and Now*, Lisson Gallery, London

Michael Asher

American, born Los Angeles, July 15, 1943
Studied Orange Coast College, Costa Mesa, California (1961–63); Univer-
sity of New Mexico, Albuquerque (1963–64); New York Studio School
(1964–65); University of California at Irvine, B.A. (1965–67)
Lives in Los Angeles

SELECTED INDIVIDUAL EXHIBITIONS:

1969 La Jolla Museum of Art, La Jolla, California
1972 Market Street Program, Venice, California
1973 Gallery A-402, California Institute of the Arts, Valencia, California
 Lisson Gallery, London
 Galerie Heiner Friedrich, Cologne
1974 Anna Loenowens Gallery, Nova Scotia College of Art and Design, Halifax, Nova Scotia
1976 The Clocktower, Institute for Art and Urban Resources, New York
 The Floating Museum, San Francisco
1977 Stedelijk van Abbemuseum, Eindhoven
1980 *Exhibitions in Europa, 1972–1977*, Stedelijk van Abbemuseum, Eindhoven
1982 Museum Haus Lange, Krefeld, Germany
1986 Hofhour Gallery, Albuquerque, New Mexico
1990 The Renaissance Society, University of Chicago, Chicago
1991 Musée national d'art moderne, Centre Georges Pompidou, Paris
 Le Nouveau Musée, Villeurbanne, France
1992 Le Consortium, Dijon, France
 Palais des Beaux-Arts, Brussels
1994 Kunsthalle Bern, Bern
1996 Kunstraum, Vienna

SELECTED GROUP EXHIBITIONS:

1967 *I am Alive*, Los Angeles County Museum of Art, Los Angeles
1969 *The Appearing/Disappearing Image/Object*, Newport Harbor Art Museum, Newport Beach, California
 Spaces, The Museum of Modern Art, New York
1972 *Documenta 5*, Museum Fridericianum, Kassel
1981 *Art in Los Angeles: The Museum as Site: Sixteen Projects*, Los Angeles County Museum of Art, Los Angeles
 Westkunst: Zeitgenössische Kunst seit 1939, Museen der Stadt, Cologne
1983 *Museums by Artists*, Art Gallery of Ontario, Toronto; traveled to Musée d'Art Contemporain, Montreal; Glenbow Museum, Calgary
1987 *Skulptur Projekte in Münster 87*, Westfälisches Landesmuseum für Kunst und Kulturgeschichte, Münster
1991 *Carnegie International 1991*, The Carnegie Museum of Art, Pittsburgh
1995 *Reconsidering the Object of Art: 1965–75*, The Museum of Contemporary Art, Los Angeles
1997 *Skulptur Projekte in Münster 97*, Westfälisches Landesmuseum für Kunst und Kulturgeschichte, Münster

Lothar Baumgarten
German, born Rheinsberg, Germany, 1944
Studied Staatliche Kunstakademie, Düsseldorf
Lives in Berlin and New York

SELECTED INDIVIDUAL EXHIBITIONS:

1972 *Guayana*, Galerie Konrad Fischer, Düsseldorf
1974 *Section 125–25 64–58, Hommage à M.B., T'E-NE-T'E* (with Michael Oppitz), Wide White Space, Antwerp and Brussels
1976 Kabinett für aktuelle Kunst, Bremerhaven
1983 Städtisches Museum Abteiberg, Mönchengladbach
1985 *Tierra de Los Perros Mudos*, Stedelijk Museum, Amsterdam
1982 *Die Namen der Bäume*, Stedelijk van Abbemuseum, Eindhoven
1987 *Makunaíma*, Marian Goodman Gallery, New York
 Métro Nome, Musée des arts Africains et Océaniens, Paris, in conjunction with *L'Époque, la mode, la morale, la passion*, Musée

national d'art moderne, Centre Georges Pompidou, Paris
1988 *Terra Incognita*, Marian Goodman Gallery, New York
1990 *Carbon*, The Museum of Contemporary Art, Los Angeles
1993 *America Invention*, Solomon R. Guggenheim Museum, New York
1995 *Theatrum Botanicum*, Fondation Cartier pour l'art contemporain, Paris
1994 *Silencium*, Transmission Gallery, Glasgow
1996 *Steinschlag*, University of St. Gallen, St. Gallen, Switzerland
 A Mi-Chemin, Marian Goodman Gallery, Paris
1997 Museum Kurhaus Kleve, Kleve, Germany

SELECTED GROUP EXHIBITIONS:

1972 *Documenta 5*, Museum Fridericianum, Kassel
1974 *Projekt '74*, Kunsthalle Köln, Cologne
1978 *La Biennale di Venezia XXXVIII*, Venice
1984 *Von Hier Aus*, Messehallen, Düsseldorf
1985 *Recent Films from West Germany*, The Museum of Modern Art, New York
1987 *Skulptur Projekte in Münster 87*, Westfälisches Landesmuseum für Kunst und Kulturgeschichte, Münster
1991 *Carnegie International 1991*, The Carnegie Museum of Art, Pittsburgh
1995 *Reconsidering the Object of Art: 1965–75*, The Museum of Contemporary Art, Los Angeles
1997 *Documenta 10*, Museum Fridericianum, Kassel

Barbara Bloom
American, born Los Angeles, July 11, 1951
Studied California Institute of the Arts, Valencia, B.F.A. (1968–72)
Lives in New York

SELECTED INDIVIDUAL EXHIBITIONS:

1974 Byrd Hoffman Foundation, New York
1976 Artists Space, New York
1977 De Appel, Amsterdam
1980 *Lost and Found (Eins wie das Andere)*, DAAD Galerie, Berlin
1987 *Lost and Found*, Haags Gemeentemuseum, The Hague
1989 *The Reign of Narcissism*, Jay Gorney Gallery, New York
1990 *The Reign of Narcissism*, Würtembergischer Kunstverein, Stuttgart; traveled to Kunsthalle Zürich, Zurich; Serpentine Gallery, London
1992 *Never Odd or Even*, The Carnegie Museum of Art, Pittsburgh
1995 *Pictures from the Floating World*, Leo Castelli Gallery, New York
1998 *The Collections of Barbara Bloom*, Wexner Center for the Arts, The Ohio State University, Columbus, Ohio

SELECTED GROUP EXHIBITIONS:

1981 *Westkunst: Zeitgenössische Kunst seit 1939*, Museen der Stadt, Cologne
1986 *Damaged Goods: Desire and Economy of the Object*, The New Museum of Contemporary Art, New York
1989 *A Forest of Signs: Art in the Crisis of Representation*, The Museum of Contemporary Art, Los Angeles
1990 *Die Endlichkeit der Freiheit*, various sites, Berlin
1991 *El Jardin Salvaje*, Fundacion Caja de Pensiones, Madrid
1992 *Postcards from Alphaville: Jean-Luc Godard in Contemporary Art, 1963–1992*, P.S. 1, Institute for Contemporary Art, New York
1996 *René Magritte: Die Kunst der Konversation: Barbara Bloom, Marcel Broodthaers, Robert Gober, Joseph Kosuth, Sturtevant*, Kunstsammlung Nordrhein-Westfalen, Düsseldorf
1998 *At Home in the Museum*, The Art Institute of Chicago, Chicago

Christian Boltanski
French, born Paris, September 6, 1944
Lives and works in Malakoff, France

SELECTED INDIVIDUAL EXHIBITIONS:

1968 *La Vie Impossible de Christian Boltanski*, Cinéma le Ranelagh, Paris

1971 *Essai de reconstitution d'objets ayant appartenu à Christian Boltanski entre 1948–1954*, Galerie Sonnabend, Paris

1974 *Le Musée de Christian Boltanski*, Musée Archéologique, Dijon

1976 *Photographies couleurs—Images modèles*, Musée national d'art moderne, Centre Georges Pompidou, Paris

1988 *Christian Boltanski: Lessons of Darkness*, Museum of Contemporary Art, Chicago; traveled to The Museum of Contemporary Art, Los Angeles; The New Museum of Contemporary Art, New York; Vancouver Art Gallery, Vancouver, 1989; University Art Museum, University of California, Berkeley; The Power Plant, Toronto, 1990

1990 *Christian Boltanski: Reconstitution*, Whitechapel Gallery, London; traveled to Stedelijk van Abbemuseum, Eindhoven; Musée de Grenoble, Grenoble, France
Les Suisses Morts, Marian Goodman Gallery, New York

1993 *Books, Prints, Printed Matter, Ephemera*, New York Public Library, New York
Diese Kinder suchen ihre Eltern, Museum Ludwig, Cologne

1995 *New York Projects*, Public Art Fund, various sites, New York

1997 Anthony d'Offay Gallery, London
Galleria d'Arte Moderna, Villa delle Rose, Bologna

SELECTED GROUP EXHIBITIONS:

1970 *Art Concepts from Europe*, Bonino Gallery, New York

1971 *Prospekt '71: Projection*, Städtische Kunsthalle, Düsseldorf

1972 *Documenta 5*, Museum Fridericianum, Kassel
La Biennale di Venezia XXXVI, Venice

1978 *Couples*, P.S. 1, Institute for Art and Urban Resources, New York

1986 *Chambres d'amis*, Museum van Hedendaagse Kunst, Ghent

1988 *Saturne en Europe*, Musée des Beaux-Arts, Strasbourg

1990 *Die Endlichkeit der Freiheit*, various sites, Berlin

1991 *Carnegie International 1991*, The Carnegie Museum of Art, Pittsburgh

1992 *1968*, Espace FRAC, Dijon

1995 *Els Límits del Museu*, Fundació Antoni Tàpies, Barcelona
Take Me (I'm Yours), Serpentine Gallery, London

1997 *Deep Storage*, Haus der Kunst, Munich; traveled to Neue Nationalgalerie, Berlin; P.S. 1 Contemporary Art Center, New York, 1998; Henry Art Gallery, Seattle

Marcel Broodthaers
Belgian, born Brussels, January 28, 1924
Briefly studied chemistry, University of Brussels (1942)
Died Brussels, January 28, 1976

MUSÉE D'ART MODERNE, DÉPARTEMENT DES AIGLES:

1968 *Musée d'Art Moderne, Département des Aigles, Section XIXe siècle*, rue de la Pépinière, Brussels
M.U.S.É.E.. D'.A.R.T. CAB.INE.T D.ES. E.STA.MP.E.S., Département des Aigles, Librairie Saint-Germain des Prés, Paris

1968–70 *Musée d'Art Moderne, Département des Aigles, Section Littéraire*, rue de la Pépinière, Brussels

1969 *Musée d'Art Moderne, Département des Aigles, Section Documentaire*, Le Coq, Belgium

Musée d'Art Moderne, Département des Aigles, Section XVIIe siècle, A 37 90 89, Antwerp

1970 *Musée d'Art Moderne, Département des Aigles, Section XIXe siècle (bis)*, Städtische Kunsthalle, Düsseldorf
Musée d'Art Moderne, Département des Aigles, Section Folklorique/Cabinet de Curiosités, Zeeuws Museum, Middelburg, the Netherlands

1971 *Musée d'Art Moderne, Département des Aigles, Section Cinéma*, Burgplatz 12, Düsseldorf
Musée d'Art Moderne, Département des Aigles, Section Financière: Musée d'Art Moderne à vendre pour cause de faillite, Cologne Kunstmarkt, Cologne

1972 *Musée d'Art Moderne, Département des Aigles, Section des Figures (Der Adler vom Oligozän bis heute)*, Städtische Kunsthalle, Düsseldorf
Musée d'Art Moderne, Département des Aigles, Section Publicité, Documenta 5, Neue Galerie, Kassel
Musée d'Art Moderne, Département des Aigles, Section d'Art Moderne, Documenta 5, Neue Galerie, Kassel
Musée d'Art Ancien, Département des Aigles, Galerie du XXe siècle, Documenta 5, Neue Galerie, Kassel

SELECTED INDIVIDUAL EXHIBITIONS:

1964 *Moi aussi, je me suis demandé si je ne pouvais pas vendre quelque chose…*, Galerie Saint-Laurent, Brussels
Exposition surprise, Parc du Mont des Arts, Brussels

1965 *Objets de Broodthaers*, Galerie Aujourd'hui, Brussels

1966 Galerie J, Paris
Moules Oeufs Frites Pots Charbon, Wide White Space, Antwerp

1967 *Le Court-Circuit/Marcel Broodthaers*, Palais des Beaux-Arts, Brussels

1968 *Le Corbeau et le Renard*, Wide White Space, Antwerp
Galerie Rudolf Zwirner, Cologne
La Collection privée de Marcel Broodthaers, Galerie 44, Brussels

1970 *Modèle/M. Broodthaers*, Galerie Michael Werner, Cologne

1971 *Film als Objekt—Objekt als Film*, Städtisches Museum Abteiberg, Mönchengladbach, Germany

1972 *Marcel Broodthaers: La signature de l'artiste*, Galerie Grafikmeyer, Karlsruhe, Germany

1973 *Marcel Broodthaers: Retrospective, Octobre 1963–Mars 1973*, Art & Project, Amsterdam

1974 *Un Voyage en Mer du Nord/A Voyage on the North Sea*, Petersburg Press, London
Marcel Broodthaers: Catalogue—Catalogus, Palais des Beaux-Arts, Brussels

1975 *Le privilège de l'art*, Museum of Modern Art, Oxford
Décor: A Conquest by Marcel Broodthaers, Institute of Contemporary Arts, London

1977 *Marcel Broodthaers (1924–1976)*, Multiples/Marian Goodman Gallery, New York

1980 Tate Gallery, London

1981 *Marcel Broodthaers*, Museum Boymans-van Beuningen, Rotterdam

1984 *L'Entrée de l'exposition*, Galerie Michael Werner, Cologne

1986 *Marcel Broodthaers: Selected Editions*, John Gibson Gallery, New York

1988 *Marcel Broodthaers: Le salon noir 1966*, Galerie Ronny Van De Velde & Co., Antwerp

1989 *Marcel Broodthaers*, Walker Art Center, Minneapolis; traveled to The Museum of Contemporary Art, Los Angeles; The Carnegie Museum of Art, Pittsburgh; Palais des Beaux-Arts, Brussels

1991 *Marcel Broodthaers*, Galerie Nationale du Jeu de Paume, Paris; traveled to Museo Nacional Centro de Arte Reina Sofía, Madrid

1995 *Marcel Broodthaers: Musée d'Art Moderne, Département des Aigles, Section Publicité*, Marian Goodman Gallery, New York

1997 *Marcel Broodthaers: Cinéma*, Fundació Antoni Tapies, Barcelona; traveled to Centro Galego de Arte Contemporánea, Santiago de Compostela

SELECTED GROUP EXHIBITIONS:

1964 *Lauréats du Prix Jeune Sculpture Belge 1964*, Palais des Beaux-Arts, Brussels

1965 *Pop Art, Nouveau Réalisime, Etc...*, Palais des Beaux-Arts, Brussels

1968 *Prospect '68*, Städtische Kunsthalle, Düsseldorf

1969 *Language III*, Dwan Gallery, New York

1970 *Information*, The Museum of Modern Art, New York
 Art Concepts from Europe, Bonino Gallery, New York

1972 *Documenta 5*, Museum Fridericianum, Kassel
 Book as Artwork, 1960–1972, Nigel Greenwood Gallery, London

1974 *Projekt '74*, Kunsthalle Köln, Cologne

1975 *Von Pop zum Konzept: Kunst unserer Zeit in belgischen Privatsammlungen*, Neue Galerie-Sammlung Ludwig, Aachen

1977 *Europe in the Seventies: Aspects of Recent Art*, The Art Institute of Chicago, Chicago; traveled to Hirshhorn Museum and Sculpture Garden, Smithsonian Institution, Washington, D.C., 1978; San Francisco Museum of Modern Art, San Francisco; Fort Worth Art Museum, Fort Worth, Texas; The Contemporary Arts Center, Cincinnati, 1979

1982 *'60–'80: Attitudes/Concepts/Images*, Stedelijk Museum, Amsterdam

1983 *Museums by Artists*, Art Gallery of Ontario, Toronto; traveled to Musée d'Art Contemporain, Montreal; Glenbow Museum, Calgary
 Der Hang zum Gesamtkunstwerk: Europäische Utopienzeit 1800, Kunsthaus Zürich, Zurich; traveled to Städtische Kunsthalle, Düsseldorf; Museum Moderner Kunst, Museum des 20. Jahrhunderts, Vienna; Orangerie des Schloss Charlottenburg, Berlin, 1984

1984 *Von Hier Aus: Zwei Monate neue deutsche Kunst in Düsseldorf*, Messehallen, Düsseldorf

1986 *Individuals: A Selected History of Contemporary Art 1945–1986*, The Museum of Contemporary Art, Los Angeles

1988 *Zeitlos*, Hamburger Bahnhof, Berlin

1989 *A Forest of Signs: Art in the Crisis of Representation*, The Museum of Contemporary Art, Los Angeles

1994 *Wide White Space: Behind the Museum, 1966–1976*, Palais des Beaux-Arts, Brussels; traveled to Kunstmuseum Bonn, Bonn, 1995; MAC, galeries contemporaines des Musées de Marseilles, Marseilles, 1996

1995 *Reconsidering the Object of Art: 1965–75*, The Museum of Contemporary Art, Los Angeles
 Els Límits del Museu, Fundació Antoni Tàpies, Barcelona

1997 *Deep Storage*, Haus der Kunst, Munich; traveled to Neue Nationalgalerie, Berlin; P.S. 1 Contemporary Art Center, New York, 1998; Henry Art Gallery, Seattle
 Documenta 10, Museum Fridericianum, Kassel

Daniel Buren

French, born Paris, March 25, 1938
Lives and works in situ

SELECTED INDIVIDUAL EXHIBITIONS:

1967 *Buren o Toroni o Chichessia*, Galleria Flaviana, Lugano, Switzerland

1968 Musée d'Art Moderne de la Ville de Paris, Paris
 Galleria Flaviana, Milan

1969 *Travail in Situ*, Wide White Space, Antwerp

1971 *Position—Proposition*, Städtisches Museum, Mönchengladbach

1973 *Sanction of the Museum*, Museum of Modern Art, Oxford
 New Theater, New York
 Within and Beyond the Frame, John Weber Gallery, New York

1976 *Arbeit in Situ*, Stedelijk Museum, Amsterdam

1977 *Dominoes*, Wadsworth Atheneum, Hartford, Connecticut

1984 *La cabane éclatée no.1*, Galerie Konrad Fischer, Düsseldorf

1987 *Mur sur mur, mur sous mur, peinture sous peinture, peinture sur peinture* Musée Saint-Denis, Reims, France

1988 *Travail in Situ*, The Brooklyn Museum, Brooklyn, New York

1990 Staatsgalerie, Stuttgart

1996 *D'une place l'autre: Placer, déplacer, ajuster, situer, transformer, Travail in situ, Museum Boymans-van Beuningen, 1993–1996*, Museum Boymans-van Beuningen, Rotterdam

SELECTED GROUP EXHIBITIONS:

1968 *Prospect '68*, Galerie Apollinaire, Düsseldorf

1970 *Information*, The Museum of Modern Art, New York
 Conceptual Art and Conceptual Aspects, New York Cultural Center, New York

1971 *Guggenheim International VI*, Solomon R. Guggenheim Museum, New York
 Projects: Pier 18, The Museum of Modern Art, New York

1972 *Documenta 5*, Museum Fridericianum, Kassel
 Book as Artwork, 1960–1972, Nigel Greenwood Gallery, London

1974 *Eight Contemporary Artists*, The Museum of Modern Art, New York
 Projekt '74, Kunsthalle Köln, Cologne

1977 *Europe in the Seventies: Aspects of Recent Art*, The Art Institute of Chicago, Chicago; traveled to Hirshhorn Museum and Sculpture Garden, Smithsonian Institution, Washington, D.C., 1978; San Francisco Museum of Modern Art, San Francisco; Fort Worth Art Museum, Fort Worth, Texas; The Contemporary Arts Center, Cincinnati, 1979

1983 *Currents*, Institute of Contemporary Art, Boston
 Museums by Artists, Art Gallery of Ontario, Toronto; traveled to Musée d'Art Contemporain, Montreal; Glenbow Museum, Calgary

1988 *Zeitlos*, Hamburger Bahnhof, Berlin

1994 *Wide White Space: Behind the Museum, 1966–1976*, Palais des Beaux-Arts, Brussels; traveled to Kunstmuseum Bonn, Bonn, 1995; MAC, galeries contemporaines des Musées de Marseilles, Marseilles, 1996

1995 *Reconsidering the Object of Art: 1965–75*, The Museum of Contemporary Art, Los Angeles

1997 *Skulptur Projekte in Münster 97*, Westfälisches Landesmuseum für Kunst und Kulturgeschichte, Münster

Sophie Calle

French, born Paris, October 9, 1953
Lives in Paris

SELECTED INDIVIDUAL EXHIBITIONS:

1981 Galerie Canon, Geneva

1983 Galerie Chantal Crousel, Paris

1984 Espace Formi, Nîmes

1986 De Appel, Amsterdam
 Centre d'art contemporain, Orléans

1990 Institute of Contemporary Art, Boston
 Matrix Gallery, University of California, Berkeley

1991 Luhring Augustine Gallery; Pat Hearn Gallery, New York

1993 *Last Seen…*, Leo Castelli Gallery, New York
Proofs, Hood Museum of Art, Dartmouth College, Hanover, New Hampshire
1994 *Absence*, Museum Boymans-van Beuningen, Rotterdam
1996 *Sophie Calle: True Stories*, The Tel Aviv Museum of Art, Tel Aviv
La Visite guidée, Museum Boymans-van Beuningen, Rotterdam
Sophie Calle: Relatos, Sala de Exposiciones de la Fundación, La Caixa, Madrid
1998 *The Birthday Ceremony*, Tate Gallery, London

SELECTED GROUP EXHIBITIONS:
1980 *11e Biennale des Jeunes*, Musée d'Art Moderne de la Ville de Paris, Paris
Une Idée l'Air, The Clocktower, Institute for Art and Urban Resources, New York
1982 *Du Livre*, Musée des Beaux-Arts, Rouen
1985 *Kunst mit Eigen-Sinn*, Museum Moderne Kunst, Vienna
1989 *Culture Medium*, International Center of Photography, New York
1990 *8th Sydney Biennale: The Readymade Boomerang: Certain Relations in 20th Century Art*, Art Gallery of New South Wales, Sydney
1991 *Dislocations*, The Museum of Modern Art, New York
Carnegie International 1991, The Carnegie Museum of Art, Pittsburgh
1995 *Art Museum: Sophie Calle, Louise Lawler, Richard Misrach, Diane Neumaier, Richard Ross, Thomas Struth*, Center for Creative Photography, University of Arizona, Tucson, Arizona
Féminin/masculin: le sexe de l'art, Musée national d'art moderne, Centre Georges Pompidou, Paris
1997 *Deep Storage*, Haus der Kunst, Munich; traveled to Neue Nationalgalerie, Berlin; P.S. 1 Contemporary Art Center, New York, 1998; Henry Art Gallery, Seattle
1998 *Mysterious Voyages*, Contemporary Museum, Baltimore

Janet Cardiff
Canadian, born Brussels, Ontario, 1957
Studied Queens University, Kingston, Ontario B.F.A. (1976–80); University of Alberta, Edmonton, M.V.A. (1981–83); Artist in Residence, The Banff Centre, Banff, Canada (1991)
Lives in Lethbridge, Alberta, Canada

SELECTED INDIVIDUAL EXHIBITIONS:
1988 Macdonald Stewart Art Centre, Guelph, Canada
1990 Evelyn Aimis Gallery, Toronto
1992 Eye Level Gallery, Halifax, Nova Scotia
1993 *To Touch: An Installation by Janet Cardiff*, Edmonton Art Gallery, Edmonton
1994 *Inability to Make a Sound*, Randolph Street Gallery, Chicago
1995 *The Dark Pool* (with George Bures Miller), Walter Philips Gallery, The Banff Centre, Banff
1997 *The Empty Room*, Raum Aktueller Kunst, Vienna
Playhouse, Galerie Barbara Weiss, Berlin

SELECTED GROUP EXHIBITIONS:
1988 *Transgressions Figurative en Terrain Singular*, Gallery III, Quebec City
1990 *Inaugural Exhibition*, Extensions Gallery, Toronto
1993 *Local Stories*, Edmonton Art Gallery, Edmonton
1996 *Thinking, Walking and Thinking* in conjunction with the exhibition *Now/Here*, Louisiana Museum of Modern Art, Humlebaek, Denmark

1997 *Skulptur Projekte in Münster 97*, Westfälisches Landesmuseum für Kunst und Kulturgeschichte, Münster
Present Tense: Nine Artists for the '90s, San Francisco Museum of Modern Art, San Francisco
1998 *Bienal Internacional de São Paulo*, São Paulo
Voices, Witte de With, Rotterdam; traveled to La Frenois, Lille; Fundación Joan Miró, Barcelona

Henri Cartier-Bresson
French, born Chanteloup (Seine et Marne), France, August 22, 1908
Studied painting under Cotenet, Paris (1922–23); studied painting under André Lhote, Paris (1927–28); studied painting and literature, Cambridge University (1928–29)
Lives in Paris

SELECTED INDIVIDUAL EXHIBITIONS:
1932 Julien Levy Gallery, New York
1934 Palacio de Bellas Artes, Mexico City (with Manuel Alvarez Bravo)
1946 The Museum of Modern Art, New York
1952 Institute of Contemporary Arts, London
1964 The Phillips Collection, Washington, D.C.
1970 *En France*, Grand Palais, Paris
1979 Zeit Photo Salon, Tokyo
International Center of Photography, New York
1981 Kunsthaus Zürich, Zurich
1987 *Henri Cartier-Bresson: The Early Work*, The Museum of Modern Art, New York
1994 *À Propos de Paris*, Hamburger Kunstverein, Hamburg
1997 *Henri Cartier-Bresson: Europeans*, Maison Européenne de la Photographie, Paris; traveled to Hayward Gallery, London, 1998

SELECTED GROUP EXHIBITIONS:
1951 *Memorable Life Photographs* and *Five French Photographers: Brassai/Cartier-Bresson/Doisneau/Izis/Ronis*, The Museum of Modern Art, New York
1959 *Hundert Jahre Photographie 1839–1939*, Museum Folkwang, Essen, Germany
1977 *Concerning Photography*, The Photographer's Gallery, London
1984 *Subjective Photography: Images of the 50s*, San Francisco Museum of Modern Art, San Francisco
Paris à vue d'oeil, Musée Carnavalet, Paris

Christo
American, born Christo Javacheff, Gabrovo, Bulgaria, 1935
Studied Academy Fine Arts, Sofia (1952–56)
Studied Academy of Fine Arts, Vienna (1957)
Lives in New York

SELECTED REALIZED PROJECTS:
1962 *Iron Curtain—Wall of Oil Barrels*, rue Visconti, Paris
1968 *Packed Kunsthalle*, Kunsthalle Bern, Bern
Packed Fountain and *Packed Medieval Tower*, Spoleto, Italy
5,600 Cubic Meter Package, Kassel
1969 *Packed Museum of Contemporary Art*, Museum of Contemporary Art, Chicago
Wrapped Coast—One Million Square Feet, Little Bay, Sydney
1972 *Valley Curtain*, Rifle, Colorado
1976 *Running Fence*, Sonoma and Marin counties, California
1978 *Wrapped Walk Ways*, Loose Park, Kansas City, Missouri
1983 *Surrounded Islands*, Biscayne Bay, Miami

1985 *The Pont-Neuf Wrapped*, Paris
1991 *The Umbrellas*, United States and Japan
1995 *Wrapped Reichstag*, Berlin (with Jeanne-Claude)

SELECTED INDIVIDUAL EXHIBITIONS:
1961 Galerie Haro Lauhus, Cologne
1962 Galerie J, Paris
1963 Galleria Appollinaire, Milan
1966 Leo Castelli Gallery, New York
 Stedelijk van Abbemuseum, Eindhoven
1967 Wide White Space, Antwerp
1968 *Christo Wraps the Museum*, The Museum of Modern Art, New York
 Institute of Contemporary Art, University of Pennsylvania, Philadelphia
1969 Museum of Contemporary Art, Chicago
 Central Street Gallery, Sydney
 John Gibson Gallery, New York
1971 Galerie Yvon Lambert, Paris
 Museum of Fine Arts, Houston
 Galerie Mikro, Berlin
1972 Museum of Contemporary Art, La Jolla, California
1973 Rijksmuseum Kröller-Müller, Otterlo, the Netherlands
 Louisiana Museum of Modern Art, Humlebaek, Denmark
1977 Museum Boymans-van Beuningen, Rotterdam
1979 *Christo: Urban Projects*, The Institute of Contemporary Art, Boston
1982 *Surrounded Islands, Project for Biscayne Bay, Greater Miami, Florida, Documentation Exhibition*, Miami-Dade Public Library, Miami
1984 *Objects, Collages and Drawings 1958–83*, Annely Juda Fine Art, London
1986 *Wrapped Reichstag, Project for Berlin, Documentation Exhibition*, Satani Gallery, Tokyo
1989 *Christo*, Deutsches Theater, East Berlin
1991 *Christo: Projects Not Realized, and Works in Progress*, Annely Juda Fine Art, London
1994 *Christo: The Reichstag and Urban Projects*, Villa Stuck, Munich

SELECTED GROUP EXHIBITIONS:
1960 *Proposition pour un jardin—Lieux poétiques*, Orsay-Ville, France
1962 *New Realists*, Sidney Janis Gallery, New York
1964 *4*, Leo Castelli Gallery, New York
1965 *Pop Art, Nouveau Réalisme, Etc.*, Palais des Beaux-Arts, Brussels
1967 *Scale Models and Drawings for Monuments*, Dwan Gallery, New York
1968 *Dada, Surrealism, and Their Heritage*, The Museum of Modern Art, New York; traveled to Los Angeles County Museum of Art, Los Angeles; The Art Institute of Chicago, Chicago
1969 *Ecologic Art*, John Gibson Gallery, New York
1973 *American Drawing*, Whitney Museum of American Art, New York
1977 *Paris—New York*, Musée national d'art moderne, Centre Georges Pompidou, Paris
1981 *Westkunst: Zeitgenössische Kunst seit 1939*, Museen der Stadt, Cologne
1986 *Qu'est-ce que la sculpture moderne?*, Musée national d'art moderne, Centre Georges Pompidou, Paris
1997 *Deep Storage*, Haus der Kunst, Munich; traveled to Neue Nationalgalerie, Berlin; P.S. I Contemporary Art Center, New York, 1998; Henry Art Gallery, Seattle

Joseph Cornell

American, born Nyack, New York, December 24, 1903
Studied Phillips Academy, Andover, Massachusetts (1917–21)
Died Flushing, New York, December 29, 1972

SELECTED INDIVIDUAL EXHIBITIONS:
1932 *Objects by Joseph Cornell*, Julien Levy Gallery, New York
1945 *Portrait of Ondine*, The Museum of Modern Art, New York
1946 *The Romantic Museum: Portraits of Women: Constructions and Arrangements by Joseph Cornell*, Hugo Gallery, New York
1953 *Joseph Cornell*, Walker Art Center, Minneapolis
1965 *The Boxes of Joseph Cornell*, The Museum of Art, Cleveland
1966 *An Exhibition of Works by Joseph Cornell*, Pasadena Art Museum, Pasadena
1967 *Joseph Cornell*, Solomon R. Guggenheim Museum, New York
1972 *A Joseph Cornell Exhibition for Children*, The Cooper Union, New York
1975 ACA Galleries, New York
1976 *Joseph Cornell: Collages*, James Corcoran Gallery, Los Angeles, in association with Leo Castelli Gallery and Richard L. Feigen & Co., New York
1980 *Joseph Cornell*, The Museum of Modern Art, New York; traveled to The Art Institute of Chicago, Chicago; Whitechapel Art Gallery, London; Musée d'Art Moderne de la Ville de Paris, Paris; Städtische Kunsthalle Düsseldorf, Düsseldorf; Palazzo Vecchio, Florence
1983 *Joseph Cornell and the Ballet*, Castelli, Feigen, and Corcoran Gallery, New York
1986 Pace Gallery, New York
1992 Galerie Karsten Greve, Paris
1993 *Joseph Cornell: Seven Boxes*, Kawamura Memorial Museum of Art, Kawamura, Japan
1995 C & M Arts Gallery, New York
 Joseph Cornell: Cosmic Travels, Whitney Museum of American Art, New York
1998 *Joseph Cornell—Marcel Duchamp: In Resonance*, Philadelphia Museum of Art, Philadelphia; traveled to The Menil Collection, Houston, 1999

SELECTED GROUP EXHIBITIONS:
1932 *Surréalisme*, Julien Levy Gallery, New York
1936 *Fantastic Art, Dada, Surrealism*, The Museum of Modern Art, New York
1938 *Exposition internationale du surréalisme*, Galerie Beaux-Arts, Paris
1942 *Objects by Joseph Cornell; Marcel Duchamp: Box Valise; Laurence Vail: Bottles*, Art of This Century, New York
1945 *Poetic Theater*, Hugo Gallery, New York
1961 *The Art of Assemblage*, The Museum of Modern Art, New York; traveled to Dallas Museum for Contemporary Arts, Dallas; San Francisco Museum of Art, San Francisco
1968 *The 1930s: Painting and Sculpture in America*, Whitney Museum of American Art, New York
1972 *Documenta 5*, Museum Fridericianum, Kassel
1977 *Paris—New York*, Musée national d'art moderne, Centre Georges Pompidou, Paris
1978 *Art about Art*, New York, Whitney Museum of American Art; traveled to North Carolina Museum of Art, Raleigh, North Carolina; Frederick S. Wight Art Gallery, University of California, Los Angeles, 1979; Portland Art Museum, Portland, Oregon

1980 *Mysterious and Magical Realism*, Aldrich Museum of Contemporary Art, Ridgefield, Connecticut

1990 *High and Low: Modern Art and Popular Culture*, The Museum of Modern Art, New York; traveled to The Art Institute of Chicago, Chicago; The Museum of Contemporary Art, Los Angeles

1993 *Copier créer: de Turner à Picasso: 300 oeuvres inspirées par les maîtres du Louvre*, Musée du Louvre, Paris

1997 *Deep Storage*, Haus der Kunst, Munich; traveled to Neue Nationalgalerie, Berlin; P.S. 1 Contemporary Art Center, New York, 1998; Henry Art Gallery, Seattle

Jan Dibbets

Dutch, born Gerardus Johannes Marie Dibbets, Weert, the Netherlands, May 9, 1941
Briefly studied fine art, St. Martin's School of Art, London (1967)
Lives in Amsterdam

SELECTED INDIVIDUAL EXHIBITIONS:
1965 Galerie 845, Amsterdam
1966 Galerie Swart, Amsterdam
1968 *Rasenrolle—Holzbündel—Wasserpfütze*, Galerie Konrad Fischer, Düsseldorf
1969 *24 min; TV as a Fireplace*, Fernsehgalerie Gerry Schum, Hannover
1970 Galerie Yvon Lambert, Paris
1971 Stedelijk van Abbemuseum, Eindhoven
1972 *La Biennale di Venezia XXXVI*, Dutch Pavilion, Venice
1975 Leo Castelli Gallery, New York
1976 Scottish Arts Council, Edinburgh; traveled to Arnolfini Gallery, Bristol, England; Unit Gallery, Cardiff, Wales, 1977; Museum of Modern Art, Oxford
1978 Bonnefantenmuseum, Maastricht, the Netherlands
1980 Stedelijk van Abbemuseum, Eindhoven
1981 *Saenredam Sénanque: Jan Dibbets 1980–81*, Centre Internationale de Création Artistque, Abbaye de Sénanque, Gordes, France
1984 Waddington Gallery, London
1987 Solomon R. Guggenheim Museum, New York; traveled to Walker Art Center, Minneapolis; Detroit Institute of Arts, Detroit; Norton Gallery and School of Art, West Palm Beach, Florida, 1988; Stedelijk van Abbemuseum, Eindhoven, 1989
1989 Galerie Lelong, Paris
1990 Fundació Espai Poblenou, Barcelona
1991 Centre national de la photographie, Palais du Tokyo, Paris
1995 Bonnefantenmuseum, Maastricht
1996 Witte de With, Rotterdam
Galerie Lelong, Paris
1997 Waddington Galleries, London

SELECTED GROUP EXHIBITIONS:
1967 *Liga Nieuw Beelden*, Stedelijk Museum, Amsterdam
1968 *Public Eye*, Hamburger Kunstalle, Hamburg
1969 *Earth Art*, Herbert F. Johnson Museum of Art, Cornell University, Ithaca, New York
When Attitudes Become Form: Works—Concepts—Processes—Situations—Information: Live in Your Head, Kunsthalle Bern, Bern; traveled to Museum Haus Lange, Krefeld, Germany; Museum Folkwang, Essen; Institute of Contemporary Arts, London
Art by Telephone, Museum of Contemporary Art, Chicago
Land Art, Fernsehgalerie Gerry Schum, Hannover, and TV Germany Chanel 1, Berlin

Ecologic Art, John Gibson Gallery, New York
1970 *Information*, The Museum of Modern Art, New York
Conceptual Art and Conceptual Aspects, New York Cultural Center, New York
Conceptual Art—Arte Povera—Land Art, Galleria Civica d'Arte Moderna, Turin
1971 *Projects: Pier 18*, The Museum of Modern Art, New York
Guggenheim International VI, Solomon R. Guggenheim Museum, New York
1972 *Documenta 5*, Museum Fridericianum, Kassel
Book as Artwork, 1960–1972, Nigel Greenwood Gallery, London
1974 *Projekt '74*, Kunsthalle Köln, Cologne
Eight Contemporary Artists, The Museum of Modern Art, New York
1977 *Europe in the Seventies: Aspects of Recent Art*, The Art Institute of Chicago, Chicago; traveled to Hirshhorn Museum and Sculpture Garden, Smithsonian Institution, Washington, D.C., 1978; San Francisco Museum of Modern Art, San Francisco; Fort Worth Art Museum, Fort Worth, Texas; The Contemporary Arts Center, Cincinnati, 1979
The History of Panorama Photography, Grey Art Gallery, New York University, New York
1981 *Westkunst: Zeitgenössische Kunst seit 1939*, Museen der Stadt, Cologne
1984 *Die Sprache der Geometrie*, Kunstmuseum Bern, Bern
1989 *Conceptual Art: A Perspective*, Musée d'Art Moderne de la Ville de Paris, Paris
1995 *Reconsidering the Object of Art: 1965–75*, The Museum of Contemporary Art, Los Angeles

Lutz Dille

Canadian, born Leipzig, Germany, September 29, 1922
Studied Kunstschule Hamburg (1947–51)
Lives in Monflanquin, France

SELECTED INDIVIDUAL EXHIBITIONS:
1961 Photographers Studio, Toronto
1965 National Film Board of Canada, Toronto
1967 *The Many Worlds of Lutz Dille*, Canadian Government Photo Centre, Montreal
1968 *NFB Expo*, University of Toronto, Toronto
1969 Saltzman Gallery, Toronto
1982 Arnolfini Gallery, Bristol, England
Maison de Lot et Garonne, Paris
1992 Griffelkunst, Hamburg and Berlin
1993 *Street Photography: Lutz Dille*, Galeries Photo de la FNAC, Paris, Berlin, Bordeaux
1994 Galeries Photo de la FNAC, Antwerp
1995 View Point Gallery, Manchester, England
1996 PPS Galerie, Hamburg

SELECTED GROUP EXHIBITIONS:
1967 *Bytown International Exhibition*, Toronto
1971 *The Magic World of Childhood*, Photo Gallery, Ottawa

Mark Dion

American, born New Bedford, Massachusetts, August 28, 1961
Studied fine art, Hartford Art School, University of Hartford, Connecticut (1981–82); School of Visual Arts, New York (1982–84)
Lives in New York

1990 Galerie Sylvana Lorenz, Paris
1991 Galerie Christian Nagel, Cologne
1993 *The Great Munich Bug Hunt*, K-Raum Daxer, Munich
1994 *When Dinosaurs Ruled the Earth (Toys 'R' U.S.)*, American Fine Arts Co., New York
1995 *Flotsam and Jetsam*, De Vleeshal, Middleburg, the Netherlands
1997 *Mark Dion: Natural History and Other Fictions*, Ikon Gallery, Birmingham, England; traveled to Hamburger Kunstverein, Hamburg; De Appel, Amsterdam
 Curiosity Cabinet for the Wexner Center for the Arts, Wexner Center for the Arts, The Ohio State University, Columbus, Ohio
1998 Deutsches Museum, Bonn

SELECTED GROUP EXHIBITIONS:
1985 Four Walls, Hoboken, New Jersey
1986 *The Fairy Tale: Politics, Desire, and Everyday Life*, Artists Space, New York
1987 *Fake*, The New Museum of Contemporary Art, New York
1989 *Here and There: Travels*, The Clocktower, The Institute for Contemporary Art, New York
 The Desire of the Museum, Whitney Museum of American Art, Downtown at Federal Reserve Plaza, New York
1990 *Commitment*, The Power Plant, Toronto
1992 *True Stories: Part II*, Institute for Contemporary Arts, London
1993 *What Happened to the Institutional Critique?*, American Fine Arts, New York
1994 *Cocido y Crudo*, Museo Nacional Centro de Arte Reina Sofía, Madrid
1995 *Platzwechsel*, Kunsthalle Zürich, Zurich
1997 *Land marks*, John Weber Gallery, New York
 Skulptur Projekte in Münster 97, Westfälisches Landesmuseum für Kunst und Kulturgeschichte, Münster
1998 *S.O.S.*, Tate Gallery Liverpool, Liverpool
 The Storey Institute Tasting Garden, Storey Gallery, Lancaster, England

Herbert Distel

Swiss, born Bern, August 7, 1942
Studied Kunstgewerbeschule, Biel, Switzerland; École des Beaux-Arts, Paris
Lives in Campiglia Marittima, Italy

SELECTED INDIVIDUAL EXHIBITIONS:
1963 Galerie Ateliertheater, Bern
1964 Galerie Kleintheater, Bern
1967 *Die Rampe*, Galerie Regio, Lörrach, Switzerland
1968 Galerie Toni Gerber, Bern
1969 Galerie Bischofberger, Zurich
 Galerie Reckermann, Cologne
1971 Galerie Bernard, Solothurn, Switzerland
1972 *Herbert Distel: Plastiken und Objekte, 1966–1972*, Galerie Kornfeld & Klipstein, Bern
1976 *Herbert Distel: The Museum of Drawers*, Internationaal Cultureel Centrum, Antwerp
1977 Kunsthalle Düsseldorf, Düsseldorf
 Israel Museum, Jerusalem
1978 Cooper-Hewitt Museum, New York
 Matrix 45: Herbert Distel, Wadsworth Atheneum, Hartford, Connecticut

Dallas Museum of Fine Arts, Dallas (with Claes Oldenburg)
1982 Musée d'ethnographie, Neuchâtel, Switzerland
1990 *Diesseits, Jenseits: Menschen aus Edgar Lee Master's Spoon River Anthology*, Kunstmuseum Bern, Bern; traveled to Warsaw
1991 Karl Ernst Osthausmuseum, Hagen, Germany
1993 Galerie Ester Münger, Burgdorf, Switzerland

SELECTED GROUP EXHIBITIONS:
1964 *25 Berner und Bieler Künstler*, Städtische Galerie, Biel, Switzerland
1966 Galerie Rudolf Zwirner, Cologne
 Weiss auf Weiss, Kunsthalle Bern, Bern
1968 *Multiples*, Palais des Beaux-Arts, Brussels
1971 *The Swiss Avantgarde*, The New York Cultural Center, New York
 Travel Art, Museum of Modern Art, Oxford
1972 *Documenta 5*, Museum Fridericianum, Kassel
1986 *La Biennale di Venezia XLII*, Venice
1989 *Dimensions: Petit*, Musée cantonal des Beaux-Arts, Lausanne
1996 *2. Biennale Video-installationen: Szene Schweiz 1996*, Kunsthaus Langenthal, Langenthal, Switzerland

Marcel Duchamp

American, born Blainville, Normandy, France, July 28, 1887
Studied painting, Académie Julian, Paris (1904–05)
Died Neuilly-sur-Seine, France, October 2, 1968

SELECTED INDIVIDUAL EXHIBITIONS:
1937 *Exhibition of Paintings by Marcel Duchamp*, Chicago Arts Club, Chicago
1959 Sidney Janis Gallery, New York
1963 *Marcel Duchamp: A Retrospective Exhibition*, Pasadena Art Museum, Pasadena
 Galerie Burén, Stockholm
1964 *Omaggio a Marcel Duchamp*, Galleria Schwarz, Milan; traveled to Kunsthalle Bern, Bern; Gimpel Fils Gallery, London; Haags Gemeentemuseum, The Hague, 1965; Stedelijk van Abbemuseum, Eindhoven; Museum Haus Lange, Krefeld; Kestner-Gesellschaft, Hannover
1966 *The Almost Complete Works of Marcel Duchamp*, Tate Gallery, London
1968 *Tribute to Marcel Duchamp*, The Museum of Modern Art, New York
1973 *Marcel Duchamp*, The Philadelphia Museum of Art, Philadelphia, and The Museum of Modern Art, New York; traveled to The Art Institute of Chicago, Chicago, 1974
1977 *L'oeuvre de Marcel Duchamp*, Musée national d'art moderne, Centre Georges Pompidou, Paris
1981 The Museum of Modern Art, Tokyo
1984 *Duchamp*, Fundación Joan Miró, Barcelona; traveled to Fundación Caja de Pensiones, Madrid; Museum Ludwig, Cologne
1986 Moderna Museet, Stockholm
1993 *Marcel Duchamp*, Palazzo Grassi, Venice (in conjunction with La Biennale di Venezia XLV)
1996 *The Portable Museums of Marcel Duchamp: De ou par Marcel Duchamp ou Rrose Sélavy*, L & R Entwistle and Co., London
1998 *Joseph Cornell—Marcel Duchamp: In Resonance*, Philadelphia Museum of Art, Philadelphia; traveled to The Menil Collection, Houston, 1999

SELECTED GROUP EXHIBITIONS:
1907 *Salon des Artistes Humoristes*, Palais de Glace, Paris
1909 *Société des Artistes Indépendants, 25e exposition*, Jardin des Tuileries, Paris

1913 *International Exhibition of Modern Art*, 69th Regiment Armory, New York; traveled to The Art Institute of Chicago, Chicago; Copley Society, Boston

1915 *First Exhibition of Works by Contemporary French Artists*, Carroll Gallery, New York

1920 *International Exhibition of Modern Art* (inaugural), Société Anonyme, Inc. Gallery, New York

1921 *Salon Dada*, Galerie Montaigne, Paris

1926 *International Exhibition of Modern Art*, The Brooklyn Museum, Brooklyn, New York; traveled to Anderson Galleries, New York; Albright Art Gallery, Buffalo; Toronto Art Gallery, Grange Park
 The John Quinn Collection of Paintings, Watercolors, Drawings, and Sculpture, Art Center, New York

1930 *La Peinture au défi*, Galerie Goemans, Paris

1931 *Newer Super-Realism*, The Wadsworth Atheneum, Hartford, Connecticut

1935 *Modern Works of Art: Fifth Anniversary Exhibition*, The Museum of Modern Art, New York

1936 *Cubism and Abstract Art*, The Museum of Modern Art, New York; traveled to San Francisco Museum of Art, San Francisco; Cincinnati Art Museum, Cincinnati; Minneapolis Institute of Arts, Minneapolis; Cleveland Museum of Art, Cleveland, 1937; Baltimore Museum of Art, Baltimore; Rhode Island School of Design, Providence; Grand Rapids Art Gallery, Grand Rapids, South Dakota
 Fantastic Art, Dada, Surrealism, The Museum of Modern Art, New York

1938 *Exposition Internationale du Surréalisme*, Galerie des Beaux-Arts, Paris

1942 *First Papers of Surrealism*, 451 Madison Avenue, New York
 Art of This Century: Objects, Drawings, Photographs, Paintings, Sculpture, Collages, 1910 to 1942, Art of This Century, New York

1943 *Art in Progress*, The Museum of Modern Art, New York

1945 *Duchamp, Duchamp-Villon, Villon*, Yale University Art Gallery, New Haven

1948 *Through the Big End of the Opera Glass*, Julien Levy Gallery, New York

1952 *Duchamp Frères et soeur*, Rose Fried Gallery, New York

1953 *Dada 1916–1923*, Sidney Janis Gallery, New York

1957 *Jacques Villon, Raymond Duchamp-Villon, Marcel Duchamp*, Solomon R. Guggenheim Museum, New York

1961 *Art in Motion*, Stedelijk Museum, Amsterdam; traveled to Moderna Museet, Stockholm

1967 *Art in the Mirror*, The Museum of Modern Art, New York

1968 *Dada, Surrealism, and Their Heritage*, The Museum of Modern Art, New York; traveled to Los Angeles County Museum of Art, Los Angeles; The Art Institute of Chicago, Chicago
 The Machine as Seen at the End of the Mechanical Age, The Museum of Modern Art, New York; traveled to University of St. Thomas, Houston, 1969; San Francisco Museum of Modern Art, San Francisco

1975 *Junggesellenmaschinen (Les Machines Célibataires)*, Kunsthalle Bern, Bern; traveled to Biennale di Venezia, Venice; Palais des Beaux-Arts, Brussels; Städtische Kunsthalle, Düsseldorf; Musée des Arts Décoratifs, Paris; Musée de l'Homme et de l'Industrie, Le Creusot; Konsthall Malmö, Malmö; Stedelijk Museum, Amsterdam

1988 *Übrigens sterben immer die anderen, Marcel Duchamp und die Avantgarde seit 1950*, Museum Ludwig, Cologne

1990 *High and Low: Modern Art and Popular Culture*, The Museum of Modern Art, New York; traveled to The Art Institute of Chicago, Chicago; The Museum of Contemporary Art, Los Angeles

1996 *Making Mischief: Dada Invades New York*, Whitney Museum of American Art, New York

1997 *Deep Storage*, Haus der Kunst, Munich; traveled to Neue Nationalgalerie, Berlin; P.S. 1 Contemporary Art Center, New York, 1998; Henry Art Gallery, Seattle
 The Story of Varian Fry and the Emergency Rescue Committee, The Jewish Museum, New York

Kate Ericson and Mel Ziegler

Kate Ericson, American, born New York, December 25, 1955
Died 1995
Mel Ziegler, American, born Cambelltown, Pennsylvania, January 24, 1956
Lives in New York
Both studied California Institute of the Arts, Valencia (M.F.A.S 1980–82); The Art Institute, Kansas City (B.F.A.S 1974–78)

SELECTED INDIVIDUAL EXHIBITIONS:

1986 *Stones Have Been Known to Move*, White Columns, New York

1987 *If Landscapes Were Sold*, DiverseWorks, Houston

1988 *The Conscious Stone*, Hirshhorn Museum and Sculpture Garden, Smithsonian Institution, Washington, D.C.
 Temporary Public Art: Changes and Interventions, Storefront for Art and Architecture, New York
 Projects 14: Signature Piece: Kate Ericson and Mel Ziegler, The Museum of Modern Art, New York
 Dark on That Whiteness, Wolff Gallery, New York

1990 *House Monument*, The Los Angeles Institute of Contemporary Art, Los Angeles

1995 *Anybody Can Make History*, Michael Klein Gallery, New York

SELECTED GROUP EXHIBITIONS:

1991 *Camouflaged House*, Spoleto Festival, Charleston, South Carolina

1994 *Die Orte der Kunst*, Sprengel Museum, Hannover

1998 *Blurring the Boundaries: Installation Art, 1969–1996*, San Diego Museum of Contemporary Art, La Jolla, California; traveled to Worcester Art Museum, Worcester, Massachusetts, 1998

Elliott Erwitt

American, born France, July 26, 1928
Studied photography, Los Angeles City College (1945–47); studied film, New School for Social Research, New York (1948–50)
Lives and works in New York

SELECTED INDIVIDUAL EXHIBITIONS:

1947 The Artists Club, New Orleans

1957 Limelight Gallery, New York

1965 *Elliott Erwitt: Improbable Photographs*, The Museum of Modern Art, New York

1971 The Photographers' Gallery, London

1989 *Personal Exposures*, Palais, Tokyo

1993 The Royal Photographic Society, Bath

1998 *Museum Watching*, Mitsokoshi, Tokyo

SELECTED GROUP EXHIBITIONS:

1955 *The Family of Man*, The Museum of Modern Art, New York

1966 *The Photographer's Eye*, The Museum of Modern Art, New York

1967 *Photography in the 20th Century*, The National Gallery of Canada, Ottawa
1977 *Concerning Photography*, The Photographers' Gallery, London
1980 *Photography of the 50s*, The International Center of Photography, New York

Roger Fenton

British, born Heap, Lancashire, England, March 28, 1819
Studied University College, London, B.A. (1836–1840); studied drawing, University College, London, under tutor Charles Lucy (1841); studied painting in the atelier of Paul Delaroche, Paris (1844)
Died Little Heath, Potter's Bar, England, August 9, 1869

SELECTED INDIVIDUAL EXHIBITIONS:
1855 The Old Watercolor Society, London
1934 The Royal Photographic Society, London
1979 *Roger Fenton: The First Secretary of the Royal Photographic Society*, Royal Photographic Society, Bath
1988 *Roger Fenton: Photographer of the 1850s*, Hayward Gallery, London
1994 *Aux origines du reportage de guerre: le photographe anglais Roger Fenton et la guerre de Crimée*, Musée Condé, Chantilly, France

SELECTED GROUP EXHIBITIONS:
1849 The Royal Academy, London
1850 The Royal Academy, London
1851 The Royal Academy, London
1855 L'Exposition Universelle, Paris
1859 The Photographic Society, London
1862 Universal Exposition, London
1991 *The Kiss of Apollo: Photography and Sculpture, 1845 to the Present*, Fraenkel Gallery, San Francisco
1993 *The Waking Dream: Photography's First Century: Selections from the Gilman Paper Company Collection*, The Metropolitan Museum of Art, New York; traveled to Edinburgh International Festival, Edinburgh
1998 *The Museum and the Photograph: Collecting Photography at the Victoria and Albert Museum 1853–1900*, Sterling and Francine Clark The Art Institute, Williamstown, Massachusetts

Robert Filliou

French, born Sauve, January 17, 1926
Studied economics and science, University of California, Los Angeles, M.A. (1948–51)
Died Les Eyzies de Tayac, France, December 2, 1987

SELECTED INDIVIDUAL EXHIBITIONS, PERFORMANCES, EVENTS:
1960 *Performance Piece for a Lonely Person in a Public Place* (with Peter Cohen), various sites, Paris
1962 *Galerie Légitime*, street performance, Paris, Frankfurt, London
 No-Play in Front of No-Audience, street performance, Paris
1964 *The Pink Spaghetti Handshake, Extra-Sensory Misperception Platitude en relief* (with Daniel Spoerri), Galerie Rudolf Zwirner, Cologne
1965 *La Cédille qui Sourit* (with George Brecht), Villefranche-sur-Mer, France and Café au Go-Go, New York
1967 *The Key to Art (?)*, Tiffany's & Co, New York
1969 *The Eternal Network*, Städtisches Museum, Mönchengladbach, *Création permanente—principe d'équivalence*, Galerie Schmela, Düsseldorf
1972 *Defrosting the Frozen Exhibition*, Galerie Philomène Magers, Bonn

1973 *1.000.010. Geburtstag der Kunst*, Aix-la-Chapelle, France
1974 *Telepathische Musik Nr. 2*, Akademie der Künste, Berlin
1975 *A World of False Fingerprints*, Galerie René Block, Berlin
1976 *Telepathic Music*, John Gibson Gallery, New York
1984 *The Eternal Network: Robert Filliou*, Sprengel Museum, Hannover; traveled to Musée d'Art Moderne de la Ville de Paris, Paris; Kunsthalle Bern, Bern)
1988 *Robert Filliou, 1926–1987: Zum Gedächtis*, Städtische Kunsthalle, Düsseldorf
1990 *Robert Filliou*, Musée d'art contemporain, Nîmes; traveled to Kunsthalle Basel, Basel, 1991; Hamburger Kunstverein, Hamburg; Musée national d'art moderne, Centre Georges Pompidou, Paris
1995 *Robert Filliou: From Political to Poetical Economy*, Morris and Helen Belkin Art Gallery, University of British Columbia, Vancouver
1997 *Robert Filliou, Poet: Sammlung Feelisch*, Galerie der Stadt, Remscheid, Germany
1998 Robert Miller Gallery, New York

SELECTED GROUP EXHIBITIONS, PERFORMANCES, EVENTS:
1960 *Festivals d'art d'avant-garde*, Palais des expositions de la Porte de Versailles, Paris
1962 *Fluxus Internationale Festspiele Neuester Musik*, Wiesbaden, Germany
 Festival of Misfits, Gallery One, London
 Fluxus Fluxorum Nikolai Kirke, Copenhagen
 Festum Fluxorum, American Students and Artists Center, Paris
1964 *Festival der neuen Kunst, Actions/Agit-Pop/DeCollage/Happenings/Events/Antiart/L'Autrisme/Art Total/Refluxus*, Aix-la-Chapelle, France
1965 *First World Congress: Happenings*, St. Mary's of the Harbor, New York
1970 *Happenings and Fluxus*, Kölnischer Kunstverein, Cologne
1972 *Documenta 5*, Museum Fridericianum, Kassel
1981 *Westkunst: Zeitgenössische Kunst seit 1939*, Museen der Stadt, Cologne
1983 *Museums by Artists*, Art Gallery of Ontario, Toronto; traveled to Musée d'Art Contemporain, Montreal; Glenbow Museum, Calgary
1984 *Von Hier Aus*, Messehallen, Düsseldorf
1987 *Berlinart, 1961–1987*, The Museum of Modern Art, New York; traveled to San Francisco Museum of Modern Art, San Francisco
1988 *Übrigens sterben immer die anderen, Marcel Duchamp und die Avantgarde seit 1950*, Museum Ludwig, Cologne
1993 *In the Spirit of Fluxus*, Walker Art Center, Minneapolis; traveled to Whitney Museum of American Art, New York; Museum of Contemporary Art, Chicago, 1994; Wexner Center for the Arts, The Ohio State University, Columbus, Ohio; San Francisco Museum of Modern Art, San Francisco; Fundació Antoni Tàpies, Barcelona, 1995
1997 *Art Games: Die Schachteln der Fluxuskünstler*, Staatsgalerie, Stuttgart
1998 *Out of Actions: Between Performance and the Object, 1949–1979*, The Museum of Contemporary Art, Los Angeles

Larry Fink

American, born Brooklyn, New York, November 3, 1941
Studied Coe College, Cedar Rapids, Iowa; New School for Social Research, New York; studied photography privately with Lisette Model
Lives in Martin's Creek, Pennsylvania

SELECTED INDIVIDUAL EXHIBITIONS:
1971 Paley and Lowe Gallery, New York
1973 Yale University School of Fine Arts, New Haven

1975 Cedar Crest College, Allentown, Pennsylvania

1977 Center for Creative Photography, University of Arizona, Tucson, Arizona

1979 *Larry Fink*, The Museum of Modern Art, New York
Simon Lowinsky Gallery, San Francisco

1981 Kunstmuseum Düsseldorf, Düsseldorf

1984 Sander Gallery, New York

1985 Gallery Forum, Tarragona, Spain

1987 Haverford College, Bryn Mawr, Pennsylvania

1993 Neuberger Museum, State University of New York Purchase, New York
Les Rencontres de Photographie, Arles; traveled to Musée de l'Elysée, Lausanne, Switzerland; Photo Forum, Frankfurt; Musée de la Photographie, Charleroi, Belgium

1997 Yancey Richardson Gallery, New York
Larry Fink: Boxing Photographs, Whitney Museum of American Art, New York

SELECTED GROUP EXHIBITIONS:

1970 The Museum of Modern Art, New York
MIT Gallery of Creative Photography, Boston

1972 Princeton University, Princeton, New Jersey

1975 Midtown Y Gallery, New York

1978 The Museum of Modern Art, New York

1979 Allentown Museum, Allentown, Pennsylvania

1985 Dubois Gallery, Lehigh University, Bethlehem, Pennsylvania

1987 Light Gallery, New York

1992 The Museum of Modern Art, New York

1993 Allentown Museum, Allentown, Pennsylvania

1994 National Institute of Photography, the Netherlands

Fluxus

Founded in 1962 by George Maciunas, Fluxus was an eclectic international collective, counting among its ranks at various points Joseph Beuys, George Brecht, Robert Filliou, Alison Knowles, Charlotte Moorman, Yoko Ono, Nam June Paik, Daniel Spoerri, Ben Vautier, Wolf Vostell, Robert Watts, and LaMonte Young, among others. With primarily social, not formalist, concerns, Fluxus incorporated diverse types of activities such as concrete music concerts, guerrilla theater, experimental poetry, street performances, mail art, and the creation of object, text, and image editions. Spirited and aggressive, Fluxus artists were united by a shared anti-aesthetic iconoclasm, and by the desire to redefine art and its relation to everyday life.

SELECTED EXHIBITIONS, PERFORMANCES, EVENTS:

1962 *Kleines Sommerfest 'Après John Cage'* Galerie Parnass, Wuppertal, Germany
Neo-Dada in der Musik, Kammerspiele, Düsseldorf
Fluxus Internationale Festspiele Neuester Musik, Wiesbaden, Germany
Fluxus Fluxorum, Nikolai Kirke, Copenhagen
Festum Fluxorum, American Students and Artists Center, Paris
Festival of Misfits, Gallery One, London

1963 *Festum Flororum*, Düsseldorf
Fluxus Festival of Total Art and Comportment, Nice
Fluxus Festival: Theatre Compositions—Street Compositions—Exhibits—Electronic Music, Hypokriterion Theater, Amsterdam

1964 *Flux Festival at Fluxhall*, New York
Fluxus Concerts at Fluxhall/Fluxshop, New York

1965 *Perpetual Fluxus Festival*, Cinemathèque, New York

Fluxorchestra at Carnegie Recital Hall, Carnegie Recital Hall, New York

1970 *Flux-Mass, Flux-Sports, Flux-Show*, New Brunswick, New Jersey
Happenings and Fluxus, Kölnischer Kunstverein, Cologne

1973 *Flux Game Fest*, New York

1974 *Fluxus/éléments d'information*, Musée d'Art Moderne de la Ville de Paris, Paris

1976 *Flux-Labyrinth*, Akademie der Künste, Berlin

1977 *Flux Snow Event*, New Marlborough, Massachusetts

1981 *Fluxus—Aspekte Eines Phänomens*, Kunst- und Museumsverein Wuppertal, Wuppertal, Germany

1988 *Fluxus: Selections from the Gilbert and Lila Silverman Collection*, The Museum of Modern Art, New York

1990 *Ubi Fluxus Ibi Motus*, (in conjunction with *La Biennale XLIV*), Ex Granai della Repubblica, Venice

1991 *Under the Influence of Fluxus*, Plug In Inc., Melnychenko Gallery, Winnipeg, Canada
FluxAttitudes, Hallwalls Contemporary Art Center, Buffalo, New York; traveled to The New Museum of Contemporary Art, New York

1992 *Fluxers*, Museion, Museo D'Arte Moderna, Bolzano, Italy

1993 *In the Spirit of Fluxus*, Walker Art Center, Minneapolis; traveled to Whitney Museum of American Art, New York; Museum of Contemporary Art, Chicago, 1994; Wexner Center for the Arts, The Ohio State University, Columbus, Ohio; San Francisco Museum of Modern Art, San Francisco; Fundació Antoni Tàpies, Barcelona, 1995

1997 *Art Games: Die Schachteln der Fluxuskünstler*, Staatsgalerie, Stuttgart

SELECTED GROUP EXHIBITIONS:

1983 *Museums by Artists*, Art Gallery of Ontario, Toronto; traveled to Musée d'Art Contemporain, Montreal; Glenbow Museum, Calgary

1987 *Berlinart, 1961–1987*, The Museum of Modern Art, New York; traveled to San Francisco Museum of Modern Art, San Francisco

1997 *Deep Storage*, Haus der Kunst, Munich; traveled to Neue Nationalgalerie, Berlin; P.S. 1 Contemporary Art Center, New York, 1998; Henry Art Gallery, Seattle

1998 *Out of Actions: Between Performance and the Object, 1949–1979*, The Museum of Contemporary Art, Los Angeles

Günther Förg

German, born Füssen, Germany, 1952
Studied Akademie der Bildenden Künste, Munich, under K.F. Dahmen (1973–79)
Lives in Areuse, Switzerland

SELECTED INDIVIDUAL EXHIBITIONS:

1984 Galerie Max Hetzler, Cologne
Stedelijk Museum, Amsterdam (with Jeff Wall)

1987 Museum Haus Lange, Krefeld, Germany; traveled to Maison de la culture et de la communication, Saint-Etienne, France; Haags Gemeentemuseum, The Hague, 1988

1988 Karsten Schubert, London

1989 *Günther Förg: The Complete Editions, 1974–1988*, Museum Boymans van-Beuningen, Rotterdam; traveled to Neue Galerie am Landesmuseum, Graz, Austria
Galerie Gisela Capitain, Cologne
Günther Förg: Painting/Sculpture/Installation, Newport Harbor Art Museum, Newport Beach, California; traveled to San Francisco

Museum of Modern Art, San Francisco; Milwaukee Art Museum, Milwaukee

1990 Museum Fridericianum, Kassel; traveled to Museum van Hedendaagse Kunst, Ghent; Museum der Bildenden Künste, Leipzig; Kunsthalle Tübingen, Tübingen; Kunstraum München, Munich
Stations of the Cross, Galerie Max Hetzler, Cologne
Chinati Foundation, Marfa, Texas
Luhring Augustine Gallery, New York

1991 Musée d'Art Moderne de la Ville de Paris, Paris
1992 Dallas Museum of Art, Dallas
1993 Camden Art Centre, London
1995 Stedelijk Museum, Amsterdam
1996 Galerie Max Hetzler, Berlin
Kunstmuseum Lucerne, Lucerne

SELECTED GROUP EXHIBITIONS:

1979 *Europa '79*, Kunstausstellungen Gutenbergstrasse 62a, Stuttgart
1981 *Junge Kunst aus Westdeutschland 81*, Galerie Max Hetzler, Stuttgart
1986 *Chambres d'amis*, Museum van Hedendaagse Kunst, Ghent
Prospect 86, Frankfurter Kunstverein, Frankfurt
1988 *Carnegie International 1988*, The Carnegie Museum of Art, Pittsburgh
1989 *Another Objectivity*, Institute of Contemporary Arts, London
1991 *Metropolis*, Martin-Gropius-Bau, Berlin
1992 *Allegories of Modernism*, The Museum of Modern Art, New York
Photography in Contemporary German Art, 1960 to the Present, Walker Art Center, Minneapolis
1994 *Zwanzig Jahre Kunstraum München*, Kunstraum, Munich
1995 *Poème-Image*, Galerie Lelong, Zurich

Andrea Fraser

American, born Billings, Montana, September 27, 1965
Studied School of Visual Arts, New York (1982–84); Whitney Museum of American Art Independent Study Program (1984–86)
Lives in New York

SELECTED INDIVIDUAL EXHIBITIONS:

1986 *Damaged Goods Gallery Talk Starts Here*, The New Museum of Contemporary Art, New York
1989 *Museum Highlights: A Gallery Talk*, The Philadelphia Museum of Art, Philadelphia
1990 Galerie Christian Nagel, Cologne
1991 *Welcome to the Wadsworth*, The Wadsworth Atheneum, Hartford, Connecticut
How May I Help You? (with Allan McCollum) American Fine Arts, New York
1992 *Aren't They Lovely?*, University Art Museum, University of California, Berkeley
1993 *Please Ask for Assistance*, American Fine Arts, New York
1995 *An Introduction to the Sprengel Museum*, Sprengel Museum, Hannover
1997 *White People in West Africa*, American Fine Arts, New York

SELECTED GROUP EXHIBITIONS:

1984 *Opposing Force*, Hallwalls, Buffalo, New York
1985 *Transitional Objects*, Philip Nelson Gallery, Lyon
1988 *Re: Placement*, LACE, Los Angeles
1990 *The Desire of the Museum*, Whitney Museum of American Art, Downtown at Federal Reserve Plaza, New York

1993 *1993 Biennial Exhibition*, Whitney Museum of American Art, New York
1994 *Die Orte der Kunst*, Sprengel Museum, Hannover
1995 *Els Límits del Museu*, Fundació Antoni Tàpies, Barcelona
1997 *Collected*, The Photographers' Gallery, London
1998 *Bienal Internacional de São Paulo*, São Paulo,
Genius Loci, Kunsthalle Bern, Bern

General Idea

General Idea was formed in 1969 by AA Bronson, Felix Partz, and Jorge Zontal in Toronto, and dissolved as a productive entity upon the deaths of Felix Partz and Jorge Zontal.
AA Bronson (a.k.a. Michael Tims), born Vancouver, British Columbia, 1946
Studied University of Manitoba, School of Architecture (1964–67)
Felix Partz (a.k.a. Ron Gabe), born Winnipeg, Manitoba, 1945
Studied University of Manitoba, School of Art (1963–67)
Died Toronto, June 1994
Jorge Zontal (a.k.a. Jorge Saia), born Parma, Italy, 1944
Studied Dalhousie University, Halifax, Nova Scotia, B.ARCH. (1968)
Died Toronto, February 4, 1994

SELECTED INDIVIDUAL EXHIBITIONS:

1969 *Garb Age*, 78 Gerrard Street West, Toronto
1971 *The 1971 Miss General Idea Pageant Entries*, Art Gallery of Ontario & A Space, Toronto
1976 *Search for the Spirit*, Galerie Gaetan, Geneva
1977 Galleria Lucio Amelio, Naples
1979 *The Colour Bar Lounge*, Stedelijk Museum, Amsterdam
1981 *Miss General Idea Boutique*, Carmen Lamanna Gallery, Toronto
1984 *The 1984 Miss General Idea Pavillion*, Basel, Kunsthalle Basel; traveled to Stedelijk van Abbemuseum Eindhoven; Art Gallery of Ontario, Toronto; Musée d'art contemporain, Montreal
1987 *AIDS: Poster Project for New York City*, New York
1989 *General Idea's Yen Boutique*, Esther Schipper Galerie, Cologne
1991 *PLA©EBO/General Idea's Yen Boutique*, Stampa Gallery, Basel
1992 *General Idea's Fin de Siècle*, Württembergischer Kunstverein, Stuttgart; traveled to Centre d'Art Santa Monica, Barcelona; Hamburger Kunstverein, Hamburg, 1993; Wexner Center for the Arts, The Ohio State University, Columbus, Ohio; San Francisco Museum of Modern Art, San Francisco
1994 *One Day of AZT / One Year of AZT*, National Gallery of Canada, Ottawa
1995 *General Idea: Infections*, S.L. Simpson Gallery, Toronto; traveled to René Blouin Gallery, Montréal; Vancouver Art Gallery, Vancouver
1997 *Projects 56: General Idea*, The Museum of Modern Art, New York

SELECTED GROUP EXHIBITIONS:

1970 *Image Bank Postcard Show*, National Gallery of Canada, Ottawa
1973 *Canada Trajectories '73*, Musée d'Art Moderne de la Ville de Paris, Paris
1977 *Paris Biennale*, Paris
1978 *Kanadischer Künstler* Kunsthalle Basel, Basel
1980 *La Biennale di Venezia XXXIX*, Venice
1982 *Documenta 7*, Museum Fridericianum, Kassel
2nd Sydney Biennale, Art Gallery of New South Wales, Sydney
1983 *Museums by Artists*, Art Gallery of Ontario, Toronto; traveled to Musée d'Art Contemporain, Montreal; Glenbow Museum, Calgary
1984 *An International Survey of Painting and Sculpture*, The Museum of Modern Art, New York

1990 *Team Spirit*, Neuberger Museum, State University of New York, Purchase, New York; traveled to Cleveland Center for Contemporary Art Cleveland; Vancouver Art Gallery, Vancouver; The Art Museum at Florida International University, Miami; Spirit Square Center for the Arts, Charlotte, North Carolina; Laumeier Sculpture Park, St. Louis

1994 *L'Hiver de l'amour*, Musée d'Art Moderne de la Ville de Paris, Paris; traveled to P.S. 1, Institute for Contemporary Art, New York

1995 *A Different Light*, University Art Museum, University of California, Berkeley

1996 *Thinking Print: Books to Billboards, 1980–95*, The Museum of Modern Art, New York

1997 *Disrupture: Postmodern Media*, (with Dara Birnbaum and Nam June Paik) San Francisco Museum of Modern Art, San Francisco

Hans Haacke

German, born Cologne, August 12, 1936
Studied Staatliche Hochschule für Bildende Künste, Kassel, M.F.A. (1956–60); Atelier 17, Paris (1960–61); Tyler School of Art, Philadelphia (1961–62)
Lives in New York

SELECTED INDIVIDUAL EXHIBITIONS:

1962 *Hans Haacke: Lithographs, Relief Prints*, Wittenborn One-Wall Gallery, New York

1965 *Hans Haacke: Wind und Wasser* Galerie Schmela, Düsseldorf,

1966 Howard Wise Gallery, New York

1967 Heyden Gallery, Massachusetts Institute of Technology, Cambridge, Massachusetts

1968 95 East Houston Street, New York

1971 Galerie Paul Maenz, Cologne

1972 *Hans Haacke, New York: Demonstrationen der physikalischen Welt; Biologische und gesellschaftliche Systeme*, Museum Haus Lange, Krefeld, Germany

1973 John Weber Gallery, New York

1974 *Manet–PROJEKT '74*, Galerie Paul Maenz, Cologne

1975 *Hans Haacke: Seurat's 'Les Poseuses' (small version), 1888–1975*, John Weber Gallery, New York

1976 Lisson Gallery, London
Frankfurter Kunstverein, Frankfurt

1977 *Matrix 31: Hans Haacke*, The Wadsworth Atheneum, Hartford, Connecticut
Badischer Kunstverein, Karlsruhe, Germany

1978 Galerie Durand-Dessert, Paris

1979 Stedelijk van Abbemuseum, Eindhoven
Hans Haacke: Recent Work, The Renaissance Society, University of Chicago, Chicago

1981 Hans Haacke: *Der Pralinenmeister*, Galerie Paul Maenz, Cologne

1984 Tate Gallery, London

1986 *Hans Haacke: Unfinished Business*, The New Museum of Contemporary Art, New York

1989 *Artfairismes*, Musée national d'art moderne, Centre Georges Pompidou, Paris

1993 *La Biennale di Venezia XLV*, Venice

1995 *Hans Haacke: "Obra Social,"* Fundació Antoni Tàpies, Barcelona

1997 *Boven: ter inzage*, Museum Boijmans Van Beuningen, Rotterdam

SELECTED GROUP EXHIBITIONS:

1962 *Nul*, Stedelijk Museum, Amsterdam

1965 *Licht und Bewegung: Kinetische Kunst*, Kunsthalle Bern, Bern

1966 *Directions in Kinetic Sculpture*, University Art Gallery, University of California, Berkeley

1968 *The Machine as Seen at the End of the Mechanical Age*, The Museum of Modern Art, New York; traveled to University of St. Thomas, Houston, 1969; San Francisco Museum of Modern Art, San Francisco

1969 *Earth Art*, Herbert F. Johnson Museum of Art, Cornell University, Ithaca, New York
Art by Telephone, Museum of Contemporary Art, Chicago
When Attitudes Become Form: Works—Concepts—Processes—Situations—Information: Live in Your Head, Kunsthalle Bern, Bern; traveled to Museum Haus Lange, Krefeld; Museum Folkwang, Essen; Institute of Contemporary Arts, London

1970 *Information*, The Museum of Modern Art, New York
Conceptual Art and Conceptual Aspects, New York Cultural Center, New York
Software: Information Technology: Its Meaning for Art, The Jewish Museum, New York; traveled to Smithsonian Institution, Washington, D.C., 1971

1972 *Documenta 5*, Museum Fridericianum, Kassel

1978 *Museum des Geldes: Über die seltsame Natur des Geldes in Kunst, Wissenschaft und Leben*, Städtischer Kunstverein, Düsseldorf

1982 *'60–'80: Attitudes/Concepts/Images*, Stedelijk Museum, Amsterdam

1983 *Museums by Artists*, Art Gallery of Ontario, Toronto; traveled to Musée d'Art Contemporain, Montreal; Glenbow Museum, Calgary

1987 *L'Époque, la mode, la morale, la passion*, Musée national d'art moderne, Centre Georges Pompidou, Paris
Committed to Print, The Museum of Modern Art, New York

1989 *Magiciens de la Terre*, Musée national d'art moderne, Centre Georges Pompidou and La Grande Halle, La Villette, Paris

1992 *Territorium Artis*, Kunst- und Austellungshalle der Bundesrepublik Deutschland, Bonn

1994 *The Art of Memory: Holocaust Memorials in History*, The Jewish Museum, New York

1995 *Reconsidering the Object of Art: 1965–75*, The Museum of Contemporary Art, Los Angeles

1996 *Face à l'histoire*, Musée national d'art moderne, Centre Georges Pompidou, Paris

1997 *Documenta 10*, Museum Fridericianum, Kassel

Richard Hamilton

British, born London, February 24, 1922
St. Martin's School of Art, London (1936); Royal Academy Schools, London (1938–40/1945–46); Slade School of Fine Art, London (1948–51)
Lives in London

SELECTED INDIVIDUAL EXHIBITIONS:

1950 *Variations on the Theme of a Reaper*, Gimpel Fils, London

1951 *Growth and Form*, Institute of Contemporary Arts, London

1955 *Man, Machine, & Motion*, University of Durham, Newcastle-upon-Tyne

1966 *The Solomon R. Guggenheim: Six Fiberglass Reliefs*, Robert Fraser Gallery, London

1970 *Richard Hamilton*, Tate Gallery, London; traveled to Stedelijk van Abbemuseum, Eindhoven; Kunsthalle Bern, Bern

1973 *Richard Hamilton*, Solomon R. Guggenheim Museum, New York

1980 *Interiors: 1964–79*, Waddington Galleries, London

1985 Fundació Caja de Pensiones, Madrid

1986 Los Angeles County Museum of Art, Los Angeles

1992 *Richard Hamilton*, Tate Gallery London; traveled to The Irish Museum of Modern Art, Dublin

1996 *Richard Hamilton: Site-Referential Paintings*, San Francisco Museum of Modern Art, San Francisco

SELECTED GROUP EXHIBITIONS:

1956 *This is Tomorrow*, Whitechapel Art Gallery, London

1957 *An Exhibit*, Hatton Gallery, Newcastle-upon-Tyne

1964 *Nieuwe Realisten*, Haags Gemeentemuseum, The Hague

1968 *Documenta 4*, Museum Fridericianum, Kassel

1969 *Information*, Kunsthalle Basel, Basel
Art by Telephone, Museum of Contemporary Art, Chicago

1970 *British Painting and Sculpture 1960–1970*, National Gallery of Art, Washington, D.C.

1972 *Book as Artwork, 1960–1972*, Nigel Greenwood Gallery, London

1976 *Pop Art in England*, Hamburger Kunstverein, Hamburg

1978 *Interfaces: Dieter Roth and Richard Hamilton*, Waddington and Tooth Galleries, London

1981 *Westkunst: Zeitgenössische Kunst seit 1939*, Museen der Stadt, Cologne

1987 *Berlinart, 1961–1987*, The Museum of Modern Art, New York; traveled to San Francisco Museum of Modern Art, San Francisco

1988 *This Is Tomorrow Today*, Institute for Art and Urban Resources, New York

1990 *The Independent Group: Postwar Britain and the Aesthetics of Plenty*, Institute of Contemporary Arts, London; traveled to IVAM, Centro Julio Gonzalez, Valencia; The Museum of Contemporary Art, Los Angeles; University Art Museum, University of California, Berkeley; Hood Museum of Art, Dartmouth College, Hanover, New Hampshire
High and Low: Modern Art and Popular Culture, The Museum of Modern Art, New York; traveled to The Art Institute of Chicago, Chicago; The Museum of Contemporary Art, Los Angeles

1991 *Carnegie International 1991*, The Carnegie Museum of Art, Pittsburgh
Pop Art, Royal Academy of Arts, London

1995 *Five Rooms*, Anthony d'Offay Gallery, London

1996 *Small Format*, Alan Cristea Gallery, London

1997 *Documenta 10*, Museum Fridericianum, Kassel

Susan Hiller
American, born Tallahassee, Florida, 1942
Studied Smith College, Northhampton, Massachusetts, B.A. (1961); Tulane University, New Orleans, Louisiana, M.A. (1965)
Lives in London

SELECTED INDIVIDUAL EXHIBITIONS:

1973 Gallery House, London

1976 Serpentine Gallery, London

1978 Museum of Modern Art, Oxford

1980 *Work in Progress*, Matt's Gallery, London

1982 The Arnolfini Gallery Bristol, England

1984 Orchard Gallery, Londonderry, Northern Ireland

1986 Institute of Contemporary Arts, London

1990 The Mappin Museum and Art Gallery, Sheffield, England

1994 The Sigmund Freud Museum, London

1996 Tate Gallery, Liverpool

1997 Galeria Foksal, Warsaw

1998 Experimental Art Foundation, Adelaide

Institute of Contemporary Art, University of Pennsylvania, Philadelphia
Projektgalerie, Leipzig, Germany

SELECTED GROUP EXHIBITIONS:

1984 *The British Art Show*, Arts Council of Great Britain, London

1985 *Un Seul Visage*, Centre National de la Photographie, Paris

1986 *Staging the Self*, National Portrait Gallery, London

1990 *Signs of the Times: Video Installations of the 1980s*, The Museum of Modern Art, Oxford

1991 *Exploring the Unknown Self*, Metropolitan Museum of Photography, Tokyo

1995 *Rites of Passage: Art for the End of the Century*, Tate Gallery, London

1996 *Now/Here*, Louisiana Museum of Modern Art, Humlebaek, Denmark
Inside the Visible: An Elliptical Traverse of 20th Century Art, Institute of Contemporary Art, Boston
Sydney Biennale, Art Gallery of New South Wales, Sydney

1997 *Material Culture*, Hayward Gallery, London

1998 *In Visible Light*, Moderna Museet, Stockholm
Out of Actions: Between Performance and the Object, 1949–1979, The Museum of Contemporary Art, Los Angeles

Candida Höfer
German, born Eberswalde, Germany, 1944
Studied Staatliche Kunstakademie, Düsseldorf (1973–76)
Lives in Cologne

SELECTED INDIVIDUAL EXHIBITIONS:

1975 Galerie Konrad Fischer, Düsseldorf

1979 Galerie Arno Kohnen, Düsseldorf

1982 *Öffentliche Innenräume 1979–82*, Museum Folkwang, Essen

1984 *Candida Höfer: Innenraum, Photografien 1979–1984*, Landesmuseum, Bonn

1985 *Räume*, Gallery Rüdiger Schöttle, Munich

1989 *Fotografien*, Kunstverein Bremerhaven, Germany

1990 Nicole Klagsbrun Gallery, New York

1992 *Räume/Spaces*, Portikus, Frankfurt
Galerie Grita Insam, Vienna

1993 *Photographie II—Zoologische Gärten*, Hamburger Kunsthalle, Hamburg

1994 Nicole Klagsbrun Gallery, New York

1996 Sonnabend Gallery, New York,

1997 Gallery Condé, Goethe Institut, Paris

1998 *Candida Höfer: Photographie*, Kunstverein Wolfsburg, Wolfsburg; traveled to Kunstverein Recklinghausen, Recklinghausen, Germany; Oldenburger Kunstverein, Oldenburg
Kunstverein Wolfsburg, Wolfsburg, Germany

SELECTED GROUP EXHIBITIONS:

1976 *Nachbarschaft*, Kunsthalle Düsseldorf, Düsseldorf

1986 *Gursky, Höfer, Hütte*, Ausstellungsraum Brückenstrasse, Düsseldorf

1988 *Klasse Bernhard Becher*, Galerie Johnen und Schöttle, Cologne

1991 *Typologies: Nine Contemporary Photographers*, Newport Harbor Art Museum, Newport Beach, California
Aus der Distanz, Kunstsammlung Nordrhein-Westfalen, Düsseldorf

1992 *Four Visions of Interior and Exterior Landscapes*, Galerie Lehmann, Lausanne

1993 *Distanz und Nähe*, Neue Nationalgalerie, Berlin

1996 *Making Pictures: Women and Photography, 1975–Now*, Nicole
 Klagsbrun Gallery, New York
1997 *German Photographs*, John Gibson Gallery, New York

Komar and Melamid

Vitaly Komar, American, born Moscow, September 11, 1943
Alexander Melamid, American, born Moscow, July 14, 1945
Both studied Stroganov Insitute of Art & Design, Moscow (1962–67)
Both live in New York

SELECTED INDIVIDUAL EXHIBITIONS:

1965 Academy of Art, Vilnius, Soviet Union
 Stroganov Institute of Art and Design, Moscow
1967 Blue Bird Café, Moscow
1972 *Sots-art*, private apartment, Moscow
1974 *Art Belongs to the People* (performance), private apartment, Moscow
1976 *Color is a Mighty Power!*, Ronald Feldman Fine Arts, New York
1977 Ohio State University Gallery of Fine Arts, Columbus, Ohio
 A Space, Toronto
1978 *Matrix 43: Komar and Melamid*, The Wadsworth Atheneum,
 Hartford, Connecticut
1979 Performance, Hirshhorn Museum and Sculpture Garden,
 Smithsonian Institution, Washington, D.C.
1980 Ronald Feldman Fine Arts, New York
 Edwin A. Ulrich Museum of Art, Wichita State University,
 Wichita, Kansas
1983 Portland Center for the Visual Arts, Portland, Oregon
1984 Palace Theater of the Arts, Stamford, Connecticut
 Business as Usual, Ronald Feldman Fine Arts, New York
1985 Fruitmarket Gallery, Edinburgh; traveled to Museum of Modern
 Art, Oxford; Musée des arts décoratifs, Paris; Arts Council Gallery,
 Belfast
1986 Tyler School of Art, Temple University Philadelphia
1987 *Komar and Melamid: History Painting*, Artspace, Sydney
1988 *Death Poems*, Neue Gesellschaft für Bildende Kunst, Berlin
1989 *Bergen Point Brass Foundry, Bayonne*, Ronald Feldman Fine Arts,
 New York
1990 *Grand Lobby Installation*, The Brooklyn Museum, Brooklyn, New
 York
1991 Ljubliana Congress Center, Cankarjev Dom, Yugoslavia
1993 The Stepped Pyramid, Guelman Gallery, Contemporary Art
 Center, Moscow
 What to Do with Lenin's Mausoleum? (performance), Red Square,
 Moscow
1994 *Monumental Propaganda: A Traveling Exhibition*, Independent
 Curators Inc., New York
1996 *Made to Order: America's Most Wanted Paintings*, Alternative Museum,
 New York
1997 *Jukebox: Sound Works*, Copenhagen Contemporary Art Center
 Copenhagen

SELECTED GROUP EXHIBITIONS:

1974 *Outdoor Exhibition*, Beljaevo, Moscow
1977 *New Art from the Soviet Union*, Arts Club of Washington, D.C.,
 Washington, D.C., and Herbert F. Johnson Museum of Art, Cornell
 University, Ithaca, New York
1978 *Couples*, P.S. 1, Institute for Art and Urban Resources, New York
1982 *Illegal America*, Franklin Furnace, New York

1984 *An International Survey of Recent Painting and Sculpture*, The Museum
 of Modern Art, New York
1985 *Alles und noch viel Mehr*, Kunsthalle Bern and Kunstmuseum Bern,
 Bern
1987 *Documenta 8*, Museum Fridericianum, Kassel
1988 *The Social Club*, Exit Art, New York
1989 *Image World: Art and Media Culture*, Whitney Museum of American
 Art, New York
1990 *The Decade Show: Frameworks of Identity in the 1980s*, The New
 Museum of Contemporary Art and The Studio Museum of
 Harlem, New York
1993 *Stalin's Choice: Soviet Socialist Realism 1932–1956*, P.S. 1, Institute for
 Contemporary Art, New York
1996 *Zeitgenössische Kunst im Museum Ludwig*, Museum Ludwig, Cologne
1998 *Out of Actions: Between Performance and the Object, 1949–1979*, The
 Museum of Contemporary Art, Los Angeles

Louise Lawler

American, born Bronxville, New York, February 3, 1947
Studied Cornell University, Ithaca, New York (1965–69)
Lives in New York

SELECTED INDIVIDUAL EXHIBITIONS:

1973 University of California Davis
1979 *A Movie Will Be Shown Without the Picture*, Santa Monica, California
1981 Jancar-Kuhlenschmidt Gallery, Los Angeles
1984 The Wadsworth Atheneum, Hartford, Connecticut
1985 Nature Morte Gallery, New York
1987 Galerie Isabella Kacprzak, Stuttgart
 Metro Pictures Gallery, New York
 Projects 9: Louise Lawler, The Museum of Modern Art, New York
 What is the Same: Louise Lawler, Maison de la Culture de Saint-
 Etienne, Saint-Etienne
1988 Galerie Yvon Lambert, Paris
1990 *The Enlargement of Attention, No One Between the Ages of 21 and 35 is
 Allowed*, Museum of Fine Arts, Boston
 Galerie Yvon Lambert, Paris
1991 *For Sale*, Metro Pictures Gallery, New York
 Connections: Louise Lawler, Museum of Fine Arts, Boston
1993 Sprengel Museum, Hannover
1994 Centre d'Art Contemporain, Geneva
1996 *It Could Be Elvis and Other Pictures*, S.L. Simpson Gallery, Toronto
1997 *Monochrome*, Hirshhorn Museum and Sculpture Garden,
 Smithsonian Institution, Washington, D.C.
1998 Metro Pictures Gallery, New York

SELECTED GROUP EXHIBITIONS:

1972 Protetch-Rivkin Gallery, Washington, D.C.
1978 Artists Space, New York
1981 *Love is Blind*, Leo Castelli, New York
1984 *Ideal Settings* (with Allan McCollum), Diane Brown Gallery, New
 York
 Re-place-ment, Hallwalls, Buffalo
1985 *The Art of Memory/The Loss of History*, The New Museum of
 Contemporary Art, New York
1987 *Implosion: A Postmodern Perspective*, Moderna Museet, Stockholm
1989 *A Forest of Signs: Art in the Crisis of Representation*, The Museum of
 Contemporary Art, Los Angeles

The Desire of the Museum, Whitney Museum of American Art, Downtown at Federal Reserve Plaza, New York

1990 The Decade Show: Frameworks of Identity in the 1980s, The New Museum of Contemporary Art and The Studio Museum of Harlem, New York

1991 1991 Biennial Exhibition, Whitney Museum of American Art, New York
Carnegie International 1991, The Carnegie Museum of Art, Pittsburgh

1992 Special Collections: The Photographic Order from Pop to Now, International Center of Photography, New York

1993 Das Bild der Ausstellung/The Image of the Exhibition, Hochschule für angewandte Kunst/Heiligenkreuzerhof, Vienna

1995 Els Límits del Museu, Fundació Antoni Tàpies, Barcelona
Art Museum: Sophie Calle, Louise Lawler, Richard Misrach, Diane Neumaier, Richard Ross, Thomas Struth, Center for Creative Photography, University of Arizona, Tucson

1997 Deep Storage, Haus der Kunst, Munich; traveled to Neue Nationalgalerie, Berlin; P.S. 1 Contemporary Art Center, New York, 1998; Henry Art Gallery, Seattle

Jean-Baptiste Gustave Le Gray
French, born Villiers-le-Bel (Seine et Oise) France, August 30, 1820
Studied painting in the atelier of Paul Delaroche, Paris (1839–43)
Died Cairo, Egypt, 1882

SELECTED INDIVIDUAL EXHIBITIONS:

1978 Le Camp de Châlons: un reportage de Gustave Le Gray, 1857, Galerie Louvois, Bibliothèque nationale, Paris

1987 The Photography of Gustave Le Gray, The Art Institute of Chicago, Chicago

1988 Gustave Le Gray, J. Paul Getty Museum, Malibu, California

1993 Gustave Le Gray and Carleton W. E. Watkins: Pioneers of Landscape Photography: Photographs from the Collection of the J. Paul Getty Museum, Städtische Galerie im Städelschen Kunstinstitut Frankfurt am Main Graphische Sammlung, Frankfurt

1996 Une visite au camp de Châlons sous le Second Empire: Photographies de Messieurs Le Gray et Prévot, Musée de l'armée, Hôtel des Invalides, Paris

SELECTED GROUP EXHIBITIONS:

1848 Produits de l'Industrie, Paris
1849 Produits de l'Industrie, Paris
1851 Universal Exposition, London
1852 Crystal Palace, London
1854 Salon, Paris
1855 S.F.P., Exposition Universelle, Paris
1856 Exposition Universelle, Brussels
1858 Photographic Society of Scotland, Edinburgh
1859 Exposition S.F.P., Paris
1862 Amsterdam
1867 Exposition Universelle, Paris
1980 La Mission héliographique: photographies de 1851, Direction des Musées de France, Paris
1993 The Waking Dream: Photography's First Century: Selections from the Gilman Paper Company Collection, The Metropolitan Museum of Art, New York; traveled to Edinburgh International Festival, Edinburgh

1998 The Museum and the Photograph: Collecting Photography at the Victoria and Albert Museum 1853–1900, The Sterling and Francine Clark Art Institute, Williamstown, Massachusetts

Jac Leirner
Brazilian, born São Paulo, July 4, 1961
Studied College of Fine Arts, Fundação Armando Alvares Penteado, São Paulo (1979–83); Licenciatura (1984)
Lives in São Paulo

SELECTED INDIVIDUAL EXHIBITIONS:

1987 Os Cem, Petite Galerie, Rio de Janeiro
Pulmão, Galeria Millan, São Paulo

1989 Jac Leirner: Nomes, Galeria Millan, São Paulo

1991 Currents, Institute of Contemporary Art, Boston
Museum of Modern Art, Oxford
Viewpoints: Jac Leirner, Walker Art Center, Minneapolis

1992 Directions: Jac Leirner, Hirshhorn Museum and Sculpture Garden, Smithsonian Institution, Washington, D.C.

1993 Corpus Delicti, Centre d'Art Contemporain, Geneva
Galeria Camargo Vilaça, São Paulo

1994 Galerie Lelong, New York

1997 Paço Imperial, Rio de Janeiro
Nice to Meet You, Galerie Lelong, New York

1998 Sala Mendoza, Caracas

SELECTED GROUP EXHIBITIONS:

1983 Bienal Internacional de São Paulo, São Paulo

1988 Tridimensional Forms, Museum of Modern Art, São Paulo

1989 Bienal Internacional de São Paulo, São Paulo

1990 Transcontinental: An Investigation of Reality: Nine Latin American Artists, Ikon Gallery and Cornerhouse Gallery, Manchester, England
$, Gust Vasiliades Gallery, New York

1992 By Arrangement, Galerie Ghislaine Hussenot, Paris
Documenta 9, Museum Fridericianum, Kassel

1993 Latin American Artists of the Twentieth Century, The Museum of Modern Art, New York; traveled to Estación Plaza de Armes, Seville; Hôtel des Arts, Paris; Museum Ludwig, Cologne

1994 Sense and Sensibility: Women Artists and Minimalism in the Nineties, The Museum of Modern Art, New York

1995 About Place: Recent Art of the Americas, The Art Institute of Chicago, Chicago
Latin American Woman Artists, 1915–1995, Milwaukee Museum of Art, Milwaukee; traveled to Phoenix Art Museum, Phoenix; Denver Art Museum, Denver; National Museum of Women in the Arts, Washington, D.C.; Center for Fine Arts, Miami

1997 La Biennale di Venezia XLVII, Venice

1998 Bienal Internacional de São Paulo, São Paulo

Zoe Leonard
American, born Liberty, New York, 1961
Lives in New York

SELECTED INDIVIDUAL EXHIBITIONS:

1979 Fourth Street Photo Gallery, New York
1983 Hogarth Gallery, Sydney
1985 Greathouse, New York
1991 Information: Zoe Leonard, Galerie Gisela Capitain, Cologne
Luhring-Augustine-Hetzler Gallery, Los Angeles

University Art Museum, University of California, Berkeley
Galerie Richard Fonke, Ghent
1992 Paula Cooper Gallery, New York
1993 The Renaissance Society, University of Chicago, Chicago
1995 *Strange Fruit*, 131 Essex Street, New York
La Casa d'Arte, Milan
1997 Paula Cooper Gallery, New York
Wiener Secession, Vienna
1998 Centre National de la Photographie, Paris
Zoe Leonard: Second Skin/Shell, The Israel Museum, Jerusalem

SELECTED GROUP EXHIBITIONS:
1980 Club 57, New York
1982 *Times Square Show*, Times Square, New York
1984 *Soon to Be a Major Motion Picture*, Greathouse, New York
1987 *Consonance*, ISD, New York
1988 *Selections from the Artists' File*, Artists Space, New York
1989 *Strange Attractors: Signs of Chaos*, The New Museum of Contemporary Art, New York
First Amendment Show, Sally Hawkins Gallery, New York
1990 Luhring Augustine Gallery, New York
Wendy Jacob and Zoe Leonard, Andrea Rosen Gallery, New York
Act Up Auction for Action, Paula Cooper Gallery, New York
1991 *8th Annual Day of the Dead/Dia de los Muertos*, Los Angeles Photography Center, Los Angeles
1992 *Documenta 9*, Museum Fridericianum, Kassel
1995 *Féminin/masculin: le sexe de l'art*, Musée national d'art moderne, Centre Georges Pompidou, Paris
1996 *Nudo & Crudo: Corpo Sensibile, Corpo Visibile*, Claudia Gian Ferrari Arte Contemporanea, Milan
1997 *1997 Biennial Exhibition*, Whitney Museum of American Art, New York
1998 *Travel and Leisure*, Paula Cooper Gallery, New York

Sherrie Levine
American, born Hazleton, Pennsylvania, 1947.
Studied University of Wisconsin, Madison, B.F.A. (1969); M.F.A. (1973)
Lives in New York

SELECTED INDIVIDUAL EXHIBITIONS:
1974 De Saisset Museum, Santa Clara, California
1977 3 Mercer Street, New York
1979 The Kitchen, New York
1981 Metro Pictures Gallery, New York
1983 Richard Kuhlenschmidt Gallery, Los Angeles
1984 Nature Morte Gallery, New York
1987 The Wadsworth Atheneum, Hartford, Connecticut
1988 Hirshhorn Museum and Sculpture Garden, Smithsonian Institution, Washington, D.C.
1991 Kunsthalle Zürich, Zurich; traveled to Westfälisches Landesmuseum für Kunst und Kulturgeschichte, Münster; Rooseum—Center for Contemporary Art, Malmö, Sweden; Hôtel des Arts, Paris
Sherrie Levine: Fountain, Mary Boone Gallery, New York
1993 *Sherrie Levine: Newborn*, The Philadelphia Museum of Art, Philadelphia; traveled to Portikus, Frankfurt am Main
Pictures, Artists Space, New York
1994 Marian Goodman Gallery, New York
1995 The Menil Collection, Houston

1996 *Sherrie Levine: Cathedrals*, Margo Leavin Gallery, Los Angeles
Cathedrals and Hobbyhorses, Galerie Jablonka, Cologne
Musée d'art moderne et contemporain, Geneva
1998 Museum Morsbroich, Leverkusen, Germany; traveled to Musée d'art moderne et contemporain, Geneva

SELECTED GROUP EXHIBITIONS:
1977 *Pictures*, Artists Space, New York
1981 *Love is Blind*, Leo Castelli Gallery, New York
1982 *Documenta 7*, Museum Fridericianum, Kassel
1984 *Difference: On Representation and Sexuality*, The New Museum of Contemporary Art, New York
1985 *1985 Biennial Exhibition*, Whitney Museum of American Art, New York
1989 *A Forest of Signs: Art in the Crisis of Representation*, The Museum of Contemporary Art, Los Angeles
1990 *Culture and Commentary: An Eighties Perspective*, Hirshhorn Museum and Sculpture Garden, Smithsonian Institution, Washington, D.C.
1991 *The Picture after the Last Picture*, Galerie Metropol, Vienna
1992 *Allegories of Modernism*, The Museum of Modern Art, New York
1995 *Passions Privées*, Musée d'Art Moderne de la Ville de Paris, Paris
1996 *Rational and Irrational*, Whitney Museum of American Art, New York
Thinking Print: Books to Billboards, 1980–95, The Museum of Modern Art, New York
1998 *Travel and Leisure*, Paula Cooper Gallery, New York

El Lissitzky
Russian, born Lazar Markovich Lissitzky, Potschinok, Smolensk, Russia, November 23, 1890
Studied Technische Hochschule, Darmstadt, Germany (1909–1914)
Died Moscow, December 21, 1941

SELECTED INDIVIDUAL EXHIBITIONS:
1923 Kestner-Gesellschaft, Hannover
1924 *El Lissitzky: Shau der Arbeit 1922–23*, Graphisches Kabinett J.B. Neumann, Berlin
1925 Dresden
1927 Bauhaus, Dessau, Germany
1949 Rose Fried Gallery, New York
1950 Yale University Art Gallery, New Haven
1960 Mayakovski Museum, Moscow
1965 Stedelijk van Abbemuseum, Eindhoven; Kunsthalle Basel, Basel, 1966; Kestner-Gesellschaft, Hannover
1968 Stedelijk van Abbemuseum, Eindhoven
1976 Galerie Gmurzynska, Cologne
1977 *El Lissitzky: 1890–1941*, Museum of Modern Art, Oxford
1983 Hochschule für Grafik und Buchkunst, Leipzig
1985 Stedelijk van Abbemuseum, Eindhoven
1987 *El Lissitzky: 1890–1941*, Busch-Reisinger Museum, Harvard University, Cambridge, Mass.; Sprengel Museum, Hannover; Staatliche Galerie Moritzburg, Halle, Germany
1990 *El Lissitzky: 1890–1941: Architect, Painter, Photographer, Typographer*, Stedelijk van Abbemuseum, Eindhoven; Fundacion Caja de Pensiones, Madrid; Musée d'Art Moderne de la Ville de Paris, Paris
1991 *El Lissitzky: Experiments in Photography*, Houk Friedman Gallery, New York

SELECTED GROUP EXHIBITIONS:

1937 *Konstructivisten: Van Doesburg, Domela, Eggeling, Gabo, Lissitzky, Moholy-Nagy, Mondrian, Pevsner*, Kunsthalle Basel, Basel

1959 *Kleinere Werkgruppen von Pougny: Lissizky und Mansourov aus den Jahren des Suprematismus*, Kunsthalle Bern, Bern

1962 *Two Decades of Experiment in Russian Art, 1902–1922*, Grosvenor Gallery, London

1975 *Russian Contructivism: "The Laboratory Period,"* Annely Juda Fine Art, London

1977 *Malevich, Suetin, Chasnik, Lissitzky: The Suprematist Straight Line*, Annely Juda Fine Art, London

1978 *Revolution: Russian Avant-Garde, 1912–1930*, The Museum of Modern Art, New York
Russische Avantgarde, 1910–1930, Galerie Bargera, Cologne

1980 *The Avant-Garde in Russia, 1910–1930: New Perspectives*, Los Angeles County Museum of Art, Los Angeles

1981 *Art of the Avant-Garde in Russia: Selections from the George Costakis Collection*, Solomon R. Guggenheim Museum, New York

1983 *The First Russian Show: A Commemoration of the Van Diemen Exhibition, Berlin 1922*, Annely Juda Fine Art, London

1988 *Kunst und Revolution: Russische und Sowjetische Kunst, 1910–1932*, Österreichischen Museum für angewandte Kunst, Vienna
Müvészet és Forradalom Orosz-Szovjet Mévészet, Mücsarnok, Budapest

1990 *Russische Avantgarde 1910–1930, aus Sowjetische und Deutschen Sammlungen*, Wilhelm Lehmbruck Museum, Duisburg, Germany

1992 *The Great Utopia: The Russian Avant-Garde, 1915–1932*, Solomon R. Guggenheim Museum, New York; traveled to Stedelijk Museum, Amsterdam; Schirn Kunsthalle, Frankfurt

SELECTED EXHIBITION DESIGNS:

1923 *Prounenraum*, Grosse Berliner Kunstausstellung, Berlin

1926 *Raum für Konstruktive Kunst*, Internationale Kunstausstellung, Dresden

1927 *Kabinett der Abstrakten*, Provinzialmuseum, Hannover

1928 *Soviet Pavilion*, Internationale Presse-Ausstellung (Press Exhibition), Cologne

1929 *Soviet Pavilion*, Internationale Werkbundausstellung Film und Foto (Film and Photo Exhibition), Stuttgart

1930 *Soviet Pavilion*, Internationale Hygiene-Ausstellung, (International Health Exhibition), Dresden
Soviet Pavilion, Internationale Pelz-Fachausstellung (Fur Trade Exhibition), Leipzig

Allan McCollum
American, born Los Angeles, 1944
Lives in New York

SELECTED INDIVIDUAL EXHIBITIONS:

1971 Jack Glenn Gallery, Corona Del Mar, California

1974 Nicholas Wilder Galler, Los Angeles

1977 Claire S. Copley Gallery, Los Angeles

1979 *Surrogate Paintings*, Julian Pretto and Co., New York

1980 *Surrogate Paintings*, Galerie Yvon Lambert, Paris
Artists Space, New York

1982 Galerie Nicole Gonet, Lausanne

1983 Marian Goodman Gallery, New York

1984 *For Presentation and Display: Ideal Settings* (with Louise Lawler), Diane Brown Gallery, New York

1985 *Plaster Surrogates*, Lisson Gallery, London
Actual Photos (with Laurie Simmons), Gallery Nature Morte, New York

1986 *Perfect Vehicles*, Cash/Newhouse Gallery, New York
Investigations 1986: Allan McCollum, Institute of Contemporary Art, University of Pennsylvania, Philadelphia
Perpetual Photos, New York, Diane Brown Gallery

1988 *Allan McCollum*, Portikus, Frankfurt; traveled to De Appel, Amsterdam; Städtische Kunsthalle und Kunstverein für die Rheinlande und Westfalen, Düsseldorf, 1989
Individual Works, John Weber Gallery, New York

1989 *Allan McCollum*, Stedelijk van Abbemuseum, Eindhoven; traveled to Serpentine Gallery, London, 1990; IVAM Centre del Carme, Valencia; Rooseum—Center for Contemporary Art, Malmö, Sweden

1991 *May I Help You?* (with Andrea Fraser), American Fine Arts, Co., New York

1992 *The Dog from Pompeii*, John Weber Gallery, New York

1993 *Drawings*, Centre d'Art Contemporain, Geneva

1995 *Allan McCollum: Natural Copies*, Sprengel Museum, Hannover

1997 *Visible Markers*, Susan Inglett Gallery, New York

1998 Musée d'art moderne, Villeneuve d'Ascq, France

SELECTED GROUP EXHIBITIONS:

1969 *Los Angeles Annual Art Exhibition*, Los Angeles, Municipal Art Gallery

1975 *1975 Biennial Exhibition*, Whitney Museum of American Art, New York

1977 *Unstretched Surfaces*, Los Angeles Institute of Contemporary Art, Los Angeles

1982 *Louise Lawler, Allan McCollum, Sherrie Levine*, Halifax, Nova Scotia, Eye Level Gallery

1984 *Re-place-ment*, Hallwalls, Buffalo

1986 *Damaged Goods: Desire and Economy of the Object*, The New Museum of Contemporary Art, New York

1988 *La Biennale di Venezia XLIII, Aperto*, Venice
Art at the End of the Social, Rooseum—Center for Contemporary Art, Malmö, Sweden

1989 *A Forest of Signs: Art in the Crisis of Representation*, The Museum of Contemporary Art, Los Angeles
Image World: Art and Media Culture, Whitney Museum of American Art, New York

1990 *8th Sydney Biennale: The Readymade Boomerang: Certain Relations in 20th Century Art*, Art Gallery of New South Wales, Sydney

1991 *Carnegie International 1991*, The Carnegie Museum of Art, Pittsburgh

1992 *Allegories of Modernism*, The Museum of Modern Art, New York

1993 *Aura: The Reality of the Artwork between Autonomy, Reproduction, and Context*, Wiener Secession, Vienna

1995 *Temporarily Possessed*, The New Museum of Contemporary Art, New York

1996 *Bringing It All Back Home*, Gracie Mansion Gallery, New York
Fixed Intervals, John Weber Gallery, New York

1997 Brooke Alexander/Brooke Alexander Editions, New York

Christian Milovanoff
French, born Nîmes, December 22, 1948
Studied sociology, Université d'Aix-en-Provence, France, B.A., M.A., PH.D.;
history of art, University of Urbino, Italy
Lives in Arles

SELECTED INDIVIDUAL EXHIBITIONS:

1981 Cabinet des Estampes et de la Photographie, Beaugrenelle, Bibliothèque Nationale, Paris

1984 École des Beaux-Arts d'Innsbruck, Innsbruck, Austria

1986 *Le Louvre revisité*, Galerie Michèle Chomette, Paris

1988 *Peinture et Architecture, une conversation avec Hubert Robert*, Galerie des Arènes/Carré d'Art, Nîmes
La Galerie imaginée, Institut Culturel Français de Stuttgart, Stuttgart

1990 *Derniers Tableaux*, Abbaye de Bouchemaine, France

1993 *D'un regard l'autre, 1986–1993*, Chateau d'Amboise, France

1994 *Christian Milovanoff: Le Jardin 1948–1968*, Saint-Etienne, France

SELECTED GROUP EXHIBITIONS:

1980 *Avant-Gardes*, Galerie Ufficio dell'Arte, Paris

1983 *L'Atelier photographique en France*, Centre de Création Contemporaine, Tours, France

1984 *Regards sur l'art*, Centre nationale de la photographie, Palais de Tokyo, Paris

1985 *Photographies contemporaines en France*, Musée national d'art moderne, Centre Georges Pompidou, Paris

1987 *Rapports: Contemporary Photography from France*, The Photographers' Gallery, London

1988 *Invention and Continuity in Contemporary Photographs*, The Metropolitan Museum of Art, New York

1992 *Musa Museu*, Palau de la Vireina, Barcelona

1995 *La Collection*, Musée d'art contemporain de Nîmes, Carré d'art, Nîmes

1997 *Imagerie, Le Musée photographique*, Lannion, France
Ethique, esthétique, politique, Actes Sud, Arles

Vik Muniz
Brazilian, born São Paulo, 1961
Lives in Brooklyn, New York

SELECTED INDIVIDUAL EXHIBITIONS:

1989 Stux Gallery, New York

1990 Stephen Wirtz Gallery, San Francisco

1991 Kicken-Pauseback, Cologne
Gabinete De Arte Rachel Arnaud, São Paulo

1992 *Vik Muniz: Equivalents*, Galleria Ponte Pietra, Verona

1993 *Equivalents*, Tricia Collins Contemporary Art, New York

1994 *Representations*, Wooster Gardens, New York

1996 Galeria Casa da Imagen, Curitiba, Brazil
The Sugar Children, Tricia Collins Contemporary Art, New York

1997 *Pictures of Thread*, Wooster Gardens, New York

1998 *Seeing Is Believing*, International Center of Photography, New York

SELECTED GROUP EXHIBITIONS:

1989 *On the Edge: Between Sculpture and Photography*, Cleveland Center for Contemporary Art, Cleveland, Ohio

1991 *Anni Novanta*, Galleria d'Arte Moderna, Bologna, Italy

1992 *Multiples*, The Aldrich Museum of Contemporary Art, Ridgefield, Connecticut

1994 *Up the Establishment: Reconstructing the Counterculture*, Sonnabend Gallery, New York

1995 *Panorama Da Arte Contemporanea Brasileira*, Museu de Arte Moderna, Rio de Janeiro
Garbage, Thread Waxing Space, New York

1996 *Some Assembly Required*, The Art Institute of Chicago, Chicago

1997 *New Photography 13*, The Museum of Modern Art, New York

1998 *Bienal Internacional de São Paulo*, São Paulo

Claes Oldenburg
American, born Stockholm, January 28, 1929
Studied literature and art, Yale University, B.A. (1946–50); The Art Institute of Chicago (1952–54)
Lives in New York

SELECTED INDIVIDUAL EXHIBITIONS:

1954 *An Exhibit of Paintings and Drawings*, Tally-Ho Restaurant, Evanston, Illinois

1959 *Figure Drawings*, The Cooper Union Library, New York

1960 *Ray Gun Show*, Judson Gallery, New York

1961 *The Store*, Ray Gun Mfg. Co., 107 East Second Street, New York

1962 Green Gallery, New York

1963 Dwan Gallery, Los Angeles

1964 Sidney Janis Gallery, New York

1966 *Claes Oldenburg: Skulpturer och teckningar, 1963–66*, Moderna Museet, Stockholm

1967 *Claes Oldenburg: Drawings: Projects for Monuments*, Museum of Contemporary Art, Chicago

1969 *Claes Oldenburg*, The Museum of Modern Art, New York; traveled to Stedelijk Museum, Amsterdam, 1970; Städtische Kunsthalle Düsseldorf; Düsseldorf; Tate Gallery, London

1971 *Claes Oldenburg: Object into Monument*, Pasadena Art Museum, Pasadena; traveled to University Art Museum, University of California, Berkeley, 1972; William Rockhill Nelson Gallery of Art and Mary Atkins Museum of Fine Arts, Kansas City, Missouri; Fort Worth Art Center Museum, Fort Worth, Texas; Des Moines Art Center, Des Moines, Iowa; The Philadelphia Museum of Art, Philadelphia; The Art Institute of Chicago, Chicago, 1973

1974 *Claes Oldenburg: Geometric Mouse Scale X*, Dag Hammarskjold Plaza Sculpture Garden, New York

1976 Leo Castelli Gallery, New York

1977 *Claes Oldenburg: Tekeningen, aquarellen en grafiek*, Stedelijk Museum, Amsterdam; traveled to Musée national d'art moderne, Centre Georges Pompidou, Paris; Moderna Museet, Stockholm
The Mouse Museum—The Ray Gun Wing: Two Collections/Two Buildings, Museum of Contemporary Art, Chicago; traveled to Phoenix Art Museum, Phoenix, 1978; Saint Louis Museum of Art, Saint Louis; Dallas Museum of Fine Arts, Dallas; Whitney Museum of American Art, New York;, Rijksmuseum Kröller-Müller, Otterlo, the Netherlands, 1979; Museum Ludwig, Cologne

1978 Margo Leavin Gallery, Los Angeles

1983 *The Screwarch Project*, Museum Boymans-van Beuningen, Rotterdam

1987 *Claes Oldenburg: The Haunted House*, Museum Haus Lange, Krefeld

1990 The Mayor Gallery, London
Leo Castelli Gallery, New York

1992 *Claes Oldenburg: In the Studio*, Walker Art Center, Minneapolis

1994 Pace Gallery, New York

1995 *Claes Oldenburg: An Anthology*, The National Gallery of Art, Washington, D.C., and Solomon R. Guggenheim Museum, New York; traveled to The Museum of Contemporary Art, Los Angeles; Kunst- und Austellungshalle der Bundesrepublik Deutschland, Bonn; Hayward Gallery, London

SELECTED GROUP EXHIBITIONS:
1953 Club St. Elmo, Chicago
1958 *Drawings*, City Gallery, New York
1959 *Xmas Show: Drawings, Prints*, Judson Gallery, New York
1960 *Paintings*, Reuben Gallery, New York
1961 *Painting and Sculpture Acquisitions*, The Museum of Modern Art,
 New York
1963 *Pop Art Show*, Richard Feigen Gallery, Chicago
 Americans 1963, The Museum of Modern Art, New York
 The Popular Image, The Washington Gallery of Modern Art,
 Washington, D.C.
1964 *Nieuwe Realisten*, Haags Gemeentemuseum, The Hague; traveled to
 Museum Moderner Kunst, Museum des 20. Jahrhunderts, Vienna;
 Akademie der Künste, Berlin, 1965; Palais des Beaux-Arts, Brussels
1966 *Environments: Painting and Constructions*, The Jewish Museum, New
 York
1968 *Dada, Surrealism, and Their Heritage*, The Museum of Modern Art,
 New York; traveled to Los Angeles County Museum of Art, Los
 Angeles; Chicago, The Art Institute of Chicago
 The Machine as Seen at the End of the Mechanical Age, The Museum
 of Modern Art, New York; traveled to University of St. Thomas,
 Houston, 1969; San Francisco Museum of Modern Art, San
 Francisco
1969 *Art by Telephone*, Museum of Contemporary Art, Chicago
1972 *Documenta 5*, Museum Fridericianum, Kassel
1976 *Drawing Now*, The Museum of Modern Art, New York; traveled to
 Kunsthaus Zürich, Zurich; Staatliche Kunsthalle Baden-Baden,
 Baden-Baden, Germany; Graphische Sammlung Albertina; Vienna;
 Sonia Henie-Niels Onstad Foundation, Oslo
1977 *Paris—New York: An Album*, Musée national d'art moderne, Centre
 Georges Pompidou, Paris
1978 *Art about Art*, New York, Whitney Museum of American Art; trav-
 eled to North Carolina Museum of Art, Raleigh, North Carolina;
 Frederick S. Wight Art Gallery, University of California, Los
 Angeles, 1979; Portland Art Museum, Portland, Oregon
1981 *Westkunst: Zeitgenössische Kunst seit 1939*, Museen der Stadt,
 Cologne
1983 *Museums by Artists*, Art Gallery of Ontario, Toronto; traveled to
 Musée d'Art Contemporain, Montreal; Glenbow Museum, Calgary
1984 *Drawings 1974–1984*, Hirshhorn Museum and Sculpture Garden,
 Smithsonian Institution, Washington, D.C.
1986 *Qu'est-ce que la sculpture moderne?*, Musée national d'art moderne,
 Centre Georges Pompidou, Paris
1987 *Skulptur Projekte in Münster 87*, Westfälisches Landesmuseum für
 Kunst und Kulturgeschichte, Münster
1989 *Magiciens de la Terre*, Musée national d'art moderne, Centre Georges
 Pompidou and La Grande Halle, La Villette, Paris
1990 *High and Low: Modern Art and Popular Culture*, The Museum of
 Modern Art, New York; traveled to The Art Institute of Chicago,
 Chicago; The Museum of Contemporary Art, Los Angeles
1991 *Pop Art*, Royal Academy of Arts, London; traveled to Museum
 Ludwig, Cologne, 1992; Museo Nacional Centro de Arte Reina
 Sofía Madrid
1992 *Territorium Artis*, Kunst- und Ausstellungshalle der Bundesrepublik
 Deutschland, Bonn
1994 *Sculptor's Maquettes*, Pace Wildenstein Gallery, New York

1997 *Deep Storage*, Haus der Kunst, Munich; traveled to Neue
 Nationalgalerie, Berlin; P.S. 1 Contemporary Art Center, New
 York, 1998; Henry Art Gallery, Seattle
1998 *Pop Art: Selections from The Museum of Modern Art*, High Museum
 of Art, Atlanta
 Out of Actions: Between Performance and the Object, 1949–1979, The
 Museum of Contemporary Art, Los Angeles

Dennis Oppenheim

American, born Mason City (now Electric City), Washington,
September 6, 1938
Studied California College of Arts and Crafts, Oakland, California,
B.F.A.(1959–64); Stanford University, Palo Alto, California, M.F.A.(1964–65)
Lives in New York

SELECTED INDIVIDUAL EXHIBITIONS:
1968 John Gibson Gallery, New York
1969 *A Report: Two Ocean Projects* (with Peter Hutchinson), The Museum
 of Modern Art, New York
 Galerie Françoise Lambert, Milan
 Below Zero Projects, John Gibson Gallery, New York
1970 Reese Palley Gallery, San Francisco
1972 Nova Scotia College of Art and Design, Halifax, Nova Scotia
 Tate Gallery, London
 Sonnabend Gallery, New York
1974 Stedelijk Museum, Amsterdam
1975 Palais des Beaux-Arts, Brussels
1976 Museum Boymans-van Beuningen, Rotterdam
1977 Galerie Hans Mayer, Düsseldorf
1978 Musée d'Art Contemporain, Montreal
1979 Kunsthalle Basel, Basel
 Eels Gallery, Kent State University, Kent, Ohio
 The Kitchen, New York
1982 Ikon Gallery, Birmingham, England
1983 Whitney Museum of American Art, New York
1987 Gallery 360, Tokyo
1989 Holly Solomon Gallery, New York
1991 *Dennis Oppenheim: Selected Works, 1967–90*, P.S. 1, Institute for
 Contemporary Art, New York
1995 Musée d'art moderne de la communaute urbaine de Lille, Lille
1996 Mannheimer Kunstverein, Mannheim, Germany
1997 Los Angeles County Museum of Art, Los Angeles

SELECTED GROUP EXHIBITIONS:
1968 *Earthworks*, Dwan Gallery, New York
1969 *Earth Art*, Herbert F. Johnson Museum of Art, Cornell University,
 Ithaca, New York
 Art by Telephone, Museum of Contemporary Art, Chicago
 The Artist's View, The Jewish Museum, New York
 Land Art, Fernsehgalerie Gerry Schum, Hannover and TV
 Germany Chanel 1, Berlin
 Ecological Art, John Gibson Gallery, New York
 *When Attitudes Become Form: Works—Concepts—Processes—Situations—
 Information: Live in Your Head*, Kunsthalle Bern, Bern; traveled to
 Museum Haus Lange, Krefeld, Germany; Museum Folkwang,
 Essen; Institute of Contemporary Arts, London
1970 *Information*, The Museum of Modern Art, New York
 Body, Museum of Contemporary Art, San Francisco

Conceptual Art and Conceptual Aspects, New York Cultural Center, New York

Conceptual Art—Arte Povera—Land Art, Galleria Civica d'Arte Moderna, Turin

1971 *Projects: Pier 18*, The Museum of Modern Art, New York

Beyond Law and Order, Stedelijk Museum, Amsterdam

1974 *Words and Works*, The Clocktower, Institute for Art and Urban Resources, New York

Projekt '74, Kunsthalle Köln, Cologne

1975 *Body Art*, Museum of Contemporary Art, Chicago

1977 *Words*, Whitney Museum of American Art, New York

1981 *Mythos and Ritual*, Kunsthaus Zürich, Zurich

1982 *'60–'80: Attitudes / Concepts / Images*, Stedelijk Museum, Amsterdam

Documenta 7, Museum Fridericianum, Kassel

1990 *Construction in Process: Back in Lodz 1990*, History Museum of Lodz, Lodz, Poland

1993 *Sonsbeek '93*, Gemeentemuseum Arnhem, Arnhem, the Netherlands

1995 *Reconsidering the Object of Art: 1965–75*, The Museum of Contemporary Art, Los Angeles

1997 *L'Empreinte*, Musée national d'art moderne, Centre Georges Pompidou, Paris

Blurring the Boundaries: Installation Art 1969–1996, San Diego Museum of Contemporary Art, La Jolla, California; traveled to Worcester Art Museum, Worcester, Massachusetts, 1998

1998 *Bienal Internacional de São Paulo*, São Paulo

Charles Willson Peale

American, born Queen Anne's County, Maryland, April 15, 1741
Studied painting under John Singleton Copley (1762–63); under Benjamin West, London (1767–69)
Died Philadelphia, Pennsylvania, February 22, 1827

SELECTED INDIVIDUAL EXHIBITIONS:

1923 *Exhibition of Portraits by Charles Willson Peale, James Peale, and Rembrandt Peale*, Pennsylvania Academy of Fine Arts, Philadelphia

1939 *Paintings and Watercolors by James Peale and His Family*, Walker Art Galleries, Minneapolis

1953 *Exhibition of Paintings by Members of the Peale Family*, Century Association, New York

A Selection of Works of Charles Willson Peale Executed Between 1810 and 1821, La Salle College, Philadelphia

1963 *The Peale Heritage, 1763–1963*, Washington County Museum of Fine Arts, Hagerstown, Maryland

1971 *Charles Willson Peale: Artist from Chestertown*, Washington College, Chestertown, Maryland

1975 Maryland Historical Society, Baltimore

1996 *The Peale Family: Creation of a Legacy, 1770–1870*, The Philadelphia Museum of Art, Philadelphia; traveled to M.H. De Young Memorial Museum, San Francisco, 1997; Corcoran Gallery of Art, Washington, D.C.

SELECTED GROUP EXHIBITIONS:

1940 *Portraits of George Washington: The First President, As Seen By Ten Artists*, Scott & Fowles, New York

1976 *Maryland Heritage: Five Baltimore Institutions Celebrate the American Bicentennial*, Maryland Historical Society, Baltimore

1983 *Three American Families: A Tradition of Artistic Pursuit*, Whitney Museum of American Art at Philip Morris, New York

1987 *A Proud Heritage: Two Centuries of American Art: Selections from the Collections of the Pennsylvania Academy of the Fine Arts, Philadelphia and the Terra Museum of American Art, Chicago*, Terra Museum of American Art, Chicago

1997 *The Cadwalader Family: Art and Style in Early Philadelphia*, The Philadelphia Museum of Art, Philadelphia

Hubert Robert

French, born Paris, May 22, 1733
Studied under sculptor René-Michel Slodtz, Paris, (1752–53); Académie de France à Rome, (1754–63)
Died Paris, April 15, 1808

SELECTED INDIVIDUAL EXHIBITIONS:

1919 *Hubert Robert*, R. Gimpel Gallery, New York

1922 *Exposition Hubert Robert et Louis Moreau*, Galeries Jean Charpentier, Paris

1933 *Exposition Hubert Robert, à l'occasion du deuxième centenaire de sa naissance*, Musée de l'Orangerie, Paris

1962 *Hubert Robert, 1733–1808: Paintings and Drawings*, Vassar College Art Gallery, Poughkeepsie, New York

1967 *Hommage à Hubert Robert*, Galerie Cailleux, Paris

1978 *Hubert Robert: Drawings and Watercolors*, National Gallery of Art, Washington, D.C.

1979 *Le Louvre d'Hubert Robert*, Musée du Louvre, Paris

1985 *Hubert Robert et les dessins de la collection Veyrene*, Musée de Valence, Valence

1988 *Hubert Robert: The Pleasure of Ruins*, Wildenstein and Co., New York

1989 *Hubert Robert et la revolution*, Musée de Valence, Valence

1991 *Hubert Robert und die Brücken von Paris*, Staatliche Kunsthalle Karlsruhe, Karlsruhe, Germany

Hubert Robert und seine Zeitgenossen in der Graphischen Sammlung des Hessischen Landesmuseums Darmstadt, Hessisches Landesmuseum Darmstadt, Darmstadt, Germany

SELECTED GROUP EXHIBITIONS:

1767 Salon, Paris

1769 Salon, Paris

1781 Salon, Paris

1789 Salon, Paris

1796 Salon, Paris

1889 Exposition Universelle, Paris

1900 Exposition Universelle, Paris

1925 *Exposition du paysage français de Poussin à Corot*, Palais des Beaux-Arts de la Ville de Paris, Paris

1947 *Vingt peintures et dessins illustrant l'histoire de la Grande Galerie du Louvre*, Musée du Louvre, Paris

1958 *De Clouet à Matisse*, Musée de L'Orangerie, Paris

1967 *Zeichner Sehen Die Antike*, Staatliche Museen, Berlin-Dahlem

1972 *French Master Drawings of the 17th and 18th Centuries in North American Collections*, Art Gallery of Ontario, Toronto; traveled to The National Gallery of Canada, Ottawa; California Palace of the Legion of Honor, San Francisco; The New York Cultural Center, New York

1976 *Piranèse et les Français, 1740–1790*, Villa Medici, Rome; traveled to Palais des Etats de Bourgogne, Dijon; Hôtel de Sully, Paris

1981 *Three Masters of Landscape: Fragonard, Robert, and Boucher*, Virginia Museum of Fine Arts, Richmond, Virginia

1990 *Fragonard e Robert a Roma*, Villa Medici, Rome
1993 *Copier créer: de Turner à Picasso: 300 oeuvres inspirées par les maîtres du Louvre*, Musée du Louvre, Paris

Edward Ruscha
American, born Omaha, Nebraska, December 16, 1937
Studied The Chouinard Art Institute, Los Angeles (1956–60)
Lives in Los Angeles

SELECTED INDIVIDUAL EXHIBITIONS:
1963 Ferus Gallery, Los Angeles
1967 *Gunpowder Drawings*, Alexander Iolas Gallery, New York
1968 Galerie Rudolf Zwirner, Cologne
1969 La Jolla Museum of Art, La Jolla, California
1970 *Edward Ruscha: Prints 1966–1970/Books 1962–1970*, Hansen Fuller Gallery, San Francisco
1972 *Edward Ruscha: Books and Prints*, Mary Porter Senson Gallery, University of California, Santa Cruz, California
1973 *Edward Ruscha: Drawings*, Leo Castelli Gallery, New York
1976 *Exhibitions and Presentations*, Los Angeles Institute of Contemporary Art, Los Angeles
Stedelijk Museum, Amsterdam
1978 *Edward Ruscha: Recent Paintings and Drawings*, Ace Gallery, Vancouver
1980 *Ruscha: Selected Works, 1966–1980*, Foster Goldstrom Fine Arts, San Francisco
1981 *Edward Ruscha: D Drawings*, Leo Castelli Gallery, New York
1982 *The Works of Edward Ruscha*, San Francisco Museum of Modern Art, San Francisco; traveled to Whitney Museum of American Art, New York; Vancouver Art Gallery, Vancouver; San Antonio Museum of Art, San Antonio, 1983; Los Angeles County Museum of Art, Los Angeles
1986 *Ed Ruscha: New Works 4X6*, Westfälischer Kunstverein, Münster
1988 *Edward Ruscha: Words Without Thoughts Never to Heaven Go*, Lannan Museum, Lake Worth, Florida
1989 *Edward Ruscha: Paintings—Schilderijen*, Museum Boymans-van Beuningen, Rotterdam
1990 *Edward Ruscha*, Musée national d'art moderne, Centre Georges Pompidou, Paris; traveled to Museum Boymans-van Beuningen Rotterdam; Fondació Caixa de Pensions Barcelona; Serpentine Gallery, London; The Museum of Contemporary Art, Los Angeles, 1991
Edward Ruscha: Los Angeles Apartments, Whitney Museum of American Art, New York
1992 *Edward Ruscha: Stains 1971 to 1975*, Robert Miller Gallery, New York
1993 *Cameo Cuts 1992*, Leo Castelli, New York

SELECTED GROUP EXHIBITIONS:
1960 *Four Oklahoma Artists*, Oklahoma City Art Center, Oklahoma City
1962 *New Painting of Common Objects*, Pasadena Art Museum, Pasadena, California
1964 *American Drawings*, Solomon R. Guggenheim Museum, New York
1966 *Los Angeles Now*, Robert Fraser Gallery, London
1969 *Pop Art*, Hayward Gallery, London
West Coast 1945–1969, Pasadena Art Museum, Pasadena, California; traveled to City Art Museum, Saint Louis; Art Gallery of Ontario, Toronto; Fort Worth Art Center Museum, Fort Worth, Texas
1971 *Sonsbeek '71*, Gemeentemuseum Arnhem, Arnhem, the Netherlands

1972 *Book as Artwork, 1960–1972*, Nigel Greenwood Gallery, London
1973 *American Drawings, 1970–1973*, Yale University Art Gallery, New Haven
1976 *30 Years of American Printmaking*, The Brooklyn Museum, Brooklyn
1978 *Artwords and Bookworks*, Los Angeles Institute of Contemporary Art Los Angeles; traveled to Artists Space, New York; Herron School of Art Indianapolis; New Orleans Contemporary Art Center, New Orleans
1979 *Twentieth-Century American Drawings from the Whitney Museum of American Art*, Whitney Museum of American Art, New York
1980 *Pier + Ocean*, Kröller Müller Museum, Otterlo, the Netherlands
1981 *California: The State of the Landscape, 1872–1981*, Newport Harbor Art Museum, Newport Beach, California
1982 *Documenta 7*, Museum Fridericianum, Kassel
1983 *Language, Drama, Source and Vision*, The New Museum of Contemporary Art, New York
1984 *Artists' Books—Book Art*, Museum of Contemporary Art, Chicago
1986 *Text and Image: The Wording of American Art*, Holly Solomon Gallery, New York
1987 *1987 Biennial Exhibition*, Whitney Museum of American Art, New York
Made in U.S.A.: An Americanization in Modern Art, the 50s and 60s, University Art Museum, University of California, Berkeley; traveled to Nelson-Atkins Museum of Art, Kansas City; Virginia Museum of Fine Arts, Richmond, Virginia
1989 *Suburban Home Life: Tracking the American Dream*, Whitney Museum of American Art, Downtown at Federal Reserve Plaza, New York
1990 *High and Low: Modern Art and Popular Culture*, The Museum of Modern Art, New York; traveled to The Art Institute of Chicago, Chicago; The Museum of Contemporary Art, Los Angeles
Word as Image: American Art, 1960–1990, Milwaukee Art Museum, Milwaukee; traveled to Oklahoma City Art Museum, Oklahoma City; Contemporary Arts Museum, Houston
1992 *Hand Painted Pop: American Art in Transition 1955–1962*, The Museum of Contemporary Art, Los Angeles; traveled to Museum of Contemporary Art Chicago; Whitney Museum of American Art New York
Artist's Books from the Permanent Collection, Museum of Contemporary Art, Chicago
1994 *A Century of Artists Books*, The Museum of Modern Art, New York
1995 *Reconsidering the Object of Art: 1965–75*, The Museum of Contemporary Art, Los Angeles
1997 *Deep Storage*, Haus der Kunst, Munich; traveled to Neue Nationalgalerie, Berlin; P.S. 1 Contemporary Art Center, New York, 1998; Henry Art Gallery, Seattle
1998 *Pop Art: Selections from The Museum of Modern Art*, High Museum of Art, Atlanta

David Seymour
American, born David Szymin (dit Chim), Warsaw, Poland, November 20, 1911
Studied Akademie für Graphische Künste, Leipzig (1929–31); Sorbonne, Paris (1931–33)
Died Suez, Egypt, December 10, 1956

SELECTED INDIVIDUAL EXHIBITIONS:
1957 *Chim's Children*, The Art Institute of Chicago, Chicago
1958 *Photokina '58*, Cologne
1966 Galerie Form, Zurich

Chim's Times, Compo Photocolor, New York
1967 School of Visual Arts, New York
1986 *David Seymour Chim: The Early Years, 1933–1939*, International Center of Photography, New York
1996 *Chim: The Photographs of David Seymour*, International Center of Photography, New York

SELECTED GROUP EXHIBITIONS:
1955 *The Family of Man*, The Museum of Modern Art, New York
1956 *Magnum, Photokina '56*, Cologne
1959 *Photography in the Fine Arts*, The Metropolitan Museum of Art, New York
1962 *Man's Inhumanity to Man, Photokina '62*, Cologne
1967 *The Concerned Photographer*, Riverside Museum, New York
1974 International Center of Photography New York
1988 *Alliance Photo: Agence Photographique 1934–1940*, Bibliothèque Historique de la Ville de Paris, Paris

Robert Smithson
American, born Rutherford, New Jersey, January 2, 1938
Studied Art Students League, New York (1953)
Died Tecovas Lake, near Amarillo, Texas, July 20, 1973

SELECTED INDIVIDUAL EXHIBITIONS:
1959 Artist's Gallery New York
1966 Dwan Gallery, New York
1968 Dwan Gallery, New York
 Konrad Fischer Gallery, Düsseldorf
1969 Galleria L'Attico, Rome
1970 Dwan Gallery, New York
 Ace Gallery, Vancouver
1974 *Robert Smithson: Drawings*, New York Cultural Center, New York; traveled to Corcoran Gallery, Washington, D.C.; Indianapolis Museum of Art, Indianapolis; Brown University, Providence, Rhode Island; Dallas Museum of Fine Arts, Dallas; San Francisco Museum of Modern Art, San Francisco; Städtisches Museum, Mönchengladbach, Germany; Palais des Beaux-Arts, Brussels; Arnolfini Gallery, Bristol, England; Whitechapel Gallery, London; The Museum of Modern Art, Oxford, England; Kröller-Müller Museum, Otterlo, the Netherlands
1976 John Weber Gallery, New York
1979 *Robert Smithson,* The Akron Art Institute, Akron, Ohio
1980 *Robert Smithson: 1938–1973*, Galerie Ricke, Cologne
1980 *Robert Smithson: Sculpture*, Herbert F. Johnson Museum of Art, Cornell University Ithaca, New York; traveled to Walker Art Center, Minneapolis; Museum of Contemporary Art, Chicago; La Jolla Museum of Contemporary Art, La Jolla, California; Whitney Museum of American Art, New York; Musée d'Art Moderne de la Ville de Paris, Paris; Saro Hilder Museum, Helsinki; Wilhelm Lehmbruck Museum, Duisburg, Germany; Museum of Modern Art, Belgrade, Yugoslavia; Rijksmuseum Kröller-Müller, Otterlo, the Netherlands
1983 *Robert Smithson: Drawings*, John Weber Gallery, New York
1985 *Robert Smithson: The Early Work: 1959–1962*, Diane Brown Gallery, New York
1989 *Robert Smithson: Zeichnungen aus dem Nachlass/Drawings from the Estate*, Westfälisches Landesmuseum für Kunst und Kulturgeschichte, Münster; traveled to Kunstraum München e.V., Munich

1990 *Robert Smithson's Partially Buried Woodshed*, School of Art, Kent State University, Kent, Ohio
1991 *Robert Smithson Unearthed: Works on Paper, 1957–73*, Miriam and Ira D. Wallach Art Gallery, Columbia University, New York
1993 *Robert Smithson: Photoworks*, Los Angeles County Museum of Art, Los Angeles; traveled to International Center of Photography, New York
 Robert Smithson: Une Rétrospective, Le Paysage Entropique: 1960–1973, IVAM, Centre Julio Gonzalez, Valencia; traveled to Palais des Beaux-Arts, Brussels, 1994; MAC, galeries contemporaines des Musées de Marseilles
1995 *Robert Smithson: Spiral Jetty, Hotel Palenque*, Kunst Werke Berlin, Berlin
1999 *Robert Smithson*, National Museum of Contemporary Art, Oslo; traveled to Moderna Museet, Stockholm; Statens Museum, Copenhagen

SELECTED GROUP EXHIBITIONS:
1961 *New Work by New Artists*, Alan Gallery, New York
1966 *Primary Structures*, Jewish Museum, New York
 Pattern Art, Betty Parsons Gallery, New York
1968 *Minimal Art*, Haags Gemeetemuseum, The Hague
 Art of the Real, The Museum of Modern Art, New York
1969 *Earthworks*, Dwan Gallery, New York
 Earth Art, Herbert F. Johnson Museum of Art, Cornell University, Ithaca, New York
 Art by Telephone, Museum of Contemporary Art, Chicago
 When Attitudes Become Form: Works—Concepts—Processes—Situations—Information: Live in Your Head, Kunsthalle Bern, Bern; traveled to Museum Haus Lange, Krefeld, Germany; Museum Folkwang, Essen; Institute of Contemporary Arts, London
 Ecologic Art, John Gibson Gallery, New York
 Between Object and Environment, Institute of Contemporary Art, University of Pennsylvania, Philadelphia
 Land Art, Fernsehgalerie Gerry Schum, Hannover and TV Germany Chanel 1, Berlin
 557,087, Seattle Art Museum Pavilion, Seattle Art Museum, Seattle; traveled to Vancouver Art Gallery, Vancouver as *955,000*
1970 *Information*, The Museum of Modern Art, New York
1972 *Documenta 5*, Museum Fridericianum, Kassel
1978 *Probing the Earth: Contemporary Land Projects*, Hirshhorn Museum and Sculpture Garden, Smithsonian Institution, Washington, D.C.
1980 *Pier + Ocean*, Rijksmuseum Kröller-Müller, Otterlo, the Netherlands
1986 *Qu'est-ce que la sculpture moderne?*, Musée national d'art moderne, Centre Georges Pompidou, Paris
1990 *Minimalism and Postminimalism*, Hood Museum, Dartmouth College, Hanover, New Hampshire
1995 *Beat Culture and the New America: 1950–1965*, Whitney Museum of American Art, New York; traveled to Walker Art Center, Minneapolis
1996 *L'Informe: Mode d'emploi*, Musée national d'art moderne, Centre Georges Pompidou, Paris

Thomas Struth
German, born Geldern, Germany, 1954
Studied Kunstakademie, Düsseldorf (1973–80); painting under Gerhard Richter and photography under Bernd Becher
Lives in Düsseldorf

SELECTED INDIVIDUAL EXHIBITIONS:

1978 P.S. 1, Institute for Art and Urban Resources, New York
1980 Galerie Rüdiger Schöttle, Munich
1986 Gallery Shimada, Yamaguchi, Japan
1987 Galerie Max Hetzler, Cologne
 Kunsthalle Bern, Bern
1989 *Invisible Cities*, Leeds City Art Gallery, Leeds, England
1990 *Thomas Struth: Portraits*, Marian Goodman Gallery, New York
1992 Museum Haus Lange, Krefeld
 Thomas Struth: Museum Photographs, Hirshhorn Museum and
 Sculpture Garden, Smithsonian Institution, Washington, D.C.
1993 *Thomas Struth: Museum Photographs*, Hamburger Kunsthalle,
 Hamburg
1994 *Thomas Struth: Landschaften: Photographien 1991–1993*, Achenbach
 Kunsthandel, Dusseldorf
 Institute of Contemporary Arts, London
 Thomas Struth: Streets, Houses, People: Photographs 1988–1992, Institute
 of Contemporary Art, Boston
1995 *Strangers and Friends*, Art Gallery of Ontario, Toronto
 Thomas Struth: Straßen: Photografie 1976 bis 1995, Kunstmuseum
 Bonn, Bonn
1997 Marian Goodman Gallery New York
 Thomas Struth: Portraits, Sprengel Museum, Hannover
1998 Thomas Struth/Klaus von Bruch: The Berlin Project,
 Kunstmuseum Luzern, Lucerne

SELECTED GROUP EXHIBITIONS:

1979 Schlaglichter: Junge Kunst im Rheinland, Rheinisches
 Landesmuseum, Bonn
1982 Art Galaxy, New York
1987 *Foto/Realismen*, Kunstverein München, Munich
 Skulptur Projekte in Münster 87, Westfälisches Landesmuseum für
 Kunst und Kulturgeschichte, Münster
1989 *Une autre objectivité/Another Objectivity*, Centre national des arts
 plastiques, Paris; traveled to Centro per l'Arte Contemporanea
 Luigi Pecci, Prato, Italy
1990 *The Becher Influence: Bechers, Gursky, Hutte, Ruff, Struth*, Glen Dash
 Gallery, Los Angeles
1991 *Typologies: Nine Contemporary Photographers*, Newport Harbor Art
 Museum, Newport Beach, California
 Carnegie International 1991, The Carnegie Museum of Art,
 Pittsburgh
1993 *Das Bild der Ausstellung/The Image of the Exhibition*, Hochschule für
 angewandte Kunst/Heiligenkreuzerhof, Vienna
1994 *The Epic and the Everyday: Contemporary Photographic Art*, Hayward
 Gallery, London
 Exhibited, Center for Curatorial Studies, Bard College, Annandale-
 on-Hudson, New York
1995 *Art Museum: Sophie Calle, Louise Lawler, Richard Misrach, Diane
 Neumaier, Richard Ross, Thomas Struth*, Center for Creative
 Photography, University of Arizona, Tucson, Arizona
1997 *Evidence: Photography and Site*, Wexner Center for the Arts, The
 Ohio State University, Columbus, Ohio

Hiroshi Sugimoto
Japanese, born Tokyo, 1948
Studied St. Paul's University, Tokyo, B.A. (1966–70);
Studied Art Center College of Design, Los Angeles, B.F.A. (1970–72)
Lives in New York

SELECTED INDIVIDUAL EXHIBITIONS:

1977 Minami Gallery, Tokyo
1981 Sonnabend Gallery, New York
1988 *Photographs by Hiroshi Sugimoto: Dioramas, Theaters, Seascapes*, Zeito
 Photo Salon, Tokyo and Sonnabend Gallery, New York
1989 The National Museum of Contemporary Art, Osaka, Japan
 Cleveland Museum of Art, Cleveland, Ohio
1990 Urbi et Orbi, Paris
1992 CAPC, Musée d'art contemporain, Bordeaux
 Fraenkel Gallery, San Francisco
1993 White Cube Gallery, London
1994 Sonnabend Gallery, New York
1995 Kunsthalle Basel, Basel
 The Metropolitan Museum of Art, New York
1996 Contemporary Arts Museum, Houston
 Studio Guenzani, Milan
 Moderna Museet, Stockholm
1997 Berkeley Art Museum, Berkeley
 Sonnabend Gallery, New York
1998 Fundación Caixa de Pensions, Madrid; traveled to Centro Cultural
 de Belém Exhibition Centre, Lisbon
 Akron Art Museum, Akron, Ohio

SELECTED GROUP EXHIBITIONS:

1985 *The Art of Memory/The Loss of History*, The New Museum of
 Contemporary Art, New York
1987 *Contemporary Japanese Art in America*, Japan Society, New York
1990 *Natural History Recreated*, The Center for Photography, Woodstock,
 New York
 Photography Past and Present, National Museum of Modern Art,
 Tokyo
1991 *Carnegie International 1991*, The Carnegie Museum of Art,
 Pittsburgh
1994 *Japanese Art after 1945: Scream Against the Sky*, Yokohama Museum of
 Art, Yokohama, Japan; traveled to Guggenheim Museum SoHo,
 New York; San Francisco Museum of Modern Art, San Francisco
1996 *By Night*, Fondation Cartier pour l'art contemporain, Paris
1997 *Evidence: Photography and Site*, Wexner Center for the Arts, The
 Ohio State University, Columbus, Ohio
1998 *Terra Incognita*, Neues Museum Weserburg, Bremen, Germany

Charles Thurston Thompson
British, born 1816
Died 1868

SELECTED GROUP EXHIBITIONS

1856 *Exhibition of Photographs and Daguerreotypes*, Gallery of the Society
 of Water Color Painters, London
1858 *Exhibition of the Photographic Society of London and the Société française
 de Photographie*, South Kensington Museum, London
1998 *The Museum and the Photograph: Collecting Photography at the Victoria
 and Albert Museum 1853–1900*, The Sterling and Francine Clark Art
 Institute, Williamstown, Massachusetts

Stephen Thompson
British, born c.1830
Died Melbourne, Australia, 1893

SELECTED GROUP EXHIBITIONS:

1860 *Annual Exhibition*, Photographic Society of London, London

1861	*Annual Exhibition*, Architectural Photographic Association, London

1861 *Annual Exhibition*, Architectural Photographic Association, London
1862 *International Exhibition*, London
1870 *Annual Exhibition*, Photographic Society of London, London
1873 *Annual Exhibition*, Photographic Society of London, London
1878 *Annual Exhibition*, Photographic Society of London, London
1991 *The Kiss of Apollo: Photography and Sculpture, 1845 to the Present*, Fraenkel Gallery, San Francisco
Nineteenth-Century European Photographs, The Metropolitan Museum of Art, New York

Jeff Wall

Canadian, born Vancouver, 1946
Studied fine art, University of British Columbia, Vancouver, M.A. (1964–70); London, Courtauld Institute of Art, University of London, (1970–73)
Lives in Vancouver

SELECTED INDIVIDUAL EXHIBITIONS:

1978 Nova Gallery, Vancouver
1982 David Bellman Gallery, Toronto
1983 The Renaissance Society, University of Chicago, Chicago
1984 *Jeff Wall: Transparencies*, Institute of Contemporary Arts, London; traveled to Kunsthalle Basel, Basel
1986 Ydessa Hendeles Gallery, Toronto
1987 Galerie Johnen and Schöttle, Cologne
Young Workers, Museum für Gegenwartskunst, Basel
1989 Marian Goodman Gallery, New York
1991 San Diego Museum of Contemporary Art, San Diego
1992 Palais des Beaux-Arts, Brussels
Louisiana Museum of Modern Art, Humlebaek, Denmark
1993 The Irish Museum of Modern Art, Dublin
Jeff Wall: Restoration, Kunstmuseum Luzern, Lucerne; traveled to Städtische Kunsthalle, Düsseldorf, 1994
1994 White Cube Gallery, London
Museo Nacional Centro de Arte Reina Sofía, Madrid
NGBK Gallerie, Berlin
1995 Galerie Nationale du Jeu de Paume, Paris
1996 *Jeff Wall: Landscapes and Other Pictures*, Kunstmuseum Wolfsburg, Wolfsburg
1997 Hirshhorn Museum and Sculpture Garden, Smithsonian Institution Washington, D.C.; traveled to The Museum of Contemporary Art, Los Angeles; Art Tower, Mito, Japan
1998 Marian Goodman Gallery, New York

SELECTED GROUP EXHIBITIONS:

1969 *557,087*, Seattle Art Museum Pavilion, Seattle Art Museum, Seattle; traveled to Vancouver Art Gallery, Vancouver as *955,000*
1970 *Information*, The Museum of Modern Art, New York
3→∞: New Multiple Art, Whitechapel Art Gallery, London
1980 *New Work: Mac Adams, Roger Cutforth, Dan Graham, John Hillard, Jeff Wall*, Hal Bromm Gallery, New York
1981 *Westkunst: Zeitgenössische Kunst seit 1939*, Museen der Stadt, Cologne
1982 *Documenta 7*, Museum Fridericianum, Kassel
1984 *Difference: On Representation and Sexuality*, The New Museum of Contemporary Art, New York
1987 *Bestiarium/Theatergarten*, Künstlerwerkstatt, Munich; traveled to P.S. 1, Institute for Contemporary Art, New York, 1988
L'époque, la mode, la morale, la passion, Musée national d'art moderne, Centre Georges Pompidou, Paris

1989 *Une autre objectivité/Another Objectivity*, Centre national des arts plastiques, Paris; traveled to Centro per l'Arte Contemporanea Luigi Pecci, Prato, Italy
1993 *Post-Human*, Deichtorhallen, Hamburg
1994 *The Epic and the Everyday: Contemporary Photographic Art*, Hayward Gallery, London
1995 *Public Information: Desire, Disaster, Document*, San Francisco Museum of Modern Art, San Francisco
1995 Biennial Exhibition, Whitney Museum of American Art, New York
Hall of Mirrors: Art and Film Since 1945, The Museum of Contemporary Art, Los Angeles
1997 *Documenta 10*, Museum Fridericianum, Kassel

Gillian Wearing

British, born Birmingham, England, 1963
Studied Chelsea School of Art, London, B. TECH (1985–87); Goldsmith's College, University of London (1987–90)
Lives in London

SELECTED INDIVIDUAL EXHIBITIONS:

1993 City Racing, London
1994 Maureen Paley—Interim Art, London
1995 *Gillian Wearing: Western Security*, Hayward Gallery, London
1996 *Wish You Were Here*, De Appel, Amsterdam
Gillian Wearing: City Projects—Prague, Part II, The British Council, Prague
1997 Jay Gorney Gallery, New York
Wiener Secession, Vienna
Maureen Paley—Interim Art, London
Kunsthaus Zürich, Zurich
Emi Fontana, Milan
1998 Centre d'art contemporain, Geneva
1999 Maureen Paley—Interim Art, London

SELECTED GROUP EXHIBITIONS:

1991 *Empty Gestures*, Diorama Art Centre, London
1993 *Okay Behaviour*, 303 Gallery, New York
1994 *3.016.026*, Theoretical Events, Naples
1995 *Brilliant!: New Art from Britain*, Walker Art Center, Minneapolis
The British Art Show 4 (touring exhibition), Arts Council of Great Britain, London
1996 *Traffic*, CAPC Musée contemporain Bordeaux, Bordeaux
1997 *Sensation: Young British Artists from the Saatchi Collection*, Royal Academy of Arts, London
The Turner Prize 1997: An Exhibition of Work by Shortlisted Artists: Christine Borland, Angela Bulloch, Cornelia Parker, and Gillian Wearing, Tate Gallery, London
1998 *A Collection in the Making*, The Museum of Modern Art, Dublin

Christopher Williams

American, born Los Angeles, June 9, 1956
Studied California Institute of the Arts, Valencia, B.F.A. (1975–79); California Institute of the Arts, Valencia, M.F.A. (1979–81)
Lives in Los Angeles

SELECTED INDIVIDUAL EXHIBITIONS:

1979 *One Film (Approximately 3 1/2 Minutes in Length) Will Be Shown, Rewound, and Shown Again*, Bijoux Theatre, California Institute of the Arts, Valencia, California

1982 Source, *The Photographic Archive, John F. Kennedy Library*, Jancar/ Kuhlenschmidt Gallery, Los Angeles
1989 Galerie Crousel-Robelin/BAMA, Paris
1990 Luhring-Augustine-Hetzler Gallery, Santa Monica, California
1992 Galerie Gisela Capitain, Cologne
 Luhring Augustine Gallery, New York (with Sophie Calle)
1993 *For Example: Die Welt Ist Schön (First Draft)*, Kunstverein München, Munich
1995 *Oehlen Williams 95*, Wexner Center for the Arts, The Ohio State University, Columbus, Ohio
1997 Museum Boijmans Van Beuningen, Rotterdam
 Kunsthalle Basel, Basel
 Hamburger Kunstverein, Hamburg
1998 Luhring Augustine Gallery, New York

SELECTED GROUP EXHIBITIONS:

1978 *Approximately One-Half Hour of Dance Activity (An Unrehearsed Situation)*, California Institute of the Arts, Valencia, California
 Unclaimed: 1 Pkg. Photos, 88 lbs., Identification Number 085-65950006, U.S. Customs, Terminal Island, California
1985 *The Art of Memory/The Loss of History*, The New Museum of Contemporary Art, New York
1987 *CalArts: Skeptical Belief(s)*, The Renaissance Society, University of Chicago, Chicago
1988 *Wittgenstein and the Art of the 20th Century*, Wiener Secession, Vienna; traveled to Palais des Beaux-Arts, Brussels
1989 *A Forest of Signs: Art in the Crisis of Representation*, The Museum of Contemporary Art, Los Angeles
1991 *Vanitas*, Galerie Crousel-Robelin, Paris
 Carnegie International 1991, The Carnegie Museum of Art, Pittsburgh
1994 *Radical Scavenger(s): The Conceptual Vernacular in Recent American Art*, Museum of Contemporary Art, Chicago
 Die Orte der Kunst, Sprengel Museum, Hannover
1997 *Places That Are Elsewhere*, David Zwirner Gallery, New York

Fred Wilson

American, born Bronx, New York, 1954
Studied State University of New York, Purchase, New York, B.F.A. (1972–76)
Lives in New York

SELECTED INDIVIDUAL EXHIBITIONS:

1987 *Rooms with a View: The Struggle Between Culture, Content, and the Context of Art*, The Longwood Arts Project, Bronx Council of the Arts, New York
1988 *Portrait of Audubon* (outdoor sculpture), The Public Art Fund, New York
1990 *The Other Museum*, White Columns Gallery, New York
1991 *Primitivism: High and Low*, Metro Pictures Gallery, New York
1992 *Mining the Museum: An Installation by Fred Wilson*, The Contemporary and Maryland Historical Society, Baltimore, Maryland
1993 *The Museum: Mixed Metaphors*, Seattle Art Museum, Seattle
 The Spiral of Art History, Indianapolis Museum of Art, Indianapolis, Indiana
1994 *OpEd: Fred Wilson*, Museum of Contemporary Art, Chicago
 Insight: In Site: In Sight: Incite—Memory, Artist and the Community: Fred Wilson, Southeastern Center for Contemporary Art, Winston-Salem, North Carolina

1995 *Collectibles*, Metro Pictures Gallery, New York
1997 *Reshuffling the Deck: Selections from the UC Davis Collections*, Richard L. Nelson Gallery and the Fine Arts Collection, University of California, Davis, California

SELECTED GROUP EXHIBITIONS:

1981 *Festive Works*, A.I.R. Gallery, New York
1983 *The Monument Redefined*, Gowanus Memorial Artyard, New York
1985 *Art on the Beach*, Creative Time Inc., New York
1987 *Selections from the Artists File*, Artists Space, New York
1990 *Public Mirror: Artists Against Racial Prejudice*, The Clocktower, Institute for Art and Urban Resources, New York
1992 *Past Imperfect: A Museum Looks at Itself*, The Parrish Art Museum, Southampton, New York
1993 *1993 Biennial Exhibition*, Whitney Museum of American Art, New York
 Readymade Identities, The Museum of Modern Art, New York
1994 *Die Orte der Kunst*, Sprengel Museum, Hannover
 Black Male: Representations of Masculinity in Contemporary American Art, Whitney Museum of American Art, New York
 Cocido y Crudo, Museo Nacional Centro de Arte Reina Sofía, Madrid
1997 *Collected*, The Photographers' Gallery, London
1998 *Postcards from Black America*, Hedendaagse Afrikaans-Amerikaanse Kunst, Boschstraat, the Netherlands

Garry Winogrand

American, born New York, 1928
Studied painting, City College, New York (1947–48) and Columbia University (1948–51); studied photography, New School for Social Research, New York, under Alexey Brodovitch
Died Tijuana, Mexico, March 19, 1984

SELECTED INDIVIDUAL EXHIBITIONS:

1960 *Photographs by Garry Winogrand*, Image Gallery, New York
1969 *The Animals*, The Museum of Modern Art, New York
1971 *Garry Winogrand's Photographs*, Light Gallery, New York
1972 *Garry Winogrand*, Toronto Gallery of Photography, Toronto
1975 *Garry Winogrand: Women Are Beautiful*, Light Gallery, New York
1977 *Public Relations*, The Museum of Modern Art, New York; traveled to Reed College, Portland, Oregon; Laguna Gloria Art Museum, Austin, Texas; Florida International University, Miami
1980 *Garry Winogrand*, Galerie de Photographie, Bibliothèque Nationale, Paris
1983 *Garry Winogrand: Big Shots: Photographs of Celebrities, 1960–80*, Fraenkel Gallery, San Francisco
1985 *Garry Winogrand: Photographs*, Williams College Museum of Art, Williamstown, Massachusetts
1986 *Little-known Photographs by Garry Winogrand*, Fraenkel Gallery, San Francisco
1988 *Garry Winogrand: Figments from the Real World*, The Museum of Modern Art, New York; traveled to The Art Institute of Chicago, Chicago; Carnegie Mellon University Gallery, Pittsburgh; The Museum of Contemporary Art, Los Angeles; Archer M. Huntington Art Gallery, Austin, Texas; Center for Creative Photography, University of Arizona, Tucson, Arizona; Museum Folkwang, Essen
1990 Hayward Gallery, London
1993 Pace/MacGill Gallery, New York

1994 Fraenkel Gallery, San Francisco
1998 *Garry Winogrand: Selections from a Major Acquisition*, The Museum of Modern Art, New York

SELECTED GROUP EXHIBITIONS:

1955 *The Family of Man*, The Museum of Modern Art, New York
1957 *Seventy Photographers Look at New York*, The Museum of Modern Art, New York
1959 *Photographer's Choice*, Workshop Gallery, New York
1963 *Photography '63*, The George Eastman House of Photography, Rochester, New York
 Five Unrelated Photographers, The Museum of Modern Art, New York
1964 *The Photographer's Eye*, The Museum of Modern Art, New York
1967 *New Documents*, The Museum of Modern Art, New York
1970 *The Descriptive Tradition: Seven Photographers*, Boston University, Boston

1975 *14 American Photographers*, The Baltimore Museum of Art, Baltimore
1978 *Mirrors and Windows: American Photography since 1960*, The Museum of Modern Art, New York
1983 *Masters of the Street: Henri Cartier-Bresson, Josef Koudelka, Robert Frank, and Garry Winogrand*, Museum of Photographic Arts, San Diego, California
1991 *Mean Streets: American Photographs from the Collection 1940s–1980s*, The Museum of Modern Art, New York
1994 *American Politicians: Photographs from 1843–1993*, The Museum of Modern Art, New York; traveled to Corcoran Gallery of Art, Washington, D.C., 1995; San Francisco Museum of Modern Art, San Francisco
1998 *Airports*, Nederland Foto Instituut, Rotterdam

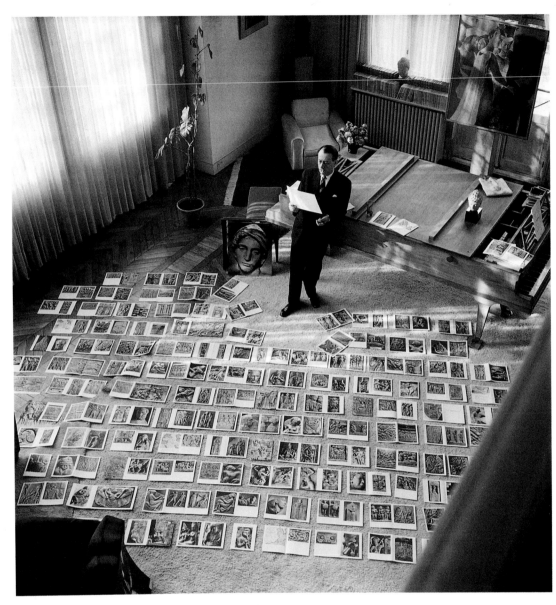

André Malraux selecting photographs for *Le Musée imaginaire*
(*The Museum without Walls*), Paris, c. 1947.

I. GENERAL

Books

Adorno, Theodor W. "Valéry Proust Museum." In *Prisms*. Cambridge, Mass.: The MIT Press, 1967.

Alderson, William T. *Mermaids, Mummies, and Mastodons: The Emergence of the American Museum*. Washington, D.C.: American Association of Museums, 1992.

Alexander, E.P. *Museum Masters: Their Museums and Their Influence*. Nashville, Tenn.: American Association for State and Local History, 1983.

Battcock, Gregory. *Minimal Art: A Critical Anthology*. New York: E.P. Dutton, 1968.

———, and Robert Nickas, eds. *The Art of Performance: A Critical Anthology*. New York: E.P. Dutton, 1984.

Baudrillard, Jean. "Le Système des objets." In *Selected Writings*. Ed. Mark Poster. Oxford and London: Oxford University Press, 1988.

Bazin, Germain. *The Museum Age*. New York: Universe Books, 1967.

Benjamin, Walter. "Unpacking My Library: A Talk about Book Collecting." In *Illuminations*. New York: Schocken Books, 1969.

Bennett, Tony. *The Birth of the Museum: History, Theory, Politics*. London and New York: Routledge, 1995.

Blotkamp, Karel. *Museums in Motion?: The Art Museum at Issue*. The Hague: Government Printing Office, 1979.

Bruce, Chris, et al. *Breaking Down the Boundaries: Artists and Museums*. Seattle: Henry Art Gallery, University of Washington, 1989. Texts by Mary Livingstone Beebe, Chris Bruce, Richard Koshalek, Norie Sato, and Charles Wright.

Clifford, James. *The Predicament of Culture*. Cambridge, Mass.: Harvard University Press, 1988.

Compton, Michael. "The Art Museum—As Environment/Its Environment." In *CIMAM Japan Meeting Official Report 1994*. Tokyo: CIMAM Japan Meeting Organizing Committee, 1994.

Conn, Steven. *Museums and American Intellectual Life, 1876–1926*. Chicago: University of Chicago Press, 1998.

Cooke, Lynne. "New Stories of Telling." In *CIMAM Japan Meeting Official Report 1994*. Tokyo: CIMAM Japan Meeting Organizing Committee, 1994.

———, and Peter Wollen, eds. *Visual Display: Culture Beyond Appearances*. New York: Dia Center for the Arts; Seattle: Bay Press, 1995.

Crimp, Douglas. *On the Museum's Ruins*. Cambridge, Mass.: The MIT Press, 1993.

Crow, Thomas. "The Birth and Death of the Viewer: On the Public Function of Art." In *Discussions in Contemporary Culture*. Ed. Hal Foster. New York: Dia Art Foundation; Seattle: Bay Press, 1987.

Danto, Arthur C. "The Museum of Museums." In *Beyond the Brillo Box: The Visual Arts in Post-Historical Perspective*. New York: Farrar, Straus & Giroux, 1992.

———. "Museums and the Thirsting Millions." In *After the End of Art: Contemporary Art and the Pale of History*. Princeton, N.J.: Princeton University Press, 1995.

Davis, Douglas. "The Idea of a Twenty-First-Century Museum," and "The Size of Non-Size." In *Artculture: Essays on the Post-Modern*. New York: Harper & Row, 1977.

Decter, Joshua. *Transgressions in the White Cube: Territorial Mappings*. Bennington, Vt.: Suzanne Lemberg Usdan Gallery, Bennington College, 1992.

Donato, Eugenio. "The Museum's Furnace: Notes Towards a Contextual Reading of Bouvard and Pécuchet." In *Textual Strategies: Perspectives in Post-Structuralist Criticism*. Ed. Josué Harari. Ithaca, N.Y.: Cornell University Press, 1979.

Dosi-Delfini, Luca. *Le Futur du musée d'art moderne: Analyse socio-semiologique effectuée avec la participation de François Peraldi*. Haarlem, the Netherlands: J.H. Gottmer, 1974.

Duncan, Carol. *The Aesthetics of Power: Essays in Critical Art History*. Cambridge, England: Cambridge University Press, 1993.

———. *Civilizing Rituals: Inside Public Art Museums*. London and New York: Routledge, 1995.

Elderfield, John, ed. *Imagining the Future of The Museum of Modern Art: Studies in Modern Art 7*. New York: The Museum of Modern Art, 1998. Additional texts by Janet Abrams, Jorge Klor de Alva, Mary Lea Bandy, Glenn D. Lowry, Terence Riley, Helen Searing, Robert A.M. Stern, Fred Wilson, and Henri Zerner.

Elsner, John, and Roger Cardinal, eds. *The Cultures of Collecting*. Cambridge, Mass.: Harvard University Press, 1994.

The End(s) of the Museum. Barcelona: Fundació Antoni Tàpies, 1996. Introduction by Thomas Keenen; texts by Alexander García Düttman, Werner Hamacher, Friedrich Kittler, Gyan Prakash, Andrew Ross, and Kristin Ross. Excerpts from symposium held in conjunction with the exhibition *Els Límits del Museu* at the Fundació Antoni Tàpies, Barcelona.

Fisher, Philip. *Making and Effacing Art: Modern American Art in a Culture of Museums*. New York and Oxford: Oxford University Press, 1991.

Foucault, Michel. "La Bibliothèque Fantastique." Introduction to Gustave Flaubert, *La Tentation de Saint Antoine*. Ed. Henri Ronse. Paris: Gallimard, 1967.

———. *The Order of Things: An Archeology of Human Science*. New York: Pantheon, 1970.

Fuchs, Rudi. "The Museum's Role and Responsibility in Society." In *CIMAM Japan Meeting Official Report 1994*. Tokyo: CIMAM Japan Meeting Organizing Committee, 1994.

Greenberg, Reesa, Bruce W. Ferguson, and Sandy Nairne, eds. *Thinking About Exhibitions*. London and New York: Routledge, 1996.

Harris, Neil. "Museums, Merchandising, and Popular Taste: The Struggle for Influence." In *Material Culture and the Study of American Life*. Ed. Ian M.G. Quimby. New York: W. W. Norton for the Henry Francis du Pont Winterthur Museum, 1978.

Hein, Hilda. *The Exploratorium: The Museum as Laboratory*. Washington, D.C.: Smithsonian Institution Press, 1990.

Hendricks, Jon, and Jean Toche. *GAAG: The Guerrilla Art Action Group, 1969–1976: A Selection*. New York: Printed Matter, 1978.

Hodin, J. P. "The Museum and Modern Art: The Mission of the Museum in Our Time." In *Modern Art and the Modern Mind*. Cleveland: The Press of Case Western Reserve University, 1972.

Hooper-Greenhill, Eilean. *Museums and the Shaping of Knowledge*. London and New York: Routledge, 1992.

Horne, Donald. *The Great Museum: The Re-Presentation of History*. London: Pluto Press, 1984.

Hudson, Kenneth. *A Social History of Museums*. London: Macmillan, 1975.

"The Impact of Museums upon Modern Art History." In *Validating Modern Art*. Los Angeles: Los Angeles County Museum of Art, 1975. Texts by Michael Compton, James Demetrion, Werner Hofmann, Pontus Hultén, Thomas M. Messer, Richard Oldenburg, and E. E. de Wilde. Excerpts from a symposium held at the seventieth annual meeting of the American Association of Museums.

Impey, Oliver, and Arthur MacGregor. *The Origins of Museums: The Cabinet of Curiosities in Sixteenth and Seventeenth Century Europe.* Oxford: Clarendon Press, 1985.

Karp, Ivan, and Steven D. Lavine, eds. *Exhibiting Cultures: The Poetics and Politics of Museum Display.* Washington, D.C., and London: Smithsonian Institution Press, 1991.

Lippard, Lucy R. *Six Years: The Dematerialization of the Art Object from 1966 to 1972.* Berkeley: University of California Press, 1997.

Levin, Michael D. *The Modern Museum: Temple or Showroom?* Jerusalem: Dvir Publishing House, 1983.

Low, Theodore Lewis. *The Museum as a Social Instrument.* New York: American Association of Museums, 1942.

Lumley, Robert, ed. *The Museum Time Machine: Putting Culture on Display.* London and New York: Routledge, 1988.

Macdonald, Sharon, and Gordon Fyfe, eds. *Theorizing Museums: Representing Identity and Diversity in a Changing World.* Oxford and Cambridge, Mass.: Blackwell Publishers/The Sociological Review, 1996.

Malraux, André. *Museum Without Walls.* New York: Doubleday and Co., 1967.

Meyer, Karl. *The Art Museum: Power, Money, and Ethics: A Twentieth-Century Fund Report.* New York: William Morrow and Co., 1979.

Mondrian, Piet. "An International Museum of Contemporary Art." In *The New Art—The New Life: The Collected Writings of Piet Mondrian.* Eds. Harry Holtzman and Martin S. James. Boston: G.K. Hall and Co., 1986.

Morse, John D., ed. *The Artist and the Museum: The Report of the Third Woodstock Art Conference Sponsored by Artists Equity Association and the Woodstock Artists Association.* New York: American Artists Group, 1950.

The Museum and the Artist: Principles and Procedures Recommended by The Joint Artists-Museums Committee. New York: American Federation of Artists, 1958. Introduction and texts by Lloyd Goodrich.

O'Doherty, Brian. *Inside the White Cube: The Ideology of the Gallery Space.* Santa Monica and San Francisco: The Lapis Press, 1976. Introduction by Thomas McEvilley.

———. *Museums in Crisis.* New York: Georges Braziller, 1971.

Orosz, Joel J. *Curators and Culture: The Museum Movement in America, 1740–1870.* Tuscaloosa, Ala., and London: University of Alabama Press, 1990.

Pearce, Susan M. *Museums, Objects, and Collections: A Cultural Study.* Leicester, England: Leicester University Press, 1992.

Preiß, Achim, Karl Stamm, and Günter Zehnder, eds. *Das Museum: Die Entwicklung in den 8oer Jahren—Festschrift für Hugo Borger zum 65. Geburtstag.* Munich: Klinkhardt und Biermann, 1990.

Ripley, Dillon. *The Sacred Grove: Essays on Museums.* New York: Simon and Schuster, 1969.

Rosenberg, Harold. "Old Age of Modernism." In *Art on the Edge: Creators and Situations.* New York: Macmillan Publishing Co., Inc., 1975.

Ross, Richard. *Museology.* New York: Aperture, 1989. Text by David Mellor.

Serota, Nicholas. *Experience or Interpretation: The Dilemma of Museums of Modern Art.* London: Thames and Hudson, 1996.

Schwalbe, Douglas, and Janet Baker-Carr. *Conflict in the Arts: The Relocation of Authority: The Museum.* Cambridge, Mass.: Arts Administration Research Institute, 1976.

Schneider, Pierre. *Louvre Dialogues.* New York: Atheneum, 1971.

Stocking, George W., Jr., ed. *Objects and Others: Essays on Museums and Material Culture.* Madison: University of Wisconsin Press, 1985.

Taylor, F. H. *Babel's Tower: The Dilemma of the Modern Museum.* New York: Columbia University Press, 1945.

Theewen, Gerhard, ed. *Obsession—Collection.* Cologne: Odeon Verlag, 1994. Additional texts by Jean-Christophe Ammann, Daniel Buchholz, Eric Otto Frihd, Hans Irrek, Dieter Koepplin, Walter König, Hartmut Kraft, Paul Maenz, Reiner Speck, and Harald Szeemann.

Tuchman, Maurice. *Art and Technology: A Report on the Art and Technology Program of the Los Angeles County Museum of Art, 1967–1971.* Los Angeles: Los Angeles County Museum of Art; New York: Viking Press, 1971.

Valéry, Paul. "Le Problème des musées." In *Pièces sur l'art.* Vol. 1. Paris: Éditions de la N.R.F., 1938.

Vergo, Peter, ed. *The New Museology.* London: Reaktion Press, 1989.

Wallis, Brian, ed. *Art after Modernism: Rethinking Representation.* New York: The New Museum of Contemporary Art; Boston: Godine, 1984.

Weil, Stephen E. *Beauty and the Beasts: On Museums, Art, the Law, and the Market.* Washington, D.C., and London: Smithsonian Institution Press, 1983.

———. *A Cabinet of Curiosities: Inquiries into Museums and Their Prospects.* Washington, D.C., and London: Smithsonian Institution Press, 1995.

———. *Rethinking the Museum and Other Meditations.* Washington, D.C., and London: Smithsonian Institution Press, 1995.

Weschler, Lawrence. *Mr. Wilson's Cabinet of Wonder: Pronged Ants, Horned Humans, Mice on Toast, and Other Marvels of Jurassic Technology.* New York: Pantheon Books, 1995.

Exhibition Catalogues

Art in the Mirror. New York: The Museum of Modern Art, 1966. Text by Gene R. Swenson.

Beer, Evelyn, and Riet de Leeuw, eds. *L'Exposition imaginaire: The Art of Exhibiting in the Eighties.* 's-Gravenhage, the Netherlands: Rijksdienst Beeldende Kunst, 1989. Texts by Jean-Christophe Ammann, Guillaume Bijl, Bernard Blistène, Daniel Buren, Benjamin H.D. Buchloh, Douglas Crimp, Luciano Fabro, Rudi Fuchs, Johannes Gachnang, E.H. Gombrich, Boris Groys, Charles Harrison, J.C.J. van der Heyden, Werner Hofmann, Jan Hoet, Patrick Ireland and Brian O'Doherty, Ilya Kabakov, J.L. Locher, Jean-François Lyotard, Thomas McEvilley, Urs Raussmüller, Harald Szeemann, Marcia Tucker, Dirk van Weelden, and Rémy Zaugg.

Breitwieser, Sabine, ed. *White Cube/Black Box.* Vienna: EA-Generali Foundation, 1996. Essays by Steve Anker, Ute Meta Bauer, Benjamin H.D. Buchloh, Corinne Diserens, Xavier Douroux, Silvia Eiblmayr, Valie Export, Dan Graham, Malcolm Le Grice, and Birgit Pelzer.

Bronson, AA, and Peggy Gale, eds. *Museums by Artists.* Toronto: Art Metropole, 1983. Introduction by Gale; additional texts by Jean-Christophe Ammann, Michael Asher, Marcel Broodthaers, Benjamin H.D. Buchloh, Daniel Buren, Marcel Duchamp, Robert Filliou, Vera Frenkel, General Idea, Walter Grasskamp, Hans Haacke, Wulf Herzogenrath, Donald Judd, On Kawara, Garry Neill Kennedy, Joseph Kosuth, Les Levine, Glenn Lewis, George Maciunas, Piero Manzoni, Museum of Conceptual Art, N.E. Thing Co., Claes Oldenburg, Harald Szeemann, and Ursula Wevers.

Cocido y Crudo. Madrid: Museo Nacional Centro de Arte Reina Sofía, 1994. Texts by Jerry Saltz; Mar Villaespesa, Gerardo Mosquera, Jean Fisher, and Dan Cameron.

Carnegie International 1991. 2 vols. Pittsburgh: Carnegie Museum of Art, 1991. Texts by Lynne Cooke, Mark Francis, Fumio Nanjo, and Zinovy Zinik.

Copier créer: de Turner à Picasso: 300 oeuvres inspirées par les maîtres du Louvre. Paris: Éditions de la Réunion des musées nationaux, 1993. Texts by Bernard Ceysson, Jean-Pierre Cuzin, Marie-Anne Dupuy, Henri Loyrette, Jean Loyrette, and Arlette Sérullaz.

Damaged Goods: Desire and the Economy of the Object. New York: The New Museum of Contemporary Art, 1986. Texts by Judith Barry, Gretchen Bender, Deborah Bershad, Barbara Bloom, Hal Foster, Andrea Fraser, Jeff Koons, Justen Ladda, Ken Lum, Allan McCollum, Haim Steinbach, and Brian Wallis.

The Desire of the Museum. New York: Whitney Museum of American Art, Downtown at Federal Reserve Plaza, 1989. Texts by Jackie McAllister and Benjamin Weil.

Documenta 5: Befragung der Realität-Bildwelten heute. 3 vols. Kassel: Neue Galerie and Museum Fridericianum, in association with Documenta and C. Bertelsmann, 1972. Introduction by Klaus Honnef and Gisela Kaminski; artists' statements.

Els Límits del Museu. Barcelona: Fundació Antoni Tàpies, 1995. Texts by Manuel J. Borja-Villel, Marcel Broodthaers, Sophie Calle, Bill Fontana, Joan Fontcuberta, Andrea Fraser, Dan Graham, John G. Hanhardt, Anthony Iannacci, Thomas Keenen; interview with Ilya Kabakov by J. Bakstein.

Feux pâles: Une Pièce à conviction. Bordeaux: Capc, Musée d'art contemporain, 1990. Introduction by Georges Perec; texts by Jean-Philippe Antoine, Jean-Marc Avrilla, Simone de Cosi, Sylvie Couderc, Eric Duyckaerts, Bernard Edelman, Stéphane Mallarmé, Jean-Hubert Martin and Michel Bourel, Jean-Marc Poinsot, and Jacques Salomon.

Georgel, Chantal, ed. *La Jeunesse des musées: les musées de France au XIXe siècle*. Paris: Editions de la réunion des musées nationaux, 1994.

Gudis, Catherine, ed. *A Forest of Signs: Art in the Crisis of Representation*. Cambridge, Mass., and London: The MIT Press; Los Angeles: The Museum of Contemporary Art, 1989. Texts by Ann Goldstein, Anne Rorimer, and Howard Singerman.

Lipman, Jean, and Richard Marshall. *Art About Art*. New York: E.P. Dutton, in association with the Whitney Museum of American Art, 1978. Introduction by Leo Steinberg.

A Museum Looks at Itself: Mapping Past and Present at The Parrish Art Museum. Southhampton, N.Y.: The Parrish Art Museum, 1992. Texts by Maurice Berger, Donna De Salvo, and Alan Wallach.

Reconsidering the Object of Art: 1965–75. Los Angeles: The Museum of Contemporary Art, 1995. Introduction by Ann Goldstein and Anne Rorimer; texts by Goldstein, Susan L. Jenkins, Lucy R. Lippard, Stephen Melville, Jeff Wall, and Rorimer.

Schaffner, Ingrid, and Matthias Winzen, eds. *Deep Storage: Collecting, Storing, and Archiving in Art*. Munich and New York: Prestel Verlag, 1998. Texts by Geoffrey Batchen, Eugen Blume, Benjamin H.D. Buchloh, Susan Buck-Morss, Sheryl Conkleton, Trevor Fairbrother, Hubertus Gaßner, E.H. Gombrich, Kai-Uwe Hemken, Justin Hoffman, Stefan Iglhaut, Jon Ippolito, Brigitte Kölle, Geert Lovink, Dirk Luckow, Elizabeth Lunning, Otto Neumaier, Carter Ratcliff, Iris Reepen, Stephanie Rosenthal, Ingrid Schaffner, Ingrid Scharlau, Bernhart Schwenk, Claudia Seelmann, John W. Smith, Susan Stewart, Birgit Stöckmann, and Matthias Winzen. [English edition of catalogue published in conjunction with exhibition at P.S. 1 Contemporary Art Center, New York.]

Schimmel, Paul. *Out of Actions: Between Performance and the Object 1949–1979*. Los Angeles: The Museum of Contemporary Art, 1998. Introduction by Schimmel; additional essays by Guy Brett, Hubert Klocker, Shinichiro Osaki, and Kristine Stiles.

Theatergarden Bestiarium: The Garden as Theater as Museum. New York: P.S. 1, Institute for Contemporary Art; Cambridge, Mass., and London: The MIT Press, 1990. Introduction by Alanna Heiss; texts by Marianne Brouwer, Chris Dercon, Antje von Graevenitz, Dan Graham, Johanne Lamoureaux, Frédéric Migayrou, Naomi Miller, Rüdiger Schöttle, and Richard Sennett.

What Happened to the Institutional Critique? New York: American Fine Arts, 1993. Text by James Meyer.

Wide White Space: Behind the Museum, 1966–1976. Brussels: Societé des Expositions du Palais des Beaux-Arts; Düsseldorf: Richter Verlag, 1995. Introduction by Yves Aupetitallot; interviews by Aupetitallot with Daniel Buren, Johannes Cladders, Anny De Decker, Isi Fiszman, Bernd Lohaus, Martin Visser, and Lawrence Weiner.

Wunderkammer des Abendlandes: Museum und Sammlung im Spiegel der Zeit. Bonn: Kunst- und Ausstellungshalle der Bundesrepublik Deutschland, 1994. Texts by Annesofie Becker, Arnfinn Bø-Rygg, Walter Grasskamp, Hans Holländer, Poul Ingemann, Jørgen Jensen, Jens Erik Kristensen, Arne Losman, Arno Victor Nielsen, Marie-Louise von Plessen, Krzysztof Pomian, Inger Sjørslev, Sverker Sörlin, Frederik Stjernfelt, Carsten Thau, and Gottfried Wilhelm von Leibniz.

Journals and Periodicals

Alloway, Lawrence, and John Coplans. "Talking with William Rubin: 'The Museum Concept Is Not Infinitely Expandable.'" *Artforum* 13, no. 2 (October 1974): 51–56.

Annis, Sheldon. "The Museum as Staging Ground for Symbolic Action." *Museum* (Paris), no. 151 (1986): 168–71.

Buchloh, Benjamin H.D. "Conceptual Art 1962–1969: From the Aesthetic of Administrations to the Critique of Institutions." *October* 55 (winter 1990): 105–44.

Cassedy, Susannah. "The Museum Mine Field." *Museum News* (Washington, D.C.) 71, no. 4 (July–August 1992): 12–14.

Clark, Kenneth. "The Ideal Museum." *Artnews* 52 (January 1954): 28–31, 83–84.

Coles, Robert. "Whose Museums?" *American Art* 6, no. 1 (winter 1992): 6–11.

David, Catherine. "L'art contemporain au risque du musée." *Les Cahiers du Musée national d'art moderne* 28 (summer 1989): 54–58.

Decter, Joshua. "The Administration of Cultural Resistance." *Texte zur Kunst* 2, no. 5 (spring 1992): 107–17.

———. "De-Coding the Museum." *Flash Art* 23, no. 155 (December 1990): 140–42.

Duncan, Carol, and Alan Wallach. "MoMA: Ordeal and Triumph on 53rd Street." *Studio International* 194, no. 988 (1977): 48–57.

———. "The Museum of Modern Art as Late Capitalist Ritual." *Marxist Perspectives* (winter 1978): 28–51.

———. "The Universal Survey Museum." *Art History* 3, no. 4 (December 1980): 448–69.

Fleissig, Peter. "Lèche-Vitrine." *Parkett* 35 (1993): 102–07.

Grimes, Ron. "Breaking the Glass Barrier: The Power of Display." *Journal of Ritual Studies* (Pittsburgh) 4, no. 2 (summer 1990): 239–62.

Haacke, Hans. "Museums: Managers of Consciousness." *Art in America* 72, no. 2 (February 1984): 9–17.

Henderson, Mary. "Art in a Non-Art Museum." *Museum News* (Washington, D.C.) 65, no. 1 (October–November 1986): 42–47.

Holliday, Taylor. "When Museums and Photos Were New." *The Wall Street Journal*, March 24, 1998, p. A20.

Horne, Lee. "Linking the Past with the Present: Ethnoarcheology in a Museum Context." *Museum* (Paris), no. 157 (1998): 57–61.

"How Vital Are Museums?" *Art International* 10 (spring 1990): 33–59. Includes statements by Guillaume Bijl, Jean Clair, Richard Hamilton, Jan Hoet, Alpha Oumar Konare, Nicholas Serota, and Kirk Varnedoe.

Jinkner-Lloyd, Amy. "Musing on Museology." *Art in America* 80, no. 6 (June 1992): 44–51.

Karp, Ivan, and Fred Wilson. "Constructing the Spectacle of Culture in Museums." *Art Papers* (May–June 1993): 2–9.

Kimmelman, Michael. "The Improbable Marriage of Artist and Museum." *The New York Times*, August 2, 1992, p. H1.

Kirstein, George G. "Trustee, Resign!" *The Nation* 208, no. 23 (June 9, 1969): 727–30.

Krauss, Rosalind. "Le Musée sans Murs du Postmodernisme." *L'Oeuvre et son Accrochage*, special issue of *Les Cahiers du Musée national d'art moderne*, nos. 17/18 (1986): 152–58.

———. "The Cultural Logic of the Late Capitalist Museum." *October* 54 (fall 1990): 3–17.

Kuspit, Donald. "The Art of Exhibition: The Only Art Worth Exhibiting?" *The New Art Examiner* (November 1993): 14–17.

———. "The Magic Kingdom of the Museum." *Artforum* 30, no. 2 (February 1992): 58–63.

Lippert, Werner. "Der Blick hinter den Spiegel: Kunstgeschichte als Ready-Made." *Kunstforum International* 123 (1993): 118–22.

Meinhardt, Johannes. "Eine andere Moderne: Die künstlerische Kritik des Museums und der gesellschaftlichen Institution Kunst." *Kunstforum International* 123 (1993): 160–91.

Michaud, Yves. "L'art contemporain au risque du musée." *Les Cahiers du Musée national d'art moderne* 28 (summer 1989): 76–82.

O'Doherty, Brian. "The Gallery as a Gesture." *Artforum* 20, no. 4 (December 1981): 25–34.

———, ed. "Special Museum Issue." *Art in America* 59, no. 4 (July–August 1971). Additional texts by John E. Bowlt, Edward F. Fry, Grace Glueck, Ernest van den Haag, Max Kozloff, Hugh Kenner, Thomas W. Leavitt, Linda Nochlin, Bryan Robertson, and John R. Spencer.

Schütz, Heinz. "Jenseits von Utopie und Apokalypse: Zum Mnemismus der Gegenwartskunst." *Kunstforum International* 123 (1993): 64–100.

Smith, Roberta. "The Gallery Is the Message." *The New York Times*, October 23, 1996, p. B35.

Szeemann, Harald. "Museum of Obsessions." *Rivista trimestrale di architettura* 9 (1987): 6–9.

Van Keuren, David K. "Museums and Ideology: Augustus Pitt Rivers, Anthropological Museums, and Social Change in Later Victorian Britain." *Victorian Studies* (Bloomington, Ind.) 28, no. 1 (autumn 1984): 171–89.

Wallach, Alan. "The Museum of Modern Art: The Past's Future." *Journal of Design History* 5, no. 3 (1992): 207–15.

Ward, Frazer. "The Haunted Museum: Institutional Critique and Publicity." *October* 73 (summer 1995): 71–89.

Weil, Stephen E. "For Students of Museums, a Dense but Disciplined Discussion." *Museum News* (Washington, D.C.) 70, no. 4 (July–August 1991): 63–64.

"What Should a Museum Be?" *Art in America* 49, no. 2 (1961): 23–45. Special issue, including texts by Larry Aldrich, John Canaday, C.C. Cunningham, Herbert Ferber, Katherine Kuh, Thomas M. Messer, Robert Motherwell, Edward Durell Stone, and Georges Wildenstein.

de Wilde, E. "Notes on the Role of a Museum of Modern Art." *Art and Artists* (London) 4, no. 10 (January 1970): 14–15.

Zervos, Christian. "Pour la création à Paris d'un musée des artistes vivants." *Les Cahiers d'art* 5, no. 7 (1930): 337–39.

II. INDIVIDUAL ARTISTS: SELECTED ARTICLES, MONOGRAPHS, AND EXHIBITION CATALOGUES

Vito Acconci

Avalanche (New York), no. 6 (fall 1972). Special issue on Acconci. Interview by Liza Béar.

Krauss, Rosalind. "Video: The Aesthetics of Narcissism." *October* 1 (spring 1976): 50–64.

Kunz, Martin. "Interview with Vito Acconci about the Development of His Work Since 1966." In *Vito Acconci: Cultural Space Pieces 1974–1978.* Lucerne: Kunstmuseum Luzern, 1978. Exhibition catalogue.

Licht, Jennifer. *Eight Contemporary Artists.* New York: The Museum of Modern Art, 1974. Exhibition catalogue.

Linker, Kate. *Vito Acconci.* New York: Rizzoli, 1994.

McShine, Kynaston, ed. *Information.* New York: The Museum of Modern Art, 1970. Text by McShine; artists statements. Exhibition catalogue.

Pincus-Witten, Robert. "Vito Acconci and the Conceptual Performance." *Artforum* 10, no. 8 (April 1972): 47–49.

Schimmel, Paul. *Out of Actions: Between Performance and the Object, 1949–1979.* Los Angeles: The Museum of Contemporary Art; New York: Thames and Hudson, 1998.

Shearer, Linda. *Vito Acconci: Public Places.* New York: The Museum of Modern Art, 1988. Additional texts by Acconci. Exhibition catalogue.

Software: Information Technology: Its New Meaning for Art. New York: The Jewish Museum, 1970. Introduction by Karl Katz; texts by Jack Burnham, James A. Mahoney, Theodor Nelson, Ned Woodman; artists statements. Exhibition catalogue.

Sondheim, Alan. "Vito Acconci: Work, 1973–1974." *Arts Magazine* 49, no. 7 (March 1975): 49–52.

Reconsidering the Object of Art: 1965–75. Los Angeles: The Museum of Contemporary Art, 1995.

Sharp, Willoughby. "Body Works." *Avalanche* (New York), no. 1 (fall 1970): 14–17.

Vito Acconci. Prato, Italy: Museo d'Arte Contemporanea Prato, 1992. Texts by Acconci, Jeffrey Kipnis, and Jefferey Ryan. Exhibition catalogue.

Vito Acconci: Photographic Works 1969–70. Chicago: Rhona Hoffman Gallery, 1988. Exhibition catalogue.

Vito Acconci: A Retrospective. Chicago: Museum of Contemporary Art, 1980. Text by Judith Russi Kirshner. Exhibition catalogue.

Eve Arnold

Arnold, Eve. *Eve Arnold: In Retrospect.* New York: Alfred A. Knopf, 1995.

Arnold, Eve. *Flashback!: The 50's.* New York: Alfred A. Knopf, 1978.

Arnold, Eve. *In America.* New York: Alfred A. Knopf, 1983.

Arnold, Eve. *The Unretouched Woman.* New York: Alfred A. Knopf, 1976.

Levitas, Mitchel. *America in Crisis: Photographs for Magnum.* New York: Holt, Rinehart, and Winston, 1969.

Art & Language

Art & Language. *Art & Language: 1966–75.* Oxford: Museum of Modern Art, 1975. Exhibition catalogue.

Art & Language. *Art & Language: Texte zum Phänomen Kunst und Sprache.* Cologne: Verlag Dumont-Schauberg, 1972.

Art & Language. Los Angeles: Los Angeles Institute of Contemporary Art, 1983. Exhibition catalogue.

Art & Language. Paris: Galerie Nationale du Jeu de Paume, 1993. Texts by Art & Language, Charles Harrison, and Paul Wood. Exhibition catalogue.

Art & Language, Now They Are. Paris: Galerie Isy Brachot and Labor, 1992. Text by Paul Wood. Exhibition catalogue.

Harrison, Charles. *Confessions: Incidents in a Museum.* London: Lisson Gallery, 1986. Exhibition catalogue.

———, and Fred Orton. *A Provisional History of Art & Language.* Paris: Éditions Eric Fabre, 1982.

———, and John Roberts. *Art & Language: The Paintings.* London: Lisson Gallery; New York: Marian Goodman Gallery, 1987. Exhibition catalogue for an exhibition at the Societé des Expositions du Palais des Beaux-Arts, Brussels.

Kosuth, Joseph. "Art After Philosophy." *Studio International* 178, no. 916 (October–December 1969): 134–37, 160–61.

Reconsidering the Object of Art: 1965–75. Los Angeles: The Museum of Contemporary Art, 1995.

Smith, Terry. "Art and Art & Language." *Artforum* 12, no. 6 (February 1974): 49–52.

Michael Asher

Art in Los Angeles: The Museum as Site: Sixteen Projects. Los Angeles: Los Angeles County Museum of Art, 1981. Introduction and texts by Stephanie Barron. Exhibition catalogue.

Asher, Michael. *Writings 1973–1983 On Works 1969–1979.* Ed. Benjamin H.D. Buchloh. Halifax: The Nova Scotia College of Art and Design; Los Angeles: The Museum of Contemporary Art, 1983.

Bronson, AA, and Peggy Gale, eds. *Museums by Artists.* Toronto: Art Metropole, 1983.

Crow, Thomas. "The Simple Life: Pastoralism and the Persistence of Genre in Recent Art." *October* 63 (winter 1993): 58–61.

Licht, Jennifer. *Spaces.* New York: The Museum of Modern Art, 1969. Exhibition catalogue.

Michael Asher. Chicago: The Renaissance Society, University of Chicago, 1990. Texts by Birgit Pelzer and Anne Rorimer. Exhibition catalogue.

Michael Asher. Villeurbanne: Le Nouveau Musée, 1991. Introduction by Asher; text by Frederik Leen. Exhibition catalogue.

Michael Asher. Paris: Musée national d'art moderne, Centre Georges Pompidou, 1991. Text by Birgit Pelzer. Exhibition catalogue.

Michael Asher: Exhibitions in Europa 1972–77. Eindhoven: Stedelijk van Abbemuseum, 1980. Texts by Benjamin H.D. Buchloh and R.H. Fuchs. Exhibition catalogue.

Reconsidering the Object of Art: 1965–75. Los Angeles: The Museum of Contemporary Art, 1995.

Rorimer, Anne. "Michael Asher: Recent Work." *Artforum* 18, no. 8 (April 1980): 46–50.

Stork, Gerhard. *Michael Asher.* Krefeld: Museum Haus Lange, 1982. Exhibition catalogue.

Lothar Baumgarten

Baumgarten, Lothar. *Carbon.* Los Angeles: The Museum of Contemporary Art, 1991. Includes ten short stories by Baumgarten. Exhibition catalogue.

Baumgarten, Lothar. *Land of the Spotted Eagle.* Mönchengladbach: Städtisches Museum Abteiberg, 1983. Exhibition catalogue.

Baumgarten, Lothar. *Makunaíma.* New York: Marian Goodman Gallery, 1987.

Baumgarten, Lothar. "Status Quo." *Artforum* 26, no. 7 (March 1988): 108–11.

Brayer, Marie-Ange. "Lothar Baumgarten." *Forum International* 4, no.19 (October–November 1993): 103–11.

Lothar Baumgarten: Tierra de Los Perros Mudos. Amsterdam: Stedelijk Museum; Munich: Buchhandels Vertrieb in Deutschland; Munich: Schirmer/Mosel, 1985. Text by Alejo Carpentier. Exhibition catalogue.

Lothar Baumgarten: Unsettled Objects. New York: Solomon R. Guggenheim Museum, 1993. Texts by Vincent Crapanzano, Hal Foster, Michael Govan, Robert S. Grumet, N. Scott Momaday, and Craig Owens. Exhibition catalogue for *America Invention.*

Owens, Craig. "Improper Names." *Art in America* 74, no. 10 (October 1986): 126–134, 187.

Reconsidering the Object of Art: 1965–75. Los Angeles: The Museum of Contemporary Art, 1995.

Barbara Bloom

"Barbara Bloom." *The MOCA Contemporary* (Los Angeles) 1, no. 1 (October–November 1991): 5.

Bloom, Barbara. *The Reign of Narcissism: Guide Book.* Stuttgart: Würtembergischer Kunstverein; Zurich: Kunsthalle Zürich; London: Serpentine Gallery, 1990. Exhibition catalogue.

Damaged Goods: Desire and the Economy of the Object. New York: The New Museum of Contemporary Art, 1986.

Gudis, Catherine, ed. *A Forest of Signs: Art in the Crisis of Representation.* Los Angeles: The Museum of Contemporary Art; Cambridge, Mass., and London: The MIT Press, 1989.

Levin, Kim. "Cameo Appearance." *The Village Voice,* October 17, 1989, p. 108.

Rimanelli, David. "Barbara Bloom and Her Art of Entertaining." *Artforum* 28, no. 2 (October 1989): 142–46.

Schleifer, Kristen Brooke. "Detective Stories: An Interview with Barbara Bloom." *The Print Collector's Newsletter* 21, no. 3 (July–August 1990): 92–96.

Christian Boltanski

Boltanski, Christian. *Album de photos de la famille D., 1939–1964.* Lucerne: Kunstmuseum Luzern, 1972.

Boltanski, Christian. *Archives.* Arles: Le Méjun and Actes Sud, 1989.

Boltanski, Christian. *Inventaire des objets ayants appartenu à une femme de Bois-Colombes.* Paris: Centre national d'art contemporain, 1974.

Boltanski, Christian. *La Maison manquante*. Paris: Flammarion, 1991.

Boltanski, Christian. *Recherche et présentation de tout ce qui reste de mon enfance, 1944–1950*. Paris: Edition Givaudon, 1969.

Christian Boltanski: Lessons of Darkness. Chicago: The Art Institute of Chicago, 1988. Texts by Boltanski, Lynn Gumpert, and Mary Jane Jacob. Exhibition catalogue.

Christian Boltanski: Reconstitution. Eindhoven: Stedelijk van Abbemuseum; London: Whitechapel Art Gallery; Grenoble: Musée de Grenoble, 1990. Texts by Lynn Gumpert, Serge Lemoine, and Georgia Marsh. Exhibition catalogue.

Christian Boltanski. Milan: Charta, 1997. Texts by Boltanski, Danilo Eccher, Paolo Fabbri, and Daniel Soutif. Exhibition catalogue for an exhibition at Villa delle Rose, Galleria d'Arte Moderna, Bologna.

Els Límits del Museu. Barcelona: Fundació Antoni Tàpies, 1995.

Gumpert, Lynn. *Christian Boltanski*. Paris: Flammarion, 1994.

Kuspit, Donald. "Christian Boltanski's Art of Gloom." *C*, no.19 (September 1988): 24–29.

Semin, Didier. "Christian Boltanski: Ombres et lumières." *Art Press*, no. 107 (October 1986): 34–35.

———, Tamar Garb, and Donald Kuspit. *Christian Boltanski*. London: Phaidon Press, 1997. Texts by Kuspit, Georges Perec, and Semin; interview by Garb; artist's statement.

Marcel Broodthaers
Baker, George. "This is not an Advertisement." *Artforum* 34, no. 9 (May 1996): 86–89, 124.

Borja-Villel, Manuel J., and Michael Compton, eds., in collaboration with Maria Gilissen. *Marcel Broodthaers: Cinéma*. Santiago de Compostela: Centro Galego de Arte Contemporánea, 1997. Introduction by Gloria Moure; texts by Bruce Jenkins and Jean-Christophe Royoux; artist's writings. Exhibition catalogue. [Revised version of catalogue for exhibition at Fundació Antoni Tàpies, Barcelona.]

Bronson, AA, and Peggy Gale, eds. *Museums by Artists*. Toronto: Art Metropole, 1983.

Buchloh, Benjamin H.D., ed. *Marcel Broodthaers: Writings, Interviews, Photographs*. Cambridge, Mass., and London: The MIT Press/October Books, 1988.

Buchloh, Benjamin H.D., and Maria Gilissen, eds. *Section Publicité du Musée d'Art Moderne, Département des Aigles, Marcel Broodthaers*. New York: Marian Goodman Gallery, 1995. Text by Buchloh. Exhibition catalogue.

Europe in the Seventies: Aspects of Recent Art. Chicago: The Art Institute of Chicago, 1977. Introduction by A. James Speyer and Anne Rorimer; texts by Jean-Christophe Ammann, David Brown, and Benjamin H.D. Buchloh. Exhibition catalogue.

Els Límits del Museu. Barcelona: Fundació Antoni Tàpies, 1995.

Marcel Broodthaers. London: Tate Gallery, 1980. Texts by Alan Bowness, Michael Compton, Maria Gilissen, Pontus Hultén, and Barbara M. Reise. Exhibition catalogue.

Marcel Broodthaers. Minneapolis: Walker Art Center; New York: Rizzoli, 1989. Introduction by Marge Goldwater; texts by Michael Compton, Douglas Crimp, Bruce Jenkins, and Martin Mosebach. Exhibition catalogue.

Marcel Broodthaers. Paris: Galerie nationale du Jeu de Paume, 1991. Texts by Catherine David and Birgit Pelzer; biography by Michael Compton. Exhibition catalogue.

Marcel Broodthaers: Der Adler vom Oligozän bis Heute. 2 vols. Düsseldorf: Städtische Kunsthalle, 1972. Texts by Broodthaers, Jürgen Harten, Michael Oppitz, and Karl Ruhrberg. Exhibition catalogue.

Marcel Broodthaers. Brussels: Societé des Exposition du Palais des Beaux-Arts. 1974. Exhibition catalogue.

Reconsidering the Object of Art: 1965–75. Los Angeles: The Museum of Contemporary Art, 1995.

Rorimer, Anne. "Photography—Language— Context: Prelude to the 1980s." In *A Forest of Signs: Art in the Crisis of Representation*. Ed. Catherine Gudis. Cambridge, Mass., and London: The MIT Press; Los Angeles: The Museum of Contemporary Art, 1989. Exhibition catalogue.

Thill, Robert. "Marcel Broodthaers: Reading the Section Publicité." *Flash Art*, no. 188 (May–June 1996): 98–101.

Wide White Space: Behind the Museum, 1966–1976. Brussels: Societé des Exposition du Palais des Beaux-Arts; Düsseldorf: Richter Verlag, 1995.

Daniel Buren
Bronson, AA, and Peggy Gale, eds. *Museums by Artists*. Toronto: Art Metropole, 1983.

Buren, Daniel. "The Function of the Museum." *Artforum* 12, no. 1 (September 1973): 68.

———. *Les couleurs: sculptures/Les formes: peintures*. Ed. Benjamin H.D. Buchloh. Halifax: The Nova Scotia College of Art and Design; Paris: Musée national d'art moderne, Centre Georges Pompidou, 1981. Additional texts by Buchloh, Jean-François Lyotard, and Jean-Hubert Martin.

———. *Les Écrits (1965–1990)*. Ed. Jean-Marc Poinsot. Bordeaux: Capc, Musée d'art contemporain, 1991.

Daniel Buren. Stuttgart: Staatsgalerie, 1990. Exhibition catalogue.

Daniel Buren. Mönchengladbach: Städtisches Museum, 1971. Texts by Buren and Johannes Cladders. Exhibition catalogue.

Daniel Buren: Photo-Souvenirs 1965–88. Villeurbanne: Art Édition, 1988.

Licht, Jennifer. *Eight Contemporary Artists*. New York: The Museum of Modern Art, 1974. Exhibition catalogue.

Europe in the Seventies: Aspects of Recent Art. Chicago: The Art Institute of Chicago, 1977. Introduction by A. James Speyer and Anne Rorimer; texts by Jean-Christophe Ammann, David Brown, and Benjamin H.D. Buchloh. Exhibition catalogue.

Francblin, Catherine. *Daniel Buren*. France: Artpress, 1987.

Reconsidering the Object of Art: 1965–75. Los Angeles: The Museum of Contemporary Art, 1995.

Rorimer, Anne. "Up and Down, In and Out, Step by Step, a Sculpture, a Work by Daniel Buren." *Museum Studies* (Chicago) 11, no. 2 (spring 1985): 140–55.

Wide White Space: Behind the Museum, 1966–1976. Brussels: Societé des Exposition du Palais des Beaux-Arts; Düsseldorf: Richter Verlag, 1995.

Sophie Calle
Calle, Sophie. *La Visite guidée*. Rotterdam: Museum Boymans-van Beuningen, 1996. Music compact disc insert by Laurie Anderson. Exhibition catalogue.

Calle, Sophie. *Suite Vénitienne*. Seattle: Bay Press, 1988. Postface by Jean Baudrillard.

Curiger, Bice. "In Conversation with Sophie Calle." In *Talking Art*. Ed. Adrian Searle. London: Institute of Contemporary Arts, 1993.

Kuspit, Donald. "Sophie Calle at Leo Castelli." *Artforum* 31, no. 9 (May 1993): 101.

Els Límits del Museu. Barcelona: Fundació Antoni Tàpies, 1995.

McFadden, Sarah. "Report from New York: The French Occupation." *Art in America* 69, no. 3 (March 1981): 35–41.

Meinhardt, Johannes. "Ersatzobjekte und bedeutende Rahmen: Allan McCollum, Louise Lawler, Barbara Bloom." *Kunstforum International* 99 (March–April 1989): 200–20.

Sante, Luc. "Sophie Calle's Uncertainty Principle." *Parkett* 36 (1993): 74–87.

Sophie Calle: Absence. Rotterdam: Museum Boymans-van Beuningen; Lausanne: Musée cantonal des Beaux-Arts, 1994. Texts by Elbrig de Groot and Jörg Zutter. Exhibition catalogue.

Sophie Calle: Proofs. Hanover, N.H.: Hood Museum of Art, Dartmouth College, 1993. Texts by Kathleen Merrill and Lawrence Rinder. Exhibition catalogue.

Sophie Calle: Relatos. Madrid: Sala de Exposiciones de la Fundación "La Caixa"; Barcelona: Centre Cultural de la Fundación "La Caixa," 1996. Texts by Hervé Guibert and Manuel Clot. Exhibition catalogue.

Stack, Trudy Wilner. *Art Museum: Sophie Calle, Louise Lawler, Richard Misrach, Diane Neumaier, Richard Ross, Thomas Struth*. Tucson, Az.: Center for Creative Photography/University of Arizona, 1995. Exhibition catalogue.

Storr, Robert. *Dislocations*. New York: The Museum of Modern Art, 1991. Artists notes. Exhibition catalogue.

Wagstaff, Sheena. "C'est Mon Plaisir: Such Is My Pleasure/Such Is My Will." *Parkett* 24 (1990): 6–10.

Janet Cardiff

The Dark Pool. Banff, Canada: Walter Phillips Gallery, 1995. Text by Catherine Crowstone. Exhibition catalogue.

Drobnick, Jim. "Mock Excursions and Twisted Itineraries, Tour Guide Performances." *Parachute* (Montreal) 80 (October–December 1995): 35.

Garneau, David. "Janet Cardiff and George Bures Miller, Glenbow Museum, Calgary." *Art/Text* 57, (May–July 1997): 93–94.

Fricke, Harald. "Now/Here, Louisiana Museum." *Artforum* 35, no. 3 (November 1996): 95, 127.

Lounder, Barbara. "Janet Cardiff." *Parachute* (Montreal) 71 (July–September 1993): 40–41.

Marks, Laura. "Janet Cardiff." *Artforum* 33, no. 7 (March 1995): 96.

To Touch: An Installation by Janet Cardiff. Edmonton: Edmonton Art Gallery, 1993. Text by Kitty Scott. Exhibition catalogue.

Henri Cartier-Bresson

Galassi, Peter. *Henri Cartier-Bresson: The Early Work*. New York: The Museum of Modern Art; 1987. Exhibition catalogue.

Henri Cartier-Bresson: About Russia. New York: Viking Press, 1974.

Henri Cartier-Bresson: À Propos de Paris. Boston and New York: Little, Brown and Co., 1994. Texts by Vera Feyder and André Pieyre de Mandiargues.

Henri Cartier-Bresson: The Decisive Moment: Photographs, 1930–1957. New York: American Federation of Artists, 1958.

Henri Cartier-Bresson: Europeans. London: Hayward Gallery, 1998. Text by Jean Clair. Exhibition catalogue.

Henri Cartier-Bresson: Photoportraits. New York and London: Thames and Hudson, 1985. Preface by André Pieyre de Mandiargues.

Christo

Bourdon, David. *Christo*. New York: Harry N. Abrams, 1970.

Christo. Eindhoven: Stedelijk van Abbemuseum, 1966. Introduction by Lawrence Alloway. Exhibition catalogue.

Christo and Jeanne-Claude: Wrapped Reichstag, Berlin 1971–95. Cologne: Taschen Verlag, 1996. Text by David Bourdon.

Christo: The Pont Neuf Wrapped, Paris, 1975–85. New York: Harry N. Abrams; Paris: Adam Biro; Cologne: Dumont Buchverlag. Texts by David Bourdon and Bernard de Montgolfier.

Christo: Urban Projects. Boston: The Institute of Contemporary Art, 1979. Text by Pamela Allara and Stephen S. Prokopoff. Exhibition catalogue.

Gruen, John. "Christo Wraps the Museum." *New York Magazine* (June 24, 1968): 12.

Laporte, Dominique. *Christo*. Paris: Art Press/Flammarion; New York: Pantheon Books, 1985.

Rubin, William. *Christo Wraps the Museum*. New York: The Museum of Modern Art, 1968. Exhibition brochure.

Schellman, Jörg, and Joséphine Benecke, eds. *Christo and Jeanne-Claude, Prints and Objects, 1963–95: A Catalogue Raisonné*. Munich and New York: Edition Schellman; Munich: Schirmer/Mosel, 1995. Introduction by Werner Spies.

Joseph Cornell

Ashton, Dore. *A Joseph Cornell Album*. New York: Viking Press, 1974.

Caws, Mary Ann, ed. *Joseph Cornell's Theater of the Mind: Selected Diaries, Letters, and Files*. New York: Thames and Hudson, 1993. Introduction by Caws; foreword by John Ashbery.

Copier créer: de Turner à Picasso: 300 oeuvres inspirées par les maîtres du Louvre. Paris: Éditions de la Réunion des musées nationaux, 1993.

Cornell, Joseph. "Americana Fantastica." *View*, series 2, no. 4 (January 1943): cover, 10–16, 21, 36.

Cornell, Joseph. "'Enchanted Wanderer': Excerpt from a Journal Album for Hedy Lamarr." *View*, series 1, nos. 9/10, (December 1941–January 1942): 3.

Cornell, Joseph. *The Romantic Museum: Portraits of Women: Constructions and Arrangements by Joseph Cornell*. New York: Hugo Gallery, 1946. Exhibition brochure.

An Exhibition of Works by Joseph Cornell. Pasadena: Pasadena Art Museum, 1966. Text by Fairfield Porter. Exhibition catalogue.

Joseph Cornell: Cosmic Travels. New York: Whitney Museum of American Art, 1995. Texts by Charles A. Whitney and Angela Kramer Murphy. Exhibition brochure.

McShine, Kynaston, ed. *Joseph Cornell*. New York: The Museum of Modern Art, 1980. Introduction by McShine; texts by Dawn Ades, Lynda Roscoe Hartigan, Carter Ratcliff, and P. Adams Sitney. Exhibition catalogue.

Simic, Charles. *Dime-Store Alchemy: The Art of Joseph Cornell*. Hopewell, N.J.: Ecco Press, 1992.

Solomon, Deborah. *Utopia Parkway: The Life and Work of Joseph Cornell*. New York: Farrar, Straus & Giroux, 1996.

Starr, Sandra Leonard. *Joseph Cornell and the Ballet*. New York: Castelli, Feigen, and Corcoran, 1983. Exhibition catalogue.

Tashjian, Dickran. *Joseph Cornell: Gifts of Desire*. Miami Beach: Grassfield Press, 1992.

Waldman, Diane. *Joseph Cornell*. New York: Braziller, 1977.

Jan Dibbets

Boice, Bruce. "Jan Dibbets: The Photograph and the Photographed." *Artforum* 11, no. 8 (April 1973): 45–49.

Licht, Jennifer. *Eight Contemporary Artists*. New York: The Museum of Modern Art, 1974. Exhibition catalogue.

Europe in the Seventies: Aspects of Recent Art. Chicago: The Art Institute of Chicago, 1977. Introduction by Anne Rorimer and A. James Speyer; texts by Jean-Christophe Ammann, David Brown, and Benjamin H.D. Buchloh. Exhibition catalogue.

Fuchs, R.H., and Gloria Moure. *Jan Dibbets: Interior Light, Works on Architecture 1969–1990*. New York: Rizzoli, 1991.

Jan Dibbets. Edinburgh: Scottish Arts Council; Cardiff: Welsh Arts Council, 1976. Texts by Barbara M. Reise and M.M.M. Vos. Exhibition catalogue.

Jan Dibbets. Eindhoven: Stedelijk van Abbemuseum, 1980. Text by R.H. Fuchs. Exhibition catalogue.

Jan Dibbets. Minneapolis: Walker Art Center, 1987. Introduction by Martin Friedman; texts by R.H. Fuchs and M.M.M. Vos. Exhibition catalogue.

McShine, Kynaston, ed. *Information*. New York: The Museum of Modern Art, 1970. Text by McShine; artists statements. Exhibition catalogue.

Reconsidering the Object of Art: 1965–75. Los Angeles: The Museum of Contemporary Art, 1995.

Reise, Barbara M. "Jan Dibbets: A Perspective Correction." *Art News* 71, no. 4 (Summer 1972): 38–41.

Saenredam Sénanque Jan Dibbets 1980–81. Abbaye de Sénanque, Gordes: Renault recherches Art et Industrie, Centre Internationale de Création Artistique, 1981. Texts by M.M.M. Vos, Micheline Renard, and George Duby. Exhibition catalogue.

Sharp, Willoughby. "Interview with Jan Dibbets." *Avalanche* (New York), no. 1 (Fall 1970): 33–39.

Lutz Dille

Bauret, Gabriel. *Street Photography*. Paris: FNAC Publications, 1993.

Goffaux, Catherine. "Lutz Dille: Instantanés d'une Existence." *Photographies Magazine* (summer 1995): 41–44.

Lambeth, Michel. "Lutz Dille: The Bertolt Brecht of the Camera." *Arts Canada* 24 (November 11, 1967): supplement, n.p.

The Many Worlds of Lutz Dille. Ottawa: National Film Board, 1967. Introduction by Lorraine Monk. Exhibition catalogue.

Mark Dion

Cocido y Crudo. Madrid: Museo Nacional Centro de Arte Reina Sofía, 1994.

Decter, Joshua. "De-Coding the Museum." *Flash Art* 23, no. 155 (November–December 1990): 140–42.

The Desire of the Museum. New York: Whitney Museum of American Art, Downtown at Federal Reserve Plaza, 1989. Text by Jackie McAllister and Benjamin Weil. Exhibition catalogue.

Dion, Mark, and Alexis Rockman. "Concrete Jungle." *Journal of Contemporary Art* 4, no.1 (spring–summer 1991): 24–33.

Kwon, Miwon. "Unnatural Tendencies: Scientific Guises of Mark Dion." *Forum International* 4, no. 18 (May–August 1993): 104–07.

Mark Dion. London: Phaidon Press, 1997. Interview by Miwon Kwon; texts by John Berger, Norman Bryson, and Lisa Graziose Corrin; artist writings.

Mark Dion: Theatrum Mundi. Columbus, Ohio: Wexner Center for the Arts, The Ohio State University; Cologne: Salon Verlag, 1997.

Mark Dion: Natural History and Other Fictions. Birmingham, England: Ikon Gallery; Hamburg: Hamburger Kunstverein, 1997. Texts by Saskia Bos, Miwon Kwon, Jackie McAllister, Erhard Schüttpelz, and Jason Simon. Exhibition catalogue.

On Taking a Normal Situation and Translating It into Overlapping and Multiple Readings of Conditions Past and Present. Antwerp: Museum van Hedendaagse Kunst, 1993. Texts by Yves Aupetitallot, Homi K. Bhabha, Iwona Blazwik, Bart Cassiman, Mauro Ceruti, Carolyn Christov-Bakargiev, Bruce Ferguson, Reesa Greenberg, Sandy Nairne, and Hugo Soly. Exhibition catalogue.

Praet, Michel van. "Renovating Nature." *Flash Art* 23, no. 155 (November–December 1990): 132–33. Interview.

Herbert Distel

Caumont, Jacques. "Un Musée pour les musées." *Opus International* 33 (March 1972): 49–50. Interview.

Das Schubladenmuseum von Herbert Distel. Zurich: Kunsthaus Zürich, 1978. Introduction by Distel; foreword by Peter Killer.

Distel, Herbert. *Diesseits, Jenseits: Menschen aus Edgar Lee Masters' Spoon River Anthology*. Bern: Kunstmuseum Bern and Benteli, 1990. Exhibition catalogue.

Documenta 5: Befragung der Realität Bildwelten heute. Kassel: Documenta, 1972. Exhibition catalogue.

Herbert Distel: The Museum of Drawers: Tentoonstellingen. Antwerp: Internationaal Cultureel Centrum, 1976. Introduction by Florent Bex; text by Peter Killer; artist statement. Exhibition catalogue.

Groh, Klaus. *If I Had a Mind…(Ich stelle mir vor…) Conceptart, Project art*. Cologne: M. DuMont Schauberg, 1971.

Killer, Peter. "Das Kleinste Museum der Welt." *Du* (Zurich) 34, no. 7 (July 1974): 44–53, 73.

Matrix 45: Herbert Distel. Hartford, Conn.: The Wadsworth Atheneum, 1978. Exhibition brochure.

Marcel Duchamp

Bonk, Ecke. *Marcel Duchamp, The Box in a Valise: De ou par Marcel Duchamp ou Rrose Sélavy: Inventory of an Edition*. New York: Rizzoli, 1989.

Bronson, AA, and Peggy Gale, eds. *Museums by Artists*. Toronto: Art Metropole, 1983.

By or of Marcel Duchamp or Rrose Sélavy. Pasadena: Pasadena Art Museum, 1963. Foreword by Walter Hopps. Exhibition catalogue.

Cabanne, Pierre. *Dialogues with Marcel Duchamp*. New York: Viking Press, 1971.

Duchamp. Barcelona: Fundació Joan Miró; Madrid: Fundación Caixa de Pensions, 1984. Texts by Dawn Ades, John Cage, Maurizio Calvesi, and Germano Celant, Anne d'Harnoncourt, Gloria Moure, Octavio Paz, Eulàlia Serra, Ignasi de Solá-Morales, and Yoshihaki Tono. Exhibition catalogue.

Hamilton, Richard. *The Bride Stripped Bare by Her Bachelors Even Again*. Newcastle-upon-Tyne: University of Newcastle-upon-Tyne, 1966.

D'Harnoncourt, Anne, and Kynaston McShine, eds. *Marcel Duchamp*. Philadelphia: Philadelphia Museum of Art; New York: The Museum of Modern Art, 1973. Introduction by d'Harnoncourt; texts by David Dantin, Richard Hamilton, Robert Lebel, Lucy R. Lippard, McShine, Octavio Paz, Michel Sanouillet, Arturo Schwarz, Lawrence D. Steefel Jr., and John Tancock. Exhibition catalogue.

Hultén, Pontus, ed. *Marcel Duchamp*. Milan: Bompiani, 1993. Additional text by Luciano Berio; chronology by Jennifer Gough-Cooper and Jacques Caumont. Exhibition catalogue for an exhibition at the Palazzo Grassi, Venice.

Lebel, Robert. *Marcel Duchamp*. New York: Grove Press; London and Paris: Trianon, 1959. Texts by Duchamp, André Breton, H.-P. Roché. Catalogue raisonné.

L'Oeuvre de Marcel Duchamp. 4 vols. Paris: Musée national d'art moderne, Centre Georges Pompidou, 1977. Vol. 1: Biography and chronology by Jennifer Gough-Cooper and Jacques Caumont; Vol. 2: Catalogue raisonné edited by Jean Clair; Vol. 3: Texts by Clair, Jindrich Chalupecky, Thierry de Duve, Pontus Hultén, Robert Lebel, François Le Lionnais, Ulf Linde, Jean-François Lyotard, Olivier Micha, Georges Raillard, Carl Frédéric Reuterswärd, and Arturo Schwarz; Vol. 4: *Victor (Marcel Duchamp)*, a novel by Henri-Pierre Roché. Exhibition catalogue.

Naumann, Francis M. *The Mary and William Sisler Collection*. New York: The Museum of Modern Art, 1984.

————, and Beth Venn. *Making Mischief: Dada Invades New York*. New York: Whitney Museum of American Art, 1996. Exhibition catalogue.

The Portable Museums of Marcel Duchamp: De ou par Marcel Duchamp or Rrose Sélavy. London: L & R Entwistle and Co., 1996. Introduction by Francis M. Naumann. Exhibition catalogue.

Schwarz, Arturo, ed. *The Complete Works of Marcel Duchamp*. 2 vols. New York: Delano Greenridge Editions, 1997. Catalogue raisonné. 3rd revised edition.

Tomkins, Calvin. *Duchamp: A Biography*. New York: Henry Holt and Co., 1996.

Kate Ericson and Mel Ziegler
Cooper, Dennis. "Kate Ericson and Mel Ziegler at Wolff Gallery." *Artforum* 26, no. 8 (April 1988): 141–42.

Cross, Andrew. "Ericson and Ziegler." *Art Monthly* 174 (March 1994): 17–20.

Gardner, Colin. "Kate Ericson and Mel Ziegler at Burnett Miller Gallery." *Artforum* 27 (April 1989): 172.

Pagel, David. "The Implications of Small Differences." *Artweek* 20, no. 5 (February 4, 1989): 7.

Projects 14: Kate Ericson and Mel Ziegler: Signature Piece. New York: The Museum of Modern Art, 1988. Text by Kathleen Slavin. Exhibition brochure.

Smith, Roberta. "Kate Ericson and Mel Ziegler at White Columns." *The New York Times*, November 28, 1986, p. C28.

Lewis, Jo Ann. "Tracking Their Quarry: At the Hirshhorn, A Tour of The Stones of Washington." *The Washington Times*, March 9, 1988, pp. B1–2.

Elliott Erwitt
Elliott Erwitt: Between the Sexes. New York and London: W. W. Norton and Co., 1994. Introduction by Erwitt.

Elliott Erwitt: Museum Watching. Tokyo: Creo Corporation, 1998.

Elliott Erwitt: Personal Exposures. Tokyo: Pacific Press Service, 1978.

Roger Fenton
Baldwin, Gordon. *Roger Fenton: Pasha and Bayadère*. Los Angeles: J. Paul Getty Museum, 1996.

Hamber, Anthony. *A Higher Branch of the Art: Photographing the Fine Arts in England, 1839–1880*. London: Gordon and Breach Publishers; Amsterdam: Overseas Publishers Association, 1996.

Hannavy, John. *Roger Fenton of Crimble Hall*. Boston: Godine, 1976.

Haworth-Booth, Mark, and Anne McCauley. *The Museum and the Photograph: Collecting Photography at the Victoria and Albert Museum 1853–1900*. Williamstown, Mass.: Sterling and Francine Clark Art Institute, 1998. Exhibition catalogue.

Jacobson, Ken, and Jenny Jacobson. *Étude d'Après Nature: 19th Century Photographs in Relation to Art*. Great Bardfield, England: Ken and Jenny Jacobson, 1996. Additional text by Anthony Hamber.

The Kiss of Apollo: Photography and Sculpture, 1845 to the Present. San Francisco: Fraenkel Gallery, in association with Bedford Arts, Publishers, 1991. Introduction by Jeffrey Fraenkel; text by Eugenia Parry Janis. Exhibition catalogue.

Roger Fenton. New York: Aperture Books, 1987. Text by Richard Pare.

Roger Fenton: Photographer of the 1850s. London: Hayward Gallery; New Haven: Yale University Press, 1988. Introduction by Valerie Lloyd. Exhibition catalogue.

Robert Filliou
Bronson, AA, and Peggy Gale, eds. *Museums by Artists*. Toronto: Art Metropole, 1983.

Conzen, Ina. *Art Games: Die Schachteln der Fluxuskünstler*. Stuttgart: Staatsgalerie, VG Bild-Kunst, and Oktagon Verlag, 1997. Exhibition catalogue.

Filliou, Robert. *Information Box*. Munich: Galerie Bucholz, 1973.

Filliou, Robert. "Poème Collectif de Robert Filliou et Cie." In *Les Poquettes*. Ed. A. Balthazar. La Louvière, Belgium: Daily-Bul, 1968. Texts by Paul-Hervé Parsy and Roland Recht.

Filliou, Robert. *A Proposition, a Problem, a Danger and a Hunch, Manifestos*. New York: Something Else Press, 1966.

Robert Filliou. Paris: Musée national d'art moderne, Centre Georges Pompidou, 1991. Texts by Paul-Hervé Parsy and Roland Recht. Exhibition catalogue.

Schimmel, Paul. *Out of Actions: Between Performance and the Object 1949–1979*. Los Angeles: The Museum of Contemporary Art; New York: Thames and Hudson, 1998.

Schmidt, Hans-Werner, ed. *Robert Filliou: 1926–1987: Zum Gedächtnis*. Düsseldorf: Städtische Kunsthalle, 1988. Additional texts by Wolfgang Becker, René Block, Johannes Cladders, Wolfgang Drechsler, Michael Erlhoff, Wolfgang Feelisch, Filliou, Jürgen Harten, Armin Hundertmark, Thomas Kellein, Jürgen H. Meyer, Tony Morgan, Karl Ruhrberg, Daniel Spoerri, and Emmett Williams. Exhibition catalogue.

Erlhoff, Michael, ed. *The Eternal Network Presents: Robert Filliou*. Hannover: Sprengel Museum; Paris: Musée d'Art Moderne de la Ville de Paris; Bern: Kunsthalle Bern, 1984. Additional text by Filliou. Exhibition catalogue.

Robert Filliou: From Political to Poetical Economy. Vancouver: Morris and Helen Belkin Art Gallery, University of British Columbia, 1995. Introduction by Scott Watson; texts by Hank Bull, Kate Craig, Filliou, Michael Morris, Clive Robertson, Sharla Sava, and Vincent Trasor. Exhibition catalogue.

Robert Filliou: Poet—Sammlung Feelisch. Remscheid: Galerie der Stadt, 1997. Texts by Wolfgang Feelisch, Michael Erlhoff, Wolf Kahlen, and Paul-Hervé Parsy. Exhibition catalogue.

Larry Fink
Kozloff, Max. "The Lights and Darks of Living It Up." *Art in America* 67, no. 5 (September 1979): 84–87.

Larry Fink: Boxing Photographs. New York: Whitney Museum of American Art, 1997. Text by Adam Weinberg. Exhibition brochure.

Schlatter, Christian. "New York's People Not Working." *Creatis* (New York), no. 12 (November 1979): 5–10.

Social Graces: Photographs by Larry Fink. Millerton, N.Y.: Aperture, 1984. Introduction by Fink.

Fluxus

Altshuler, Bruce. "Fluxus Redux." *Arts Magazine* 64, no. 1 (September 1989): 66–70.

Block, René. "Fluxus and Fluxism in Berlin 1964–1976." In *Berlinart, 1961–1987.* Ed. Kynaston McShine. New York: The Museum of Modern Art, 1987. Exhibition catalogue.

Conzen, Ina, ed. *Art Games: Die Schachteln der Fluxuskünstler.* Stuttgart: Staatsgalerie and Oktagon Verlag, 1997. Exhibition catalogue.

Di Maggio, Gino, ed. *Ubi Fluxus Ibi Motus.* Milan: Nuove edizioni Gabriele Mazzotta, in association with the Biennale di Venezia, 1990. Exhibition catalogue.

Hendricks, Jon, ed. *Fluxus Codex.* Detroit: The Gilbert and Lila Silverman Fluxus Collection; New York: Harry N. Abrams, 1988. Introduction by Robert Pincus-Witten; text by Hendricks; correspondence and artists statements.

———, ed. *Fluxus etc.* Bloomfield Hills, Mich.: Cranbrook Academy of Art Museum, 1981. Exhibition catalogue.

Hendricks, Jon, and Clive Philpot. *Fluxus: Selections from the Gilbert and Lila Silverman Collection.* New York: The Museum of Modern Art, 1988. Exhibition catalogue.

In the Spirit of Fluxus. Minneapolis: Walker Art Center, 1993. Texts by Simon Anderson, Elizabeth Armstrong, Andreas Huyssen, Bruce Jenkins, Douglas Kahn, Owen F. Smith, and Kristine Stiles. Exhibition catalogue.

Kellein, Thomas. *Fluxus.* New York and London: Thames and Hudson, 1995. Additional text by Jon Hendricks.

Moore, Barbara. "George Maciunas: A Finger in Fluxus." *Artforum* 21, no. 2 (October 1982): 33–45.

Schimmel, Paul. *Out of Actions: Between Performance and the Object, 1949–1979.* Los Angeles: The Museum of Contemporary Art; New York: Thames and Hudson, 1998.

Williams, Emmett, and Ann Noel, eds. *Mr. Fluxus: A Collective Portrait of George Maciunas, 1931–1978.* London: Thames and Hudson, 1997.

Günther Förg

Une autre objectivité / Another Objectivity. Paris: Centre national des arts plastiques; Prato, Italy: Centro per l'Arte Contemporanea Luigi Pecci; Milan: Idea Books, 1989. Texts by Jean-François Chevrier and James Lingwood. Exhibition catalogue.

Günther Förg. Krefeld: Museum Haus Lange, 1987. Texts by Max Wechsler and Britta E. Buhlmann. Exhibition catalogue.

Günther Förg: Painting / Sculpture / Installation. Newport Beach, Calif., Newport Harbor Art Museum, in association with Chicago: The Renaissance Society, University of Chicago, 1989. Introduction by Paul Schimmel; texts by Bonnie Clearwater, Stephen Ellis, Christoph Schenker, Schimmel, and Max Wechsler. Exhibition catalogue.

Günther Förg. Kassel: Museum Fridericianum; Ghent: Museum van Hedendaagse Kunst; Leipzig: Museum der Bildenden Künste; Tübingen: Kunsthalle Tübingen; Munich: Kunstraum; Stuttgart: Edition Cantz, 1990. Texts by Ingrid Rein and Veit Loers. Exhibition catalogue.

Günther Förg. Amsterdam: Stedelijk Museum, 1995. Text by Rudi Fuchs. Exhibition catalogue.

Günther Förg: The Complete Editions, 1974–1988. Rotterdam: Museum Boymans-van Beuningen; Cologne: Galerie Gisela Capitain; Stuttgart: Edition Cantz, 1989. Texts by Luise Horn and Karel Schampers. Exhibition catalogue.

Günther Förg: Stations of the Cross. Cologne: Galerie Max Hetzler; New York: Edition Julie Sylvester, 1990. Text by Reiner Speck. Exhibition catalogue.

Kuspit, Donald. "Totalitarian Space: The Installations of Günther Förg and Gerhard Merz." *Arts Magazine* 63, no. 10 (summer 1989): 44–50.

Schenker, Christoph. "Günther Förg: An Effort to Re-engage the Rubble of Modernism—An Incomplete, Liquidated Project—and to Render It Useful Through Fresh Conclusions." *Flash Art,* no. 144 (January–February 1989): 66–70.

Schmidt-Wulffen, Stephen. "Room as Medium." *Flash Art,* no. 131 (December 1986): 74–77.

Andrea Fraser

Damaged Goods: Desire and the Economy of the Object. New York: The New Museum of Contemporary Art, 1986.

Decter, Joshua. "De-Coding the Museum." *Flash Art* 23, no. 155 (November–December 1990): 140–42.

———. "Interview with Andrea Fraser." *Flash Art* 23, no. 155 (November–December 1990): 138.

Fraser, Andrea. "Notes on the Museum's Publicity." *Lusitania* 1, no. 1 (fall 1990): 49–53.

———. "Museum Highlights: A Gallery Talk." *October* 57 (summer 1991): 103–23.

Els Límits del Museu. Barcelona: Fundació Antoni Tàpies, 1995.

Miller-Keller, Andrea. *Andrea Fraser: Welcome to the Wadsworth: A Museum Tour.* Hartford: The Wadsworth Atheneum, 1991. Exhibition brochure.

General Idea

Bronson, AA, and Peggy Gale, eds. *Museums by Artists.* Toronto: Art Metropole, 1983.

Celant, Germano. "General Idea in Canadada: Un Gruppo Canadese." *Domus,* no. 539 (November 1974): 52.

Decter, Joshua. "General Idea." *Journal of Contemporary Art* 3, no. 1 (spring–summer 1991): 49–64. Interview.

General Idea. *General Idea, Multiples: Catalogue Raisonné: Multiples and Prints, 1967–93.* Toronto: General Idea and S.L. Simpson, 1993.

General Idea. *General Idea: Pharmacopia.* Barcelona: Centre d'Art Santa Monica, 1992. Introduction by Brigitte Rambaud; text by General Idea. Exhibition catalogue.

General Idea's Fin de Siècle. Stuttgart: Württembergischer Kunstverein; Hamburg: Hamburger Kunstverein; Toronto: The Power Plant; Columbus, Ohio: Wexner Center for the Arts, The Ohio State University; San Francisco: San Francisco Museum of Modern Art, 1992. Introduction by Tilman Osterwold; texts by Joshua Decter, Friedemann Malsh, Louise Dompierre, Stephan Schmitt-Wulffen, and Jean-Christophe Ammann. Exhibition catalogue.

General Idea, 1968–1984. Basel: Kunsthalle Basel; Eindhoven: Stedelijk van Abbemuseum; Toronto: The Art Gallery of Ontario; Montreal: Musée d'art contemporain, 1984. Introduction by Rudi Fuchs; texts by General Idea and Jean-Christophe Ammann. Exhibition catalogue.

The Search for the Spirit: General Idea, 1968–1975. Toronto: Art Gallery of Ontario, 1997. Texts by Fern Bayer, AA Bronson, and Christina Ritchie. Exhibition catalogue.

Sharp, Willoughby. "The Gold Diggers of '84: An Interview with General Idea, Toronto." *Avalanche* (New York), no. 7 (spring 1973): 14–21.

Hans Haacke

Bronson, AA, and Peggy Gale, eds. *Museums by Artists.* Toronto: Art Metropole, 1983.

Bois, Yve-Alain, Douglas Crimp, and Rosalind Krauss. "A Conversation with Hans Haacke." *October* 30 (fall 1984): 23–48.

Burnham, Jack. "Hans Haacke's Cancelled Show at the Guggenheim." *Artforum* 9, no. 10 (June 1971): 67–71.

Bußmann, Klaus, and Florian Matzner, eds. *Hans Haacke: Bodenlos.* Stuttgart: Edition Cantz, 1993. Preface by Bußmann; text by Haacke.

Haacke, Hans. "Museums, Managers of Consciousness." *Art in America* 72, no. 2 (February 1984): 9–17.

Hans Haacke: Artfairismes. Paris: Musée national d'art moderne, Centre Georges Pompidou, 1989. Exhibition catalogue.

Hans Haacke: Framing and Being Framed: 7 Works 1970–75. Halifax: The Press of the Nova Scotia College of Art and Design; New York: New York University Press, 1975. Editor's note by Kasper König; texts by Howard S. Becker and John Walton, Jack Burnham, and Haacke.

Hans Haacke: "Obra Social." Barcelona: Fundació Antoni Tàpies, 1995. Texts by Benjamin H.D. Buchloh, Walter Grasskamp, and Haacke. Exhibition catalogue.

Hans Haacke: Unfinished Business. New York: The New Museum of Contemporary Art; Cambridge, Mass.: The MIT Press, 1986. Texts by Leo Steinberg, Rosalyn Deutsche, Haacke, Frederic Jameson, and Brian Wallis. Exhibition catalogue.

McShine, Kynaston, ed. *Information.* New York: The Museum of Modern Art, 1970. Text by McShine; artists statements. Exhibition catalogue.

Reconsidering the Object of Art: 1965–75. Los Angeles: The Museum of Contemporary Art, 1995.

Software: Information Technology: Its New Meaning for Art. New York: The Jewish Museum, 1970. Introduction by Karl Katz; text by Jack Burnham, James A. Mahoney, Theodor Nelson, and Ned Woodman; artists statement. Exhibition catalogue.

Wallis, Brian. "The Art of Big Business." *Art in America* 74, no. 6 (June 1986): 28–33.

Richard Hamilton

Alloway, Lawrence. "This Is Tomorrow." *Artnews* 55, no. 5 (September 1956): 64.

An Exhibit. Newcastle-upon-Tyne: Hatton Gallery, 1957. Text by Lawrence Alloway. Exhibition catalogue.

Banham, Reyner. "Man, Machine, and Motion." *Architectural Review* 118, no. 3 (July 1955): 51–53.

Baro, Gene. "Hamilton's Guggenheim." *Art & Artists* (London) 1, no. 8 (November 1966): 28–31.

Cooke, Lynne. "Richard Hamilton: Pop Pioneer and Technophile." *The Journal of Art* 4, no. 3 (March 1991): 10.

Hamilton, Richard. *The Bride Stripped Bare by Her Bachelors Even Again.* Newcastle-upon-Tyne: University of Newcastle-upon-Tyne, 1966.

———. *Collected Words.* London and New York: Thames and Hudson, 1982.

———. "Hommage à Chrysler Corp." *Architectural Design* 28, no. 3 (March 1958): 120–21.

The Independent Group: Postwar Britain and the Aesthetics of Plenty. Cambridge, Mass.: The MIT Press; London: Institute of Contemporary Arts, 1990. Introduction by Jacquelynn Baas; chronology by Graham Whitham; texts by Lawrence Alloway, Theo Crosby, Barry Curtis, Richard Hamilton, Diane Kirkpatrick, David Mellor, David Robbins, Denise Scott Brown, Alison and Peter Smithson, and David Thistlewood. Exhibition catalogue.

Man, Machine & Motion. Newcastle-upon-Tyne: University of Durham, 1955. Introduction by Richard Hamilton and Lawrence Gowing; text by Reyner Banham. Exhibition catalogue.

Morphet, Richard, ed. *Richard Hamilton.* London: Tate Gallery, 1992. Additional texts by David Mellor, Sarat Maharaj, and Stephen Snoddy. Exhibition catalogue.

Varnedoe, Kirk, and Adam Gopnik. *High and Low: Modern Art and Popular Culture.* New York: The Museum of Modern Art, 1990. Exhibition catalogue.

Susan Hiller

Brett, Guy. "Susan Hiller's Shadowland." *Art in America* 79, no. 4 (April 1991): 136–43.

Bush, Kate. "Susan Hiller: Freud Museum." *Untitled: A Review of Contemporary Art* 5 (summer 1994): 12.

Clifford, James. "Immigrant." Chapter 11 in *Routes: Travel and Translation in the Late 20th Century.* Cambridge, Mass.: Harvard University Press, 1997.

Einzig, Barbara, ed. *Thinking About Art: Conversations with Susan Hiller.* Manchester, England: Manchester University Press, 1995. Introduction by Lucy R. Lippard.

Fisher, Jean. "Elan and Other Invocations." In *Inside the Visible: An Elliptical Traverse of 20th Century Art in, of, and from the Feminine.* Ed. M. Catherine de Zegher. Cambridge, Mass.: The MIT Press, 1996. Exhibition catalogue.

Hiller, Susan. *After the Freud Museum.* London: Book Works Press, 1995.

———. "Dream Mapping." *British Journal of Psychotherapy* 14, no. 4 (Summer 1998): 444–52.

———. *Freudsche Objekte.* Leipzig: Institut für Buchkunst, 1998.

———. *Rough Sea.* Brighton, England: University of Sussex, Gardner Centre for the Arts, 1976. Published in conjunction with the exhibition *Dedicated to the Unknown Artists.*

Morgan, Stuart. "Beyond Control." *Frieze*, no. 23 (summer 1995): cover, 52–58. Interview.

Renton, Andrew. "In Conversation with Susan Hiller." In *Talking Art.* Ed. Adrian Searle. London: Institute of Contemporary Arts, 1993.

Robinson, Denise. "Thought Buried Alive: The Work of Susan Hiller." *Third Text*, no. 37 (winter 1996–97): cover, 37–58.

Schimmel, Paul. *Out of Actions: Between Performance and the Object, 1949–1979.* Los Angeles: The Museum of Contemporary Art; New York: Thames and Hudson, 1998.

Susan Hiller. Liverpool: Tate Gallery, 1996. Preface by Nicholas Serota and Lewis Biggs; introduction by Fiona Bradley; texts by Guy Brett, Rebecca Dimling Cochran, and Stewart Morgan. Exhibition catalogue.

Susan Hiller 1973–1983: The Muse My Sister. Londonderry: Orchard Gallery, 1984. Texts by Guy Brett, Roszika Parker, and John Roberts. Exhibition catalogue.

Susan Hiller: The Revenants of Time. London: Matt's Gallery; Sheffield: Mappin Gallery; Glasgow: Third Eye Centre, 1990. Text by Jean Fisher. Exhibition catalogue.

Susan Hiller: Wild Talents. Warsaw: Galeria Foksal; Philadelphia: Institute of Contemporary Art, 1998. Texts by Stuart Morgan, Patrick Murphy, Denise Robinson, and Adam Szymczyk. Exhibition catalogue.

Candida Höfer

Butler, Susan. "The Mise-en-Scène of the Everyday." *Art and Design* 10, nos. 9/10 (September–October 1995): 16–23.

Candida Höfer: Innenraum, Photografien 1979–1984. Xanten: Regionalmuseum; Bonn: Landesmuseum; Cologne: Rheinland Verlag, 1984. Exhibition catalogue.

Candida Höfer: Photographie. Munich and New York: Schirmer/Mosel, 1998. Text by Siegfried Gohr. Exhibition catalogue.

Candida Höfer: Räume/Spaces. Frankfurt am Main: Portikus, 1992. Foreword by Martin Hentschel and Kasper König; text by Gregorio Magnani. Exhibition catalogue.

Decter, Joshua. "Candida Höfer at Nicole Klagsbrun." *Artforum* 31, no. 5 (January 1993): 84–85.

Hofleitner, Johanna. "Candida Höfer." *Forum International* 16 (January–February 1993): 93–96.

Volkart, Yvonne. "Medusa and Co." *Flash Art* 27, no. 176 (May–June 1994): 81–83.

Komar and Melamid

Frazier, Ian. "Profiles: Partners." *The New Yorker* 62 (December 29, 1986): 33–54.

Glueck, Grace. "Dissidence as a Way of Art." *The New York Times Magazine*, May 8, 1977, p. 25.

Indiana, Gary. "Komar and Melamid Confidential." *Art in America* 73, no. 6 (June 1985): 94–101.

Komar, Vitaly, and Alexander Melamid. *Gedichte über den Tod: das Gespenst des Eklektizismus.* Berlin: NGBK, 1988.

———. "On Constructivism." *The Print Collector's Newsletter* 11, no. 2 (May–June 1980): 48–49.

———. "On the Experiment of Artistic Association in Soviet Russia." *Journal of Arts Management and Law* 13 (spring 1983): n.p.

Komar and Melamid. Edinburgh: Fruitmarket Gallery, 1985. Text by Peter Woolens. Exhibition catalogue.

Komar and Melamid: Painting History. Sydney: Artspace, 1987. Exhibition catalogue.

Monumental Propaganda: A Traveling Exhibition. New York: Independent Curators Inc., 1994. Texts by Dore Ashton, Vitaly Komar, and Alexander Melamid. Exhibition catalogue.

Nathanson, Melvyn B., ed. *Two Soviet Dissident Artists.* Carbondale and Edwardsville, Ill.: Southern Illinois University Press; London and Amsterdam: Feffer and Simons, Inc., 1979. Introduction by Jack Burnham.

Ratcliff, Carter. *Komar and Melamid.* New York: Abbeville Press, 1988. Additional texts by Vitaly Komar and Alexander Melamid.

Schimmel, Paul. *Out of Actions: Between Performance and the Object, 1949–1979.* Los Angeles: The Museum of Contemporary Art; New York: Thames and Hudson, 1998.

Schjeldahl, Peter. "Komar and Melamid." *Flash Art*, no. 125 (December 1985–January 1986): 64–65. Interview.

Wypijewski, Jo Ann, ed. *Painting by Numbers: Komar and Melamid's Scientific Guide to Art.* New York: Farrar, Straus & Giroux, 1997.

Louise Lawler

Bankowsky, Jack. " 'Spotlight' Louise Lawler." *Flash Art*, no. 133 (April 1987): 86.

Das Bild der Ausstellung/The Image of the Exhibition. Vienna: Hochschule für angewandte Kunst, 1993. Introduction by Markus Brüderlin; texts by Brüderlin, Rudolf Bumiller, Wolfgang Kemp, Lucius Burckhardt, Guido Mangold, Ulf Wuggenig, and Vera Kockot. Exhibition catalogue.

Buskirk, Martha. "Interviews with Sherrie Levine, Louise Lawler, and Fred Wilson." *October* 70 (fall 1994): 109–12.

Connections: Louise Lawler. Boston: Museum of Fine Arts, 1991. Text by Trevor Fairbrother. Exhibition brochure.

Decter, Joshua. "De-Coding the Museum." *Flash Art* 23, no. 155 (November–December 1990): 140–42.

The Desire of the Museum. New York: Whitney Museum of American Art, Downtown at Federal Reserve Plaza, 1989. Text by Jackie McAllister and Benjamin Weil. Exhibition catalogue.

Fraser, Andrea. "In and Out of Place." *Art in America* 73, no. 6 (June 1985): 122–29.

Gudis, Catherine, ed. *A Forest of Signs: Art in the Crisis of Representation.* Los Angeles: The Museum of Contemporary Art, in association with Cambridge, Mass., and London: The MIT Press, 1989.

Els Límits del Museu. Barcelona: Fundació Antoni Tàpies, 1995.

Linker, Kate. "Rites of Exchange." *Artforum* 25, no. 3 (November 1986): 99–101.

Louise Lawler: For Sale. Stuttgart: Cantz Verlag, 1994. Texts by Dietmar Elger and Thomas Weski.

Matrix 77: Louise Lawler. Hartford, Conn.: Wadsworth Atheneum, 1984. Exhibition brochure.

Meinhardt, Johannes. "Ersatzobjekte und bedeutende Rahmen: Allan McCollum, Louise Lawler, Barbara Bloom." *Kunstforum International* 99 (March–April 1989): 200–20.

———. "Louise Lawler: Kontext, Situation, Markt." *Zyma* (Sindelfingen, Germany) (January–February 1992): 4–9.

Storr, Robert. "Louise Lawler: Unpacking the White Cube." *Parkett* 22 (December 1989): 105–08.

Stack, Trudy Wilner. *Art Museum: Sophie Calle, Louise Lawler, Richard Misrach, Diane Neumaier, Richard Ross, Thomas Struth.* Tucson, Az.: Center for Creative Photography/University of Arizona, 1995. Exhibition catalogue.

What Is the Same: Louise Lawler/The Same and the Other in the Work of Louise Lawler. Saint-Etienne: Maison de la Culture de Saint-Etienne, 1987. Text by Claude Gintz. Exhibition catalogue.

Jean-Baptiste Gustave Le Gray

Gustave Le Gray and Carleton E. Watkins: Pioneers of Landscape Photography: Photographs from the Collection of The J. Paul Getty Museum. Malibu, Calif.: The J. Paul Getty Museum; Frankfurt am Main: Städtische Galerie im Städelschen Kunstinstitut, 1993. Exhibition catalogue.

Haworth-Booth, Mark, and Anne McCauley. *The Museum and the Photograph: Collecting Photography at the Victoria and Albert Museum 1853–1900.* Williamstown, Mass.: Sterling and Francine Clark Art Institute, 1998. Exhibition catalogue.

Jacobson, Ken, and Jenny Jacobson. *Étude d'Après Nature: 19th Century Photographs in Relation to Art.* Great Bardfield, England: Ken and Jenny Jacobson, 1996. Additional texts by Anthony Hamber.

Janis, Eugenia Perry. *The Photography of Gustave Le Gray.* Chicago: The Art Institute of Chicago and University of Chicago Press, 1987. Exhibition catalogue.

La Mission héliographique: Photographies de 1851. Paris: Inspection générale des musées classés et contrôlés, 1980. Text by Phillipe Néagu. Exhibition catalogue.

Le Camp de Châlons: Un reportage de Gustave Le Gray. Paris: Bibliothèque nationale, 1978. Exhibition catalogue.

Le Gray, Gustave. *A Practical Treatise on Photography, upon Paper and Glass, by Gustave Le Gray, Painter and Photographer, Paris,* translated by Thomas Cousins. London: T & R Willats, Opticians and Philosophical Instrument Makers, 1850.

Une visite au camp de Châlons sous le Second Empire. Paris: Musée de l'Armée, 1996. Exhibition catalogue.

Jac Leirner

Brett, Guy. *Transcontinental: An Investigation of Reality: Nine Latin American Artists.* London and New York: Verso; Manchester, England: Ikon Gallery and Cornerhouse Gallery, 1990. Texts by Brett, Waltércio Caldas Júnior, and Paulo Venancio Filho.

Directions: Jac Leirner. Washington, D.C.: Hirshhorn Museum and Sculpture Garden, Smithsonian Institution, 1992. Text by Amada Cruz. Exhibition catalogue.

Grynsztejn, Madeleine. *About Place: Recent Art of the Americas.* Chicago: The Art Institute of Chicago, 1995. Additional text by Dave Hickey. Exhibition catalogue.

Jac Leirner. Oxford: The Museum of Modern Art; Glasgow: Third Eye Centre, 1991. Text by David Elliott. Exhibition catalogue.

Jac Leirner. São Paulo: Galeria Camargo Vilaça, 1993. Text by Paulo Herkenhoff. Exhibition catalogue.

Jac Leirner. Caracas: Sala Mendoza, 1998. Text by Ariel Jiménez. Exhibition catalogue.

Jac Leirner: 1990–1992. São Paulo: Galeria Camargo Vilaça, 1992. Exhibition catalogue.

Jac Leirner: Nomes. São Paulo: Galeria Millan, 1989. Text by Guy Brett. Exhibition catalogue.

Larson, Kay. "When Worlds Collide." *New York Magazine* (June 21, 1993): 65–66.

Rasmussen, Waldo, ed. *Latin American Artists of the Twentieth Century.* New York: The Museum of Modern Art, 1993. Introduction by Rasmussen; texts by Edward J. Sullivan, Rina Carvajal, Daniel E. Nelson, Fatima Bercht, Max Kozloff, Florencia Bazzano Nelson, Aracy Amaral, Guy Brett, Dore Ashton, Elizabeth Ferrer, Jacqueline Barnitz, Paulo Herkenhoff, Charles Merewether, and Mari Carmen Ramírez. Exhibition catalogue.

Schjeldahl, Peter. "In-Flight Emergency." *The Village Voice*, February 15, 1994, p. 95.

Sullivan, Edward J. "Fantastic Voyage: Latin American Explosion." *Artnews* 92, no. 6 (summer 1993): 140–41.

Viewpoints: Jac Leirner. Minneapolis: Walker Art Center, 1991. Text by Bruce W. Ferguson. Exhibition catalogue.

Zelevansky, Lynn. *Sense and Sensibility: Women Artists and Minimalism in the Nineties.* New York: The Museum of Modern Art, 1994. Exhibition catalogue.

Zoe Leonard

Cotter, Holland. "Art After Stonewall." *Art in America* 82, no. 6 (June 1994): 56–65.

Hirsch, David. "East Side Story." *New York Native*, December 19, 1988, p. 36.

Information: Zoe Leonard. Cologne: Galerie Gisela Capitain, 1991. Exhibition catalogue.

Koether, Jutta. "Zoe Leonard." *Flash Art* 23, no. 153 (summer 1990): 154.

Leonard, Zoe. "The Question of Gender in Art: Zoe Leonard." *Tema Celeste* (Syracuse, Italy), nos. 37/38 (autumn 1992): 70.

Schjeldahl, Peter. "Missing: The Pleasure Principle." *The Village Voice*, March 13, 1993, pp 34–38.

Strange Attractors: Signs of Chaos. New York: The New Museum of Contemporary Art, 1989. Exhibition catalogue.

Zoe Leonard. Berkeley: University Art Museum, University of California, 1991. Text by Laurence Rinder. Exhibition brochure.

Sherrie Levine

Anna, Suzanne, ed. *Museum Vitale: Offenes Labor zur Tradition und Zukunft einer Institution.* Ostfildern: Edition Cantz; Schloss Morsbroich: Städtisches Museum Leverkusen, 1997.

Buchloh, Benjamin H.D. "Allegorical Procedures: Appropriation and Montage in Contemporary Art." *Artforum* 21, no. 1 (September 1982): 43–56.

Buskirk, Martha. "Interviews with Sherrie Levine, Louise Lawler, and Fred Wilson." *October* 70 (fall 1994): 109–12.

Crimp, Douglas. "The Photographic Activity of Postmodernism." *October* 15 (winter 1980): 91–101.

Gudis, Catherine, ed. *A Forest of Signs: Art in the Crisis of Representation.* Los Angeles: The Museum of Contemporary Art; Cambridge, Mass., and London: The MIT Press, 1989.

Krauss, Rosalind. "The Originality of the Avant-Garde: A Postmodern Repetition." *October* 18 (fall 1981): 47–66.

Pictures. New York: Artists Space, 1993. Text by Douglas Crimp. Exhibition catalogue.

Sherrie Levine. Zurich: Kunsthalle Zürich, 1991. Text by David Deitcher; interview by Jeanne Siegel. Exhibition catalogue.

Temkin, Ann. *Sherrie Levine: Newborn.* Philadelphia: Philadelphia Museum of Art, 1993. Includes artist's statement.

El Lissitzky

Dorner, Alexander. "Zur abstrakten Malerei." *Die Form* 3, no. 4 (April 1928): 110–14.

El Lissitzky: Experiments in Photography. New York: Houk Friedman Gallery, 1991. Text by Margarita Tupitsyn. Exhibition catalogue.

El Lissitzky 1890–1941. Oxford: Museum of Modern Art, 1977. Exhibition catalogue.

El Lissitzky 1890–1941: Architect, Painter, Photographer, Typographer. Eindhoven: Stedelijk van Abbemuseum; London and New York: Thames and Hudson, 1990. Texts by Yve-Alain Bois, Kai-Uwe Hemken, Jean Leering, S.O. Khan-Magomedov, Peter Nisbet, M.A. Nemirovskaja, and Henk Puts. Exhibition catalogue.

El Lissitzky: Shau der Arbeit 1922–23. Berlin: Graphisches Kabinett J.B. Neumann, 1924. Exhibition catalogue.

Helms, Dietrich. *Das Abstrakte Kabinett.* Hannover: Hannover Landesgalerie, 1968.

Lissitzky, El. *El Lissitzky: Life, Letters, Texts.* Ed. Sophie Lissitzky-Küppers. London: Thames and Hudson, 1980. Introduction by Herbert Read.

Lissitzky, El. *El Lissitzky's First Kestner Portfolio, 1923.* Rotterdam: Van Hezik-Fonds, 1992. Originally published as *10. Kestnermappe-Proun.* Hannover: Verlag Ludwig Ey-Hannover, 1923.

Mansbach, Steven. *Visions of Totality: László Moholy-Nagy, Theo van Doesburg, and El Lissitzky.* Ann Arbor, Mich.: UMI Research Press, 1980.

Margolin, Victor. *The Struggle for Utopia: Rodchenko, Lissitzky, Moholy-Nagy: 1917–1946.* Chicago: University of Chicago Press, 1997.

Nisbet, Peter, ed. *El Lissitzky: 1890–1941: Retrospektive.* Hannover: Sprengel Museum; Frankfurt am Main and Berlin: Propyläen, 1988. Additional texts by Christian Grohn, Kai-Uwe Hemken, Walter Kambartel, and Norbert Nobis. Exhibition catalogue.

Richter, Horst. *El Lissitzky: Sieg über die Sonne: zur Kunst des Konstruktivismus.* Cologne: Verlag Galerie Christophe Czwiklitzer, 1958.

Allan McCollum

Allan McCollum. Frankfurt am Main: Portikus; Amsterdam: De Appel; Cologne: Buchhandlung Walther König, 1988. Text by Andrea Fraser and Ulrich Wilmes. Exhibition catalogue.

Allan McCollum. Eindhoven: Stedelijk van Abbemuseum, 1989. Texts by Anne Rorimer, Lynne Cooke, and Selma Klein-Essink. Exhibition catalogue.

Allan McCollum. Hannover: Sprengel Museum, 1996. Text by Dietmar Elger. Exhibition catalogue.

Allan McCollum. Los Angeles: A.R.T. Press, 1996. Interview by Thomas Lawson.

Allan McCollum: Surrogates. London: Lisson Gallery, 1985. Text by Craig Owens. Exhibition catalogue.

Damaged Goods: Desire and the Economy of the Object. New York: The New Museum of Contemporary Art, 1986.

Fraser, Andrea. "Individual Works." *Faces*, no. 9 (spring 1988): 26–29.

Gudis, Catherine, ed. *A Forest of Signs: Art in the Crisis of Representation*. Los Angeles: The Museum of Contemporary Art, in association with Cambridge, Mass., and London: The MIT Press, 1989.

Halley, Peter, and Roberta Smith. *Beyond Boundaries: New York's New Art*. New York: Alfred van der Marck Editions, 1986.

Jinker-Lloyd, Amy. "Musings on Museology." *Art in America* 71, no. 8 (June 1992): 47–51.

Meinhardt, Johannes. "Ersatzobjekte und bedeutende Rahmen: Allan McCollum, Louise Lawler, Barbara Bloom." *Kunstforum International* 99 (March–April 1989): 200–20.

Owens, Craig. "Allan McCollum: Repetition and Difference." *Art in America* 71, no. 8 (September 1983): 130–32.

Plagens, Peter. "The Decline and Rise of Younger Los Angeles Art." *Artforum* 10, no. 9 (May 1972): 72–81.

Wallis, Brian. *Art after Modernism: Rethinking Representation*. Boston: David Godine, 1985.

Christian Milovanoff

Arrouye, Jean. "Déplacements Muséographique." *Impressions du Sud* (Aix-en-Provence, France), no. 14 (Autumn 1986): 62.

Christian Milovanoff: Le Jardin, 1948–1993. Saint-Etienne: Musée d'Art Moderne Saint-Etienne, 1994. Texts by Jacques Beauffet, Bernard Ceysson, and Martine Dancer. Exhibition catalogue.

Ethique, Esthétique, Politique. Arles: Actes Sud, 1997. Exhibition catalogue.

Le Louvre revisité: Christian Milovanoff. Paris: Contrejour, 1992. Preface by Jean-François Chevrier.

Pittolo, Véronique. "Christian Milovanoff at Galerie Michèle Chomette, Paris." *Art Press* (Paris), no. 107 (October 1986): 76.

Sztulman, Paul. "The Lonely Voice." *Galeries Magazine*, no. 58 (February–March 1994): 51–52, 112.

Vik Muniz

Aletti, Vince. "Organized Confusion: Vik Muniz Constructs Perceptual Timebombs." *The Village Voice*, December 2, 1997, p. 38.

Bonetti, David. "The Inevitability of Vik Muniz." *The San Francisco Examiner*, April 6, 1990.

Grundberg, Andy. "Sweet Illusions." *Artforum* 36, no. 1 (September 1997): 102–07.

Katz, Vincent. "The Cunning Artificer: An Interview with Vik Muniz." *On Paper* 1, no. 4 (March–April 1997): 26–31.

Leffingwell, Edward. "Through a Brazilian Lens." *Art in America* 86, no. 4 (April 1998): 78–85.

Muniz, Vik. "The Unbearable Likeness of Being." *Parkett* 40 (1994): 136–39.

Vik Muniz. New York: Stux Gallery, 1990. Text by Joshua Decter. Exhibition catalogue.

Vik Muniz: Equivalents. Verona: Galleria Ponte Pietra, 1992. Text by Richard Milazzo. Exhibition catalogue.

Vik Muniz: Seeing Is Believing. Santa Fe, N.M.: Arena Editions, 1998. Introduction by Charles Ashley Stainbeck; text by Mark Alice Durant; interview by Stainbeck. Exhibition catalogue for an exhibition at the International Center of Photography, New York.

Claes Oldenburg

Baro, Gene. *Claes Oldenburg: Drawings and Prints*. New York: Paul Bianchini; London and New York: Chelsea House, 1969.

Bronson, AA, and Peggy Gale, eds. *Museums by Artists*. Toronto: Art Metropole, 1983.

Claes Oldenburg: An Anthology. New York: Solomon R. Guggenheim Museum; Washington, D.C.: The National Gallery of Art, 1995. Texts by Germano Celant, Dieter Koepplin, and Mark Rosenthal. Exhibition catalogue.

Coplans, John. "The Artist Speaks: Claes Oldenburg." *Art in America* 57, no. 2 (March 1969): 68–75.

Henri, Adrian. *Total Art: Environments, Happenings, and Performance*. New York: Frederick A. Praeger, 1974.

Hughes, Robert. "Magician, Clown, Child." *Time* (February 21, 1972): 60–63.

Krim, Seymour. "An Art for Downtown Persons." *The Village Voice*, March 23, 1960, pp. 4, 6.

Lippard, Lucy, ed. *Pop Art*. New York and Washington, D.C.: Frederick A. Praeger, 1966.

Maus Museum: Eine Auswahl von Objekten gesammelt von Claes Oldenburg/Mouse Museum: A Selection of Objects Collected by Claes Oldenburg. Kassel: Documenta, 1972. Text by Kasper König. Supplement to *Documenta 5* exhibition catalogue.

The Mouse Museum—The Ray Gun Wing: Two Collections/Two Buildings. Chicago: Museum of Contemporary Art, 1977. Introduction by Judith Russi Kirshner. Exhibition catalogue.

Oldenburg, Claes. *Ray Gun Poems*. New York: Judson Gallery, 1960.

———. "A Statement." In *Happenings: An Illustrated Anthology*. Ed. Michael Kirby. New York: E.P. Dutton, 1965.

———. *Store Days: Documents from The Store (1961) and Ray Gun Theater (1962)*. New York: Something Else Press, 1967.

———. "Claes Oldenburg Collecting Ray Guns in New York." *Vision* (Oakland), no. 3 (November 1976): 22–25.

Restany, Pierre. "Une Personnalité charnière de l'art américain: Claes Oldenburg, premières oeuvres." *Metro* (Milan), no. 9 (March–April 1965): 20–26.

Rose, Barbara. *Claes Oldenburg*. New York: The Museum of Modern Art, 1969. Additional text by Oldenburg. Exhibition catalogue.

———. "Claes Oldenburg's Soft Machines." *Artforum* 5, no. 10 (summer 1967): 30–35.

Siegel, Jeanne. "How to Keep Sculpture Alive In and Out of a Museum: An Interview with Claes Oldenburg on His Retrospective Exhibition at The Museum of Modern Art." *Arts Magazine* 44, no.1 (September–October 1969): 24–28.

Schimmel, Paul. *Out of Actions: Between Performance and the Object, 1949–1979*. Los Angeles: The Museum of Contemporary Art; New York: Thames and Hudson, 1998.

Van Bruggen, Coosje. *Claes Oldenburg: Mouse Museum/Ray Gun Wing*. Cologne: Museum Ludwig, 1979. Exhibition catalogue.

Varnedoe, Kirk, and Adam Gopnik. *High and Low: Modern Art and Popular Culture*. New York: The Museum of Modern Art, 1990. Exhibition catalogue.

Dennis Oppenheim

Beardsley, John. *Earthworks and Beyond: Contemporary Art in the Landscape*. New York: Abbeville Press, 1984.

Blurring the Boundaries: Installation Art 1969–1996. La Jolla, Calif.: San Diego Museum of Contemporary Art, 1997. Texts by Hugh M. Davies and Ronald J. Onorato. Exhibition catalogue.

Bourgeois, Jean-Louis. "Dennis Oppenheim." *Artforum* 8, no. 2 (October 1969): 34–38.

Dennis Oppenheim. Brussels: Société des Expositions du Palais des Beaux-Arts, 1975. Texts by Jean-Pierre van Tieghem and Vincent Baudoux. Exhibition catalogue.

Dennis Oppenheim. Milan: Edizioni Charta, in association with La Biennale di Venezia, 1997. Texts by Germano Celant and Oppenheim. Exhibition catalogue.

Heiss, Alanna. *Dennis Oppenheim: Selected Works, 1967–90: And the Mind Grew Fingers*. New York: P.S. 1, Institute for Contemporary Art, and Harry N. Abrams, 1991. Introduction and interview by Heiss; text by Thomas McEvilley. Exhibition catalogue.

Land Art: Fernsehgalerie Gerry Schum, Television Gallery. Hannover: Druck Hartwig Popp, 1970. Texts by Ursula Wevers and Gerry Schum. Exhibition catalogue.

L'Empreinte. Paris: Musée national d'art moderne, Centre Georges Pompidou, 1997. Text by Georges Didi-Huberman. Exhibition catalogue.

McShine, Kynaston, ed. *Information*. New York: The Museum of Modern Art, 1970. Text by McShine; artists statements. Exhibition catalogue.

Reconsidering the Object of Art: 1965–75. Los Angeles: The Museum of Contemporary Art, 1995. Introduction by Ann Goldstein and Anne Rorimer; texts by Goldstein, Susan L. Jenkins, Lucy R. Lippard, Stephen Melville, Rorimer, and Jeff Wall. Exhibition catalogue.

Sharp, Willoughby. "An Interview with Dennis Oppenheim." *Studio International* (London) 182, no. 983 (November 1971): 186–93.

Tiberghien, Gilles A. *Land Art*. Paris: Carré, 1993.

Charles Willson Peale

Brigham, David R. *Public Culture in the Early Republic: Peale's Museum and Its Audience*. Washington, D.C.: Smithsonian Institution Press, 1995.

———. *A World in Miniature: Charles Willson Peale's Philadelphia Museum and Its Audience, 1788–1827*. Philadelphia: University of Pennsylvania, 1992. Ph. D. dissertation.

Fortune, Brandon Brame. *Charles Willson Peale's Portrait Gallery: Persuasion and the Plain Style*. London: Word and Image, 1990.

Miller, Lillian B., ed. *The Peale Family: Creation of a Legacy, 1770–1870*. New York: Abbeville Press; Washington, D.C.: Trust for Museum Exhibitions and the National Portrait Gallery, Smithsonian Institution, 1996. Exhibition catalogue.

———, and David C. Ward, eds. *New Perspectives on Charles Willson Peale: A 250th Anniversary Celebration*. Pittsburgh: University of Pittsburgh Press; Washington, D.C.: Smithsonian Institution, 1991.

Neff, Terry A., ed. *A Proud Heritage: Two Centuries of American Art: Selections from the Collections of the Pennsylvania Academy of the Fine Arts, Philadelphia and the Terra Museum of American Art, Chicago*. Chicago: Terra Museum of American Art, 1987. Texts by D. Scott Atkinson, Linda Bantel, Judith Russi Kirshner, Elizabeth Milroy, and Michael Sanden. Exhibition catalogue.

Sacco, Ellen. "Racial Theory/Museum Practice: The Colored World of Charles Willson Peale." *Museum Anthropology* (Arlington, Va.) 20, no. 2 (fall 1996): 25–32.

Sellers, Charles Coleman. *Mr. Peale's Museum: Charles Willson Peale and the First Popular Museum of Natural History*. New York: W. W. Norton, 1980.

———. *Peale's Museum and "The New Museum Idea."* Philadelphia: American Philosophical Society, 1980.

Stewart, Susan. "Death and Life, in That Order, in the Works of Charles Willson Peale." In *Visual Display: Culture Beyond Appearances*. Eds. Lynne Cooke and Peter Wollen. Seattle: Bay Press, 1995.

Hubert Robert

Boulot, Catherine. *Hubert Robert et la revolution*. Valence: Musée de Valence, 1989. Exhibition catalogue.

Boyer, Ferdinand. *Hubert Robert dans les prisons de la Terreur*. Paris: Armand Colin, 1963.

Cayeux, Jean de. *Hubert Robert*. Paris: Fayard, 1989.

Copier créer: de Turner à Picasso: 300 oeuvres inspirées par les maîtres du Louvre. Paris: Editions de la Réunion des musées nationaux, 1993.

Dombrowski, Daniela. *Hubert Robert's Paintings of the Louvre: Studies of Gender and Institutions in Revolutionary France*. Eugene: University of Oregon, 1993. Ph. D. dissertation.

Hubert Robert: The Pleasure of Ruins. New York: Wildenstein and Co., 1988. Introduction by Georges Bernier. Exhibition catalogue.

McClellan, Andrew. *Inventing the Louvre: Art, Politics, and the Origins of the Modern Museum in Eighteenth Century Paris*. Cambridge, England: Cambridge University Press, 1994.

Radisich, Paula Rea. *Hubert Robert: Painted Spaces of the Enlightenment*. Cambridge and New York: Cambridge University Press, 1998.

Robert, Hubert. *Un Album de Croquis d'Hubert Robert, 1733–1808*. Paris: Galerie Cailleux, 1979.

Sahut, Marie-Catherine. *Le Louvre d'Hubert Robert*. Paris: Éditions de la Réunion des musées nationaux, 1979. Additional text by Nicole Garnier. Exhibition catalogue.

Edward Ruscha

Alloway, Lawrence. "HiWay Culture: Man at the Wheel." *Arts* 41 (February 1967): 28–33.

Antin, Eleanor. "Reading Ruscha." *Art in America* 61, no. 6 (November–December 1973): 64–71.

Bois, Yve-Alain. *Edward Ruscha: Romance with Liquids: Paintings 1966–1969*. New York: Rizzoli, 1993. Interview by Walter Hopps.

Clearwater, Bonnie, and Christopher Knight. *Edward Ruscha: Words Without Thoughts Never to Heaven Go*. Lake Worth, Fla.: Lannan Museum, 1988. Exhibition catalogue.

Coplans, John. "Concerning 'Various Small Fires': Edward Ruscha Discusses His Perplexing Publications." *Artforum* 3, no. 5 (February 1965): 24–25.

Edward Ruscha: Books and Prints. Santa Cruz: Mary Porter Senson Gallery, University of California, 1972. Texts by Nan R. Piene and Marcia R. McGrath. Exhibition catalogue.

Lippard, Lucy, ed. *Pop Art*. New York and Washington, D.C.: Frederick A. Praeger, 1966.

———. *Six Years: The Dematerialization of the Art Object from 1966 to 1972*. Berkeley: University of California Press, 1997.

Marshall, Richard. *Edward Ruscha: Los Angeles Apartments, 1965*. New York: Whitney Museum of American Art, 1990.

McShine, Kynaston, ed. *Information*. New York: The Museum of Modern Art, 1970. Text by McShine; artists statements. Exhibition catalogue.

Reconsidering the Object of Art: 1965–75. Los Angeles: The Museum of Contemporary Art, 1995.

Schjeldahl, Peter. *Edward Ruscha: Stains 1971 to 1975*. New York: Robert Miller Gallery, 1992. Exhibition catalogue.

The Works of Edward Ruscha: San Francisco: San Francisco Museum of Modern Art, in association with New York: Hudson Hills Press, 1982. Introduction by Anne Livet; texts by Dave Hickey and Peter Plagens. Exhibition catalogue.

David Seymour
Capa, Cornell, ed. *David Seymour—"Chim."* New York: Grossman Publishers, 1974.

Bondi, Inge. *Chim: The Photographs of David Seymour*. Boston and New York: Little, Brown and Co.; New York: International Center of Photography, 1996. Foreword by Cornell Capa; introduction by Henri Cartier-Bresson. Exhibition catalogue.

David Seymour Chim: The Early Years, 1933–1939. New York: International Center of Photography, 1986. Exhibition catalogue.

Farova, Anna, ed. *David Seymour—"Chim."* New York: Grossman Publishers, 1966.

Gunther, Thomas Michael. *Alliance Photo: Agence Photographique 1934–1940*. Paris: Bibliothèque Historique de la Ville de Paris, 1988. Exhibition catalogue.

Soria, George. *Robert Capa, David Seymour—Chim: les grandes photos de la guerre d'Espagne*. Paris: Éditions Jannick, 1980.

Robert Smithson
Beardsley, John. *Earthworks and Beyond: Contemporary Art in the Landscape*. New York: Abbeville Press, 1984.

———. *Probing the Earth: Contemporary Land Projects*. Washington, D.C.: Smithsonian Institution Press, 1978. Exhibition catalogue.

Bremser, Sarah E. "Mono Lake Non-Site (Cinders Near Black Point)." In *San Diego Museum of Contemporary Art: Selections from the Permanent Collection*. La Jolla, Calif.: San Diego Museum of Contemporary Art, 1990. Exhibition catalogue.

Land Art: Fernsehgalerie Gerry Schum, Television Gallery. Hannover: Druck Hartwig Popp, 1970. Texts by Ursula Wevers and Gerry Schum. Exhibition catalogue.

Lippard, Lucy R. *Overlay: Contemporary Art and the Art of Prehistory*. New York: Pantheon Books, 1983.

McShine, Kynaston, ed. *Information*. New York: The Museum of Modern Art, 1970. Text by McShine; artists statements. Exhibition catalogue.

Owens, Craig. "Earthwords." In *Beyond Recognition: Representation, Power and Culture*, Eds. Scott Bryson, Barbara Kruger, Lynne Tillman, and Jane Weinstock. Berkeley: University of California Press, 1992.

Reconsidering the Object of Art: 1965–75. Los Angeles: The Museum of Contemporary Art, 1995.

"Robert Smithson: Hotel Palenque, 1969–72." *Parkett* 43 (1995): 117–32. Insert.

Robert Smithson: Sculpture. Ithaca, New York: Herbert F. Johnson Museum of Art, Cornell University Press, 1980. Introduction by Robert Hobbs; texts by Lawrence Alloway, John Coplans, and Lucy R. Lippard. Exhibition catalogue.

Robert Smithson: Une Rétrospective, Le Paysage Entropique: 1960–1973. Valencia: IVAM, Centre Julio Gonzalez; Brussels: Palais des Beaux-Arts; Marseilles: MAC, galeries contemporaines des Musées de Marseilles, 1993. Texts by Marianne Brouwer, Jean-Pierre Criqui, Maggie Gilchrist, Kay Larson, and James Lingwood. Exhibition catalogue.

Robert Smithson: Zeichnungen aus dem Nachlass/Drawings from the Estate. Münster: Westfälisches Landesmuseum für Kunst und Kulturgeschichte, 1989. Preface by Klaus Bussmann, Christian Gether, and Michael Tacke; interview with Dan Graham by Eugenie Tsai; texts by Tsai, Eva Schmidt, Dieter Meschede, and Friedrich Meschede. Exhibition catalogue.

Robert Smithson's Partially Buried Woodshed. Kent, Ohio: School of Art, Kent State University, 1990. Text by Dorothy Shinn. Exhibition catalogue.

Shapiro, Gary. *Earthwards: Robert Smithson and Art after Babel*. Berkeley: University of California Press, 1995.

Smithson, Robert. *The Writings of Robert Smithson*. Ed. Nancy Holt. New York: New York University Press, 1979. Introduction by Philip Leider.

Tiberghien, Gilles A. *Land Art*. Paris: Carré, 1993.

Tsai, Eugenie. *Robert Smithson Unearthed: Drawings, Collages, Writings*. New York: Miriam and Ira D. Wallach Art Gallery, Columbia University and Columbia University Press, 1991. Introduction by Johanna Drucker. Exhibition catalogue.

———. "The Unknown Smithson." *Arts Magazine* 60, no. 7 (March 1986): 33–35.

Thomas Struth
Une autre objectivité/Another Objectivity. Paris: Centre national des arts plastiques; Prato, Italy: Centro per l'Arte Contemporanea Luigi Pecci, in association with Milan: Idea Books, 1989. Texts by Jean-François Chevrier and James Lingwood. Exhibition catalogue.

Das Bild der Ausstellung/The Image of the Exhibition. Vienna: Hochschule für angewandte Kunst, 1993. Introduction by Markus Brüderlin; texts by Brüderlin, Wolfgang Kemp, Lucius Burckhardt, Guido Mangold, Ulf Wuggenig, and Vera Kockot. Exhibition catalogue.

Butler, Susan. "The Mise-en-Scène of the Everyday." *Art and Design* 10, nos. 9/10 (September–October 1995): 16–23.

Batkin, Norton. "The Museum Exposed." In *Exhibited*. Annandale-on-Hudson, N.Y.: Bard College, Center for Curatorial Studies, 1994. Exhibition catalogue.

Bryson, Norman. "Not Cold, Not Too Warm: The Oblique Photography of Thomas Struth." *Parkett* 50/51 (December 1997): 156–65.

Invisible Cities. Leeds: Leeds City Art Gallery, 1989. Exhibition catalogue.

Loock, Ulrich. "Thomas Struth: 'Unconscious Places.'" *Parkett* 23 (spring 1990): 28–31.

Reust, Hans Rudolf. "Backdrop." *Artscribe International* (London), no. 68 (March–April 1988): 56–59.

Stack, Trudy Wilner. *Art Museum: Sophie Calle, Louise Lawler, Richard Misrach, Diane Neumaier, Richard Ross, Thomas Struth*. Tucson, Az.: Center for Creative Photography/University of Arizona, 1995. Exhibition catalogue.

Thomas Struth: Landschaften: Photographien 1991–1993. Düsseldorf: Achenbach Kunsthandel; Berlin: Galerie Max Hetzler, 1994. Exhibition catalogue.

Thomas Struth: Museum Photographs. Munich: Schirmer/Mosel Verlag; Hamburg: Hamburger Kunsthalle, 1993. Text by Hans Belting. Exhibition catalogue.

Thomas Struth: Portraits. New York: Marian Goodman Gallery, 1990. Interview with Benjamin H.D. Buchloh. Exhibition catalogue.

Thomas Struth: Portraits. Munich: Schirmer/Mosel Verlag; Hannover: Sprengel Museum, 1997. Exhibition catalogue.

Thomas Struth, Strangers and Friends: Photographs 1986–1992. London: Institute of Contemporary Arts; Toronto: Art Gallery of Ontario; Boston: The Institute of Contemporary Art; Munich: Schirmer/Mosel Verlag; Cambridge, Mass.: The MIT Press, 1994. Text by Richard Sennett. Exhibition catalogue.

Thomas Struth, Straßen: Photografie 1976 bis 1995. Bonn: Kunstmuseum Bonn; Cologne: Wienand Verlag, 1995. Foreword by Dieter Ronte; essays by Christoph Schreier, Stefan Gronert, and Rupert Pfab. Exhibition catalogue.

Hiroshi Sugimoto

Bonami, Francesco. "Hiroshi Sugimoto: Zen Marxism." *Flash Art* 27, no.180 (January–February 1995): 71–73.

Bryson, Norman. "Sugimoto's Metabolic Photography." *Parkett* 46 (May 1996): 120–24.

Kellein, Thomas. *Hiroshi Sugimoto: Time Exposed.* Stuttgart: Edition Hansjörg Mayer; New York and London: Thames and Hudson, 1995. Text and interview by Kellein.

Kuspit, Donald. "Hiroshi Sugimoto." *Artforum* 22, no. 3 (November 1988): 139.

Munroe, Alexandra, ed. *Contemporary Japanese Art in America.* New York: Japan Society, 1987. Exhibition catalogue.

Photographs by Hiroshi Sugimoto: Dioramas, Theaters, Seascapes. New York: Sonnabend Gallery; Tokyo: Zeito Photo Salon, 1988. Introduction by Atsuko Koyanagi. Exhibition catalogue.

Rugoff, Ralph. "Half Dead." *Parkett* 46 (1996): 132–37.

Sugimoto. Madrid: Fundación "La Caixa," 1998. Introduction by Luis Monreal; interview by Helena Tatay Huici; texts by Peter Hay Halpert, Jacinto Lageira, Kerry Brougher, and John Yau. Exhibition catalogue.

Yau, John. "Hiroshi Sugimoto: No Such Thing as Time." *Artforum* 23 (April 1984): 48–52.

Charles Thurston Thompson

Fontanella, Lee. *Charles Thurston Thompson: e o proxecto fotográfico ibérico.* La Coruña, Spain: Centro Galego de Artes da Imaxe-Xunta de Galicia, 1996.

Hamber, Anthony. *A Higher Branch of the Art: Photographing the Fine Arts in England, 1839–1880.* London: Gordon and Breach Publishers; Amsterdam: Overseas Publishers Association, 1996.

Haworth-Booth, Mark, and Anne McCauley. *The Museum and the Photograph: Collecting Photography at the Victoria and Albert Museum 1853–1900.* Williamstown, Mass.: Sterling and Francine Clark Art Institute, 1998. Exhibition catalogue.

Jacobson, Ken, and Jenny Jacobson. *Étude d'Après Nature: 19th Century Photographs in Relation to Art.* Great Bardfield, England: Ken and Jenny Jacobson, 1996. Additional text by Anthony Hamber.

Physick, John Frederick. *Photography and the South Kensington Museum.* London: Victoria & Albert Museum, 1975.

Stephen Thompson

Hamber, Anthony. *A Higher Branch of the Art: Photographing the Fine Arts in England, 1839–1880.* London: Gordon and Breach Publishers; Amsterdam: Overseas Publishers Association, 1996.

Howitt, William. *Ruined Abbeys and Castles of Great Britain and Ireland. Second series, by William Howitt; The photographic illustrations by Thompson, Sedgfield, Ogle, and Hemphill.* London: Alfred W. Bennett, 1864.

Jacobson, Ken, and Jenny Jacobson. *Étude d'Après Nature: 19th Century Photographs in Relation to Art.* Great Bardfield, England: Ken and Jenny Jacobson, 1996. Additional text by Anthony Hamber.

The Kiss of Apollo: Photography and Sculpture, 1845 to the Present. San Francisco: Fraenkel Gallery, in association with Bedford Arts, Publishers, 1991. Introduction by Jeffrey Fraenkel; text by Eugenia Parry Janis. Exhibition catalogue.

Thompson, Stephen. *A Catalogue of a Series of Photographs (by S. Thompson) from the Collections in the British Museum.* W. A. Mansell & Co., 1872. Introduction by Charles Harrison.

———. *Masterpieces of Antique Art: Twenty-Five Examples in Permanent Photography from the Celebrated Collections in the Vatican, The Louvre, and the British Museum.* London: Griffith and Farren, 1878.

———. *Old English Homes: A Summer's Sketch-book, by Stephen Thompson.* London: Sampson Low, Marston, Low and Searle, 1876.

———. *Studies from Nature, by Stephen Thompson.* London: Sampson Low, Marston, Low, and Searle, 1875.

Waring, John Burley. *Masterpieces of Industrial Art and Sculpture at the International Exhibition, 1862. Selected and described by J.B. Waring…Chromolithographed by and under the direction of W.R. Tymms, A. Warren, and G. Macculloch, from photographs supplied by the London photographic society and stereoscopic company, taken exclusively for this work by Stephen Thompson.* London: Day & son, 1863.

Jeff Wall

Ammann, Jean-Christophe, and Ian Wallace. *Jeff Wall: Transparencies.* London: Institute of Contemporary Arts; Basel: Kunsthalle Basel, 1984. Text by Wallace; interview by Els Barent. Exhibition catalogue.

Une autre objectivité / Another Objectivity. Paris: Centre national des arts plastiques; Prato, Italy: Centro per l'Arte Contemporanea Luigi Pecci; Milan: Idea Books, 1989. Texts by Jean-François Chevrier and James Lingwood. Exhibition catalogue.

Crow, Thomas. "Profane Illuminations: Social History and the Art of Jeff Wall." *Artforum* 31, no. 5 (February 1993): 62–69.

De Duve, Thierry, Arielle Pélenc, and Boris Groys. *Jeff Wall.* London: Phaidon Press, 1996. Texts by de Duve, Groys, Franz Kafka, and Blaise Pascal; interview by Pélenc; artist's writings.

Jeff Wall. Los Angeles: The Museum of Contemporary Art; Zurich and New York: Scalo, 1997. Text by Kerry Brougher. Exhibition catalogue.

Jeff Wall: Restoration. Lucerne: Kunstmuseum Luzern; Düsseldorf: Kunsthalle Düsseldorf, 1994. Interview by Martin Schwander; texts by Schwander and Arielle Pélenc. Exhibition catalogue.

McShine, Kynaston, ed. *Information.* New York: The Museum of Modern Art, 1970. Text by McShine; artists statements. Exhibition catalogue.

Muir, Gregor. "The Epic and the Everyday at the Hayward Gallery, London." *Flash Art* 27, no. 178 (October 1994): 93.

Pélenc, Arielle. "Jeff Wall: Excavation of the Image." *Parkett* 22 (December 1989): 78–84.

Public Information: Desire, Disaster, Document. San Francisco: San Francisco Museum of Modern Art, 1995. Text by Gary Garrells. Exhibition catalogue.

Gillian Wearing

Barrett, David. "Gillian Wearing at the Hayward Gallery, London." *Art Monthly* (London), no. 191 (November 1995): 28–30.

Gibbs, Michael. "ID—An International Survey on the Notion of Identity in Contemporary Art." *Art Monthly* (London), no. 203 (February 1997): 26–27.

Gillian Wearing. Vienna: Weiner Secession, 1997. Exhibition catalogue.

Gillian Wearing. London: Phaidon Press, 1999. Texts by Russell Ferguson, Donna de Salvo, and John Sluce.

Judd, Ben. "Gillian Wearing Interviewed." *Untitled* (London), no. 12 (winter 1996–97): 4–5.

Miles, Anna. "Pictura Brittanica: Te Papa Museum, Tongewara." *Artforum* 36, no. 10 (summer 1998): 144.

Muir, Gregor. "Sign Language." *Dazed and Confused* 25 (December 1996): 52–55.

Searle, Adrian. "Gillian Wearing." *Frieze* 18 (September–October 1994): 61–62.

Sensation: Young British Artists from the Saatchi Collection. London: Thames and Hudson, in association with the Royal Academy of Arts, 1997. Texts by Norman Rosenthal, Richard Stone, Martin Maloney, Brooks Adams, and Lisa Jardine. Exhibition catalogue.

Wearing, Gillian. *Signs That Say What You Want Them To Say and Not What Someone Else Wants You To Say.* London: Maureen Paley/Interim Art, 1997.

Williams, Gilda. "Gillian Wearing: New Work." *Art Monthly* (London), no. 203 (February 1997): 26–27.

Williams, Gilda. "Wah-Wah: The Sound of Crying or the Sound of an Electric Guitar." *Parkett* 52 (May 1998): 146–50.

———. "Wearing Well." *Art Monthly* (London), no. 184 (March 1995): 24–26.

Christopher Williams
The Art of Memory/The Loss of History. New York: The New Museum of Contemporary Art, 1985. Texts by William Olander, David Deitcher, and Abigail Solomon-Godeau. Exhibition catalogue.

Christopher Williams. Tokyo: Person's Weekend Museum, 1993. Text by Raoul Coutard.

Christopher Williams. Rotterdam: Museum Boijmans Van Beuningen, 1997. Exhibition catalogue.

Deitcher, David. "Angola to Vietnam: Unnatural Selection." *Visions* (West Hollywood, Calif.) 3, no. 1 (winter 1988): 24–25.

Gardner, Colin. "Christopher Williams and the Loss of History." *Artspace* 15, no. 6 (fall 1991): 68–71.

Gudis, Catherine, ed. *A Forest of Signs: Art in the Crisis of Representation.* Los Angeles: The Museum of Contemporary Art; Cambridge, Mass., and London: The MIT Press, 1989. Texts by Ann Goldstein, Anne Rorimer, and Howard Singerman. Exhibition catalogue.

———. *Oehlen Williams 95.* Columbus, Ohio: Wexner Center for the Arts, The Ohio State University, 1995. Texts by Thomas Crow, Diedrich Diederichsen, Timothy Martin, Stephen Melville, Friedrich Petzel. Exhibition catalogue.

Martin, Timothy. "Undressing the Institutional World." *Fame & Fortune Bulletin* (Fall 1995).

Weissman, Benjamin. "Christopher Williams' Dark Green Thumb." *Artforum* 28, no. 7 (March 1990): 132–36.

Williams, Christopher. *Angola to Vietnam★.* Ghent: Imschoot, Uitgevers Voor IC, 1989.

Wittgenstein and the Art of the 20th Century. Vienna: Wiener Secession; Brussels: Palais des Beaux-Arts, 1988. Texts by Chris Bezzel, Gabriele Hammel-Haider, and Joseph Kosuth. Exhibition catalogue.

Fred Wilson
Buskirk, Martha. "Interviews with Sherrie Levine, Louise Lawler, and Fred Wilson." *October* 70 (fall 1994): 109–12.

Cocido y Crudo. Madrid: Museo Nacional Centro de Arte Reina Sofia, 1994. Texts by Jerry Saltz, Mar Villaespesa, Gerardo Mosquera, Jean Fisher, and Dan Cameron. Exhibition catalogue.

Coles, Robert. "Whose Museums?" *American Art* (New York and Washington, D.C.) 6, no. 1 (winter 1992): 6–11.

Cooke, Lynne, and Peter Wollen, eds. *Visual Display: Culture Beyond Appearances.* New York: Dia Center for the Arts; Seattle: Bay Press, 1995.

Corrin, Lisa G., ed. *Mining the Museum: An Installation by Fred Wilson.* Baltimore, Maryland: The Maryland Historical Society, and New York: The New Press, 1994. Additional texts by Ira Berlin; interview by Leslie King-Hammond. Exhibition catalogue.

Garfield, Donald. "Making the Museum Mine: An Interview with Fred Wilson." *Museum News* 72, no. 3 (May–June 1994): 46–49, 90.

Insight: In Site: In Sight: Incite—Memory: Artist and the Community: Fred Wilson. Winston-Salem, N.C.: Southeastern Center for Contemporary Art, 1994. Introduction by Susan Lubowsky; texts by John C. Larson and Jeff Fleming. Exhibition catalogue.

Kimmelman, Michael. "An Improbable Marriage of Artist and Museum." *The New York Times,* August 2, 1992, p. 27.

Kuspit, Donald. "The Magic Kingdom of the Museum." *Artforum* 30, no. 8 (April 1992): 58–63.

The Museum, Mixed Metaphors: Fred Wilson. Seattle: Seattle Art Museum, 1993. Text by Patterson Sims. Exhibition catalogue.

Wilson, Fred. "Mining the Museum." *Grand Street* 44, no. 4 (1993): 151–72.

Garry Winogrand
The Animals. New York: The Museum of Modern Art, 1969. Afterword by John Szarkowski.

Karmel, Pepe. "Garry Winogrand: Public Eye." *Art in America* 69, no. 9 (November 1981): 39–41.

Lifson, Ben. "Winogrand: De Tocqueville with a Camera." *The Village Voice,* November 7, 1977, p. 74.

The Man in the Crowd: The Uneasy Streets of Garry Winogrand. San Francisco: Fraenkel Gallery, 1999. Exhibition catalogue.

Public Relations. New York: The Museum of Modern Art, 1977. Introduction by Tod Papageorge. Exhibition catalogue.

Szarkowski, John. *Winogrand: Figments from the Real World.* New York: The Museum of Modern Art, 1988. Text by Szarkowski. Exhibition catalogue.

Winogrand, Garry. "A Photographer Looks at Evans." *Walker Evans: Photographs from "Let Us Now Praise Famous Men" Project.* Austin: University of Texas Press, 1974.

Women Are Beautiful. New York: Light Gallery Books, 1975. Text by Helen Gary Bishop. Exhibition catalogue.

Donald Judd. *Bench # 76 / 77*. 1976–77. Birch plywood, 39 ⅜ x 39 ⅜ x 78 ¾"
(100 x 100 x 200 cm). Courtesy PaceWildenstein, New York.

Lenders to the Exhibition

Stedelijk Museum, Amsterdam
Marieluise Hessel Collection, Center for
 Curatorial Studies, Bard College,
 Annandale-on-Hudson, New York
The Royal Photographic Society, Bath
Museum of Fine Arts, Boston
Busch-Reisinger Museum, Harvard University
 Art Museums, Cambridge, Massachusetts
Stedelijk van Abbemuseum, Eindhoven
Sprengel Museum, Hannover
The Menil Collection, Houston
The Louisiana Museum of Modern Art, Humlebaek,
 Denmark
Tate Gallery, London
Victoria & Albert Museum, London
The Museum of Contemporary Art, Los Angeles
Kunstmuseum Luzern
Solomon R. Guggenheim Museum, New York
The Museum of Modern Art, New York
Musée du Louvre, Paris
Pennsylvania Academy of the Fine Arts, Philadelphia
Fonds National d'Art Contemporain, Ministère de la
 culture et de la communication, Paris
Museum of Contemporary Art, San Diego
Art Gallery of Ontario, Toronto
Museum Moderner Kunst Stiftung Ludwig, Vienna
Hirshhorn Museum and Sculpture Garden,
 Smithsonian Institution, Washington, D.C.
National Museum of American Art, Washington D.C.
Kunsthaus Zürich

Vito Acconci, New York
Erik Andersch, Neuss, Germany
Eve Arnold, London
Michael Asher, Los Angeles
Lothar Baumgarten, New York
The Bohen Foundation, New York
Rudolf Bumiller, Stuttgart
Daniel Buren, Paris
Sophie Calle, Paris
Janet Cardiff, Lethbridge, Alberta
Henri Cartier-Bresson, Paris
Jan Dibbets, Amsterdam
Mark Dion, New York
Elliott Erwitt, New York
Wolfgang Feelisch, Remscheid

Larry Fink, Martin's Creek, Pennsylvania
Andrea Fraser, New York
Liesbeth Giesberger, Amsterdam
Howard Gilman Foundation, New York
Thomas Grässlin, St. Georgen
Charles Heilbronn, New York
Ydessa Hendeles, Toronto
Susan Hiller, London
Bente Hirsch, New York
Louise Lawler, New York
Joseph LeBon, Roeselare, Belgium
Mr. and Mrs. Robert Lehrman, Washington, D.C.
Zoe Leonard, New York
Sherrie Levine, New York
Cindy and Alan Lewin, courtesy Ronald Feldman,
 New York
Mr. and Mrs. Gene Locks
Nicholas and Caroline Logsdail, London
Allan McCollum, New York
Christian Milovanoff, Arles
Vik Muniz, New York
Dennis Oppenheim, New York
Marcel Ospel, Basel
The Over Holland Collection
Ben Shneiderman, Washington, D.C.
Gilbert and Lila Silverman, Detroit
Sandra Simpson, Toronto
Estate of Robert Smithson, courtesy John Weber Gallery,
 New York
Ronny Van de Velde, Antwerp
Fred Wilson, New York
Anonymous lenders

American Fine Arts Co., New York
Galerie Beaumont, Luxembourg
Richard L. Feigen & Co., New York
Fraenkel Gallery, San Fransisco
Marian Goodman Gallery, New York
Maureen Paley/Interim Art, London
Luhring Augustine Gallery, New York
Sonnabend Gallery, New York
Michael Werner Gallery, New York

Trustees of The Museum of Modern Art

Ronald S. Lauder
Chairman of the Board

Sid R. Bass
Donald B. Marron
Robert B. Menschel
Richard E. Salomon
Jerry I. Speyer
Vice Chairmen

Agnes Gund
President

John Parkinson III
Treasurer

David Rockefeller*
Chairman Emeritus

Mrs. Henry Ives Cobb*
Vice Chairman Emeritus

Edward Larrabee Barnes ★
Celeste Bartos ★
H.R.H. Duke Franz of Bavaria ★★
Mrs. Patti Cadby Birch ★★
Leon D. Black
Clarissa Alcock Bronfman
Hilary P. Califano
Thomas S. Carroll ★
Leo Castelli ★★
Patricia Phelps de Cisneros
Marshall S. Cogan
Mrs. Jan Cowles ★★
Douglas S. Cramer
Lewis B. Cullman ★★
Elaine Dannheisser
Gianluigi Gabetti
Paul Gottlieb
Vartan Gregorian
Mimi Haas
Mrs. Melville Wakeman Hall ★
George Heard Hamilton ★
Kitty Carlisle Hart ★★
S. Roger Horchow
Barbara Jakobson
Philip Johnson ★
Werner H. Kramarsky

Mrs. Henry R. Kravis
Mrs. Frank Y. Larkin ★
Dorothy C. Miller ★★
J. Irwin Miller ★
Mrs. Akio Morita
S. I. Newhouse, Jr.
Philip S. Niarchos
James G. Niven
Richard E. Oldenburg ★★
Michael S. Ovitz
Peter G. Peterson
Mrs. Milton Petrie ★★
Gifford Phillips ★
Emily Rauh Pulitzer
David Rockefeller, Jr.
Mrs. Robert F. Shapiro
Joanne M. Stern
Isabel Carter Stewart
Mrs. Donald B. Straus ★
Eugene V. Thaw ★★
Jeanne C. Thayer ★
Joan Tisch
Paul F. Walter
Thomas W. Weisel
Richard S. Zeisler ★

★Life Trustee
★★Honorary Trustee

Patty Lipshutz
Secretary

Ex Officio

Glenn D. Lowry
Director

Rudolph W. Giuliani
Mayor of the City of New York

Alan G. Hevesi
Comptroller of the City of New York

Jo Carole Lauder
*President of The International
Council*

Melville Straus
Chairman of The Contemporary

Photograph Credits

Photographs of works of art reproduced in this volume have been provided in most cases by the owners or custodians of the works, identified in the captions. Individual works of art appearing herein may be protected by copyright in the United States of America or elsewhere, and may thus not be reproduced in any form without the permission of the copyright owners. The following copyright and/or other photograph credits appear at the request of the artists, their heirs and representatives, and/or owners of the works.

Courtesy Vito Acconci: 171 left, center, and right, 173 (all).

David Allison: 148.

Courtesy American Fine Arts Co., New York: 99, 100 top.

Courtesy Erik Andersch: 133 top left and right, bottom left.

© Eve Arnold, Magnum Photos, Inc.: 38, 39.

Courtesy Galerie Bärbel Grässlin, Frankfurt: 112.

Lothar Baumgarten, courtesy the artist: 95 top and bottom, 96 top, center, and bottom, 97 top, center, and bottom.

Heinz Blezen, courtesy Claes Oldenburg and Coosje van Bruggen: 70 top.

© 1968, Christo, 126, 127.

© 1971, Christo and Landfall Press, Chicago, 125.

Courtesy Christiaan Braun: 88.

Courtesy AA Bronson: 175.

Courtesy Rudolf Bumiller, Stuttgart: 113.

© Daniel Buren: 151 top and bottom, 150.

Courtesy Busch-Reisinger Museum, Harvard University Art Museums, Cambridge, Mass.: 48 top left, top right, bottom left, and bottom right.

Courtesy Sophie Calle: 139 bottom.

© Henri Cartier-Bresson: 41, 42.

Courtesy Leo Castelli Photo Archives: 137 top and bottom, 139 top.

Courtesy Linda Cathcart Gallery: 296.

Geoffrey Clements, courtesy Claes Oldenburg and Coosje van Bruggen: 74 left.

© The Joseph and Robert Cornell Memorial

Foundation, 56, 57, 59, 60, 61.

J. Cornelis, 1972, courtesy Maria Gilissen: 68 bottom.

D. James Dee, courtesy Ronald Feldman Fine Arts, Inc.: 188.

Courtesy Jan Dibbets: back cover, top, 114 top and bottom.

© Marcel Duchamp, ARS, New York/ADAGP, Paris, 1998: front cover, frontispiece, 51, 52 top, center, and bottom, 53, 55 top left and right, center left and right, and bottom.

© El Lissitzky, 1999 Artists Rights Society (ARS), New York/VG Bild-Kunst, Bonn.

© Elliott Erwitt: 32, 33 top and bottom, 34, 35.

Mike Fear Photography: 240.

© Courtesy Richard Feigen & Co., New York: 60.

© Larry Fink: 176, 177, 178, 179, 180, 181.

Courtesy Andrea Fraser: 163 top and bottom, 165 top, center, and bottom.

© 1980 General Idea: 175.

Maria Gilissen, courtesy Maria Gilissen: 65 top and bottom, 66 top, 67 top, 68 top, 69 top.

Courtesy Maria Gilissen: 63 left, 60 bottom.

Courtesy Gilman Paper Company: 30, 31.

Courtesy Marian Goodman Gallery, New York: 91.

© 1999 Richard Hamilton/DACS, London/Artists Rights Society (ARS, New York), 110, 111.

David Heald and Carmelo Guadagno, © Solomon R. Guggenheim Museum, New York: 110 left and right, 111 right.

Courtesy Thomas Healy Gallery, New York: 167 top and bottom.

Michael Herling/Uwe Vogt: back cover, center, 47.

Hickey-Robertson, Houston, courtesy The Menil Collection, Houston: 57 bottom.

Martha Holmes, courtesy Claes Oldenburg and Coosje van Bruggen: 72 (all).

Konstantinos Ignatiadis, Paris, courtesy Lisson Gallery, London: 147.

Intercolor, courtesy Stedelijk van Abbemuseum, Eindhoven: 115.

Brad Iverson, courtesy The Gilbert and Lila Silverman Fluxus Collection Foundation, Detroit, Michigan: 82, 83.

© Jarnoux-Paris-Match: 269.

Courtesy Georg Kargl, Vienna: 101.

Kate Keller, The Museum of Modern Art, New York: 219, 225, 226, 230, 232, 238.

Jennifer Kotter, The Museum of Modern Art, New York: 189.

© 1998 Kunsthaus, Zurich. All rights reserved: 77, 78 top and bottom, 79 top and bottom.

Courtesy Louise Lawler: 142, 143 top left and right, bottom.

Courtesy Robert Lehrman, Washington, D.C.: 56 bottom left, 57 top.

Courtesy Sherrie Levine: 140 top, center, and bottom, 141 top left and right, bottom left and right.

Courtesy Locks Gallery, Philadelphia: 56 top.

© Richard K. Loesch, courtesy Mark Dion: 100 bottom.

Courtesy Louisiana Museum of Modern Art, Humlebaek, Denmark: 111 left.

Courtesy Allan McCollum: 144, 145.

© Christian Milovanoff: 130 top and bottom left, right, 131 left, top and bottom right.

Studio Müller and Schmitz, Remscheid, courtesy Wolfgang Feelisch: 133 bottom right.

© Vik Muniz: front and back cover, 134 left and right, 135 left and right.

Courtesy Musée d'Art Moderne de Saint-Etienne: 146.

Courtesy Museum of Contemporary Art, San Diego: 87, 129 bottom left and right.

© 1998 The Museum of Modern Art, New York: 56 bottom right, 59 left and right, 61, 103 top, 125, 127, 159.

Courtesy Claes Oldenburg and Coosje van Bruggen: 75.

Courtesy Maureen Paley/Interim Art: 169 left.

Courtesy Pennsylvania Academy of the Fine Arts, Philadelphia: 45.

Adam Reich, courtesy Zoe Leonard and Paula

Cooper Gallery, New York: 36, 37.

© RMN-G. Biot/J. Schormans: 192, 193.

J. Romero, courtesy Maria Gilissen: 63 right, 67 bottom.

The Royal Photographic Society Picture Library, Bath: 28, 29.

© 1989 Ken Schles, courtesy Gorney, Bravin & Lee, New York: 80, 81 top, upper center, lower center, bottom.

© David Seymour, Magnum Photos, Inc./Courtesy Magnum Photos, Inc., New York: 40.

Courtesy Sonnabend Gallery, New York: 103 bottom, 104 top and bottom, 105 top and bottom, 120, 121, 122, 123 top and bottom.

Sprengel Museum, Hannover, Germany: 49 top and bottom.

Lee Stalsworth, courtesy Hirshhorn Museum and Sculpture Garden, Smithsonian Institution, Washington, D.C.: 191.

© Thomas Struth, Düsseldorf, courtesy Museum of Fine Arts, Boston: 117.

© Thomas Struth, Düsseldorf, courtesy Charles

Heilbronn, New York: 118.

© Thomas Struth, Düsseldorf, courtesy Marian Goodman Gallery, New York: back cover, bottom, 119.

David Sundberg, New York, courtesy Dennis Oppenheim: 85.

Nic Tenwiggenhorn: 70 bottom, 71 top and bottom.

V&A Picture Library, London: 26, 27.

Courtesy Ronny Van de Velde, Antwerp, Belgium: 53, 55 top right, center left and right, and bottom.

Courtesy Galeria Camargo Vilaça, São Paulo, Brazil: 161.

Elke Walford, Fotowerkstatt, Hamburger Kunsthalle, courtesy Yvon Lambert, Paris: 90.

© Jeff Wall, courtesy Marian Goodman Gallery, New York: 196-197.

Courtesy Gillian Wearing: 169 right top and bottom.

Courtesy John Weber Gallery, New York: 89 top, bottom left, and bottom right, 152 top, bottom left and right, 153, 155.

Steve White, courtesy Book Works, London: 93 top and bottom.

Christopher Williams, courtesy the artist and Luhring Augustine Gallery, New York: 107 top and bottom, 108 top and bottom, 109 top and bottom.

© 1995 Ellen Page Wilson, courtesy Claes Oldenburg and Coosje van Bruggen: 74 right.

Ellen Page Wilson, courtesy PaceWildenstein, New York: 288.

© The Estate of Garry Winogrand, courtesy The Museum of Modern Art, New York: 182, 183, 187.

© The Estate of Garry Winogrand, courtesy Fraenkel Gallery, San Francisco: 182, 183, 184, 185, 186, 187.

E. Woodman, courtesy Susan Hiller: 92.

John Wronn, © 1998 The Museum of Modern Art, New York: 51, 52 top, center, and bottom, 55 top left, 126.

Courtesy Mel Ziegler: 129 top.

Jim Shaw. *You Break It, You Bought It*. 1986. Gouache and watercolor on paper, cracked glass,
17 x 14" (43.2 x 35.6 cm). Collection Judy and Stuart Spence, South Pasadena, California.